NATIONAL GALLERY OF ART
KRESS FOUNDATION STUDIES
IN THE HISTORY OF EUROPEAN ART

NUMBER FOUR

FRANS HALS

BY SEYMOUR SLIVE

Φ

PHAIDON

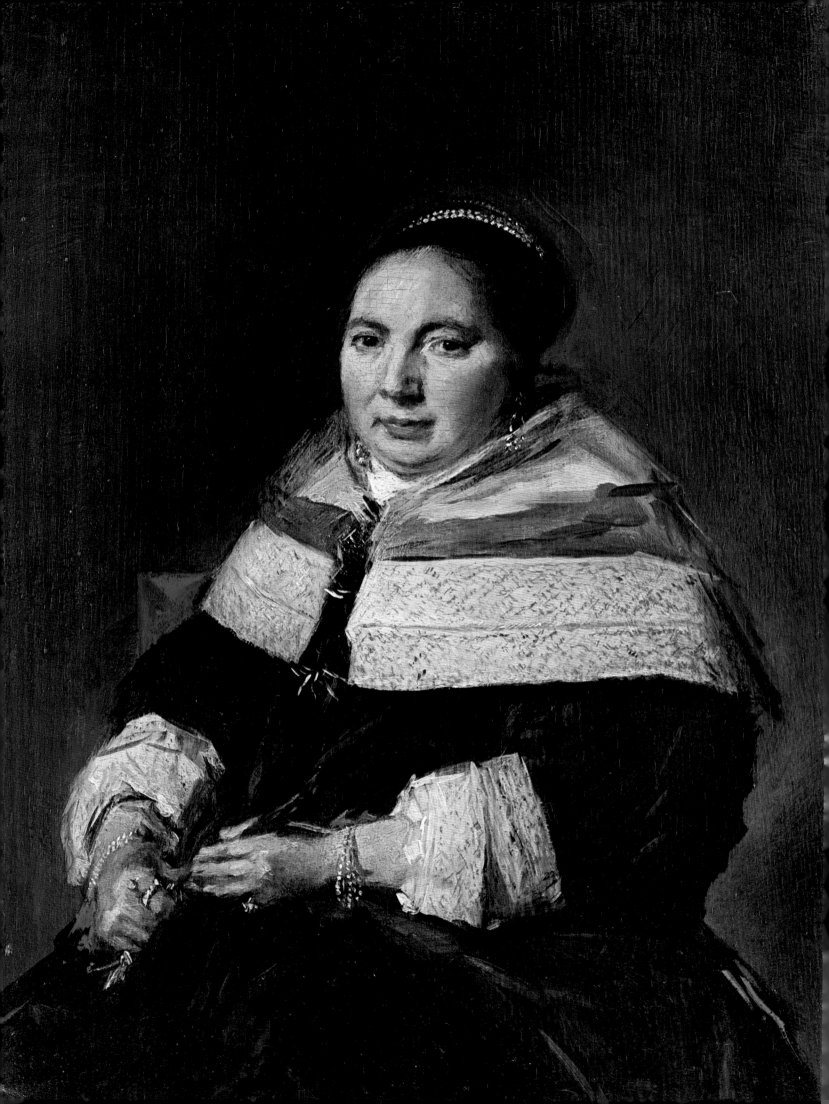

NATIONAL GALLERY OF ART : KRESS FOUNDATION
STUDIES IN THE HISTORY OF EUROPEAN ART

Frans Hals

SEYMOUR SLIVE

VOLUME THREE : CATALOGUE

 PHAIDON

ALL RIGHTS RESERVED BY PHAIDON PRESS LTD
5 CROMWELL PLACE · LONDON S.W.7
1974

PHAIDON PUBLISHERS INC · NEW YORK
DISTRIBUTORS IN THE UNITED STATES:
PRAEGER PUBLISHERS INC
111 FOURTH AVENUE · NEW YORK · N.Y. 10003

LIBRARY OF CONGRESS CATALOG
CARD NUMBER 71-112414

ISBN 0 7148 1443 1 (set of three volumes)
ISBN 0 7148 1447 4 (catalogue volume)

PRINTED BY WESTERN PRINTING SERVICES LIMITED · BRISTOL
COLOUR PLATE PRINTED BY HENRY STONE AND SON (PRINTERS) LTD · BANBURY

Contents

Preface

THE present volume is companion to *Frans Hals, Volume One: Text* and *Frans Hals, Volume Two: Plates*. Discussions in the Text Volume regarding the authorship, dating, and iconography of works attributed to Hals are based upon conclusions reached in this catalogue. The Plate Volume illustrates all the paintings catalogued in this volume as authentic.

The Catalogue is divided into three parts.

The first section comprises all works which I believe to be authentic, arranged in an order that approximates their invention. I have had the opportunity to examine most of them. Those known to me only from photographs or reproductions have been catalogued when I have found them consistent with the artist's originals. Damaged and extensively restored pictures have been included in cases when enough of the original design and paint layer remains to justify an attribution to the artist.

Lost and destroyed paintings which can be presumably ascribed to Hals, on the basis either of existing copies and variants or of other probative visual and documentary evidence, are catalogued in the second section. They have been grouped by subject (genre pictures, portraits of men, portraits of women) in an order that is approximately chronological.

The third section deals with paintings which, in my judgement, have a doubtful status or have been wrongly attributed to Hals. Apart from a few too poor to mention, an endeavour has been made to include all pictures which I believe have wrongly entered the literature as originals. Some of them may be copies or variants after unidentified works by Hals; when there is sufficient reason to entertain this possibility, it has been stated in the entries. Firm or tentative attributions have been offered for a small number of other works. However, most of them remain nameless. The paintings in this section have been grouped by subject, ordered by their relation to the main lines of Hals' stylistic development.

In my opinion, not one of the handful of drawings which have been attributed to Hals is autograph. They are here discussed in the entries that deal with the paintings to which they have been related.

Copies and variants in all media are listed with their models or prototypes.

A concordance and analytical indexes conclude the volume.

Harvard University, Fogg Art Museum S.S.
Cambridge, Massachusetts
August, 1972

Corrigenda

Text volume

p. 4, line 13, *read:* to Huis te Sevenberghe, a castle between Haarlem and Alkmaar

p. 23, line 20, *read:* the vanity of man's earthly life

p. 34, Fig. 16, *now:* Dienst voor 's-Rijks Verspreide Kunstvoorwerpen

p. 34, line 4, *read:* Vastenavonts-Gasten; line 5, *read:* Vastenavond

p. 81, line 2, *read:* crock (Fig. 60).

p. 151, Fig. 158, *read:* The Hague, S. Holdan

p. 154, Fig. 159, *read:* Daniel van Aken (Plate 211)

p. 160, line 35, *read:* professor of theology at Utrecht University

Plate volume

LIST OF PLATES

Amsterdam, 144, *read:* Sara Wolphaerts van Diemen

Cape Town, 249, *read:* 75·9×62·5 cm.

Dijon, 24, *read:* 89×76 cm.

Dublin, 117, *read:* 72×58 cm.

Fort Worth, 241, *read:* 87·9×65·1 cm.

Haarlem, 124, *read:* Dated 1631.

London, Miss Jean Alexander: *now* National Gallery. 181, *read:* 83·4×68·1 cm. 194, *read:* 21×16·5 cm.

London, Baroness G. W. H. M. Bentinck-Thyssen-Bornemisza, 23: *now* Paris

London, Buckingham Palace, 109, *read:* 116·8×90·2 cm.

London, Wallace Collection, 52, *read:* 86×69 cm.

Lugano, 87, *read:* 83·5×67·5 cm.

Lugano, 279, *read:* 202×285 cm.

Munich, 56, *read:* 204·5×134·5 cm.

Formerly New York, Mrs. Charles S. Payson, 230: *now* Stockholm, National Museum

Oeiras, 63, *read:* 87×70 cm.

Paris, formerly A. Schloss, 319: *now* Oslo, Lud. G. Braathen. Panel, 27·9×22·8 cm.

Stettin, Museum: *now* Stiftung Preussischer Kulturbesitz, on loan to Kiel, Schloss Museum, Stiftung Pommern. 228, *read:* 79·2×65·3 cm.

Washington, 253, *read:* Portrait of a Seated Man (probably Willem Coymans)

White Plains, *read:* Henry Reichhold.

Zürich, 336, 339, *read:* (Cat. no. 219).

CAPTIONS

23. *now:* Paris, Baroness G. W. H. M. Bentinck-Thyssen-Bornemisza

144. *read:* Sara Wolphaerts van Diemen

181. *read:* Portrait of a Woman, possibly Marie (or Maria) Larp. London, National Gallery

194. *now:* London, National Gallery

228. *now:* Stiftung Preussischer Kulturbesitz, on loan to Kiel Schloss Museum, Stiftung Pommern

230. *now:* Stockholm, National Museum (since 1972)

253. *read:* Portrait of a Seated Man, possibly Willem Coymans

319. *now:* Oslo, Lud. G. Braathen

BIBLIOGRAPHY: ABBREVIATIONS

van der Aa	A. J. van der Aa, *a.o.*, *Biographisch Woordenboek der Nederlanden* . . . , 21 vols., Haarlem, 1852–78.
Baard 1967	Hendricus Petrus Baard, *Frans Halsmuseum*, Munich and Ahrbeck, Hannover, 1967.
Bartsch	Adam Bartsch, *Le Peintre Graveur*, 21 vols., Leipzig, 1854–70.
B.M.	*The Burlington Magazine.*
Bode 1883	W. Bode, *Studien zur Geschichte der holländischen Malerei*, Braunschweig, 1883.
Bode-Binder	Wilhelm v. Bode and M. J. Binder, *Frans Hals, sein Leben und seine Werke*, 2 vols., Berlin, 1914.
Bredius	Abraham Bredius, *Künstler-inventare; Urkunden zur Geschichte der holländischen Kunst des XVI^{ten}, XVII^{ten} und XVIII^{ten} Jahrhunderts*, 8 vols., The Hague, 1915–22.
Bredius-Rembrandt	Abraham Bredius, *Rembrandt: The Complete Edition of the Paintings*, 3rd ed., revised by H. Gerson, London-New York, 1969.
Elias	Johan E. Elias, *De vroedschap van Amsterdam, 1578-1795* . . . , 2 vols., Haarlem, 1903–05.
FARL	Frick Art Reference Library, New York.
Franken and Van der Kellen	Daniel Franken and J. Ph. van der Kellen, *L'oeuvre de Jan van de Velde*, Amsterdam-Paris, 1883; 2nd ed., with additions and corrections by Simon Laschitzer, Amsterdam, 1968.
G.B.A.	*Gazette des Beaux-Arts.*
Granberg 1911	Olof Granberg, *Inventaire Général des Trésors d'Art . . . en Suède*, vol. 1, Stockholm, 1911.
van Hall	H. van Hall, *Portretten van Nederlandse Beeldende Kunstenaars*, Amsterdam, 1963.
HdG	C. Hofstede de Groot, *Beschreibendes und kritisches Verzeichnis der Werke der hervorragendsten holländischen Maler des XVII. Jahrhunderts*, vol. III, Frans Hals . . . , Esslingen a.N.-Paris, 1910. English translation of vol. III by E. G. Hawke, London, 1910.
Hoet	Gerard Hoet, *Catalogus of naamlyst van schilderyen, met derzelver pryzen zedert een lange reeks van jaaren* . . . , 2 vols., The Hague, 1752.
Hollstein	F. W. H. Hollstein, *Dutch and Flemish Etchings, Engravings and Woodcuts*, Amsterdam, 1949——.
Houbraken	A. Houbraken, *De Groote Schouburgh der Nederlantsche Konstschilders en Schilderessen*, 3 vols., Amsterdam, 1718–21.
Hubbard 1956	R. H. Hubbard, *European Paintings in Canadian Collections: Earlier Schools*, Toronto, 1956.
Icon. Bat.	E. Moes, *Iconographia Batava*, 2 vols., Amsterdam, 1897–1905.
KdK 1921	W. R. Valentiner, *Frans Hals . . . in 318 Abbildungen mit einer Vorrede von Karl Voll* (*Klassiker der Kunst*, vol. XXVIII), Stuttgart-Berlin, 1921.
KdK	W. R. Valentiner, *Frans Hals . . . in 322 Abbildungen mit einer Vorrede von Karl Voll* (*Klassiker der Kunst*, vol. XXVIII), 2nd revised edition, Stuttgart-Berlin-Leipzig, 1923.
Lugt	Frits Lugt, *Répertoire des catalogues de ventes publiques*, 3 vols., The Hague, 1938–64.
Moes	E. W. Moes, *Frans Hals, sa vie et son oeuvre*. Traduit par J. de Bosschere. Brussels, 1909.
Molhuysen	P. G. Molhuysen, Fr. K. H. Kossmann, *a.o.*, *Nieuw Nederlandsch Biografisch Woordenboek*, 10 vols., Leiden, 1911–37.
Muller	F. Muller, *Beschrijvende catalogus van 7000 portretten, van Nederlanders, en buitenlanders, tot Nederland in betrekking staande* . . . , Amsterdam, 1853.
N.K.J.	*Nederlands Kunsthistorisch Jaarboek.*
O.H.	*Oud-Holland: Nieuwe Bijdragen voor de Geschiedenis der Nederlandsche Kunst, Letterkunde, Nijverheid, enz.*
RKD	Rijksbureau voor Kunsthistorische Documentatie, The Hague.
Siccama	W. Hora Siccama, *Louis Bernard Coclers*, Amsterdam, 1895.
Slive	Seymour Slive, 'Frans Hals Studies: I. Juvenilia; II. *St. Luke* and *St. Matthew* at Odessa; III. Jan Franzoon Hals', *O.H.*, LXXVI, 1961, pp. 173–200.

Someren J. F. van Someren, *Beschrijvende catalogus van gegraveerde portretten van Nederlanders . . . vervolg op Frederik Mullers Catalogus van 7000 portretten van Nederlanders . . .*, 3 vols., Amsterdam, 1888–91.

Terwesten Pieter Terwesten, *Catalogus of naamlyst van schilderyen, met derzelver pryzen, zedert den 22. Aug. 1752 tot den 21. Nov. 1768 . . . verkogt . . .*, The Hague, 1770.

Trivas N. S. Trivas, *The Paintings of Frans Hals*, London-New York, 1941.

Valentiner 1925 W. R. Valentiner, 'The Self Portraits of Frans Hals', *Art in America*, XIII, 1925, pp. 148–54.

Valentiner 1928 W. R. Valentiner, 'Rediscovered Paintings by Frans Hals', *Art in America*, XVI, 1928, pp. 235–49.

Valentiner 1935 W. R. Valentiner, 'New Additions to the Work of Frans Hals', *Art in America*, XXIII, 1935, pp. 85–103.

Valentiner 1936 W. R. Valentiner, *Frans Hals Paintings in America*, Westport, Connecticut, 1936.

Waagen (G. F.) Waagen, *Treasures of Art in Great Britain . . .*, 3 vols., London 1854; supplemental volume, London 1857.

Waagen, Ermitage, Gustav Friedrich Waagen, *Die Gemäldesammlung in der Kaiserlichen Ermitage zu St. Peters-*
1864 *burg . . .*, Munich, 1864.

Wessely J. E. Wessely, *Wallerant Vaillant. Verzeichnis seiner Kupferstiche und Schabkunstblätter*, 2nd ed., Vienna, 1881.

Weyerman J. C. Weyerman, *De levensbeschryvingen der Nederlandsche Kunstschilders*, 4 vols., The Hague, 1729–69.

Witt Witt Library, Courtauld Institute, University of London.

Wurzbach A. von Wurzbach, *Niederländisches Künstler-Lexikon*, 3 vols., Vienna-Leipzig, 1906–11.

Wussin M. J. Wussin, *Jonas Suyderhoef, son oeuvre gravé . . .*, traduit de l'allemand, annoté et augmenté par H. Hymans, Brussels, 1863.

EXHIBITIONS: ABBREVIATIONS

Allentown 1965 *Seventeenth-Century Painters of Haarlem*, Allentown Art Museum, Allentown, Pennsylvania, 2 April–13 June 1965.

Amsterdam 1906 *Catalogue . . . de Maîtres Hollandais du XVII^e Siècle organisée par Mon. F. Muller . . . en l'honneur . . . Rembrandt*, Amsterdam, 10 July–15 September, 1906.

Amsterdam 1950 *120 Beroemde Schilderijen uit het Kaiser-Friedrich Museum te Berlijn*, Rijksmuseum, Amsterdam, 17 June – 17 September 1950.

Amsterdam 1952 *Drie Eeuwen Portret in Nederland*, Rijksmuseum, Amsterdam, 29 June – 5 October 1952.

Baltimore 1941 *A Century of Baltimore Collecting: 1840–1940*, The Baltimore Museum of Art, Baltimore, Maryland, 6 June – 1 September 1941.

Bristol 1946 *Exhibition of Dutch Old Masters*, Red Lodge, Park Row, Bristol, 14 March – 6 April 1946.

Brussels 1946 *De hollandsche schilderkunst van Jeroen Bosch tot Rembrandt*, Palais des Beaux-Arts, Brussels, 2 March – 28 April 1946.

Brussels 1971 *Rembrandt en zijn tijd*, Palais des Beaux-Arts, Brussels, 23 September – 21 November 1971.

Cape Town 1952 *Exhibition of XVII Century Dutch Painting*, National Gallery of South Africa, Cape Town, 1952.

Chicago 1933 *A Century of Progress Exhibition of Paintings and Sculpture*, The Art Institute of Chicago, Chicago, 1 June – 1 November 1933.

Chicago 1934 *A Century of Progress Exhibition of Paintings and Sculpture*, The Art Institute of Chicago, Chicago, 1 June – 1 November 1934.

Chicago 1942	*Paintings by the Great Dutch Masters of the Seventeenth Century*, The Art Institute of Chicago, Chicago, 18 November – 16 December 1942.
Cleveland 1936	*Catalogue of the Twentieth Anniversary Exhibition of the Cleveland Museum of Art Exhibition of the Great Lakes Exposition*, The Cleveland Museum of Art, Cleveland, 26 June – 4 October 1936.
Detroit 1925	*Loan Exhibition of Dutch Paintings of the Seventeenth Century*, Detroit Institute of Arts, 9–25 January 1925.
Detroit 1929	*Catalogue of a Loan Exhibition of Dutch Genre and Landscape Painting*, The Detroit Institute of Arts, Detroit, 16 October – 10 November 1929.
Detroit 1935	*An Exhibition of Fifty Paintings by Frans Hals*, The Detroit Institute of Arts, Detroit, 10 January – 28 February 1935.
Haarlem 1937	*Frans Hals Tentoonstelling ter gelegenheid van het 75-jarig bestaan van het Gemeentelijk Museum te Haarlem*, Frans Hals Museum, Haarlem, 1 July – 30 September 1937.
Haarlem 1962	*Frans Hals Exhibition on the Occasion of the Centenary of the Municipal Museum at Haarlem*, Frans Hals Museum, Haarlem, 16 June – 30 September 1962.
The Hague 1903	*Catalogus van de Tentoonstelling van Oude Portretten*, Haagsche Kunstkring, The Hague, 1 July – 1 September 1903.
Indianapolis 1937	*Dutch Paintings of the Seventeenth Century*, The John Herron Art Museum, Indianapolis, Indiana, 27 February – 11 April 1937.
Indianapolis-San Diego 1958	*The Young Rembrandt and His Times*, John Herron Art Museum, Indianapolis—The Fine Arts Gallery, San Diego, 1958.
London 1929	*Exhibition of Dutch Art, 1450–1900*, Royal Academy, London, 4 January – 9 March 1929.
London 1938	*Exhibition of 17th-Century Art in Europe*, Royal Academy of Arts, London, 13 January – 12 March 1938.
London 1945	*Dutch Paintings of the 17th Century*, Arts Council of Great Britain, London, 1945.
London 1949	*Masterpieces of Dutch and Flemish Painting . . . for the Benevolent Fund of . . . British Picture Restorers*, E. Slatter, London, 16 February – 16 March 1949.
London 1952–53	*Dutch Pictures: 1450–1750*. Winter Exhibition, Royal Academy of Arts, London, 1952–1953.
London, National Gallery 1961	*From Van Eyck to Tiepolo: An Exhibition of Pictures from the Thyssen-Bornemisza Collection . . .*, National Gallery, London, 2 March – 20 April 1961.
Los Angeles 1947	*Frans Hals-Rembrandt*, Los Angeles County Museum, Los Angeles, 18 November – 31 December 1947.
Lugano 1949	*Aus dem Besitz der Stiftung Sammlung Schloss Rohoncz*, Ausstellung in der Villa Favorita, Castagnola-Lugano, 1949.
Manchester 1929	*Dutch Old Masters*, Art Gallery, Manchester, 27 March – 4 May 1929.
Manchester 1957	*European Old Masters . . . Commemorating the Famous Exhibition, The Art Treasures of the United Kingdom, held in Manchester in 1857*, Art Gallery, Manchester, 30 October – 31 December 1957.
Milan 1954	*Mostra di pittura olandese del seicento*, Palazzo Reale, Milan, 25 February – 25 April 1954.
Montreal 1944	*Five Centuries of Dutch Art*, Art Association, Montreal, 9 March – 9 April 1944.
Munich 1930	*Sammlung Schloss Rohoncz*, Ausstellung Neue Pinakothek, Munich, 1930.
New York, Hudson-Fulton Celebration, 1909	*The Hudson-Fulton Celebration: Catalogue of an Exhibition Held in The Metropolitan Museum of Art*, vol. I, Metropolitan Museum of Art, New York, September to November, 1909.
New York 1937	*Paintings by Frans Hals, Exhibition for the benefit of . . . New York University*, Schaeffer Galleries, Inc., New York, 9–23 November 1937.
New York 1939	*Catalogue of European Paintings and Sculpture from 1300–1800, Masterpieces of Art*, New York World's Fair, New York, May to October, 1939.
New York 1940	*Catalogue of European and American Paintings: 1500–1900, Masterpieces of Art*, New York World's Fair, New York, May to October, 1940.

New York, *Dutch Painting: The Golden Age, an Exhibition of Dutch Pictures of the Seventeenth Century,*
 Toledo, Toronto The Metropolitan Museum of Art, The Toledo Museum of Art, The Art Gallery of
 1954–55 Toronto, 1954–55.

Oslo-Bergen 1955 *Gamle Mestere, Malerier fra Alte Pinakothek München og Wallraf Richartz-Museum Köln,*
 Oslo-Bergen, 1955.

Paris 1921 *Exposition Hollandaise,* Musée National du Luxembourg, Paris, April – May 1921.

Paris 1955 *Chefs-d'Oeuvre du Musée de Cologne,* Musée de l'Orangerie, Paris, 1955.

Paris 1960 *Exposition de 700 Tableaux de toutes les Écoles antérieurs à 1800 tirés des Réserves du Département
 des Peintures,* Louvre, Paris, 1960.

Paris 1970 *Choix de la Collection Bentinck,* Institut Néerlandais, Paris, 20 May – 28 June 1970.

Paris 1970–71 *Le siècle de Rembrandt. Tableaux hollandais des collections publiques françaises,* Musée du Petit
 Palais, Paris, 17 November 1970 – 15 February 1971.

Providence 1938 *Dutch Painting in the Seventeenth Century,* Rhode Island School of Design, Providence, 1938.

Raleigh 1959 *Masterpieces of Art: W. R. Valentiner Memorial Exhibition,* North Carolina Museum of Art,
 Raleigh, 6 April – 17 May 1959.

Rome 1928 *Mostra di Capolavori della Pittura Olandese,* Galleria Borghese, Rome, 1928.

Rome 1954 *Mostra di Pittura Olandese del Seicento,* Palazzo delle Esposizioni, Roma, 4 January – 14
 February 1954.

Rome 1956–57 *Le XVIIᵉ Siècle Européen,* Palais des Expositions, Rome, December 1956 – January 1957.

Rotterdam 1938 *Meesterwerken uit Vier Eeuwen: 1400–1800 . . . Schilderijen . . . uit Particuliere Verzamelingen
 in Nederland,* Museum Boymans, Rotterdam, 25 June – 15 October 1938.

Rotterdam 1955 *Kunstschatten uit Nederlandse Verzamelingen,* Museum Boymans, Rotterdam, 19 June – 25
 September, 1955.

Rotterdam-Essen *Collectie Thyssen-Bornemisza (Schloss Rohoncz),* Museum Boymans-van Beuningen, Rotter-
 1959–60 dam, 14 November – 3 January 1960 (also shown in Museum Folkwang, Essen, 1960).

San Francisco 1939 *Masterworks of Five Centuries,* Golden Gate International Exposition, San Francisco, 1939.

San Francisco 1940 *Art: Official Catalogue, Golden Gate International Exposition,* San Francisco, 1940.

San Francisco, *The Age of Rembrandt. An Exhibition of Dutch Paintings of the Seventeenth Century,* California
 Toledo, Boston Palace of the Legion of Honor, The Toledo Museum of Art, Museum of Fine Arts, Boston,
 1966–67 1966–67.

Schaffhausen 1949 *Rembrandt und seine Zeit,* Ausstellung Museum zu Allerheiligen, Schaffhausen, April–
 October, 1949.

Tokyo-Kyoto *The Age of Rembrandt: Dutch Paintings and Drawings of the 17th Century,* The National
 1968–69 Museum of Western Art (Tokyo), Kyoto Municipal Museum, 1968–69.

Utrecht-Antwerp *Caravaggio en de Nederlanden,* Centraal Museum, Utrecht-Koninklijk Museum voor Schone
 1952 Kunsten, Antwerp, 1952.

Zürich 1953 *Holländer des 17. Jahrhunderts,* Kunsthaus, Zürich, 4 November – 20 December, 1953.

Catalogue

PAINTINGS BY FRANS HALS

1. **Jacobus Zaffius** (Plate 1; text, pp. 12, 23, 24, 26).
Haarlem, Frans Hals Museum (Cat. 1924, no. 486).
Panel, 54·6×41·2 cm. Inscribed and dated below the coat-of-arms on the left; AETATIS SVAE/77 AN° 1611.

PROVENANCE: According to a note in KdK 3 it was 'discovered in 1919 by the London art dealer H. M. Clark'. Acquired by the Frans Hals Museum in 1920 as a gift from Mr. and Mrs. Philips-de Jongh, Eindhoven.
EXHIBITIONS: Haarlem 1937, no. 1; Haarlem 1962, no. 3.
BIBLIOGRAPHY: *Icon. Bat.*, no. 9378; Moes 86; HdG 245; Bode-Binder 298; S. Kalff, 'Eene vroege Schilderij van Frans Hals', *Oude Kunst*, V (1919–20), pp. 265ff.; G. D. Gratama, 'Le Portrait de Jacobus Zaffius par Frans Hals', *La Revue d'Art*, XXIII (1922), pp. 60–65 and in *Onze Kunst*, XXXIX (1922), pp. 36–40; KdK 3; Slive 1961, pp. 173f.; Baard 1967, p. 39.

Jacobus Zaffius (1534–1618) was made Abbot of the Augustine Monastery at Heiloo in 1568. Three years later he was invested in St. Bavo's Cathedral at Haarlem as Provost and Arch-Deacon of the Episcopal Chapter. Hals' unsigned portrait of him, the earliest extant dated work which can be attributed to the artist, is a fragment. The identification is based upon a reversed engraving of the portrait by Jan van de Velde (c. 1593–1641) inscribed AETA 84 [the age Zaffius attained the year he died] . . . *F. Hals/ pinxcit . . . J. V. Velde/sculpsit anno/1630* (text, Fig. 6; Franken and Van der Kellen 44). The engraving represents Zaffius seated in an armchair at a table with his left hand resting on a skull, a commonplace *vanitas* symbol (see text, p. 23f.). If Van de Velde's print is an accurate copy of the portrait—and to judge by his exact copies after five other known paintings by Hals (Cat. nos. 36, 38, 47, 57, 76), there is no reason to believe it is not—the coat-of-arms and inscription originally on the portrait were cut away when it was reduced in size, and the present arms and inscription were added after it was mutilated.
The pasty pinks and rose colour of the flesh recall the palette used by Hals' teacher Van Mander and other Haarlem mannerists, but Zaffius' intense expression, the suggestion of cast daylight upon the solid form of his head, and the detached brushwork are indications of the artist's future development.
Valentiner attempted (KdK 1921, 1 repr.; KdK 1, repr.) to push back the date of the artist's earliest known dated

painting a year by attributing to him the *Portrait of a Man* of 1610 at the Städelsches Kunstinstitut, Frankfurt (inv. no. 178), (see reproduction opp. p. 54 below). The Frankfurt portrait is ascribed in the 1966 Städel catalogue (p. 74) to a 'Holländischer Meister, um 1610, aus der Umgebung des Frans Hals'. It appears, however, to be the effort of an anonymous Flemish painter who emulated the dry impasto but missed the glowing glazes and fluency of the vigorous portraits Rubens made after his return to Antwerp. Van Dyck succeeded in assimilating these aspects of Rubens' style in the robust portraits he precociously painted around 1616–18: e.g., *Jan Vermeulen*, 1616, Vaduz, Liechtenstein Collection; *Portrait of a Man*, Oberlin, Ohio, Allen Memorial Art Museum, Cat. 1967, no. 44.28; the pendant portraits of a man and woman at Dresden, nos. 1023c, 1023d; *Portrait of a Man*, Brunswick, Herzog-Anton-Ulrich Museum (text, Fig. 109). The last named-portrait was ascribed by earlier cataloguers and by the compiler of the 1969 Brunswick catalogue (p. 119, no. 86) to Rubens; however, I find Cornelius Müller-Hofstede's attribution of it to young Van Dyck fully convincing (cf. *Kunstchronik*, IV [1951], pp. 242–243). For a note on Hals' possible contact with Rubens' works before he made his 1616 trip to Antwerp, see Cat. no. 3.

2. **Portrait of a Man Holding a Skull** (Plates 2, 4; text, pp. 24, 51). Birmingham, The Barber Institute of Fine Arts.
Panel, 94×72·5 cm. Unidentified coat-of-arms in the upper right flanked by the inscription: . . . ITA MORI/AETAT SVAE 60.

PROVENANCE: Before 1914 in the collection of Mrs. Yves of Moynes Park, Halsted. She gave the following account of its earlier history in a letter which is cited in the *Catalogue of the Paintings, Drawings and Miniatures in the Barber Institute of Fine Arts, University of Birmingham*, Cambridge, 1952, p. 58: 'The picture came to me through my mother's father Mr. Patrick Murray, who inherited from Patrick [Murray], 5th Lord Elibank, who died in 1778. I have always heard that it came into Lord Elibank's possession by his marriage with Maria Margaretta, daughter of Cornelius de Young, Lord of Elmeat (of the house of La Marck) and Receiver General of the United Provinces. She was the widow of Lord North and Grey and died in 1762.' About

1914 the picture was sold by the dealers Messrs. Sulley, London, to Ayerst H. Buttery, and it passed to his son Horace A. Buttery. It appeared in a sale at Christie's, 14 May 1926, no. 75, but was presumably bought in, as it was still owned by Buttery in 1929 and 1937. Purchased by the Barber Institute of Fine Arts from Mr. H. A. Buttery in 1938.

EXHIBITIONS: London 1929, no. 116; Haarlem 1937, no. 7 (1620–26); London 1952–53, no. 68; Haarlem 1962, no. 1.

BIBLIOGRAPHY: Bode-Binder 88; KdK 4 (c. 1610–12); Trivas 2 ('. . . obviously connected with the period of the first group portrait of 1616 . . . whether it was executed a few years earlier or later remains a matter of conjecture'). *Catalogue of the Paintings, Drawings and Miniatures in the Barber Institute of Fine Arts*, University of Birmingham, Cambridge, 1952, p. 58.

Companion piece to Cat. no. 3. A cleaning of the picture around 1938 revealed the coat-of-arms. At that time it was suggested that the arms belonged to Bartout van Assendelft (ca. 1558–1622). This identification was based on the assumption that the coat-of-arms showed a white horse on a red shield, whereas in fact it is a white horse on a dark grey field. Moreover, neither the coat-of-arms nor the age of the woman in the pendant correspond with those of Assendelft's wife, Margriet van der Laan (cf. A. C. Sewter, 'A Frans Hals Portrait', *B.M.*, LXXXI [1942], p. 259).

The painting can be tentatively dated around 1611 on the basis of its similarity to *Jacobus Zaffius* (Cat. no. 1). The bold brush-work on the ruff already suggests Hals' characteristic touch. Other passages, where the attack is more timid, and the rigid pose, which shows the artist's connection with Dirck Barendsz. and Cornelis Ketel, justify dating the work a bit earlier than *Zaffius*, but until more is known about Hals' juvenilia it would be foolish to try to assign precise dates to the rare works of his first phase.

3. **Portrait of a Woman** (Plates 3, 5, 6; text, pp. 24, 51). Chatsworth, The Trustees of the Chatsworth Settlement. Panel, 94×71 cm. Unidentified coat-of-arms in upper left corner flanked by the inscription: AETA SVAE 32(?); the last digit has been read as a 7 by some students.

PROVENANCE: The Duke of Devonshire owns two portraits by Hals, this one and a *Portrait of a Man*, 1622 (Cat. no. 18). According to Dodsley's *London and its Environs*, 1761 (vol. II, p. 120 and p. 230), a Hals was in the collection of the 3rd Earl of Burlington, at Chiswick Villa, in 1761, while another was in the possession of the Duke of Devonshire, at Devonshire House, Piccadilly, in the same year; but regrettably there is no indication which portrait is referred to in each case (this reference kindly provided by T. S. Wragg, Keeper of the Devonshire Collections).

EXHIBITIONS: London 1929, no. 53; London 1952–53, no. 69; Haarlem 1962, no. 2.

BIBLIOGRAPHY: Bode 1883, 145 (ca. 1628); S. A. Strong, *The Masterpieces in the Duke of Devonshire Collection*, 1901, no. 27; Moes 197; HdG 382 (c. 1630–35); Bode-Binder 91; KdK 1921, 14 (c. 1619); KdK 48 (c. 1626–28); Trivas 3 ('. . . little doubt of its being executed in the period 1615–18'); Sturla J. Gudlaugsson, 'Zur Frans-Hals-Ausstellung in Haarlem: Juni–September 1962', *Kunstchronik*, XVI, pp. 8–9 ('questionable if it is a companion picture to the Birmingham portrait and perhaps painted after Hals' 1616 trip to Antwerp').

Despite slight differences in style between the painting and Cat. no. 2, I accept the suggestion, first made by the compilers of the catalogue of the 1929 Royal Academy Exhibition of Dutch Art, that the portrait is a pendant to the Barber Institute painting.

Although Valentiner's date of about 1626–28 for this portrait is much too late, the possibility that it was painted a few years after its companion piece cannot be ruled out; for a later example cf. Cat. no. 98. The luminous flesh tints in the woman's portrait recall those in Rubens' works; they are not found in the pendant at Birmingham. Perhaps the portrait of the woman was painted after Hals had a chance to study works by the Flemish master. However, I do not think there is reason to insist that the portrait was painted after Hals' trip to Antwerp in 1616 (see Gudlaugsson, *op. cit.*). Similar gleaming flesh tones are also found in Hals' *St. George Militia Company* of 1616 (Cat. no. 7), which is known to have been painted before his Antwerp trip. To judge from it, Hals knew something about what Flanders' leading artist was painting before he made his only documented journey to Antwerp.

This supposition gains strength in the light of J. G. van Gelder's findings about Rubens' contacts with Holland around this time ('Rubens in Holland in de Zeventiende Eeuw', *N.K.J.*, 1950–51, cf. pp. 117–128). Van Gelder shows that Rubens' works were known in the northern Netherlands shortly after the Truce of 1609 was signed. Rubens' *Supper at Emmaus* (St.-Eustache Church, Paris) was probably in Holland by 1611. The engraving of it made in 1611 by the Leiden printmaker Willem Swanenburg bears a Latin verse written by the Haarlem poet and historian Petrus Scriverius (who commissioned portraits from Hals in 1626, Cat. nos. 36, 37; Plates 60, 61) which indicate that the painting belonged to De Man, a collector who lived in Delft. In the following year Swanenburg engraved Rubens' lost *Lot and His Daughters*; the location of the painting in 1612 is not known but since Swanenburg died at Leiden on 15 August 1612 the probability that it too was engraved in Holland is great. There is also excellent reason to believe that Rubens himself went to Haarlem in 1613 (cf. W. Stechow, 'Zu Rubens' erster Reise nach Holland', *O.H.*, XLIV (1927), pp. 138–139) to look for a printmaker who could do justice to the quality of the copies he wanted made of his paintings. Apparently the Haarlem engraver Jacob Matham filled the bill. Around 1613 he

made an engraving after *Samson and Delilah* which Rubens painted for his friend and patron Burgomaster Nicolaes Rockox (the picture is now in the possession of the heirs of the late Gottfried Neuerburg, Cologne). Matham dedicated the print to Rockox and his inscription states the painting can be seen in his home in Antwerp. Did Matham make his engraving in Antwerp or in Holland? Until the recent reappearance of a modello for the painting (sale, property of a gentleman, London (Christie) 25 November 1966, no. 66, £25,200) it seemed reasonable to assume that Matham engraved it in Antwerp and may even have accompanied Rubens on his return trip to the city. However, close similarities between the modello and the print indicate that Matham based his engraving on it rather than on the finished work. The small modello (panel, 53·3 × 59 cm.) may have been sent north and engraved in Haarlem. It is also possible that etchings dated *ca.* 1612–13 and cautiously attributed to Buytewech by E. Haverkamp Begemann (*Willem Buytewech*, Amsterdam, 1959, p. 7) were also done in Haarlem after the Flemish master's paintings.

4. Portrait of a Man Holding a Medallion (Plate 14; text, pp. 27, 43–44). Brooklyn, The Brooklyn Museum (inv. no. 32.821).

Canvas, 74·5 × 57 cm. Unidentified coat-of-arms in upper right.

PROVENANCE: Sale J. J. van Alen, Amsterdam (Muller) 22 November 1910, no. 59; dealer E. H. Govett, London, *ca.* 1914; acquired by the Brooklyn Museum in 1932 as a gift from Michael Friedsam, New York.
EXHIBITIONS: Haarlem 1937, no. 2; Haarlem 1962, no. 4; Allentown 1965, no. 36.
BIBLIOGRAPHY: Bode-Binder 90; KdK 1921, 5 left (*c.* 1612–14); KdK 6 left (*c.* 1615); Valentiner 1936, 1 (*c.* 1612–1614).

Probably painted shortly before the *St. George Militia Company* of 1616 (Cat. no. 7). The painted surface is thin and generally abraded. Extensive restoration is apparent in the shadows on the face and the background.
The trick of representing a sitter with his hand poking out beyond a simulated frame was popularized in the Netherlands by mannerist portrait engravers. The earliest use of this device for a life-size painted portrait appears to be Gerrit Pietersz. Sweelinck's portrait of his brother, the organist and composer *Jan Pietersz Sweelinck* (text, Fig. 9), which is now at the Gemeentemuseum, The Hague (*cf.* K. Bauch, 'Gerrit Pietersz Swelinck, der Lehrer Lastmans', *O.H.*, 55 [1938], pp. 263*ff.*). Hals continued to make use of this prop to heighten the illusionistic effect of his portraits until about 1640. His younger contemporaries, however, continued to use this *trompe l'oeil* trick; for example, Rembrandt's posthumous etched portrait of *Jan Cornelis Sylvius* of 1646 (text, Fig. 116; Bartsch 280) depicts the preacher with his arm extended beyond an etched stone frame.

5. Shrovetide Revellers (Plates 7–11, text, pp. 7, 33–36 38, 58, 67, 80, 94, 96, 152). New York, The Metropolitan Museum of Art (Cat. 1954, no. 14.40.605).

Canvas, 131·5 × 99·6 cm. Signed on the mug on the table with the monogram: f h (Fig. 53).

PROVENANCE: Perhaps identical with 'Een ryke Ordinantie van veel Beelden halver Lyf te zien, verbeeldende een Vasten-Avond Vreugd, Zeer Kragtig . . . door Frans Hals', canvas, 92·5 × 126 cm. (dimensions reversed?) which appeared in a sale, Amsterdam, 5 June 1765 (Terwesten, p. 457) no. 51 (fl. 35); Coll. Cocret, Paris; dealer F. Kleinberger, Paris, 1907; Benjamin Altman, New York, who bequeathed it to the museum in 1913.
EXHIBITIONS: Paris, Palais du Corps Législatif, 1874, no. 844; New York, Hudson-Fulton Celebration, 1909, no. 22a.
BIBLIOGRAPHY: Bode 1883, 75; Moes 208; HdG 141, possibly identical with HdG 137h; Bode-Binder 1; KdK 12 (*c.* 1616–20); Valentiner 1936, 3 (1616–17).

The only existing work by Hals which is monogrammed with lower case letters (*cf.* Fig. 53).
A cleaning in 1951 revealed that the five figures in the background had been painted out at a later date. It also revealed that someone found the gesture made by the man on the right offensive; it had been altered to show him holding a cane instead of his forefinger in his clenched fist. Reproductions of the painting before its restoration are found in Bode-Binder 1, plate 1 and KdK 12.
Evidence that cleaning would reveal the original state of the painting was published in 1914 when Bode-Binder reproduced the pen drawing made after it (text, Fig. 15) by Mathys van den Bergh (*ca.* 1617–87) in their catalogue of Hals' works (vol. 1, p. 23). Van den Bergh's drawing (31·8 × 23·1 cm, Institut Néerlandais, Fondation Custodia, Frits Lugt Coll., inv. no. 6310a) is signed: M. v. bergh fecit/1660; an inscription on the verso reads: Vastenavontsgasten. This identifies the celebrants as Shrovetide revellers; for a discussion of the Shrovetide symbolism in the painting and identification of two of the participants as 'Peeckelhaering' and 'Hanswurst', popular stock characters in theatrical farces of the time, see text, pp. 34–36.
Van den Bergh's drawing indicates that the painting may have been cut on the right and the top, and three painted variants of it by other hands suggest that it may have been cut on all four sides. The painted variants are:

1. Dirck Hals. Panel, 31·5 × 24 cm.; signed and dated 1637. Institut Néerlandais, Fondation Custodia, Frits Lugt Coll., inv. no. 2212 (Fig. 1). It is noteworthy that Dirck changed the dress of the seated young woman to one of the 1630's.

2. Imitator of Frans Hals. Coll. Stuart I. Borchard, New York, around 1953; Mrs. H. Metzger, New York (Fig. 2). The style of the painting suggests it was painted around the same time as the variant by Dirck Hals in the Lugt Collection.

3. Imitator of Frans Hals. Canvas, 67·5 × 51·5 cm. The Hague, Dienst voor 's-Rijks Verspreide Kunstvoorwerpen, inv. no. NK 1564, formerly dealer, D. Katz, Dieren (text, Fig. 16). Possibly identical with HdG 143. T. Borenius, ' "A Merry Company at Table" by Frans Hals' *Pantheon* VI (1930), p. 572, accepted it as authentic. The opinion that it is an autograph preliminary study for the New York painting was endorsed by Hofstede de Groot (*Art News Supplement*, 1928, p. 45) and Valentiner (*Art in America*, XVI (1928), p. 237); the painting was exhibited without question at Haarlem 1937, no. 4. However, its style bears only a superficial resemblance to Hals' original. M. Kauffmann rightly expressed doubts about the attribution soon after it was published (*O.H.*, XLVIII (1931), p. 228). The copyist, like Dirck, 'modernized' the dress of the seated young woman. In this variant she is wearing a costume which only became fashionable in the middle of the century; see Hals' portrait of *Isabella Coymans*, Plate 291. For references to the owl in this copy, see text, p. 152.

Dirck Hals incorporated the three central figures of the composition in his *Banquet in a Garden* of about 1620 at the Städelsches Kunstinstitut, Frankfurt (inv. no. 1587), and in a painting of the same subject made around the same time which is at the Louvre (RF. 3151). In the latter work (Fig. 3) there is one significant change; 'Hanswurst' is shown playing a violin. Kurt Erasmus vainly attempted to prove that the invention of this group belonged to Dirck and that the Metropolitan Museum picture is a forgery after Dirck's effort (*Cicerone* I [1909], p. 51). Bode (*ibid.*, p. 129) demolished Erasmus' hypothesis and appropriately called it a 'Nachtrag zum Lob der Narrheit'. Hals' 'Hanswurst' also appears as a violinist in an exuberant Flemish *Still-Life with Four Figures* (canvas, 148 × 205 cm.; sale, Paris (Palais Galliéra), 8 December 1964, no. 49). I. Q. van Regteren Altena ('Jan van den Bergh te Antwerpen', *O.H.*, LXXX, 1965, pp. 238, 240, fig. 1) has ascribed the game and fruit still life in this work to Frans Snyders, and tentatively attributed the violinist and the other three figures to the Haarlem artist Jan van den Bergh, who settled in Antwerp *ca.* 1617–20.

The central group attracted other good and less good copyists and many other variants on them done in Hals' time and later are known. The best are the two monogrammed red and black chalk drawings by Willem Buytewech which are at the Institut Néerlandais, Fondation Custodia, Frits Lugt Coll. (Figs. 4, 5). Although they are not faithful copies of Hals' 'Peeckelhaering' and 'Hanswurst', E. Haverkamp Begemann (*Willem Buytewech*, Amsterdam, 1958, nos. 27, 28) has been able to demonstrate conclusively that both are based on the Metropolitan Museum painting and are not preparatory studies for it. Haverkamp Begemann's convincing analysis of the relationship of the drawings to the painting as well as his characterization of Buytewech's achievement as a painter hopefully will lay to

rest the suggestion that the Metropolitan Museum picture can be ascribed to Buytewech. Buytewech's copies also provide a probable *terminus ante quem* for the painting. He left Haarlem for Rotterdam before August, 1617 (*ibid.*, p. 4); most likely his copies were made before he settled there.

In addition, Buytewech's drawing after Hals' 'Peeckelhaering' (Fig. 4) may offer a clue to an opaque reference to a joint effort between Hals and Buytewech. In describing portraits of the grandparents of the Haarlem painters Nicolaes and Jan (de) Kemp, a deed dated 6 November 1656 states that the 'counterfeijtsels sijn gemaeckt en geschildert bij Mr. Franchoys Hals den oude ende het comparquement bij Buytewegh, ofte anders genaemt Geestige Willem' (C. A. van Hees, 'Archivalia betreffende Frans Hals en de zijnen', *O.H.*, LXXIV (1959), p. 37. The meaning of 'comparquement' is obscure, but it possibly refers to the kind of decorative cartouche which serves as a frame for Buytewech's drawing based on Hals' 'Peeckelhaering'.

Unidentified artists also made paintings of this Falstaffian character which were probably derived from Hals. In a weak painting which appeared in a sale, London (Sotheby) 7 December 1932, no. 75, he is shown with a female companion; and he is seen alone in a picture which appeared at the sale, Samuel Burchard, New York (Parke Bernet) 9 January 1947, no. 39: canvas, 54·6 × 43·7 cm. (possibly identical with HdG 100). This model was probably a popular character in Haarlem around 1615–25. He appears again as 'Hanswurst' in Hals' lost *Merry Trio* (Cat. no. L 2; Fig. 68, text Fig. 17) and is recognizable again in the guise of a mountebank, an innkeeper and as a musician in works by Buytewech and Dirck Hals. He also makes an appearance in works by Cornelis Dusart (1660–1704). If the attribution to Hals of the painting of a *Shrovetide Fool* which appeared in Dusart's auction of 21 August 1708, no. 22 (HdG 137b) was correct, Dusart was able to turn to an original for inspiration, and if the inscription on an etching by Louis Bernhard Coclers (1740–1819) can be trusted Dirck Hals too made a copy of him (Fig. 6; Siccama, no. 22). His print bears Dirck's monogram in reverse and the date 1736 (*sic*) in reverse. Obviously the date cannot refer to the year Coclers made the print; Coclers probably intended to inscribe it 1636. Dirck Hals also incorporated Frans' stout Shrovetide fool (as well as some figures borrowed from Buytewech) in his *Musical Party*, *ca.* 1625, Michaelis Collection, Cape Town (Cat. 1967, no. 27, repr.), but it is evident that Coclers' print is not based on this representation of him.

The model who posed as Hanswurst did not enjoy the same notoriety as his fat companion. However, he has not been ignored by modern historians of Hals' works, and attempts have been made to identify him as the man who posed as the husband in the Amsterdam *Married Couple* (Plate 33), as as Hals' portrait of his brother Dirck, and as a self-portrait of Hals. In my opinion all of these identifications must be rejected.

6. **Pieter Cornelisz. van der Morsch** (Plates 12, 13; text, pp. 7, 25, 26, 83). Pittsburgh, Carnegie Institute.
Panel transferred to canvas, 87·6×69·8 cm. Inscribed on the wall to the left 'WIE BEGEERT', and at the upper right a coat-of-arms, a unicorn argent rising from the sea(?) pierced by a shaft and flanked by the inscription: AETAT SVAE 73, and below by the date: 1616.

PROVENANCE: Sale, M. van Tol, Zoeterwoude, near Leiden, 15 June 1779, no. 8; sale, Amsterdam, 16 June 1802, no. 75 (B. Kooy, 55 florins); sale, Barend Kooy, Amsterdam, 30 April 1820, no. 38; sale, C. H. Hodges and others, Amsterdam, 27 February 1838, no. 294; sale, J. A. Töpfer, Amsterdam, 16 November 1841, no. 28; Martin Colnaghi, 1866, London; Earl of Northbrook, Stratton, Micheldevers., Hants, Catalogue, 1889, no. 61; Duveen Bros., Inc., N.Y.; Coll. Mr. and Mrs. Alfred W. Erickson, N.Y., Parke-Bernet, 15 November 1961, no. 13; presented through the generosity of Mrs. Alan M. Scaife to The Carnegie Institute, Pittsburgh, Pennsylvania, 1961.
EXHIBITIONS: Detroit 1935, no. 1; Haarlem 1962, no. 6; Baltimore, The Baltimore Museum of Art, *From El Greco to Pollock: Early and Late Works by European and American Artists*, 1968, pp. 24–25.
BIBLIOGRAPHY: A. van der Willigen Pz., *Les Artistes de Harlem*, 1870, pp. 348–349; Bode 1883, 143 ('Ein Härings-händler'); Moes 259; HdG 205; Bode-Binder 89; KdK 11; Valentiner 1936, 2; Gordon Bailey Washburn, 'Two Notable Pictures for Pittsburgh', *Carnegie Magazine*, February 1962, pp. 41ff.; P. J. J. van Thiel, 'Frans Hals' Portret van de Leidse Rederijkersnar Pieter Cornelisz. van der Morsch, alias Piero (1543–1629). Een bijdrage tot de Ikonologie van de bokking', *O.H.*, LXXVI (1961), pp. 153ff.

The model for the portrait is identified as 'PIERO, STADS BODE te LEYDEN' (Piero, Municipal Beadle of Leiden) on a watercolour copy of the painting by the Haarlem artist Vincent Jansz. van der Vinne (1736–1811). The copy (Institut Néerlandais, Fondation Custodia, Frits Lugt Coll., inv. no. 505) shows Hals' characteristic connected monogram to the right of the model's shoulder; it is not visible on the original. It is difficult to determine if the monogram was Van der Vinne's invention or if it was covered or removed from the painting during a later restoration. Van der Vinne's copy also includes the coat-of-arms and the inscriptions on the painting. Since these passages of the picture have been considerably strengthened and show little evidence of an old crackle pattern it is reassuring to know that they were on the portrait during Van der Vinne's lifetime. Van der Vinne's copy as well as the traces of paint in parts of the picture which appear to be original to the naked eye and under low magnification indicate that a thorough scientific investigation would confirm their presence in the original paint surface. Extensive repaint is also apparent in the background.
On the basis of Van der Vinne's copy and the reference to the painting in the Van Tol Sale in 1779, which describes the man as 'Piro', beadle and rhetorician of Leiden, the model was securely identified by Hofstede de Groot as Pieter Cornelisz. van der Morsch (1543 [not 1546]–1629), a man well known in Leiden. He played the part of the buffoon in performances arranged by the Leiden society of rhetoricians *De Witte Accolijen*, and his name also appears on the Leiden lists of municipal beadles (*gerechts-boden*). Moreover, Van der Morsch's age agrees with the one inscribed upon Hals' portrait.
The smoked herring (*bokking*) Van der Morsch holds and the inscription WIE BEGEERT (Who Wants It) led some students to conclude that Van der Morsch was a herring fisherman or herring merchant (F. Dülberg, *Frans Hals*, Stuttgart, 1930, p. 60; Valentiner 1936, 2). P. J. J. van Thiel's revealing iconographical analysis (*op. cit.*) has shown that these interpretations of the herring were incorrect. He found the clue to its significance in a book of verses written by Van der Morsch between 1599–1618 (*Gedichten van Piero . . .*, now in the Leiden Municipal Archives, Gilden-archieven, no. 1496), which includes an epitaph. There he characterized himself as a man who distributed smoked herrings ('die deelde Bucken'; Bucken = bokkingen), and as a beadle (Bo = Bode):

> *Graf Dichtgen*
> *Hier Leyt Pier//o*
> *die deelde Bucken*
> *En was Hier//Bo*
> *Van In te Rucken*
> *overleden den . . .*
> *A° 16[29].*

His reference to himself as a beadle needs no explanation but his characterization of himself as a man who distributes herring does. Van Thiel has presented ample evidence to show that in Hals' time 'iemand een bokking geven' meant to shame someone with a sharp remark. The inscription WIE BEGEERT (Who Wants It) is not a reference to the sale of smoked herring or to Van der Morsch's own motto (which was *LX.N tyt* = elk zijn tijd); it refers to his readiness to rebuke or to ridicule. The fish and the inscription have been used by Hals to portray Van der Morsch in his role as Piero, the fool of *De Witte Accolijen*.

7. **Banquet of the Officers of the St. George Militia Company** (Plates 15–22; text, pp. 5, 10, 17, 39–49, 58, 63, 112, 136, 207). Haarlem, Frans Hals Museum (Cat. 1929, no. 123).
Canvas, 175×324 cm. Dated on the arm of the chair on the left: 1616.

PROVENANCE: Painted for the headquarters of the St. George Militia Company, Haarlem; exhibited at the museum since 1862.
EXHIBITIONS: Haarlem 1937, no. 3; Haarlem 1962, no. 5.
BIBLIOGRAPHY: Haarlem Archives, no. 31, *Registers van*

*officieren en manschappen van de St. Jorisdoelen of oude schuts,
1612–52*, volume I; Bode 1883, I; Moes I; HdG 431;
Bode-Binder 92; KdK 8; Trivas 4; H. P. Baard, *Frans Hals,
Schuttersmaaltijd der Officieren van de Sint Jorisdoelen Anno
1616*, Leiden, 1948; H. P. Baard, *Frans Hals, The Civic
Guard Portrait Groups*, Amsterdam and Brussels, 1949,
pp. 15–16, plates A and 1–8; J. van den Bosch, *Hereditaire
Ataxie*, dissertation Amsterdam, 1953; C. C. van Valken-
burg, 'De Haarlemse Schuttersstukken: I. Maaltijd van
Officieren van de Sint Jorisdoelen (Frans Hals, 1616). Identi-
ficatie der voorgestelde schuttersofficieren', *HAERLEM:
Jaarboek 1958*, Haarlem, 1959, pp. 59ff.; Seymour Slive,
*Festmahl der Offiziere der St. Georg-Schützengilde in Haarlem,
1616*, Stuttgart, 1962; Baard 1967, no. 40.

There is no longer a trace of the monogram which Bode
(1883, I), Hofstede de Groot (431), and Bode-Binder (92)
recorded when they catalogued the painting. However,
Hals' earliest civic guard portrait is clearly and unmistakably
dated 1616. The towering quality of the work heightens the
mystery of Hals' missing juvenilia and of the conspicuous
rarity of pictures painted before he was thirty.
For a discussion of the history of the St. George Militia
Company of Haarlem, the tradition of painting banquet-
pieces of its officers, and the relationship of Hals' work to
earlier Dutch group portraits see text, pp. 39–49. Literature
about the results and controversy that followed the
restoration of the painting in 1919 is cited in the text, p. 221.
The most sensational result of the cleaning was the discovery
that the large green drapery in the upper right had been
repainted brown.
In Hals' time officers of Haarlem's militia companies were
selected by the municipality to serve for three years, and
only the provost and ensigns were eligible for reappoint-
ment. The municipality of Haarlem customarily gave a
banquet to the officer corps after they had completed their
term of service. An historian of textiles has noted that the
banquet given to these men was laid on a particularly ap-
propriate table cloth; woven into the design of the white-
on-white damask cloth is a 'banket op tafel' (banquet on
the table) design (G. T. van Ysselsteyn, 'Voorouderlijke
Specialistie in Tafelversiering bij Feestmaaltijden', *Maand-
blad voor Beeldende Kunsten*, XVIII [1941], pp. 266ff.).
According to tradition the officers in this group portrait
served from 1615 to 1618. C. C. van Valkenburg's 1958
publication of an eighteenth-century manuscript (*op. cit.*)
proved that the tradition is wrong, and that these served
from 1612 to 1615. They were also officers Hals knew well;
he was a member of the St. George Company from 1612–15
and had served under them.
The eighteenth-century manuscript which identifies the
officers is based upon a survey made by a Haarlem commis-
sion in 1692 when the painting was mounted in the
Prinsenhof at Haarlem. The commission was asked to
'inspect some of the paintings or portraits in the Prinsenhof,
and in the "Oude en Nieuwe doelens" so that the people in

these paintings would become known to posterity by their
coats-of-arms and names'. The 1692 commission based its
findings upon the knowledge of an older generation—not
an impeccable source. However, the list they compiled has
turned out to be a fairly reliable one. With the exception of
two names it conforms with the roster in the St. George
Company's own record on deposit in the Haarlem
Municipal Archive (Inventaris van het Archief der
Schutterij voor 1795, no. 31, I, *Registers van officieren en
manschappen van de St. Jorisdoelen of Oude Schuts, opgemacht,
1612–1615*, p. 2). The two men erroneously listed were
officers of the Haarlem St. Hadrian Militia Company from
1612 to 1615, not of the St. George group. The servant
remains anonymous. The diagram below identifies the
officers and their rank:

1. Hendrick van Berckenrode, Colonel
2. Johan van Napels, Provost
3. Nicolaes Woutersz. (van der Meer), Captain
4. Vechter Jansz. (van Teffelen), Captain
5. Jacob Laurensz., Captain
6. Hugo Mattheusz., Steyn, Lieutenant
7. Cornelis Jacobsz., Schout, Lieutenant
8. Pieter Adriaensz. Verbeek, Lieutenant
9. Gerrit Cornelisz. Vlasman, Ensign
10. Jacob Cornelisz. Schout, Ensign
11. Boudewijn van Offenberg, Ensign
12. Servant

Even before the correct list of most men represented in the
group portrait was found, there was reason to suspect the
traditional identifications. In 1953 J. van den Bosch
identified the stout officer left of the centre in front of the
table as Nicolaes Woutersz. van der Meer, who was
painted again by Hals in 1631 (Cat. no. 77; Plate 123).
Nicolaes Woutersz. was a captain of the St. George
Company from 1612 to 1615; therefore he was not eligible
to succeed himself. The question which should have been
posed after Van den Bosch's identification of the captain
was: 'What is Nicolaes Woutersz doing at a banquet given
to the corps of officers who served from 1615 to 1618—a
corps to which he did not, indeed could not, belong?' This
question was not investigated because few if any people
interested in the guest list of a seventeenth-century Haarlem
civic guard banquet knew about Van den Bosch's astute
observation. He published it in an unorthodox place. It is
listed as one of the theses he was prepared to defend along
with his dissertation on *Hereditaire Ataxie*, which he
presented in 1953 to the University of Amsterdam for his
medical degree (*op. cit.*).

Two chalk drawings, which appear to be contemporary copies of the painting, are at the Teyler Museum (Catalogue, 1904, Portfolio O, nos. 31, 32). Both indicate that the group portrait has been cropped about 25 cm. on the right, and no. 32 suggests the painting has been trimmed a bit on the left.

8. **Theodorus Schrevelius** (Plate 23; text, pp. 8, 28–29, 59, 125, 154). Paris, Baroness G. W. H. M. Bentinck-Thyssen-Bornemisza (on loan to Kunstmuseum, Düsseldorf).

Copper oval set into a wooden panel at a later date. The copper measures 14·5 × 12 cm. Inscribed on the book: AET. 44/1617 and in the upper right: AETAT SVAE...

PROVENANCE: Aspects of the early history and references to the date inscribed on the painting as well as the identity of the sitter are confused. They are best discussed together. According to the Warneck sale catalogue (Paris) 27–28 May 1926, no. 46, the portrait was bought by Warneck in 1864 from a minister in Holland. There is also reason to believe the painting was with Count Bloudoff, Brussels, 1873 (*Icon. Bat.* 7130-1; Moes 71). Bode states (1883, p. 85, no. 79) that in 1878 Warneck, of Paris, owned a small portrait of Scriverius dated 1613. He also wrote it was the earliest dated painting by the artist (Bode 1883, pp. 43–44). This work is now untraceable; possibly it never existed. Bode may have made a double error; Warneck's 1613 painting of Scriverius may in fact have been Hals' 1617 portrait of Schrevelius. The plot thickens in 1905 when Moes listed a portrait of Theodorus Schrevelius by Hals in the collection of E. Warneck, Paris (*Icon. Bat.* 7038-1), and also listed a portrait by Hals dated 1613 of Petrus Scriverius in the Warneck collection, probably from the collection Blondoff [*sic*], Brussels, 1873 (*Icon. Bat.* 7130-1). *Icon. Bat.* 7038-1 may be identical with 7130-1. Moes 69 lists the Warneck painting as Schrevelius again and states it is dated 1617; it may be identical with Moes 71: Scriverius, dated 1613, Count Bloudoff, Brussels, 1873. After Moes published his catalogue of 1909, references to Hals' mysterious portrait of Scriverius dated 1613 disappear from the literature. Sale, Warneck, Paris, 27–28 May 1926, no. 46; Heinrich Baron Thyssen-Bornemisza, Schloss Rohoncz, Lugano-Castagnola; by descent to the present owner.
EXHIBITIONS: The Hague 1903, no. 35; Paris 1911, no. 60; Munich 1930, no. 145; Birmingham, 'Some Dutch Cabinet Pictures of the 17th Century', 1950, no. 23; Amsterdam 1952, no. 42; Haarlem 1962, no. 7; Paris 1970, no. 24.
BIBLIOGRAPHY: Possibly Bode 1883, 79; *Icon. Bat.*, no. 7038-1 and possibly no. 7130-1; Moes 69, possibly the picture identical with 71; HdG 222; Bode-Binder 93; KdK 13; *Arnoldus Buchelius*, 'Res Pictoriae', edited by G. J. Hoogewerff and J. Q. Regteren Altena, The Hague, 1928, p. 67; *Sammlung Schloss Rohoncz*, Lugano-Castagnola, 1937, vol. I, no. 181.

In some of the earlier literature the sitter was possibly erroneously identified as Petrus Scriverius and the picture incorrectly dated 1613 (see provenance above); for Hals' only known portrait of Scriverius, see Cat. no. 36.
The identity of the sitter as Theodorus Schrevelius (1572–1649) is established by two contemporary engravings. In 1618, a year after the little portrait was painted, it was used as a modello for a print by J. Matham (1571–1631) and, unless J. Suyderhoef (1613–86) based the engraving he made of it (Wussin, no. 77) on Matham's print, he also copied it; both prints reverse the painting. Valentiner's statement (KdK 13) that Matham's engraving is not after Hals' portrait but done from one by Goltzius is difficult to understand. Matham's print is not only a faithful reversed copy of the little portrait but is clearly inscribed: Fra. Hals pinxit Iac. Matham sculpsit. I have not been able to trace an engraving by Matham after a Goltzius portrait of Schrevelius.
Theodorus Schrevelius, a Haarlem schoolmaster and historian, can be credited with writing one of the rare seventeenth-century appreciations of Hals' work. His brief remarks on the artist appear in *Harlemias*, 1648, p. 383 (see text p. 8). From 1625–42 he was rector of the Latin school at Leiden. When the Utrecht jurist Aernout van Buchell visited him there he saw portraits by Hals of Schrevelius and of Petrus Scriverius (Buchelius, *op. cit.*). The latter may have been the painting of Scriverius dated 1626 now at the Metropolitan Museum (Cat. no. 36); the former may have been this portrait of 1617 or one of the two others Hals presumably painted of Schrevelius in 1628 (Cat. nos. 49, 50; Plates 75, 74), the very year Van Buchell visited him in Leiden.
The 1617 portrait, which is Hals' smallest existing painting, is miniature-like in scale but not in execution. Since copper was favoured by Dutch artists of the century for their little pictures it is not surprising to learn it is painted on copper (HdG 222 and KdK 13 erroneously catalogued it as a panel). But Hals apparently did not paint on copper often; only two others on this metal support are known: *Portrait of a Man*, 1627, Berlin-Dahlem (Cat. no. 48); *Samuel Ampzing*, 163[?], English private collection (Cat. no. 76). A weak painted copy of the portrait and a pendant (?) to it, an oval *Portrait of a Woman* (Cat. no. L 19, Fig. 99) are in the James A. Murnaghan collection, Dublin; both are on panel, and both measure 14·5 × 10·8 cm. If the pendant is in fact the mate of the copy it may be a replica of a lost portrait by Hals of Schrevelius' wife, Maria van Teylingen (1570–1652). The latter bears little resemblance to the sitter for Hals' 1628 *Portrait of a Lady*, who has been identified by some students as Schrevelius' wife (see Cat. no. 51).

9. **Portrait of a Man** (Plate 24). Dijon, Musée des Beaux-Arts (inv. no. 1366).
Canvas, 89 × 76 cm. Inscribed and dated below the coat-of-arms on the right: AETISV [*sic*] .../1619.

PROVENANCE: Bequeathed to the museum in 1899 by Joseph Chenot, *sous-préfet* of Poligny, Jura.
EXHIBITIONS: Haarlem 1937, no. 5; Recklinghausen, Kunsthalle; Beginn und Reife, Cat. 1956, no. 103; Paris, 1970–71, no. 95.
BIBLIOGRAPHY: Moes 119; HdG 270; Bode-Binder 95; KdK 14; J. Magnin, *La Peinture au Musée de Dijon*, 3rd ed. Besançon, 1933, p. 185; Dijon, Musée Magnin, Cat. 1968, no. 16.

Attributed by the donor to Van Dyck; by Taggini, an appraiser at Dijon in the nineteenth century, to Pourbus, and finally to Hals by Gaston Jolliet (information from the files of the museum). Although the picture is not in a good state of preservation—it has been cut on all four sides, the paint surface is abraded and flattened, the inscription has been reworked and there are other extensive restorations—the attribution to Hals is acceptable. The portrait is related in style to the portrait of a man at Cassel (Cat. no. 10) and the date of 1619 is confirmed by the costume as well as by the attitude of the model, which recalls the poses struck by the dashing young men who appear in Buytewech's works around this time.

10. **Portrait of a Man** (Plate 25; text, p. 50). Cassel, Hessisches Landesmuseum (Cat. 1958, no. 213).
Canvas mounted on panel, 102·5 × 79 cm.

PROVENANCE: *Haupt-Catalogus von Sr Hochfürstl. Durchlt Herren Land Grafens Wilhelm zu Hessen, sämtlichen Schildereyen, und Portraits. Mit ihren besonderen Registern. Verfertiget in Anno 1749.* No. 687: Hals, Franz. Ein Manns-Kniestuk in Spanischer Kleidung (Höhe: 3 Schuh 3 Zoll; Breite: 2 Schuh 7 Zoll). Taken to Paris by Jerome (Bonaparte?) in 1806 and returned in 1814.
BIBLIOGRAPHY: Bode 1883, 99 (*ca.* 1620); HdG 265 (*ca.* 1620); Bode-Binder 97; KdK 18 (*ca.* 1620); Trivas 5 (between 1618–20).

Pendant to a *Portrait of a Woman*, Cat. no. 11. The style and technique of both paintings closely relates them to the St. George Militia piece of 1616 (Cat. no. 7), but the regularization and simplification of the silhouettes of these three-quarter lengths suggest they were painted toward the end of the decade.

11. **Portrait of a Woman** (Plate 26; text, p. 50). Cassel, Hessisches Landesmuseum (Cat. 1958, no. 214).
Canvas mounted on panel, 103 × 82·5 cm.

PROVENANCE: *Haupt-Catalogus von Sr Hochfürstl. Durchlt Herren Land Grafens Wilhelm zu Hessen, sämtlichen Schildereyen, und Portraits. Mit ihren besonderen Registern. Verfertiget in Anno 1749.* No. 688: Hals, Franz. Ein dergleichen Frauen Kniestuk (Höhe: 3 Schuh 3 Zoll;

Breite: 2 Schuh 7 Zoll). Taken to Paris by Jerome (Bonaparte?) in 1806 and returned in 1814.
BIBLIOGRAPHY: Bode 1883, 100 (*ca.* 1620); HdG 374 (*ca.* 1620); Bode-Binder 98; KdK 19 (*ca.* 1620); Trivas 6 (*ca.* 1618–20).

Pendant to *Portrait of a Man*, Cat. no. 10. The costume of the woman is particularly colourful; her satin skirt is bright pink shot with violet and green, her stomacher and sleeves are violet and gold.

12. **Paulus van Beresteyn** (Plate 27; text, p. 50). Paris, Louvre (inv. no. RF 424).
Canvas, 137·1 × 104 cm. (original support). Inscribed to the right below the coat-of-arms: AETAT SVAE 40/1629.

PROVENANCE: Acquired with Cat. no. 13 and Cat. no. D 80 from the Hofje van Beresteyn, Haarlem, by the Louvre in March, 1885 (100,000 florins for the lot).
EXHIBITIONS: Paris 1950, no. 856; Amsterdam 1952, no. 45; Paris 1960, no. 417; Paris 1970–71, no. 96.
BIBLIOGRAPHY: Bode 1883, 9 (dated 1629); *Icon. Bat.*, no. 519-2 (as Nicolaes van Beresteyn); M. G. Wildeman, 'De portretten der Beresteijn's in het Hofje van Beresteijn te Haarlem', *O.H.*, XVIII (1900), pp. 129–136; Moes 15 (dated 1629); HdG 154 (probably 1620); Bode-Binder 121; L. Demonts, Louvre, Catalogue, 1922, p. 21, no. 2386 (dated 1629); KdK 16 (probably 1620); Trivas 7 (probably 1620); E. A. van Beresteyn, *Genealogie van het Geslacht van Beresteyn*, vol. II, The Hague, 1941, p. 58ff., no. 117 (argues for a date of 1629); E. A. van Beresteyn and W. F. del Campo Hartman, *ibid.*, vol. I, 1954, pp. 219ff. (this 2 vol. work is a bibliographical curiosity; vol. I was published 13 years after vol. II).

Pendant to Cat. no. 13. Identified by Wildeman (*op. cit.*) as Paulus van Beresteyn (1588–1636), a member of an old Haarlem family, who was active as a lawyer in his native town. As a Catholic he did not qualify for many public offices; however, he served as a judge (commissaris van de Kleine Bank) from 1615 to 1617. He also worked as an attorney for the Haarlem St. Luke Guild. On 12 December 1619 he married Catharina van der Eem (1589–1666), his third wife; see Cat. no. 15 for references to his earlier marriages.
It is apparent to the eye that the inscription on Paulus' portrait has been corrupted by a later hand: the *4* of the *40* and the *9* of the *1629* have been repainted. This observation has been confirmed by ultra-violet examination; the *4* and the *9* appear on the varnish layer of the painting. Hofstede de Groot (154) noted as early as 1910 that the inscription had been changed; he suggested that it originally gave Paulus' age as 30 and was dated 1620. On the basis of style, technique and costume a date of about 1620 for both portraits is fully convincing and was rightly accepted by Valentiner and Trivas. However, it should be noted that in

1620 Paulus was 31 or 32 years of age, not 30. Why the discrepancy? Perhaps the inscription was added to the portrait at a later date when members of the Beresteyn family were a bit vague about Paulus' year of birth or even the identity of the model, and the confusion was probably compounded by the subsequent changes which were made to it. The adjustments made to the inscription on Paulus' portrait raise doubts about the partially legible one on the painting of his wife. But conclusions about its authenticity must await the removal of the heavy coat of varnish which now covers it; an ultra-violet examination of it has revealed nothing. In brief: despite the troublesome inscriptions on the imposing portraits, I see no reason to question a date of about 1620 for both of them and since the couple were married on 12 December 1619 they probably were commissioned to help celebrate the event.

One of the children of Paulus' third marriage was Nicolaas van Beresteyn (1629–84), an amateur artist (see H. Gerson, 'Leven en Werken van Claes v. Beresteyn' in E. A. van Beresteyn, *Genealogie van het Geslacht van Beresteyn*, The Hague, 1941) and the founder of the Hofje van Beresteyn at Haarlem, a charitable institution for Catholic men and women established in 1684. Perhaps he inherited the portraits of his parents and left them to the Hofje he founded. In any event they formerly belonged to the Hofje along with the portrait of his *Emerentia van Beresteyn* (Cat. no. D 70) now at Waddesdon Manor and the large *Paulus van Beresteyn Family Portrait* in the Louvre (Cat. no. D 80). Today the Waddesdon portrait and the Louvre family group are ascribed to Pieter Claesz. Soutman but during the nineteenth century all four pictures were attributed to Hals. When the Hofje decided to sell them in 1876 an attempt was made to raise money to purchase them for Holland. The attempt failed. In 1882 the portrait of Emerentia was sold by the Hofje to Baroness Wilhelm von Rothschild for 210,000 francs, and in 1885 the Louvre acquired the other three for 104,950 francs (100,000 florins). The sale of these paintings caused a familiar scandal. Many Dutchmen deplored the loss of national treasures, while many Frenchmen considered the high price paid for three of the paintings unjustifiable (for an extensive bibliography of these sales, with special emphasis on the Dutch side of the story, see H. van Hall, *Repertorium voor de Geschiedenis der Nederlandsche Schilder- en Graveerkunst*, vol. I, 1936, nos. 10314–10325).

13. Catharina Both van der Eem, wife of Paulus van Beresteyn (Plate 28; text, p. 50). Paris, Louvre (inv. no. RF 425).

Canvas, 137·2×99·8 cm. (original support). Inscribed to the left below the coat-of-arms: AETAT SVAE.../... 29(?).

PROVENANCE: Acquired with Cat. no. 12 and Cat. no. D 80 from the Hofje van Beresteyn, Haarlem, by the Louvre in March, 1885 (100,000 florins for the lot).

EXHIBITIONS: Amsterdam 1952, no. 46; Paris 1960, no. 418.

BIBLIOGRAPHY: Bode 1883, 10 (dated 1629); M. G. Wildeman, 'De portretten der Beresteijn's in het Hofje van Beresteijn te Haarlem', *O.H.*, XVIII (1900), pp. 129–136; Moes 16 (dated 1629); HdG 155; Bode-Binder 122; L. Demonts, Louvre, Catalogue, 1922, p. 22, no. 2387 (dated 1629); KdK 17 (probably 1620); Trivas 8 (probably 1620); E. A. van Beresteyn, *Genealogie van het Geslacht van Beresteyn*, vol. II, The Hague, 1941, p. 60, no. 122 (accepts date of 1629); vol. I, 1954, pp. 219ff.

Pendant to Cat. no. 12. I can see no reason to accept the suggestion made in the exhibition catalogue, Paris 1970–71, p. 89, no. 96, that Pieter Soutman possibly participated in the execution of the portrait. Nothing is known about the works Soutman painted before he left Haarlem for Antwerp *ca.* 1619; for references to those which he may have painted after his return to his native city by 1628, see Cat. nos. D 70, D 75, D 80.

For a discussion of the problems posed by the inscriptions on the portrait and its companion piece see Cat. no. 12. I have not been able to decipher the age inscribed on the portrait. Others have read it as 40 (HdG; Bode-Binder; KdK; Beresteyn, *op. cit.*, vol. II, p. 60); the compilers of the catalogues of the exhibitions held at Amsterdam 1952 (no. 46) and Paris 1960 (no. 418) read it as 38.

14. Nurse and Child (Plates 36–38; text, pp. 60–61). Berlin-Dahlem, Staatliche Museen (Cat. 1966, no. 801 G). Canvas, 86×65 cm.

PROVENANCE: Probably identical with 'Een minne met een kindje van Frans Hals' (appraised at 30 florins) which appeared in the 8 March 1709 inventory of Pieter de Graeff, Vrijheere van Zuyd Polsbroek, of Purmerland and Ilpendam (Amsterdam Archives, NAA no. 5001, p. 483; information from S. A. C. Dudok van Heel). Sale, Ilpenstein Castle, Amsterdam, 3 December 1872, no. 16 (4,500 florins, Roos for Suermondt); Coll. Suermondt, Aachen, 1874.

EXHIBITION: Amsterdam 1950, no. 50; Haarlem 1962, no. 8.

BIBLIOGRAPHY: Bode 1883, 87 (*ca.* 1630); Moes 92; HdG 429 (1630–35); Bode-Binder 131; KdK 15 (c. 1620); Trivas 1 (1615–17).

Painted *c.* 1620. The rather dark tonality, the minute execution of the child's rich costume relieved by more lively brushwork in the light passages, and the absence of atmospheric effects relate the work to the Beresteyn portraits at the Louvre (Cat. nos. 12, 13) and the Chatsworth portrait of a man of 1622 (Cat. no. 18). The models for this double portrait remain anonymous. For a discussion of the erroneous identification of the child as a member of the

Ilpenstein family and the relationship of the woman to the child, see text, p. 60.

15. **Family Portrait in a Landscape** (Plates 29, 31; text, pp. 61–66, 141; text, Figs 41, 42, 43, 44). Bridgnorth, Shropshire, Viscount Boyne. (On extended loan to the National Museum of Wales, Cardiff.)

Canvas, 151 × 163·6 cm (original support). Signed on the rock with the connected monogram: FH; and on the left sole of the shoe of the child seated on the left: S. de Bray/16[2]8.

PROVENANCE: Sale, J. A. Bennet, Leiden, 10 April 1829, no. 57 (45 florins, bought in).
EXHIBITIONS: London 1929, no. 369; Brussels 1971, no. 43A.
BIBLIOGRAPHY: HdG 444; C. Hofstede de Groot, 'Twee Teruggevonden Schilderijen door Frans Hals', *O.H.*, XXXIX (1921), pp. 65ff. (*ca.* 1635–40); KdK 159–161 (*ca.* 1630–40); Seymour Slive, 'A Proposed Reconstruction of a Family Portrait by Frans Hals', *Miscellanea I. Q. van Regteren Altena*, Amsterdam, 1969, pp. 114ff.

Painted around 1620; Hals' earliest existing family portrait. Until recently the painting has led a rather covert existence. It was rediscovered and published by Hofstede de Groot in 1921 (*op. cit.*). He noted that he had seen it at an estate in the north of England and that its owner desired to remain anonymous. Hofstede de Groot did not succeed in procuring a photograph of it but was able to publish five chalk drawings made after the heads of the parents and three of the children by the Leiden artist Abraham Delfos (1731–1820), which were at the time in his own collection (*op. cit.*, 1921, Figs. 1–5; Delfos' copies were sold as a lot in the sale, C. Hofstede de Groot, Leipzig [Boerner] 4 November 1931, no. 283).

Hofstede de Groot wrote that the group bore the title 'The Family of Jan de Bray' and observed that this title was an impossible one; Jan de Bray was born in 1625 and was married 21 October 1668, two years after Hals' death. He did not, however, note that the seated child on the left (text, Fig. 41) was painted, signed and dated 1628 by Jan de Bray's father, Salomon de Bray; confusion at a later date between father and son may account for the traditional title of the work. Hofstede de Groot's failure to spot Salomon's work on the canvas as well as the improbable date of 1635–40 which he assigned to the group portrait can be explained by his remark that the visit he made to the house was too brief for him to make detailed notes and he had no comparative material at hand (*op. cit.*, 1921, p. 67). His candour is refreshing.

Valentiner apparently did not know the picture first hand; he dated it 1630–40 and reproduced Delfos' five copies (KdK 159–161). The group portrait was first exhibited and reproduced when it was shown at the great exhibition of

Dutch art held in 1929 at the Royal Academy (no. 369; repr. *Illustrated Souvenir . . .*, London, 1929, p. 228, fig. 28). The compilers of the 1929 catalogue accepted Hofstede de Groot's late date and his rejection of the idea that it represents Jan de Bray's family. They also rightly dismissed the suggestion that it may represent the family of Hals' son-in-law Pieter Roestraeten (*ca.* 1630–1700); Roestraten married Hals' daughter Adriaentgen in 1654. No mention of the child painted by Salomon de Bray in the portrait was made by the cataloguers or reviewers of the 1929 exhibition. The proposal that the family portrait and the Brussels *Three Children with a Goat Cart* (Cat. no. 16) were originally part of one large family portrait which included nine figures, and that De Bray added a tenth to it in 1628, was made in 1969 (Slive, *op. cit.*) and is discussed in the text, pp. 61–66 (see text, Fig. 44); my investigation of the relationship of these paintings to each other was facilitated by assistance from Roger d'Hulst, Patricia M. Butler and S. Rees Jones, and I gratefully acknowledge my debt to them.

The exhibition of the two paintings at Brussels in 1971, where they were shown side by side in one frame (no. 43A-B), clinched the proposed reconstruction. Their appearance as separate pictures in the J. A. Bennet sale, Leiden, 10 April 1829, nos. 57 and 58, establishes that the large family portrait was cut before that date. Although a veil of discoloured varnish hides some of the qualities of the Boyne *Family Portrait*, it is evident that it is in a better state of preservation than the fragment at Brussels.

Gregory Martin, 'The Inventive Genius of Frans Hals', *Apollo*, XCIV (1971), no. 115, p. 243, suggestively wrote that the ultimate source for the painting may perhaps stem from the Venetian High Renaissance, or paintings of the Rest on the Flight into Egypt. But he rightly stresses Hals' originality; there is no precedent in the Netherlands for the breadth and relaxed tone of the group portrait. He also points out that a date of about 1620 may be too early since this date suggests an interval of about six years between the time Hals completed the portraits of the nine children the wife had apparently already borne and the time she gave birth to the young child painted by De Bray: 'In those pill-less times such a delay seems improbable (unless the husband went to sea)' The point is well taken.

I have repeatedly tried to emphasize that the dates given in the text volume to Hals' works on the basis of stylistic evidence are not rigid ones. This is an appropriate place to underline this axiom. The rather dark tonality of the family, its crowded composition and the absence of a trace of atmospheric life lead me to date it around 1620. But a date in the early twenties is also perfectly acceptable for the reconstructed painting.

However, in this case I should like to point out that the gap between the ages of the children does not seem improbable unless we assume the wife Hals portrayed was the mother of all of them. The rate of pregnancies among seventeenth-century Dutch women is worth considering. But it should be controlled by consideration of their rate of mortality and

the death rate of the children they bore. Firm statistics on these topics are not available but every indication supports the conclusion that these rates were appallingly high. For example, Rembrandt's wife Saskia bore three children between December 1635 and July 1640; none of them lived more than two months. After bearing her fourth child in September 1641 Saskia died in June of the following year (I. H. van Eeghen, 'De Kinderen van Rembrandt', *Maandblad Amstelodamum*, XLIII [1956], pp. 114–116). A review of the life and death of members of Paulus van Beresteyn's (see Cat. no. 12) family tells a similar story. His first wife died in 1617 at the age of 19; in 1614 the couple had buried the first infant she bore and in 1616 they buried the second. He married again in January 1618 and his second wife died less than ten months later. His third marriage took place in December, 1619 (E. A. van Beresteyn and W. F. del Campo Hartman, *Genealogie van het Geslacht van Beresteyn*, vol. I, The Hague, 1954, pp. 219–220). These vital statistics, as well as a host of others, indicate that unequivocal conclusions about the precise familial relationship of the sitters in a seventeenth-century Dutch family portrait cannot be made without documentary evidence. Not a shred of documentation has been found to help establish the kinship of the models of any of Hals' family portraits. Until some appears we can only guess at the relationship of the people portrayed in them and without documentation we must continue to depend upon an analysis of style as the most reliable method for establishing approximate dates.

Valentiner noted that the half-length *Portrait of a Boy* posed against a background of tree trunks, foliage and a bit of sky is probably a fragment of a larger picture (KdK 21, repr.; canvas, 52 × 45.7 cm.; London, H. M. Clark; New York, dealer F. Mont, *ca.* 1959). To judge from the style of the painting and the boy's costume the portrait can be dated around the same time as Cat. nos. 15 and 16, and it is not unreasonable to assume that it was once part of a group portrait in a landscape. I have not seen the portrait; photographs indicate that it is abraded, flattened and restored. I must reserve final judgement about its state of preservation and attribution until it reappears.

16. **Three Children with a Goat Cart** (Plates 30, 32; text, pp. 63–66; Fig. 44). Brussels, Musées Royaux des Beaux-Arts (cat. 1959, inv. no. 985).
Canvas, 150.8 × 107.5 cm. (original support).

PROVENANCE: Sale, J. A. Bennet, Leiden, 10 April 1829, no. 58 (25 florins); sale, Charles John Palmer, 27 February 1867, no. 93 (£31: 10s); coll. Hughes (probably J. Newington Hughes in Winchester); dealer E. Warneck, Paris; dealer Arthur Stevens, Brussels; Mrs. E. Brugmans, Brussels, who gave it to the museum in 1928 in memory of her husband.

EXHIBITIONS: Delft 1953, no. 18; Brussels 1971, no. 43B.

BIBLIOGRAPHY: Bode 1883, 36; Moes 91; HdG 430 (*ca.* 1625–30); Bode-Binder 111; C. H[ofstede]. d[e]. G[root], 'Een Nog Nooit Afgebeeld Meesterwerk van Frans Hals', *O.H.*, XXXVII (1919), p. 128; KdK 22 (*ca.* 1620–22). Leo van Puyvelde, 'Les Enfants à la Chèvre par Frans Hals', *Bulletin des Musées Royaux des Beaux-Arts de Belgique*, II (1929) 62*ff.*, repr. (*ca.* 1630), Van Puyvelde also published the painting in ' "Children with a Goat" by Frans Hals', *B.M.*, LIV (1929), pp. 80–85, repr. p. 83; W. R. Valentiner, 'Rediscovered Paintings by Frans Hals', *Art in America*, XVI (1928), pp. 236–237; Seymour Slive, 'A Proposed Reconstruction of a Family Portrait by Frans Hals', *Miscellanea I. Q. van Regteren Altena*, Amsterdam, 1969, pp. 114*ff.*

Painted *ca.* 1620. The paint surface is extensively abraded, flattened and restored.

Early students of Hals' work found it difficult to procure a photograph of the painting. It is the only one listed in Bode-Binder which is not reproduced in their sumptuous 1914 catalogue. In his preface Bode noted that 'Nur von Mme Brugmans in Brüssel, die das köstliche Kinderbild von F. Hals besitzt, sind wir auf unsere Anfragen ohne Antwort geblieben'. Hofstede de Groot wrote that others had the same problem and therefore he thought it helpful to publish a pen drawing (1919, *op. cit.*, facing p. 128) which he recognized among the anonymous drawings at the Rijksprentenkabinet (inv. no. 09:12). He tentatively ascribed the copy to the Leiden artist Pieter de Mare (1757–96) and suggested that it may have been made as a preparatory study for an engraving; the name of the late eighteenth- or early nineteenth-century artist who made the drawing remains an open question. Valentiner, too, was unable to obtain a photo of the original and reproduced the copy in the Rijksmuseum (KdK 22).

After the picture was presented to the Brussels museum in 1928 Puyvelde published and reproduced it (*op. cit.*). The date of about 1630 which he gave to the painting is unconvincing but he rightly noted the striking similarity of the handling between it and the Boyne *Family Portrait* (Cat. no. 15). The proposal that it and the Boyne *Family Portrait* were originally one large family portrait was made in 1969 (Slive, *op. cit.*) and is discussed in the text, pp. 63–66 and Cat. no. 15; also *cf.* text, Fig. 44.

The pen over chalk drawing called a copy after Hals which appeared in the Sale Gustav Heis, and others, Cologne, 28 October 1903, no. 107: 'Die Kinder des Frans Hals, mit einem Ziegenwagen spielend', 24.3 × 18.8 cm., was possibly done after the fragment now in Brussels.

17. **Married Couple in a Garden** (Plates 33–35; text, pp. 25, 26, 51, 53–54, 57, 63, 66–68, 179). Amsterdam, Rijksmuseum (Cat. 1960, no. 1084).
Canvas, 140 × 166.5 cm.

PROVENANCE: Sale, Jan Six, Amsterdam, 6 April 1702

(bought in); sale, H. Six van Hillegom, Amsterdam, 25 November 1851; acquired by the Rijksmuseum in 1852.

EXHIBITIONS: London 1929, no. 64; Haarlem 1937, no. 10; Brussels 1946, Bosch tot Rembrandt, no. 38; New York, Toledo, Toronto 1954–55, Dutch Painting: The Golden Age, no. 28; Haarlem 1962, no. 10.

BIBLIOGRAPHY: Bode 1883, 15 (ca. 1624, Portrait of Frans Hals with his second wife); Moes 90; HdG 427; Bode-Binder 96; KdK 20 (ca. 1621); Trivas 13 (ca. 1624–27); H. van de Waal, 'Frans Hals, Het Echtpaar', Openbaar Kunstbezit, v, 25 (1961); E. de Jongh and P. J. Vinken, 'Frans Hals als voortzetter van een emblematische traditie: Bij het huwelijksportret van Isaac Massa en Beatrix van der Laen', O.H., LXXVI (1961), pp. 117–152.

Painted ca. 1622. The emblematic and symbolic references in the double portrait are discussed in the text pp. 66–68; also see H. van de Waal (op. cit.) and, for a more exhaustive study, E. de Jongh and P. J. Vinken (op. cit.). The venerable tradition of representing a seated couple in a landscape is discussed by H. Kauffmann, 'Rubens und Isabella Brant in der Geissblattlaube', Form und Inhalt, Festschrift für Otto Schmidt, Stuttgart, 1950, pp. 257ff., and W. Schöne, Peter Paul Rubens, Die Geiszblattlaube, Doppelbildnis des Künstlers mit Isabella Brant, Stuttgart. The imaginary garden in which Hals placed the couple can also be related to the type he used as a setting for lovers in one of the earliest pictures attributable to him, the Banquet in a Park, which was destroyed in 1945 (Cat. no. D 1). During the second and third decades of the century other Dutch painters used similar gardens as settings for genre, moralizing, and allegorical pictures of fashionable young people.

Many attempts have been made to identify the sitters for the double portrait. During the nineteenth century it was called a self-portrait of Hals with his second wife Lysbeth Reyniers. Valentiner continued to champion this identification (KdK 20; Art in America, XIII (1925), pp. 148ff., ibid., XXIII (1935), pp. 90–95), but as far as I can discover he found few, if any, supporters. Students rightly followed Hofstede de Groot (427), who stated in 1910 that the traditional identification was incorrect. Binder (op. cit., 1914, p. 19) called it a portrait of Dirck Hals and his wife Anietje Jansdr. Since Dirck and his wife baptized their first child on 17 October 1621 (the date of their marriage is unknown) and the portrait is datable to around 1622, Binder's suggestion is not an impossible one. But until an undisputed portrait of Dirck is discovered Binder's hypothesis will remain untested. Moreover, it is as hard to imagine Frans painting this double portrait of his brother and his bride as it is to imagine Dirck living in a house which would have offered an appropriate setting for the painting. Its exceptional size and iconographic burden suggests it was painted for a patron of more than modest means and learning.

A patron who fits these specifications and whose physiognomy is subject to closer scrutiny than Dirck Hals' is Isaac Massa, who was painted by Hals in 1626 (Cat. no. 42; Plate 64) and again in 1635 (Cat. no. 103; Plate 168). He was tentatively suggested as the model in the entries on the painting in the Rijksmuseum catalogues of 1934 and 1960, and E. de Jongh and P. J. Vincken (1961) concluded upon the basis of the evidence offered by Hals' two portraits that the husband in the double portrait is Massa. They strengthened their case that the painting is a marriage portrait of Massa and his first wife Beatrix van der Laen with documentary evidence; Massa's first marriage took place on 25 April 1622, a date that could hardly be more compatible with the one assigned to the work on the basis of its style. The catalogue of the 1962 Haarlem exhibition (no. 10) provisionally accepted their identification and expressed the hope that confrontation of the Amsterdam double portrait with Hals' 1626 portrait of Massa (Plate 64) at the show would confirm the identification. When the works were juxtaposed, similarities between the two heads were evident but not compelling enough to secure the identification. In a review of the exhibition Sturla J. Gudlaugsson came to the same conclusion (Kunstchronik, XVI (1963), p. 9).

Others have argued that the identical sitter is not only seen in the double portrait and the 1626 Massa portrait but also served as a model for 'Hanswurst' in Hals' Shrovetide painting (Cat. no. 5; Plate 8) and was the sitter for the Portrait of a Man at Chatsworth (Cat. no. 18; Plate 39). Valentiner maintained that they not only represented the same man but were self-portraits (Art in America, XIII [1925], pp. 148ff., ibid., XXIII [1935], pp. 90–95). The compilers of the 1929 Dutch exhibition at the Royal Academy (nos. 48, 64) more cautiously concluded that they represented the same unidentified man. Trivas (13) was more exclusive. He limited his identification to the Chatsworth portrait and wrote that the man was without doubt the same one who posed for the double portrait. I do not find any of these identifications convincing.

Why have so many qualified specialists offered so many different solutions to this iconographic problem? Why has none of these been generally accepted? In my opinion a partial answer to these questions lies in the portrait schemes Hals used as well as his personal idiosyncrasies as a painter. Both are capable of endowing his individual works with a family likeness which can be mistaken for an identical likeness.

Chalk drawings of both heads, by the Amsterdam painter and mezzotintist Pieter Louw (active ca. 1743–ca. 1800), are at the Rijksprentenkabinet (without inv. nos.; 39×13.6 cm. and 39×13·5 cm. respectively).

18. **Portrait of a Man** (Plates 39, 54; text, pp. 52, 67, 105). The Trustees of the Chatsworth Settlement, Chatsworth.

Canvas mounted on panel, 107×85 cm. Inscribed in the corners in the upper left: AETAT SVAE 36, and in the upper right: AN° 1622.

PROVENANCE: The Duke of Devonshire owns two portraits by Hals, this one and the *Portrait of a Woman* (Cat. no. 3). According to Dodsley's *London and its Environs*, 1761 (vol. II, p. 120 and p. 230), a Hals was in the collection of the 3rd Earl of Burlington, at Chiswick Villa, in 1761, while another was in the possession of the Duke of Devonshire, at Devonshire House, Piccadilly, in the same year; but unfortunately there is no indication which portrait is referred to in each case (this reference kindly given by T. S. Wragg, Keeper of the Devonshire Collections).

EXHIBITIONS: Whitechapel 1904, no. 280; London 1929, no. 48; London 1952–53, no. 52; City Art Gallery, Leeds 1955, no. 52; Manchester 1957, no. 107; Haarlem 1962, no. 9; San Francisco, Toledo, Boston 1966–67, no. 16.

BIBLIOGRAPHY: Waagen, II, 1854, pp. 94–95; Bode 1883, 137 (*ca.* 1622, self-portrait); *Icon. Bat.*, 3139-4 (self-portrait); S. A. Strong, *The Masterpieces in the Duke of Devonshire's Collection*, 1901, no. 26; Moes 156, identical with Moes 157; HdG 287 (*ca.* 1630–35); Bode-Binder 152; KdK 41 (*ca.* 1625); Trivas 9.

The inscription and the date of 1622 were revealed by cleaning in 1928 (information from T. S. Wragg), confirming the date Bode (137) assigned to the portrait in his pioneer study on Hals published in 1883. The suggestion was put forward by Bode 1883 (137), in *Icon. Bat.*, 3139-4, by Gerald S. Davies, *Frans Hals*, London, 1902, pp. 94*ff.*, and repeated by W. R. Valentiner, *Art in America*, XIII (1925), pp. 148*ff.*; *ibid.*, XXIII (1935), pp. 90–95, that the painting is a self-portrait. As early as 1909 E. W. Moes, *Frans Hals, sa vie et son oeuvre*, Brussels, p. 27, correctly rejected that identification.

Attempts have been made to identify the model with other sitters Hals painted. Trivas (13) wrote that the man was without doubt the husband who appears in the Amsterdam *Married Couple in a Garden* (Cat. no. 17; Plate 33). I share the serious doubts E. de Jongh and P. J. Vinken (*O.H.*, LXXVI [1961], p. 147) expressed about this identification and along with them reject it. Some scholars (most recently S. J. Gudlaugsson, *Kunstchronik* XVI [1963], p. 9) have claimed that the similarities between the man and Hals' 1626 portrait of Massa (Cat. no. 42; Plate 64) are so striking that the Chatsworth picture must be a portrait of Massa. Though the inscription offers support for the claim (Massa was 36 in 1622) I am not convinced that they represent the same sitter. For additional unsuccessful attempts to pinpoint the model in yet other works by Hals, see Cat. no. 17. The model's unusual pose and its meaning are discussed in the text, pp. 52, 105.

19. **Lute-Player** (Plate 40; text, pp. 85, 86; text, Fig. 70). Paris, Baron Alain de Rothschild.
Canvas, 70·4 × 62·1 cm. Signed with the connected monogram in the upper right corner: FHF (the final F is not linked to the H).

PROVENANCE: Baron Gustave de Rothschild, Paris; Baron Robert de Rothschild, Paris.

EXHIBITIONS: Cleveland 1936, no. 219; Haarlem 1937, no. 20; Haarlem 1962, no. 12.

BIBLIOGRAPHY: Bode 1883, 45; Moes 216; HdG 98; Bode-Binder 71; KdK 29 (*ca.* 1623–25); Trivas Appendix 4 (variant).

A seventeenth-century copy of the picture (text, Figs. 68, 71) which was once attributed to Hals himself (Bode 1883, 16) and then to Dirck Hals (G. S. Davies, *Frans Hals*, London, 1902, p. 102) or to one of his sons (E. W. Moes, *Frans Hals*, Brussels, 1909, p. 37), and which is now attributed to Judith Leyster, is at the Rijksmuseum (Cat. no. 1455 A2). This copy was most likely used as the basis for a drawing by David Bailly dated 1626 (text, Fig. 69; Rijksprentenkabinet, Amsterdam), which provides a *terminus ante quem* for the Rothschild painting. Bailly also included a copy of a drawing of the picture, in an oval format, as part of the paraphernalia in his *Vanitas Still-life with a Young Painter*, 1651; Coll. Mlle Maria de Coussemaker, Bailleul near Lille; sale, Paris (Palais Galliéra) 3 December 1966, no. 14; acquired by the Lakenhal, Leiden in 1968 (see *Ijdelheid den Ijdelheden*, Museum de Lakenhal, Leiden, 26 June–23 August 1970, no. 1, repr.). For reproductions of both of Bailly's copies see Kjell Boström, 'David Bailly's Still-leben', *Konsthistorisk Tidskrift*, XVIII (1949), p. 100, fig. 1 and p. 104, fig. 6, and J. Bruyn, 'David Bailly', *Oud-Holland*, LXVI (1951), p. 218, figs. 15, 17.

During the eighteenth and nineteenth centuries the lute-player was identified as Adriaen Brouwer (*cf. ibid.*, p. 222, note 1); Moes (*op. cit.*, pp. 37–38) suggested he was the Leiden rhetorician and buffoon, Van der Morsch called Piero (Cat. no. 6). Neither identification is acceptable.

The vogue in Holland for life-size, half-length pictures of musicians was started by Caravaggio's Dutch followers who were active in Utrecht during the early twenties. The intense light and vivid colours of the *Lute-Player* clearly show the impact of the Dutch Caravaggisti upon Hals and indicate that the painting was done soon after the fashion for pictures in their style began. A date of *ca.* 1620–22 is probably more accurate than the date of *ca.* 1624–26 suggested in 1962 Haarlem catalogue, no. 12.

There is no way of establishing whether the Rothschild *Lute Player* or a lost one by Hals was listed in the effects of Laurens Mauritsz., Amsterdam, 18 January 1669, appraised at 15 fl. (HdG 88a).

20. **So-called Jonker Ramp and His Sweetheart (The Prodigal Son?)** (Plate 42; text, pp. 72–73, 75, 76, 80, 100, 141). New York, The Metropolitan Museum of Art (Cat. 1954, no. 14.40.602).
Canvas mounted on panel, 105·4 × 79·2 cm. Signed and dated over the fireplace: FHALS 1623 (the F and H connected).

PROVENANCE: Sale, J. A. Versijden, Leiden, 29 October 1791, no. 103 (130 fl.); sale, Copes van Hasselt of Haarlem, Amsterdam, 20 April 1880, no. 1; sale, Pourtalès, Paris; dealer Duveen; Benjamin Altman, who bequeathed it to the museum in 1913.

BIBLIOGRAPHY: Bode 1883, 13; Moes 209; HdG 139; Bode-Binder 2; KdK 23; Valentiner 4; Trivas App. 2.

The earliest known reference to the traditional title of 'Jonker Ramp and his Sweetheart' appears in a description of a drawing offered in the sale, Johannes Enschede, Haarlem, 30 May 1786, p. 16, no. 54: 'The Portrait of Jonker Ramp and his Sweetheart, beautifully drawn in the manner of C. Visser, by Cornelis van Noorde, after the painting by Frans Hals.' The drawing after the painting now in the Haarlem Municipal Archives by Cornelis van Noorde (1731–95), done à la Cornelis Visscher, is most likely identical with the one in the 1786 sale. For a discussion of a drawing, now at Groningen, done in Visscher's style by Jan Gerard Waldorp (1740–1809), and which may be a copy of a lost Hals portrait, see Cat. no. L 20.

Valentiner (KdK 23) published the reference to the romantic title in the 1786 sale and pointed out that the model cannot be identical with Pieter Ramp, who appears in Hals' St. Hadrian banquet piece painted around 1627 (Cat. no. 45; Plate 78). Valentiner also suggested that the painting may be identical with the large 'Prodigal Son' which was in the possession of Cornelia van Lemens, wife of Abr. Macarée, and given by her on 24 March 1646 at Amsterdam in payment of rent; it was valued at 48 florins (HdG 1). A painting by Hals of the same subject was included with goods and paintings worth 8,000 florins to be delivered in Amsterdam to Martin van der Broeck on 28 March 1647 (HdG 2). This prodigal son scene may have been identical with the picture used to pay rent in 1646 or it may have been identical with Hals' lost Banquet in a Park (Cat. no. L 1).

The close relation of the Metropolitan Museum's painting to representations of the Prodigal Son, which was a popular subject with Hals' predecessors and contemporaries, and the probable derivation of the dog from a print designed by Goltzius depicting the sense of smell (see text, Fig. 55) are discussed in the text, pp. 72–73. Rembrandt's interpretation of the theme is discussed by W. Weisbach, *Rembrandt*, Berlin, 1926, pp. 49f., 172, 483, and at greater length by I. Bergström, 'Rembrandt's Double-Portrait of Himself and Saskia at the Dresden Gallery', *N.K.J.*, XVII (1936), pp. 143ff.

Neither the rejection of the painting by Trivas nor his suggestion [App. 2] that it is closely related to the copy after Hals' *Lute-Player* at the Rijksmuseum (text, Fig. 68) is convincing. A reduced copy of the original by another hand with changes in the background is now in the collection of Bernard C. Solomon, Los Angeles (panel, 27·3 × 22·9 cm.; HdG 140 [wrong dimensions; replica]; Bode-Binder 3 [wrong dimensions]; KdK 298 [wrong dimensions; replica perhaps by Dirck Hals]; Valentiner, 1936, 4 [perhaps a

preliminary study]). Formerly J. P. Heseltine, London, 1908; Frits Lugt; J. W. Nienhuys, Amsterdam; sale, New York (Parke-Bernet), 2 March 1950, no. 16 ($12,000); sale, London (Sotheby), 25 June 1969, no. 68. Exhibited at Haarlem 1937, no. 16.

21. Young Man Smoking, with a Laughing Girl

(Plate 41; text, pp. 76, 77, 79, 80, 97). New York, The Metropolitan Museum of Art (Cat. 1954, no. 89.15.34). Octagonal panel, 46·7 × 49·5 cm.

PROVENANCE: R. G. Wilberforce, London; Henry G. Marquand, who bequeathed it to the museum in 1889.

EXHIBITIONS: London, Royal Academy, Winter Exhibition, 1887, no. 95; New York, Hudson-Fulton Celebration, 1909, no. 22.

BIBLIOGRAPHY: Moes 212 (replica); B. Haendke, 'Der Raucher von Frans Hals', *Zeitschrift für bildende Kunst*, XXI, 1910, p. 301 (copy); HdG 133, note (replica, parts of it worthy of Hals); Bode-Binder 6; KdK 27, note (probably a variant done in the studio); Valentiner 1936, 5 (ca. 1623; original).

Like other Dutch artists of his time Hals occasionally used an octagonal format but since his only other known works which employ this format are his pendant portraits done in the thirties, which are now at Stuttgart (Cat. nos. 98, 99; Plates 160, 161), he apparently did not favour it.

Variant:

Another version of the painting on a circular panel (diameter 35·3 cm.) is (or was) in the Municipal Museum, Königsberg (now Kaliningrad), Prussia, before 1940 (Fig. 7):

PROVENANCE: Collection Theodor Gottlieb von Hippel; given by him to the museum in 1837.

BIBLIOGRAPHY: Von Hippel Collection Catalogue, 1841, no. 12 (as signed by Jacob Jordaens); Bode 1883, 114 (ca. 1625); Moes 211; HdG 133; Bode-Binder 5; KdK 27 (ca. 1623); Valentiner, 1936, 5, note (original); *Kunstsammlungen der Stadt Königsberg, Pr. Cat.* [1931], no. 57 (original; Metropolitan Museum version a copy).

I have neither seen nor been able to determine the present location of the Königsberg version. As noted in the bibliographical references to the two pictures, opinions about their authenticity have varied. The New York painting was accepted as a replica until Valentiner endorsed it as an original in his 1909 catalogue of the Hudson-Fulton Celebration, no. 22, and again in a review of that exhibition, *Monatshefte für Kunstwissenschaft*, III (1910), p. 6 ('earlier ascribed to Frans Hals' school and which will rightly be given to the master again by Hofstede de Groot'. When Hofstede de Groot catalogued it in 1910 (133) he called it a replica and noted that the man's head is very good and fully worthy of Frans Hals; the other two heads are less good. In the same year Haendke (*op. cit.*) argued that it was

a copy but added that he could not give a definitive judgement because he had never seen the original. Valentiner expressed reservations about it in 1923 (KdK 27) and concluded that the Königsberg version was probably the original and the New York variant a studio work. In his 1936 catalogue of Hals' paintings in America (*op. cit.*), Valentiner wrote: 'In opposition to Hofstede de Groot and to my earlier opinions, according to which the Koenigsberg example is given preference, after further examination I regard the picture ... as an uncontestable original. The Koenigsberg example shows so many variations in details that it may likewise be regarded as original.'

I can see no reason to doubt Valentiner's conclusions about the authenticity of the New York version. Only the small figure holding a tankard appears to lack Hals' decisive touch, which clearly defines forms as well as their position in space. But such slack passages are found in the background of other paintings by the artist (Cat. nos. 5, 20) and in my view should not serve as the basis for excluding a work from his *oeuvre*. To judge from reproductions of the Königsberg painting, the head of the girl embracing the young man is less expressive than in the New York version and the accents in the spirited brushwork which give coherence to the form are missing, but final judgement must be reserved until it can be examined.

The close similarity of the technique and spatial composition to Hals' so-called Jonker Ramp (Cat. no. 20) of 1623 suggests that it was painted around the same time; however, the fluid brushwork does not rule out a slightly later date. The ambivalent subject of the painting is discussed in the text, p. 80.

22. Young Woman with a Glass and Flagon (Plate 43; text, pp. 74, 77, 80). Washington, The Corcoran Gallery of Art (cat. 1955, p. 25, inv. no. 26.99).

Canvas, 77·3 × 63·5 cm. Signed with the monogram in the centre left: F HAL (the letters are interconnected).

PROVENANCE: Sale, Count André Mniszech, Paris, 9 April 1902, no. 128 (10,000 francs, Agnew); dealer T. Agnew and Sons, London; dealer Sir George Donaldson, London, who sold it in 1906 to William A. Clark, New York; bequeathed to the gallery by William A. Clark in 1926.
EXHIBITIONS: London, Royal Academy, Winter Exhibition, 1903, no. 59.
BIBLIOGRAPHY: Bode 1883, 63 (*ca.* 1635); HdG 117; Bode-Binder 167; KdK 64 (*ca.* 1627–30); Valentiner 1936, 12 (*ca.* 1625–27).

The painting has suffered moderate to severe abrasion damage from past harsh cleanings; extensive losses of the paint surface are especially apparent in the head, hair and left hand, and in the background. Despite its state of preservation, enough remains—the woman's left hand and the tankard are well preserved—to secure the attribution.

The painting, which fortunately has not been heavily restored, also allows us to see something of Hals' way of using the fawn-coloured ground as a middle value upon which he laid in the darks, and worked up the light areas. Its condition compounds the difficulty of assigning a date to the picture, but the size of the figure in relation to the ground, the emphasis on the solidity of forms, and the use of props in the background suggest a date of *ca.* 1623–25. Whether or not the props give a clue to an allegorical meaning is discussed in the text, pp. 77, 80.

The unusual monogram is also abraded but seems to be contemporary. It recalls one used by Harmen Hals on some of his works (for example, *The Old Couple*, Hamburg, Kunsthalle, Cat. 1956, no. 143), but nothing about the painting's style can be related to Harmen's rather coarse and leathery life-size figures. It will be noticed that the monogram does not include the 's' of Hals' name; traces of paint above the 'H' may be remains of an 's'. Affinities of this painting to Judith Leyster are more apparent than any relationship that can be established with Harmen's work. However, when Leyster works on a life-size scale, she does not achieve the robustness, the fullness of form and the animated touch still recognizable in this imperfectly preserved work.

Valentiner (1936, 12) suggested that the painting was a pendant to another work. This is not impossible, but in my opinion the painting he offered as its probable mate was done by one of Hals' followers: *Man Holding a Large Jug* (see Cat. no. D 17; Fig. 131).

23. Two Singing Boys (Plate 44; text, pp. 80, 100). Cassel, Hessisches Landesmuseum (Cat. 1958, no. 215).

Canvas, 66 × 52 cm. Signed on a book in the lower left corner with the connected monogram: FH (Fig. 54).

PROVENANCE: *Haupt-Catalogus von Sr Hochfürstl. Durchlt Herren Land Grafens Wilhelm zu Hessen, sämtlichen Schildereyen, und Portraits. Mit ihren besonderen Registern. Verfertiget in Anno 1749.* No. 623: Hals (Franz), Ein auf Laute spielender Jüngling, in vergoldetem Rahmen (Höhe: 1 Schuh 1/2 Zoll [*sic*]; Breite: 1 Schuh 9 Zoll). Taken to Paris by Denon in 1806 and returned in 1815.
EXHIBITION: Haarlem 1937, no. 31.
BIBLIOGRAPHY: Bode 1883, 98 (*ca.* 1625); Moes 224; HdG 134; Bode-Binder 52; KdK 56 (*ca.* 1627); Trivas 14 (*ca.* 1624–27).

Painted *ca.* 1623–25. The spatial arrangement of the principal figure, the light grey background and the general tonality can be related to the *Laughing Cavalier*, dated 1624 (Cat. no. 30; Plate 52). Although Hals' single commissioned portraits of the 1620's are not handled as freely as his genre pieces, similarities in the treatment of the heads and hair are striking.

The mezzotint in reverse (Fig. 10) by Wallerant Vaillant

(1623–77) has been cited in the earlier literature on Hals as a copy after the painting. However, changes in the composition and in the costume of the boy holding the lute suggest that his print may have been done after a lost variant of it painted around the same time; a similar costume is worn by the boy making the fingernail test (Cat. no. 24; Plate 47). Unlike most of the gifted seventeenth-century engravers who copied Hals' paintings (J. Matham, J. van de Velde, J. Suyderhoef), Vaillant failed to give a suggestion of Hals' detached brushwork. Admittedly mezzotint is not the ideal medium for transcribing Hals' highly individual brushwork but the taste of another generation for a high finish is probably also reflected in Vaillant's print.

Hofstede de Groot (134) refers to a copy of the painting which was in the sale, H. R. Willett, London, 20 April 1895, no. 106 and to a second, which was with the dealer Klencke, London, 1907. The version which appeared in the sale, anon. [L. Nardus], Amsterdam (Muller), 5 June 1917, no. 6 repr., may be identical with one of the copies cited by Hofstede de Groot. In any event the Nardus copy is based on Vaillant's mezzotint, not on Hals' original. Trivas (14) notes that the Nardus copy may have been with the dealer A. L. Nicolson, London, in 1929.

Of greater interest than inferior, untraceable copies, is a drawing signed and dated 1663 by Lodewyck van der Helst (Fig. 9) which appears to have been inspired by part of the Cassel painting, or perhaps was made after a lost variant of it by Hals himself. Lodewyck van der Helst (1642–ca. 1684) was the son of Bartholomeus and probably his pupil. Lodewyck's very rare paintings are mainly reflections of his father's stylish portraits; the drawing, which is in Jacobus Heyblock's *Album Amicorum* at the Royal Library, The Hague, is the only one known by him. It confirms Houbraken's luke-warm estimate of his talent (*De Groote Schouburgh*, vol. II, Amsterdam, 1719, p. 10), but is of some consequence because it provides the name of a contemporary artist who possibly copied Hals' paintings or attempted to work in his style. Lodewyck may have been the author of some so-called Hals school pieces. A painting clearly related to Lodewyck's drawing was with the London dealer Marshall Spink in 1970 (Fig. 8; panel, 34·5 × 31·5 cm.) but not enough is known about Lodewyck's work as a painter of genre pictures to attribute it or other seventeenth-century paintings done in Hals' style to him.

24. **The Finger-Nail Test** (Plate 47; text, p. 88). New York, The Metropolitan Museum of Art (Cat. 1954, no. 14.40.604).
Canvas, 72·1 × 59 cm.

PROVENANCE: J. Napper of Lough Crew Castle, Oldcastle, Meath; sale, Dublin, 6 April 1906 (£3990, Sulley); dealers Dowdeswell, London; dealer C. Wertheimer, London; dealers Kleinberger and Wildenstein, Paris;

Benjamin Altman, New York, who bequeathed it to the museum in 1913.
EXHIBITION: Dublin 1857.
BIBLIOGRAPHY: Moes 210; HdG 86, possibly identical with HdG 74; Bode-Binder 57; KdK 59 (*ca.* 1627); Valentiner 1936, 21 (*ca.* 1627).

Painted *ca.* 1623–25. Closely related to the *Merry Lute-Player* (Cat. no. 26; Plate 48). Moderate to severe abrasion throughout; the dark areas, the lute, the table in the foreground and the back cloth have especially suffered. The impact of the bold foreshortening of the lute is lost. Some of the restoration is clumsy, *e.g.* the strings of the lute have been repainted over the model's left thumb instead of behind it.

The boy has inverted his glass to demonstrate that he has drained it so thoroughly that not a drop will fall on his fingernail. A slightly larger painting of the same subject attributed to Hals appeared in the sale, F. Kamermans, Rotterdam, 3 October 1825, no. 47 (75 florins, Lamme), canvas, 84 × 65 cm. (HdG 74); perhaps it was identical with the Metropolitan Museum painting.

25. **Boy with a Flute** (Plates 45, 46; text, p. 88). Berlin-Dahlem, Staatliche Museen (Cat. 1966, no. 801A).
Canvas 62 × 54·5 cm. Signed at the lower right with the connected monogram: FH.

PROVENANCE: Sale, B. Ocke, Leiden, 21 April 1817, no. 45 (78 florins, Lelie); sale, Amsterdam, 16 December 1856, no. 19 (panel, 68 × 56 cm.); collection Suermondt, Aachen, 1874.
EXHIBITION: Amsterdam 1950, no. 51.
BIBLIOGRAPHY: Bode 1883, 90 (*ca.* 1625); Moes 218; HdG 81; Bode-Binder 56; KdK 55 (*ca.* 1627); Trivas 25 (*ca.* 1625–27).

Even before the painting was restored at the museum in 1959–60, it was apparent that a strip about 6 cm. wide had been added to the bottom. Examination of its paint layer demonstrated that the strip had not been painted by Hals and that the book and end of the flute as well as the drapery on it, which are visible on reproductions of the painting made before it was restored (*cf.* KdK 55), had been added by another hand. The later addition has not been removed but is now covered by the frame. The 1959–60 restoration also freed the work of some repaint.

Valentiner's categorical assertion (KdK 55) that this painting of a young musician as well as others which belong to the same group (Cat. nos. 23, 24, 26) surely represent Hals' children is an appealing one and finds some support in Houbraken's statement that he was told by J. Wieland, an old art lover who knew the artist, that all of Hals' children were lively and loved to sing and play musical instruments (*De Groote Schouburgh*, vol. I,

Amsterdam, 1718, p. 95). However, until further evidence is available identification of these models must remain tentative.

The style and the subject of the painting are strongly reminiscent of works done by the Utrecht *Caravaggisti* during the 1620's. Baburen used the motif of a singer beating time with his raised hand held in the same manner in a painting dated 1622 (text, Fig. 66) and Terbrugghen employed it in his *Singer* at Gothenburg, 162[?], and in his *Boy Singing*, Museum of Fine Arts, Boston, which is dated 1627.

26. **Merry Lute-Player** (Plate 48; text, p. 88). England, Private collection.

Panel, 90 × 75 cm. Signed at the lower right with the connected monogram: FH.

PROVENANCE: Possibly sale, Capello, Amsterdam, 6 May 1767, no. 28: canvas (58 florins); according to O. Granberg, *Sveriges privat tafelsamlingar...*, Stockholm, 1885, p. 5, it was bought in 1826 from the collection of Professor Fahlcrantz and remained in the possession of the Counts Trolle-Bonde after that date; Coll. Count F. Bonde, Säfstaholm, 1885; dealer Martin H. Colnaghi, London; Coll. Jules Porgès, 1891; dealer C. Sedelmeyer, Cat. 1896, no. 19; Coll. A. Veil-Picard, Paris; dealer Duveen, Paris and New York, *ca.* 1933; Coll. John R. Thompson, Jr., Chicago; sale, J. R. Thompson, New York (Parke Bernet) 15 January 1944, no. 35; Coll. Oscar B. Cintas, Havana; sale, Oscar B. Cintas, New York (Parke Bernet), 1 May 1963, no. 10 ($600,000; Speelman).
EXHIBITIONS: Possibly, Royal Academy, London, 1891, no. 72 (canvas; Porgès); Paris, Jeu de Paume, 1911, no. 55 (Veil-Picard). Exhibited from the Thompson collection in the following exhibitions: Detroit 1925, no. 4; London 1929, no. 372; Chicago 1933, no. 62; Detroit 1935, no. 9; Haarlem 1937, no. 30; New York 1940, no. 82; Chicago 1942, no. 11.
BIBLIOGRAPHY: O. Granberg, *Sveriges privat tafelsamlingar...*, Stockholm, 1885, p. 5, no. 4; HdG 82 (wrong provenance); Bode-Binder 58 (in the Coll. A. Veil-Picard); KdK 58 (*ca.* 1627; in the Coll. A. Veil Picard with the note that it went to Duveen when the book was in the press); Valentiner, 1936, 20 (*ca.* 1627; in the Coll. J. R. Thompson, Jr.); Trivas 27 (canvas, *ca.* 1625–27; in the Coll. J. R. Thompson, Jr.).

The history of the painting is badly confused. Hofstede de Groot (vol. IV, p. ii) noted that the provenance he had compiled in his Hals entry no. 82 was mistaken and substituted a new one. I have not been able to confirm his statements that the painting was with the London dealer Wertheimer, the late Baron Ferdinand von Rothschild,

Waddesdon Manor, and then with the London dealer Gooden, London, 1896, and I do not understand why he deleted Jules Porgès as a former owner while accepting the fact that the painting was exhibited at the Royal Academy, London, 1891, no. 72, when it was in the Porgès collection. But the rest of the revised provenance he gave (*ibid.*) appears to be correct. Valentiner (1936, 20) and Trivas (27) used parts of Hofstede de Groot's confirmed and unconfirmed provenance, and Trivas added to the confusion by introducing a new error (see below). The principal cause of the muddle is a copy which was formerly in the collection of Sir Edgar Vincent, Esher, Surrey (Moes 214); parts of its provenance have been confounded with the original's history. The Vincent version is now untraceable and is only known from an old photograph (Fig. 11). The photo leaves little doubt that the painting was an inferior copy; it may be identical with the painting which appeared in the sale, T. Sheffield, London (Foster's), 25 February 1885, no. 103 (J. C. Robinson; 10 gns.).

In 1910 Hofstede de Groot (82) confused the Vincent version with the original. In 1911 (vol. IV, p. ii) he corrected his error and wrote that the original was in the collection of A. V. Picard, Paris; he did not cite the Vincent version but stated that a modern copy was in an English private collection. Valentiner (KdK 58) wrote that the replica formerly with Sir Edgar Vincent appeared to be a forgery. Trivas (27) wrote that a 'modern copy (fake)' was with Sedelmeyer, Paris, Cat. 1896, no. 19, and that Sedelmeyer's painting was the 'fake' which entered Sir Edgar Vincent's collection. Trivas does not give any reason for his conclusion that Sedelmeyer's painting was a copy or a fake, and everything I have been able to learn about it suggests that there is no foundation to his charge. I see nothing about the good reproduction of it in the 1896 Sedelmeyer catalogue (facing p. 28) that raises doubts. Moreover, the data Sedelmeyer gives about the painting (panel, 35 × 20½ inches; from Mr. Martin H. Colnaghi, who bought it at Stockholm; from the Coll. of Jules Porgès, exhibited Royal Academy, London, 1891) are consistent with the information which Trivas himself presents about the original version—with one exception: Trivas erroneously states the original is on canvas.

Knowledge that a copy has been confused with an authentic work is sufficient to make one uneasy about an attribution; however, recent examination of the painting raised no doubts about the ascription. The painting is closely related to Cat. nos. 23, 24, 25, and its slightly freer brushwork suggests it may have been the latest work done in this attractive group.

Bad copies of the head of the youth have made sporadic appearances on the market: dealer Weustenberg, Berlin, 1915; sale, C. Robertson of London, New York (Anderson Galleries), 20 February 1922, no. 129 (circular panel, diameter 16·2 cm.); Roberts Art Gallery, Toronto, 1923; sale, R. S., Paris (Drouot), 11 March 1931, no. 49 (panel, 17 × 14 cm.).

27. **Laughing Boy Holding a Flute (Hearing?)** (Plate 50, pp. 75-76, 79). Storrington, Sussex, Lady Munro.
Circular panel, diameter 29 cm.

PROVENANCE: Alfred Beit, London; Sir Otto Beit, London.
BIBLIOGRAPHY: Moes 240; HdG 31; W. Bode, *Catalogue of the Collection of . . . Otto Beit*, London, 1913, pp. 26, 75, no. 23 (1625-30); Bode-Binder 20; KdK 34 right (*ca.* 1623-25).

The similarities of the style of Cat. nos. 27, 28, 29 relate these little oil sketches to Hals' larger paintings of music-making children (see Cat. nos. 23-26). Conceivably small oil sketches of this type preceded the more ambitious compositions of about 1623-25; hence a date of about 1620-25 is suggested for the group. The dark background of this sketch and the low viscosity of the paint place it closer to the beginning than to the middle of the decade. Discussion of the flute as an attribute of the sense of hearing is found in the text, pp. 75-76, 79.

According to Hofstede de Groot (31) a copy of Lady Munro's painting is in the Museum Boucher de Perthes in Abbeville. Copies and variants of Hals' paintings of children seem to have been made shortly after the artist finished them and later artists continued to produce them *en gros*. Some of the questionable ones which have been attributed to him also exist in numerous versions; these variants may have been based on lost autograph pieces (see Cat. nos. D 1, D 4, D 5, D 6, D 7, D 8).

28. **Laughing Boy with a Soap Bubble (Vanitas?)** (Plate 51, text, pp. 75-76). Hollywood, California, Hans Cohn.
Circular panel, diameter 28 cm. Signed at the upper right with the connected monogram: FH.

PROVENANCE: Jules Porgès, Paris; M. Lüders, New York; E. L. Lueder, New York; sale, John Bass, New York, 25 January 1945, no. 11.
EXHIBITIONS: Haarlem 1937, no. 23; New York 1937, no. 6; San Francisco 1940, no. 189.
BIBLIOGRAPHY: HdG 19A; Bode-Binder 34; KdK 30 right (*ca.* 1623-25); Valentiner 1936, 8.

The bubble in the lower right, which has not been mentioned in the earlier literature on the painting, was a familiar *vanitas* symbol in sixteenth- and seventeenth-century Netherlandish art (see B. Knipping, *De Iconographie van de Contra-Reformatie in de Nederlanden*, Hilversum, 1939, pp. 117ff., Seymour Slive, 'Realism and Symbolism in Seventeenth-Century Dutch Painting', *Daedalus, Journal of the American Academy of Arts and Sciences*, Summer [1962], pp. 489ff.). Its presence here suggests that Hals was referring to the commonplace theme *Homo bulla*. A weak copy

(Fig. 12; canvas, 34 × 30·5 cm.; exhibited in Haarlem 1937, no. 13, private collection) indicates that the original may have been slightly larger. Two paintings which may have been made after a lost original by Hals suggest that the artist treated the theme more than once (*cf.* Cat. nos. D 7-1, D 7-2; Figs. 116, 117). *A Laughing Child with a Flute*, formerly Dwight W. Davis, Washington, D.C. (Cat. no. D 4-1; Fig. 106) has been called a pendant to the Cohn picture. In my judgement neither it nor the variants of it discussed in Cat. no. D 4 are originals.

The Cohn tondo is possibly related to two pendant pictures, a *Head of a Laughing Child*, in full face, blowing soap bubbles, and a *Head of a Laughing Boy*, almost in full face, blowing soap bubbles (painted tondos on rectangular panels or oval panels; each 34 × 31 cm.), which appeared in the sale, Wiermann, Amsterdam, 18 August 1762 (HdG 35, 36, respectively). Untraceable companion pictures of bubble-blowers by Hals are also cited in the manuscript *Catalogue raisonné des tableaux qui se trouvent dans les Galeries, Salons et Cabinets du Palais Impérial de S. Petersbourg, commencé en 1773 et continué jusqu'en 1783* compiled by E. Mienich, now in the library of the Hermitage, Leningrad:

1898. François Hals. Buste d'un jeune garçon. Il représente un petit garçon soutenant sur sa main une boule de savon et suivant des yeux une autre qui est en l'air. Petit morceau de l'expression la plus naive.
Sur bois, H. 8 v. L 6¾ v. Pend. du No. 1899.

1899. François Hals. Buste d'un jeune garçon. C'est encore un petit garçon tenant une boule de savon sur une main et faisant un geste d'admiration, ou de contentement de l'autre. Très joli tableau pour son expression.
Sur bois. H 8 v. 6¾ v. Pend. du No. 1898.

The description of these small pendants (1 vershkov = 2·45 cm.) relates them more closely to the variant after Cat. no. 28 (Fig. 12) than to the versions listed in Cat. no. D 4. I am indebted to J. Kuznetsov for these references from Mienich's manuscript catalogue.

29. **Laughing Boy** (Plate 49; text, p. 75). The Hague, Mauritshuis (inv. no. 1032).
Circular panel, 29·5 cm. Signed with the connected monogram to the left of the collar: FH; traces of a second connected monogram at the upper left: FHF.

PROVENANCE: Baron Albert von Oppenheim, Cologne; sale, Baron Albert von Oppenheim, Berlin (Lepke) 19 March 1918, no. 16; Mrs. Friedländer-Fuld, Berlin (files RKD); Mrs. M. von Kühlmann, Berlin (later Mrs. Goldschmidt-Rothschild, Paris). Acquired by the Mauritshuis in 1968.
EXHIBITIONS: Cologne 1876, no. 46; Düsseldorf 1886, no. 132; Haarlem 1937, no. 22; Haarlem 1962, no. 11; The Hague, Vijfentwintig jaar anwinsten: 1945-70, Mauritshuis, 1970, no. 15.

BIBLIOGRAPHY: Bode 1886, 113; Moes 235; HdG 28 (wrongly described as a boy holding a flute); Bode-Binder 29; KdK 31 right (*ca.* 1623–25).

One of Hals' most attractive studies of a fleeting moment in the life of a child. Three copies of it testify to the popularity of the work and show how Hals' suggestive touch and sparkling accents disintegrate in the hands of his followers. The copies, which have in the past been erroneously attributed to Hals by some students, are:

1. Dijon, Museum (Fig. 13): panel, 34×29·8 cm.; HdG 18; Bode-Binder 31; KdK 31 right, note (less good replica); J. Magnin, *La Peinture au Musée de Dijon*, 3rd ed., Besançon, 1933, p. 185, no. 133 (erroneously listed as on canvas).
2. Albert Lehmann, Paris; sale, Lehmann, Paris (Petit), 12–13 June 1925, no. 253; sale, William Berg, New York (Parke-Bernet), 15 April 1953, no. 64; sale, Martin Schoenemann of Lugano, London (Christie), 24 November 1967, no. 85 (3,000 gns, Beck); sale, Zürich (Koller), 26*ff.*, May 1972 (175,000 Swiss fr.) (Fig. 14): circular panel, diameter 30 cm.; Bode-Binder 30; KdK 31, right, note (less good replica).
3. Location unknown (Fig. 15); Bode-Binder 32; KdK 31 right, note (less good replica).

The painting has been called a pendant to a *Child Holding a Flute* (Cat. no. D 5-1; Fig. 108; formerly coll. Baron Albert von Oppenheim; Mrs. E. W. Edwards, Cincinnati) by Hofstede de Groot (29) and Valentiner (KdK 31 right). Apart from the fact that both paintings were in the Oppenheim collection and both are the same size there is no compelling reason to call them companion pictures. The Edwards *Child Holding a Flute* as well as the six other versions of it listed in Cat. no. D 5 all appear to be variants by anonymous followers after a lost original by Hals.

30. **Laughing Cavalier** (Plates 52, 53, 55; text, pp. 15, 21–23, 86, 88; Fig. 3). London, Wallace Collection (Cat. 1968, no. 84).
Canvas, 86×69 cm. Inscribed in the upper right corner: AETA·SVAE 26/A° 1624.

PROVENANCE: Sale, J. H. van Heemskerk, The Hague, 29–30 March 1770, no. 44, canvas mounted on panel (180 florins, Locquet); sale, P. Locquet, Amsterdam, 22 September 1783, no. 129 (247 florins, Fouquet); sale, Jan Gildemeester Jansz., Amsterdam, 11 June 1800, no. 64 (300 florins, Achtienhoven); sale, J. A. Brentano, Amsterdam, 13*ff.*, May 1822, no. 134 (700 florins, de Vries for Pourtalès); sale, Comte de Pourtalès, Paris, 27 March 1865, no. 158 (51,000 francs, Lord Hertford).
EXHIBITIONS: Bethnal Green, Branch of the South Kensington Museum, London 1872–75, no. 236; Royal Academy, Winter Exhibition, London 1888, no. 75.
BIBLIOGRAPHY: Bode 1883, 141; Moes 120; HdG 291

(erroneously listed as on panel and provenance partially incorrect); Bode-Binder 100 (erroneously listed as on panel); KdK 38 (erroneously listed as on panel); Trivas 12.

The painting shows that by 1624 Hals had incorporated the stylistic innovations of the Dutch *Caravaggisti* into his portraits. The handsome twenty-six-year-old model remains unidentified; whether the rich collection of embroidered emblems on his colourful jacket and sleeve offers a clue to his identity remains problematic (see text, pp. 21-23).

The popular title is not quite accurate and was acquired rather late. The earliest known published reference to the portrait as 'The Laughing Cavalier' is found in the Royal Academy Old Master Exhibition Catalogue of 1888 (no. 75), when the picture was lent by Sir Richard Wallace. Mr. R. A. Cecil of the Wallace Collection has kindly informed me that the title also appears on the entry slip, which the Academy still has in its records, and therefore one assumes that the title had already been given to the picture, as titles were normally filled in by the owners. The model had made an appearance as *A Cavalier* when the painting was exhibited by Sir Richard Wallace at the Bethnal Green Museum from 1872 to 1875. When the picture was sold at the Pourtalès sale in 1865 it bore the straightforward title *Portrait d'homme vu à mi-corps*. Thus it appears that the title must date from the period 1875-88.

Like its title, the portrait acquired its wide popularity long after it was painted. It could not have generated much interest at the Heemskerk sale held in Amsterdam in 1770, for it only fetched 180 florins while a Griffier landscape brought 435 florins, a Berchem landscape 1,265 florins, a Huysum still-life 2,100 florins, and a Jan van der Heyden was carried away for 1,305 florins. At Locquet's sale in 1783 at Amsterdam the portrait brought 247 florins, not an impressive price when we learn that an Asselyn fetched 626 florins and a Berchem was sold for 3,000 florins. Some paintings, however, fetched lower prices: an Avercamp was sold for eight florins. When the painting appeared in subsequent sales during the early part of the nineteenth century, collectors began to show more interest in it (see Provenance above). But no one was prepared for the radical change in the estimation of its value—at least in the opinion of two millionaires—which occurred in 1865. In that year Lord Hertford acquired the picture for 51,000 francs at the Pourtalès sale, after winning what has been described as a Homeric contest with his powerful antagonist Baron James de Rothschild. The price he paid was considered mad at the time. It was hundreds of times more than had been paid for Hals' works during the eighteenth and first half of the nineteenth century. This sale did not start the sensational rise in prices paid for Hals' works but the boom was around the corner. Salesroom prices began to soar steadily about a decade later. In 1889 Lord Iveagh paid 110,500 francs at the Secrétan sale for *Pieter van den Broecke* (Cat. no. 84; Plate 136), and by the turn of the century eyebrows were

raised if bidding on a work by Hals closed rather than began at the price Lord Hertford paid for his portrait.

31. **Willem van Heythuyzen** (Plates 56, 57; text, pp. 52–54, 57, 67, 115, 130). Munich, Alte Pinakothek. Canvas, 204·5 × 134·5 cm.

PROVENANCE: Sale, G. W. van Oosten de Bruyn, Haarlem, 8 April 1800, no. 13 (51 florins); acquired by Johann I. Josef (1760–1836), Prince of Liechtenstein (as a work by Bartholomeus van der Helst) in 1821; purchased by the Alte Pinakothek in 1969 for 12,000,000 DM.

EXHIBITION: Meisterwerke... Liechtenstein, Kunstmuseum, Lucerne 1948, no. 157.

BIBLIOGRAPHY: A. Loosjes, *Frans Hals: Lierzang vorgeleezen bij gelegenheid der uitdeeling van de prijzen in de Tekenakademie te Haarlem, 1789*, Haarlem, [1789], pp. 12–13; G. F. Waagen, *Die vornehmsten Kunstdenkmäler in Wien*, Vienna, 1866, vol. I p. 271 (Hals, not B. van der Helst); W. Burger [É. J. T. Thoré], 'Frans Hals', *G.B.A.*, XXIV (1868), p. 441 (Hals, not B. van der Helst); *Katalog der Fürstlich Liechtensteinschen Bildergalerie*, Vienna, 1873, p. 19, no. 150 (identified as Heythuyzen); Bode 1883, 123 (*ca.* 1630); *Icon. Bat.* 3507-1 (wrong provenance); Th. Frimmel, 'Wann ist das Heythuysen-Bildnis in die Liechtenstein Sammlung gekommen?', *Blätter für Gemäldekunde*, Beilage, Lief. II, May, 1907, p. 30; Moes 44; HdG 191 (*ca.* 1635; wrong provenance); Bode-Binder 220; KdK 153 (*ca.* 1636); A. Stix-E. von Strohmer, *Die Fürstlich Liechtensteinsche Gemäldegalerie in Wien*, Vienna, 1938, pp. xi, 99, no. 54; Trivas 64 (*ca.* 1633–36); Erich Steingräber, 'Willem van Heythuysen von Frans Hals', *Pantheon*, XXVIII (1970), pp. 300*ff*.

Little is known about Willem van Heythuyzen. He was born in Weert, Limbourg (date unknown), and settled in Haarlem, where he was active as a merchant. His testament of 1636 cites seven sisters; to his sister Geertruyt he bequeathed two houses. He also endowed a 'hofje' (home for old people) in Weert and another in Haarlem; the latter was established in 1651 on his estate at Middenhout outside of Haarlem and is still in existence (Gerda H. Kurtz, *Geschiedenis en Beschrijving der Haarlemse Hofjes*, Haarlem, 1951, pp. 124*f*.) He died 6 July 1650 and was buried at St. Bavo's Church in Haarlem; also see text, pp. 52–54. For Hals' other portrait of Heythuyzen, see Cat. no. 123; Plate 198.

The painting is the artist's only life-size full-length portrait. It is also the only one which makes such conspicuous use of baroque trappings. Earlier students dated it in the thirties (HdG 191, *ca.* 1635; KdK 153, *ca.* 1636; Trivas 64, *ca.* 1633–36) but passages of rather pasty paint, the relatively cool colour harmony, the insistence upon a sculptural quality in the treatment of head and figure, and the close relation of the handling of the garden to the one in Hals'

Married Couple at the Rijksmuseum (Cat. no. 17; Plate 33) support a date of about 1625. The cut of the model's tapered jacket, his balloon knickerbockers and style of his ruff also place the portrait in the mid-twenties. Steingräber (*op. cit.*) has noted that the large black-on-black acanthus pattern on his satin costume and the clearly differentiated hilt of his sword seem to point to a date in the 1630's, but these observations need not rule out the earlier date if Heythuyzen was a man who was just one step ahead of widely accepted fashion. To judge from everything we can deduce from the style of the great portrait as well as from Hals' characterization of the model he was such a man.

It is also noteworthy that although Heythuyzen is shown in a garden there is a strong impression of studio rather than outdoor light on the figure. This light as well as the technique relates the painting closely to Hals' 1625 portrait of *Jacob Pietersz Olycan*, Cat. no. 32; Plate 58.

The portrait was praised by A. Loosjes in a poem he delivered at the distribution of prizes at Haarlem's Drawing Academy in 1789 (*op. cit.*). His poem apparently did not impress potential buyers and when the picture was sold in Haarlem in 1800 it only brought fifty-one florins. In 1821 it was acquired for the Prince of Liechtenstein as a work by Bartholomeus van der Helst. At that time the name of the model was either suppressed or forgotten. Robert Theer published a lithograph of it in Vienna in 1843. He, too, did not know a Hals from a Van der Helst and inscribed his lithograph: 'Barth. v.d. Helst pinx.' Waagen was the first to recognize the hand of the artist who painted it in his volume on Vienna's art treasures published in 1866 (*op. cit.*). In 1868 Bürger-Thoré wrote: 'En Allemagne, quoique les Hals ne soient pas rares, il paraît qu'on ne les connaît pas très-bien, du moins à Vienne; car, dans la splendide galerie Lichtenstein, un de ses plus beaux portraits et des plus importants est attribué à van der Helst!' (*op. cit.*). In the same article Bürger-Thoré (*ibid.*, p. 431, note 1) cited the reference to the sale of a portrait of Heythuyzen by Hals in the 1800 sale at Haarlem but failed to relate the reference to the Liechtenstein painting. The Liechtenstein catalogue of 1873 corrected the attribution and identified the sitter. Subsequent critics have universally acknowledged the portrait as one of Hals' major works.

A weak copy of the Munich painting appeared in the sale, Vienna (Dorotheum) 23–25 October 1928, no. 159 (canvas, 102 × 67 cm.).

An oil sketch of a *Standing Man* at Buckingham Palace (Fig. 16; canvas, 62·5 × 42 cm.) has been called a preparatory study for the Munich painting:

PROVENANCE: No. 95 in the list of Dutch and Flemish pictures acquired by George III with the collection of Consul Smith in 1762 as Jordaens: A Young Man, full length; recorded at Kensington 1818, no. 421, and thereafter in the Royal inventories.

BIBLIOGRAPHY: Bode 1883, 146 (*ca.* 1628); *Catalogue of Paintings at Hampton Court*, 1898, no. 676; L. Cust, *The Royal Collection of Paintings*, vol. I, Buckingham

Palace, 1905; HdG 285; L. Cust, 'Notes on Pictures in the Royal Collections, xxxv: On a Portrait Sketch of a Youth by Frans Hals', *B.M.*, xxviii (1915–16), p. 186; KdK 152 (*ca.* 1636, study); Trivas 63 (*ca.* 1635–36, study). L. Cust (*op. cit.*, 1915–16) took Bode-Binder to task for omitting this painting from their 1914 catalogue of Hals' work. But since neither the broad, unmodulated tonal areas nor the detached brushstrokes succeed in defining forms or establishing clear spatial relationships as they do in Hals' authentic works, I endorse Bode's and Binder's rejection of the painting and do not agree with those who have accepted it as an original. The Buckingham Palace painting is related to a group of Judith Leyster's works (see Cat. no. D 26), and can be tentatively ascribed to her. A weaker version of the sketch is at the University of California, Los Angeles, Art Galleries, Willitts J. Hole Collection (Fig. 17). Canvas, 66×45 cm.: inscribed on the stretcher 'From the Collection of Mrs. Swann [?] of Halston, Oswestry, Shropshire'; dealer F. Sabin, London, 1924; G. Camerino, Venice, 1925; J. Boehler, Munich; acquired *ca.* 1927 from Chapellier, Brussels. Valentiner (KdK 152, note) called this version a 'hardly authentic repetition' of the Buckingham painting; Trivas (63) listed it as a copy.

A full-length drawing of a *Standing Man* (Fig. 18) at the Rijksprentenkabinet, Amsterdam (inv. no. 1914.10), has been related to Munich's Heythuyzen and the Buckingham Palace painting as well as to Hals' militia piece of the St. George Company done around 1627 (Cat. no. 46).

> Black chalk, heightened with white on grey paper; 41·9×22·7 cm. Inscribed on the verso, in an eighteenth-century hand: 'F. Hals' and 'E 11'.
>
> PROVENANCE: acquired from Jan H. Odink by the Rijksprentenkabinet in 1914.
>
> EXHIBITIONS: Washington, New York, Minneapolis, Boston, Cleveland, Chicago, Dutch Drawings: Masterpieces of Five Centuries, 1958–59, no. 46 (Frans Hals); Brussels, Hollandse Tekeningen uit de Gouden Eeuw, 1961, no. 20 (Frans Hals); Hamburg, Holländische Zeichnungen der Rembrandt-Zeit, 1961, no. 20 (Frans Hals); Amsterdam, Keuze van Tekeningen Bewaard in het Rijksprentenkabinet, 1963, no. 47 (Frans Hals); New York, Boston, Chicago, Dutch Genre Drawings of the Seventeenth Century, 1972–73, no. 46 (Frans Hals, attributed to).
>
> BIBLIOGRAPHY: J. G. van Gelder, *Prenten en Tekeningen*, Amsterdam, 1958, pp. 25, 94.
>
> Copy: Fondation Custodia, Paris; black and white chalk, 47×26 cm. (inv. no. 15040). It appeared in the sale, Earl of Warwick, London (Sotheby), 17 June 1936, no. 132, repr.

J. G. van Gelder introduced the Amsterdam drawing into the literature in 1958 (*op. cit.*) when he cautiously published it as a work done around 1625 by 'Frans Hals (attributed to)'. Subsequently the sheet has been frequently exhibited as an authentic drawing by the artist. The costume, technique and chiaroscuro effect indicate that it was done by

a draughtsman active in the twenties, but in my opinion the artist was not Frans Hals. Admittedly, it is not possible to turn to a single authentic drawing to help establish the character and quality of sketches Hals may have made, but there are no parallels in his painted *oeuvre* for the marked weaknesses of the stubby foreshortened arm and the absence of spatial clarity in the cloak around it. The vigorous, yet unmodulated and rather schematic hatching also speaks against the attribution. Karel Boon, Director of the Rijksprentenkabinet (written communication) and Pieter Schatborn, compiler of the 1972–73 Dutch Genre Drawings Exhibition Catalogue (*op. cit.*, no. 46), have suggested that the drawing may be Flemish rather than Dutch. A connection can be established between it and a group of drawings which Frits Lugt ascribed to Cornelis de Vos, particularly the *Head of a Young Boy* at the Louvre (*École Flamande*, vol. ii, Paris, 1949, p. 76, no. 1386, repr.; also see no. 1384, repr. and no. 1385, repr.). Other drawings Lugt associated with De Vos are at the British Museum, Brussels, Dresden, Berlin and Besançon (*ibid.*). Michael Jaffé has attributed the Besançon drawing, and four additional studies clearly related to it, to Jordaens (see Ottawa, National Gallery of Canada, *Jacob Jordaens*, 1968–69, nos. 152, 153, 154, 156); for the view that they are not by Jordaens but by an unidentified Flemish artist see Julius Held, 'Jordaens at Ottawa', *B.M.*, cxi, 1969, p. 268. It cannot be claimed that the Amsterdam sheet finds a permanent home with the chalk drawings which belong to this disputed group—it is bolder and less methodical in attack—but the general stylistic affinities it shares with them give weight to the supposition that it may have been done by a Fleming or by a Dutch artist who had close contact with his southern neighbours.

A weaker drawing of a full-length *Standing Man Leaning on a Parapet*, formerly in the Fürst von Liechtenstein collection, was wrongly attributed to Frans Hals in J. Schönbrunner and J. Meder, *Handzeichnungen alter Meister*, vol. xi, Vienna, n.d., no. 1238, repr.: black chalk with grey wash; flesh colour wash on the face and hands; signed at the lower left in pencil (not charcoal): F. Hals. The drawing appeared in the sale, Fürsten von Liechtenstein, Bern, Klipstein and Kornfeld, 16 June 1960, no. 100 (Frans Hals, zugeschrieben). F. Lugt has rightly noted that the drawing is a copy by an unidentified hand of the guardsman leaning over the balustrade in the upper right of Flinck's 1645 group portrait of the *Company of Captain Albert Bas and Lieutenant Lucas Conijn* (*cf.* J. W. von Moltke, *Govaert Flinck: 1615–1660*, Amsterdam, 1965, pp. 167, 264, no. 187, repr.). The drawing was probably made by an eighteenth-century artist.

32. **Jacob Pietersz. Olycan** (Plate 58; text, pp. 50, 123–124). The Hague, Mauritshuis (Cat. 1968, no. 459). Canvas, 124·6×97·3 cm. Inscribed in the upper right: AETAT SVAE 29/A°. 1625. His coat-of-arms hangs on the left.

PROVENANCE: Sale, Amsterdam, 16 May 1877, no. 9 (bought in with the pendant 19,580 florins); bought by the Dutch government with the pendant from the Van Sypestein family for 10,000 florins in 1880.
BIBLIOGRAPHY: V. de Stuers, 'Twee portretten van Frans Hals', *Nederlandsche Kunstbode*, III (1881), pp. 44–46; Bode 1883, 24; *Icon Bat.* 5537-1; Moes 58; HdG 208; Bode-Binder 102; KdK 42; Trivas 18.

Companion piece to Cat. no. 33. According to Hofstede de Groot (208, 209) and the Mauritshuis Cat. 1935 (p. 123, no. 459; p. 124, no. 460), the coats-of-arms on the portrait and its pendant are later additions.
Olycan was born in Haarlem on 9 July 1596, married Aletta Hanemans at Zwolle on 14 July 1624, and was buried in Haarlem 4 December 1638. Hals portrayed him again in his St. George banquet piece of 1627 (Cat. no. 46; Plate 85), seated in the centre behind the table. Hals also made impressive portraits of his father Pieter Jacobsz. Olycan and his mother Maritge Vooght (Cat. nos. 128, 129; Plates 206, 207) and five other members of his family (see text, pp. 123–124).

33. Aletta Hanemans, wife of Jacob Pietersz. Olycan
(Plate 59; text, p. 123). The Hague, Mauritshuis (Cat. 1968, no. 460).
Canvas, 124·2×98·2 cm.: Inscribed in the upper left: AETAT SVAE 19/AN° 1625. Her coat-of-arms hangs on the right.

PROVENANCE: Sale, Amsterdam, 16 May 1877, no. 10 (bought in with the pendant 19,580 florins); bought by the Dutch government with the pendant from the Van Sypestein family for 10,000 florins in 1880.
BIBLIOGRAPHY: V. de Stuers, 'Twee portretten van Frans Hals', *Nederlandsche Kunstbode*, III (1881), pp. 44–46; Bode 1883, 25; *Icon. Bat.* 3134; Moes 59; HdG 209; Bode-Binder 103; KdK 43; Trivas 19.

Companion picture to Cat. no. 32. Aletta Hanemans was born in 1606 at Zwolle. She married Jacob Pietersz. Olycan in 1624 (see Cat. no. 32) and on 29 January 1641 married Nicolaes van Loo (baptized Haarlem 8 May 1607 and buried end of August 1641, at Haarlem). She died in 1653. Her second husband was also portrayed by Hals. He appears as a sergeant in the artist's St. George militia piece of 1639 (Cat. no. 124, Plate 201; text, Fig. 140).

34. Portrait of a Man
(Plates 66, 70). New York, The Metropolitan Museum of Art, Jules S. Bache Collection (Cat. 1954, no. 49.7.34).
Canvas, 76·2×63·5 cm. Inscribed at the upper right: AETAT 36/AN° 1625.

PROVENANCE: Carl Thomson, London, *ca.* 1923 (files R.K.D.); dealer Ayerst H. Buttery, London; Jules S. Bache, New York, who gave it to the museum in 1949.
EXHIBITIONS: London, Barbizon House 1925, no. 41; dealer F. Kleinberger, New York 1925, Cat. no. 22; Detroit 1935 no. 3.
BIBLIOGRAPHY: KdK, p. ix; Valentiner 1928, p 247; Valentiner 1935, p. 101, no. 2; Valentiner 1936, 13; *Catalogue of Paintings in the Bache Collection*, New York, 1937, no. 35; *ibid.*, 1944, no. 35; Trivas 17.

Valentiner noted in 1923 (KdK p. ix) that he knew that this excellent portrait was with A. H. Buttery, London, and added that he was unable to procure a photograph of it in time for the publication of the second edition of his catalogue. Thus it was probably rediscovered in the early 1920's. According to Kleinberger's 1925 exhibition catalogue the portrait was formerly in the collection of the Countess of Dartrey.

35. Portrait of a Man
(Plate 67). Berlin-Dahlem, Staatliche Museen (Cat. 1966, no. 801F).
Panel, 26·2×20 cm. Inscribed on the verso: 1625.

PROVENANCE: Collection Suermondt, Aachen, 1874.
BIBLIOGRAPHY: Bode 1883, 89; Moes 121; HdG 255; Bode-Binder 94; KdK 44; Trivas 16.

The date inscribed on the back of the panel appears contemporary and is entirely consistent with the style of the portrait. The sitter has been described by some cataloguers as a humpback but it is difficult to determine if he was deformed or if his costume creates this impression. I fail to see the certain resemblance Valentiner noted (KdK 44, note) between the model and the engraving of Palamedes Palamedesz by Paul Pontius which appears in Van Dyck's *Iconographie* (see M. Mauquoy-Hendrickx, *L'Iconographie d'Antoine van Dyck*, Académie royale de Belgique, Classe des Beaux-Arts, Mémoires, vol. IX (1956), no. 58).
A copy of the painting was on the London art market in 1961 (panel, 27·6×20 cm.).

36. Petrus Scriverius
(Plate 60; text, pp. 58–59, 77). New York, The Metropolitan Museum of Art, H. O. Havemeyer Collection (Cat. 1954, no. 29.100.8).
Panel, 22·2×16·5 cm. Signed at the bottom of the moulding of the simulated oval frame with the connected monogram FHF and dated 1626. Inscribed to the right of the model's head: A° AETAT. 50.

PROVENANCE: J. J. Caan van Maurik, Oudewater; sale, John W. Wilson of Brussels, Paris, 14 March 1881, no. 56 (80,000 francs with pendant); sale, E. Secrétan, Paris,

1 July 1889, no. 124 (91,000 francs with pendant); H. O. Havemeyer, New York, bequeathed to the museum by Mrs. H. O. Havemeyer in 1929.

EXHIBITIONS: Brussels 1873; Paris, 1874; Detroit 1935, no. 6.

BIBLIOGRAPHY: *Collection de M. John W. Wilson, exposée dans la galerie du cercle artistique et littéraire de Bruxelles*, Paris, 1873, p. 81; Charles Tardieu, 'Les Grandes Collections Étrangères. II. M. John W. Wilson', *G.B.A.*, VIII, 1873, p. 219; mentioned by Paul Eudel, *L'Hôtel Drouot en 1881*, p. 72; Bode 1883, 65; *Icon. Bat.* no. 7130–32; Moes 72; HdG 224; Bode-Binder 106; KdK 50 left; Valentiner 1936, 17 (erroneously described as an oval panel).

Pendant to Cat. no. 37. Petrus Scriverius (1575–1660) was a historian and poet of Haarlem. Like many of Hals' small portraits the painting served as a modello for a print; it was engraved (without being reversed) by Jan van de Velde; inscribed: '. . . A° 1626 . . . Harlemi, Fr. Hals pinxit. I. v. Velde sculpsit' (Franken and Van der Kellen 33). No engraving of the pendant is known. The pair are exquisite miniature examples of Hals' colourful impressionistic illusionism of the twenties. Possibly they were in the collection of Theodorus Schrevelius in Leiden in 1628 (see text, p. 59).

Moes, *Icon. Bat.* 7130–31, refers to another portrait by Hals of Scriverius dated 1613 in the Warneck Collection, Paris, probably from the Bloudoff Collection, Brussels, 1873. This untraceable portrait is either lost or the reference is an error. Moes may have confused a presumed 1613 portrait of Scriverius with Hals' 1617 portrayal of Theodorus Schrevelius, which was in the Warneck collection, and possibly came from the Bloudoff collection (see Cat. no. 8). In any event, another portrait by Hals of Scriverius is not known, and none of his existing works is dated 1613— would that one were.

Petrus Scriverius' library was sold at auction in Amsterdam on 8 August 1663. J. G. Frederiks (*O.H.*, XII, 1894, pp. 62–63) published a manuscript supplement of the catalogue (Leiden University Library) which lists 24 paintings. Lot 21 is described as: 'Dry byzondere Speelmannetjes, van Hals'. These paintings have not been identified, but S. A. C. Dudok van Heel (*Amstelodamum*, 'Het Maecenaat de Graeff en Rembrandt, II', LVI, 1969, pp. 249ff.) threw new light on them when he showed that the 24 paintings most likely came from the collection of Willem Schrijver (1608–61), brother-in-law of the wealthy Amsterdam burgomaster and art patron Andries de Graeff. Dudok van Heel's collation of the inventory of Schrijver's estate dated 26 October 1661 (NAA no. 2804-B, pp. 971–994) with the 24 paintings auctioned in 1663 supports the view that virtually all of them were in Schrijver's collection. The paintings described in his 1661 inventory as 'Drie schildereijties van de Vijff sinnen door hals gedaen' can be identified with the 'Dry byzondere Speelmannetjes, van Hals' which appeared in the 1663 auction. For other references to Hals' paintings of the Five Senses see Cat. nos. 27, 58, 59, 60. Schrijver's 1661 inventory also lists portraits of Floris Soop, Pieter Soop, and two of Jan Soop, without citing the name of the artist who painted them. Investigation by I. H. van E[eghen]., (*Amstelodamum*, 'De Vaandeldrager van Rembrandt,' LVIII, 1971, pp. 173–180) has established that they were painted by Frans Hals. These four portraits have not been traced either. However, thanks to Van Eeghen's identification of Rembrandt's *Standard Bearer*, 1654, The Metropolitan Museum, New York (Bredius-Rembrandt 275) as Floris Soop (*op. cit.*) we know that Hals' portrait of him should bear a resemblance to Rembrandt's portrayal of Floris Soop.

37. **Anna van der Aar, wife of Petrus Scriverius** (Plate 61; text, pp. 58–59). New York, The Metropolitan Museum of Art, H. O. Havemeyer Collection (Cat. 1954, no. 29.100.9).
Panel, 22·2 × 16·5 cm. Signed at the bottom of the moulding of the simulated oval frame with the connected monogram FHF and dated 1626. Inscribed to the left of the model's head: A° AETAT/50.

PROVENANCE: M. J. Caan van Maurik, Oudewater; sale, John W. Wilson of Brussels, Paris, 14 March 1881, no. 57 (80,000 francs with pendant); sale, E. Secrétan Paris, 1 July 1889, no. 125 (91,000 francs with pendant); H. O. Havemeyer, New York; bequeathed to the museum by Mrs. H. O. Havemeyer in 1929.

EXHIBITIONS: Brussels 1873; Paris 1874; Detroit 1935, no. 7.

BIBLIOGRAPHY: *Collection de M. John W. Wilson, exposée dans le galerie du cercle artistique et littéraire de Bruxelles*, Paris, p. 82; Charles Tardieu, 'Les Grandes Collections Étrangères, II, M. John W. Wilson', *G.B.A.*, VIII, 1873, p. 219; mentioned by Paul Eudel, *L'Hôtel Drouot en 1881*, p. 72; Bode 1883, no. 66; *Icon. Bat.*, no. 7; Moes 73; HdG 225; Bode-Binder 107; KdK 50 right; Valentiner 1936, 18 (erroneously described as an oval panel).

Pendant to Cat. no. 36.

38. **Michiel Jansz. van Middelhoven** (Plate 62; text, p. 58). Formerly Paris, A. Schloss.
Canvas, 87 × 70 cm.

PROVENANCE: Comte André Mniszech, Paris; dealer Kleinberger, Paris; A. Schloss, Paris; the painting has remained untraced since it was confiscated by the Germans during World War II.

BIBLIOGRAPHY: Probably identical with Bode 1883, 57 (1638) and 64 (1626); *Icon. Bat.* 5051; Moes 55 (1626); HdG 202; Bode-Binder 141; R. E. D[ell], 'Portrait of

Pastor Middelhoven by Frans Hals', *B.M.* xx (1911-12), p. 289; KdK 46 (1626).

Companion piece to Cat. no. 39. The portrait was engraved in reverse by Jan van de Velde. His print gives the sitter's age as 64 and is inscribed '. . . Anno. 1626/F. hals. pinxit . . . Velde. sculpsit.' (Franken and Van der Kellen 27). These data as well as the style of the portraits justify a date of around 1626 for both works. Since the couple were married in 1586, the portraits were possibly made to celebrate their fortieth wedding anniversary. Middelhoven was born in Dordrecht in 1562 and died in Leiden in 1638. From 1592 to 1634 he served as a preacher at Voorschoten; his seven sons also became preachers (A. J. van der Aa, *Biographisch Woordenboek der Nederlanden . . .*, Haarlem, 1869, vol. XII, part 2, pp. 838–839). Voorschoten is a small town about three miles south of Leiden and twenty miles from Haarlem. Apart from one commission which Hals received from a group of patrons who lived outside of Haarlem it is not known if his sitters who were residents of other towns had to make the trip to his studio or if he ever travelled to suit their convenience; the single exception is *The Meagre Company* (Cat. no. 80; Plate 134), which Hals began in Amsterdam in 1633 but never finished.

Bode (1883, 64) mentions a 'Kleines Brustbild des Predigers M. Middelhoven. Datirt 1626' in the collection of Comte Mniszech, Paris. He also cites (nos. 57 and 58) 'Brustbilder eines Herrn und seiner Gattin. Um 1638.' Since his nos. 57 and 58 most likely refer to our Cat. nos. 38 and 39 he probably inadvertently doubled his listing of Middelhoven's portrait; the date he assigned to the pendants is the year of Middelhoven's death.

39. Sara Andriesdr. Hessix, wife of Michiel Jansz. van Middelhoven (Plate 63; text, pp. 58, 75). Oeiras, Portugal, Calouste Gulbenkian Foundation (Cat. 1965, no. 76, inv. no. 214).
Canvas, 87 × 70 cm.

PROVENANCE: Comte André Mniszech, Paris; dealer Kleinberger, New York and Paris; A. de Ridder, Cronberg, Germany; sale, A. de Ridder, Paris, 2 June 1924, no. 24 (920,000 francs, Gulbenkian).
EXHIBITIONS: London 1929, no. 66; on extended loan to the National Gallery, London, 1936–49 (except during World War II); on extended loan to the National Gallery, Washington, D.C. 1950–*ca.* 1955; Paris, Centre Culturel Luso-Français, Cat. 1960, no. 30.
BIBLIOGRAPHY: Probably identical with Bode 1883, 58 (*ca.* 1638); Moes 56 (1626); HdG 203; W. Bode, *Catalogue of the A. de Ridder Collection*, F. Kleinberger Galleries, New York 1913, no. 5; Bode-Binder 142; KdK 47 (1626); *Pictures from the Gulbenkian Collection Lent to the National Gallery*, London, Catalogue, 1937, p. 44 (shortly before 1626); Trivas 21; *European Paintings from the Gulbenkian*

Collection, National Gallery of Art, Washington, D.C., Catalogue (by F. R. Shapley), 1950, p. 46, no. 18 (probably 1626).

Companion piece to Cat. no. 38. Hals' earliest known life-size portrait of a seated woman. In the following decades he used variations on the pose for some of his most compelling portraits of women.

40. Portrait of a Man (Plate 68). London, Viscountess Swinton.
Canvas, 81 × 66 cm. Inscribed to the right: AETAT SVA . . ./Anno 55; inscribed on the book: Gerustheit des gemoets.

PROVENANCE: William Danby of Swinton Park (died 1821); inherited by his widow Anne Holwell, who, marrying Admiral Octavius Vernon Harcourt, became Mrs. Danby Harcourt; on her death, by descent to George Affleck; bought in 1882–83 with the house, by Samuel Cunliffe-Lister, who became first Lord Masham in 1891; thence by descent to the present owner.
EXHIBITIONS: London 1952–53, no. 62; Kingston upon Hull, Ferens Art Gallery, *Dutch Painting of the Seventeenth Century*, Cat., 1961, no. 38.
BIBLIOGRAPHY: Possibly HdG 349c; C. H. Collins Baker, 'Two Unpublished Portraits by Frans Hals', *B.M.*, XLVI (1925), pp. 42*ff.* (*ca.* 1626); Valentiner 1928, p. 248 (middle thirties); Valentiner 1935, p. 101, no. 6 (*ca.* 1627).

The inscription giving the sitter's age has been strengthened by a later hand. The one on the book is difficult to read; when Collins Baker published the picture (*op. cit.*) he tentatively deciphered it as 'Geriest betitles gemoels', a reading followed in the 1952 London exhibition catalogue, no. 62. This transcription suggests that the words have been written in an unbreakable code. In the 1961 Hull catalogue (no. 38) it was transcribed as 'Gerust hert des Gemoets.' It can be roughly translated as 'Peace of mind'.

Painted around 1625–27. Collins Baker rightly noted that the hair and beard are treated in what is, for Hals, an exceptionally minute way like that of *Michiel Jansz. van Middelhoven* (Cat. no. 38; Plate 62), datable to 1626.

41. Portrait of a Preacher (Plate 69). Cambridge, Massachusetts, Fogg Art Museum (no. 1930.186).
Canvas, 62 × 52 cm. Inscribed at the right lower edge in red the number: 208.

PROVENANCE: Stanislaus August Poniatowski, King of Poland (died 1798); Count Grabowski, Warsaw; Alexander Kahanowicz, Brooklyn; dealer Ehrich Galleries, New York; Mrs. Aaron Naumburg, New York, who bequeathed it to Harvard University in 1930.

EXHIBITION: Detroit 1935, no. 26 (about 1635).
BIBLIOGRAPHY: Valentiner 1925, p. 153, note 1 (writes the painting is in the possession of Dr. Kahanswiez, Brooklyn; the museum records give the name as Kahanowicz); Valentiner 1928, p. 248 (middle thirties); Fogg Art Museum Notes, 1930, pp. 222ff.; Valentiner 1935, p. 101 (about 1627); Valentiner 1936, 15 (about 1625–27).

Restored and relined at the museum in 1966. The general condition of the paint layer is excellent. Painted on the back of the old relining, the monogram of King Stanislaus Augustus and 'no. 208'; on the old stretcher, the seal of (?)Stanislaus Augustus, and inscribed in ink: 'No. Katal. 208' and, in another hand, also in ink, an inscription; only the first word 'Massa' and the number 344 are legible. The portrait does not appear to be listed in Tadeusz Mańkowski's exhaustive annotated catalogue of the paintings which belonged to the King in 1795 (Galerja Stanisława Augusta, Lwów, 1932).

The large pattern of the folds of the back cloth as well as the cramped space suggest the painting has been cropped on all four sides. The impression that it was once larger is confirmed by X-rays; they show no evidence on any side of the scalloping which ordinarily appears along the tacking edges of an old stretched canvas.

Valentiner rightly corrected the late date of 1635, which he had given to the portrait when he published it (1928, p. 248), to about 1625–27 (Valentiner 1936, 15). The portrait is related to the 1625 Portrait of a Man at the Metropolitan Museum (Cat. no. 34; Plate 66) and the Swinton Portrait of a Man (Cat. no. 40; Plate 68), and the hatched brushwork in the hair and beard is similar to analogous passages in Michiel Jansz. van Middelhoven (Cat. 38; Plate 62).

The basis for the identification of the man as a preacher is the black skull-cap he wears. Similar headgear is worn by identifiable divines painted by Hals and many other seventeenth-century portraitists. However, it should be noted that Dutchmen engaged in other professions were also portrayed wearing them; for example, Hals depicted the Haarlem brewer Cornelis Guldewagen wearing one (see Cat. no. 212; Plate 325).

42. Isaac Abrahamsz. Massa (Plates 64, 65; text, pp. 26, 54–58, 67, 88, 120, 133, 202; text, Fig. 38). Toronto, Art Gallery of Ontario.

Canvas, 80 × 65 cm. Inscribed and dated on an upright of the chair: AETA/41/1626.

PROVENANCE: Earl Spencer, Althorp Park, Northampton; Duveen Brothers, New York; Frank P. Wood, Toronto, who bequeathed it to the gallery in 1955; stolen in September 1959, and returned to the gallery in the same year.
EXHIBITIONS: London, Royal Academy, Winter Exhibition, 1907, no. 41; Art Gallery of Toronto Inaugural Exhibition, 1926, no. 149; London 1929, no. 376; Haarlem 1937, no. 25; Chicago 1942, no. 10; Montreal 1944, no. 25; New York, Toledo, Toronto 1954–55, no. 30; Indianapolis–San Diego 1958, no. 47; Raleigh 1959, no. 56; Haarlem 1962, no. 13; Montreal, Man and his World, Expo 67, 1967, no. 23.
BIBLIOGRAPHY: Catalogue of the Pictures at Althorp House, in the County of Northampton, with Occasional Notices, Biographical or Historical, 1851, p. 63, no. 262 (Frank Hals. Himself. 2 feet 7 inches by 2 feet 1 inch); A. van der Linde, Isaac Massa van Haarlem, Amsterdam, 1864; Histoire des guerres de la Moscovie (1601–1610) par Isaac Massa de Haarlem, edited by Michael Obolensky and A. van der Linde, Brussels, 1866; Moes 122; HdG 246; Bode-Binder 108; KdK 45; Valentiner 1925, pp. 148ff (self-portrait); Valentiner 1935, pp. 90–95 (self-portrait); Valentiner 1936, 14 (self-portrait); J. L. A. A. M. van Rijckevorsel, 'De beide portretten van Isaac Abrahamsz. Massa op de Frans Hals-tentoonstelling', Historia, III (1937), pp. 173–175; Trivas 20; J. A. Leerink, 'Een Nederlandsche cartograaph in Rusland: Amsterdam-Moskou in de zeventiende eeuw', Phoenix I (1946), pp. 1–7; Johannes Keuning, 'Isaac Massa, 1586–1643', Imago Mundi, A Review of Early Cartography, X (1953), pp. 65ff.; Hubbard 1956, pp. 78, 151, repr. pl. XXXVII; E. de Jongh and P. J. Vinken, 'Frans Hals als voortzetter van een emblematische traditie: Bij het huwelijksportret van Isaac Massa en Beatrix van der Laen', O.H., LXXVI (1961), pp. 146–147; Seymour Slive, 'Master Works in Canada, No. 7, Frans Hals, Isaac Abrahamsz. Massa', Canadian Art, XXIII (1966), pp. 42–43.

The wiry lettering and digits inscribed on the chair have nothing in common with Hals' other inscriptions of the twenties; they were probably added by another hand. There is, however, no reason to doubt the date. Perhaps the inscription was copied from the back of the canvas during the course of an old relining. The painting was cut out of its stretcher when it was stolen in 1959. This barbaric act produced scattered losses, particularly along the outer edges of the painted surface; they were restored after the painting was recovered.

Valentiner's repeated attempts to prove that the painting is a self-portrait were futile (1925, pp. 148ff.; 1935, pp. 90–95; 1936, no. 14). J. L. A. A. M. van Rijckevorsel identified the model in 1937 (op. cit.) when he observed that the sitter bears an unmistakable resemblance to Hals' securely identified small portrait of Isaac Abrahamsz. Massa (Cat. no. 103; Plate 168), which was painted around 1635. For references to less compelling attempts to demonstrate that Massa appears in other works by the artist, see Cat. nos. 17 and 18.

According to the baptismal rolls of St. Bavo's Church, Massa was born in Haarlem on 7 October 1586; he was buried at St. Bavo's on 20 June 1643. For details about his residence in Russia, and his activities as merchant, historian, geographer, and cartographer, see the bibliography cited above and text, p. 55. On 21 July 1623 he was a witness

at the baptism of Hals' daughter, Adriaentgen (A.v.d. Willigen, *Les Artistes de Harlem*, Haarlem-The Hague, 1870, p. 140).

The painting is an outstanding example of Hals' vivid characterizations and power to paint a momentary pose and instantaneous expression. It also appears to be the earliest existing single portrait of a seated man with his arm resting on the back of a chair. Hals often used the casual pose during the following four decades, but always with significant variations (Cat. nos. 86, 155, 166, 167, 186, 206, 216, 217). Some antecedents of the novel pose, and its use by later artists are cited in the text, pp. 55–56; Figs. 33–37. The view of a landscape through an opening in the wall only occurs in two other of Hals' works (Cat. nos. 125, 217; Plates 202, 334). He usually employed a neutral background for his portraits. In my judgement the landscape in the portrait was painted by the Haarlem landscapist Pieter Molyn (see text, pp. 57–58; Figs. 38–40); evidence of collaboration between Hals and Pieter Molyn (1595–1661) is also found in the family portraits at Cincinnati (Cat. no. 102), London (Cat. no. 176), and Lugano (Cat. no. 177). Before Valentiner tried to identify the sitter as Hals himself and before the model was firmly identified as Massa, Valentiner wrote that the landscape and the branch of holly probably refer to his name or profession (KdK 44, note). His supposition about the northern landscape is probably correct; it could very well be a reference to Massa's activities in Russia. However, the evergreen plant he holds is more likely an emblematic reference to constancy. De Jongh and Vinken (*op. cit.*, p. 150) suggest that it is a symbol of friendship.

43. **St. Luke** (Plate 72; text, pp. 15, 76, 100–103, 183; Fig. 94). Odessa, State Museum.
Canvas, 70·2 × 55 cm. Signed above the head of the ox with the connected monogram: FH. Inscribed at a later date in the lower right corner: 1895; and by another hand, in the lower left corner: 1914.

PROVENANCE: Sale, Gerard Hoet, The Hague, 25 August 1760, no. 134 (Jan Iver, 120 florins); sale, The Hague, 13 April 1771, no. 35; sale, F. W. Baron van Borck, Amsterdam, 1 May 1771, no. 35 (Jan Iver, 33 florins); acquired by Catherine II for the Hermitage by 1773; 20 March 1812 removed from the Hermitage and sent to Tavricheskaia Guberniia.
EXHIBITION: Haarlem 1962, no. 77.
BIBLIOGRAPHY: Pieter Terwesten, *Catalogus of Naamlyst van schilderyen met derzelver prysen . . .*, The Hague, 1770, vol. III, p. 231, no. 134; Ernst Mienich, *Catalogue des Tableaux que se trouvent dans les Galeries, Salons et Cabinets du Palais Impérial de S. Petersbourg*, 1774, no. 1895; C. Kramm, *De Levens en Werken der hollandsche en Vlaamsche Kunstschilders . . .*, vol. II, Amsterdam, 1858, p. 362; Bode 1883, p. 70, note 1; HdG 4–7; I. Linnik, 'Newly Discovered

Paintings by Frans Hals', *Iskusstvo*, 1959, no. 10, pp. 70–76 (Russian text); I. Linnik, 'Rediscovered Paintings by Frans Hals', *Soobcheniia Gosudarstvennogo Ermitazha*, XVII, 1960, pp. 40–46 (Russian text); Seymour Slive, 'Frans Hals Studies: 2. St. Luke and St. Matthew at Odessa', *O.H.*, LXXVI (1961), pp. 174–176.

Traces of what appear to be additional letters of Hals' name (or a date?) follow the faint monogram; however, abrasion in this area makes it difficult to determine if the inscription was in fact once longer or if one's imagination lengthens it. Abrasion in the background has also revealed distinct pentimenti in the ox; its head and the horn on the left were once higher. Pentimenti are unusual in Hals' work. Their presence as well as the awkward drawing of parts of St. Luke's drapery indicate that Hals struggled with a subject that is an exception in his *oeuvre*. His *St. Matthew* (Cat. no. 44; Plate 73) shows even greater weaknesses in the modelling of the drapery and in the perfunctory execution of the left hand and book. However, the heads in both of these religious paintings tell another story. The solidity of their forms has been enlivened by the swift, fluid brushstrokes which make their appearance in Hals' genre pieces datable before the middle of the twenties and which are found in his commissioned portraits before the end of the decade. For the relation of the style of the paintings to other works by Hals and to other Dutch representations of Saints, see text, pp. 100–103; text, Figs. 94–100.

References in old inventories to eight religious paintings by Hals have been known to students since Hofstede de Groot published his catalogue of the artist's work in 1910 (HdG 1–8). But apart from two paintings of *The Prodigal Son* which were recorded at Amsterdam in 1646 and 1647 (HdG 1 and 2; possibly identical with Cat. no. 20; HdG 2 is possibly identical with Cat. no. L 1), few specialists put much faith in the accuracy of these attributions until the brilliant rediscovery by Irina Linnik of Hals' *St. Luke* and *St. Matthew* in the depot of the State Museum at Odessa. These two works belong to the set of four *Evangelists* which Hofstede de Groot grouped together (HdG 4–7). Kramm (1858, *op. cit.*) and Bode (1883, p. 70, note 1) also knew about a reference to them in a 1760 sale, and, as noted below, there is good evidence that the series was still intact early in the nineteenth century. Thus it is now possible to account for four—or perhaps six—of the eight published references to Hals' religious works. Still missing are: *The Denial of Peter* (HdG 3; canvas, 121·5 × 225·4 cm.; sale, P. Bout, The Hague, 20 April 1779, no. 5 (17 florins, 10) and *The Magdalene* (HdG 8; panel, 48 × 38·4 cm.; sale, F. H. de Groof, Antwerp, 20 March 1854, no. 64). We have no way of determining if the attributions given to these two untraced biblical paintings were correct but to judge from what we know about the artist's work and the conspicuous rarity of references in old catalogues to religious pictures by Hals, I am as sceptical of them as I am of the ascription of a *St. Francis Praying in a Landscape* to him and of a *Virgin and*

Child with St. Anthony in a Desert, attributed to him and Gaspar de Crayer, which appeared in a sale at Ghent in 1838 (sale, A. M. Vissers, widow of P. B. Emmanuel, Ghent, 21 November 1838, nos. 23, 24). Today there may be disagreement about the correct attribution of the *David with the Head of Goliath* at Copenhagen which was acquired in 1755 as a Frans Hals and which bore his name for about a century but I do not think anyone in our time who has a nodding acquaintance with the artist's work would ascribe it to him. The painting was subsequently attributed to Jan de Bray, Jacob Backer and Pieter de Grebber (see Copenhagen, Royal Museum of Fine Arts, Cat. 1951, no. 14, repr.). One other religious picture related to Hals is worth mentioning. A *St. Peter* catalogued as in the style of Hals appeared in a sale at Amsterdam 26 September 1763, no. 118 (St. Petrus, in de manier van F. Hals; 12 florins). Possibly it was identical with a *Head of St. Peter* by Hals' son and follower Jan Hals which was sold at the sale, Joshua van Belle, 6 September 1730, no. 42 (Een trony van St. Pieter, door Jan Hals alias den Gulden Ezel, h. 1 v. 6 d., br. 11½ d.; 16 florins).

When Linnik found Hals' *St. Luke* and *St. Matthew* at Odessa they were catalogued as works of an unknown nineteenth-century painter. Linnik corrected the attribution and gave an account of their history in Russia in the articles she published in 1959 and 1960 (*op. cit.*).

Four separate pictures by Frans Hals of the four *Evangelists*, each of them a half-length and showing the hands, were in the Gerard Hoet Sale, The Hague, 25 August 1760, lot no. 134: 'De vier Evangelisten, zynde vier Borst-Stukken met Handen, door F. Hals; hoog 26½, breet 21 duimen.' They were acquired by the Dutch auctioneer Jan Yver for 120 florins. Four *Evangelists* by Hals appeared again in a sale at The Hague, 13 April 1771, lot no. 35. A few weeks later they were put on the block in Amsterdam at the F. W. Baron van Borck Sale, 1 May 1771, lot no. 35, where they fell into Yver's hands a second time (33 florins). Yver was commissioned by Catherine II to buy pictures for the Hermitage in 1771, the same year he acquired the set. Since four *Evangelists* by Hals are listed in the manuscript catalogue Ernst Meinich compiled of the Hermitage in 1773, there is excellent reason to believe that Hals' *Evangelists* were among the group of pictures Yver bought and shipped to the Russian court. Meinich's catalogue, the first one made of the Hermitage collection, was published in 1774. (This exceedingly scarce work was reprinted by Paul Lacroix, 'Musée du palais de l'Ermitage sous le règne de Catherine II', *Revue Universelle des Arts*, XIII [1861], pp. 164–179; pp. 244–258; XIV [1861], pp. 212–225; XV [1862], pp. 47–53; pp. 106–123; references to Hals' four *Evangelists* are found *ibid.*, XV [1862], p. 114, no. 1894–1897). The inscribed number '1895' in the lower right corner of the painting corresponds to the number given to Hals' *St. Luke* in the 1773 catalogue. The description and measurements of *St. Luke* as well as of the other *Evangelists* in the 1773 catalogue (half-length; life-size; canvas;

height: 1 arschine; width: 12½ vershkov) coincide with the descriptions and measurements (hoog 26½, breet 21 duimen = 69·5 × 55 cm.) of the four *Evangelists* sold in Holland in 1760 and 1771.

Hals' *St. Matthew* is listed in the 1773 catalogue under number 1896; this number appears in the lower right corner of the painting (Cat. no. 44). *St. Mark* is assigned number 1894 and *St. John* is number 1897; these two works have not been found. The author of the early catalogue attributed three of the *Evangelists* to 'F. Hals'. The fourth (*St. Mark*) he ascribed to 'François Gals', a curious permutation of the master's surname that can be explained. There is no 'h' sound in the Russian language; 'g' is the sound Russians normally substitute for it. Hals' name was Russianized only once in the catalogue. It appears in its western form in ten other places. The slip is the kind which draws sympathetic understanding from compilers of catalogues.

Mienich was impressed by the four *Evangelists*. He wrote that they were very expressive and painted with the mastery of a quick brush. Another generation thought less highly of them. In 1812 Tsar Alexander I ordered F. Labensky, the head of the gallery of paintings at the Hermitage, to select a group of pictures for the decoration of churches in Tavricheskaia Guberniia (one of the administrative districts of pre-revolutionary Russia located in the Crimea, the centre of which was Simferpol). Thirty paintings were selected, among them Hals' four *Evangelists*. They left the Hermitage on 20 March 1812. Why or when the set was broken is not known. Until there is word that they were destroyed there is still reason to hope that Hals' *St. Mark* and *St. John* will be found. The tantalizing rumour heard in some circles around 1962–63 that they had been rediscovered in eastern Germany has never been confirmed.

An untraced drawing of St. Luke after Frans Hals by the Haarlem artist Frans Decker (or Dekker; 1684–1751) that appeared in the sale, C. van den Berg, Haarlem 29 August 1775, no. 247 (St. Lucas naar F. Hals, door F. Dekker), was possibly a copy after the painting now in Odessa.

44. St. Matthew (Plates 71, 73; text, pp. 15, 76, 80, 100–103). Odessa, State Museum.

Canvas, 70·2 × 55 cm. Inscribed at a later date in the lower right corner: 1896; and by another hand, in the lower left corner: 1908.

EXHIBITION: Haarlem, 1962, no. 78.

See Cat. no. 43.

45. Banquet of the Officers of the St. Hadrian Militia Company (Plates 78–80; text, pp. 6–7, 17, 39, 63, 69–71,

72, 110; Fig. 95). Haarlem, Frans Hals Museum (Cat. 1929, no. 125).

Canvas, 183 × 266·5 cm. Signed with a connected monogram on the chair on the left: FHF. The numbers inscribed on the officers have been added at a later date to identify them.

PROVENANCE: Originally painted for headquarters of the St. Hadrian Militia Company; at the museum since 1862.
EXHIBITIONS: Haarlem 1937, no. 28; Amsterdam, Weerzien der Meesters, 1945, no. 37; London 1952–53, no. 60; Haarlem 1962, no. 14.
BIBLIOGRAPHY: Bode 1883, 3 (1627); Moes 3 (1627); HdG 433 (1627); Bode-Binder 112; KdK 37 (ca. 1623–24); Trivas 11; H. P. Baard, *Frans Hals, the Civic Guard Portrait Groups*, Amsterdam and Brussels, 1949, pp. 17–18, plates B and 9–16; C. C. van Valkenburg, 'Die Haarlemse Schuttersstukken: V. Maaltijd van Officieren van de Cluveniersdoelen (Frans Hals, 1627)', HAERLEM: *Jaarboek 1961*, Haarlem 1962, pp. 53ff.; Baard 1967, no. 43.

The Haarlem *Cluveniersdoelen* (*Cluvenier* = Harquebusier) was organized in 1519 expressly as a fire-arms unit under the patronage of St. Hadrian. To distinguish it from the St. George Company (*cf.* Cat. no. 7), the older group, or *de oude schuts*, it was called *de jonge schuts*.
According to an old tradition this group portrait of the Cluveniersdoelen was made to commemorate an expedition the officers made to Hasselt in 1622. The tradition is wrong. The officers who went to Hasselt belonged to

the militia corps which served from 1621 to 1624; their names are listed in the 1628 edition of Samuel Ampzing's *Beschryvinge ende Lof der Stad Haerlem* and portraits of some of them appear in a rare engraving designed by Pieter Molyn and engraved by Gillis van Scheyndel (F. Muller, *Nederlandsche Geschiedenis in Platen*, Amsterdam, 1863–70, no. 1474) to celebrate the expedition. Ampzing also noted (*op. cit.*, p. 371) that Hals' St. Hadrian banquet piece is 'seer stout naer 't leven gehandeld'. The phrase is a hackneyed one of the time but is worth noting as the earliest published reference to a specific work by the artist.
The officers represented in this portrait served in the St. Hadrian Company from 1624 to 1627. Moreover, the picture must have been painted after 2 November 1625 because it includes Johan Damius as provost, or as he was called after 1621, fiscal (the third standing figure from the left), and Captain Gilles de Wildt (seated in the centre behind the table). Both Damius and De Wildt received their appointments 2 November 1625 (communication from C. C. van Valkenburg).
Acceptance of the erroneous relation of the picture to the 1622 Hasselt expedition led some critics (Valentiner, KdK 37; Trivas 11) to date the picture 1623–24. Comparison with the *Banquet of the St. George Company* (Cat. no. 46), traditionally dated 1627, which is much freer in technique and has a less obviously calculated composition, seems to support the early date. It is now clear, however, that the painting could not have been painted before 2 November 1625, and it seems reasonable to assume that it was painted,

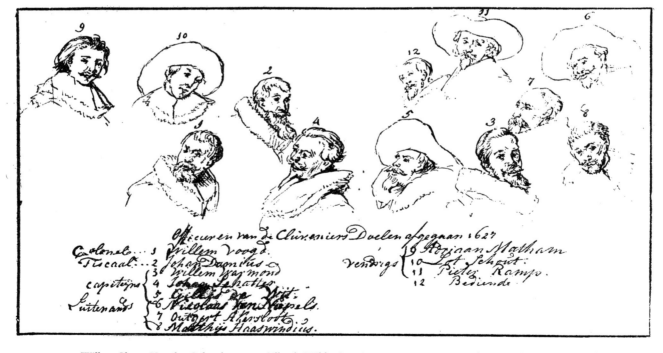

1. Willem Claesz. Vooght, Colonel
2. Johan Damius, Fiscal
3. Willem Warmont, Captain
4. Johan Schatter, Captain
5. Gilles de Wildt, Captain
6. Nicolaes van Napels, Lieutenant
7. Outgert Akersloot, Lieutenant
8. Matthijs Haeswindius, Lieutenant
9. Adriaen Matham, Ensign
10. Lot Schout, Ensign
11. Pieter Ramp, Ensign
12. Willem Ruychaver, Servant

as was the custom, after the farewell banquet given to the officers, that is, in 1627. Here again it should be stressed that Hals' undated works, like those of most masters, defy a year by year chronology based solely upon stylistic criteria. Hals was capable of working in more than one manner not only in the same year, but in the same picture. This is evident in his *Banquet of the St. George Company* (Cat. no. 46), where the relatively high finish and heavy paint of the portraits on the right side make a sharp contrast with the looser brushwork and thin paint of those on the left.

The painting was cleaned in 1925. Except for damage to the red band of the flag held by the standing ensign on the left and some scattered losses, it is well preserved.

A finished water-colour copy (27·8 × 41·5 cm.), inscribed on the verso 'Vincent van der Vinne/na Schilderij van F. Hals/berustende op de Doelen te/Haarlem', is in the Municipal Archives at Haarlem; it was probably made by Vincent van der Vinne III (1736–1811). Two drawings of the painting by Wybrand Hendricks (1744–1831) are at the Teyler Foundation. One is a carefully executed water-colour (Cat. 1904, no. W. 43; 34·7 × 48 cm.) and the other is a pen drawing of the heads only and bears the names of the sitters (no. W. 43a). The latter is reproduced opposite.

46. Banquet of the Officers of the St. George Militia Company (Plates 83–85; text, pp. 63, 69–71, 124, 136, 138; Fig. 46). Haarlem, Frans Hals Museum (Cat. 1929, no. 124).

Canvas, 179 × 257·5 cm. The numbers inscribed on the officers were added at a later date to identify them.

PROVENANCE: Originally painted for the headquarters of the St. George Militia Company; at the museum since 1862.

EXHIBITIONS: Haarlem 1937, no. 29; Amsterdam, Weerzien der Meesters, 1945, no. 36; Haarlem 1962, no. 15.

BIBLIOGRAPHY: Haarlem Archives, no. 31. *Registers van officieren en manschappen van de St. Jorisdoelen of oude schuts*, 1612–52, vol. 2; Bode 1883, 2 (1627); Moes 2 (1627); HdG 432 (1627); Bode-Binder 113; KdK 63 (1627); Trivas 31; H. P. Baard, *Frans Hals, The Civic Guard Portrait Groups*, Amsterdam and Brussels, 1949, pp. 19–20, plates C and 17–24; C. C. van Valkenburg, 'De Haarlemse Schuttersstukken: IV. Maaltijd van Officieren van de Sint Jorisdoelen (Frans Hals, 1627)', HAERLEM: *Jaarboek 1961*, Haarlem 1962, pp. 47ff., Baard 1967, no. 44.

Restored in 1920. Cleaning revealed scattered minor losses and that the original tacking edge at the top of the picture (about 5 cm. wide) was brought to the front during the course of an old relining.

The painting is neither signed nor dated. Three of the officers posed for other portraits by Hals: Captain Michiel de Wael (the officer seated in the foreground with an inverted glass in his hand) and Ensign Dirck Dicx (second standard bearer from the right) appear in the St. George militia piece of 1639 (Cat. no. 124; Plates 200–201); Lieutenant Jacob Olycan (seated in the centre behind the table) was painted by Hals in 1625 (Cat. no. 32; Plate 58).

Since these men only served as officers from 1624–27 it is safe to conclude that the painting represents the officer corps of that period. The rule that ensigns could only hold their appointments while they were bachelors enables us to narrow the approximate date. Ensign Cornelis Dicx was married 21 April 1626 (information from C. C. van Valkenburg); he was replaced by Ensign Dirck Dicx, who, as noted above, appears as the second standard bearer from the right. Hence the picture must have been painted after 21 April 1626, probably in 1627 to commemorate the end of the corps' term of service. It is noteworthy that Pieter Andrianesz. Verbeek, who served as fiscal, the second highest ranking officer of the company, was not included in the group portrait. Valkenburg (*op. cit.*) suggests that he was excluded because he had already made an appearance in two other collective portraits of the company: Hals' banquet piece of 1616 (Cat. no. 7) and Pieter de Grebber's banquet picture of about 1624 (Frans Hals Museum, Cat. 1929, no. 114).

This group portrait and the one of the St. Hadrian Company (Cat. no. 45) painted around the same time show Hals' unrivalled ability to represent an animated group in a room filled with bright, silvery daylight. The breadth and surety of his drawing strengthen the momentary impression of both works, while the dominant light tonality, which all the local colours are either dependent upon or to which they are subordinated, contribute to their pictorial unity and harmony. Ingenious variety of gesture and expression relates the figures to their neighbours or to the spectator. In both the candid effect is a carefully calculated one; the principal groups have been built around a figure seated behind the table. The emphatic diagonals which heighten the impression of instantaneous life and activity in the St. Hadrian picture, and which are such an important part of its framework, have been suppressed a bit here. As a result the painting appears less contrived and even more casual.

Among Hals' most memorable characterizations is Michiel de Wael, the captain in the chamois jerkin, who looks directly at us as he holds his glass upside down to indicate that it is empty. He was a brewer at the 'Sun' and 'Red Hart' breweries in Haarlem and the portrait Hals painted of him in the 1639 group portrait of the *St. George Company* (Cat. no. 124; Plates 200–201) indicates that his interest in drinking was not a passing fancy. Haarlem's municipal authorities must have had men of his nature in mind when they passed fifty-two ordinances in 1621 to regulate the activities of the civic guards. The city officials took cognizance of the fact that some of the banquets of the guardsmen lasted a week. Since the city had to pay for

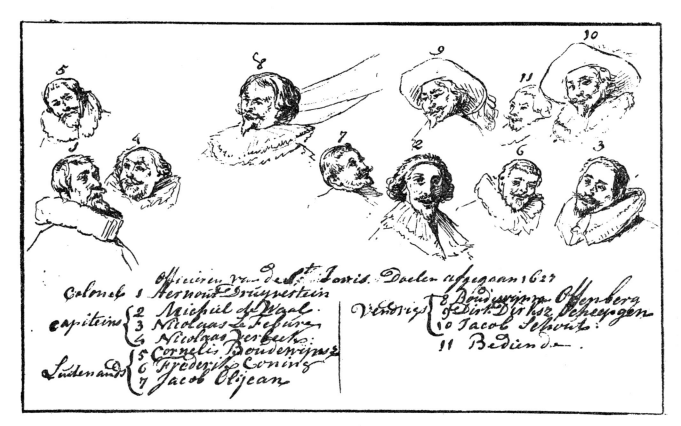

1. Aernout Druyvesteyn, Colonel	5. Cornelis Boudewijnsz., Lieutenant	8. Boudewijn van Offenberg, Ensign
2. Michiel de Wael, Captain	6. Frederik Coning, Lieutenant	9. Dirck Dicx, Ensign
3. Nicolaes Le Febure, Captain	7. Jacob Olycan, Lieutenant	10. Jacob Schout, Ensign
4. Nicolaes Verbeek, Captain		11. Arent Jacobsz. Koets, Servant

the costs and the times were troubled they decreed that the celebrations 'were not to last longer than three or at the most four days' ('en dat deselve vergarderinghe niet langer en zal duuren als 3, of ten langsten 4 dagen'). The manuscript of the fifty-two ordinances is in the Municipal Archives of Haarlem (*Oud Archief Schutterij*, no. 21) and is dated 31 December 1621. The rules of 1621 were printed in 1633: *Nieuwe Ordonnatie van de Schutterije der Stadt Haarlem*, Ghedruckt tot Haerlem, by Adriaen Roman, Ordinaris Boeck-drucker wonende aen't Sant by 't Stadt-Huys in de Vergulde Parsse, Anno 1633 (A. J. Enschede, *Inventaris van het Archief der Stad Haarlem*, 1846, vol. II, no. 151).

A pen drawing by Wybrand Hendricks (1744–1841) after the painting is reproduced above (Teyler Foundation, no. 40a).

Moes (32) and Hofstede de Groot (175) noted that a portrait attributed to Hals of Aernout Druyvesteyn, who appears as the colonel of the officer corps, was auctioned (probably in Haarlem) 10 August 1785, no. 134 (25 florins, Wubbels). Valentiner (KdK 62) suggested that it was probably identical with a painting formerly in the Cintas collection (Fig. 19) and that it was either a preparatory study by Hals for the figure in the group portrait

or was executed as a special commission by him after the banquet piece was painted. In my judgement it is a copy by another hand. It is excluded with special regret since it was the only known work which could have qualified as a preparatory study for one of Hals' militia pieces:

PROVENANCE: John G. Johnson, Philadelphia (sold because authentiticy doubted [*cf.* KdK 62, note]); dealer Kleinberger, Paris; Sir Hugh Lane, London; dealer Agnew, London; John Levy Galleries, New York; sale Oscar B. Cintas of Havana, New York (Parke-Bernet), 1 May 1963, no. 13 ($80,000).

EXHIBITIONS: Detroit 1935, no. 8; New York 1939, no. 176.

BIBLIOGRAPHY: Moes 32; HdG 175; Bode-Binder, 118; KdK 67 (1627); Valentiner 1936, 19 (1627); Trivas 31b (copy).

An untraceable drawing by Cornelis van Noorde (1731–1795) of Aernout Druyvesteyn, bust, life size, black chalk, wash, heightened with white on blue paper appeared in the sale, A. van der Willigen, The Hague, 10 June 1874, no. 110. The banquet piece was copied frequently. In addition to the summary sketch reproduced above Wybrand Hendricks (1744–1831), who had a passion for making copies of Hals' group portraits, made two finished watercolours of it

which are now at the Teyler Foundation, Haarlem (Cat. 1904, no. 41, 40×54 cm.; no. 42, 27·5×39·2 cm., signed on the verso). More interesting are the copies of heads made by John Singer Sargent when he was in Haarlem in the spring of 1880 (Figs. 20, 21). Like so many portraitists of his generation Sargent's admiration for Hals was boundless and he studied him to learn spontaneity, economy of touch and control of light and dark values. His copies are a tour de force but by the side of the originals his exaggeration of the bravura of Hals' brushwork results in a loss of solidity of form and clarity. Another difference is the viscosity and texture of the paint. When passages of the white ruffs Sargent painted are juxtaposed to those done by Hals they look as if they were painted with cold cream. Sargent's copies as well as one he made of two figures in Hals' late regentess piece (Cat. no. 222) were in the collection Alvan T. Fuller, Boston, Massachusetts, and are now in the collection of Mrs. Robert L. Henderson, Chestnut Hill, Massachusetts.

47. **Johannes Acronius** (Plate 81; text, p. 58). Berlin-Dahlem, Staatliche Museen (Cat. 1931, no. 767).
Panel, 19·3×17·1 cm. Inscribed at the right: AETAT SVAE 62/A° 1627.

PROVENANCE: Possibly sale, Corn. Asc. van Sypesteyn, Haarlem, 20 October 1744, no. 37; sale, J. Enschedé, Haarlem, 30 May 1786, no. 83; sale, Jer. de Bosch, Amsterdam, 6 April 1812, no. 28; sale, B. de Bosch, Amsterdam, 10 March 1817, no. 10. In the Reimer collection, Berlin; bought from it for the museum in 1843.
BIBLIOGRAPHY: Bode 1883, 85; *Icon. Bat.* 22; Moes 10; HdG 149; Bode-Binder 109; KdK 54 left.

The inscription is faint but legible; the paint surface is moderately abraded. An engraving by Jan van de Velde II (*ca.* 1593–1641) inscribed '...IOHANNES ACRONIVS... Fr. Hals/pinxit/I.v.Velde sculpsit' identifies the sitter (Franken and van der Kellen, no. 1). The painting was probably made as a modello for the print. Van de Velde's engraving is one of the few contemporary prints which do not reverse Hals' original but the style and technique of the sparkling little painting offer no reason to suggest that it was done by a copyist who worked from the print.
A lengthy Dutch inscription on the back of the panel written in an eighteenth(?)-century hand gives details of Acronius' career as a minister and professor of theology. He was a native of East Friesland and in 1584 he had a parish at Eilsum in that part of the Netherlands. He was called to Groningen in 1601, and to Wezel in 1611. Then he preached at Deventer, and in 1617 he became professor at Franeker. On 8 March 1619 he was called to Haarlem, where he died 20 September 1627. These data are confirmed by the biography of Acronius in A. J. van der Aa, *Biographisch Woordenboek der Nederlanden* ..., vol. I, Haarlem 1854, p. 43.

Portraits showing models behind simulated round or oval frames were ultimately derived from Hellenistic sepulchral art when marble or bronze discs bearing relief portraits of the deceased were placed on graves. In Roman times these 'clipei' were done in high relief or as detached busts inserted in circular cavities. The early Christians copied the 'imagines clipeatae' on their sarcophagi and after the Roman era they were not forgotten. During the fifteenth century there was a revival of interest in them for sepulchral sculpture and around the middle of the sixteenth century effigies began to be placed in oval medallions or recesses (see Johannes Bolton, *Die Imago Clipeata*, Paderborn (1937); Henriette s'Jacob, *Idealism and Realism: A Study of Sepulchral Symbolism*, Leiden (1954), pp. 190–193). Ample evidence shows that *imagines clipeatae* were not exclusively used for portraits of dead people during Renaissance and Baroque times. But it is not improbable that some patrons and artists found the venerable scheme particularly suitable for posthumous portraits. Rembrandt may have been aware of its connection with sepulchral portraiture when he employed it for his etching of *Jan Cornelis Sylvius* (text, pp. 121–122; Fig. 116) in 1648, eight years after the preacher's death. Knowledge that Hals' 1627 portrait of Acronius was painted in the year his subject died raises the possibility that it too is a posthumous portrait and that the artist's patron or Hals himself found the scheme appropriate for a portrait of the deceased preacher.

48. **Portrait of a Man** (Plate 82; text, pp. 58, 122). Berlin-Dahlem, Staatliche Museen (Cat. 1966, no. 766).
Copper, 19·9×14·1 cm. Dated at the upper right: [1]62[7].

PROVENANCE: Reimer collection, Berlin, from which it was acquired by the museum in 1843.
BIBLIOGRAPHY: Bode 1883, 86 (1627); Moes 123 (1627); HdG 252 (1627); Bode-Binder 110 (1627); KdK 54, right (1627); Trivas 24 (1627, the last digit not quite distinct; possibly a portrait of Nicolaes Le Febure).

The date of 1627 read by earlier students is now indistinct. The first digit of it is illegible, the second and third numerals can be read clearly, and the final digit can be interpreted as *1* or *7*. The style of the painting, which is entirely consistent with Hals' small dated portraits made after the middle of the decade (Cat. nos. 36, 37, 49, 50, 51) suggests that the final digit was *7*. Trivas' tentative identification of the model as Nicolaes Le Febure (Trivas 24), the dwarf who appears as a captain in Hals' St. George banquet piece of 1627 (Cat. no. 46, Plate 85; text, Fig. 46), is not convincing.

49. **Portrait of a Man, presumably Theodorus Schrevelius** (Plate 75; text, pp. 8, 59, 154). Essen, Berthold von Bohlen und Halbach.
Panel, 22×17·5 cm. Inscribed at the right: AETAT SVAE 56/AN° 1628.

PROVENANCE: Empress Frederick; Princess Karl of Hesse, Cronberg; Krupp von Bohlen und Halbach, Essen; by descent to the present owner.
EXHIBITIONS: Berlin 1890, no. 79; Haarlem 1937, no. 34; Essen, Villa Hügel, 'Aus der Gemäldesammlung der Familie Krupp', 1965, no. 34.
BIBLIOGRAPHY: *Icon. Bat.*, no. 7038–2; Moes 70; HdG 223; Bode-Binder 117; KdK 71.

The identification of the sitter rests on his resemblance to Hals' 1617 portrait of Theodorus Schrevelius (Cat. no. 8; Plate 23). I recognize similarities in their features and am prepared to make allowances for the changes which can occur to a face during the course of eleven years but I do not find the likeness striking enough to accept the traditional identification without reservation. It should be stressed, however, that the inscription supports the identification; Schrevelius, who was born in 1572, was fifty-six in 1628.

50. **Portrait of a Man, presumably Theodorus Schrevelius** (Plate 74, text, pp. 8, 59, 154). Salisbury, Longford Castle, The Earl of Radnor.
Circular panel, diameter 22·8 cm. Inscribed and dated to the right: AETAT SVAE 66/AN 1628.

PROVENANCE: Probably sale, J. Blackwood, 20 February 1778 (lot 12/1), information from Prof. Ellis K. Waterhouse.
EXHIBITIONS: London, Winter Exhibition 1876, no. 209; London 1929, no. 54; London 1949, no. 11; London 1952–1953, no. 135; Haarlem 1962, no. 19.
BIBLIOGRAPHY: G. F. Waagen, *Galleries and Cabinets . . . in Great Britain*, Supplement, London 1857, pp. 353–354; 'Additions to the collection at Longford Castle, Seat of Lord Folkestone [eldest son of the Earl of Radnor] . . . Small circular portraits of an old man and woman, without numbers. Such slight but spirited little specimens of this great master are justly esteemed by the connoisseur.' Bode 1883, 149; Moes 93; *Catalogue of the Pictures in the Collection of the Earl of Radnor*, Part I, London 1909, no. 21; HdG 292 ('said to be a portrait of the artist, but the date makes this impossible'); Bode-Binder 119; KdK 72.

Pendant to Cat. no. 51.

Valentiner (KdK 1921, 70) first suggested that this forceful little portrait and its equally impressive companion (Cat. no. 51) probably represent Hals' early patron Theodorus Schrevelius (1572–1649) and his wife Maria van Teylingen (1570–1652). He based his identification upon the resemblance of the man to Hals' 1617 portrait of Schrevelius now in the collection of Baroness Bentinck-Thyssen-Bornemisza (Cat. no. 8; Plate 23) and to the portrait in the Krupp von Bohlen und Halbach collection (Cat. no. 49; Plate 75). The reservations expressed about the identification of the

latter sitter (see Cat. no. 49) are applicable here. Moreover a simple arithmetical calculation shows that the inscriptions on the pendants do not tally with the ages of the couple in 1628. If these paintings are portraits of Schrevelius and his wife, Hals erred when he inscribed them or the inscriptions were additions or alterations made before Bode catalogued them in 1883 (nos. 149, 150, 'Datirt 1628 Aet. 66 und 60'). Finally, the portrait of the wife bears little resemblance to the copy of a presumed portrait of Maria van Teylingen, James A. Murnaghan collection, Dublin (see Cat. nos. 8; L 19, and Fig. 99).
A reproduction of a chalk drawing of Cat. no. 50 is at the Witt; it appears to be a faithful copy ([Rudolf?] Weigel Collection, Gera; no. 19, oval format; additional information not available).

51. **Portrait of a Woman, presumably Maria van Teylingen, wife of Theodorus Schrevelius** (Plate 76). Salisbury, Longford Castle, The Earl of Radnor.
Circular panel, diameter 22·8 cm. Inscribed and dated to the left: AETAT SVAE 60/AN 1628.

PROVENANCE: Probably sale, J. Blackwood, 20 February 1778 (lot 12/2), information from Prof. Ellis K. Waterhouse.
EXHIBITIONS: London, Winter Exhibition 1876, no. 212; London 1929, no. 55; London 1949, no. 12; London 1952–53, no. 139; Haarlem 1962, no. 20.
BIBLIOGRAPHY: Waagen *Supplement*, London, 1857, *cf.* Bibliography to Cat. no. 50; Bode 1883, 150; Moes 94; *Catalogue of the Pictures in the Collection of the Earl of Radnor*, Part I, London 1909, no. 22; HdG 386; Bode-Binder 120; KdK 73.

For comments about the identification of the sitter, see the note to the companion piece Cat. no. 50, Cat. nos. 8, and L 19.

52. **Portrait of a Woman** (Plate 77; text, p. 185). Chicago, The Art Institute of Chicago, Max and Leola Epstein Collection (Cat. 1961, inv. no. 54.287).
Canvas, 87×67 cm. Inscribed at the upper left: AETAT SVAE 33/ANº 1627.

PROVENANCE: Dealer P. T. Smith and Sons; dealer F. Steinmeyer, Lucerne; Max Epstein, Chicago; presented to the museum in 1954 by Max and Leola Epstein; entered the museum in 1969.
EXHIBITIONS: London 1929, no. 348; Detroit 1935, no. 25.
BIBLIOGRAPHY: KdK 128 (*ca.* 1635); Valentiner 1936, 43 (*ca.* 1630–35); *Painting in the Art Institute of Chicago*, Catalogue, 1961, p. 209 (about 1640); Marigene Butler, 'Portrait of a Lady by Frans Hals', *Museum Studies 5*, The

Art Institute of Chicago, 1970, pp. 7–21; C. C. Cunningham, 'Note on a Portrait of a Lady by Frans Hals', *ibid.*, p. 5.

When Valentiner published the painting in 1923 (KdK 128) it showed a view of a city seen in rosy evening light in the left background. The cityscape was suspicious on two counts: it was clumsily painted, and it made a notable exception in Hals' *oeuvre*. Most of the backgrounds of the artist's commissioned portraits are neutral. Restoration at the museum in 1969 proved that the cityscape in this painting could not be classified as one of the exceptional cases; it was a later addition and was removed during the course of cleaning. Removal of the repaint revealed the predictable back of the chair on the left, and the inscription and date of 1627, which is consistent with the style of the painting; for a discussion of the 1969 restoration of the painting and the results of a scientific examination of the work see Butler, *op. cit.* The treatment of the flesh tones and lace is related to the 1625 portrait of *Aletta Hanemans* at the Mauritshuis (Cat. no. 33; Plate 59). The painting has probably been cropped on all four sides; it is hardly likely that Hals would paint a commissioned portrait which showed a bit of lace on a cuff and not include the model's hand. To judge from the position of the sitter, the painting once had a companion picture of a man. The only existing portrait by Hals with a cityscape in the background is the *Portrait of a Woman* at the Metropolitan Museum; it too is a later addition by another hand (see Cat. no. 187; Plate 289).

53. **Boy Playing a Violin** (Plate 88). Chicago, The Art Institute of Chicago. On loan from the Angell Norris Collection.
Lozenge panel, 18·4 × 18·8 cm. Signed at the left with the connected monogram: FH.

PROVENANCE: Dealer Lawrie and Co., London; C. T. Yerkes, New York; John W. Gates, New York; R. F. Angell, Chicago; Angell Norris Collection.
EXHIBITION: Chicago 1933, no. 61 D; Chicago 1934, no. 90b; Detroit 1935, no. 12.
BIBLIOGRAPHY: C. T. Yerkes Catalogue, 1904, no. 37; Moes 237; HdG 87; Bode-Binder 45; KdK 68, upper (*ca.* 1627–30); W.A.P., 'The Angell Collection', *Bulletin, The Art Institute of Chicago*, XVII, 1923, p. 51; Valentiner 1936, 24 (*ca.* 1627–30).

Companion picture to Cat. no. 54. Both of these small paintings are painted in the sparkling technique of the little portraits which Hals executed during the second half of the 1620's. Their blond tonality and the variety of touch are closely related to the 1626 portraits of Scriverius and his wife at the Metropolitan Museum (Cat. nos. 36, 37; Plates 60, 61) and the portraits of a man and his wife (Cat.

nos. 50, 51; Plates 74, 76). There are also close analogies between them and *Two Laughing Boys* at Rotterdam (Cat. no. 60; Plate 90); the works share the same swiftness of touch and loaded brush. The fur hat worn by the boy looking into a jug in the Rotterdam picture is one of Hals' most dazzling performances; the violinist's fur hat is a miniature version of it.
The lozenge format of the small panels is unusual. Perhaps they were intended as inserts for a cabinet or a musical instrument.

54. **Singing Girl** (Plate 89). Chicago, The Art Institute of Chicago. On loan from the Angell Norris Collection.
Lozenge panel, 18·2 × 18·4 cm. Signed at the right with the connected monogram: FH.

PROVENANCE: Dealer Lawrie and Co., London; C. T. Yerkes, New York; John W. Gates, New York; R. F. Angell, Chicago; Angell Norris Collection.
EXHIBITIONS: Chicago 1933, no. 61a; Chicago 1934, no. 90a; Detroit 1935, no. 11.
BIBLIOGRAPHY: C. T. Yerkes Catalogue, 1904, no. 38; Moes 238; HdG 118; Bode-Binder 46; KdK 68, lower (*ca.* 1627–30); W. A. P., 'The Angell Collection', *Bulletin, Art Institute of Chicago*, XVII, 1923, p. 51; Valentiner 1936, 23 (*ca.* 1627–30).

Companion picture to Cat. no. 53.

55. **Laughing Fisherboy** (Plate 86; text, pp. 104, 106). Burgsteinfurt, Westphalia, Prince zu Bentheim und Steinfurt.
Canvas, 82 × 60·2 cm. Signed on the jug with the connected monogram: FHF.

PROVENANCE: Princes zu Bentheim und Steinfurt, Burgsteinfurt.
EXHIBITIONS: Haarlem 1937, no. 47; Schaffhausen 1949, no. 43; Haarlem 1962, no. 21.
BIBLIOGRAPHY: Moes 253; HdG 50; Bode-Binder 74; KdK 114 (*ca.* 1633–35).

The boy's platinum blond hair makes an unforgettable contrast with his shaggy wool blue cap and blue under-jacket. These strong colour accents and the rather heavy, creamy paint suggest that Valentiner's date of about 1633–1635 is too late for the work. In my opinion it was painted about 1627–30 and is one of the earliest known fisher-children painted by the artist. The modest dunescape in the background is done with the bold touch used for the figure and appears to have been painted by Hals; it is related to the tonal landscapes which Pieter Molyn, Salomon van Ruysdael and Jan van Goyen began to paint around this time.

A feeble copy of the painting is at the Fisher Gallery, University of Southern California, Los Angeles: canvas, 80·3 × 64·7 cm. Provenance: Anthony F. Reyre, London; Gimbel Brothers, New York; Armand Hammer, New York, who gave it to the university in 1965. Reproduced in *Frans Hals, Rembrandt Loan Exhibition*, Los Angeles County Museum, Catalogue, 1947, no. 9, and *The Armand Hammer Collection*, University of Southern California, 1965, p. 29.

Valentiner (KdK 114, note) wrote that the original at Burgsteinfurt was probably a pendant to the *Fishergirl* at the Wallraf-Richartz-Museum, Cologne (Cat. D 32; Fig. 151). In my opinion the attribution of the latter work is doubtful and to judge by its dark tonality and liquid touch it was painted after Hals did his genre pieces of the 1630's.

56. **Left-Handed Violinist** (Plate 87; text, pp. 104, 106). Lugano-Castagnola, Thyssen-Bornemisza Collection (Cat. 1969, no. 123).
Canvas, 83·5 × 67·5 cm.

PROVENANCE: Dealer Julius Boehler, Munich-Lucerne; A. Reyre, Ireland; acquired for the collection before 1930.
EXHIBITIONS: London 1929, no. 379; Munich 1930, no. 44; Lugano 1949, no. 105; Schaffhausen 1949, no. 44a; Tokyo-Kyoto 1968–69, no. 22.
BIBLIOGRAPHY: C. Hofstede de Groot, 'Frans Hals as a Genre Painter', *Art News* XXVI, 14, April 1928, pp. 45*f.* (not earlier than the second half of the thirties); Valentiner 1928, p. 238 (late twenties or early thirties); Valentiner 1935, p. 102, no. 14 (about 1635); *The Thyssen-Bornemisza Collection, Catalogue of the Paintings*, Castagnola, 1969, pp. 139*f.*, no. 123 (*ca.* 1630).

Restored in 1963; a heavy coat of old brown varnish was removed. Hofstede de Groot, who published the picture in 1928 (*op. cit.*), dated the work too late when he placed it 1635–40. It is closely related to the *Laughing Fisherboy* at Burgsteinfurt (Cat. no. 55; Plate 86) and was probably done around the same time. J. C. Ebbinge Wubben, the author of the entry in the 1969 catalogue of the Thyssen-Bornemisza collection, states that the tower on the dune may represent the beacon near Zandvoort, a village on the coast about five miles from Haarlem. He also suggests that the landscape could have been added by someone else, perhaps Molyn. But he notes rightly that, if it was the work of another artist, Hals still must have added a few touches, for instance at the lower left near the violinist's right sleeve. It is also apparent that Hals painted the collar over the landscape on the left. These passages can be explained by assuming that Hals worked on the picture after his collaborator finished his assignment. On the other hand, the difference between the figure and the dunescape is not pronounced enough to insist that both could not have been painted by Hals.

Two variants of the painting have entered the literature; neither is an original:

1. W. C. Escher Abegg, Zurich, *ca.* 1921–25 (Fig. 22). Panel 25 × 20 cm. Valentiner (KdK 25; *ca.* 1623) erroneously stated that it was identical with Bode-Binder 78. He added that since the violinist is playing with his left hand it is possible to conclude that the artist could have used himself as a model. Valentiner reproduced the Borchard variant (see below) in the first edition of his Hals catalogue (KdK 1921, 25). In 1923 (KdK 25) he wrote that the Borchard variant was surely after the Escher Abegg panel, possibly by the artist. Valentiner 1928, p. 238 (authentic, perhaps a preparatory study); Valentiner 1936, no. 50, note (autograph; first of the series).

2. Formerly dealer Kleinberger, Paris, Cat. 1911, no. 27; Stuart I. Borchard, New York; and now in the collection of Mrs. H. Metzger, New York (Fig. 23). Canvas, 62·3 × 59·8 cm. Bode-Binder 78; KdK 1921, 25 (*ca.* 1623; 'Ein besseres Exemplar befindet sich nach Hofstede de Groot in der Sammlung Escher-Abegg in Zürich'); KdK 25 (possibly by the artist); Valentiner 1936, no. 50 (*ca.* 1630–35; the attempt to explain the player's left-handedness from its being a self-portrait is rejected). Exhibition: Detroit 1935, no. 4.

57. **Verdonck** (Plate 96; text, pp. 76, 80, 81–83; Figs. 61, 62). Edinburgh, National Gallery of Scotland (Cat. 1957, no. 1200).
Panel, 46·5 × 35·6 cm. Signed on the right above the collar: FHF (the last two letters in monogram).

PROVENANCE: Sale [Laurence W. Vaile], London (Christie), 13 July 1895, no. 85. 'Man with Glass of Wine' (£430; Lesser); sold by Messrs. Agnew to John J. Moubray of Naemoor, who presented it to the gallery in 1916. According to a letter from L. W. Vaile's daughter in the files of the National Gallery of Scotland, Vaile's father was given the picture by his stepmother about the 1820's.
EXHIBITIONS: Haarlem 1937, no. 6; Haarlem 1962, no. 16.
BIBLIOGRAPHY: *Icon. Bat.*, no. 8369; Moes 80; HdG 235, identical with HdG 77; Bode-Binder 297; T. Borenius, 'The Discovery of a Lost Painting by Frans Hals', *Apollo*, VIII (1928), pp. 191–192; *Pantheon* II (1928), pp. 518 and 521; A. M. de Wild, 'Gemälde-Röntgenographie', *Technische Mitteilungen für Malerei*, no. 20, 15 October 1930, pp. 230–234; Valentiner 1935, p. 101, no. 4 (about 1626); A. M. de Wild, 'Frans Hals: Het portret van Verdonck', *Historia*, III (1937), pp. 18–21; Trivas 10 (*ca.* 1624–27); *Catalogue of Paintings and Sculpture, National Gallery of Scotland*, Edinburgh 1957, no. 1200, pp. 119–120.

When the painting was given to the National Gallery of Scotland in 1916 it was called *The Toper* and showed the

sitter wearing a large cap of claret-coloured velvet and holding in his right hand a short-stemmed glass (text, Fig. 61); Hofstede de Groot (77) listed it in this form. In 1927 A. M. de Wild suggested that the hat and glass were later additions. His observations were confirmed by X-ray photographs, and by the engraving by Jan van de Velde II (text, Fig. 62; Franken and Van der Kellen 42), which shows the original state of the painting in reverse. Van de Velde's engraving was known to Moes (*Icon. Bat.*, no. 8369; Moes 80), Hofstede de Groot (235), and Binder-Bode (297); they listed the original as missing. When De Wild removed there paints the original painting was found intact.

De Wild published his findings and the procedure he used for removing the overpainting in 1930 (*op. cit.*). For a letter by H. Birzenick concerning a version of the painting which was in St. Petersburg in the 1890's and De Wild's response to him, see *ibid.*, no. 24, 15 December 1930, pp. 283*ff.* and text, pp. 82–83.

Borenius (*op. cit.*) and the author of the 1929 Edinburgh catalogue (p. 131) erroneously attributed the contemporary print of the painting (text, Fig. 62) to Jan van de Velde I, who died in 1623 and, therefore, concluded that the picture had been painted prior to 1623. However, the print was made by Jan van de Velde II (*ca.* 1593–1641); the style of the picture fits well with works Hals painted around 1627. A poor copy, made before the repaint on the picture was removed, was in the sale Nardus and Bourgeois, Paris (Drouot), 31 May 1924, no. 20 (J. Bruinse), catalogued as 'School of Hals'; canvas, 62 × 48 cm.

A reduced copy which shows Verdonck behind a simulated circular frame was in the London art market in 1952 (see *Apollo*, LVI, no. 329, July, 1952, p. 58, repr. on the cover: panel, 14 × 10·8 cm.; signed with the connected monogram FHF and dated 1627.

After the painting was cleaned Verdonck's quasi-emblem was identified as the jawbone of an ass (Borenius, *Apollo*, *op. cit.* and *Pantheon*, *op. cit.*). O. Charnock Bradley, principal of the Royal Dick Veterinary College, Edinburgh, pointed out that it was the jawbone of a cow (letter dated 12 August 1928 in the files of the gallery). We can only guess whether Hals would have used the jawbone of an ass as a prop if he had been able to beg or borrow one, but there can be no doubt that in a country where stock and dairy farming was one of the principal sources of revenue it was easier to procure the jawbone of a cow than of an ass. Van de Velde's engraving after Hals' portrait indicates that Verdonck was a popular if disrespectful figure in Haarlem; his print of the unruly wit was probably sold as a broadside. Salomon de Bray (1597–1664) also made a drawing of Verdonck holding his quasi-emblem with both of his hands, which is dated '1638 3/22' and inscribed 'Verdonk die Stoute Gast,/Wiens Kaakebeen elk een aentast' (text, Fig. 63; Haarlem Archives [P.V.X. 37], pen and grey wash, 12·1 × 8·9 cm.).

A third portrait of Verdonck, by an unidentified artist

(Fig. 24), who was probably active in Haarlem, is in a Swiss private collection: canvas, 56 × 42 cm.

58. **Drinking Boy (Taste?)** (Plates 91, 93, 94; text, pp. 79, 106–107). Schwerin, Staatliches Museum (Cat. 1962, no. 111; inv. no. 2476).
Circular panel, diameter 38 cm. Signed at the right with the connected monogram: FHF.

PROVENANCE: Listed with the companion piece in Johann Gottfried Groth, *Verzeichnis der Gemälde in der Herzoglichen Gallerie*, Schwerin, 1792 (S.54.7, 'Unbekannt') and again in F. C. G. Lenthe's 1836 catalogue of the collection (279, 'Unbekannt'). It was identified as a painting by Hals in Eduard Prosch's ms. catalogue of 1863 (IV, 53) and appears a such in subsequent Schwerin catalogues.
EXHIBITION: Celle, Schloss, *Kostbarkeiten alter Kunst*, July–September, 1954, Catalogue, no. 421.
BIBLIOGRAPHY: Bode 1883, 117; Moes 229; HdG 11; Bode-Binder 8; KdK 52 (1626–27); Trivas 29 (1626–27); Schwerin, *Holländische Maler des XVII. Jahrhunderts*, Catalogue 1962, no. 111.

Companion picture to Cat. no. 59. The monogram is legible but faint. An unidentified label on the back is inscribed: No. 188/1808. For the probable identification of the paintings as representations of 'Taste' and 'Hearing' and the possibility that they belonged to a set of the 'Five Senses' see text p. 79. Reference in the inventory of Dirck Thomas Molengraeft, Amsterdam, taken 13 January 1654, to 'The Five Senses' by Frans Hals (HdG 10) lends support to the supposition that the artist made a complete series; for other references to Hals' paintings of the Five Senses see Cat. nos. 27, 36, 60. The close relation of the silver tonality and the suggestive power of the brushwork of the Schwerin pendants to the shimmering light and the boldest passages in Hals' group portraits of 1627 (Cat. nos. 45, 46) support a date of about 1626–28 for these matchless tondos.

Many copies and variants have been made by different hands of both paintings; most of them are poor caricatures of the originals. They come in assorted sizes and shapes, and some copyists have coupled the boys in one picture and others have made pastiches by combining one of the boys with the other laughing children by or after Hals; for an example of the latter see sale, Holle, Paris (Drouot), 23 June 1950, no. 5, repr.

59. **Boy Holding a Flute (Hearing?)** (Plates 92, 95; text, pp. 79, 106–107). Schwerin, Staatliches Museum (Cat. 1962, no. 110, inv. no. 2475).
Circular panel, diameter 37·3 cm.

PROVENANCE: Listed with the companion piece in Johann Gottfried Groth, *Verzeichnis der Gemälde in der Herzoglichen*

Gallerie, Schwerin, 1792 (S. 54, 8, 'Unbekannt') and again in F. C. G. Lenthe's 1836 catalogue of the collection (283 'Unbekannt'). It was identified as a painting by Hals in Eduard Prosch's ms. catalogue of 1863 (IV, 54) and appears as such in subsequent Schwerin catalogues.

EXHIBITION: Celle, Schloss, *Kostbarkeiten alter Kunst*, July–Sept. 1954, Catalogue, no. 420, repr.

BIBLIOGRAPHY: Bode 1883, 118 (said to be signed); Moes 230; HdG 32; Bode-Binder 9; KdK 53 (1626–27); Trivas 30 (1626–27); Schwerin, *Holländische Maler des XVII. Jahrhunderts*, Catalogue 1962, no. 110.

Companion picture to Cat. no. 58. An unidentified label on the back is inscribed: No. 189/1808. Mezzotinted in reverse by the little known engraver Jan Verkolje II (probably died before 1763; Wurzbach, no. 1). This painting has been copied more frequently than its pendant (*e.g.*, sale, London (Christie) 10 December 1948, no. 19: circular panel, diameter 27·9 cm. [Leger]; sale, London (Christie) 6 February 1953, no. 112; panel, 43 × 53 cm.), perhaps because few artists were eager to accept the challenge of copying the suggestive brushwork of the hand holding a glass (Plate 93) in the companion piece.

Two copies of the painting have been incorrectly catalogued by some students as genuine works:

1. Lille, Museum. Cat. 1893, no. 372: panel, 54 × 43 cm.; coll. A. Brasseur, 1885; Moes 219; HdG 83; KdK 53 (weak studio piece); Trivas 30-e (copy).

2. Gothenburg, Sweden, Art Gallery: panel 43 × 38 cm.
 PROVENANCE: Sale, London, 3 May 1902, no. 96 (£819; H. P. Lane); H. P. Lane, Dublin; dealers Dowdeswell and Dowdeswell, London; dealer Sir G. Donaldson, London; Ernst Elliot, Stockholm; presented to the museum by Gustav Werner, 1923.
 EXHIBITION: London, Guildhall, 1903, no. 164.
 BIBLIOGRAPHY: Moes 220; HdG 85 (according to a later note at the RKD, a copy); Bode-Binder 7 repr. plate 5a; KdK 53, note (one of the best replicas); Trivas 30-a (copy); Göteborgs Konstmuseum, Catalogue, 1945, no. 74 (as Frans Hals); A. Westholm and N. Ryndel, *Göteborgs Konstmuseum . . .*, Stockholm, 1951, p. 68, no. 27 (as Frans Hals).

According to Trivas (30-b) a copy of the Schwerin tondo (circular panel, diameter 38 cm.) which appeared at the sale, Duchange, Brussels 25 June 1923, no. 84, and then belonged to A. Keller, New York, is identical with HdG 31A. This is an error. HdG 31A is one of the many variants of a *Child Holding a Flute* which were apparently made after a lost original; it was formerly in the Jules Porgès collection (see Cat. no. D 5-2, Fig. 109).

60. **Two Laughing Boys, One with a Jug (Sight? Gluttony?)** (Plate 90; text, pp. 80, 100). Rotterdam, Boymans-van Beuningen Museum, on loan from the Hofje van Aerden, Leerdam (Cat. 1962, Br. L4).

Canvas, 69·5 × 58 cm. Signed on the right above the jug with the connected monogram: FH.

PROVENANCE: Maria van Aerden-Ponderus, The Hague; since 1770 at the Hofje van Aerden, Leerdam; on loan to the Boymans-van Beuningen Museum since 1951.

EXHIBITIONS: Haarlem 1937, no. 33; Utrecht-Antwerp 1952, no. 38; Zürich 1953, no. 41; Milan 1954, no. 50; Rome 1854, no. 43; Haarlem 1962, no. 17; Brussels 1971, no. 44.

BIBLIOGRAPHY: Bode 1883, 29; Moes 227; HdG 125; Bode-Binder 43; KdK 69 (*ca.* 1627–30); Trivas 15 (*ca.* 1624–27).

Painted around 1626–28. The composition is a brilliant variation on a scheme Hals employed earlier for the *Two Boys Singing* at Cassel (Cat. no. 23; Plate 44) and *St. Matthew and the Angel* at Odessa (Cat. no. 44; Plate 73). To judge from his existing works he abandoned the scheme before the end of the decade, and subsequently concentrated on single figure subject or genre pictures. However, other Haarlem artists continued to ring changes on this arrangement of a dominant and a subordinate figure; for Salomon de Bray's use of it about a decade later, see text, pp. 80–81; text, Figs. 59, 60.

This excellently preserved painting was probably intended as a secularized depiction of 'Sight' or 'Gluttony'. P. J. J. van Thiel ('Marriage Symbolism in a Musical Party by Jan Miense Molenaer', *Simiolus* II [1967–68], pp. 92–93) has argued for the latter interpretation. He notes that the Dutch have a special name for someone who always peers into a jug to see what there is to drink. He is called a *kannekijker*, which is synonymous with a 'tippler' or 'soak', and adds that in Holland someone peering into a jug generally symbolizes the sin of gluttony. Van Thiel writes that a *kannekijker* in Molenaer's *Allegory of Fidelity o₁ Marriage* (dated 1633, The Virginia Museum of Fine Arts, Richmond, Virginia, acc. no. 49.11.19) has this meaning. He also states that the boy in Hals' painting is not merely looking into his jug nor does he represent the sense of 'Sight' (see exhibition catalogue, Haarlem 1962, no. 17): 'he has just drunk a whole flagon of wine or beer and still is not satisfied, but greedily looking for more. He is a *kannekijker*, a soak, and in this painting Frans Hals has, I am sure, depicted the sin of Gluttony' (*ibid.*). Van Thiel's interpretation of the meaning of Hals' painting is a possible one. However, there is ample evidence that the actions of figures in Dutch genre and subject pictures of the period are subject to different interpretations. A *kannekijker* is a case in point. Molenaer may have used one to symbolize 'Gluttony' in the Richmond picture, but there can be no question that he used a man peering into a jug to symbolize the sense of 'Sight' in one of the paintings of his 'Five Senses' series dated 1636 now at The Hague (text, Fig. 56). Thus it is possible that Hals intended to depict 'Sight' in the Rotterdam painting. In my opinion, a good case can

be made for either interpretation and until more evidence is available it would be best not to assert categorically that one or the other is correct. For other examples of multivalent meanings in Hals' pictures, see text, p. 80.

A small, crude copy was listed in the Mesdag Collection (HdG 125, note); sale, London (Robinson and Fisher), 31 May 1928, no. 151A; dealer Larsen, London, 1928; dealer P. de Boer, Amsterdam, Catalogue, 1930, no. 46. A copy by another hand of only the boy with the jug is at the Brooklyn Museum (inv. no. 34.496; panel, 21·5 × 18 cm.).

> PROVENANCE: Sale, Max Kann, Paris (Drouot), 3 March 1879, no. 25 (1520 francs); dealer Sedelmeyer, Paris, Catalogue, 1898, no. 50; Moritz Kann, Paris; Michael Friedsam, New York, who bequeathed it to the Brooklyn Museum in 1934.
>
> BIBLIOGRAPHY: Moes 241, identical with 270; HdG 68; Bode-Binder 44, repr.; KdK 69, note (replica which may be autograph); Valentiner 1936, 25 (probably a study); Trivas, 15-b (the whole is rather doubtful).

Another copy of the boy with the jug was in the Vienna art market, 1971 (panel, 31·2 × 28 cm.; possibly identical with HdG 14).

61. **Young Man Holding a Skull (Vanitas?)** (Plates 97-99; text, pp. 24, 88-89; Fig. 72). Peterborough, Major Sir Richard Proby, Bt.
Canvas, 92·2 × 80·8 cm.

PROVENANCE: According to the Elton Hall Catalogue (1924, no. 24) the painting was purchased for Sir James Stuart, Bart., by Andrew Geddes, the painter; inherited by his daughter, Mrs. Woodcock, 1849; inherited by her son, the Rev. E. Woodcock, 1875; inherited by his sister, Mrs. Stuart Johnson, 1893; purchased from her by the Fifth Earl of Carysfort, Glenart Castle, Ireland in 1895 through Messrs. Lawrie and Co., London (£3,800). By descent to Col. D. J. Proby; Granville Proby, London; and then to the present owner.

EXHIBITIONS: Dublin, National Gallery, 1896; Haarlem 1937, no. 93; London, Exhibition of Seventeenth-Century Art, 1928, no. 132; London 1952-53, no. 102; Haarlem 1962, no. 18; San Francisco, Toledo, Boston 1966-67, no. 17.

BIBLIOGRAPHY: HdG 102 (as Hamlet); Bode-Binder 64 ('Der sogennante Hamlet'); KdK 227 ('Der sogennante Hamlet'; ca. 1645; Valentiner, who did not know the original in 1923, added that perhaps it was painted earlier); Tancred Borenius and J. V. Hodgson, *A Catalogue of the Pictures at Elton Hall*, London (1924), p. 29, no. 24; Valentiner 1936, 80, note (obviously a work of the twenties; most likely a *vanitas*); Trivas 26 (1625-27); E. Plietzsch, 'Ausstellung holländischer Gemälde in der Londoner Akademie', *Kunstchronik*, VI, 1953, p. 123 (Judith Leyster).

Plietzsch (*op. cit.*) wrote that Cat. no. 61 was done around

1630-35 by Judith Leyster who, with feminine adaptability, came deceptively close to her teacher here. I know nothing in Leyster's documented *oeuvre* which approximates the vigorous power of the work. In my opinion it is a fully convincing original by Frans Hals.

Hofstede de Groot (102) first catalogued the painting as 'Hamlet'; Bode-Binder (64) and Valentiner (KdK 227) expressed laconic reservations about the title. Borenius and Hodgson, the compilers of the 1924 catalogue of the Elton House pictures, were the first to discuss it (*op. cit.*); they aptly wrote: 'The description of the subject as Hamlet is perhaps more attractive than accurate.' There is nothing absolutely impossible in the suggestion that Hals may have been inspired by a strolling player's performance of the character in Shakespeare's play, but, they noted, '. . . it should be remembered that the introduction of a skull as an emblem into portraits, more especially of youthful sitters, was a frequent device ever since the sixteenth century' (*ibid.*).

Borenius and Hodgson erred when they bracketed the painting with conventional portraits. The boy's costume has nothing in common with the fashions of the day. It is the kind which the Dutch *Caravaggisti* used for their stagey genre and allegorical pieces and which Hals himself had employed earlier in the decade for pictures of the same type (*cf.* Cat. nos. 23, 24, 25, 26). But they rightly emphasized the emblematic character of the skull. Valentiner wrote that Hals' painting is likely a *vanitas* (1936, no. 80, note) and relates it to a tradition which begins in the northern Netherlands with Lucas van Leyden's 1516 engraving of a *Young Man Holding a Skull* (text, Fig. 73; Bartsch 174). P. J. J. van Thiel ('Marriage Symbolism in a Musical Party by Jan Miense Molenaar', *Simiolus*, II [1967-68], p. 94, note 3) notes that the tradition is continued in Holland by Goltzius and Jan Muller (1571-1628). Goltzius' drawing is dated 1614 and inscribed 'QUIS EVADET/NEMO' (text, Fig. 74; Pierpont Morgan Library, New York, inv. no. III, 145). Drawings by Muller of the same theme are at Haarlem, Teyler Foundation, and in the art market; the latter is inscribed 'Cognita mori' (see E. K. J. Reznicek, 'Jan Harmensz. Muller als Tekenaar', *N.K.J.*, VII (1956), p. 115, no. 24, fig. 24 and p. 116, no. 26, fig. 25).

This hardy Netherlandish pictorial tradition supports the conclusion that the skull held by the boy in Hals' painting is meant as a reminder of the transience of life and the certainty of death, and that the picture was intended as a *vanitas*. A *Vanitas* by Hals is cited in the inventory of Peter Codde's effects made at Amsterdam, 5 February 1636 (HdG 9), but there is no way of determining whether that picture is identical with Cat. no. 61. The possibility that the Proby painting had a companion picture is discussed in the text, p. 89.

The painting, which can be dated *ca.* 1626-28, is distinguished from Hals' earlier half-length, life-size genre and allegorical pictures (Cat. nos. 23, 24, 25, 26) by the intensifi-

cation of the *plein air* effect, the greater fluidity of the suggestive brushwork, and the vibrant hatched strokes which soften the edges of forms without diminishing their weight or solidity.

In the sale, K. van Winkel, Rotterdam, 20 October 1791, lot no. 175, is described as 'Een Jong Manspersoon met een Doodshoofd in zij hand, hoog 8, breed 6 duim, op paneel." This untraced small panel may have been a copy of the Proby painting or one of Hals' lost preparatory studies. It is also possible that it is identical with a 'little copy of the so-called Hamlet' which Hofstede de Groot saw at the Gallery Locarno in Paris, December 1928. He described the boy in the copy as looking 'horridly skew-eyed' (unpublished note, RKD).

62. Gipsy Girl (Plates 100, 101; text, pp. 17, 85, 92–94; Figs. 84, 85). Paris, Louvre (inv. no. M. I.926). Panel, 57·8 × 52·1 cm.

PROVENANCE: M. de Marigny, Marquis de Ménars; sale, Marquis de Ménars, Paris, 18 March 1782 (not, as stated in the catalogue, 'la vente s'en sera vers la fin de février, 1782'; information from Dr. M. Roy Fisher, New York), no. 39 (301 francs, Remy); Dr. La Caze, Paris, who bequeathed it to the Louvre in 1869.
EXHIBITIONS: Haarlem 1962, no. 23; Paris 1970–71, no. 92.
BIBLIOGRAPHY: P. Mantz, 'La Collection La Caze au Musée du Louvre, *G.B.A.*, III (1870), p. 396; Bode 1883, 41 (*ca.* 1630); Moes 263; HdG 119; Bode-Binder 72 (erroneously, on canvas); L. Demonts, Louvre, Catalogue, 1922, p. 21, no. 2384; KdK 130 (*ca.* 1635) (erroneously, on canvas); Trivas 36 (about 1628).

Painted about 1628–30. The landscape behind the girl is as unusual in seventeenth-century Dutch painting as it is summarily treated. It appears to be a landscape, rather than a landscape with clouds.

According to the annotated 1782 sale catalogue of the Marquis de Ménars' collection at the Frick Art Reference Library, New York, the painting was bought by Rémy for 301 francs; at the same auction Greuze's *L'Accordée de Village*, now at the Louvre, was sold for '16,690 pour le Roi de France'. Hals' painting was not given a title at the sale. It was merely described as: 'Un Buste de femme en chemise, avec corset rouge largment peint, & d'un ton de couleur très vigoureux; la tête riante, sans autre parure que ses cheveux épars.' It is evident, however, that she is a courtesan. Her uncovered head, the casual arrangement of her hair, and her audacious décolletage mark her as a special type. Mantz called the model 'La Bohémienne' when he published the painting in 1870 (*op. cit.*). Bode was more straightforward when he listed it as 'Lachende Dirne' in his 1883 catalogue (no. 41). However, he and later critics returned to the title which this masterwork now

bears: 'La Bohémienne', 'Die Zigeunerin', 'The Gipsy Girl'.

Examination of this excellently preserved painting under raking light reveals that originally Hals arranged his model's clothes in a more conventional manner (see text, pp. 93–94; text, Figs. 84, 85). Courtesans depicted by other seventeenth-century Dutch artists and the markets for some of their works are discussed in the text, pp. 91–93.

63. Merry Drinker (Plates 105–107; text, pp. 110–111). Amsterdam, Rijksmuseum (Cat. 1960, no. 1091). Canvas, 81 × 66·5 cm. Signed at the right with the connected monogram: FH (Fig. 55).

PROVENANCE: Sale, Baronesse van Leyden van Warmond, Warmond, 31 July 1816, no. 13 (320 florins).
EXHIBITIONS: Paris 1921, no. 21; London 1929, no. 61; Haarlem 1937, no. 32; Brussels 1946, Bosch tot Rembrandt, no. 39; Cape Town 1952, no. 19; Zürich 1953, 42; Rome 1954, no. 44; Milan 1954, no. 51; New York, Toledo, Toronto 1954–55, *Dutch Painting: The Golden Age*, no. 1; Haarlem 1962, no. 22; Brussels 1971, no. 45.
BIBLIOGRAPHY: Bode 1883, 17 (*ca.* 1625–30); Moes 264; HdG 63; Bode-Binder 53; KdK 1921, 59 (*ca.* 1627–30); KdK 61 (*ca.* 1627); Trivas 32 (*ca.* 1627).

Painted around 1628–30. Cleaned at the museum in 1971. Removal of an old, discoloured film of varnish revealed a greater contrast between the warm flesh tones and the drinker's golden-ochre chamois jerkin and the cool, silvery-grey background. The spontaneous brushwork, thin paint and restriction of vibrant impasto touches to the high-lights relate the work to the small tondos at Schwerin (Cat. nos. 58, 59; Plates 91, 92) and to Hals' life-size, half-lengths of *Peeckelhaering* (Cat. 64; Plate 102) and his so-called *Mulatto* (Cat. 65; Plate 103). The distinctive hatching is also related to a technique employed for the *Boy with a Skull* (Cat. 61; Plate 97) but here it is used with greater economy.

Hans Kauffmann ('Die Fünfsinne in der niederländischen Malerei des 17. Jahrhunderts', *Kunstgeschichtliche Studien*, edited by Hans Tintelnot, Breslau, 1943, p. 141, fig. 22) connects the picture with the tradition of representing the five senses and suggests that it can be viewed as the sense of taste—or more specifically, the pleasure of drinking. For a brief survey of drinkers depicted by earlier Dutch artists, see text, pp. 107–111. The medal worn by the model has been identified as a portrait medal of Prince Maurice of Orange (HdG 63; KdK 1921, 59; KdK 61; Trivas 32; Rijksmuseum Cat. 1932, no. 1091; *ibid.*, 1960); however, Hals' summary treatment of it makes the identification tenuous.

A poor copy of the head was once in the collection Mrs. Bischoffsheim, London; sale, Bishcoffsheim, London (Christie) 7 May 1926, no. 37; canvas, 60 × 50 cm. Exhibition: Burlington Fine Art Club, London, 1905, no. 22.

Bibliography: HdG 284 Bode-Binder 54, Pl. 22b; KdK 61 (copy); Trivas 32 (copy). A poorer one of the head appeared at the sale, Ehrich Galleries, New York (American Art Association and Anderson Galleries) 18–19 April 1934, no. 55, repr.: circular panel, 63 cm. According to the sale catalogue it was attributed to Nicolaes Claes [sic] Hals by A. Bredius. The attribution was a safe one. Hals' son Nicolaes (or Claes) Fransz. Hals is not a crystal-clear personality (see Cat. no. D 81), but as far as I know the only work that has ever been attributed to Nicolaes Claes Hals, whoever he may be, is this copy.

Hofstede de Groot (63, note) mentions a copy (different in colour) which appeared in the sale, Cleveland and others, London, 8 April 1902, no. 96 (£21). Trivas (32-c) cites one in the sale, Mich. Abrahams and others, London, 5 April 1897, no. 96. A 'réplique modifiée du tableau d'Amsterdam' of 'Le joyeux buveur' (canvas, 80×66 cm.) is listed in 'Les 100 Portraits Collection du Comte Cavens', Brussels, 1 May–1 June, 1909, no. 32. A copy (canvas, 76×60 cm.) also appeared in the sale, Earl of Derby, London (Christie), 21 April 1967, no. 13. The relationship of these copies to each other and to those cited above has not been established.

For a modern forgery based on the *Merry Drinker*, see Cat. no. D 21.

64. Peeckelhaering (Plate 102, 104; text, pp. 80, 94, 96; Figs. 87, 88, 92, 93). Cassel, Hessisches Landesmuseum (Cat. 1958, no. 216).

Canvas, 75×61·5 cm. Inscribed to the right of the model's shoulder: *f. hals f.* (Fig. 56).

PROVENANCE: *Haupt-Catalogus von Sr Hochfürstl. Durch^{lt} Herren Land Grafens Wilhelm zu Hessen, sämtlichen Schildereyen, und Portraits. Mit ihren besondern Registern. Verfertiget in Anno 1749.* No. 363: 'Hals, Francois. Ein lachender Bauer mit einem Krug in der linken Hand, auf Leinen in schwarzem Rahmen mit vergulder Leiste' (Höhe: 2 Schuh 5 Zoll; Breite: 1 Schuh 11 Zoll).

EXHIBITIONS: Schaffhausen 1949, no. 45; Amsterdam 1952, no. 44; Haarlem 1962, no. 25.

BIBLIOGRAPHY: Bode 1883, 97 (*ca.* 1640); Moes 267; HdG 95; Bode-Binder 66; KdK 1921, 129 (*ca.* 1635–40; Porgés copy erroneously reproduced instead of the Cassel original); KdK 140 (*ca.* 1635–40; Porgés copy erroneously reproduced instead of the Cassel original); Trivas 35 (*ca.* 1627).

The lower-case signature is unique in Hals' *oeuvre* (Fig. 56); although it has been partially strengthened I find no reason to doubt its authenticity. Trivas (35) noted that the dates of about 1640 given to the work by Bode (1883, 97) and of around 1635–40 by Valentiner (KdK 140) were too late. He justly pointed out that the painting is closely related in style to the *Merry Drinker* (Cat. no. 63; Plate 107)

and the so-called *Mulatto* (Cat. no. 65; Plate 103) and placed the group in the late twenties. However, his statement that a print by Jacques de Gheyn, who died in 1629, provides a *terminus ante quem* for these three paintings is an error (see Cat. no. 65).

The title 'Peeckelhaering' is derived from a verse inscribed on an engraving in reverse of the painting made by Jonas Suyderhoef (text, Fig. 88; Wussin no. 117). Suyderhoef's print is inscribed: F Hals Pinxit. The verse reads:

> Siet Monsieur Peeckelhaering an
> Hy pryst een frisse volle kan
> En hout het met de vogte back
> Dat doet syn keel is altyt brack.

(Look at Monsieur Peeckelhaering/He praises the brimful mug/And is constantly occupied with the wet vessel/Because his throat is always dry.)

'Peeckelhaering' was the name of a popular theatrical character in comedies of the period (see S. J. Gudlaugsson, *De Komedianten bij Jan Steen en zijn Tijdgenooten*, The Hague, 1945, pp. 58ff.). During the seventeenth century, when comic figures of Dutch farces did not have the fixed traditions of the Italian players, Peeckelhaering sometimes assumed a different character and costume. Hals represented him as a Falstaffian type in his *Shrovetide Revellers* at the Metropolitan Museum (Cat. no. 5; Plate 8). In the Cassel picture and the one Hals painted of him which is now in Leipzig (Cat. no. 65; Plate 103), the buffoon has some resemblance to Brighella, who figures in the repertoire of *Commedia dell'Arte* players.

The painting may have belonged to Jan Steen. It makes an appearance as a picture within a picture in Steen's *The Doctor's Visit* at Apsley House (text, Fig. 87; Wellington Museum, cat. no. 1525). It also hangs on the back wall of Steen's *Baptismal Party* (text, Figs. 92, 93; Berlin-Dahlem, Cat. no. 795D) as the pendant to a picture which is probably a copy of a lost *Woman with a Pipe* (Malle Babbe?) by Hals (Cat. no. L 7; text, Fig. 91). Perhaps the Cassel painting had a companion picture. Valentiner (KdK 140, note) suggested that it was the Metropolitan Museum version of *Malle Babbe* (text, Figs. 146, 156); in my opinion that painting is by an unidentified close follower of Hals (see Cat. no. D 34 and text, p. 146).

Hals' *Peeckelhaering* was also appropriately used as the engraved frontispiece of a small anthology of jokes and jests published in 1648 (Fig. 26): *Nugae Venales sive Thesaurus ridendi & Jocandi* ... [n.p.], 1648. The engraving, which reverses the picture, is inscribed NVGAE VENALES (Jests for Sale). It is one of the rare seventeenth-century book illustrations based on a work by Hals; for others see Cat. no. 122 and Cat. no. L 11. Both the engraver of the print and the complier of the 1648 joke book remain anonymous. The place of publication of the volume is not known either (the Haarlem 1962 exhibition catalogue [no. 25] erroneously states it was published in London). Since the joke book went through more than one edition it must

have enjoyed some success but it could not have done much to spread Hals' fame; his name is not inscribed on the frontispiece. Copies of the volume are scarce. Editions dated 1642, 1648, 1663, 1689, and 1720 are recorded. The engraving appears in a 1663 edition (Houghton Library, Harvard University; weak impression from the worn plate); it is lacking in the 1642, 1689 and 1720 editions which have been examined.

There is a reference to 'en peekelharing van Frans Hals' in an auction list dated 17 November 1631 of pictures belonging to Hendrick Willemsz. den Abt, landlord of the Haarlem inn 'De Coninck van Vranckryck'. Abt's inventory is published by C. A. van Hees, 'Archivalia betreffende Frans Hals en de zijnen', *O.H.*, LXXIV (1959), pp. 37*ff*. It is not known if Abt's *Peeckelhaering* was the picture now in Cassel, the Leipzig painting (Cat. no. 65) or a lost variant, but the reference provides a *terminus ante quem* for Hals' depiction of the subject. 'Peeckelhaering' continued to be a popular and recognizable figure in seventeenth-century Holland. Dirck Hals shows him pouring wine in a *Merry Company* scene dated 1639 (text, Figs. 89, 90; Stockholm, National Museum, Cat. 1958, no. 1549). Hofstede de Groot (95) notes that paintings bearing the title 'Peeckelhaering' are cited in the inventories of Hendric Brugge, Leiden 1666; Hendric Huyck, Nymwegen, 10 January 1669; and Jan Zeeuw and Marie Bergervis, who died in Amsterdam in 1690.

A copy of the Cassel picture (Fig. 27) has been confused with the original. It is erroneously reproduced by Valentiner (KdK 1921, 129; KdK 140) and S. J. Gudlaugsson, *De Komedianten bij Jan Steen en zijn Tijdgenooten*, The Hague, 1945, p. 61, fig. 65, as the Cassel painting. Trivas (35-a; 35-b) divided its provenance; the two copies he lists are in fact one. The copy is on canvas, 78·5×67·3 cm., signed with the connected monogram in the lower right corner. PROVENANCE: sale, Vicomte de Buissert sale, Brussels (Le Roy), 29 April 1891, no. 41; Jules Porgès, Paris; sale, Brussels (Sainte-Gudule) 3–4 July 1919, no. 93; dealer Knoedler, Paris-New York; dealer D. Katz, Dieren; Mrs. Hartog-Hijmans, Arnhem (not Van den Bergh collection as stated in the Haarlem exhibition catalogue, 1962, no. 25); confiscated by the Nazis after they occupied the Netherlands during World War II; sale, The Hague (Van Marle and Bignell), 1 July 1941, no. 12. At the 1941 sale the copy fell into the hands of the notorious forger Han van Meegeren; a painting which appears to be the copy can be seen in a photograph of Van Meegeren's living room published in *The London Illustrated News*, 207 (1945), p. 561. A week later the copy was reproduced, *ibid.*, p. 696, as a work by the ingenious forger. Van Meegeren is known to have made fake Hals' pictures (see Cat. no. 75; text, Fig. 150), but he certainly did not paint this copy of the Cassel picture. The painting in Van Meegeren's possession was confiscated by the Dutch government and returned to its lawful owner. In 1962 it was in a private collection in Salisbury, Southern Rhodesia. Exhibitions: The Hague,

Kleykamp, 1928, no. 11, repr.; Denver, Art Museum, *Loan Exhibition of Dutch Paintings*, 1929, repr.; Haarlem 1937, no. 65. Bibliography: Moes 266; HdG 95, note, identical with HdG 99a (apparently a replica of the Cassel painting); Bode-Binder 67, repr.; KdK 140, note (hardly authentic); Trivas 35-a (copy); *Kunst-Rundschau*, IXL (1941), Heft 8.

65. So-called Mulatto (Plate 103; text, pp. 94, 96–97, Fig. 86). Leipzig, Museum der bildenden Künste (Cat. 1924, no. 1017).

Canvas, 75·5×63·5 cm. Signed in the lower right corner with the connected monogram: FH.

PROVENANCE: Probably in England around 1670; sale, D. P. Sellar of London, Paris (Petit), 6 June 1889, no. 38; purchased in 1889 from dealer C. Sedelmeyer, Paris, by A. Thieme, Leipzig, who bequeathed it to the museum in 1916.

EXHIBITIONS: London, Royal Academy, Winter Exhibition 1887, no. 80; Munich 1892; Haarlem 1962, no. 24.

BIBLIOGRAPHY: Alfred Thieme, Leipzig, Catalogue, no. 31. Moes 268; HdG 96; Bode-Binder 65; KdK 143 (*ca.* 1635–40); Trivas 34 (before 29 or 31 March 1629).

Painted around 1628–30. Closely related to the *Merry Drinker* (Cat. no. 63; Plate 107) and *Peeckelhaering* (Cat. no. 64; Plate 102). Passages of the paint layer have been moderately to severely abraded and flattened. However, the vivacity of Hals' brushwork, particularly in the model's head, can still be appreciated. The 1924 Leipzig catalogue noted that traces of a date (1627?) were apparent near the monogram; they are no longer visible.

The painting is a portrait of 'Peeckelhaering'. Probably the model who posed for Hals' other picture of the stock theatrical character (Cat. no. 64) is portrayed here wearing the same costume. His ruddy complexion conceivably accounts for the title 'Mulatto', the popular name the painting acquired around the end of the nineteenth century. A. Blankert has noted that this Peeckelhaering's pointing forefinger is a gesture traditionally given to fools, and generally implies scorn or derision ('not worth sticking your finger out'). He has established that the gesture was used in a score of seventeenth-century Dutch representations of Democritus. In these works the laughing philosopher is shown disparaging his weeping fellow philosopher Heraclitus (A. Blankert, 'Heraclitus en Democritus', *N.K.J.*, XVIII (1967), p. 57, note 57). Perhaps the Leipzig 'Peeckelhaering' once pointed to a companion picture; however, there is no convincing reason to accept the suggestion made by Valentiner (KdK 143, note) that its pendant was Hals' famous *Malle Babbe* in Berlin-Dahlem (Cat. no. 75; Plate 120). As students of Hals' work know, Valentiner had a predilection for mating Hals' pictures,

particularly the genre pieces. There is an astonishingly early precedent for Valentiner's practice. Around 1670 the English printmaker Edward Le Davis (1640?–84?) coupled two of Hals' works which could hardly have been intended as pendants. Le Davis paired the Leipzig 'Peeckelhaering' as a 'Merry Andrew' and Hals' straightforward Hermitage *Portrait of a Man* painted about a decade later (Cat. no. 134; Plate 214) on a single engraved plate (text, Fig. 86); both pictures were reversed by the engraver. The first state of Le Davis' print is inscribed: 'The Mountebanck Doctor/ and His Merry Andrew/Printed and Sold by Henry Overton/at the White Horse without Newgate/London Franc Haultz Pinxt. Edwardus Le Dauis Londini, Sculp.' In the second state Le Davis changed the spelling of the artist's surname to 'Hault' and added a doggerel verse:

I am a Fool but not for want of wit
I play the fool that wee by Fools may get
For whosoever does the Packets buy
In troth I think they're greater fool then I
In parting with their Gold and Silver Coin
To Cure your poor Consumptive Purse and mine
My Antick fool in thy fantastick Dress
With Grinning Looks thy wonted words Express
And let thy Humours all be Acted well
That so I may my worthy Packets Sell
For tho I in a Velvet Coat Appear
I am not worth one single Groat a Year.

Le Davis' transformation of Hals' 'Peeckelhaering' into a Merry Andrew, the name given to a mountebank's assistant in England, was not a radical one. A 'Merry Andrew' and 'Peeckelhaering' had similar occupations: they entertained with their antics and buffoonery. Le Davis's engraving indicates that the painting has been cut at the bottom and that 'Peeckelhaering's' bright red and yellow cap and costume were originally decorated with feathers (or stiff hairs?). Conceivably the latter were abraded or have been covered with repaint. Juxtaposition of the print with the painting also indicates that the flying outer locks of 'Peeckelhaering's' hair have been lost or over-painted. It is noteworthy too that Le Davis eliminated 'Peeckelhaering's' hand; this change can be attributed to artistic licence. Le Davis can also be credited with making the earliest known references in England to the artist as well as finding highly original ways to spell Frans Hals' name. Few Englishmen adopted his orthography (Franc Haultz or Hault), but permutations on the spelling of the artist's name are frequent in England during the eighteenth and early nineteenth century. George Vertue wrote of a painting of a 'Doctor by France Hals' (see Cat. no. 134), and when Horace Walpole presented a list of prints by Edward Le Davis in his *Anecdotes of Painting* he included: 'A Merry Andrew, after Francis Halls, graved in an odd manner' (*Anecdotes of Painting in England*, ed. Ralph N. Wornum, vol. III, London 1849, p. 942). 'Frank Halls' is another common variant used in England until about 1850.

The portion of Le Davis' print which depicts 'Peeckelhaering' was known to Trivas (34). He incorrectly attributed it to Jacques de Gheyn II, who died 29 March 1629 (J. Q. van Regteren Altena, *Jacques de Gheyn: An Introduction to the Study of His Drawings*, Amsterdam (1935), p. 21) and concluded that the painting must have been painted before that date. Although the documentary evidence Trivas offered to support a date late in the twenties for the picture must be rejected, the date he assigned to it is acceptable on the basis of style.

Le Davis' print indicates that two of Hals' pictures were in England around 1670. What is known about the subsequent history of the portrait, which he dubbed a 'Mountebank Doctor', is discussed in Cat. no. 134. As noted in the provenance listed above, little is known about the history of the painting he called 'Merry Andrew'. Perhaps it was the 'Merry Andrew' by Hals which was in the sale, London, 2–3 May 1765, no. 3, which only fetched 10s. 10p. Hofstede de Groot (96) noted in 1910 that a copy of the picture was in the hands of a German dealer some years before and that a second study of the same model was in the Wiesbaden Museum. He also recorded a copy which appeared in the sale, Mniszech, Paris, 9 April 1902, no. 127: 69 × 54 cm. (16,000 francs). Other copies are:

1. sale, Jean Dollfus, Paris (Petit), 20–21 May 1912, no. 49; panel, 61 × 48 cm.
2. Onnes Jan Nyenrode collection (on a green background, smaller than the original).
3. M. von Nemes collection, Budapest and Munich (probably identical with the Mniszech version cited above).
4. sale, W. Locket Agnew and others, London (Christie), 15 June 1923, no. 102, panel, 30 × 34·7 cm.

66. **Seated Boy** (Plate 110). Washington, D.C., National Gallery of Art, Andrew W. Mellon Collection (Cat. 1965, acc. no. 498).
Panel, 29 × 23 cm.

PROVENANCE: Collection Van der Hoop; Collection Slochteren; Collection C. J. G. Bredius, Woerden; Dealers Knoedler and Co., New York–Paris; A. W. Mellon, Washington, D.C.; gift of the A. W. Mellon Educational and Charitable Trust to the gallery in 1940.
EXHIBITION: The Hague, Mauritshuis, 1919.
BIBLIOGRAPHY: H. Schneider, 'Ein neues Bild von Frans Hals', *Kunstchronik und Kunstmarkt*, N.F., XXX (1918–19), pp. 368–369; KdK 51 (ca. 1626–27; wrong size); Valentiner 1936, 16 (ca. 1626–27; wrong size); Trivas 23 (ca. 1627).

According to Schneider, who published the painting (*op. cit.*), it was acquired by C. J. G. Bredius of Woerden as a work by Jan Miense Molenaer for 60 guilders. This erroneous attribution is an understandable one. Around

1630 Molenaer as well as Judith Leyster and Dirck Hals must have been inspired by Hals' little informal oil sketches of this type. But they never matched the airiness, fluidity of touch and surety of drawing found in this engaging portrait of a boy seated in an exceptionally complicated pose. The subdued colour contrast relieved by only a few vivid accents places the work around 1628–30.

67. Portrait of a Man (Plate 108; text, p. 113). New York, The Frick Collection (Cat. 1968, vol. I, p. 209, no. 10.1.69).
Canvas, 115·6×91·4 cm.

PROVENANCE: Lord Arundell of Wardour; dealer C. J. Wertheimer, London (sold 10 January 1895 for 74,265 [currency not mentioned], according to an unpublished note at RKD); dealer C. Sedelmeyer, Paris, Catalogue, 1895, no. 13; Maurice Kann, Paris (price 105,000 [currency not mentioned] according to an unpublished note at RKD); dealer Duveen, New York; acquired by Henry Clay Frick in 1910.
EXHIBITIONS: London, Grafton Galleries, National Loan Exhibition, 1909–10, no. 37; Boston, Museum of Fine Arts, Frick Collection, 1910, no. 6.
BIBLIOGRAPHY: Possibly Moes 146; HdG 303 (ca. 1627); Bode-Binder 149; KdK 108 (1633); Valentiner 1936, 40 (1633); Trivas 40 (ca. 1631–33).

A cleaning done in 1943 revealed that the lower edge of the picture has been irregularly cut; it now curves upward at the centre. Possibly the painting was originally somewhat larger and showed more of the figure and the back of the chair. Valentiner (KdK 108, note; 1936, 40), followed by Trivas (40), stated that the painting was a companion picture of the *Portrait of a Woman* dated 1633 at the National Gallery, Washington (Cat. no. 82; Plate 135). On the basis of the relationship which Valentiner saw between the two works he dated the Frick portrait 1633. The sizes and provenances do not bolster the assertion that the works were intended as pendants, and the style of Frick portrait does not support the date of 1633. Its distinctive blond tonality and the thin paint used for the flesh tints find their closest parallels in the portraits on the left side of Hals' St. George banquet piece of 1627 (Cat. no. 46; Plate 85); they suggest that the portrait was painted in the late twenties. Hals used a similar pose for his 1631 portrait of *Nicolas van der Meer* in Haarlem (Cat. no. 77; Plate 123). In the 1631 portrait the contrast in value between the figure and the background has been reduced and the general effect has become more monochromatic.

68. Portrait of a Man (Plate 109). London, Buckingham Palace, H.M. The Queen.

Canvas, 116·8×90·2 cm. Inscribed at the upper right: AETAT SVAE 36/AN 1630.

PROVENANCE: The little that is known about the history of the painting is published in Sir Oliver Millar's catalogue of *Dutch Pictures from the Royal Collection*, The Queen's Gallery, Buckingham Palace, 1971–72, pp. 17, 72–73. The portrait is first referred to at Buckingham House during the reign of George III; it may have been acquired by him, or conceivably by his father, Frederick, Prince of Wales. The latter's accounts include, under 30 September 1753, 2s. to a man 'for Measureing the Dutch pickters, in the Wardrope' (Accounts of the Prince and Prince and Princess preserved in the Duchy of Cornwall Office, vol. XXV (I), f. 54).
EXHIBITIONS: London, Royal Academy, Winter Exhibition 1875, no. 102; London, Royal Academy, Winter Exhibition, 1892, no. 124; London, Exhibition of the King's Pictures, Royal Academy, 1946–47, no. 358; Haarlem 1962, no. 26; London, The Queen's Gallery, Buckingham Palace, *Dutch Pictures from the Royal Collection*, 1971–72, no. 5.
BIBLIOGRAPHY: Waagen 1854, vol. II, p. 4; Bode 1883, 134; Moes 125; HdG 286; Bode-Binder 126; KdK 84; Trivas 37.

The results of a cleaning done in 1970–71 are reported in the Buckingham Palace Exhibition Catalogue of 1971–72, no. 5. The picture 'had been overpainted, particularly heavily in the costume. The fall of drapery below the sitter's elbow and an area of draping below the waist on the right had been painted out. The inscription had been strengthened.'
This imposing knee-length marks a shift which begins to take place in Hals' style during the thirties, when his paintings acquired a greater unity and simplicity. The silhouettes of figures became more regular and bright colours are replaced by more monochromatic effects. Areas of attraction are reduced and there is a new restraint in the use of pictorial accents.
When Waagen published his notes about the Buckingham Palace portrait (*op. cit.*) in 1854 he wrote that 'Van Dyck's admiration for Hals is well justified by this specimen; for the conception is unusually spirited and animated even for Frank Hals, and agrees in every way with the firm and broad execution. In my opinion the real value of this painter in the history of Dutch painting has never been sufficiently appreciated.' Waagen's reference to Van Dyck's admiration for Hals is probably based on the story Houbraken told about the meeting the artists had in Haarlem (see A. Houbraken, *De Groote Schouburgh*, vol. I, 1718, pp. 90–92, and text, p. 186).
There is no foundation to Valentiner's suggestion (KdK 85) that the portrait is probably a pendant to our Cat. no. D 65.

69. **Portrait of a Man** (Plate 111). Vienna, formerly Julius Priester.
Panel, 69·5 × 58·5 cm.

PROVENANCE: H. von Altenhaim, Vienna, 1921; Valentiner (KdK 89) noted that the portrait entered the collection of Julius Priester, Vienna, while his 1923 catalogue was in the press.
EXHIBITION: Haarlem 1937, no. 37.
BIBLIOGRAPHY: KdK 1921, 86 (*ca.* 1630); KdK 89 (*ca.* 1630); Trivas 53 (*ca.* 1634).

First published in 1921 by Valentiner, who writes that he received a photograph of it from W. von Bode. To judge from photographs of this untraceable work, it was painted by Hals around 1630 but I must reserve final judgement.

70. **Fruit and Vegetable Seller** (Plates 112, 113; text, pp. 58, 75, 140–143), Bridgnorth, Shropshire, Viscount Boyne.
Canvas, 157 × 200 cm. Signed and dated on the stone wall on the right: *CVHevssen fecit A° 1630* (the first four letters and the *se* are joined).

PROVENANCE: Probably sale, Amsterdam, 6 August 1810, no. 41 (50 florins, Roos); probably sale, E. M. Engelberts, Amsterdam, 25 August 1817, no. 33 (47 florins, Woodburn).
EXHIBITIONS: London 1929, no. 122; London 1952–53, no. 97.
BIBLIOGRAPHY: HdG 121c; C. Hofstede de Groot, 'Twee Teruggevonden Schilderijen door Frans Hals', *O.H.*, XXXIV (1921), pp. 67–68.

Hofstede de Groot published the painting in 1921 (*op. cit.*) and noted that it was probably identical with a painting which appeared in sales at Amsterdam in 1810 and 1817 (HdG 121c). The former work is described in the 1810 catalogue (no. 41) as a painting by 'Hals en Gheusen, H. 60 br. 74d. Doek'; the 1817 painting is catalogued as a work by 'Frans Hals en P. Gijzen, h. 60, b. 79d. Doek'. HdG 121c noted that these references to Hals' collaborator are said to refer to the Flemish painter Pieter Gijsels (or Gijssens), but rightly added that Gijsels (1621–c. 1691), a Flemish artist who painted on a small scale in Jan Bruegel's and Jan Weenix's manner, could hardly have worked with Hals on it. When he published the painting in 1921 (*op. cit.*) he wrote that the unknown artist Ghyssen was said to have painted the still-life. The painting was skied and he did not have an opportunity to examine it closely. It was first exhibited in the Dutch exhibition at London in 1929 (no. 122); the compilers of the catalogue of that exhibition transcribed the signature and date, and identified the painting as a joint effort by Hals and Nicolaes van Heussen (born *ca.* 1600), a little known Haarlem still-life painter.

Hals' touch is clearly recognizable in the figure of the girl and he may have brushed in the ivy that clings to the wall and fluted column behind her. The remainder of the large, highly finished picture can be attributed to Van Heussen. Nothing about the figure which Hals incorporated into the work suggests it was not painted in 1630, the year Van Heussen inscribed on the painting. The date is of special interest to students of Hals' chronology because dated genre pieces by the artist are conspicuously rare; the only other work which bears a date is his so-called *Jonker Ramp* of 1623 (Cat. no. 20; Plate 42).
The discrepancies in size between the paintings cited in the 1810 and 1817 catalogues and the Boyne picture raise the possibility that Hals and Van Heussen collaborated on another, smaller painting of the same subject. There is also a reference in the sale (supplementary) Daniel Mansveld, Amsterdam, 13 August 1806, no. 323 (2 florins) to a *Fruit and Vegetable Dealer* by Hals which measures 95 × 145 cm.

71. **Fisherboy** (Plates 114, 115; text, pp. 104, 141–143). Antwerp, Musée Royal des Beaux-Arts (Cat. 1958, no. 188).
Canvas, 74 × 61 cm. Signed at the lower right with the connected monogram: FH.

PROVENANCE: Sale, Alphonse Oudry, Paris, 16 April 1869, no. 33; purchased by the museum from J. C. Mertz, Paris, in 1871. According to C. Sedelmeyer's 1898 *Catalogue of 300 Paintings*, no. 46, the painting was also in his possession.
EXHIBITIONS: Haarlem 1937, no. 53; Haarlem 1962, no. 27; Brussels 1971, no. 46.
BIBLIOGRAPHY: Bode 1883, 37 (*ca.* 1640); Moes 254; HdG 49; Bode-Binder 76; KdK 117 right (*ca.* 1633–35).

Popularly called 'De Strandloper van Haarlem'. The fine tonal harmony and the similarity of the technique to the *Fruit and Vegetable Seller* of 1630 (Cat. no. 70; Plate 112) suggest a date in the early thirties. Analogies in the treatment of the heads are particularly striking (see Plates 113, 114); in both, Hals' brush draws rather than paints the shadows and highlights which define and model the features of the face with exceptional economy. The bold attack coupled with an exquisite pictorial refinement is also found in the *Fishergirl* formerly at Brooklyn (Cat. no. 72; Plate 116) and the *Fisherboy* at Dublin (Cat. no. 73; Plate 117). They can be dated around the same time. A weak copy of the Antwerp painting is at the depot of the Rijksmuseum, Amsterdam, inv. no. 1091–BZ.
Valentiner (KdK 117, right) suggested that the Antwerp *Fisherboy* and the Brooklyn *Fishergirl* (Cat. no. 72) were possibly pendants. Although both paintings have similar dimensions and both were in the 1869 Oudry sale at Paris, it is doubtful if they were intended as companion pictures.

72. **Fishergirl** (Plate 116, 119; text, p. 143). Formerly in the Brooklyn Museum, New York.
Canvas, 80·6 × 66·7 cm. Signed on the barrel with the connected monogram: FH.

PROVENANCE: Sale, Alphonse Oudry, Paris, 16 April 1869, no. 32; sale, Baron de Beurnonville, Paris, 9–16 May 1881, no. 302; sale, M. E. May, Paris (Petit) 4 June 1890, no. 105; Augustus A. Healy, who bequeathed it to the museum in 1921 (acc. no. 21.143); sold by the museum to dealers Wildenstein, New York, 1967.
EXHIBITIONS: Detroit 1935, no. 28; Haarlem 1937, no. 54; Los Angeles 1947, no. 11; Raleigh 1959, no. 59; Haarlem 1962, no. 28.
BIBLIOGRAPHY: Bode 1883, 51; HdG 114; Bode-Binder 288; KdK 117 left (*ca.* 1633–35); Valentiner 1936, 52 (1635).

The painting disappeared after it was sold in Paris in 1881. Bode-Binder (288, Plate 191a) and Valentiner (1921, 110) recorded it as lost and untraceable, respectively; they reproduced the etching Eugène Gaujean (1850–1900) made of it for the 1881 Beurnonville sale.
Valentiner recognized the painting in the Brooklyn Museum and published it in 1923 (KdK 117 left) as a possible pendant to the Antwerp *Fisherboy* (Cat. no. 71). Both pictures were probably painted in the early thirties, but most likely as independent works.
The painting is in good condition with abrasion limited to the right side of the barrel. The girl's unfinished left arm gives us a glimpse of the way the artist began to brush in forms. On the other hand, the tonal dunescape is fully realized. Gregory Martin, 'The Inventive Genius of Frans Hals', *Apollo* XCIV (1971), no. 115, p. 243, has correctly observed that the debt of Hals' pupil Wouwermans can be seen in Hals' ravishing landscape backgrounds of this type. Technical details about the painting recorded in a restorer's report in the files of the Brooklyn Museum (7 April 1937) are worth noting. Examination revealed that it was executed on a canvas which was not tacked to its support but suspended in the centre of it by cords. The original size of the support is preserved and the holes where the cords pierced the fabric are visible at the edges. Seventeenth-century Dutch paintings which show a canvas suspended in a frame are not uncommon. One was painted, around the time Hals painted the *Fishergirl*, by Jan Miense Molenaer: *The Artist's Studio* dated 1631 (Fig. 25; Berlin [East], Staatliche Museen). Molenaer had contact with Hals during these years. Indeed he must have known the artist's *Fishergirl Holding a Barrel*, or a version of it; she appears along with other fisherchildren derived from Hals' work in two of his paintings (text, Figs. 143, 144).
Hofstede de Groot (114) notes that an old copy was in the London art market in 1908. It may be identical with a copy which was in the coll. J. H. Garkin, London, 1905; coll. S. J. Graaf van Limburg-Stirum, The Hague; sold for £1,800 by Sabin (31·8 × 26 cm.; photo FARL).

73. **Fisherboy** (Plate 117; text, pp. 143–44). Dublin, National Gallery of Ireland (Cat. 1971, no. 193).
Canvas, 72 × 58 cm. Signed at the lower left with the connected monogram: FH.

PROVENANCE: Sale, John W. Wilson of Brussels, Paris, 14 March 1881, no. 60, purchased by the gallery at the sale (7,100 francs).
EXHIBITIONS: Brussels 1873; Haarlem 1937, no. 49; London 1952–53, no. 86.
BIBLIOGRAPHY: *Collection de M. John W. Wilson, exposée dans la galerie du cercle artistique et littéraire de Bruxelles*, Paris, 1873, p. 85; Charles Tardieu, 'Les Grandes Collection Etrangères, II, M. John W. Wilson', *G.B.A.*, VIII (1873), pp. 218–219; Bode 1883, 68 (*ca.* 1620); Moes 255; HdG 51; Bode-Binder 77; KdK 118 (*ca.* 1633–35).

When the compiler of the Antwerp catalogue, 1958, p. 102, no. 188, called the Dublin *Fisherboy* a 'répétition avec variantes' of the Antwerp *Fisherboy* (Cat. no. 71) he stretched the term 'répétition' beyond recognition. In my opinion it is an original done in the early thirties and has close stylistic affinities with the Antwerp *Fisherboy* and the *Fishergirl* formerly at Brooklyn (Cat. no. 72). Jan Miense Molenaer incorporated a variant of the Dublin boy, seen full-length, in his *Beach Scene with Fisherfolk* (text, Fig. 144).

74. **Man with a Beer Jug** (Plate 118; text, pp. 144–45, 200). White Plains, New York, Henry Reichhold.
Canvas, 83 × 66 cm.

PROVENANCE: Miss Vera Bellingham; sale, London (Sotheby), 9 June 1932, no. 82 (£3,600, Ascher); dealer D. Katz, Dieren; dealer Schaefer Galleries, New York.
EXHIBITIONS: Detroit 1935, no. 27; Haarlem 1937, no. 83, New York 1939, no. 180; Chicago 1942, no. 14.
BIBLIOGRAPHY: T. Borenius, 'A New Frans Hals', *B.M.*, LXI (1932), pp. 245–246 (*ca.* 1630–35).

Borenius (*op. cit.*) noted that the picture was traditionally known in the Irish family to which it belonged as *The Smuggler*. He rightly added that this description attempts too great a degree of anecdotal definition. The picture's compositional scheme and, on the whole, its execution are similar to Hals' paintings of fisherboys at Antwerp and Dublin (Cat. nos. 71, 73), which are datable to the early thirties. The work may have been painted around the same time; however, the unusual breadth of treatment of the hand and jug suggest a later date. Did Hals anticipate aspects of his late style here? Or did mature Hals return to a subject he had favoured in the thirties? The dearth of documented genre pictures by the artist does not permit categorical answers to these questions.
The vivid red stag on the beer jug probably indicates that it belonged to the Red Hart brewery of Haarlem; around

1660 Hals painted a portrait of Cornelis Guldewagen (Cat. no. 212; Plate 325), the owner of 'Het Rode Hert'.

75. Malle Babbe (Plates 120–122; text, pp. 15, 145–52). Berlin-Dahlem, Staatliche Museen (Cat. 1966, no. 801C). Canvas, 75×64 cm.

PROVENANCE: Possibly sale, Amsterdam, 1 October 1778, no. 58 (9 florins, 5; Altrogge); possibly sale, Nymegen, 10 June 1812, no. 88; sale, J. F. Sigault and J. J. van Limbeek, Amsterdam, 12 May 1834, no. 92 (9 florins, Roos): said to be on panel; sale, Stokbroo van Hoogwoud en Aartswoud, Hoorn, 3 September 1867; no. 69 (1,660 florins, Suermondt); coll. B. Suermondt, Aachen, from which it was acquired by the museum in 1874.

EXHIBITIONS: Munich 1869, no. 135; Brussels 1873, no. 19; Amsterdam 1950, no. 52.

BIBLIOGRAPHY: W. Bürger [Étienne Jos. Théoph. Thoré], 'Nouvelles Études sur la Galerie Suermondt: VIII. Les Hals', G.B.A., 1 (1869), pp. 162–164; C. von Lützow, 'Hille Bobbe van Haarlem. Oelgemälde von Franz Hals in der Galerie Suermondt zu Aachen', Zeitschrift für bildende Künste V (1870), pp. 78–80; Bode 1883, 92 (ca. 1650); Icon. Bat., no. 748-1; Moes 260; HdG 108; Bode-Binder 68 · KdK 142 (ca. 1635-40); Trivas 33 (ca. 1628).

Probably painted around 1633–35. Valentiner (KdK 142) and the Berlin-Dahlem Catalogue, 1966, p. 58, no. 801C, call it a companion picture of the so-called Mulatto at Leipzig (Cat. no. 65; Plate 103). However, the marked differences in tonality and brushwork indicate that the pictures were painted during different phases of the artist's career and neither surface pattern nor spatial arrangement convincingly relates them to each other.

The identification of the model is based on an old (eighteenth-century?) inscription on a piece of the painting's old stretcher which has been let into the new one; it reads: 'Malle Babbe van Haerlem . . . Fr[a]ns Hals' (Fig. 65). An erroneous reading of the inscription accounts for the title 'Hille Bobbe van Haarlem', which is found in the early literature. Bode-Binder transcribed it as 'Malle Babbe van Haerlem P. Frans Hals' in their 1914 catalogue, p. 31, no. 68; the 'P.' is no longer legible.

A letter dated 22 January 1868, Aachen, from B. Suermondt to the Haarlem doctor and amateur archivist A. van der Willigen establishes that Suermondt purchased the painting at the Stockbroo sale at Hoorn in 1867 (information kindly provided by J. W. Niemeyer; the letter is now at the RKD). The Stockbroo sale catalogue incorrectly noted that the inscription on the stretcher reads: 'Hille Bobbe van Haarlem fecit Frans Hals.' Suermondt accepted this transcription and wrote that 'Hille Bobbe' must have been 'une espèce de Sorcière ou diseuse de bonne aventure' and asked Van der Willigen 'si dans les anciennes chroniques de ville il ne se trouve aucune

mention ou rien qui puisse jeter quelque lumière sur la personne de Hille Bobbe; si nous avions la date de sa naissance, cela nous aiderait à constater l'année dans laquelle a été peint notre tableau et que nous estimons vers 1640 à 45'. Suermondt also wrote that: 'Monsieur [Léopold] Flameng premier graveur de la gazette des Beaux-Arts est occupé à faire une eau-forte du tableau, qui doit paraître dans l'un des prochains numéros de cette gazette; Monsieur Burger a été chargé d'y ajouter un texte, où il compte bien profiter de toutes les découvertes si importantes et si intéressantes que vous avez publié sur le compte de F. Hals dans votre dernier ouvrage si méritoire sur les anciens peintres formant l'ancienne école de Haarlem' (the reference is to Van der Willigen's Geschiedkundige Aanteekeningen over Haarlemische Schilders . . . Haarlem, 1866).

Neither Flameng nor Bürger-Thoré failed Suermondt; the former's etching and the latter's article appeared in the Gazette des Beaux-Arts in 1869 (op. cit.), a year after the collector wrote to Van der Willigen. However, there can be little doubt that the archivist was unable to give Suermondt the assistance he wanted. When Lützow published the painting he noted that Van der Willigen was unable to discover anything about the subject of the painting (op. cit., pp. 78–79). Careful scrutiny of the data in Haarlem's archives by later students has not produced a single reference to mythical Hille Bobbe or to Malle Babbe either. Perhaps the old crone immortalized by Hals bore another name; Malle Babbe may have been her nickname. Possible meanings of the owl perched on her shoulder are discussed in the text, pp. 147ff.

A copy by Courbet (text, Fig. 149) is at the Kunsthalle, Hamburg (86×71 cm.; inv. no. 316). It is inscribed at the bottom left: '69/G. Courbet'; at the bottom right: 'Aix la Chapell . . .'. To the right of the model's arm Courbet boldly scratched into the wet paint Hals' interconnected monogram and the date 1645. There is ample proof that the monogram and troublesome date were Courbet's inventions. The well preserved original does not show a trace of a monogram or date. Bürger-Thoré did not cite them when he published the painting in 1869 (op. cit.), the very year Courbet copied it; he dated it in the 1630's. As noted above, when Suermondt wrote to Van der Willigen he tentatively dated the painting around 1640–45, and asked for possible information about Hille Bobbe's birthdate to help him pinpoint the year his newly acquired painting was made; if it bore the date Courbet placed on it the collector surely would have seen it. And finally it is noteworthy that Lützow, who published the painting in 1870, did not mention the monogram and wrote that he disagreed with Bürger-Thoré's date in the 1630's and suggested it was painted in the following decade (op. cit., p. 80). Lützow knew Hals' original and Courbet's copy. In his article (ibid.), he tells the circumstances under which Courbet painted his copy when Suermondt's painting was on loan at the international exhibition in Munich in 1869.

He also passes judgement on the quality of the French painter's effort:

> Auch ein berühmter Maler der Gegenwart hat sich an unsrer Hille Bobbe versucht. Als Gustave Courbet zur Ausstellungszeit nach München kam, erbat er sich trotz der Kürze seines Aufenthaltes von Hrn. Suermondt die Erlaubniss, das Bild kopiren zu dürfen, das er für eines der grössten Meisterwerke der Kunst erklärte. Er brachte die Kopie denn auch in erstaunlich kurzer Zeit fertig und erreichte den Gesammteffect des Originals fast vollkommen; nur Eines fehlte, was immer das sicherste Kriterium der Originalität eines Kunstwerkes bleibt: die Helligkeit des Tons. Das Leuchten der Farben erschien stark abgedämpft und dadurch auch der Ausdruck des Kopfes weniger lebendig.

Hals probably made at least one other painting of Malle Babbe, and his followers also based pictures on the subject. What appears to be a copy of a lost *Malle Babbe* by Hals appears in Jan Steen's *Baptismal Party* at Berlin-Dahlem, no. 795D (see Cat. no. L 7; text, pp. 96, 145; Figs. 91, 93) as a companion piece to the artist's *Peeckelhaering* now at Cassel (Cat. no. 64, Plate 102; text, Fig. 92). *Malle Babbe and a Drinking Man*, The Hague, S. Holdan; canvas, 105 × 75 cm. (text, p. 146; text, Fig. 158), formerly coll. Paul Schoenberg, Riga, is a crude pastiche by an anonymous follower which incorporates the Berlin-Dahlem painting. For other doubtful and wrongly attributed paintings which have been said to represent Malle Babbe see Cat. nos. L 34, L 35, and L 36.

The forger H. A. van Meegeren painted a *Woman Drinking* (text, Fig. 150) in Hals' style which he may have intended to pass off as a Malle Babbe; canvas, 78 × 66 cm.; signed with the connected monogram. The painting was seized in Van Meegeren's studio in 1945; for a discussion of aspects of this counterfeiter's work, see P. B. Coremans, *Van Meegeren's Faked Vermeers and De Hoochs*, Amsterdam, 1949. Bernard Keisch's findings ('Dating Works of Art Through Their Natural Radioactivity: Improvements and Applications', *Science*, CLX (1968), pp. 413–415) conclusively confirm that the *Woman Drinking* done in Hals' manner as well as four of Van Meegeren's paintings done in Vermeer's style are modern. He states that for the results of his analysis of the samples taken from these five pictures to have been derived from 300-year-old white lead would require the originals to have been produced from an incredible, uranium-rich ore (~25 per cent uranium). Such an ore would also require the large uranium content to be homogeneously mixed with the lead because heterogeneities containing the entire uranium series would have been removed during ore beneficiation. Needless to say, such an ore is unknown, particularly in the lead mines of seventeenth-century Europe (*ibid.*, pp. 414–415). Keisch's analysis of the white lead used in the *Boy Smoking a Pipe*, now at Groningen, confirmed that it too is a twentieth-century painting (see Cat. no. D. 21).

76. Samuel Ampzing (Plate 139; text, pp. 5–7, 71, 125, 140). England, Private Collection.
Copper, 16·2 × 12·3 cm. Inscribed at the right: AETAT 40/A[N?]° 163

PROVENANCE: Said to have been bought by an ancestor of Lord Clancarty in Holland; sale, Lord Clancarty, London, 12 March 1892, no. 32 (£735; Lesser, who sold it to Wallis); Sir William C. van Horne, Montreal; Miss L. Adaline van Horne, Montreal.
EXHIBITION: New York, Hudson-Fulton Celebration, 1909, no. 25.
BIBLIOGRAPHY: *Icon. Bat.*, no. 149–1; Moes 12 (1630); Martin Conway, 'Sir William van Horne's Collection at Montreal', *The Connoisseur*, XII, 1905, p. 140, repr. p. 137; HdG 151 (1630); Bode-Binder 128 (1630); KdK 82 (1630); Valentiner 1936, 34 (1630); Hubbard 1956, p. 151.

The 1892 Clancarty sales catalogue states the painting appeared in the 1820 Van Eyck sale at The Hague but this appears to be an error. Lugt lists three van Eyck sales around this time: Amsterdam, 21 October 1821; Loosduinen, 7 June 1822; The Hague, 18–24 December 1822. The painting does not appear in any of these sales.
Samuel Ampzing (1590 [not 1591]–1632) was a Haarlem preacher and poet. In his *Het Lof der Stadt Haerlem in Hollant*, Haarlem, 1621 (unpaginated), he makes a passing reference to Frans Hals and his brother Dirck, and in his *Beschryvinge ende lof der Stad Haerlem in Holland*, Haarlem, 1628 (p. 371) he briefly characterized the differences between the artists.
The last digit of the year inscribed on the small painting is illegible. All earlier students have read it as an *o*; this reading tallies with the model's age, which is inscribed on the portrait. The portrait was engraved in reverse by Jan van de Velde (*c.* 1593–1641); his print is inscribed: 'AETATS 41/a° 1632 . . . F. H. pinx . . .' and bears Van de Velde's monogram (Franken and Van der Kellen 3). It was engraved again in reverse by Jonas Suyderhoef (*c.* 1613–86). Suyderhoef's print (Wussin 6), which is more than twice the size of the small painting, is inscribed: 'AETAT.40/F. Hals pinxit/I. Suijderhoef Sculp.'.

77. Nicolaes van der Meer (Plate 123; text, pp. 112–113, 124). Haarlem, Frans Hals Museum (Cat. 1929, no. 131).
Panel, 128 × 100·5 cm. Inscribed and dated under the coat-of-arms on the right: AETAT SVAE 56/AN° 1631.

PROVENANCE: Jonkheer J. C. W. Fabricius van Leyenburg bequeathed the painting with its pendant (*cf.* Cat. no. 78) to the Frans Hals Museum, 1883.
EXHIBITIONS: Haarlem 1937, no. 40; San Francisco 1939, no. 77; Chicago 1942, no. 12; Haarlem 1962, no. 29.

BIBLIOGRAPHY: *Icon. Bat.*, no. 4927; Moes 53; HdG 200; Bode-Binder 134; KdK 94; Trivas 38.

Pendant to Cat. no. 78. Nicolaes van der Meer (1575–1638) was a brewer, alderman, and burgomaster of Haarlem. He also served as an officer in the St. George Militia Company and appears as a Captain in the banquet Hals painted of the company in 1616 (Cat. no. 7; Plate 19). The dark grey backgrounds, the rather dark tonalities, and the regularization of the silhouettes of these imposing portraits of a husband and wife are characteristic of the change that takes place in Hals' style in the early 1630's. After these pendants were painted Hals seldom employed panel as a support for his paintings, and none of his existing three-quarter length, life-size companion pictures done after 1631 are painted on wood.

A copy of the bust appeared in the sale, Schloss B . . . and others, Frankfurt a/M. (Helbing), 4–5 July 1933, no. 121, canvas, 67 × 56 cm.

Old copies of the pendants (both canvas, 126 × 103·5 cm.) are in the possession of the Dienst voor s'-Rijks Verspreide Kunstvoorwerpen, inv. nos. C 140, C 141.

78. Cornelia Vooght Claesdr., wife of Nicolaes van der Meer (Plate 124; text, pp. 112–113, 115, 124). Haarlem, Frans Hals Museum (Cat. 1929, no. 132).

Panel, 126·5 × 101 cm. Inscribed and dated on the left: AETAT SVAE 53/A° 1631. Her coat-of-arms is in the upper left.

PROVENANCE: Jonkheer J. C. W. Fabricius van Leyenburg bequeathed the painting with its pendant (*cf.* Cat. no. 77) to the Frans Hals Museum, 1883.

EXHIBITIONS: Haarlem 1937, no. 41; San Francisco 1939, no. 78; Chicago 1942, no. 13; Haarlem 1962, no. 30.

BIBLIOGRAPHY: Moes 54; HdG 201; Bode-Binder 135; KdK 95; Trivas 39.

Pendant to Cat. no. 78. Cornelia Vooght married Nicolaes van der Meer in 1598. The scheme Hals employed for this three-quarter length portrait of a seated woman became a favourite one of the artist and his patrons during the following decades. In 1639 he employed it with minor variations for his portrait of Cornelia's older sister (Cat. no. 129; Plate 207).

A grey wash drawing (Fig. 28; 38·2 × 29·5 cm.) of the portrait, inscribed on the verso 'Jan Van Der Sprang Fecit/1762', is in the Haarlem Archives. If it is a faithful copy—and it has all the hallmarks of one—the inscription and coat-of-arms on the picture may have been added after 1762; neither appears on that obscure copyist's drawing.

79. Officers and Sergeants of the St. Hadrian Civic Guard Company (Plates 125–128; text, pp. 39, 41, 124, 134–136). Haarlem, Frans Hals Museum (Cat. 1929, no. 126).

Canvas, 207 × 337 cm. The numbers painted on the officers have been added at a later date to identify them.

PROVENANCE: Originally painted for the headquarters of the St. Hadrian Militia Company; at the museum since 1862.

EXHIBITIONS: Haarlem 1937, no. 45; Heerlen, 's-Hertogenbosch 1945; Brussels 1946, Bosch tot Rembrandt, no. 49; Haarlem 1962, no. 32.

BIBLIOGRAPHY: Bode 1883, 4 (1633); Moes 4 (1633); HdG 434; Bode-Binder 137; KdK 107 (1633); Trivas 44; H. P. Baard, *Frans Hals, The Civic Guard Portrait Groups*, Amsterdam and Brussels, 1949, pp. 21–22, plates D and 25–32; C. C. van Valkenburg, 'De Haarlemse Schuttersstukken: VI. Officieren en Onderofficieren van de Cluveniersdoelen (Frans Hals, 1633)', *HAERLEM: Jaarboek 1961*, Haarlem 1962, pp. 59–65.

C. C. van Valkenburg (*op. cit.*) has conclusively established that these officers and sergeants served in the St. Hadrian Company from 1630 to 1633. Customarily group portraits were made of an officer corps when it had finished its term of service; thus the traditional date of 1633 is most likely correct.

It is Hals' first group portrait of a civic guard set out-of-doors. The officers are probably shown in the yard of their headquarters, which was known as 'De Oude Doelen'; the building still stands. Wybrand Hendriks' (1744–1831) watercolour copy of the painting (text, Fig. 137), Teyler Museum (Catalogue, 1904, Portfolio W, no. 44), indicates that the spatial relationships in the background were originally clearer and more intricate than they now appear. Hendriks' copies of Hals' works are generally trustworthy. The one he made of this picture clearly shows the wooden picket fence behind the officers, which can hardly be seen now. His copy also indicates that the landscape in the background was formerly more clearly differentiated and spacious. Natural ageing of the oil medium and pigment has darkened the thinly brushed greens and browns of this large area. A surface layer of discoloured varnish also covers the dark background. Perhaps the painting was selectively cleaned when it was restored in 1921–23. In any event judicious removal of the old surface coating may help restore a balance between the men in the foreground and the view behind them.

Hendriks also made a design for a print which was engraved by J. de Wit and P. H. Jonxis to commemorate an oath which members of the Haarlem society 'Pro Aris et Focis' took in 1787 at 'De Oude Doelen' (text, Fig. 138). The engraving, which shows the militia piece mounted on the wall above the door on the left, is the only existing view of one of Hals' large group portraits *in situ*.

The tendency toward a greater restraint which becomes apparent in the thirties is also evident in the large group

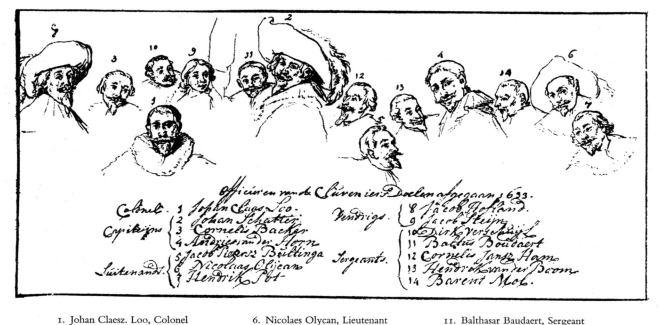

1. Johan Claesz. Loo, Colonel
2. Johan Schatter, Captain
3. Cornelis Backer, Captain
4. Andries van der Horn, Captain
5. Jacob Pietersz. Buttinga, Lieutenant

6. Nicolaes Olycan, Lieutenant
7. Hendrick Gerritsz. Pot, Lieutenant
8. Jacob (?) Hofland, Ensign
9. Jacob Steyn, Ensign
10. Dirck Verschuyl, Sergeant

11. Balthasar Baudaert, Sergeant
12. Cornelis Jansz. Ham, Sergeant
13. Hendrik van den Boom, Sergeant
14. Barent Mol, Sergeant

portraits painted in that decade. Here there is less movement than in the two banquet scenes of the twenties (Cat. nos. 45, 46) and the emphatic diagonals of the earlier works have given way to a horizontal composition. However, the dazzling brushwork, which animates the foreground of the painting, and the colouristic vivacity of the preceding decade have been retained.

Wybrand Hendrick's pen drawing of the heads of the members of the officer corps, now at the Teyler Foundation (no. 44a), which is reproduced above, identifies the officers and sergeants. One of the lieutenants was the painter Hendrick Gerritsz. Pot (c. 1585–1657). He appears again as a lieutenant in Hals' 1639 group portrait of *Officers of the St. George Company* (Cat. 124; Plate 201). Pot's group portrait of *Officers of the St. George Company* painted *ca.* 1630 is reproduced in the text, Fig. 139. Colonel Johan Claesz. Loo, who is seen on the left in Cat. no. 79, also appears in Hals' 1639 militia piece, and Andries van der Hoorn, who appears as the captain standing in the foreground on the right, was portrayed by Hals again in 1638 (Cat. no. 117; Plate 188).

80. The Corporalship of Captain Reynier Reael and Lieutenant Cornelis Michielsz. Blaeuw, called 'The Meagre Company' (Plates 129, 132–134; text, pp. 9, 17, 41–42, 62, 136–138, 210). Amsterdam, Rijksmuseum (Cat. 1960, no. 1085).

Canvas, 209 × 429 cm. Dated at the right edge near the centre: A°1637.

PROVENANCE: From the Amsterdam *Voetboogdoelen* (Cross-bowmen). Transferred to the Major Court Martial Chamber in the Town Hall (now the Royal Palace) and afterwards to the Burgomaster's Room in the same building. Lent to the Rijksmuseum by the City of Amsterdam since 1885.

EXHIBITIONS: From 20 May until 9 October 1946 on loan to the Frans Hals Museum; Haarlem 1962, no. 37.

BIBLIOGRAPHY: J. van Dijk, *Kunst en historiekundige beschryving en aanmerkingen over alle de schilderijen op het Stadhuis te Amsterdam*, Amsterdam, 1760, pp. 30*ff.*; [P. Scheltema], *Historische Beschrijving der Schilderijen van het Stadhuis te Amsterdam*, Amsterdam, 1879, pp. 14–15, no. 35 ('Het stuk is geteekend: FH 1637'); Bode 1883, 119; P. Scheltema, 'De Schilderijen in de Drie Doelens te Amsterdam, beschreven door G. Schaep, 1653' in *Aemstel's Oudheid*, vol. VII, Amsterdam, 1885, pp. 121*ff.*; D. C. Meijer Jr., 'De Amsterdamsche Schutters-stukken in en buiten het Nieuwe Rijksmuseum', *O.H.*, III (1885), p. 122; J. Six, 'Opmerkingen omtrent eenige meesterwerken in's Rijks Museum', *O.H.*, XI (1893), pp. 102*ff.*; *Icon. Bat.* 6214; Moes 5; HdG 428; A. Bredius, 'De Geschiedenis van een Schuttersstuk', *O.H.*, XXXI (1913), pp. 81*ff.*; Bode-Binder 159; KdK 119; H. P. Baard, *Frans Hals, The Civic Guard Portrait Groups*, Amsterdam and Brussels, 1949, pp. 23–24, plates E and 33–40.

In 1879 Scheltema wrote that the painting bore Hals' monogram (*op. cit.*); subsequent cataloguers have not mentioned it and not a trace of it is visible today.

Little more than a cursory examination is needed to reveal that Hals was mainly responsible for the officers portrayed on the left side and that a second hand was principally responsible for those on the right. What name would have been given to the second hand if a contemporary document had not provided it? It is safe to wager that one of Hals' sons would have been proposed as a likely candidate, and Judith Leyster would have had her advocates too. Would any expert have pronounced that the Amsterdam painter Pieter Codde (1599–1678) was the second artist? Virtually nothing in Codde's known *oeuvre* hints that it is he. Yet a list compiled by G. Schaep of the pictures hanging in the headquarters of the three militia companies at Amsterdam in 1653 informs us that Codde is our man. Number 23 in Schaep's 'Memorie ende lijste van de publycke schilderijen op de Voetboogsdoelen, sooals die waren in Februarij A°. 1653' is listed as 'A°. 1637. Ibidem tegenover de schoorsteen Cap\u207f. Reynier Reael, Lut. Corn. Michielsz. Blau, a°. 1637 bij Francois Hals geschildert ende bij Codde voorts opgemaeckt.' (Scheltema, *op. cit.*, p. 134.)

Schoep's reference to a 1637 militia piece opposite a fireplace in the *Voetboogsdoelen* of Captain Reynier Reael and Lieutenant Cornelis Michielsz. Blaeuw painted by Hals and brought to completion by Codde was published by Scheltema in 1885 (*op. cit.*, pp. 123ff.). News that Hals and Codde had worked on the painting travelled fast. Van Gogh was aware of it when he wrote to Theo in 1885 (probably in October) about the qualities of Hals' ensign (see *Verzamelde Brieven van Vincent van Gogh*, ed. J. van Gogh-Bonger, vol. III, Amsterdam-Antwerp, 1953, p. 66 and text, pp. 137–138). Today it is common knowledge that Codde executed part of the group portrait. No student has expressed astonishment about the fact. And rightly so. There is no reason why one of Hals' gifted contemporaries, who ordinarily painted small, rather carefully finished pictures, would not have been willing and able to shift style and scale in order to comply with the demands of a special commission. Codde's performance serves as another reminder that all of the existing anonymous seventeenth-century copies, variants and pictures done in Hals' manner need not have been painted by members of the artist's immediate circle. Another is the reduced copy Ludolph de Jongh made of Hals' 1650 portrait of *Nicolaes Stenius* (see text p. 183, text Fig. 195; Cat. no. 179). Some so-called school pieces may be works by artists who had little or no contact with Hals. Painters whose personal styles are normally readily recognizable may have been willing to adopt his manner to satisfy the demand of the market or they may have been made for more personal reasons. It is not inconceivable that some were done by established artists who copied Hals or imitated his technique because they were stimulated or challenged by his wizardry.

In 1885 D. C. Meijer Jr. (*op. cit.*) and in 1893 J. Six (*op. cit.*) misquoted Schaep's brief reference to Hals' and Codde's work on the 1636 militia piece. They transcribed the relevant passage as 'A° 1637 by Francois Hals begonnen en

bij Codde voorts opgemaeckt'. Schaep wrote 'bij François Hals geschildert...' (painted by Hals), not 'bij François Hals begonnen...' (begun by Hals). However, four documents published in 1913 by Bredius (*op. cit.*) suggest that a sixth sense told Meijer and Six to write that Hals began the painting. Bredius' discoveries in the Amsterdam and Haarlem Municipal Archives established that the painting had already been commissioned in 1633. On 19 March 1636 Hals was summoned to Amsterdam by legal writ to complete the group portrait commissioned three years earlier. He was warned that if he did not respond to the summons his patrons would no longer consider themselves bound to the agreement they had made with him. Moreover, if he failed to begin work again within fourteen days, his patrons reserved the right to have the painting finished by another artist, and legal proceedings would be instigated against him to recover the money he had already been paid. The writ was read to him by a notary on 20 March 1636 in Haarlem, where he was at home in bed with a bad leg. Hals maintained that he had agreed to make the group portrait in Haarlem, not Amsterdam, and later had consented to work on the heads in Amsterdam and finish them in Haarlem but he did not feel compelled to follow this arrangement. He would be pleased to finish the commission if the men would come to Haarlem to pose.

According to the response the officers made on 29 April 1636 Hals was reckless with the truth when he described the agreement he had made with the officers. They wanted him to come to Amsterdam within ten days and complete the work in a satisfactory manner. He was asked point blank to answer 'yes' or 'no' to their demand. This document also states that originally it was agreed that Hals was to receive sixty guilders for each figure, but later the guards agreed to pay him sixty-six guilders if he would begin and finish them in Amsterdam, as he had already done with some of the models. If he had fulfilled his contract under this arrangement he would have been paid 1,056 guilders for the group portrait. If we recall that Rembrandt was paid about 1,600 guilders for the *Night Watch* in 1642, when he was at the height of his popularity, Hals' honorarium was sizeable according to the standards of his day. (For a discussion of the fee Rembrandt received for his most famous painting, see Seymour Slive, *Rembrandt and His Critics: 1630–1730*, The Hague, 1953, pp. 4–7, 109; for the suggestion that Rembrandt probably received more than 1,600 guilders for the work, see Bob Haak, *Rembrandt: His Life, His Work, His Time*, New York [n.d.], pp. 179a–180.)

Hals did not reply until 26 July 1636, when he repeated to a notary that he was prepared to finish the painting in Haarlem if the officers would travel to his city to pose. He added one concession: he was willing to make the trip to Amsterdam to make sketches of the men who could not visit Haarlem. Here the story which can be read from archival material ends. But it is not difficult to guess what happened. The Amsterdam militia men found it impossible

to make Hals comply with their demand and they employed Codde to finish the picture. For further details about the documents published by Bredius and a note on the parts painted by Codde, see text, pp. 136–137.

The seated officers to the left are Reynier Reael (with hat) and Cornelis Michielsz. Blaeuw; the names of the standing men are unknown.

The painting is generally known as the 'Meagre Company'. In the Text Volume (p. 136) it was suggested that the group portrait received its popular title because it does not portray a single corpulent officer. Further investigation has established that this is the case. J. van Dijck can be credited with giving the picture its popular name when he described it in his list of pictures in Amsterdam's Town Hall, published in 1760 (op. cit.), and noted that all the members of the militia group are so dry and slender that one can justifiably call them the meagre company: 'dat ze alle zo dor en rank zyn, dat men ze met recht de magere Compagnie zoude kunnen noemen . . .'

81. **Portrait of a Man** (Plate 148; text, pp. 116–117). London, National Gallery (Cat. 1960, no. 1251).

Canvas, 64·8 × 50·2 cm. Signed on the right, centre, with the connected monogram: FH, and inscribed below it: AETAT SVAE 3[?]/AN°1633 (Fig. 57).

PROVENANCE: Collection Decimus Burton by 1875, when it was exhibited at the Royal Academy, no. 237. Presented to the gallery by the wish of Decimus Burton by his niece, Miss Emily Jan Wood, in 1888.

EXHIBITION: London, Royal Academy, 1875, no. 237.

BIBLIOGRAPHY: Moes 129; HdG 148 l (erroneously listed as a self-portrait), identical with HdG 281; Bode-Binder 139; KdK 110; Trivas 43; Neil MacLaren, *National Gallery Catalogues, Dutch School*, 1960, pp. 146–147.

The painting has been cut down at the right where the present edge runs through the first digit of the sitter's age. Neil MacLaren (op. cit.) first noted that although the digit is mutilated, it certainly is a *3*; it is at present covered by the rabbet of the frame. The paint surface is in generally good condition. Cleaning at the gallery in 1970 removed old retouches, which had darkened and spoilt the balance of the picture.

Erroneously exhibited at the Royal Academy in 1875 as a portrait of the artist. Valentiner's conclusion (see KdK 111) that the portrait is a companion picture to the *Portrait of a Woman* at the National Gallery (Cat. no. 131; Plate 212) is wrong. The paintings have different provenances and were executed during different phases of the artist's career.

82. **Portrait of a Seated Woman** (Plates 135, 138; text, p. 115). Washington, D.C., National Gallery of Art, Andrew W. Mellon Collection (Cat. 1965, acc. no. 67).

Canvas, 103 × 86·4 cm. Inscribed at the right: AETAT SVAE 60/AN° 1633.

PROVENANCE: Probably sale, Jurriaans, Amsterdam, 28 August 1817, no. 20 (200 florins, Roos); Comte de la Rupelle; dealer C. Sedelmeyer, Paris, Cat. 1905, no. 13; James Simon, Berlin; dealer Duveen, New York, 1927; Andrew W. Mellon, Washington, D.C., who presented it to the gallery in 1937.

EXHIBITIONS: Berlin 1906, no. 49; New York 1939, no. 179.

BIBLIOGRAPHY: Moes 186; HdG 371; Bode-Binder 138; KdK 109; Valentiner 1936, 41; Trivas 41.

One of Hals' most powerful portraits of a woman. No doubt her husband was portrayed in a companion picture. Valentiner (KdK 108; 1936, no. 41) and Trivas (41) identified him as the model who posed for the *Portrait of a Man* now at the Frick Collection (Cat. no. 67; Plate 108) but neither the known provenances of these paintings nor their dates support this marriage.

83. **Portrait of an Officer** (Plate 130; text, p. 117). São Paulo, Brazil, Museum of Art (Cat. 1963, no. 187).

Canvas, 87·5 × 65·3 cm. Inscribed at the right: AETAT. 52[?]/A° 163[?], and followed by the connected monogram: FH.

PROVENANCE: Sale, J. A. Töpfer, Amsterdam, 16 November 1841, no. 27 (62 florins; Roos). HdG 275 writes that it was with the dealer F. Kleinberger in Paris but according to a review of Hofstede de Groot's catalogue in the *Times Literary Supplement*, 1 September 1910, p. 307, it was never with Kleinberger; the anonymous reviewer states it was acquired through M. Haro from a private collection at Chartres and brought straight to London. Dealer Lawrie and Co., London; dealer Sulley, London, from whom Sir Edgar Vincent (later Lord D'Abernon), Esher, purchased it in 1902; acquired from Lord D'Abernon by Henry Goldman, New York in 1916; dealer Wildenstein, New York, ca. 1948.

EXHIBITIONS: London, Grafton Galleries, 1911, no. 65; Detroit 1925, no. 6; New York, Metropolitan Museum of Art, Paintings from the São Paulo Museum, Cat. 1957, no. 13 (dated 1631).

BIBLIOGRAPHY: Moes 127; HdG 275 (1637); Bode-Binder 164 (1637); Frank Jewett Mather Jr., 'A Portrait by Frans Hals', *Art in America*, V (1917), pp. 59–60; W. R. Valentiner, *The Henry Goldman Collection*, New York, 1922, no. 19 (1637); KdK 168 (1637); Valentiner 1936, 62.

Engraved, without the inscription or monogram, by Pieter de Mare (1757–96).

The paint surface is moderately to severely abraded; has been flattened in relining. The dark areas are thin and have

been repainted. Comparison with De Mare's print (Fig. 29) indicates that many of the shadows and half-tones have been lost; this is especially noticeable in the hat. The inscription is worn; the second digit of the age appears to have been reworked and the last digit of the year is either a 1 or 7. Mather (*op. cit.*, p. 59) noted in 1917: 'Although the 7 is partly effaced, there can be no doubt as to the reading 1637.' This is no longer the case. Moreover the shape of the numerals differs from others inscribed on Hals' paintings and the monogram is awkwardly placed. Perhaps the inscription and monogram were added by another hand.

Although the painting has suffered I have no doubts about the attribution to Hals. The technique—particularly the treatment of the lace collar—and the arrangement of the figure are closely related to the portrait of *Pieter van den Broecke* (Cat. no. 84; Plate 136) done *ca.* 1633, and in its original state the painting probably made as great an impact as the Kenwood House portrait. The dominant light grey tonality suggests that the date 1631 is closer to the year in which it was painted than the date of 1637 assigned to it on the basis of earlier readings of the inscription. (For examples of a 1 which could readily be read as a 7, if they were the last instead of the first digits of the year inscribed, see Cat. nos. 82, 100, 101; Plates 135, 158, 159.)

84. **Pieter van den Broecke** (Plates 136, 137; text, p. 117). London, Kenwood House, Iveagh Bequest (Cat. 1953, no. 51).
Canvas, 71·2 × 61 cm.

PROVENANCE: Sale, John W. Wilson, Paris, 16 March 1881, no. 59 (78,100 francs); sale, E. Secrétan, Paris, 1 July 1889, no. 123, bought by Agnew for Earl of Iveagh (110,500 francs).
EXHIBITIONS: Brussels 1873; Paris 1883, '100 Chefs d'Oeuvre', no. 1; Royal Academy 1891, no. 121; London, Royal Academy, Exhibition . . . of the Iveagh Bequest, 1928, no. 212; Manchester 1928, no. 4; Haarlem 1962, no. 33.
BIBLIOGRAPHY: F. Muller, *Beschrijvende catalogus van 7000 portretten*, 1853, no. 731; *Collection de M. John W. Wilson, exposée dans la galerie du cercle artistique et littéraire de Bruxelles*, Paris, 1873, p. 84; Charles Tardieu, 'Les Grandes Collections Étrangères, II. M. John W. Wilson', *G.B.A.*, VIII (1873), pp. 217ff.; *Icon. Bat.*, no. 1130 (1633); Bode 1883, 67 (1633); Moes 21 (1633); HdG 161; Bode-Binder 181; KdK 163 (*c.* 1637); J. G. van Gelder, 'Dateering van Frans Hals' Portet van P. v. d. Broecke', *O.H.*, LV (1938), p. 154; Trivas no. 42; *The Iveagh Bequest Kenwood, Catalogue of the Paintings*, London, 1953, no. 51, p. 13.

On the reverse are three seals, one inscribed 'E. Le Roy Commissaire expert du Musée Royal' (reference in *The*

Iveagh Bequest Kenwood, Catalogue of the Paintings, London [n.d.], no. 51, p. 13).

Literary evidence confirms the impression Hals gives us of Pieter van den Broecke (1585–1641), who was a trader in West Africa and then worked for the Dutch East India Company in Arabia, Persia and India. The journal he kept from 1605 to 1614 on a trip to West Africa (*Reizen naar West-Afrika van Pieter van den Broecke: 1605–1614*, edited by K. Ratelband, The Hague, 1950) reveals a warm, straightforward man, who must have been a good talker. When he returned from India in 1630 as the admiral of the fleet which brought the widow of Jan Pietersz Coen, principal founder of the Dutch empire in the east, back to the Netherlands he was rewarded by the Dutch East India Company for his seventeen years of service with a golden chain worth 1,200 guilders. This is the chain he wears in his portrait.

In 1634 Van den Broecke published a journal in Haarlem: *Korte historiael ende journaelsche Aenteykeninghe Van al't gheen merck-waerdich voorgevallen is, in de langhdurighe Reysen . . . als insonderheydt van Oost-Indien . . . Haerlem . . 1634*. The frontispiece of the book is an engraving of the portrait in an oval frame by A. Matham (*ca.* 1599–1660), (text, Fig. 111) inscribed: 'AETATIS SVAE 48, ANNO CIↃ IↃC XXXIII . . . F. Hals pinx. A. Matham sc.' Bode (1883, 67) and Moes (*Icon. Bat.*, no. 1130; Moes 21) knew of the existence of Matham's print when they dated the portrait 1633. Valentiner also knew of the engraving (KdK 163) but he overlooked the 1633 date on it when he placed the portrait around 1637. His date was probably based on the similarity of style and pose to Cat. no. 83, which bears a questionable date, which he read as 1637. J. G. van Gelder (*op. cit.*) called attention to the appearance of Matham's print in Van den Broecke's publication of 1634 and rightly emphasized that the style of the painting as well as the year inscribed on the engraved copy support a date of 1633 for the portrait.

The portrait was also engraved with variations by Isack Ledeboer (1692–1749) and etched by Léopold Flameng (1831–1911).

A weak copy (63·5 × 52 cm.) appeared in the sale, 9 April 1954, no. 123 (140 gns., F. Bernard), formerly T. Humphrey Ward, 1926 (presumably identical with the copy in the sale, T. Humphrey Ward, London, 11 June 1926, no. 5 (63·5 × 52 cm.)). A copy which was in the sale, C. H. Moore and others, 15 January 1925, London (Robinson, Fisher and Harding) no. 185 (63·5 × 53·3 cm.) is possibly identical with one or both of the replicas cited above.

85. **Portrait of a Man** (Plate 131). Cincinnati, Taft Museum (Cat. [n.d.], no. 242, inv. no. 1931·450).
Canvas, 121 × 95·8 cm.

PROVENANCE: Sale (supplementary), Utrecht, 27 June 1825, no. 153 (200 florins, with a pendant); Charles Pillet,

Paris; dealer Lawrie and Co., London; Arthur Sanderson, Edinburgh; acquired in 1906 by Charles Phelps Taft, Cincinnati.

EXHIBITIONS: London, Royal Academy 1902, no. 101; Detroit 1935, no. 22; Cleveland 1936, no. 220; San Francisco 1939, no. 79; New York 1940, no. 81; Minneapolis, Great Portraits by Famous Painters, 1952.

BIBLIOGRAPHY: Bode 1883, 73 ('Männliches Bildnis, unter dem Namen "der Bürgermeister" bekannt'; ca. 1630); *Icon. Bat.*, no. 8794–3 (as Michiel de Wael); Moes 83 (as Michiel de Wael); HdG 242 (Michiel de Wael [?]; 'Worauf die Benennung des Dargestellten beruht, weiss ich nicht'); Bode-Binder 168 (Michiel de Wael [?]); Maurice W. Brockwell, *A Catalogue of . . . the Collection of Mr. and Mrs. Charles P. Taft*, New York 1920, no. 17 (Michielsz de Wael); KdK 120 (Michiel de Wael [?]; ca. 1634); Valentiner 1936, 44 (probably Tieleman Roosterman; ca. 1634).

Painted around 1630–33. Although there is a vague resemblance of the model to Michiel de Wael, who plays a prominent role in Hals' group portraits of the St. George Militia companies of 1627 (Cat. no. 46; Plates 84, 85) and 1639 (Cat. no. 124; Plates 200, 201), the traditional identification as De Wael has been rightly doubted by earlier commentators, Valentiner's suggestion that it may be a portrait of Tieleman Roosterman (1936, no. 44) must be rejected; for Hals' portrait of Roosterman, see Cat. no. 93; Plate 154. The monogram at the top of the old frame comprised of the letters CHRG may offer a clue to the model's identity. The traditional identification goes back to the sale catalogue of 1825 (no. 143), when the portrait was sold with a companion picture identified as the wife of Michiel de Wael 'Cornelia van Baardorp'; three-quarter length, showing both hands (HdG 243). Moes 84 states that the pendant was in the Taft collection in 1909; this is an error. The companion picture has not been identified since it appeared in the 1825 sale. There is no reason to accept the view (see KdK 120) that the *Portrait of a Woman* at Baltimore (Cat. no. 96; Plate 157) is the companion piece, and Valentiner's opinion (1936, no. 44) that its pendant is Hals' portrait of Catherina Brugman, wife of Tieleman Roosterman (Cat. no. 94; Plate 155), is also unacceptable. For the record it may be noted that Michiel de Wael married Cunera van Baersdorp (1600–40) in Haarlem 22 April 1625.

86. Nicolaes Hasselaer (Plates 143, 145; text, pp. 117–118, 120). Amsterdam, Rijksmuseum (Cat. 1960, no. 1089). Canvas, 79·5 × 66·5 cm.

PROVENANCE: Gift of Jonkheer J. S. R. van de Poll of Arnhem to the museum in 1885.

EXHIBITIONS: Brussels 1946, no. 41; Zurich 1953, no. 44; Rome 1954, no. 46; Milan 1954, no. 53.

BIBLIOGRAPHY: *Icon. Bat.* 3254–2 (Nicolaes Hasselaer?); Moes 42; HdG 186 (probably Dirk Pietersz. Hasselaer); Bode-Binder 115 (Dirk Pietersz. Hasselaer); J. Six, 'De Frans Hals-Tentoonstelling in 's Rijksmuseum', *Onze Kunst*, XXIX, 1916, p. 95, note 1; KdK 1921, 63 (ca. 1627–1630); KdK 102 (1632–34); Trivas 60 (hardly painted before 1635).

Companion picture to Cat. no. 87. The sitters for these beautiful half-lengths have been firmly identified by J. Six (*op. cit.*) as Nicolaes Hasselaer and his second wife. Earlier students were thrown off the track when they concluded that these were portraits of Nicolaes Hasselaer and his first wife, Geertruid van Erp, who died in 1620. They realized that the style and costumes of the paintings made a date of around 1620 difficult, if not impossible, to accept. Hofstede de Groot's proposal (186) that they represented Dirck Pietersz. Hasselaer and his wife Brechtje van Schooterbosch is hard to understand after the portraits Cornelis van Voort painted of this couple are seen (Rijksmuseum, nos. 2589, 2590); moreover Brechtje died in 1618. Nicolaes Hasselaer (1593–1635) was a citizen of Amsterdam. He joined a Dutch mission to Moscow in 1616, was active as a brewer, served as a regent of Amsterdam's Orphanage and was a Captain Major of the city's troops. He married Sara Wolphaerts van Diemen (1594–1667) 14 August 1622 (J. E. Elias, *De Vroedschap van Amsterdam*, vol. I, Haarlem, 1903, p. 206). The portraits, which are datable around 1630–33, are closely related in style to the pendants at Berlin-Dahlem (Cat. nos. 88, 89; Plates 150, 151). However, Hals daringly portrayed Hasselaer in a much more unconventional pose than the man in the Berlin-Dahlem portrait. There is no precedent for the scheme Hals used for these companion pictures, and later Dutch artists seldom painted a husband relaxed, with his arm resting on the back of a chair, when he was portrayed with his wife. The type of lace-edged cap Sara wears apparently enjoyed a special vogue in Holland during the first half of the thirties; similar ones are worn by four other women who sat for Hals during these years (see Cat. nos. 89, 94, 96, 98).

87. Sara Wolphaerts van Diemen, wife of Nicolaes Hasselaer (Plates 144, 146; text, pp. 117–118, 120). Amsterdam, Rijksmuseum (Cat. 1960, no. 1090). Canvas, 79·5 × 66·5 cm.

PROVENANCE: Gift of Jonkheer J. S. R. van de Poll of Arnhem to the museum in 1885.

EXHIBITIONS: Zurich 1953, no. 45; Rome 1954, no. 49; Milan 1954, no. 54; Tokyo-Kyoto 1968–69, no. 23.

BIBLIOGRAPHY: Moes 43 (Sara van Diemen?); HdG 187 (probably Brechtje van Schooterbosch, wife of Dirk Pietersz. Hasselaer); Bode-Binder 116 (Brechtje van Schooterbosch? ; J. Six, 'De Frans Hals-Tentoonstelling

in 's Rijksmuseum', *Onze Kunst*, XXIX, 1916, p. 95, note 1; KdK 1921, 64 (*ca.* 1627–30); KdK 103 (*ca.* 1632–34); Trivas 61 (hardly before 1635).

Companion picture to Cat. no. 86.

88. **Portrait of a Man** (Plates 150, 152; text, p. 120). Berlin-Dahlem, Staatliche Museen (Cat. 1966, no. 800). Canvas, 75 × 58 cm.

PROVENANCE: Purchased by the museum in 1840.
BIBLIOGRAPHY: Bode 1883, 83 (*ca.* 1627); Moes 111; HdG 253 (*ca.* 1625); Bode-Binder 104; KdK 98 (*ca.* 1631–33); Trivas 50 (*ca.* 1633–34).

Companion picture to Cat. no. 89. The painting has been enlarged at the sides and bottom by narrow strips (*ca.* 1–3 cm. wide). Painted *ca.* 1630–33. Closely related to the pendants of Hasselaer and his wife at Amsterdam (Cat. nos. 86, 87; Plates 143, 144) and like them dated by some specialists in the second half of the twenties. The light backgrounds and the strong daylight effects in these works are indeed similar to those found in the artist's life-size genre pieces done during the late twenties but Hals' dated commissioned portraits of 1633–34 (Cat. nos. 81, 82) as well as those which can be dated around the same time (Cat. nos. 84, 93, 94, 95, 96, 100, 101) indicate that these stylistic innovations appear in his more formal portraiture after 1630. The costumes also support a date in the early thirties.
A copy (HdG 253, note; Trivas 50-a) is (or was) in the collection of Mrs. Sears Tuckerman, Beverly, Massachusetts:

> Canvas, 76 × 61 cm. Provenance: sale, J. L. Mieville, London (Christie) 29 April 1899, no. 65 (as Count Falkenstein); Collection Barlett, Boston, 1910; Herbert Sears.

Another copy was with the dealer Fritz Schneeberger, Bern, Switzerland, 1922; panel, 24 × 18·7 cm.

89. **Portrait of a Woman** (Plates 149, 151, 153; text, p. 120). Berlin-Dahlem, Staatliche Museen (Cat. 1966, no. 801).
Canvas, 75 × 58 cm.

PROVENANCE: Purchased by the museum in 1840.
BIBLIOGRAPHY: Bode 1883, 84 (*ca.* 1627); Moes 112; HdG 367; Bode-Binder 105; KdK 99 (*ca.* 1631–33); Trivas 51 (*ca.* 1634–35).

Companion picture to Cat. no. 88. A poor variant (panel, 66 × 57 cm.) by another hand showing the model holding a book was in the New York art market around 1960.

90. **Portrait of a Man** (Plate 141; text, pp. 30, 124, 125, 162, 203). Dresden, Gemäldegalerie (Cat. 1930, no. 1358). Panel, 24·7 × 19·6 cm. Inscribed at the bottom right by another hand: 2948.

PROVENANCE: According to the Dresden catalogue (1930) the painting entered the gallery in 1741, having previously been in the Wallenstein collection.
EXHIBITION: Haarlem 1937, no. 67.
BIBLIOGRAPHY: Bode 1883, 105 (*ca.* 1630); Moes 169; HdG 271; Bode-Binder 232; KdK 156 (*ca.* 1636); Trivas 56 (*ca.* 1635).

Painted around 1633. Almost identical in size and closely related in style to Cat. nos. 91 and 92. Perhaps all three of these little portraits were preparatory studies for a group portrait which was never executed. Goethe's note quoted in the text p. 125 that the Dresden portraits are 'Schöne kleine Bilder, nur untermalt' is cited from Johann Wolfgang Goethe, *Gedenkausgabe der Werke, Briefe und Gespräche*, edited by Ernst Beutler, vol. 13, Zürich, 1954, p. 92.
The amateur printmaker and dealer William Baille (1723–1792) made an etching in reverse of Cat. no. 90 which exists in at least four states. One of them is dated 1765. Another is inscribed: 'W. Baille sculp. Franciscus Hals Pictor. Se ipse pinxit. In the collection of John Blackwood Esqr.' Baille's erroneous conclusion that the painting is a self-portrait does not call for comment. However, his statement that the little painting was in the Blackwood collection in 1765 indicates either that it has not been in Dresden continuously since 1741 (see provenance above), or that Blackwood owned a copy and Baille made his print from it.
Copies:
1. Panel, 24 × 19 cm. Provenance: Sale, James Orrock, London, 4 June 1904, no. 265 (£330:15); in 1911 with the Munich dealer J. Böhler; dealer Sulley and Co., London, 1914; dealer H. Ward, London; sale, Osborn Kling of Stockholm, London, 28 June 1935, no. 29. Dealer: Rudolf Pallamar, Vienna, 1972. Perhaps identical with a copy which appeared in the sale Paris (Drouot), 27 April 1900, no. 19, repr.: panel, 23·5 × 18·5 cm. Bibliography: Bode-Binder 233, repr.; Trivas 56-a (copy).
2. Another copy was with the dealer Kleinberger, Paris, in 1912; dealer G. Neumans, Paris and Brussels (Trivas 56-b [copy]).
3. An enlarged copy (canvas, *ca.* 62 × 49·5 cm.) was in a private collection, New Hartford, New York, 1971.

91. **Portrait of a Man** (Plate 142; text, pp. 30, 124, 125, 162, 203). Dresden, Gemäldegalerie (Cat. 1930, no. 1359). Panel, 24·4 × 19·7 cm. Inscribed at the bottom right by another hand: 2947.

PROVENANCE: According to the Dresden catalogue (1930) the painting entered the gallery in 1741, having previously been in the Wallenstein collection.
EXHIBITION: Haarlem 1937, no. 68.
BIBLIOGRAPHY: Bode 1883, no. 106 (*ca.* 1630); Moes 170; HdG 272; Bode-Binder 231; KdK 157 (*ca.* 1636); Trivas 57 (*ca.* 1635).

See Cat. no. 90.

92. **Portrait of a Man** (Plate 140; text, pp. 30, 124, 162).
The Hague, Mauritshuis (Cat. 1968, no. 618).
Panel, 24·5 × 19·5 cm.

PROVENANCE: Dealer Fred. Muller and Co., Amsterdam; purchased for 5,000 florins by the museum in 1898.
BIBLIOGRAPHY: Moes 142; HdG 279; Bode-Binder 230; KdK 155 (*ca.* 1636); Trivas 55 (*ca.* 1635).

See Cat. no. 90.
A weak copy (canvas, 26 × 21·5 cm.; photo RKD) was with the dealer D. Katz, Dieren, 1939; said to have belonged to Madame L. de la Bégassière, Paris (Trivas 55, note).

93. **Tieleman Roosterman** (Plate 154; text, pp. 115–116).
Vienna, Kunsthistorisches Museum (Cat. 1963, no. 182, inv. no. 9009).
Canvas, 117 × 87 cm. Inscribed in the upper right: AETAT SVAE 36/AN° 1634. The coat-of-arms of the Roosterman family is painted above the inscription.

PROVENANCE: Sale, F. J. Gsell, Vienna, 14 March 1872, no. 40; Baron Nathaniel de Rothschild, Vienna; Baron Alphons de Rothschild, Vienna; confiscated by the Germans during World War II and returned to its rightful owner after the war; presented to the museum in 1947 by Baroness Clarisse Rothschild in memory of her husband.
EXHIBITIONS: Washington, D.C., National Gallery, Art Treasures from the Vienna Collections, 1949–50, no. 43; Zurich 1953, no. 43; Rome 1954, no. 45; Milan 1954, no. 52; Haarlem 1962, no. 34.
BIBLIOGRAPHY: Bode 1883, p. 89, note to no. 126: 'Wo sich das Portrait eines Mannes von 1634 aus derselben Sammlung Gsell jetzt befindet, ist mir unbekannt'; Moes 131 (listed as a *Portrait of a Man*); HdG 354 (listed as a *Portrait of a Man*); Ludwig Baldass, 'Two Male Portraits by Frans Hals', *B.M.*, XCIII (1951), pp. 181–182.

Companion picture to Cat. no. 94. The painting was cited in earlier literature but from the time Bode referred to it in 1883 (*op. cit.*) until Baldass published it in 1951 (*op. cit.*) it had been considered lost by cataloguers of Hals' works. The Nazis, however, knew about its existence. During

World War II they confiscated it, along with Baron Alphons de Rothschild's *Portrait of a Woman* now at Cleveland (Cat. no. 121; Plate 191) and other works of art in his collection. It was included in a list (*Verzeichnis der von den staatlichen Kunstsammlungen erbetenen Gemälde aus der Sammlung Alphons Rothschild*, no. 6) found in a portfolio in Hitler's library at Berchtesgaden. According to the list the painting was earmarked by the Nazis for the Gemäldegalerie, Vienna (see Henry S. Francis, '"Portrait of a Lady in a Ruff" by Frans Hals', *The Bulletin of the Cleveland Museum of Art*, XXXV, 1948, pp. 163–164, 168). After the war it was restored to its lawful owner. In 1947 the picture, which had been stolen and destined for the Vienna Museum by the Nazis, was given to it by the widow of Baron Alphons in memory of her husband.
Baldass (*op. cit.*) noted that restoration of the painting around 1935 by Sebastian Isepp showed that the coat-of-arms had been painted over: 'probably on aesthetic grounds, to tone down its colour; to nineteenth-century taste the garish colours [of the escutcheon] must have seemed to clash with the restrained black and white colour scheme of the picture. In the ornament of the crest, the brushwork of Frans Hals is just as unmistakable as in the lace cuff, the silken ribbons, or the glove' (*ibid.*). Discovery of the coat-of-arms revealed that the painting is the pendant to Hals' portrait of Catherina Brugman. It also disproved Valentiner's suggestion (1936, no. 44) that the *Portrait of a Man* at the Taft Museum, Cincinnati (Cat. no. 85; Plate 131), was a portrait of Roosterman.

94. **Catherina Brugman, wife of Tieleman Roosterman** (Plate 155, text, p. 115). Berlin, formerly E. Kappel.
Canvas, 115 × 86 cm. Inscribed at the left: AETA SVAE 22/AN° 1634. Her coat-of-arms is painted above the inscription.

PROVENANCE: Count André Mniszech, Paris; dealer F. Kleinberger, Paris; M. Kappel, Berlin; E. Kappel, Berlin; the Geschwister Rathenau.
EXHIBITION: Amsterdam, F. Muller and Co., 1907, no. 13; on loan to the Rijksmuseum, 1929; London 1929, no. 117.
BIBLIOGRAPHY: Bode 1883, 59; Moes 66; HdG 218; Bode-Binder 143; KdK 122.

Companion picture to Cat. no. 93. This portrait is known to me only from photographs.
Catherina (Trijntje) Brugman was the daughter of the Amsterdam cloth merchant Jan Pietersz. Brugman and Maria Adriaens van Hardebol. She was baptized in the Oude Kerk in Amsterdam, 15 October 1609 (information from Drs. J. van Ventien). If her parents followed the practice of Reformed Calvinists by baptizing her soon after she was born the age inscribed on the portrait does not tally with her age in 1634.

ILLUSTRATIONS TO THE CATALOGUE OF

PAINTINGS BY FRANS HALS (nos. 1–222)

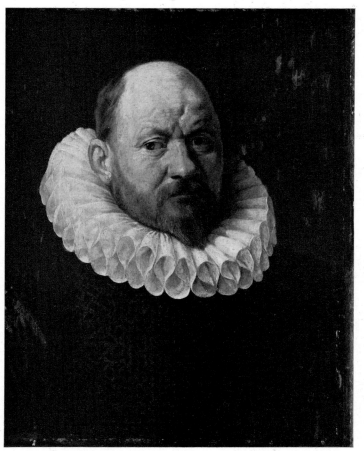

Anonymous Flemish Painter: *Portrait of a Man*. 1610. Frankfurt, Städelsches Kunstinstitut. (See Cat. no. 1.)

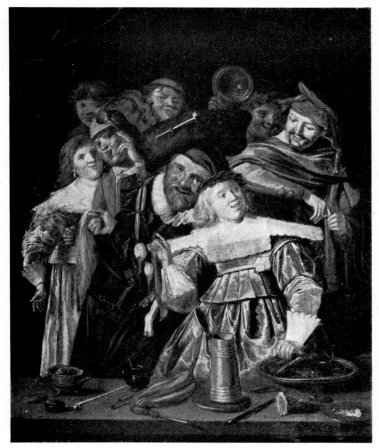

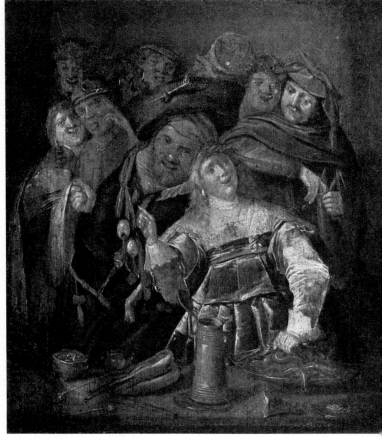

1. Dirck Hals: *Shrovetide Revellers.* 1637. Paris, Fondation Custodia. (Cat. no. 5-1.)

2. *Shrovetide Revellers.* New York, Mrs. H. Metzger. (Cat. no. 5-2.)

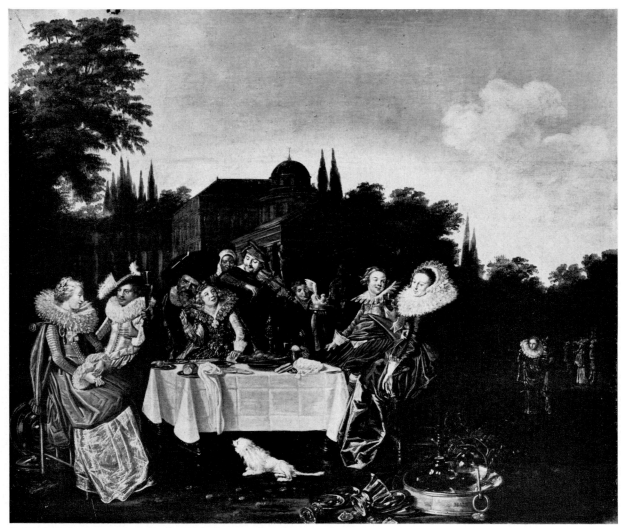

3. Dirck Hals: *Banquet in a Garden.* Paris, Louvre. (See Cat. no. 5.)

4–5. Willem Buytewech: *Peeckelhaering* and *Hanswurst*. Paris, Fondation Custodia. (See Cat. no. 5.)

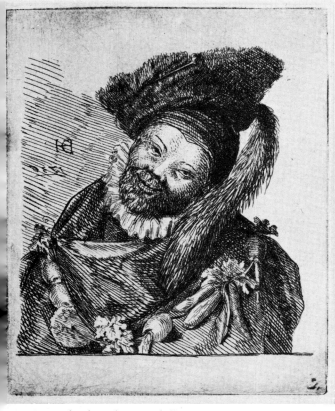

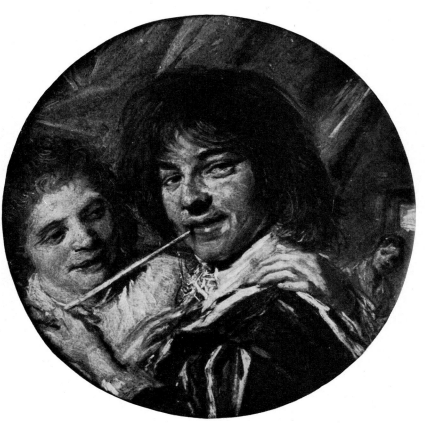

. Louis Bernhard Coclers: *Peeckelhaering*. 1736. Etching after Dirck Hals. (See Cat. no. 5.)

7. *Young Man Smoking, with a Laughing Girl*. Formerly (?) Königsberg, Municipal Museum. (See Cat. no. 21.)

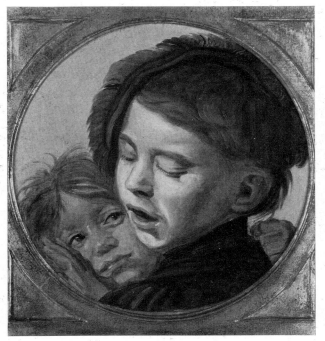

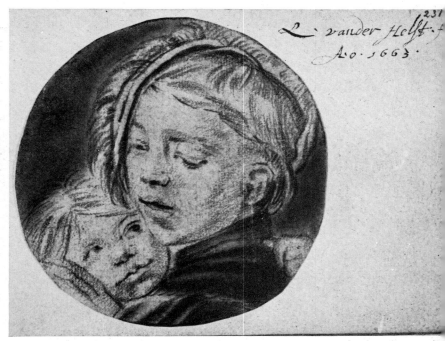

8. *Two Singing Boys*. London, dealer Marshall Spink, 1971. (See Cat. no. 23.)

9. Lodewyck van der Helst: *Two Boys*. Drawing in Jacobus Heyblock's *Album Amicorum* The Hague, Royal Library. (See Cat. no. 23.)

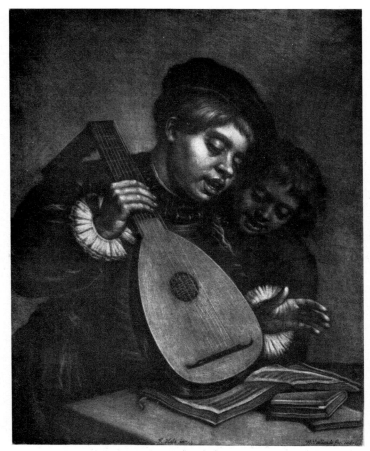

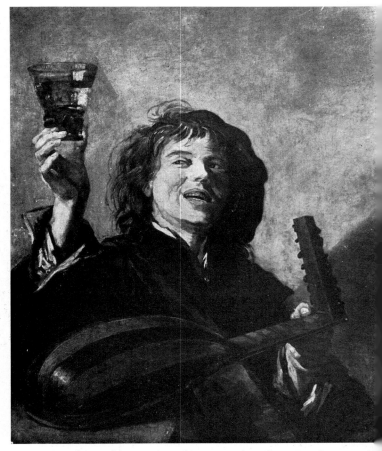

10. Wallerant Vaillant: *Two Singing Boys*. Mezzotint after Frans Hals. (See Cat. no. 23.)

11. Copy after Hals' *Merry Drinker*. Formerly Esher, Sir Edgar Vincent. (See Cat. no. 26.)

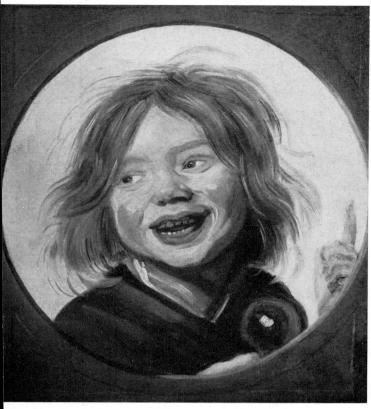

12. *Laughing Boy with a Soap Bubble*. Location unknown. (See Cat. no. 28.)

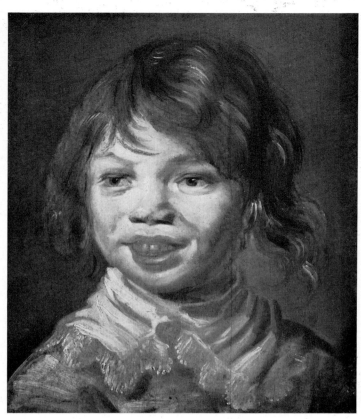

13. *Laughing Boy*, after Hals. Dijon, Museum. Cat. no. 29-1.

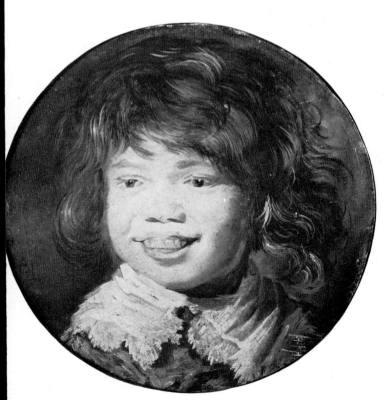

. *Laughing Boy*, after Hals. Formerly Paris, Albert Lehmann. Cat. no. 29-2.

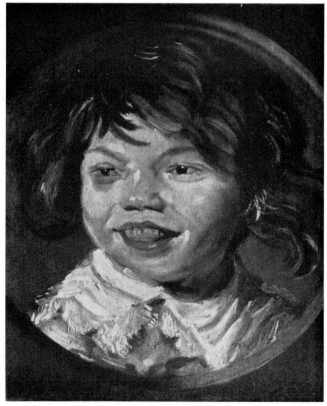

15. *Laughing Boy*, after Hals. Location unknown. Cat. no. 29-3.

16. Attributed to Judith Leyster: *Standing Man*. London, Buckingham Palace. (See Cat. no. 31.)

17. *Standing Man*. Los Angeles, University of California, Art Galleries, Willitts J. Hole Collection. (See Cat. no. 31.)

18. *Standing Man*. Black and white chalk. Amsterdam, Rijksmuseum. (See Cat. no. 31.)

19. Copy after Hals' portrait of Colonel Aernout Druyvesteyn. Formerly Havana, Oscar B. Cintas. (See Cat. no. 46.)

20. John Singer Sargent: copy after Hals' portraits of Arent Jacobsz Koets and Ensign Jacob Schout. Chestnut Hill, Massachusetts, Mrs. Robert L. Henderson. (See Cat. no. 46.)

21. John Singer Sargent: copy after Hals' portraits of Lieutenant Jacob Olycan and Captain Michiel de Wael. Chestnut Hill, Massachusetts, Mrs. Robert L. Henderson. (See Cat. no. 46.)

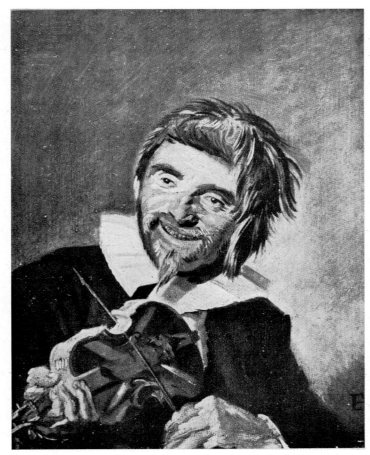

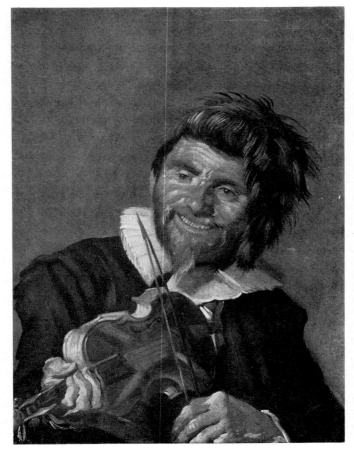

22. *Left-Handed Violinist*. Formerly Zürich, W. C. Escher Abegg. Cat. no. 56-1.

23. *Left-Handed Violinist*. New York, Mrs. H. Metzger. Cat. no. 56-2.

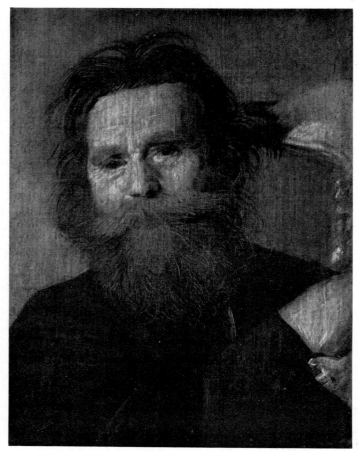

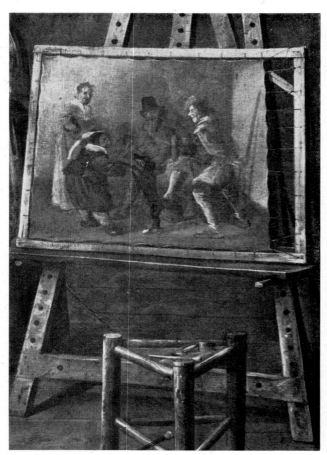

24. *Verdonck*. Switzerland, Private Collection. (See Cat. no. 57.)

25. Jan Miense Molenaer: detail from *The Artist's Studio*. 1631. Berlin (East), Staatliche Museen. (See Cat. no. 72).

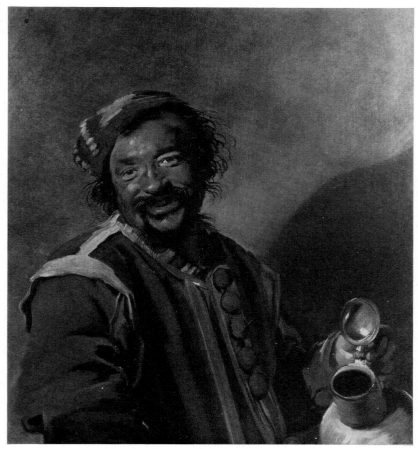

26. *Peeckelhaering*, after Hals. Engraved frontispiece of *Nugae Venales sive Thesaurus ridendi & Iocandi . . .*, 1648. (See Cat. no. 64.)

27. *Peeckelhaering*, copy after Hals. Salisbury, Rhodesia. (See Cat. no. 64.)

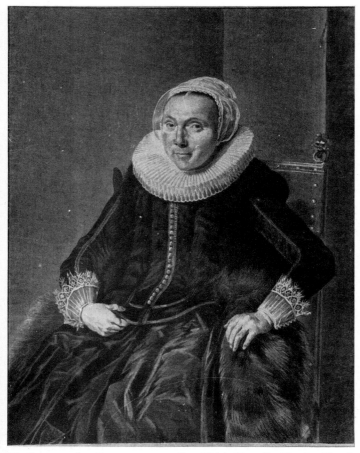

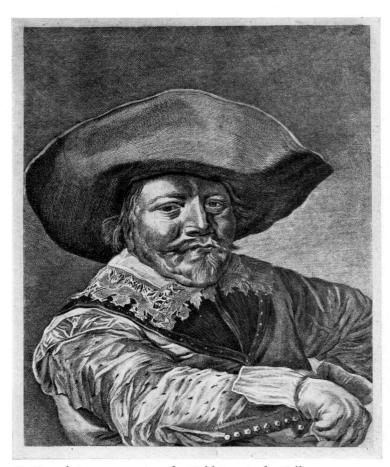

28. Jan van der Sprang: copy after Hals' *Cornelia Vooght Claesdr.* Wash drawing. Haarlem, Municipal Archives. (See Cat. no. 78.)

29. Pieter de Mare: engraving after Hals' *Portrait of an Officer*. (See Cat. no. 83.)

30. Drawing after Hals' *Portrait of a Man*. Frankfurt, Städelsches
Kunstinstitut. (See Cat. no. 95.)

31-32. Watercolours after Hals' *Portrait of a Man* (Monsieur Mers?) and *Portrait of a Woman* (Catherine V[U?]ulp?). Dayton, Ohio, The Dayton Art
Institute. (See Cat. nos. 100, 101.)

33-34. *Pieter Jacobsz. Olycan*, variant after Hals, and *Maritge Vooght Claesdr.*, copy after Hals. Formerly Charlbury, Oxfordshire, Oliver V. Watney. (See Cat. nos. 128, 129.)

35. Attributed to Frans Hals the Younger: *Portrait of a Man*. 165[?]. The Hague, Museum Bredius. (See Cat. no. 155.)

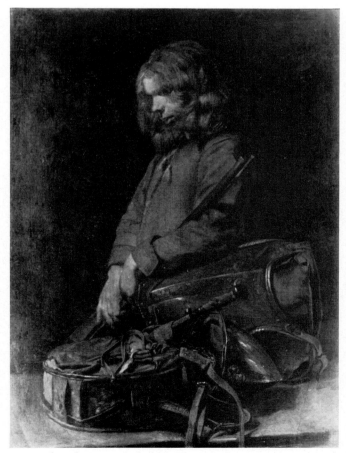

36. Attributed to Frans Hals the Younger: *The Armourer*. Leningrad, The Hermitage. (See Cat. no. 155.)

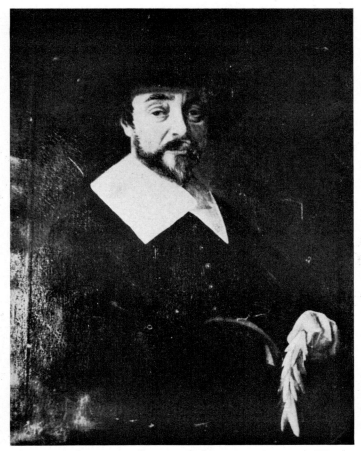

37. Frans Hals: *Portrait of a Man*, before restoration. Fort Worth, Texas, The Kimbell Museum. Cat. no. 158.

38. *Harmen Hals*. Wash Drawing. Haarlem, Municipal Archives. (See Cat. no. 164.)

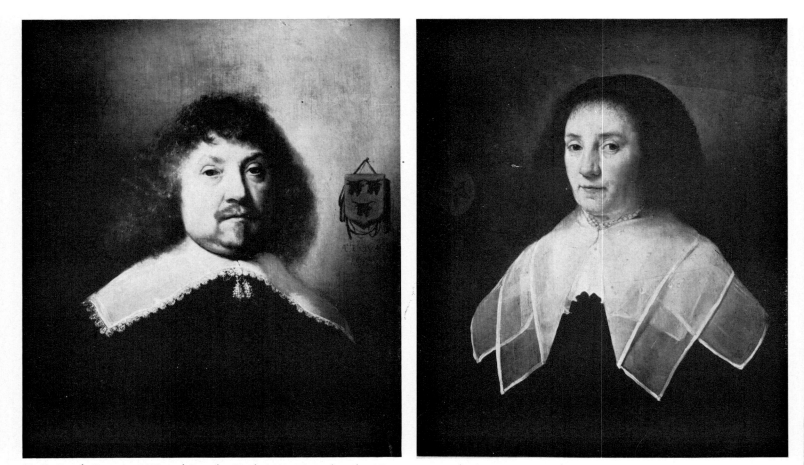

39-40. *Joseph Coymans*. 1648, and *Dorothea Berck*. 1641. Bingerden, Jhr. W. E. van Weerde. (See Cat. no. 161.)

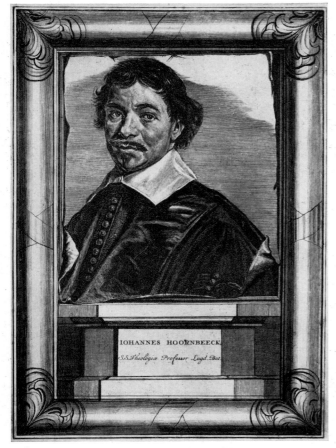

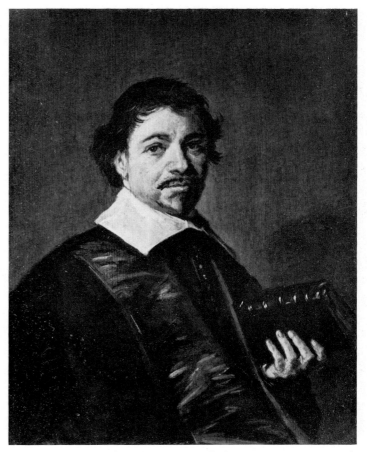

41. Jonas Suyderhoef: engraving after Hals' *Johannes Hoornbeek* Impression from the cut and reworked plate published in *Fundatoris, Curatorum et Professorum . . . Academia Lugduno*, Leiden, [1716?]. (See Cat. no. 165.)

42. Copy after Hals' *Johannes Hoornbeek*. Detroit, Emory Ford. Cat. no. 165-1.

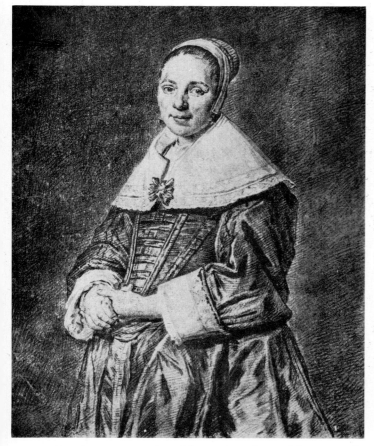

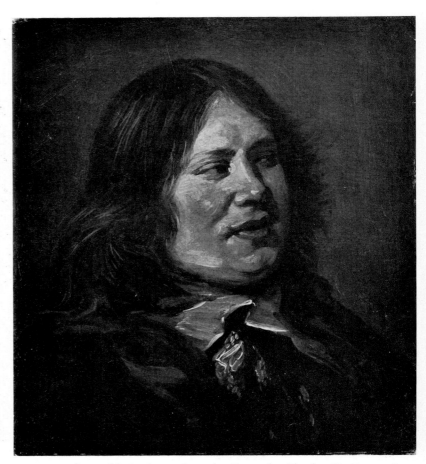

43. Attributed to Jan Gerard Waldorp: copy after Hals' *Portrait of a Woman*. Location unknown. (See Cat. no. 185.)

44. Copy after Hals' *Stephanus Geraerdts*. Formerly Almelo, H. E. ten Cate. (See Cat. no. 188.)

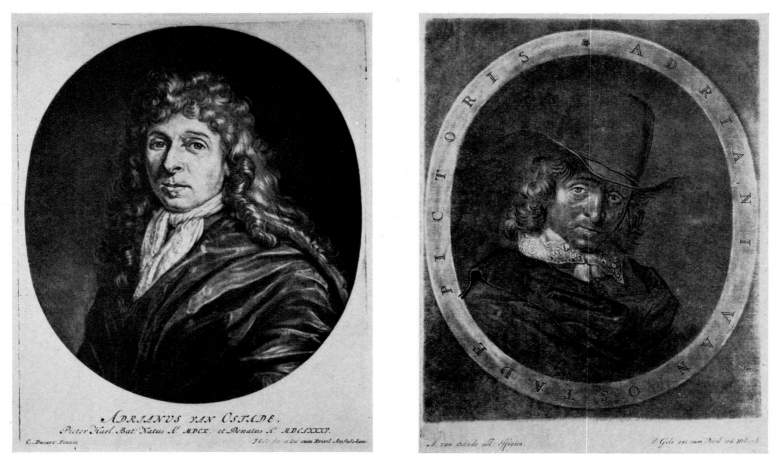

45-46. Jacob Gole: mezzotints of *Adriaen van Ostade* made after a painting by Cornelis Dusart and after Ostade's drawing of himself. (See Cat. no. 192.)

47. Attributed to Jan van Rossum: *Adriaen van Ostade*. Dublin, National Gallery of Ireland. (See Cat. no. 192.)

48. Peter Holsteyn II: drawing after Hals' *Portrait of a Man*. Rijksmuseum, Rijksprentenkabinet, Amsterdam. (See Cat. no. 198.)

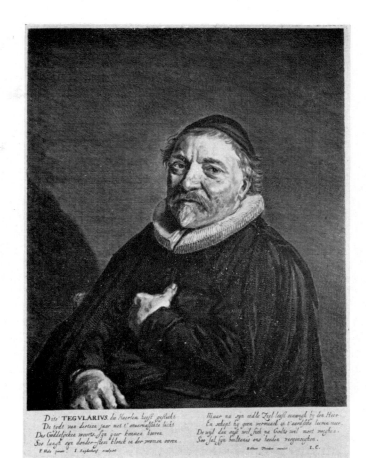

49. Jonas Suyderhoef: engraving after Hals' *Frans Post*, first state. Vienna, Albertina. (See Cat. no. 206.)

50. Jonas Suyderhoef: engraving after Hals' *Adrianus Tegularius*. (See Cat. no. 207.)

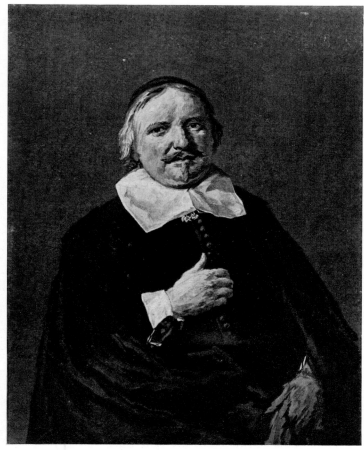

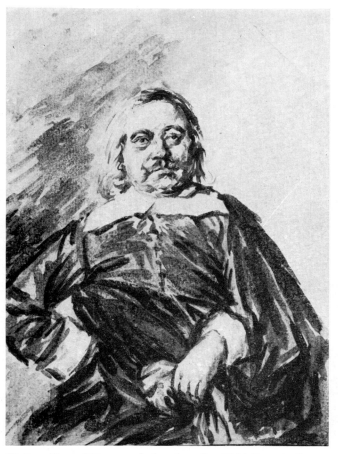

51. Cornelis van Noorde: watercolour after Hals' *Cornelis Guldewagen*. Haarlem, Municipal Archives. (See Cat. no. 212.)

52. Jean-Honoré Fragonard: drawing after Hals' *Portrait of a Man* (Willem Croes?). Stone Mountain, Georgia, George Baer. (See Cat. no. 213.)

MONOGRAMS AND INSCRIPTIONS

53. *Shrovetide Revellers*
(Cat. no. 5).
About 1615.

54. *Two Singing Boys* (Cat. no. 23).
About 1623-5.

55. *Merry Drinker* (Cat. no. 63).
About 1628-30.

56. *Peeckelhaering* (Cat. no. 64). About 1628-30.

57. *Portrait of a Man* (Cat. no. 81). 1633.

58. *The Armourer*, attributed to Frans Hals the Younger. (See Cat. no. 155.)

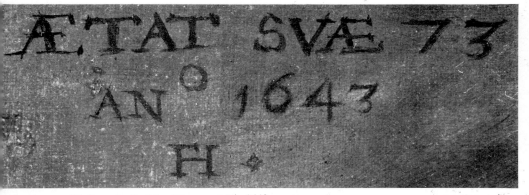

59. *Portrait of a Man* (Cat. no. 149). 1643.

60. *Portrait of a Seated Man* (Cat. no. 167). About 1645

61. *Dorothea Berck* (Cat. no. 161). 1644.

62. *Portrait of a Man* (Cat. no. 193). About 1650-2.

63. *Portrait of a Man* (Cat. no. 214). About 1660.

64. *Portrait of a Man* (Cat. no. 218). About 1660-6.

65. Inscription on the stretcher of *Malle Babbe* (Cat. no. 75). Berlin-Dahlem, Staatliche Museen.

95. **Portrait of a Man** (Plate 156). Budapest, Museum of Fine Arts (Cat. 1967, no. 4158).
Canvas, 82·5×70 cm. Inscribed at the upper right: AETAT SVAE 26/AN° 1634.

PROVENANCE: Collection Maurice Kann, Paris; sale, Maurice Kann, Paris (Petit), 9 July 1911, no. 27; dealer F. Kleinberger, Paris, from whom it was purchased by the museum in 1912.
EXHIBITION: Paris, Jeu de Paume, Exposition des grands et petits maîtres hollandais au XVIIᵉ siècle, 1911, no. 61.
BIBLIOGRAPHY: L. Gillet, 'La Collection Maurice Kann', *Revue de l'Art*, XXVI, 1909, p. 371; A. Marguillier, 'Collection de Feu M. Maurice Kann', *Les Arts*, VIII, 1909, no. 88, p. 18; Bode-Binder 147; G. von Térey, 'Eine Zeichnung von Frans Hals', *Kunstchronik*, N.F., XXVI, 1915, pp. 469–470; KdK 1921, 84 and KdK 86 (*ca.* 1630; in a note to both of these entries Valentiner added that while his book was in the press G. von Térey, director of the Budapest museum, said that the painting was dated 1634 and inscribed: AETAT SVAE 2 . . .); Trivas 52.

The inscription has been partially strengthened. The way the model's elbow pokes at the left side of the frame indicates that he needs more space on that side of the painting, and if he gains more space on that side it is evident that more is needed at the top, the bottom and on the right. In brief, the painting has been cut on all four sides.
A drawing dated 1634 at the Städelsches Kunstinstitut (Fig. 30; inv. no. 811; black chalk heightened with white, 25·5×18·2 cm.) was published by G. von Térey in 1915 (*op. cit.*) as a preliminary study by Hals for the painting. He added that the drawing shows that Hals originally intended to make a three-quarter length but the painting was finally done as a half-length. In my opinion Térey's attribution of the Frankfurt sketch to Hals is wrong. It is a copy after the Budapest portrait by a rather timid hand and shows the way it looked before it was cropped, not a change in the artist's original intention.
The portrait was most likely painted as a pendant to the *Portrait of a Woman* at Baltimore (Cat. no. 96), which is also dated 1634. It goes without saying that there are similarities in the style of two portraits done by Hals in the same year. But in this case the analogies in the treatment of the lace-trimmed cuffs and the black-on-black designs of the costumes are particularly striking. If we visualize the man's portrait as a three-quarter length the arrangement of the figures also supports the view that they are companion pictures.

96. **Portrait of a Woman** (Plate 157). Baltimore, The Baltimore Museum of Art (inv. no. 51.107).
Canvas, 111·2×83·2 cm. Inscribed at the upper left: AETA SVAE 28/AN° 1634.

PROVENANCE: Count André Mniszech, Paris; dealer F. Kleinberger, Paris; A. de Ridder, Cronberg, near Frankfurt a/M.; sale, De Ridder, Paris (Petit), 2 June 1924, no. 23 (2,100,000 francs); dealer Duveen, New York, from whom it was acquired in 1924 by Jacob Epstein, Baltimore; bequeathed to the museum by Jacob Epstein.
EXHIBITIONS: On loan at the Städelsches Kunstinstitut, Frankfurt, 1911–13; Detroit 1925, no. 8; Detroit 1935, no. 21; Baltimore 1941, p. 74.
BIBLIOGRAPHY: Bode 1883, 60; Moes 187; HdG 375; W. von Bode, *Catalogue of the A. de Ridder Collection*, F. Kleinberger Galleries, New York 1913, no. 4; Bode-Binder 144; KdK 121; Valentiner 1936, 45.

Valentiner (KdK 121) suggested that the painting may be a pendant to the *Portrait of a Man* at the Taft Museum, Cincinnati (Cat. no. 85; Plate 131), but later he rightly abandoned that proposal (Valentiner 1936, 45).
As students of Hals' work know, there have been more unsuccessful than successful attempts to find mates for portraits with compositions which seem to demand them. The large number of failures indicates that art historians are not outstanding marriage brokers. With full knowledge of the risks involved I would like to propose that the cropped *Portrait of a Man* dated 1634 at Budapest (Cat. no. 95; Plate 156) was the companion picture of the Baltimore painting.

97. **Portrait of a Woman** (Plate 147). England, Private Collection.
Canvas, 80×64·1 cm.

PROVENANCE: According to the owner it was in the possession of Mrs. Standish around 1870; with the Standish family until 1969.

Similarities in style and technique to Hals' rather large group of dated portraits of women done between 1630–35 (Cat. nos. 78, 82, 94, 96, 101, 105, 107) place this unpublished painting in the first half of the thirties. The paint surface is well preserved. However, the painting appears to have been cut on all four sides. Probably it was a three-quarter length portrait and included the model's left hand; see *Catherina Brugman* of 1634 (Cat. no. 94; Plate 155) and the *Portrait of a Woman* at Baltimore, also dated 1634 (Cat. no. 96; Plate 157).

98. **Portrait of a Woman** (Plates 160, 162; text, p. 51). Stuttgart, Staatsgalerie (Cat. 1962, inv. no. 2499).
Octagonal panel, 67·4×57 cm.

PROVENANCE: Sale, van Laanen, The Hague, 16 November 1767, no. 28 (39 florins); in the collection at Sanderstead Court; sale, H. Doetsch, London, 22 June 1895, no. 373

(£200, Shepherd); dealer C. Sedelmeyer, Paris, Catalogue 1896, no. 17; Freiherr von Heyl zu Herrnsheim, Worms; Stiftung Kunsthaus Heylshof, Worms, 1923; acquired by the gallery in 1956.

EXHIBITIONS: Worms 1902, no. 357; Düsseldorf 1904, no. 315; Berlin 1906, no. 52; Haarlem 1937, no. 44; Schaffhausen 1949, no. 42.

BIBLIOGRAPHY: Moes 114; HdG 399; Bode-Binder 133; G. Swarzenski, *Die Kunstsammlungen in Heylshof zu Worms*, 1925, no. 34: KdK 104 (*ca.* 1632–34); Trivas 48 (*ca.* 1634).

Companion picture to Cat. no. 99. Painted around 1633–1635. These are the only pendants in Hals' existing *oeuvre* which do not follow the tradition of placing the husband on the dexter side and the wife on the sinister side (see text, pp. 50–51). Perhaps the man commissioned his portrait before he was married and gave thought to such matters. However, only the difference in the backgrounds (light grey and neutral as opposed to a brown backcloth) suggest that they were not painted at the same time.

A copy in a rectangular format was scheduled to appear in the sale of the contents of Kenure Park, Rush Co., Dublin, 21–24 September 1964 (reproduced *B.M.*, CVI, 1964, p. iii); the auctioneers, James H. North and Co., Ltd., kindly informed me that it was withdrawn from the sale. Further particulars are not available.

99. **Portrait of a Man** (Plates 161, 163; text, p. 51). Stuttgart, Staatsgalerie (Cat. 1962, inv. no. 2500). Octagonal panel, 67·5 × 57 cm.

PROVENANCE: Sale, van Laanen, The Hague, 16 November 1767, no. 27 (40 florins); in the collection at Sanderstead Court; sale, H. Doetsch, London, 22 June 1895, no. 372 (£640, Shepherd); dealer C. Sedelmeyer, Paris, Cat. 1895, no. 12; Freiherr von Heyl zu Herrnsheim, Worms; Stiftung Kunsthaus Heylshof, Worms, 1923; acquired by the gallery in 1956.

EXHIBITIONS: Worms 1902, no. 556; Düsseldorf 1904, no. 314; Berlin 1906, no. 51; Haarlem 1937, no. 43; Schaffhausen 1949, no. 41.

BIBLIOGRAPHY: Moes 113; HdG 326; Bode-Binder 132; G. Swarzenski, *Die Kunstsammlungen zu Heylshof zu Worms*, 1925, no. 33; KdK 105 (*ca.* 1632–34); Trivas 49 (*ca.* 1634).

Companion picture to Cat. no. 98.

A (nineteenth-century?) wash drawing, heightened with white, after the portrait (19·4 × 15·2 cm.) by an unidentified hand is in the collection Arthur Rosenauer, Vienna; on the verso of the sheet there is an imprint of a drawing after Hals' *Portrait of a Seated Woman* in the Taft collection (Cat. no. 174). The same artist made a copy after Hals' portrait of *Jean de la Chambre* (Cat. no. 122); it is also in

the Rosenauer collection. Possibly these copies were made when the paintings were in the same collection but nothing about the known provenance of the three paintings supports this supposition.

100. **Portrait of a Man (Monsieur Mers?)** (Plate 158). San Diego, Timken Art Gallery, Putnam Foundation (Cat. 1969, no. 22). Panel, 73 × 54 cm. Inscribed at the upper right: AETA SVAE 48/AN° 1634, and signed below the inscription with the connected monogram: FH.

PROVENANCE: Collection Van der Willigen, Haarlem; collection Weber, Hamburg; sale, Galerie Weber, Berlin (Lepke), 20 February 1912, no. 223; Marcel von Nemes, Budapest; sale, M. von Nemes, Paris, 17 June 1913, no. 53 (1,950 francs); Baron M. L. Herzog, Budapest; dealer Wildenstein, New York, from whom it was acquired by the Putnam Foundation, 25 July 1955.

EXHIBITIONS: Düsseldorf 1904, no. 313; Düsseldorf, Sammlung . . . von Nemes, 1912, no. 41; Detroit 1935, no. 23; New York 1937, no. 9; Providence, Rhode Island 1938, no. 18; Los Angeles 1947, no. 5.

BIBLIOGRAPHY: Bode 1883, 111 (1634); J. von Pflugk-Hartung, 'Hamburg. Die Weber'sche Gemäldesammlung', *Repertorium für Kunstwissenschaft* VIII, 1885, p. 82 (presumably a portrait of Burgomaster Vermaersch); Moes 132 (1634); HdG 280 (erroneously dated 1624); Bode-Binder 145 (erroneously dated 1624; but plate 85a clearly shows the date 1634); KdK 1921, 117 (1634); KdK 124 (1634); Valentiner 1936, no. 46 (1634); Trivas 46 (1634).

The paint surface is moderately abraded.

In 1921 Valentiner (KdK 1921, 118) suggested that the painting was a companion piece of Cat. no. 101. At that time the pendant was dated 1635. An interval of a year or two between paintings intended as companion pictures is not an impossible one (*cf.* Cat. nos. 2 and 98); however, cleaning of Cat. no. 101 in 1935 revealed the date of 1634, thereby establishing that both pictures were painted in the same year.

Additional evidence that the paintings are pendants is offered by two eighteenth-century watercolour copies of the portraits by an unidentified hand (Figs. 31, 32): The Dayton Art Institute, Dayton, Ohio, inv. nos. 65·7, 65·8; each 33·6 × 27 cm. Each drawing is inscribed at the top right with the age and year found on the original painting, and each is inscribed at the top left: 'Joh. Vᵣ Spronck'. The latter inscriptions raise questions about the attribution of the San Diego and Detroit pictures to Frans Hals. Are they in fact by Johannes Verspronck (1597–1662), the Haarlem portraitist whose style was based on the unity and simplicity of Hals' compositions of the 1630's, but who, as far as we know, never emulated his spirited brushwork? A fresh examination of the signed San Diego and Detroit

pictures has not revealed a trace of Versponck's characteristic restrained touch or any evidence that they have been altered by a later hand so that they could pass as authentic works by Hals. In my opinion both are signed originals. But the nagging question remains unanswered: how does one account for the Verspronck inscription on the drawings? If the eighteenth-century copyist transcribed the correct dates of the portraits and the ages of the sitters why did he fail to notice the Frans Hals monogram? Possibly the Dayton watercolours were made after copies of the portraits painted by Verspronck. Contemporary copies of seventeenth-century Dutch portraits are not uncommon and sometimes they were made *en gros*: in 1662 Lambert Doomer's mother bequeathed the portraits Rembrandt painted of her and her husband to him (Bredius-Rembrandt 217, 357) on the condition that he have the pendants copied for each of his five brothers and sisters (see M. C. Visser [pseud. W. Martin], *Die Urkunden über Rembrandt*, Erstes Supplement, The Hague, 1906, pp. 6–7, no. 251a).

The versos of the Dayton drawings are inscribed: 'Mons: Mers. en/huisvrouw' and 'Cath: V[U?]ulp huisvrouw van/mons Mers'; the tentative identification of the sitters given here is based on this information. Jaap Temminck, Deputy Archivist, Haarlem, has kindly informed me that several men named Mers(ch) are mentioned in the seventeenth-century notarial archives at Haarlem but none of them married a Cath. V[U?]ulp. W. L. van der Watering, Keeper, Iconographical Bureau, The Hague, has also informed me that his bureau has no records concerning the couple.

101. Portrait of a Woman (Catherine V[U?]ulp, wife of Monsieur Mers?) (Plate 159; text, p. 119; Fig. 113). Detroit, The Detroit Institute of Arts (Cat. 1944, no. 92, inv. no. 23.27).

Panel, 73·4×55·5 cm. Inscribed at the upper left: AETA SVAE 34/AN° 1634, and with the partially abraded but still legible interconnected monogram below the inscription: FH.

PROVENANCE: Baron Albert von Oppenheim, Cologne; sale, Oppenheim, scheduled for 27 October 1914, held Berlin (Lepke), 19 March 1918, no. 14 (230,000 marks); purchased by the museum in 1923.

EXHIBITIONS: Düsseldorf 1886, no. 131; Detroit 1925, no. 7; Detroit 1935, no. 24; Haarlem 1937, no. 51; New York 1937, no. 10; Los Angeles 1947, no. 6; Raleigh 1959, no. 58.

BIBLIOGRAPHY: Moes 188 (1635); HdG 380 (1635); Bode-Binder 157 (1635); KdK 1921, 118 (1635); KdK 125 (1635); C. H. B.[urroughs], 'Painting by Franz Hals Acquired,' *Bulletin of the Detroit Institute of Arts*, v, 1923–24, pp. 2–3 (age 32; painted *ca.* 1635); Valentiner 1936, 47 (1634); Trivas 47 (date illegible).

Companion picture to Cat. no. 100. The background and inscription are moderately abraded. The 1634 date was revealed when the painting was cleaned in 1935.

102. Family Portrait (Plates 164–167; text, pp. 132–134; text, Fig. 135). Cincinnati, Art Museum (inv. no. 1927.399). Canvas, 111·8×91·5 cm.

PROVENANCE: Sale, J. van Leeuwaarden, widow of P. Merkman, Haarlem, 21 September 1773, no. 4; probably sale, O. W. J. Berg van Dussen Muilkerk, Amsterdam, 7 July 1825, no. 44 (151 florins); in the possession of dealer Nieuwenhuys, 1862; sale, Vicomte du Bus de Gisignies, Brussels, 7 May 1882, no. 33; sale, E. Secrétan, Paris, 1 July 1889, no. 126; Rudolphe Kann, Paris; London dealers Lawrie and Co.; Paris dealer C. Sedelmeyer, *Cat. of 300 Paintings*, 1898, no. 55; R. B. Angus, Montreal; Scott and Fowles sold it in 1910 to Mrs. Thomas J. Emery, Cincinnati, Ohio; bequeathed to the museum in 1927 by Mary M. Emery.

EXHIBITIONS: Detroit 1935, no. 34; Cleveland 1936, no. 221; Haarlem 1937, no. 69; New York 1937, no. 18; Montreal 1944, no. 23; Haarlem 1962, no. 35.

BIBLIOGRAPHY: Bode 1883, 35 (*ca.* 1638); Moes 87 (attribution contestée); HdG 440; Bode-Binder 192; KdK 148 (*ca.* 1636); Valentiner 1936, 58 (*ca.* 1636).

Collective portraits 'in little' of groups in domestic settings which look as if they record actual ones, but are usually imaginary, were painted during the 1630's by Thomas de Keyser, Pieter Codde and Jan Miense Molenaer. These small group portraits anticipate the 'conversation pieces' which became a popular genre of painting during the eighteenth century, particularly in Holland and England (see Mario Praz, *Conversation Pieces: A Survey of the Informal Group Portrait in Europe and America*, University Park and London, 1971). Rembrandt made one small portrait of this type in 1633 (*A Married Couple* [Isabella Stewart Gardner Museum, Boston; Bredius-Rembrandt 405]). The Cincinnati painting, which can be dated a few years later, is Hals' only existing family portrait on this scale. Moes (1909, pp. 28–29) correctly points out that early attempts to identify the standing man as Heythuyzen or as a self-portrait of Hals are without foundation. Not only do the physiognomies speak against these identifications but Heythuyzen is disqualified because, to the best of our knowledge, he was a bachelor and Hals because he had more than a half a dozen children at this date. Behind the figures there is a curious mixture of an interior and an out-of-door view. The landscape as well as the foliage on the architecture pile in the middle ground can be attributed to Pieter Molyn; see Cat. nos. 42, 176, 177 for other works which show Molyn's participation. Symbolic allusions in the painting are discussed in the text, pp. 133–134. The quotation on the symbolic significance of the rose

cited in the text, p. 134 is from Livin Lemmens, *An Herbal for the Bible* . . . Drawn into English by T. Newton, London 1587, pp. 220–221. Lemmens' [Lemnius] *Herbarum atque arborum quae in Bibliis* . . . was published in Antwerp, 1566 and 1581; Latin editions were also published in Frankfurt in 1596 and 1626.

Two drawings on parchment by Jan Gerard Waldorp (1740–1808) after figures in the family portrait are known: a three-quarter length of the mother, inscribed 'F. Hals pinxit/J. G. Waldorp delin. 1782' at the E. B. Crocker Art Gallery, Sacramento, California; the two young girls seen three-quarter length, inscribed 'F. Hals pxt/J. G. Waldorp del/1782' at the Kupferstichkabinett, Berlin-Dahlem. A chalk drawing after the painting by Abraham Delfos (1731–1820) appeared in the sale, P. van Zante, Leiden, 19 October 1792, Konstboek A. No. 4.

103. Isaac Abrahamsz. Massa (Plate 168; text, pp. 56, 127). San Diego, Fine Arts Gallery (Cat. 1947, pp. 120–121).

Panel, 21 × 20·2 cm. Signed on the middle right with the connected monogram: FH.

PROVENANCE: A mutilated printed label on the back of the panel reads: '. . . the Will of the Right Honorable Henr[y]/[M]ontagu Templetown, deceased, is given in . . ./ . . . of an Heirloom, with Castle Upton, in Ireland./ June, 1863.' The number 1493 is inscribed in ink on the label. According to Bode-Binder 148 the painting was with the dealer J. Böhler, Munich, and then with the dealer Henry Reinhardt, New York; dealer Goudstikker, Amsterdam, Catalogue, July 1915, no. 20; collection M. Kappel, Berlin; F. B. Gutmann, Heemstede; Gift of Anne R. and Amy Putnam to the museum in 1947.

EXHIBITIONS: Haarlem 1937, no. 52; Los Angeles 1947, no. 7; Indianapolis-San Diego 1958, no. 48; Raleigh 1959, no. 57.

BIBLIOGRAPHY: *Icon. Bat.* 4865, Moes 52, and HdG 199 describe the painting from Matham's engraving of 1635. Bode-Binder 148; KdK 129 (1635).

The small portrait was engraved in reverse by Adriaen Matham (*ca.* 1599–1660) with the addition of drapery in the background (text, Fig. 121). Matham's print is inscribed: 'Anno 1635. In coelis MASSA [the model's motto]. AEtatis Suae. 48/F. Hals. pinxit. A. Matham. Schulpsit . . .', and bears a Dutch text in praise of Massa. The painting was probably done in 1635 as a modello for the engraver. For Hals' 1626 portrait of Massa, and for biographical data and bibliographical references to the sitter, see Cat. no. 42.

A splendid impression of Matham's print, bearing Massa's motto and signature in Massa's own hand, is in the Haarlem Municipal Archives.

104. Lucas de Clercq (Plate 169; text, p. 116). Amsterdam, Rijksmuseum (Cat. 1960, no. 1086).

Canvas, 126·5 × 93 cm.

PROVENANCE: In the possession of the De Clercq family from the time it was painted until it was presented by Mr. and Mrs. P. de Clercq and Mr. and Mrs. P. van Eeghen with the pendant to the City of Amsterdam, 1891 (information from Miss I. H. van Eeghen). On loan to the museum, 1891.

EXHIBITIONS: Amsterdam 1867; Rome 1956–57, no. 126.

BIBLIOGRAPHY: *Icon. Bat.*, no. 1563 (1636); Moes 24 (1636); HdG 165 (very characteristic of the mid-thirties); Bode-Binder 160; J. Six 'De Frans Hals-Tentoonstellung in 's Rijksmuseum, *Onze Kunst*, XXIX, 1916, pp. 92–93 (doubts authenticity); KdK 138 (1635; the authenticity of this work and its pendant have been doubted without any justification whatsoever); Trivas 22 (pendant to the 1635 portrait but the costume as well as the technique of the portrait point to an earlier date, *ca.* 1627).

Companion picture to Cat. no. 105. This portrait of Lucas de Clercq (1603–52) was probably painted around 1635, the date inscribed on the pendant.

Both three-quarter lengths are characteristic of Hals' work around the middle of the decade when vivid colour and value contrasts are more consistently replaced by monochromatic effects. Blacks predominate and colour accents are used with great restraint. The portraits are outstanding examples of the new spaciousness and atmospheric quality his painting acquires around this time. In my opinion J. Six's doubts (*op. cit.*) about the authenticity of the portrait and his attribution of it and the companion piece to Judith Leyster are as convincing as the attempt made by Robert Dangers to attribute Rembrandt's *Jacob's Blessing* at Cassel (Bredius-Rembrandt no. 525) to Leyster (see *The Illustrated London News*, 26 January 1929, pp. 152–153).

A late eighteenth- or early nineteenth-century drawing (26·5 × 22 cm.; inscribed on the verso: . . . Hals 1635 N 242) after the painting by an unidentified artist, was in the possession of the dealer Yvonne Tan Bunzl, London, 1972.

105. Feyntje van Steenkiste, wife of Lucas de Clercq (Plate 170; text, p. 116). Amsterdam, Rijksmuseum (Cat. 1960, no. 1087).

Canvas, 123 × 93 cm. Inscribed at the upper left: AETAT SVAE 31/ANº 1635.

PROVENANCE: In the possession of the De Clercq family from the time it was painted until it was presented by Mr. and Mrs. P. de Clercq and Mr. and Mrs. P. van Eeghen with the pendant to the City of Amsterdam, 1891 (information from Miss I. H. van Eeghen). On loan to the museum, 1891.

EXHIBITIONS: Amsterdam 1867; Rome 1956–57, no. 127.
BIBLIOGRAPHY: E. W. Moes, 'Feynte van Steenkiste van Frans Hals', *Oud en Nieuw op het gebied van kunst ... in Holland en Belgie*, 1889–92, pp. 127–130 (erroneously dated 1636); *Icon. Bat.*, no. 7550 (1636); Moes 25 (1636); HdG 166 (1635); J. Six, 'De Frans Hals-Tentoonstelling in 's Rijksmuseum', *Onze Kunst*, XXIX, 1916, pp. 92–93 (attributes the painting to Judith Leyster); Bode-Binder 161 (1635); KdK 139 (1635); Trivas 58 (1635).

Companion picture to Cat. no. 104. The model was born in 1604.

106. **Portrait of a Man** (Plates 171, 173). Rotterdam, Boymans-Van Beuningen Museum (Cat. 1962, no. 1276). Canvas, 125 × 95.5 cm.

PROVENANCE: Sale, Rotterdam, 18 October 1843, no. 24, with the pendant (190 florins, Lamme); sale, A. de Beurs Stiermans (of Hamburg) and others, Rotterdam, 23 April 1845, no. 48 with the pendant (100 florins, Lamme); sale, B. A. C. de Lange van Wijngaarden, Rotterdam, 22 April 1846, no. 92; acquired by the museum, 1865.
EXHIBITIONS: Haarlem 1937, no. 48; Haarlem 1962, 36; Tokyo-Kyoto 1968–69, no. 24.
BIBLIOGRAPHY: Bode 1883, 30 (*ca.* 1635); Moes 143; HdG 313 (*ca.* 1640); Bode-Binder 185; KdK 1921, 125 (*ca.* 1635); KdK 136 (*ca.* 1635); Trivas 45 (1631–35).

Painted around 1635. Valentiner maintained (KdK 1921, 125) that the painting was a companion picture to the *Portrait of a Seated Woman* dated 1635 at the Frick Collection (Cat. no. 107; Plate 172). The similarities of style and composition do not entirely rule out this possibility. However, it should be stressed that his argument that the Frick portrait appeared with the Rotterdam painting in the 1843 and 1845 sales listed in the provenance cited above cannot be accepted as evidence to bolster his claim. The dimensions of the woman's portrait listed in the 1843 and 1845 sales catalogues do not tally with those of the Frick picture and the descriptions are too vague to secure the identification of it. Moreover, it is significant that the woman's portrait did not appear with a pendant in the Amsterdam sale of 24 November 1834 (see Cat. no. 107). Trivas' statement (59) that the Frick portrait appeared with the Boymans' portrait in the 1846 sale cited in the Provenance above is an error.
The model appears to have reached the autumn of his life and to judge by the beautifully painted hand resting on his breast he was afflicted with arthritis. Yet his air and stance recall the fashionable young dandies who appear in Buytewech's paintings of festive scenes.

107. **Portrait of a Seated Woman** (Plates 172, 174, 175; text, p. 115). New York, The Frick Collection (Cat. 1968, vol. I, p. 212, no. 10.1.12).

Canvas, 116.5 × 93.3 cm. Inscribed at the upper left: AETAT SVAE 56/AN° 1635.

PROVENANCE: Sale, J. Bernard, Amsterdam, 24 November 1834, no. 46 (160 florins, De Vries); sale, D. P. Sellar of London, Paris (Petit), 6 June 1889, no. 36; Charles Schiff, Paris. Sold by Schiff to C. T. Yerkes in 1893; sale, Yerkes, New York (American Art Association), 7 April 1910, no. 119; dealer Knoedler, New York; acquired by Henry Clay Frick in 1910.
EXHIBITIONS: London, Royal Academy 1885, no. 105; Paris, Galerie Georges Petit, Cent Chefs-d'oeuvre, 1892; Boston, Museum of Fine Arts, Frick Collection, 1910, no. 5; New York, Knoedler, Old Masters, 1912, no. 41.
BIBLIOGRAPHY: Moes 189; HdG 388; Bode-Binder 150; KdK 1921, 126; KdK 137; Valentiner 1936, 49; Trivas 59.

Cleaned in 1938. In good condition. Slight abrasions in the dark areas of the dress and along the four edges of the canvas. The original support has been trimmed on all sides. For Valentiner's suggestion that the painting is a pendant to the *Portrait of a Man* at the Boymans-Van Beuningen Museum and his unproven claim that the picture appeared with it in sales at Rotterdam in 1843 and 1845, and Trivas' erroneous statement that they appeared together again in an 1846 sale at Rotterdam, see Cat. no. 106.

108. **Portrait of a Man (possibly Pieter Tjarck)** (Plates 176, 177; text, p. 122). Nassau, Bahamas, Estate of Harry Oakes.
Canvas, 85 × 70 cm.

PROVENANCE: Sale, Comte d'Oultremont, Brussels, 27 June 1889, no. 3 (Arnold and Tripp); dealers Arnold and Tripp, Paris; Sir Cuthbert Quitter, London; Dowager Lady Quilter, Bawdsey Manor; Harry Oakes, Nassau; Sale, anon., London (Christie), 29 June 1973, no. 104 (£546,000; bought in).
EXHIBITIONS: Brussels 1882, no. 86; Paris, Exposition Mondiale 1889; London, Royal Academy 1891, no. 69; The Hague 1903, no. 36; London 1929, no. 51; Haarlem 1937, no. 75; New York 1939, no. 182; Los Angeles 1947, no. 13; Raleigh 1959, no. 61.
BIBLIOGRAPHY: *Icon. Bat.*, no. 7993–1 (incorrectly dated 1608) and no. 7993–2; Moes 77; HdG 231; Bode-Binder 178; KdK 1921, 160 (*ca.* 1638); KdK 172 (*ca.* 1638); Trivas (*ca.* 1638).

The painting has been generally accepted as a companion picture of the *Portrait of a Woman* in the National Gallery, London (Cat. no. 112; Plate 181). Although both portraits can be dated around 1635–38 the differences in the mouldings of the simulated oval frames make it difficult to accept the notion that they were intended as pendants. The man's portrait appeared in the 1889 Oultremont sale with its presumed mate as 'Pieter Tjarck' and his wife 'Maria

Larp'. Why he was identified as Tjarck by the cataloguer of that sale remains a mystery. However, it should be noted that a marriage betwen a Pieter Dircksz. and a Maria Claesdr. on 11 February 1634 is recorded in the Haarlem Archives (R. A., 96ᴵ, f. 62ᵛ). It is not known when Pieter died but a Maritgen Claesdr. Larp is mentioned as a widow of Pieter Dircksz. Tjarck in 1646 (R. A., 76⁶⁵, 28ᵛ) and as a widow of Pieter Dirksz., 'verwer' (= dyer of silk and cloth) in 1645 (R. A., 76⁶⁵, 161). These data as well as the additional information about Maria Maritgen Claesdr. Larp cited in Cat. no. 112 were kindly provided by Jaap Temminck, Deputy Archivist of Haarlem.

The rose the man holds was probably meant as a *vanitas* or love emblem; for the rose and its allusions to love in Dutch painting of the period, see E. de Jongh, *Zinne- en minnebeelden in de schilderkunst*,. 1967, pp. 25*ff.*

A feeble copy of the painting without the painted oval frame was in the New York art market in 1929. A three-quarter length variant by another hand showing the model standing, with his arm resting on the corner of a draped table is in the Museum at Liège, Cat. 1926, no. 646 (photo RKD). A weak version of Liège variant was in the European art market in the late 1920's.

109. **Portrait of a Man** (Plate 178). Montreal, Mrs. William van Horne.
Canvas, 93 × 67 cm. Inscribed at the upper right: AETAT-SVAE 37-/AN° 1637-

PROVENANCE: Purchased with the pendant (Cat. no. 110) in the nineteenth century by the Comte de Thiènnes, whose granddaughter Comtesse de Limburg-Stirum sold them to M. E. van Gelder, Castle Zeecrabbe, Uccle. Sir William C. van Horne, Montreal; by descent to the present owner.
EXHIBITION: Montreal 1944, no. 34.
BIBLIOGRAPHY: C. Hofstede de Groot, 'Twee nieuw aan het licht gekomen portretten van Frans Hals', *Onze Kunst*, XX, 1911, pp. 172–173 (a French translation appears in *L'Art Flamand et Hollandais*, XVII, 1912, pp. 1–2); editor's note, 'A propos de deux portraits attribués à Frans Hals', *L'Art Flamand et Hollandais*, XX, 1913, p. 120; Bode-Binder 162; KdK 166; Valentiner 1936, 60; Hubbard 1956, pp. 81, 151, repr. pl. XXXVIII.

Companion picture to Cat. no. 110.
Hofstede de Groot (*op. cit.*) published a romanticized version of the provenance of the pendants which was given to him by M. E. van Gelder. It was corrected by Comtesse de Limburg-Stirum (*cf. L'Art Flamand et Hollandais*, XX, 1913, p. 20); her version is cited in the provenance given above. The Comtesse also noted that the paintings were neither acquired by her family nor sold by her as works by Hals. However, in my view Hofstede de Groot (*op. cit.*) rightly attributed them to him. But he did not note that

the manner in which these three-quarter lengths fill their canvases suggest that both portraits have been slightly cut on all sides.

110. **Portrait of a Woman** (Plate 179). Montreal, Mrs. William van Horne.
Canvas, 93 × 67 cm. Inscribed at the upper left: AETAT · SVAE 36 · /AN° 1637.

PROVENANCE: Purchased with the pendant (Cat. no. 109) in the nineteenth century by the Comte de Thiènnes, whose granddaughter Comtesse de Limburg-Stirum sold them to M. E. van Gelder, Castle Zeecrabbe, Uccle. Sir William C. van Horne, Montreal; by descent to the present owner.
EXHIBITION: Montreal 1944, no. 35.
BIBLIOGRAPHY: C. Hofstede de Groot, 'Twee nieuw aan het licht gekomen portretten van Frans Hals', *Onze Kunst*, XX, 1911, pp. 172–173 (a French translation appears in *L'Art Flamand et Hollandais*, XVIII, 1912, pp. 1–2); editor's note, 'A propos de deux portraits attribués à Frans Hals', *L'Art Flamand et Hollandais*, XX, 1913, p. 120; Bode-Binder 163; KdK 167; Valentiner 1936, 61; Hubbard 1956, pp. 31, 151, repr. pl. XXXIX.

Companion picture of Cat. no. 109.

111. **Portrait of a Man** (Plate 180). Woburn Abbey, The Duke of Bedford.
Canvas, 94 × 72·4 cm.

PROVENANCE: At Woburn Abbey by 1818 (listed as a self-portrait hanging in the library with other portraits of artists in J. P. Neale, *Views of the Seats of Noblemen and Gentlemen . . .*, vol. I, London, 1918, unpaginated).
EXHIBITIONS: London, Royal Academy, Paintings and Silver from Woburn Abbey, 1950, no. 59; London, Arts Council, Paintings from Woburn Abbey, 1950, no. 35; London 1952–53, no. 67.
BIBLIOGRAPHY: Waagen, Supplement, 1857, p. 335 (in the library: 'Franz Hals—His own portrait. Highly animated, and spiritedly sketched in a powerful tone'); Bode 1883, 155 (*ca.* 1625; 'Irrthümlich als Selbstportrait des Künstlers bezeichnet'); George Scharf, *A . . . Catalogue of the . . . Pictures at Woburn Abbey*, 1890, p. 96, no. 141; Moes 133 (1635); HdG 325 (dated 1635; uncertain if it is a self-portrait); Bode-Binder 153 (dated 1635); KdK 1921, 140; KdK 149 (according to HdG dated 1635).

Bode (1883, 155) and Hofstede de Groot rightly doubted the tradition that the painting is a self-portrait.
Painted around 1635–38. The statement found in the earlier literature that the painting is dated 1635 is an error. It does not bear a trace of a date. The presumed date is derived from the 1890 catalogue of the collection (*op. cit.*), where

it is erroneously stated to have been etched by W. Unger with the inscription: Aet. Suae 50/An°. 1635. Unger's etching is in fact a print after a similar portrait, so inscribed and dated, which was formerly in the Lionel P. Straus collection; sale, L. P. Straus, New York (Parke Bernet) 11 March 1953, no. 9 (HdG 304, wrong provenance); Bode-Binder 155; KdK 150. In my judgement the Straus portrait is by one of Hals' anonymous followers; cf. Cat. no. D 53, Fig. 174.

In 1921 Valentiner published a small oil sketch which he suggested may have been a preliminary study for the Woburn Abbey painting (KdK 1921, 139 left; paper mounted on panel, 18·7 × 13·7 cm.; dealer E. Bottenwieser, London; exhibited Haarlem 1937, no. 60, repr., from the collection of F. Koenigs, Haarlem). The pendant of this sketch resembles the *Portrait of a Woman* in the National Gallery, London (our Cat. no. 112). On the basis of these two studies Valentiner proposed that the Bedford and London portraits are probably companion pictures. However, Valentiner correctly rejected the little sketches in his 1923 volume on Hals and rightly abandoned the suggestion that the originals were portraits of a husband and wife.

112. **Portrait of a Woman, possibly Marie (or Maria) Larp** (Plate 181). London, National Gallery (no. 6413). Canvas, 83·4 × 68·1 cm.

PROVENANCE: Comte d'Oultremont; sale, Comte d'Oultremont, Brussels, 27 June 1889, no. 4 (Arnold and Tripp); dealers Arnold and Tripp, Paris; purchased from Colnaghi, March 1891 for £1,750 by W. C. Alexander, London; by descent to the Misses Rachel F. and Jean I. Alexander, who presented it to the gallery in 1959; entered the gallery in 1972.

EXHIBITIONS: Brussels, 1882; London, Second National Loan Exhibition, 1913–14, no. 66; London 1938, no. 135; London 1952–53, no. 56; London, National Gallery, The Alexander Gift, 10 August–17 September 1972, no. 6413.

BIBLIOGRAPHY: *Icon. Bat.* 4378; Moes 78; HdG 232 (incorrectly on panel); Bode-Binder 179; KdK 1921, 141 (*ca.* 1635); KdK 173 (*ca.* 1638); Trivas 66 (*ca.* 1638); Alistair Smith, 'Presented by the Misses Rachel F. and Jean I. Alexander: seventeen paintings for the National Gallery', *B.M.*, CXIV, 1972, pp. 630–634.

Generally accepted as a pendant of the *Portrait of a Man* in the Oakes collection (Cat. no. 108; Plate 176). Though both portraits can be dated around 1635–38, the differences in the mouldings of their simulated oval frames indicate that they were not intended as pendants.

The sole basis for the identification of the sitter as Marie (or Maria) Larp is a label (probably in an eighteenth-century hand) pasted on the stretcher; I am indebted to Christopher Brown, Assistant Keeper, National Gallery, for providing

me with a photograph of it. The label reads: 'Mademoiselle Marie Larp fille/de Nicolas Larp et de/Mademoiselle *** de/Wanemburg———.' It led the compiler of the catalogue of the *Seventeenth Century Art Exhibition*, London, 1928, no. 135 to propose that Mlle de Wanenburg [*sic*] may have been one of the early owners of the painting; his proposal is pure speculation.

The painting appeared in the 1889 Oultremont sale with Cat. no. 108 as a portrait of 'Maria Larp' and 'Pieter Tjarck', respectively. The basis for the identification made in the 1889 sale of her presumed husband as Pieter Tjarck is not known.

For references to the marriage of a Maria Claesdr. to a Pieter Dircksz. at Haarlem in 1634 and to Maritgen Claesdr. Larp as the widow of Pieter Dircksz. Tjark in 1646, see Cat. 108. She married Leonart van Bosvelt, lawyer, on 7 February 1648 (Haarlem, R. A., 61¹, 162ᵛ) and was cited as a widow in February 1653 (N.A., 200, 30). She was buried in the choir of St. Bavo Church of Haarlem in the week of 9–15 November 1675 (DTB, 80, 45). She and Pieter had one son, Nicolaes Pietersz. Tjerk (R. A., 76⁸², 221). The above biographical information was kindly provided by Jaap Temminck, Deputy Archivist of Haarlem.

The model, in her role as Maria Larp, is one of Hals' few portraits to have inspired a poet. G. Rostrevor Hamilton sympathetically writes in 'Looking at Faces' (*The Russian Sister and Other Poems*, London, 1955, p. 72f.) that portraitists must take

. . . Commission from dull aldermen, and toil
With curious lapidary pain
On ruff and velvet for some gallery
Of grave memorial puppets.
 There were faces
Even Frans Hals could make nothing of, his paint
Without a flaw, his portrait without meaning.
But given a lucky sitter—look at Maria
Larp, whose rounded features,
Plain and healthy as an apple, show
No one fixed habit and no single mood
In sole possession, but the very fount
Of homely sense ready now to flow
Rich in gossiping humour, and now kind
Yet sharp in sympathy. You could not feel
A bond so close, never be on such terms
With the famous laughter of Hals' cavalier
Or fisher-boys, who have no thought for you
But only for one joke, their joy for ever;
While she, Maria Larp,
Knows you as you know her: you can't escape her . . .

In 1921 Valentiner published a small oil sketch which he suggested was a preparatory study (KdK 1921, 139 right); paper mounted on panel, 18·7 × 13·7 cm.; London, E. Bottenwieser; exhibited Haarlem 1937, no. 61, repr., from the collection F. Koenigs, Haarlem. Since the sketch was a pendant of a little study of the *Portrait of a Man* in a

painted oval at Woburn Abbey (see Cat. no. 111), Valentiner proposed that these pictures were most likely companion pieces. However, he correctly abandoned the idea in the 1923 edition of his catalogue and rejected both small sketches; neither is an original by Hals.

A (modern?) copy of the woman's portrait without the painted oval was with the dealer D. Katz, Dieren in 1939: canvas, 85×71 cm. (photo RKD). According to the files at the Witt Library the painting was in the Lyndhurst collection and stolen from Belgium, 1939–45.

113. **Portrait of a Man** (Plate 182; text, pp. 120–121). Stockholm, His Majesty the King of Sweden.
Canvas, 89×69·8 cm. Inscribed at the right near his shoulder: AETAT SVAE 38/AN° 1638.

PROVENANCE: Queen Joséphine; Oscar I (1799–1859), inventory no. 376.
EXHIBITIONS: Haarlem 1937, no. 72; Haarlem 1962, no. 38; Stockholm, *Holländska Mästare*, 1967, no. 66.
BIBLIOGRAPHY: O. Granberg, *Sveriges privata tafelsamlingar* . . . , Stockholm, 1885, pp. 5–6, no. 5; Moes 97; HdG 316; Granberg 1911, p. 106, no. 472; Bode-Binder 171; KdK 174; Trivas 67.

Pendant to Cat. no. 114. Hofstede de Groot (316) describes the model as a rather humpbacked man ('Bildnis eines etwas buckligen Mannes') and says he looks consumptive ('Der Mann macht den Eindruck eines Schwindsüchtigen'). What appears to be a physical deformity is, in fact, part of his costume, and his sickly appearance was caused by a veil of discoloured varnish on the surface of the picture, not tuberculosis.

With the exception of the Hermitage, few royal collections accumulated many pictures by Hals. Portraits of seventeenth-century Dutch burghers were hardly subjects to fascinate foreign sovereigns. Precisely how or when this pair came into the possession of the Swedish royal family has not been determined. The earliest reference to them in the Royal Archives at Stockholm is in the 1849 inventory of Oscar I, a king who never earned a great reputation as a collector. Granberg notes (*op. cit.*), without citing a source, that they were in the collection of Queen Josephine; the reference is probably to Josephine, Oscar's queen, who was the daughter of Eugène de Beauharnais, Duke of Leuchtenberg, and granddaughter of the Empress Joséphine.

114. **Portrait of a Woman** (Plate 183; text, p. 120). Stockholm, His Majesty the King of Sweden.
Canvas, 89·1×70·2 cm. Inscribed at the left near her shoulder: AETAT SVAE 41/AN° 1638.

PROVENANCE: Queen Joséphine; Oscar I (1799–1859), inventory no. 376.

EXHIBITIONS: Haarlem 1937, no. 73; Haarlem 1962, no. 39; Stockholm, Holländska Mästare 1967, no. 67.
BIBLIOGRAPHY: O. Granberg, *Sveriges privata tafelsamlingar* . . . , Stockholm 1885, p. 6, no. 6; Moes 98; HdG 393; Granberg 1911, p. 106, no. 473; Bode-Binder 172; KdK 175; Trivas 68.

Pendant to Cat. no. 113.

115. **Portrait of a Man** (Plates 184, 186). Frankfurt, Städelsches Kunstinstitut (Cat. 1966, inv. no. 77).
Oval panel, 94·4×70·5 cm. Inscribed at the right: AETAT SVAE 44/AN° 1638, and signed below the inscription with the connected monogram: FH.

PROVENANCE: Collection J. F. Städel, Frankfurt a.M.
BIBLIOGRAPHY: Bode 1883, 109; Moes 99; HdG 276; Bode-Binder 173; KdK 176; Trivas 69.

Companion picture to Cat. no. 116. The inscriptions and monograms on both paintings are partially abraded and have been strengthened. Minor scattered losses do not detract from the impact of this attractive pair.

116. **Portrait of a Woman** (Plates 185, 187). Frankfurt, Städelsches Kunstinstitut (Cat. 1966, inv. no. 78).
Oval panel, 94·4×70·5 cm. Inscribed at the left: AETAT SV . . . E 44/A . . .° 1638, and signed below the inscription with the connected monogram: FH.

PROVENANCE: Collection J. F. Städel, Frankfurt a.M.
BIBLIOGRAPHY: Bode 1883, 109; Moes 100; HdG 378; Bode-Binder 174; KdK 177; Trivas 70.

Companion picture to Cat. no. 115.

117. **Andries van der Horn** (Plate 188; text, p. 123). São Paulo, Museum of Art (Cat. 1963, no. 185).
Canvas, 86×67 cm. Inscribed to the right: AETAT SVAE · 3[8?]/AN 1638. The model's coat-of-arms is painted at the upper right.

PROVENANCE: Dealer Arthur Seymour (whose father purchased it in Paris for £40 (HdG 282); sale, Arthur Seymour, London, 1 April 1897, no. 113 (Agnew); J. Pierpont Morgan, London and New York; dealer D. Katz, Dieren, 1939; dealer Knoedler, New York, 1941.
EXHIBITIONS: New York, Hudson-Fulton Celebration, 1909, no. 30 (Michiel de Wael?); London 1929, no. 370; Chicago 1942, no. 15; Montreal 1944, no. 32; London, Masterpieces from the São Paulo Museum of Art at the Tate Gallery, 1954, no. 14; New York, Metropolitan

Museum, Paintings from the São Paulo Museum, 1957, no. 14a.

BIBLIOGRAPHY: *Pictures in the Collection of J. Pierpont Morgan at Princes Gate and Dover House, Dutch and Flemish. . .*, London, 1907, unpaginated and unnumbered; Moes 135; HdG 282; Bode-Binder 176; KdK 170 (not Michiel de Wael); Valentiner 1936, 64 (not Michiel de Wael); Kurt Erasmus, 'Frans Hals and Jan de Bray: Some Newly Identified Portraits', *B.M.*, LXXV, 1939, pp. 236–239; Trivas 71.

Companion picture to Cat. no. 118. The last digit of the age of the sitter is indistinct; however, it is most likely an 8. In 1939 Kurt Erasmus (*op. cit.*) conclusively identified the model as Andries van der Horn (1600–77) on the basis of the coat-of-arms, the inscription, and the portrait of Van der Horn in Hals' St. Hadrian militia piece of 1633, where he appears as a captain standing in the foreground on the right (Cat. no. 79; Plate 127). Jan de Bray's portrait of Andries van der Horn, dated 1662, is reproduced in J. Rosenberg, S. Slive, E. H. ter Kuile, *Dutch Art and Architecture: 1600–1800*, rev. ed., Harmondsworth., 1972, p. 321, fig. 254. Van der Horn was apparently one of the pillars of Haarlem's society in Hals' day; for details of the numerous boards of regents he served on and the many high municipal offices he held see Erasmus (*op. cit.*).
Maria Olycan Pietersdr. (1607–55) was Van der Horn's second wife. Since they were married at Haarlem on 25 July 1638, Hals' portraits may have been painted to commemorate the event. She also came from a family that helped rule Haarlem during the seventeenth century and members of it virtually employed Hals as their family painter. In 1625 he painted her brother and his wife (Cat. nos. 32, 33; Plates 58, 59) and in 1639 her distinguished father and mother (Cat. nos. 128, 129; Plates 206, 207); for other portraits of the Olycan family, see text, pp. 123–124.

118. **Maria Olycan Pietersdr., wife of Andries van der Horn** (Plates 189, 192; text, p. 123). São Paulo, Museum of Art (Cat. 1963, no. 186).
Canvas, 86 × 67 cm.

PROVENANCE: According to the Arts Council exhibition catalogue, 1954, no. 15 (see below) the picture formerly belonged to King George IV. Sir Oliver Millar, Surveyor of the Queen's Pictures, has kindly informed me that there is no documentary evidence in the records of the royal collection to substantiate this statement. According to Hofstede de Groot, the painting had belonged to a relative of the King's cook (HdG 384). He wrote that it was purchased by the London dealers Dowdeswell in 1893 in the Isle of Wight and the grandfather of the owner was George IV's cook. According to the Catalogue of the J. P. Morgan Collection, London, 1907: 'About the year

1896 [*sic*] it was offered in a small country sale in the Isle of Wight, and was knocked down for less than £20 to some London dealers who, well aware of the treasure they had obtained, promptly asked and obtained several thousand pounds for it.' In the possession, successively, of the London dealer C. Wertheimer; the Paris dealer C. Sedelmeyer; the London dealers Agnew; J. Pierpont Morgan, London and New York; dealer D. Katz, Dieren, 1939; dealer Knoedler, New York, 1941.

EXHIBITIONS: London, Royal Academy, 1903, no. 45; New York, Hudson-Fulton Celebration, 1909, no. 32 (*ca.* 1640); London 1929, no. 371; Chicago 1942, no. 16; Montreal 1944, no. 33; London, Arts Council, Masterpieces from the São Paulo Museum of Art at the Tate Gallery, 1954, no. 15; New York, Metropolitan Museum, Paintings from the São Paulo Museum, 1957, no. 14b.

BIBLIOGRAPHY: *Pictures in the Collection of J. Pierpont Morgan at Princes Gate and Dover House, Dutch and Flemish . . .*, London, 1907, unpaginated and unnumbered; Moes 206; HdG 384 (*ca.* 1635–40); Bode-Binder 177; KdK 171 (*ca.* 1638; pendant to our Cat. no. 117); Valentiner 1936, 65 (*ca.* 1638; pendant to our Cat. no. 117); K. Erasmus, 'Frans Hals and Jan de Bray: Some Newly Identified Portraits', *B.M.*, LXXV, 1939, pp. 236–239; Trivas 72.

Companion picture to Cat. no. 117; see that entry for details about the sitter. I have no reservations about accepting the conclusion that the portrait is a pendant of Cat. no. 117, but I am unable to explain why the companion piece bears an inscription and this portrait does not, or why the husband's armorial bearings are on his portrait and the wife's are not. The pendants Hals painted of her brother and sister-in-law in 1625 (Cat. nos. 32, 33; Plates 58, 59) and of her father and mother in 1639 (Cat. nos. 128, 129; Plates 206, 207) lack neither vital statistics nor escutcheons. The reader will notice that some other pendants by the artist pose similar problems. It is arguable that, when there is an unequal distribution of information about the sitters of companion pictures, the additional data found on one were provided by a later hand.

119. **Claes Duyst van Voorhout** (Plates 195, 197; text, pp. 86–87; 122–123). New York, The Metropolitan Museum of Art (Cat. 1954, no. 49.7.33).
Canvas, 80·6 × 66 cm.

PROVENANCE: The Earls of Egremont; Colonel Egremont Wyndham, Petworth, in 1854, no. 383 (Waagen, vol. III, p. 36); Lord Leconfield, Petworth; Duveen Bros., New York; Jules S. Bache, New York, given to the museum in 1949.

EXHIBITIONS: London 1929, no. 367; Detroit 1935, no. 33; Haarlem 1937, no. 66; New York 1939, World's Fair, Masterpieces of Art, no. 174; Los Angeles 1947, no. 12.

BIBLIOGRAPHY: Colonel Egremont Wyndham, *Cat. of Paintings at Petworth*, 1850, no. 383; Waagen, *Treasures of Art in Great Britain*, 1854, vol. III, p. 36; Bode 1883, 153 (*ca*. 1630); Moes 33; HdG 176; Bode-Binder 114; C. H. Collins Baker, *Catalogue of the Pictures in Possession of Lord Leconfield* (Petworth House), 1920, no. 383; KdK 154; *Catalogue of Paintings in the Bache Collection*, New York, 1929, unpaginated; Valentiner 1936, 59; *Catalogue of Paintings in the Bache Collection*, Metropolitan Museum, 1938, no. 34; *ibid.*, 1944, no. 33; Trivas 62 (*ca*. 1635).

In 1854, when not many people had a clear idea of Hals' *oeuvre*, Waagen was inclined to attribute this broadly painted and spirited portrait of a man with 'eyes and cheeks telling of many a sacrifice to Bacchus' to Hals. Waagen's estimate of pictures as well as people was sound. His attribution is beyond dispute, and his estimate of the model's drinking habits was virtually substantiated when it was discovered that the man portrayed was Claes Duyst van Voorhout, owner of the Swan Brewery (*de Zwaan*) at Haarlem. According to Collins Baker (*op. cit.*) the back of the painting was inscribed: 'Claas Duyst van Voorhout brouwer in des Brouwerij het Zwaanschel?' John Walsh, Curator, European Paintings Department, Metropolitan Museum, has kindly informed me that the back of the painting no longer bears the inscription. It must have been written on the panel the canvas was mounted on, and disappeared when the canvas was removed from its wooden support by Duveen around 1927. Collins Baker's transcription is the only record of the inscription.

The akimbo pose, which Hals used for his brilliant characterization of this stout, ruddy-faced brewer, was one he employed from the twenties (*Laughing Cavalier*, 1624; Cat. no. 30, Plate 52) until his late phase (*Portrait of a Man*, *ca*. 1652–54, Hermitage, Leningrad; Cat. no. 193; Plate 299). One wonders whether he reserved it for special swaggering types, or whether the pose, when used by Hals, made meek and timid souls look like bravados.

The simplified silhouette and monochromatic effect are characteristic of the mid- and late thirties. Here style in painting and style in dress go hand in hand. The embroidery, contrasting colours, and slashing so popular a few years earlier have disappeared; variety and patterns are achieved by the sheen and reflection of light on grey watered satin.

121. **Portrait of a Woman** (Plate 190). England, Private Collection.
Canvas, 116·7 × 91·5 cm.

PROVENANCE: Dealer C. Sedelmeyer, Paris, Catalogue 1899, no. 19; Marquis de Ganay, Paris; dealer Duveen, New York; Sir Ernst Cassel GCB; The Countess Montbatten of Burma, CI., GBE., DCVO.

EXHIBITIONS: London 1949, no. 10; Amsterdam 1952, no. 47; London 1952–53, no. 64.
BIBLIOGRAPHY: Moes 195; HdG 391; Bode-Binder 101; KdK 183 (*ca*. 1639); F. van Thienen, *Das Kostüm der Blütezeit Hollands: 1600–1660*, Berlin, 1930, p. 1, note 1 (*ca*. 1625, not 1639).

On the basis of the costume, Van Thienen (*op. cit.*) argued that the painting must be dated around 1625 and not in the second half of the thirties. He is correct to insist that the clothes reflect the height of Dutch fashion of about 1625 but Hals' portraits of women wearing similar costumes dated 1638 at Stockholm and Cleveland (Cat. nos. 114, 121; Plates 183, 191) indicate that the garments ladies accepted as à la mode in the mid-twenties were still worn by some women more than a decade later. In my opinion the style of the work places it around 1635–38.

We can only guess if Hals or his model selected the pose used for this life-size, three-quarter length but there is no question that it is an unorthodox one. The portrait is the only existing one by Hals which shows a woman with her arm akimbo. Valentiner suggested it may be a companion picture of the *Portrait of a Man* dated 1639 in Princess Labia's collection, Cape Town (Cat. 130; Plate 203). Neither the size nor the style of the paintings speaks against his proposal. However, it is unusual for a wife to loom a bit higher than her husband in seventeenth-century companion portraits, and the symmetrical arrangement of their figures is unusual in Hals' pendants.

121. **Portrait of a Woman** (Plates 191, 193). Cleveland, The Cleveland Museum of Art (inv. no. 48.137).
Canvas, 69·7 × 54 cm. Inscribed at the upper left: AETAT SVAE 41/AN° 1638.

PROVENANCE: Baron Anselm de Rothschild, Vienna; Baron Albert de Rothschild, Vienna; Baron Alphons de Rothschild; confiscated by the Germans during World War II and returned to its lawful owner after the war; purchased by the museum in 1948.
EXHIBITION: Vienna, World Exhibition, 1873, no. 124.
BIBLIOGRAPHY: Moes 190; HdG 398; Henry S. Francis, '"Portrait of a Lady in a Ruff" by Frans Hals', *The Bulletin of the Cleveland Museum of Art*, XXXV, 1948, pp. 163–170.

The portrait was exhibited at Vienna in 1873, recorded by Moes (190) and Hofstede de Groot (398) and then disappeared from the literature until it was published by Francis in 1948 (*op. cit.*). Francis notes (*ibid.*, pp. 163–164) that the painting was confiscated from Baron Alphons de Rothschild by the Germans during World War II. It was listed along with Hals' *Tieleman Roosterman* (Cat. no. 93; Plate 154) and other works of art from Baron Alphons' collection in an inventory found in Hitler's library at Berchtesgaden ('*Verzeichnis der von den Staatlichen Kunst-*

sammlungen erbetenen Gemälde aus der Sammlung Alphons Rothschild' no. 7). The painting was destined by the Nazis for the Gemäldegalerie in Vienna. After the war it was returned to its rightful owner.

Francis (*op. cit.*, p. 170) rightly noted that the portrait is related to our Cat. no. 120 but his suggestion that they might be of the same sitter is doubtful. The stomacher shot with gold threads and the bright red purse are exceptional colour accents in Hals' works of the late 1630's.

122. **Jean de la Chambre** (Plate 194; text, p. 127). London, National Gallery (no. 6411).
Panel, 20·6×16·8 cm. Inscribed at the upper left: 1638./ *aet* 33.

PROVENANCE: Sale, Amsterdam, 1 April 1883, no. 74 (90 florins, Roos); dealer C. Wertheimer, London; dealers P. and D. Colnaghi, London, from whom it was purchased by W. C. Alexander, London, 16 March 1892 (£650); by descent to the Misses Rachel F. and Jean I. Alexander, who presented it to the gallery in 1959; entered the gallery in 1972.
EXHIBITIONS: London, Burlington Fine Arts Club, 1900, no. 45; London 1952–53, no. 108. London, National Gallery, The Alexander Gift, 10 August–17 September 1972, no. 6411.
BIBLIOGRAPHY: *Icon. Bat.* 1523; Moes 50; HdG 164; Bode-Binder 166; KdK 169; Alistair Smart, 'Presented by the Misses Rachel F. and Jean I. Alexander: seventeen paintings for the National Gallery', *B.M.*, CXIV, 1972, pp. 630–634.

The last digit of the sitter's age has been transcribed as a *2* by earlier cataloguers.
Jean de la Chambre (died after 1666?) was a Haarlem calligrapher and French schoolmaster. The portrait served as a modello for a print engraved in the same direction by Jonas Suyderhoef (text, Fig. 123; Wussin no. 18), which was used as a frontispiece for a book by De la Chambre published with six of his own engraved specimens of his fine hand. Like the painting, Suyderhoef's print bears the date 1638 and is inscribed at the lower right: F. Hals pinxit/J. S. Hoef sculpsit. The inscription below the portrait gives the title and date of De la Chambre's book: Verscheyden geschriften, geschreven ende int Koper gesneden,/door Jean de la Chambre, liefhebber ende beminder der/pennen, tot Haarlem. Anno 1638.
Bode-Binder 166 incorrectly state that Suyderhoef's engraving is dated 1651; the reference is probably to Suyderhoef's print after Hals' lost portrait of Willem van der Camer, which is dated 1651 (see Cat. no. L 10).
Hofstede de Groot 164 notes that a copy of the painting was in the London art market in 1908; perhaps identical with the copy in the hands of the dealer Silberman, New York, 1937 (panel, 27×21 cm.; photo RKD). A (nine-teenth-century?) drawing after the painting or print is in the collection Arthur Rosenauer, Vienna (wash, heightened with white; 19·1×15·3 cm.); for another copy by the same hand after Hals' *Portrait of a Man* at Stuttgart see Cat. no. 99.

123. **Willem van Heythuyzen** (Plates 196, 198; text, pp. 53, 130–131). Brussels, Musée Royal des Beaux-Arts (Cat. 1949, no. 203).
Panel, 46·5×37·5 cm. Signed with the connected monogram at the lower right: FH.

PROVENANCE: Sold by the Hofje van Heythuyzen, Haarlem, to Le Roy, who in turn sold it to the Brussels museum, 13 May 1870 (17,000 francs).
EXHIBITIONS: London 1929, no. 49; Haarlem 1937, no. 71; Zurich 1953, no. 46; Rome 1954, no. 50; Milan 1954, no. 55; Haarlem 1962, no. 40; Brussels 1971, no. 47.
BIBLIOGRAPHY: *Nederlandsche Spectator* 1865, p. 127; Bode 1883, 31 (*ca.* 1635); *Icon. Bat.*, no. 3507–2; Moes 46 ('répétition' of the Rothschild version); HdG 188 (original; Rothschild version a copy); Bode-Binder 222; KdK 165 (*ca.* 1637; to judge from a photo of the Rothschild version, the Brussels painting is higher in quality); Trivas, App. 5 (one of three variants; 'I have not been able to see the other two variants').

The statement found in the earlier literature that the monogram on the painting is unusual is most likely based on the facsimile published in Fetis' 1889 catalogue of the paintings at the Musée Royal des Beaux-Arts, p. 361, no. 283. His facsimile is indeed unusual; it shows a very shaggy H with large flying serifs and a horizontal flourish at its base. As far as we know Hals never embellished his monogram in this fashion. However, no trace of these curious features is evident on the monogram today, and I see no reason to doubt the monogram on the painting.
The sitter is Willem van Heythuyzen (died 1650), the wealthy merchant who established the Hofje van Heythuyzen in Haarlem, a home for old people which is still in operation; the little portrait was at the Hofje until about 1870, when it was acquired by Le Roy. Hals' other portrait of Heythuyzen is the grand formal one painted around 1625, which is now at Munich (Cat. no. 31; Plate 56). It shows him, sword in hand, fully conscious of his position and importance, and is Hals' only life-size full-length. This portrait, painted more than a decade later, is small and intimate. Heythuyzen's quizzical expression, the precarious balance of his tipped-back chair, the diagonal composition, the lightning touch and flickering light all contribute to its informal and instantaneous quality. The view of the interior given here and the one in the background of the *Family Portrait*, Cincinnati (*cf.* Cat. no. 102), are exceptional in Hals' *oeuvre*; in his other works the painter set his patrons against more neutral backgrounds. Lomazzo's

admonition to portraitists not to suffer an eminent model 'to put one knee upon the other or to cross his legs', cited in the text p. 131, is from *A Tracte Containing the Artes of Curious Painting, Caruinge and Buildinge*, written first in Italian by Io. Paul Lomatius, painter of Milan and Englished by R.[ichard] H.[aydocke] student in Physik, [Oxford, 1598], p. 41.

A copy of the Brussels painting by another hand, which is considerably tighter in execution and overemphasizes details and accessories, was in the Otto Schuller collection, São Paulo, Brazil, in 1963:

> Panel, 46 × 36 cm.
>
> PROVENANCE: Sale, B. de Bosch, Amsterdam, 10 March 1817, no. 9; sale, Amsterdam, 14 May 1832, no. 30 (850 florins, Van Brienen); G. Th. A. M. Baron van Brienen van de Grootelindt of Amsterdam, Paris, 8 May 1865 (35,000 francs, Baron James de Rothschild); Baron Gustave de Rothschild, Paris; Robert de Rothschild, Paris; New York art market, 1950.
>
> BIBLIOGRAPHY: Bode 1883, 44; *Icon. Bat.*, no. 3507-3; Moes 45; HdG 190 (replica); Bode-Binder 221, reproduced plate 141a: KdK 165, note (copy).

Hofstede de Groot (192) lists another version, which is now untraceable: 46·2 × 36·2 cm., sale, Mildmay, London, 24 June 1893, no. 21. He writes that he does not remember seeing it at the Mildmay sale but to judge from the description it is a replica of the original at Brussels.

Hofstede de Groot (188) also notes that the Brussels portrait may have appeared in the sale, M. Peletier, Paris, 28 April 1870, no. 12. However, he rightly emphasizes that the picture in that sale was described as on canvas, 54 × 41 cm. The Brussels painting is on panel and measures 46·5 × 37·5 cm. It may have been yet another copy. If the Brussels painting appeared in the 1870 sale, it was wrongly described and was most probably put in by Le Roy and bought back by him since he sold it to Brussels on 13 May 1870 (museum files).

A watercolour copy of the painting by Hendrick Tavenier (1734–1807) and Cornelis van Noorde (1731–95) is in the Haarlem Municipal Archives. In the 1962 Haarlem exhibition catalogue (no. 40) I erroneously attributed the watercolour to Tavenier but an inscription on the verso states that he made the drawing and Van Noorde finished it: 'Willem van Heithuysen... door H. Tavenier Na[ar] Schilderij Getekent & d[oor] C v Noorde Na[ar] dito v[an] Frans Hals op Gemaakt.' I also suggested that some of the painted copies of Hals' works may have been made by talented eighteenth-century Haarlem artists who made drawings and watercolours after them. To date, no evidence has been found to support this hypothesis.

124. Officers and Sergeants of the St. George Civic Guard Company (Plates 199–201; text, pp. 7, 12, 136, 138–140, 207; text, Figs. 1, 140, 141). Haarlem, Frans Hals Museum (no. 127).

Canvas, 218 × 421 cm. The numbers on the men were painted at a later date to identify them.

PROVENANCE: Originally painted for the headquarters of the St. George Militia Company; at the museum since 1862.

EXHIBITIONS: Haarlem 1937, no. 76; Heerlen, 's-Hertogenbosch 1945; Haarlem 1962, 41.

BIBLIOGRAPHY: Haarlem Archives no. 31, *Registers van officieren en manschappen van de St. Jorisdoelen of oude schuts*, vol. 3; Bode 1883, 5; Moes 6; HdG 435; Bode-Binder 180; KdK 180; Trivas 75; H. P. Baard, *Frans Hals, The Civic Guard Portrait Groups*, Amsterdam and Brussels, 1949, pp. 25–27, plates F and 41–48; C. C. van Valkenburg, 'De Haarlemse Schuttersstukken: VII. Officieren en onder-officieren van de Sint Jorisdoelen (Frans Hals, 1639)', *HAERLEM: Jaarboek 1961*, Haarlem 1962, pp. 65ff.

Cleaned in 1923–24; scattered minor losses. Most of the men represented served in the militia company from 1636 to 1639; the painting was probably executed according to traditional practice and done in 1639 to commemorate the end of the corps' term of service, 30 April 1639. The diagram below identifies the men:

1. Johan Claesz. Loo, Colonel
2. Michiel de Wael, Fiscal
3. Quirijn Jansz. Damast, Captain
4. Florens van der Hoef, Captain
5. Nicolaes Grauwert, Captain
6. Hendrick Gerritsz. Pot, Lieutenant
7. François Wouters, Lieutenant
8. Cornelis Coning, Lieutenant
9. Hendrick Coning, Lieutenant
10. Dirck Dicx, Ensign
11. Lambert Wouters, Ensign
12. Pieter Schout, Ensign
13. Jacob Druyvesteyn, Ensign
14. Gabriel Loreyn, Sergeant
15. Lucas van Tetterode(?), Sergeant
16. Nicolaes Jansz. van Loo, Sergeant
17. Abraham Cornelisz. van der Schalcke, Sergeant
18. Pieter de Jong(?), Sergeant
19. Frans Hals

The number of men represented does not follow the company's normal complement of officers and sergeants. Four lieutenants and four ensigns are represented instead of three of each rank, and instead of six sergeants, only five are portrayed. C. C. van Valkenburg (*op. cit.*, pp. 70–71) has offered ingenious explanations for these discrepancies; if they are correct they indicate that at this date the officers were prepared to bend regulations in order to include a man in the picture.

Hendrick Coning, who served the company as a sergeant

from 1636 to 1639, appears here as a lieutenant. He held the latter rank in the St. Hadrian Company from 1639 to 1642. Van Valkenburg suggests that the group portrait was probably made after he had acquired his higher rank and that he was permitted to assume it here. If this is correct, it explains why only five sergeants are portrayed and why four lieutenants are represented. It is also worth noting that Nicolaes Olycan, who died on 2 April 1639, less than a month before the end of his term of service, is not represented; a place was found for Cornelis Coning, who probably finished the few weeks left in the deceased man's term. The extra ensign is Jacob Druyvenstein, who did not even belong to the 1636–39 officer corps. But he had served in this capacity at an earlier date. Since he was married on 5 July 1639 and could not hold this rank unless he was a bachelor, it is suggested he was included here for old time's sake. The portrait of another man who had served the company well is also included; in the upper left there is a self-portrait of Hals (text, Fig. 1).

Michiel de Wael and Dirck Dicx were portrayed in the banquet piece of the St. George Company of 1627 (Cat. no. 46; Plate 85); Johan Claesz. Loo and the painter Hendrick Pot in the St. Hadrian group portrait of 1633 (Cat. no. 79; Plate 127); and François Wouters in the group portrait of the governors of the St. Elizabeth Hospital of 1641 (Cat. 140; Plate 226).

The picture is the artist's swan song as a portraitist of militia companies. Dutch artists continued to receive commissions for them but the genre became less popular during the following decades. The painting is more subdued than his earlier militia pieces. The horizontal accent that is evident in his guard portraits done earlier in the decade (Cat. nos. 79, 80) has become dominant here, and their colouristic vivacity has been subordinated to an overall golden-olive glow. Although the scene is set in the open air the plein-airistic quality is minimal. The dull landscape in the background could very well be by another hand. G. D. Gratama, *Frans Hals*, The Hague, 1946, p. 41, suggests that it may have been painted by Cornelis Symonsz. van der Schalcke.

A drawing after the heads of Hals and Druyvenstein by Cornelis van Noorde (1731–95) is in the Haarlem Municipal Archives (chalk, wash; 33.5 × 42.8 cm.); a watercolour of the total composition by Wybrand Hendricks (1744–1831) belongs to the Gemeentemusea, Amsterdam (Fodor Collection, Cat. 1863, no. 407).

125. Portrait of a Man Wearing a Cuirass (Plate 202; text, p. 57). Washington, National Gallery of Art, Andrew W. Mellon Collection (Cat. 1965, acc. no. 68).
Canvas, 86 × 69 cm.

PROVENANCE: Acquired by Catherine II for The Hermitage; sold by the Soviet Union around 1932 to Andrew W.

Mellon, Washington, D.C., who gave it to the gallery in 1937.
BIBLIOGRAPHY: Catalogue, Ermitage, 1863, no. 773; Waagen, Ermitage, 1864, p. 172, no. 773; Bode 1883, 131 (*ca.* 1635); Catalogue, Ermitage, 1895, no. 773; Moes 138; HdG 310 (somewhat later than 1645); Bode-Binder 214; KdK 235 (*ca.* 1646–47); Valentiner 1936, 92 (*ca.* 1648); Trivas 74 (*ca.* 1639); National Gallery of Art, Preliminary Catalogue of Painting and Sculpture, 1941, no. 68.

Parts of the face and the background are moderately to severely abraded. Hofstede de Groot (see HdG 307, note) and Valentiner (KdK 235; 1936, 92) dated the work a bit too late. Trivas (74) rightly observed that the colour of the picture relates it closely to Hals' 1639 group portrait of the St. George Militia Company (Cat. no. 124). The view of the sea seen through the opening in the wall suggests that the model may have been a naval officer. Views of this type occur only in two other of his existing portraits (Cat. nos. 42, 217; Plates 64, 334).

The 1941 Catalogue of the National Gallery (no. 68) erroneously states that the painting came to the Hermitage in 1779 with the Walpole Collection. The only picture by Hals that Catherine acquired from the Walpole collection is the *Portrait of a Man* (Cat. no. 167; Plate 256); like Cat. no. 125 it too was sold by the Russians to Mellon and is now in the National Gallery in Washington.

126. Hendrick Swalmius (Plate 204; text, pp. 129–130, text, Fig. 127). Detroit, The Detroit Institute of Arts (inv. no. 49.347).
Panel, 27 × 20 cm. Inscribed on the right near the centre: AETAT 60/1639, and signed below the inscription with the connected monogram: FH.

PROVENANCE: Mrs. Broun Lindsay, Colstoun, Haddington, East Lothian, Scotland; sale, London (Sotheby) 12 December 1934, no. 65; dealers Asscher and Welker, London; dealer D. Katz, Dieren; H. E. ten Cate, Almelo; purchased by the museum in 1949.
EXHIBITIONS: Haarlem 1937, no. 77; New York 1939, no. 183; Montreal 1944, no. 28; Haarlem 1962, no. 42.
BIBLIOGRAPHY: *Icon. Bat.*, no. 7720; Moes 75; HdG 228; Bode-Binder 296; KdK 1921, 217; KdK 230; H. Granville Fell, 'A Recovered Franz Hals', *The Connoisseur*, XCV (1935), p. 105; W. R. Valentiner, 'New Additions to the Work of Frans Hals', *Art in America*, XXIII (1935), pp. 96, 102, no. 17; E. P. Richardson, 'A Portrait of Hendrik Swalmius', *Bulletin of the Detroit Institute o Arts*, XXIX (1949–50), pp. 3–5.

Hendrick Swalmius (*ca.* 1579–1649) was a preacher in Haarlem. Before the portrait was rediscovered in 1934 it was known from the reversed engraving Jonas Suyderhoef

(*ca.* 1613–86) made of it (Wussin 86); the print is inscribed: 'F Hals Pinxit. I. Suyderhouf Schulp.'. A verse on the print states that Swalmius served as a preacher for more than forty-six years. Since he was ordained in 1600, it was assumed by Hofstede de Groot (228) and Valentiner (KdK 1921, 217; KdK 230) that Hals' painting must have been painted after 1646. Discovery of the dated original indicates that Suyderhoef made his engraving seven or eight years after the portrait was finished, not an uncommon practice in seventeenth-century Holland. Even before the original was recovered, Valentiner made the plausible suggestion (KdK 1921, 217; KdK 230) that the *Portrait of a Woman* now at Rotterdam (Cat. no. 127; Plate 205) is the pendant of the painting.

Wussin (86) erroneously identified Suyderhoef's print as a portrait of Hendrick's brother Eleazar, who was an Amsterdam preacher. His error was spotted by the compiler of the sale catalogue, Amsterdam (Muller) 13–15 May 1881, no. 577 and since Moes listed the print in 1905 (*Icon. Bat.*, no. 7720) it has been generally acknowledged as a portrait of Hendrick. Rembrandt's 1637 portrait of Eleazar, now at Antwerp, shows that the resemblance between the brothers was striking (see text, Figs. 128, 129). Neither the attempt made by A. Heppner ('Twee geleerden geportretterd door Rembrandt en tevens door Frans Hals', *Op de Hoogte*, XXIV, 1937, pp. 236–237) to demonstrate that the Detroit picture represents Eleazar, or H. Gerson's suggestion that the Antwerp portrait is too tame for Rembrandt himself and is probably by Govaert Flinck (Bredius-Rembrandt, no. 213, p. 565) is persuasive.

Apart from the fact that Suyderhoef's engraving suggests that the Detroit panel may have been cut at the top and along the left and right edges, the little portrait is in an unusually fine state of preservation. It permits a study of the rich variety of Hals' touch and offers an excellent example of the way he began, around 1640, to achieve rich pictorial effects by juxtaposing warm and cool tones. It is a neat problem trying to decide whether the Haarlem preacher was really such a lively sixty-year-old man with a Silenus-like twinkle in his eye or whether Hals endowed him with these traits.

127. **Portrait of a Woman, presumably the wife of Hendrick Swalmius** (Plate 205). Rotterdam, Boymans-van Beuningen Museum (Cat. 1962, no. 2498).

Panel, 29·5 × 21 cm. Inscribed at the left near the centre: AETAT 57/1639.

PROVENANCE: Sale (anon.) London (Christie) 20 June 1913, no. 43; Aug. Janssen, Amsterdam; dealer Goudstikker, Amsterdam; D. G. van Beuningen, Vierhouten; acquired by the museum with the Van Beuningen collection in 1958.

EXHIBITIONS: Amsterdam, Rijksmuseum, Oude Kunst, 1929, no. 69; Haarlem 1937, no. 78; Paris, Petit Palais,

Chefs d'Oeuvre de la Collection D. G. van Beuningen, 1952, no. 95; Rotterdam 1955, no. 70; Haarlem 1962, no. 43.

BIBLIOGRAPHY: Bode-Binder 183; KdK 1921, 218 left (*ca.* 1646–47); KdK 231 left (*ca.* 1646–47); D. Hannema, *Catalogue of the D. G. van Beuningen Collection*, Amsterdam, 1949, no. 49.

Before the original of *Hendrick Swalmius* (Cat. no. 126) was rediscovered Valentiner proposed that the paintings were probably companion pictures (KdK 1921, 217; KdK 230). At that time he knew the former only from Suyderhoef's fine engraving and on the basis of it dated the untraced painting of Swalmius as well as Cat. no. 127 around 1646–47. Recovery of the portrait of Swalmius showed that the portrait is dated 1639; cleaning of the presumed pendant now at Rotterdam revealed that it too is dated 1639. Their dates as well as their composition and style support Valentiner's view that they were intended as companion pieces and the fact that the woman's portrait is a trifle larger than the painting of Swalmius helps bolster the supposition that the latter was cut (see Cat. no. 126).

No engraving of the woman's portrait is known; indeed, not a single seventeenth-century print after Hals' portraits of women has been identified.

A copy of the portrait is in the collection of Mme Weil, Paris: panel, 29 × 24·5 cm. (photo RKD); ex coll. A. Schloss, Paris. Valentiner (KdK 231 right, repr.) noted that the *Portrait of a Woman* (canvas, 40 × 33 cm.; dealer E. Warneck, Paris; Quincy Shaw, Boston; heirs of Quincy Shaw) is perhaps an old copy after the work too. Hofstede de Groot (373) states that the Shaw picture is a fragment of a larger painting. My repeated efforts to see the Shaw portrait have not been successful and I must reserve judgement until I have had an opportunity to examine it.

128. **Pieter Jacobsz. Olycan** (Plates 206, 208; text, pp. 122–123). Sarasota, Florida, The John and Mable Ringling Museum of Art (Cat. 1949, no. 251).

Canvas, 111·1 × 86·3 cm. The Olycan coat-of-arms (cut) is painted in the upper right corner.

PROVENANCE: Possibly identical with a portrait of Pieter Jacobsz. Olycan cited in the inventory of Olycan's daughter Geertruyd Olycan, widow of Jacob Benningh, Haarlem, 11 November 1666 (HdG 210); an unpublished note by Hofstede de Groot at the RKD states he examined the painting in May, 1922, for J. A. Lewis and Son at an estate, 20 to 25 minutes by auto, east of Liverpool (Sutton Hall) and that he saw the painting again in 1926 when it was with A. Reyre, London; John Ringling, Sarasota, Florida.

EXHIBITION: Haarlem 1962, no. 44.

BIBLIOGRAPHY: Valentiner 1928, pp. 248–249; Valentiner 1935, pp. 85–86, 102, no. 16; Valentiner 1936, 66; K. Erasmus, 'Frans Hals and Jan de Bray: Some Newly Identified Portraits', *B.M.*, LXXV (1939), p. 239.

Companion picture to Cat. no. 129. Overall moderate abrasion; severe abrasion in the background and on the coat-of-arms. The cut escutcheon and the larger size of the pendant (128×94·5 cm.) indicate that the work has been reduced in size. It has probably been cropped on all four sides.

Despite its less than good state of preservation this three-quarter length of Pieter Jacobsz. Olycan (1572–1658) remains one of the artist's most forceful characterizations. The brushwork is especially broad and spontaneous; it appears particularly appropriate for a portrait of this powerful personality. Olycan was a brewer at the 'Vogel-struys' and 'Hoeffijser' breweries of Haarlem; he also served as a burgomaster of the city and was a member of the States-General. He appears as the colonel in Hendrick Pot's group portrait of the St. Hadrian militia company's officers painted around 1630 (see text, Fig. 139).

In earlier commissioned single portraits the painter reserved his broad touch for a few passages; here it is found throughout the painting and anticipates the technique of the last decades. Although Hals used a more traditional composition and a less impulsive touch for the companion portrait of Maritge Vooght Claesdr. (1577–1644), his profound portrayal of her makes the painting a fitting mate to the Sarasota picture. For Hals' portraits of this couple's children and other members of the Olycan family, see text, pp. 123–124.

Rather vigorous grey wash and brush drawings by Wybrand Hendricks (1744–1831) after Hals' pendants are at the Rijksprentenkabinet, Amsterdam (inv. nos. 10:52; 10:53). Neither of them reproduces the coat-of-arms seen in the originals.

Half-length portraits of Pieter Jacobsz. Olycan (Fig. 33) and Maritge Vooght Claesdr. (Fig. 34) based on the paintings now in Sarasota and Amsterdam, but with changes in the position of the hands, were formerly in the Watney collection. Each is on panel and measures 66·2 × 56·2 cm.

PROVENANCE: Possibly the paintings mentioned in the inventory of Olycan's daughter Geertruyd Olycan, widow of Jacob Benningh, Haarlem, 11 November 1666 (HdG 210, 211); possibly Arthur Sanderson, Edinburgh; Sir G. Donaldson, London; Vernon Watney, Cornbury Park, Charlbury, Oxfordshire; Oliver V. Watney, Cornbury Park, Charlbury, Oxfordshire; sale, Watney, London (Sotheby) 23 June 1967, no. 27 (£52,500), no. 28 (£10,500) the portrait of Pieter Olycan was offered without the pendant by the London dealer L. Koetser, Catalogue, Autumn 1967, no. 1.

EXHIBITIONS: London, Guildhall, 1906, nos. 81, 86; London 1952–53, nos. 50, 54.

BIBLIOGRAPHY: Possibly *Icon. Bat.*, no. 5540–1 and no. 8653–2; Moes 60, 61; HdG 210 (the name of the man is known from an inscription on the back and from the coat-of-arms, which was painted out), 211 (the name of the woman is known from an inscription

on the back and the coat-of-arms); Bode-Binder 201, 202 (the woman's portrait bears a coat-of-arms); KdK 184 left and right (*ca.* 1639; the woman's portrait bears a coat-of-arms); Valentiner notes that her portrait was probably done by Hals, with changes, without the model posing for him again; Valentiner 1928, pp. 248–249 (doubtful if the Watney portraits are really by Hals); Valentiner 1935, pp. 85–86 (Watney portraits obviously done after the Sarasota and Amsterdam pictures); Valentiner 1936, 66 (possibly by the artist); K. Erasmus, *B.M.*, LXXV (1939), p. 239 (repetitions by Hals).

In my judgement these panels are variants by another hand after Hals' originals. Juxtaposition of them with the Sarasota and Amsterdam paintings rules out the possibility that they were preliminary studies or the artist's own later replicas. Although the portrait of the man offers a closer approximation of Hals' technique than the over-meticulous handling seen in the portrait of the woman, the artist's detached strokes fail to model form consistently and the copyist misses Hals' fine tonal gradations as well as the suggestive power of his touch. The amorphous shape of the man's hand and the enormous length of his thumb also indicate that the imitator was at a loss when he departed from his model. When the woman's portrait was sold at Christie's in 1967 it did not bear the coat-of-arms seen on old reproductions (Bode-Binder 202 and KdK 184 right).

Wybrand Hendricks' watercolour copies, probably done after the Watney variants, are at the Haarlem Municipal Archives (inscribed on the verso 'Jacob Pietersz. [*sic*] olijcan Geschildert door F: Hals' and 'Maria Classje Voogdt vrouw van J. P. olijcan Geschildert door f: Hals—Hendriks fec.'). Most likely the Watney portraits were painted before Hendricks' time but it has not been possible to determine if they were made by one of Hals' contemporaries. The reference in the 1666 inventory of Olycan's daughter to portraits by Hals of her parents (HdG 210, HdG 211) cannot be securely identified with either the artist's originals or the Watney variants.

129. Maritge Vooght Claesdr., wife of Pieter Jacobsz. Olycan (Plate 207, text, pp. 112–113; 115, 124). Amsterdam Rijksmuseum (Cat. 1960, no. 1088).

Canvas, 128×94·5 cm. Inscribed to the left of her shoulder: AETAT SVAE 62/AN° 1639. Her family coat-of-arms is painted in the upper left corner.

PROVENANCE: Possibly identical with a portrait of Maria Vooght Claesdr. cited in the inventory of her daughter Geertruyd Olycan, widow of Jacob Benningh, Haarlem, 11 November 1666 (HdG 211); sale, Amsterdam, 24 November 1834; Van der Hoop, Amsterdam; bequeathed to the City of Amsterdam, 1854; lent to the Rijksmuseum since 1885.

EXHIBITIONS: Brussels 1946, Bosch tot Rembrandt, no. 42; Haarlem 1962, no. 45.
BIBLIOGRAPHY: *Icon. Bat.* 8653–1; Bode 1883, 18; Moes 62; HdG 212; Bode-Binder 182; KdK 181; Trivas 73.

Companion picture to Cat. no. 128; see the catalogue entry to that painting for additional bibliographical references and notes on copies and variants of the pair.

130. **Portrait of a Man** (Plate 203). Cape Town, Princess Labia.
Canvas, 115 × 89·5 cm. Inscribed at the right: AETAT SVAE 52/AN° 1639.

PROVENANCE: Dealer Henry Farrer, London; sale, S. H. de Zoete, 9 May 1885, no. 230 (Colnaghi); sold by Lesser to Vicary Gibbs; Anthony Gibbs, London; bought from him by the dealer Sir George Donaldson, London, and sold to Sir Joseph B. Robinson, London; sale, Robinson, London (Christie) 6 July 1923, no. 58 (bought in); by descent to the present owner.
EXHIBITIONS: Manchester 1857, no. 681; London, Royal Academy, 1879, no. 71; London, Royal Academy, 1888, no. 146; London, Guildhall, 1892, no. 56; London, Royal Academy, The Robinson Collection, 1958, no. 52.
BIBLIOGRAPHY: W. Bürger, *Trésors d'Art en Angleterre*, Paris, 1865, p. 243. Moes 124; HdG 288 and HdG 347; Bode-Binder 125; KdK 1921, 168; KdK 182.

The age of the sitter and the date were variously transcribed until Valentiner (KdK 1921, 168) published them correctly. For his proposal that the painting is a companion to the *Portrait of a Woman*, now in an English private collection, see Cat. no. 120.

131. **Portrait of a Woman** (Plate 212). London, National Gallery (Cat. 1960, no. 1021).
Canvas, 61·4 × 47 cm. Signed on the left with the connected monogram: FH.

PROVENANCE: Purchased (out of the Lewis fund) from F. A. Keogh, 1876.
BIBLIOGRAPHY: Bode 1883, 132 (*ca.* 1645); Moes 198; HdG 381; Bode-Binder 140; KdK 1921, 106 (1633); KdK 111 (1633); Neil MacLaren, *National Gallery Catalogues, Dutch School*, 1960, p. 146.

Probably cut down at the sides and bottom; old stretcher marks show that at some time the picture surface was further reduced to *ca.* 59·5 × 44 cm.
Valentiner (KdK 1921, 106; KdK 111) called it a companion portrait of *The Portrait of a Man* dated 1633 at the National Gallery (Cat. no. 81; Plate 148) and assigned it the same date. MacLaren (*op. cit.*) rightly pointed out that

there is no reason to assume the paintings are pendants. They have different provenances; moreover, the style of the woman's portrait places it in the late 1630's. In technique and tonality the work is closely related to the *Portrait of a Woman*, dated 1639, at Ghent (Cat. no. 136; Plates 209, 210).

132. **Portrait of a Woman** (Plate 213). Düsseldorf, Kunstmuseum (on loan from the Staatliche Museen, Berlin, no. 801J).
Canvas, 69·5 × 58 cm.

PROVENANCE: Acquired by the Berlin Gallery in 1841, placed on extended loan at Düsseldorf in 1884, inv. no. 222; stolen from the Kunstmuseum, Düsseldorf, 10 February 1972; it had not been recovered when this Catalogue went to press.
BIBLIOGRAPHY: Moes 200, identical with Moes 203; HdG 376; Bode-Binder 158; KdK 1921, 166 (*ca.* 1638–40); KdK 179 (*ca.* 1638–40); Kunstmuseum, Düsseldorf, *Eine Auswahl*, p. 23, no. 64, inv. no. 222.

Painted around 1638–40. Related in style to Cat. nos. 131 and 136. The cropped painted oval frame indicates that the painting has been cut at the top and the bottom, and it has probably also been trimmed on both sides. Valentiner's suggestion that it was possibly a pendant to the *Portrait of a Man* at Vienna must be rejected; restoration of the Vienna painting around 1935 revealed that originally it was not a portrait in an oval painted frame (see Cat. no. 133).

133. **Portrait of a Man** (Plate 215). Vienna, Kunsthistorisches Museum (Cat. 1963, no. 183, inv. no. 709).
Canvas, 78·7 × 65·6 cm.

PROVENANCE: In the collection of Charles VI at the Stallburg, Vienna, between 1720–28.
EXHIBITION: Haarlem 1937, no. 74.
BIBLIOGRAPHY: Bode 1883, 121 (*ca.* 1650); Moes 177; HdG 321; Bode-Binder 195; KdK 178 (*ca.* 1638–40; possibly somewhat later, yet the composition is related to the portraits in painted ovals done *ca.* 1635–38); Ludwig Baldass, 'The Portrait by Frans Hals at Vienna', *B.M.*, LXVIII (1936), pp. 244–247 (*ca.* 1643–44); Trivas 77 (*ca.* 1639).

Until Baldass published the results of the cleaning and restoration done by Bruno Sykora around 1935, the painting was assumed to be a portrait in a painted oval (*op. cit.*). Baldass showed that it was one of the pictures Count Gundacker Althann, director of the Imperial buildings at Vienna, transformed into an oval around 1720–28. It was altered to make it fit into an elaborate

decorative scheme of round and oval panels he devised for Charles VI's paintings mounted at the Stallburg. The painting, however, was not cut into an oval. During the course of the restoration it was discovered that parts of the original canvas had been folded back and a strip had been added to the bottom. The painting now approximates its original size and shape. The four corners were added by the restorer. The paint surface is severely abraded and has been flattened during the course of old relinings; extensive areas have been repainted. The poor condition makes it difficult to assign the work a firm date but upon the basis of its composition and what can be seen of its original paint surface it appears to have been done in the late 1630's. When it was in prime condition it was probably similar in style to the *Portrait of a Man* at Leningrad (Cat. no. 134; Plate 214).

Since the portrait was not originally in a painted oval, Valentiner's hypothesis that it was probably a companion picture of the *Portrait of a Woman* at Düsseldorf (Cat. no. 132; Plate 213) is untenable.

134. Portrait of a Man (Plate 214; text, p. 97). Leningrad, Hermitage (Cat. 1958, no. 982).
Canvas, 80 × 66·5 cm. Signed near the centre on the right with the connected monogram: FH; traces of a second connected monogram are evident below and to the left of the more prominent one.

PROVENANCE: Probably in England by 1670; acquired by Catherine II from the Gotzkovsky collection, Berlin, in 1764.
BIBLIOGRAPHY: Catalogue, Ermitage 1863, no. 771; Waagen, Ermitage 1864, no. 771; Bode 1883, 129 (*ca.* 1650); Catalogue, Ermitage 1895, no. 771; Moes 181; HdG 308 (probably *ca.* 1640); Bode-Binder 194; KdK 197 (*ca.* 1642); Trivas 76 (*ca.* 1639).

The painting, which is in generally good condition, has been enlarged by the addition of narrow strips of canvas at the sides and at the top. Painted around 1640; closely related in style to Cat. nos. 137 and 140, which can be dated with reasonable certainty about 1640 and 1641 respectively.
The portrait was engraved in reverse by the English printmaker Edward Le Davis on a single plate with the so-called *Mulatto* at Leipzig (text, Fig. 86). Since Le Davis' print was published in London around 1670 it is highly likely that both paintings were in England at this early date. Le Davis dubbed the Leningrad portrait 'The Mountebank Doctor' and called the model for the Leipzig painting his 'Merry Andrew'. Coupling the pair must have been Le Davis' idea. It is highly improbable that Hals intended his conventional portrait of a young man as the pendant to a comic figure he had painted about a decade earlier. However, once the sitter for the portrait acquired the title

of doctor in England he may have kept it. R. E. Hutchinson, Keeper, Scottish Portrait Gallery, kindly informed me that in the catalogue of the sale held around 1732 of works belonging to Colonel Charteris, no. 99 is described as 'an exceeding fine portrait of a physician by Francis Halls' (purchased by Mr. Stewart). Perhaps this painting is identical with the Leningrad portrait, and conceivably with the monogrammed portrait George Vertue listed in his notebooks around 1750 as 'a picture 3/4 painted of a Doctor by France Hals' is identical with the Leningrad painting (*The Twenty-Sixth Volume of the Walpole Society, 1937-38, Vertue Note Books,* vol. v, Oxford, 1938, p. 61.
For a transcription of the verse inscribed on Le Davis' print and a discussion of the so-called *Mulatto* at Leipzig, see Cat. no. 65.

135. Daniel van Aken (Plate 211; text, pp. 80, 154). Stockholm, National Museum (Cat. 1958, no. 1567).
Canvas, 67 × 57 cm.

PROVENANCE: Possibly collection E. L. Schlegel; Collection J. A. Anckarswärd, 1844; sale, Gripenstedt, Stockholm, 3 May 1888; purchased by the museum in 1901 (Kr. 3500).
EXHIBITION: Haarlem 1937, no. 35.
BIBLIOGRAPHY: O. Granberg, *Sveriges privata tafelsamlingar* . . . Stockholm 1885, p. 5, no. 3; *Icon Bat.,* no. 87; Moes 11; HdG 150; Granberg 1911, p. 106, no. 474; Bode-Binder 79; KdK 76 (*ca.* 1629-30); Trivas 54 (*ca.* 1634).

X-ray photographs of the painting show numerous scattered losses on the face, hair, hat and the lower part of the left hand. The paint surface has been flattened in relining and is badly abraded.
Datable around 1640. The sitter is identified on the basis of a drawing dated 1655 by Mathys van den Bergh (*ca.* 1617-87) which is now at the Museum Boymans-Van Beuningen, Rotterdam (text, Fig. 159); ink over lightly sketched chalk or graphite; 18·1 × 17·9 cm.; inscribed at the lower right: . . . Bergh/1655/ . . . Dan/van Ak[e?]n. To judge from Van den Bergh's drawing the painting has been cut on all four sides and a swatch of drapery on the left may have been painted out.

136. Portrait of a Woman (Plates 209, 210; text, p. 121). Ghent, Musée des Beaux-Arts (Cat. 1938, no. 1898B).
Canvas, 84·5 × 67·5 cm. Inscribed to the left of the head: AETA SVAE 53/ . . . 1640. Traces of a monogram below the inscription.

PROVENANCE: Sale, Amsterdam, 21 June 1797, no. 91 (20 florins, with pendant, Aiman); Cassel, Akademie; sale, Lippmann von Lissingen of Vienna, Paris (Drouot), 16

March 1876, no. 22 (5,300 francs); sale, Ed. Kums, Antwerp, 17 May 1898, no. 75 (25,000 francs; Ghent Museum).
EXHIBITIONS: Vienna 1873, no. 162; Haarlem 1962, no. 46.
BIBLIOGRAPHY: Bode 1883, 39; George Hulin, 'Portrait de Dame, par Frans Hals, 1640', *Inventaire archéologique de Gand*, 1e sér., 1900, p. 174; Moes 96; HdG 379; Bode-Binder 156; KdK 151; *Chefs-d'Oeuvre du Musée des Beaux-Arts de Gand*, Brussels, 1949, p. 16, no. 22.

All of the authors cited in the Bibliography above have accepted the *Portrait of a Man in a Painted Oval*, 1635, formerly in the Lionel Straus collection (Cat. no. D 53; Fig. 174) as the companion piece to the 1640 Ghent portrait. A five-year interval between two companion portraits is not usual, but it is not impossible either. E. Trautscholdt, 'Zur Geschichte des Leipziger Sammel-wesens', *Festschrift Hans Vollmer*, p. 229, notes at the I. C. Lampe sale in Leipzig, 17 May 1819, nos. 35 and 36, a pair of portraits attributed to Hals (canvas, 'je 36 Z. × 28 Z.'), described as: 'Zwey Portraits, wovon das eine einen Mann von gesetzten Jahren in rundem Hut und spanischer Kleidung, das andere eine bejahrte Frau in einfacher Haustracht darstellt... Beyde Bilder haben die Signatur des Meisters aber verschiedene Jahreszahlen... Das männliche ist 1635, das weibliche hingegen 1640 gefertigt!' The 1810 catalogue may refer to the Ghent portrait of 1640 and the Straus painting dated 1635. However, the question of the traditional attribution of the paintings is another matter. The Ghent picture is a convincing original; its presumed pendant is too feeble to ascribe to Hals.
Around 1640 Hals apparently ceased to use the *trompe l'oeil* trick of placing his models behind simulated stone frames. The Ghent painting and Hals' lost portrait of the calligrapher *Theodore Blevet*, 1640 (Cat. no. L 13; text, Fig. 124) are the latest ones which employ the device; for its use by later artists see text, pp. 121–123.

137. **Portrait of a Man** (Plate 216; text, p. 158). Cologne, Wallraf-Richartz-Museum (Cat. 1967, no. 2529). Canvas, 120×95 cm.

PROVENANCE: Collection Hobson, Rugby; Adolph von Carstanjen, Berlin, who purchased it for £1,200 in June 1890 from Mr. Orrock through Colnaghi and Co., London; Wilhelm Adolph von Carstanjen; acquired by the museum in 1936.
EXHIBITIONS: Düsseldorf 1904, no. 316; Haarlem 1937, no. 82; Schaffhausen 1949, no. 46; Paris 1955, no. 32; Oslo-Bergen 1955, no. 112.
BIBLIOGRAPHY: Moes 101; HdG 256; Bode-Binder 186; KdK 186; Trivas 79.

Companion picture to Cat. no. 138 and most probably painted around the same time. Sewn strips *ca.* 8 cm. wide at the bottom and 2·5 cm. wide on the left side may be later additions. Scattered losses, especially along the edges. The shadows on the right side of the face are moderately abraded and retouched; the background is severely abraded. If the painting originally bore an inscription, not a trace of it remains. Adolph Carstanjen's manuscript inventory made before 1900 (published by H. Vey, 'Adolph Carstanjen und seine Gemäldesammlung', *Wallraf-Richartz-Jahrbuch*, xxx, 1968, p. 341, no. 53) states the painting is 'gezeichnet FH links, kaum erkennbar'. This monogram is no longer visible. Carstanjen's inventory also states (*ibid.*, pp. 340–341, nos. 52, 53) that Hofstede de Groot proposed that the models were Albert van Nierop (1600–1676) and his wife Cornelia van der Meer (1603–?), the daughter of Nicolaes van der Meer and Cornelia Vooght Claesdr. (Cat. nos. 77, 78; Plates 123, 124). Hofstede de Groot did not write a word about this proposal when he catalogued the paintings in 1910 (256, 368). Vey's investigation explains why; a portrait dated 1663 by Jan Mijtens of Van Nierop (Gouda Museum, on loan from the Dienst voor 's-Rijks Verspreide Kunstvoorwerpen shows that the sitters are not identical, and the inscription on the companion picture does not tally with Cornelia van der Meer's age; Cornelia was 37 in 1640, not 32.

138. **Portrait of a Woman** (Plate 217, 218; text, p. 148). Cologne, Wallraf-Richartz Museum (Cat. 1967, no. 2530). Canvas, 120×94·5 cm. Inscribed to the left at shoulder height: AETA·SVAE 32/ANº 1640; below the inscription signed with the connected monogram: FH.

PROVENANCE: Collection Hobson, Rugby; Adolph von Carstanjen, Berlin, who purchased it for £1,200 in June 1890 from Mr. Orrock through Colnaghi and Co., London; Wilhelm Adolph von Carstanjen; acquired by the museum in 1936.
EXHIBITIONS: Düsseldorf 1904, no. 317; Haarlem 1937, no. 81; Schaffhausen 1949, no. 47; Paris 1955, no. 33; Oslo-Bergen 1955, no. 113.
BIBLIOGRAPHY: Moes 102; HdG 368; Bode-Binder 187; KdK 187; Trivas 80.

Companion picture to Cat. no. 137. The painting is in a better state of preservation than its pendant. Light retouches at the lower edge and in the upper part of the upper left background.
A modern miniature copy is in the Wallraf-Richartz Museum (inv. no. 2935; copper oval, 11·4×8·5 cm.); bequest of Juliane and Werner Lindgens, Cologne-Mülheim, 1946; purchased by them in Cologne, 1922. There is also a copy at Munich, Bayerische Staatsgemäldesammlungen, inv. no. 12133 (canvas, 126×95·8 cm.).

139. **Portrait of a Man** (Plate 220). Eindhoven, Stedelijk van Abbe Museum, on loan from Dienst voor 's-Rijks

Verspreide Kunstvoorwerpen, The Hague, inv. no. NK 1663.

Canvas, 84·2×67·6 cm. Inscribed to the right of the head: AETĀ. SVAE 56/AN 1640, and signed with the monogram FH.

PROVENANCE: Collection Heilbuth, Copenhagen; dealer Ehrich Galleries, New York; Marczell von Nemes, Budapest; sale, von Nemes, Munich, 16 June 1931, no. 49; Gustav Oberlaender, Reading, Pennsylvania; sale, Oberlaender, New York (Parke Bernet) 25–26 May 1939, no. 231; dealer D. Katz, Dieren.

EXHIBITION: Amsterdam, F. Muller and Co., 1918, no. 6.

BIBLIOGRAPHY: KdK 1921, 172; KdK 185; Valentiner 1936, unnumbered supplement; H. Gerson, 'An Exhibition of Dutch Paintings', *B.M.*, LXXV (1939), p. 127.

The inscription appears to have been strengthened, particularly the wiry second line. The monogram also appears to have been tampered with; I do not know another example of a Hals' monogram done in his middle or late period which is not joined. Investigation may prove that the F is a later addition, and the rather faint H was originally part of his characteristic ligated monogram. Though the inscription and monogram raise some doubts this little known half-length portrait does not. The sobriety and restraint of its subtle colour harmony of deep blacks and olive greys are characteristic of the artist's works of the early 1640's. When it returned to Holland from America in 1939 Gerson rightly welcomed it back home as a work of great importance (*op. cit.*).

140. **The Regents of the St. Elizabeth Hospital of Haarlem** (Plates 224–226; text, pp. 153, 155–158, 174). Haarlem, Frans Hals Museum (Cat. 1929, no. 128). Canvas, 153×252 cm.

PROVENANCE: Painted for the St. Elizabeth Hospital in Haarlem, which still owns the piece. On loan to the Frans Hals Museum since 1862.

EXHIBITIONS: Haarlem 1937, no. 84; Maastricht, Heerlen, 's-Hertogenbosch 1945; Haarlem 1962, no. 47.

BIBLIOGRAPHY: Bode 1883, 6; Moes 7; HdG 436; Bode-Binder 196; KdK 194; L. C. Kersbergen, *Geschiedenis van het St. Elizabeths of Groote Gasthuis te Haarlem*, Haarlem, 1931; Trivas 81.

The style of the work supports the old tradition that it was painted in 1641. Additional evidence is found in a manuscript register at the Haarlem Municipal Archives, *Namen der Personen die gedient hebben als Regenten van St. Elizabets Gast-Huys Binnen Haerlem zedert 't Jaer, 1509*. It lists (*ibid.*, p. 440) the following regents in 1641: François Wouters, Dirk Dirks Del, Johan van Clarenbeek, Salomon

Cousaert, Sivert Sem Warmond. Wouters, the regent on the extreme right, can be securely identified. He had posed as a Lieutenant in Hals' 1639 group portrait of the St. George Militia Company (Cat. no. 124; Plate 201), standing between Colonel Loo and Fiscal de Wael. The likeness is unmistakable. Since regents of the St. Elizabeth Hospital changed annually and Wouters did not serve again around this time, it is reasonable to conclude that the group represents the regents of 1641 and that the painting was done in that year or not long afterwards. According to tradition the other men are identified from left to right as listed above.

Regent pieces had been popular in Amsterdam since the end of the sixteenth century; Hals apparently painted the first one in Haarlem. For his reliance, with significant modification, on a work in this category done by the Amsterdam portraitist Thomas de Keyser in 1638, see text, pp. 155–156. The intimate character of the group portrait, the accentuation of momentary expression, and the lively, expressive hands are his own distinctive contributions.

In 1641, Johannes Cornelisz. Verspronck (1597–1662) painted the *Regentesses of the St. Elizabeth Hospital* (owned by the St. Elizabeth Hospital, Haarlem; since 1929 on loan to the Frans Hals Museum, Cat. 1929, no. 541, canvas, 152×210 cm., signed and dated 1641). Its date and subject rather than its style, composition, and spatial arrangement make it a pendant of the Hals' regent piece. This characteristic Verspronck makes it difficult to understand how Hals' works could ever be confused with those painted by Verspronck (see Cat. no. 100). I also wonder if any of Verspronck's portraits were ever successfully tickled up by unscrupulous artists who wanted to transform a modest Verspronck into a valuable Hals. Verspronck's careful finish of figures and costumes suggest that Hals himself would have had a difficult time retouching them so that they could pass as his own works.

Watercolour copies after Hals' regent portrait by Wijbrand Hendricks (1744–1831) are in the Gemeentemusea Amsterdam, Fodor Collection (Cat. 1863, no. 410) and at the Teyler Foundation. These drawings are possibly identical with copies by Hendricks cited in Amsterdam sales of 1788, 1832, 1833, 1855 and in Haarlem in 1827 (files of the RKD). There is also a drawing at the Albertina after it, and E. K. J. Reznicek has kindly drawn my attention to an anonymous drawing (black chalk on blue paper) after it in the collection of W. van Wenz, Kasteel Heyen, Limburg. Neither the artist De Braay, who made an ink drawing after a regent piece by Hals which was in the sale, L. van Oukerke, 19 May 1818, no. 2, nor his copy has been identified. The drawing may have been after Hals' 1641 or 1664 regent piece.

Valentiner (KdK 1921, 179) published a bust portrait of François Wouters which he called a preparatory study for the regent piece (panel, 46·2×36·2 cm.; dealer, E. Bottenwieser, London; dealer Goudstikker, Amsterdam,

Catalogue no. 28, November 1924, no. 51; sale, Goud-stikker, Amsterdam (Mak van Waay), 4–10 October 1949, no. 29). He rightly eliminated the work from his 1923 catalogue; it is a feeble imitation.

141. Portrait of a Woman Holding a Fan (Plates 219, 221). London, National Gallery (Cat. 1960, no. 2529). Canvas, 79·8 × 59 cm.

PROVENANCE: This painting and the *Portrait of a Man* at the National Gallery, London (our Cat. no. 163; Plate 250) are said to have been in the possession of the London dealer Joseph Flack *ca.* 1865 (see W. S. Spanton, *An Art Student and His Teachers in the Sixties, with other rigmaroles*, London 1927, p. 33); sale, Rev. Robert Gwilt, London, 13 July 1889, no. 78 (£1,680, Agnew); sold by Agnew to George Salting, July 1889; George Salting Bequest, 1910.
EXHIBITION: London, Royal Academy, 1891, no. 127.
BIBLIOGRAPHY: Moes 192; Hofstede de Groot 385; Bode-Binder 257; KdK 201 (*ca.* 1643); Valentiner 1928, p. 248; Neil MacLaren, *National Gallery Catalogues, Dutch School*, 1960, p. 148.

The style and costume of this excellently preserved painting place it around 1640. A similar costume is worn by the woman in Pieter Codde's *Family Portrait* at the National Gallery, which is dated 1640 (Cat. 1960, 2576), and there is an even closer similarity to the costume worn by the woman whose portrait was painted by Johannes Verspronck in 1640 (dealer De Boer, Amsterdam, Cat. January, 1957, repr.).
Stanton's report that the painting and the *Portrait of a Man* now at the National Gallery (Cat. no. 163; Plate 250) were in the hands of the same London dealer *ca.* 1865 (*op. cit.*) may be correct, but it would be erroneous to conclude they were intended as pendants.
Neil MacLaren (*op. cit.*) rightly stated that there are no good reasons for accepting Valentiner's statement (KdK 201) that it is probably the companion picture of the *Portrait of a Man* formerly collection Count Xavier Branicki, sale, London (Sotheby) 26 March 1969, no. 86 (Fig. 177), or his later suggestion (Valentiner, 1928, p. 248) that it is the pendant of the *Man Fingering his Collar Tassel*, Barker Welfare Foundation, New York (Fig. 181). Both of these portraits were painted by imitators of Hals; see Cat. nos. D 56, D 60 respectively.

142. Portrait of a Man (Plate 222). Formerly London, Major A. E. Allnatt. Canvas, 73·6 × 61 cm.

PROVENANCE: The picture was bought by Mr. William Aldam, probably between 1840–50. Mr. Aldam was M.P. for Leeds during this time, and shortly afterwards moved to Frickley Hall, Dorchester. The picture is said to have hung at Frickley Hall from that time until 1926, when Mr. Aldam's son bequeathed it to a member of the Warde-Aldam family, who took it to Healey Hall, Riding Mill, Northumberland (the above information kindly given by Mr. Leonard F. Koetser); Major D. J. Warde-Aldam; sale, London (Sotheby) 7 December 1960, no. 22 (£182,000, Koetser); sold by the London dealer Leonard F. Koetser to Major A. E. Allnatt, London; sale, property of the late D. M. Allnatt, London (Sotheby), 24 June 1970, no. 11 (£120,000, Patch); dealer Brod, London.
EXHIBITIONS: Municipal Art Gallery and Museum, Doncaster, Loan Exhibition, 1922, no. 44 (*Portrait of a Gentleman*, by or attributed to Francis Hals, loaned by W. Warde-Aldam); London, Victoria and Albert Museum, International Art Treasures Exhibition, 1962; Haarlem 1962, no. 48; Brod Gallery, Twelve Portraits, London 1971, no. 3.

The portrait was apparently only exhibited once, at the Gallery in Doncaster, Yorks., in 1922, before it was sold in London in 1960. At that exhibition it was lent by W. Warde-Aldam, which indicates that it passed to Warde-Aldam family before 1935 (see Provenance above).
Close similarities in style and costume to Hals' dated works of the early forties suggest it was painted around 1640–43.

143. Portrait of a Man Holding a Book (Plate 223). Aerdenhout, formerly C. Goekoop. Canvas, 66 × 48·5 cm. Signed at the lower right with the connected monogram: FH.

PROVENANCE: J. Simon, Berlin; dealer F. Kleinberger, Paris; dealer Sulley & Co., London; dealer A. Preyer, The Hague; Mrs. J. Goekoop-de Jongh, Breda; C. Goekoop, Aerdenhout.
EXHIBITIONS: Haarlem, Frans Hals Museum, on loan 1919; Haarlem 1937, no. 92; dealer Kleykamp, The Hague, Cat. 1926, no. 16; Rotterdam 1938, no. 82; Rotterdam, 1955, no. 71; Amsterdam, Historisch Museum, CINOA, Cat. 1970, no. 29 (dealer S. Nystad, The Hague).
BIBLIOGRAPHY: HdG 290; KdK 224 (*ca.* 1645); Trivas 84 (*ca.* 1641–45).

Painted around 1640–43. A clumsy copy at the Walters Art Gallery, Baltimore (canvas, 65 × 49·5 cm.) was erroneously catalogued by Valentiner (1936, 81) as the original with the provenance and a reproduction of Cat. no. 143. In a letter dated 25 March 1938 (files of the Walters Art Gallery) Valentiner states that he had confused the copy with the original. The Baltimore copy was in the sale, Berlin (Lepke) 20 March 1900, no. 65, repr. It was purchased by William Thompson Walters as an original from M. Knoedler and Co., New York, 1903, and listed in *The Walters Collection*, Baltimore [n.d.], p. 90, no. 345. It

is now in the depot of the gallery, correctly catalogued as a copy.

A crude modern pastiche based on Cat. no. 143 was exhibited as 'Dutch School, Seventeenth Century' at the exhibition of the Society 'La Peau de l'Ours' in 1937 at Brussels (see B. J. A. Renckens, 'De Fantasie der Copiisten', *Kunsthistorische Mededeelingen van het Rijksbureau voor Kunsthistorische Documentatie*, I, 1946, pp. 63–64). It was erroneously catalogued as a work by Frans Hals in the sale, Wegg, Brussels (Grioux) 11 May 1925, no. 19.

144. Paulus Verschuur (Plate 247; text, pp. 153, 174; text, Fig. 187). New York, The Metropolitan Museum of Art (Cat. 1954, no. 26.101.11).
Canvas, 118·7×94·6 cm. Inscribed to the right of the head: AETAT SVAE 37/AN° 1643, and signed below the inscription with the connected monogram: FH.

PROVENANCE: Sale, A. J. Bösch, Vienna, 28 April 1885, no. 20 (14,000 florins); dealer C. Sedelmeyer, Paris; Mrs. Collis P. Huntington, New York; gift of Archer M. Huntington to the museum in 1926.
EXHIBITIONS: New York, Hudson-Fulton Celebration, 1909, no. 35; Detroit 1935, no. 38; Los Angeles 1947, no. 15; Raleigh 1959, no. 63.
BIBLIOGRAPHY: Moes 136; HdG 360; Bode-Binder 273; KdK 208; Valentiner 1936, 74; Trivas 85; S. J. Gudlaugsson, 'Een portret van Frans Hals geïdentificeerd', *O.H.*, LXIX (1954), pp. 235ff.

Sturla J. Gudlaugsson (*op. cit.*) identified the model of this three-quarter length as the Rotterdam merchant Paulus Verschuur (1606–67) upon the basis of a free copy of the bust by Pieter van der Werff (1655–1722). This copy (repr., *ibid.*, p. 235, fig. 2) is at the Rijksmuseum, Amsterdam (inv. no. 2651; canvas, 82×68 cm.) and is one of a series of portraits he painted of administrators of the Dutch East India Company around 1700. Verschuur was the owner of the largest textile mill in Rotterdam, often a member of the city council and burgomaster of the city seven times as well as a director of the Dutch East India Company. It is significant that this wealthy merchant and important civic leader did not choose a portraitist from Rotterdam or nearby Delft. The commission is proof that the artist continued to find patronage among upper-class circles in the forties. Gudlaugsson suggests (*ibid.*, p. 236) that perhaps the powerful Rotterdam textile manufacturer made contact with the artist through business connections with the Coymans family. The latter's powerful firm included textile dyeing among its activities; for Hals' portraits of members of the Coymans family see Cat. no. 160.

145. Portrait of a Man (Plate 227). Midhurst, Sussex, Viscount Cowdray.

Canvas, 92·7×75 cm. At the upper right an unidentified coat-of-arms (two [white?] wolves' [foxes'?] heads on a red field). Below it inscribed: AETA SVAE/AN° 1643, and signed with the connected monogram: FH.

PROVENANCE: Lord Glenesk(?), Scotland; dealer Sir G. Donaldson, London; dealer Colnaghi, London; Sir George A. Drummond, Montreal; sale, Drummond, London (Christie) 26–27 June 1919, no. 182 (£26,775; Agnew).
EXHIBITIONS: London, Royal Academy, 1891, no. 71; London, Barbizon House, no. 18; London 1952–53, no. 58; Haarlem 1962, no. 51.
BIBLIOGRAPHY: Wrongly identified as Joseph Coymans by Moes 28, HdG 169, Bode-Binder 207; KdK 209.

Attempts to identify the model have failed. He was erroneously identified as 'Johann van Loo, Colonel of the Archers of St. George' when the painting was exhibited in London, 1891; for portraits of Colonel Johan Claesz. Loo see Cat. nos. 79, 124; Plates 127, 201. As noted above, Moes, Hofstede de Groot, and Bode-Binder erred when they identified him as Joseph Coymans. Their identification was based on a wrong reading of the coat-of-arms. Coymans' arms show three black oxen's heads on a gold field, not wolves' (foxes'?) heads on a red one (see Cat. no. 160). Moes (29) and Hofstede de Groot (170) also mistakenly called the portrait a pendant to our Cat. no. 161.

146. Portrait of a Man Holding a Watch (Plate 229, text, p. 25). Merion, Pennsylvania, The Barnes Foundation (inv. no. 262).
Canvas, 82·2×66·2 cm. Inscribed to the right of the model's head: AETAT SVAE 57/AN° 1643.

PROVENANCE: Sale, Widow Merkman, née I. van Leeuwaarden, Haarlem, 21 September 1773, no. 5; Comte d'Espeilles; E. Warneck, Paris; Charles H. Senff, New York; sale, Mrs. C. H. Senff, New York (Anderson Galleries), 28 March 1928, no. 26 ($47,500; Barnes).
BIBLIOGRAPHY: HdG 332; Bode-Binder 199; KdK 203 left; Valentiner 1936, 69; Trivas 87.

Companion picture to Cat. no. 147. Both paintings have scattered losses. Trivas (87) rightly notes the letters and numerals of the inscription on the man's portrait differ from those found on other works of the period. They may have been considerably retouched by another hand or added later. The inscription on the woman's portrait appears to have been strengthened. The heads of both pictures are a bit thin, but the hands of both, which make important accents in the pendants, are in a fine state of preservation.

Although it is not inconceivable that the gold watch the man holds refers to his occupation as a horologist or his

activities as a watch collector, it is more probably a traditional allusion to the brevity of man's life and an admonition to the spectator to use his time well. For a discussion of the frequent use of watches, clocks, and hour glasses in Dutch still-lifes as symbols of the transience of human life see I. Bergström, *Dutch Still-Life Painting in the Seventeenth Century*, trans. by C. Hedström and G. Taylor, New York, 1956, pp. 154*ff.*

Excellent drawings after the Barnes picture and its pendant by Jan Gerard Waldorp (1740–1809) are at the Rijksprentenkabinet, Amsterdam (black chalk on parchment, 31×25·5 cm.); sale, Carl Schoeffer, Amsterdam, 30 May 1893, lot 457 (105 florins, bought in by Moes); sale, Jhr. Alfred Boreel and others, Amsterdam, 15 June 1908, lot 653 (bought for the Prentenkabinet). Each drawing is inscribed: F. Hals pinx 1643/J. G. Waldorp/an 1780.

147. Portrait of a Woman (Plate 230). Stockholm, National Museum (acc. no. NM 6421).
Canvas, 82·6×67·3 cm. Inscribed to the left of the sitter's head: AETAT SVAE 52/ANº 1643.

PROVENANCE: Sale, Widow Merkman, née J. van Leeuwaarden, Haarlem, 21 September 1773, no. 6; Comte d'Espeilles; E. Warneck, Paris; Charles H. Senff, New York; sale, Mrs. C. H. Senff, New York (Anderson Galleries) 28 March 1928, no. 25 ($55,000; Knoedler); Mrs. Charles S. Payson, New York; D. M. Allnatt, London; sale, property of the late D. M. Allnatt, London (Sotheby), 30 June 1971, no. 20; dealer Brod Gallery, London, Cat. 1971, no. 2; given to the National Museum in 1972 by His Majesty the King of Sweden through the Friends of the National Museum.
EXHIBITION: Brod Gallery, Twelve Portraits, London, Catalogue 1971, no. 2.
BIBLIOGRAPHY: HdG 402; Bode-Binder 200; KdK 203 right; Valentiner 1936, 70; Trivas 86.

Companion picture to Cat. no. 146.

148. Portrait of a Man (Plate 228). Stiftung Preussischer Kulturbesitz, on loan to Kiel, Schloss Museum, Stiftung Pommern.
Canvas, 79·2×65·3 cm. Signed at the lower right with the connected monogram: FH.

PROVENANCE: In the collection of Mr. Scheeffer, Stettin, about 1850, with its presumed pendant (see Cat. no. D 74). Both were given by his daughter Frau Regierungsrat Woldermann to the Municipal Museum, Stettin, in 1863. They were evacuated from Stettin to Coburg, in spring, 1945, and were acquired by the Stiftung Preussischer Kulturbesitz in 1965 when the government of the Federal Republic of Germany made the Stiftung the custodian-executor of all art and cultural treasures evacuated from the former eastern provinces of the German Reich.
BIBLIOGRAPHY: Bode 1883, 119; Moes 103; HdG 315; Bode-Binder 197; KdK 198; *Führer durch das Museum der Stadt Stettin*, 1924, pp. 64, 69; Kunze, 'Zwei Gemälde des Frans Hals', *Die Weltkunst*, XI, nos. 36–37, 12 September 1937, p. 1 (report on a restoration which revealed the monogram; *ca.* 1646–47); *Gemäldegalerie der Stiftung Pommern im Rantzaubau des Kieler Schlosses* [Neumünster, 1971], no. 47, repr.

I have not seen the painting but to judge from photographs I find no reason to doubt that it is an original painted around 1640–43. Professor Wolfgang J. Müller, who kindly provided the particulars of the Provenance cited above, has informed me that the portrait is excellently preserved. The handling is related to the treatment of the man seated on the extreme left of Hals' 1641 regent piece (Cat. no. 140; Plate 226); however, I do not see the facial resemblance Valentiner noted (KdK 198) between the two sitters. A weak copy of the portrait was with the dealer Norbert Fishman Gallery, London, in 1959, canvas, 76·5×62·2 cm., reproduced *B.M.*, CL (1959), p. XXIX. The copy was formerly in the collection Lewis Fry; exhibited London, Royal Academy, 1882, no. 107 and at the Central Museum, Northampton, around 1959.
For the *Portrait of a Woman*, formerly at Stettin, which has erroneously been called a pendant of Cat. no. 148, see Cat. no. D 74; Fig. 195.

149. Portrait of a Man (so-called Herr Bodolphe) (Plates 231, 233; text, pp. 158, 174). New Haven, Yale University Art Gallery, Bequest of Stephen C. Clark (inv. no. 1961.18.23).
Canvas, 122·4×97·5 cm. Inscribed to the right of the sitter's head: AETAT SVAE 73/ANº 1643, and signed below the inscription with the connected monogram: FH (Fig. 59).

PROVENANCE: Sale, Odier, Paris, 25 March 1861; Count André Mniszech, Paris; J. Pierpont Morgan, New York; Stephen C. Clark, New York, who bequeathed it to the gallery in 1961.
EXHIBITIONS: Th. Agnew and Sons, London, 1906; on loan in 1907 at The Metropolitan Museum, New York and in the Hudson-Fulton Celebration at that museum in 1909, no. 33; Haarlem 1937, no. 85; New York 1939, no. 184; New Haven, Yale University Art Gallery, Pictures Collected by Yale Alumni, 1956, no. 8; Haarlem 1962, no. 49.
BIBLIOGRAPHY: Bode 1883, 55; *Pictures in the Collection of J. Pierpont Morgan at Princes Gate and Dover House, Dutch and Flemish . . .*, London, 1907, unpaginated and unnumbered; B.[ryson] B[urroughs]., 'A Recent Loan', *The Bulletin of the Metropolitan Museum of Art*, II (1907), pp.

23, 140–141; Moes 105; HdG 157; Bode-Binder 208; KdK 204; Valentiner 1936, 72.

Companion picture to Cat. no. 150. These distinguished knee-length portraits rank with the finest Hals painted during the 1640's. In 1923 Valentiner wrote (KdK 204) that he did not know the basis of the traditional identification of the couple as Bodolphe and his wife. In 1936 (no. 72) he noted it was based on a later inscription on the back of the man's portrait and added that it was scarcely convincing. Today even this shred of evidence has vanished. Professor E. Haverkamp Begemann has kindly informed me that there is no name on the back of the relined canvas, stretcher or frame.

150. **Portrait of a Woman (so-called Mevrouw Bodolphe)** (Plates 232, 234; text, p. 158). New Haven, Yale University Art Gallery, Bequest of Stephen C. Clark (inv. no. 1961.18.24).

Canvas, 122·4×97·5 cm. Inscribed to the left of the sitter's head: AETAT SVAE 72/AN° 1643, and signed below the inscription with the connected monogram: FH.

PROVENANCE: Sale, Odier, Paris, 25 March 1861; Count André Mniszech, Paris; J. Pierpont Morgan, New York; Stephen C. Clark, New York, who bequeathed it to the gallery in 1961.
EXHIBITIONS: Th. Agnew and Sons, London, 1906; on loan in 1907 to The Metropolitan Museum and in the Hudson-Fulton Celebration, at that museum in 1909, no. 34; Haarlem 1937, no. 86; New York 1939, no. 185; New Haven, Yale University Art Gallery, Pictures Collected by Yale Alumni, 1956, no. 9; Haarlem 1962, no. 50.
BIBLIOGRAPHY: Bode 1883, 56; *Pictures in the Collection of J. Pierpont Morgan at Princes Gate and Dover House, Dutch and Flemish...*, London, 1907, unpaginated and unnumbered; B[ryson]. B[urroughs], 'A Recent Loan', *The Bulletin of the Metropolitan Museum of Art*, II (1907), pp. 23, 140–141; Moes 106; HdG 148; Bode-Binder 209; KdK 205; Valentiner 1936, 73.

Companion picture to Cat. no. 149.

151. **Portrait of a Man** (Plate 235). Washington, George L. Weil.

Panel, 31·7×29·2 cm. Signed below the hand, with the connected monogram and dated: FH/1643.

PROVENANCE: Collection Mihály de Munkácsy, Paris; dealer C. Sedelmeyer, Paris, Cat. 1898, no. 56; Rudolf Kann, Paris; purchased *en bloc* with the Kann collection in 1907 by the dealers Duveen; dealers Dowdeswell, London; acquired from the New York dealer Henry Reinhardt in

1912 by Meyer H. Lehman, New York (died 1918), who bequeathed it to Miss Bertha Rosenheim, New York, and by descent to the present owner.
BIBLIOGRAPHY: W. Bode, *Gemäldesammlungen des Herrn Rudolf Kann*, Vienna, 1900, no. 51; *Catalogue of the Rudolphe Kann Collection*, vol. I, Paris 1907, no. 43; Moes 137; HdG 302; Bode-Binder 204; KdK 202; Valentiner 1936, 71.

The date of 1643 inscribed on this portrait is of special interest; it is the latest known date on the small portraits which can be assigned to Hals' mature and late phases. The chronology for the others (Cat. nos. 153–155, 199, 206–213) must be established from stylistic evidence.
Hals' works were admired and studied by many nineteenth-century artists but as far as I know this fine little sketch was the only one which found its way into the collection of a painter of that period. It was owned by the Hungarian artist Mihály de Munkácsy (1844–1900), who studied in the academies at Budapest, Vienna, Munich and Düsseldorf and finally settled in 1872 in Paris, where he won great popular acclaim for his religious and historical pictures. Munkácsy was a skilful draughtsman and expert technician, who found inspiration in paintings by the seventeenth-century Dutch realists as well as those done by Courbet. No copies by Munkácsy of Hals' pictures have been identified but it would not come as a surprise if some of his works done in Hals' style appeared. It is also noteworthy that Munkácsy had close contact with the Paris dealer Charles Sedelmeyer, through whose hands dozens of paintings rightly and wrongly attributed to Hals passed. Sedelmeyer, who also possessed the Weil painting for a brief period, is best known as an old master dealer. However, he also did what he could to promote the Hungarian artist: see *Christ on Calvary by M. de Munkacsy* published by Ch. Sedelmeyer, New York and Paris, 1887, and C. Sedelmeyer, *M. von Munkácsy, Sein Leben und künstlerische Entwicklung*, Paris, 1914.

152. **Conradus Viëtor** (Plate 248; text, p. 197). London, Lord Robert Crichton-Stuart.

Canvas, 81·9×61·5 cm. Signed at the upper right with the connected monogram: FH, and inscribed below: M. CONRADVS VIËTOR/AETATIS 56/A° 1644.

PROVENANCE: Collection Marquis of Bute, London.
EXHIBITION: Glasgow 1884, no. 69.
BIBLIOGRAPHY: Bode 1883, 135 (*ca.* 1635); Jean Paul Richter, *Catalogue of Paintings Lent for Exhibition by the Marquess of Bute*, Glasgow 1884, no. 69 (identifies sitter); *Icon. Bat.* 8491–2; Moes 81; HdG 236; Bode-Binder 203; KdK 214.

Abrasion and discoloured varnish partially obscure the inscription. The portrait was engraved in reverse by Jonas Suyderhoef (text, Fig. 210; Wussin 2), inscribed: F. Hals

pinxit. I. Suijderhoef sculp. As noted in the text (p. 197), the verse inscribed on the print gives the engraver rather than the painter credit for the portrait: 'Den prenter geeft dit beelt van die dien God gaf t'wesen . . .'. The inscription on the engraving tells us the principal facts of Vietor's life: he was born in Aachen in 1588, became a Lutheran preacher and was called to Haarlem in 1617, where he remained until his death in 1657 (also see Molhuysen, vol. IX, col. 1210). It also establishes that Suyderhoef made his print at least thirteen years after Hals painted the portrait.

153. **Portrait of a Man** (Plate 237; text, pp. 30, 162). Cassel, Hessisches Landesmuseum (Cat. 1958, no. 218).
Panel, 29·5 × 23 cm. Inscribed in red with the old inventory number (see provenance) to the left of the shoulder: 1070.

PROVENANCE: Listed with the pendant (Cat. no. 154) in the *I^tes Supplement zum Haupt-Inventarium A. de anno 1749 von Sr Hochfürstl. Durch^lt Herren Land Grafens Wilhelm zu Hessen*, no. 1070, no. 1071 (our Cat. nos. 153, 154): Franz Hals. Zwey Manns-Brustbilder, mit Schnautz-Bärten, weissen Kragen und grossen Hüthen. Auf Holz. (Höhe: 11 Zoll; Breite: 9 Zoll). They were taken to Paris by Denon in 1806, and returned in 1815. The pendants are also listed in the 1783 inventory of Schloss Altstadt, Cassel, nos. 212 and 213.
BIBLIOGRAPHY: Bode 1883, 102 (*ca.* 1655); Moes 172; HdG 267 (*ca.* 1650); Bode-Binder 215; KdK 232 (*ca.* 1646–47); Trivas 82 (*ca.* 1641–44).

Pendant to Cat. no. 154. The inventory numbers assigned to the portraits in the First Supplement of the *Haupt-Inventarium* of 1749, which are still visible on the face of the paintings, are wrongly listed by Hofstede de Groot, Trivas and the Cassel catalogue of 1958.
These memorable little paintings may have been commissioned as companion pieces or were possibly studies for a group portrait which has been lost or was never executed. They are related to dated works painted around 1640–45. Cat. no. 153 is done throughout with less liquid paint than its pendant and in a raking light it is possible to see that the model was originally portrayed wearing a wide collar edged with lace. Though these features suggest that Cat. no. 153 may have been painted a few years earlier than Cat. no. 154, it would be foolhardy to insist that they were not painted around the same time. Surely, if Hals could use a different touch in passages of the same painting (see Cat. no. 46) he also could vary the viscosity of the paint he used for pendants. Moreover, painting out a white collar in order to show a slightly more fashionable one demanded heavy paint; a change in the consistency of paint in one area probably resulted in adjustments of its weight in other passages.

154. **Portrait of a Man Holding Gloves** (Plate 238; text, pp. 30, 162). Cassel, Hessisches Landesmuseum (Cat. 1958, no. 217).
Panel, 30·5 × 24·5 cm. Inscribed with the old inventory number: 1071.

PROVENANCE: See Cat. no. 153.
BIBLIOGRAPHY: Bode 1883, 103 (*ca.* 1655); Moes 173; HdG 266 (*ca.* 1650); Bode-Binder 216; KdK 233 (*ca.* 1646–1647); Trivas 83.

See the remarks about the pendant, Cat. no. 153.

155. **Seated Man Holding a Branch** (Plate 236; text, p. 162). Ottawa, National Gallery of Canada (inv. no. 15,901).
Panel, 42·4 × 33·2 cm. Signed at the lower right with the connected monogram: FH.

PROVENANCE: Probably sale, J. van der Marck, Amsterdam, 25 August 1773, no. 441 (as a portrait of Frans Post); Bononi-Cereda, Milan; dealer P. and D. Colnaghi, London; Oscar Huldschinsky, Berlin; sale, Huldschinsky, Berlin (Cassirer), 10 May 1928, no. 11, as a portrait of Frans Post; Gerald Oliven, Beverly Hills, California; sale, Oliven, London (Sotheby), 24 June 1959, no. 66, as a portrait of Frans Post (£48,000; Leonard Koetser); Major A. E. Allnatt; acquired by the gallery in 1969.
EXHIBITIONS: Dealer P. and D. Colnaghi, 1896, no. 21; Berlin, Kaiser-Friedrich Museumsverein 1906, no. 48; Berlin, Akademie, Bildnis-Ausstellung, 1909, no. 47; London, Victoria and Albert Museum, International Art Treasures Exhibition, 1962; Haarlem 1962, no. 54.
BIBLIOGRAPHY: *Icon. Bat.*, no. 6034 (as Frans Post); Moes 166; HdG 258; Bode-Binder 242; KdK 212 (*ca.* 1644).

Painted around 1645. The sitter has been erroneously identified as the Haarlem painter Frans Post more than once. Hals did indeed paint a portrait of Frans Post (Cat. no. 206; Plate 318), which can be securely identified upon the basis of Jonas Suyderhoef's contemporary engraving of it (Fig. 49). Hals' portrait of Post is also a small panel (27·5 × 23 cm.) and he too is portrayed with long hair, wearing a hat, and seated with his right arm resting on the back of a chair. But not much more than a glance is needed to show that the sitters are not identical.
Shortly after the National Gallery of Canada acquired the painting, Gyde Shepherd, Curator of European Art, kindly called my attention to the likeness the model bears to that in Hals' picture at Washington of the early fifties, which may be a portrait of Adriaen van Ostade (Cat. no. 192; Plate 303). Claus Grimm, 'Ein meisterliches Künstlerportrait: Frans Hals' Ostade-Bildnis,' *O.H.*, LXXXV (1970), p. 172, independently made the same observation. However, Grimm's argument that the Ottawa picture is a workshop

variant after the Washington portrait is as unconvincing as his suggestion that the Ottawa panel was painted by Frans Hals the Younger.

Frans II remains a shadowy figure; none of the works which have been ascribed to him (or to any of Hals' other followers) remotely approximates the quality of the Ottawa portrait. All we know for certain about Frans the Younger is that he did not paint the still-lifes formerly attributed to him; A. Bredius (*O.H.*, xxxv, 1917, pp. 1*ff.*) showed that these works were done by François Rijkhals. The attribution of the *Portrait of a Man* (Fig. 35), which bears a hardly legible signature and date, 165[?], Museum Bredius, The Hague (inv. no. 51-1946) and the *Armourer* (Figs. 36, 58) at the Hermitage (Cat. 1958, no. 986) are ascribed to him on the basis of their signatures, but until incontrovertible evidence is discovered which establishes that the enigmatic signatures on these disparate works are in fact his, these ascriptions can only be regarded as highly tentative. The intriguing Hermitage painting is vaguely related to works by Jan de Bray; see his signed and dated small oval portraits of boys, Edinburgh, Cat. 1957, no. 1502, dated 1663, and no. 1503, dated 1662; these portraits and companion pictures of a man, no. 1500, dated 166[3?], and a woman, no. 1501, dated 1663, were formerly ascribed to Hals; all four are reproduced in J. W. von Moltke, 'Jan de Bray', *Marburger Jahrbuch*, xi–xii, p. 479, fig. 50. The *Armourer* also recalls works by members of Ter Borch's circle (*e.g.*, his brother and pupil Mozes), and I have considered the unprovable supposition that Hals' pupil Philips Wouwerman may have produced works of this type. Investigation of these possible attributions has turned up nothing conclusive. There is no foundation for other attributions which have been made to Frans the Younger: *e.g.*, the Dresden pastiche of *Malle Babbe with a Smoking Man* (see Cat. D 34; text, Fig. 155) or *The Miser* at the John G. Johnson Collection, Philadelphia Museum of Art (Cat. 1972, no. 436).

Claus Grimm's article 'Frans Hals und seine "Schule" ', *Münchner Jahrbuch der bildenden Kunst*, xxii, 1971, pp. 147*ff.*, appeared after the manuscript of this catalogue had been completed. In it he drops the reservations he had expressed in 1970 (*op. cit.*) about attributing Cat. no. 155 to Frans Hals the Younger and categorically ascribes it to him. He also assigns no less than 34 other paintings to Frans the Younger. In my opinion he has put together a heterogeneous group which includes outstanding originals by Frans Hals the Younger's father, copies after his father's lost works, and pictures by his father's nameless followers and imitators, and fails to provide sufficient arguments for attributing any painting in this mixed lot to Hals' nebulous namesake. Nor am I convinced by the reasons he gives for reviving Jan Six's view that Judith Leyster painted *Feyntje van Steenkiste* at the Rijksmuseum (see Cat. no. 105) or those offered to establish that his 'Fisherchildren Master' painted the pictures he ascribes to him. Grimm also attributes 18 portraits to Jan Hals. Apart from the seven

which were first published in Slive 1961, pp. 176*ff.* and perhaps the lost *Portrait of a Seated Young Man*, which Grimm lists and dates around 1655–65 (*op. cit.*, 1971, p. 156, no. 18; pp. 159–160) on the basis of a mezzotint by the English printmaker and dealer Samuel Okey, Junior (active in London, *ca.* 1765–70; in Newport, Rhode Island, *ca.* 1773–74), I cannot accept his attributions to Jan either.

In regard to the lost *Portrait of a Seated Young Man*, the sole reason for assigning it to Jan Hals is the inscription on Okey's mezzotint. The print has been recorded as the only existing documented one after a painting by Jan (Wurzbach, vol. I, p. 642; Hollstein, vol. VIII, p. 214, no. 1). Its status is shaky, however. Neither Grimm nor earlier cataloguers have observed that the inscription can be read as 'F. Halls, pinxit.' or 'J. Halls, pinxit.'. Now, even assuming that Okey's print is a reliable reproduction, it was obviously not made after an authentic portrait by Frans Hals, but it is possible that Okey wrongly attributed it to him. If the correct reading of the inscription is 'F. Halls pinxit.' (and I think it is) the sole basis for ascribing the work to Jan crumbles. Grimm also expresses doubts about 'die Ueberlieferung für das modische Beiwerk, das häufig von den Nachstechern verändert und ergänzt wurde' (*ibid.*, p. 159). They are unjustified. The large cuffs and enormous lace-trimmed collar were not changes or additions introduced by the eighteenth-century printmaker. These accessories faithfully show fashions which began to appear in the late 1660's (see Ter Borch's *Portrait of a Young Man*, Zurich, Kunsthaus, Ruzicka Foundation; repr. in S. J. Gudlaugsson, *Gerard Ter Borch*, vol. I, The Hague, 1959, p. 356) and establish a *terminus post quem* for the portrait. Finally, a faithful painted version of the portrait, apparently unknown to Grimm, is in the estate of the late Robert W. Reford, Montreal, Canada (canvas, 90·2 × 73·7 cm). PROVENANCE: Said to have been in the collection of Mrs. Swann, Oswestry (or Whittington Oswestry), Shropshire; purchased from the dealer Wildenstein as a Frans Hals by Robert W. Reford ($70,000) in 1928. BIBLIOGRAPHY: Hubbard 1956, p. 151 (Frans Hals; *ca.* 1655). The painting, which is in the same direction as the print, is by an unidentified artist who was probably active in the eighteenth century. On the basis of our present knowledge, it is not possible to determine whether the anonymous painting served as the model for Okey's mezzotint or was copied after it. But the former possibility cannot be ruled out, and it raises additional doubts about the reliability of Okey's inscription and the attribution of the lost portrait to Jan.

Jan Gerard Waldorp (*ca.* 1740–1808) made two careful black chalk drawings on parchment after Cat. no. 155 (perhaps Waldorp owned it). One is in the Frans Hals Museum, Haarlem, and is inscribed with the connected monogram to the right of the head: FH pinx/J. G. Waldorp del/1778. Hals' monogram does not appear in the lower right corner. It does, however, make an appearance in the second drawing, made twelve years later by Waldorp, which is now at the Teyler Foundation, Haarlem

(Panpoëticon 990). Perhaps a late eighteenth-century restoration revealed it, or the monogram, which is uncommonly large, may have been added by another hand. The Teyler copy is inscribed at the upper right: F. Hals pinx/J. G. Waldorp del 1790, and on the verso: de Digter Post.

Waldorp's drawing after a lost Hals *Portrait of a Woman* (Cat. L 20; Fig. 100; Frans Hals Museum, Haarlem) is inscribed with the connected monogram: FH pinx/1644/ J. G. Waldorp del/1779, and has been called a copy after the lost companion piece to the Ottawa portrait (Bode-Binder 243, KdK 213). There is no good reason for this conclusion; neither the size of the figure nor her position in space is compatible with the arrangement of her alleged companion.

The branch the sitter holds may have an emblematic meaning but until it can be named its significance remains problematic. Botanists consulted have neither accepted Hofstede de Groot's conclusion that it is holly (HdG 258) nor been able to identify it. It is consoling to know that at times other specialists have difficulty making attributions.

156. **Portrait of a Standing Man** (Plate 239). Edinburgh, National Gallery of Scotland (Cat. 1957, no. 691).
Canvas, 114·9 × 86 cm.

PROVENANCE: Presented to the gallery by the Rt. Hon. William McEwan, 1885.
EXHIBITION: Lent to the gallery by Major Jackson, St. Andrews, 1884–85; London 1929, no. 114.
BIBLIOGRAPHY: Moes 109; HdG 274 (*ca.* 1635–40); Bode-Binder 169; KdK 206 (*ca.* 1643).

Companion picture to Cat. no. 157. Painted around 1643–45. The man's portrait is related to Hals' three-quarter length dated 1643 of *Paulus Verschuur* (Cat. no. 144; Plate 247); his pose, however, is more frontal and his face is seen in fuller light. *Dorothea Berck*, painted in 1644 (Cat. no. 161; Plate 244), wears a collar similar to the one worn by the woman.

It would be boring as well as pointless to list the countless copies which have been made after Hals' portraits. However, readers of this text will be interested to know that a faithful drawing after the bust of the man was made by Frits Lugt in 1901 (see M. F. Hennus, 'Frits Lugt: Kunstvorser, Kunstkeurder, Kunstgaarder', *Maandblad voor Beeldende Kunsten*, XXVI (1950), p. 81, repr.).

157. **Portrait of a Standing Woman** (Plates 240, 245). Edinburgh, National Gallery of Scotland (Cat. 1957, no. 692).
Canvas, 115·5 × 85·7 cm.

PROVENANCE: Presented to the gallery by the Rt. Hon. William McEwan, 1885.
EXHIBITION: Lent to the gallery by Major Jackson, St. Andrews, 1884–85.
BIBLIOGRAPHY: Moes 110; HdG 377; Bode-Binder 170; KdK 207 (*ca.* 1643).

Companion picture to Cat. no. 156.

158. **Portrait of a Man** (Plate 241). Fort Worth, Texas, Kimbell Art Museum (inv. no. AP 65.2).
Canvas, 87·9 × 65·1 cm.

PROVENANCE: Around 1930 in the possession of L. Hofman, Zutphen, who sold it to M. C. van Mourik. His widow, Mrs. M. C. van Mourik-Spoor, Huize Midwijk, Vorden, sold it in 1962 to Th. J. van Beukering, Arnhem, who put it up for sale at an auction scheduled for 19 July 1963, at Arnhem (J. C. Derksen Sr.); purchased outside of the sale on 19 July 1963 by Mr. and Mrs. Leonid Hotinov, Muiderberg (40 florins, 25 stuivers), who sold it to Mrs. Gisela Kemperdick, Kaster (near Cologne), Germany; sale, property of G. Kemperdick, London (Christie), 26 November 1965, no. 70 (£73,500; Walter Goetz for the Kimbell Foundation).
EXHIBITION: Haarlem, Frans Hals Museum, April–May, 1965.
BIBLIOGRAPHY: H. P. Baard, 'Wedergeboorte en lotgevallen van de "Hotinov-Hals" ', *O.H.*, LXXX (1965), pp. 211–219, Kimbell Art Museum, Catalogue 1972, pp. 55f.

The painting was acquired in Arnhem for 40 florins, 25 stuivers by the Hotinovs in 1963 as an anonymous work. At that time it was heavily repainted (Fig. 37) and perhaps would have been recognizable as a Hals by an expert with X-ray vision. The Hotinovs brought it to a restorer, who stripped it of its repaint. He presumably recognized it as a Hals and repainted it again, presumably to disguise its true authorship. He attempted to buy it from the Hotinovs, but they did not sell it and subsequently brought it to another cleaner, who removed the first restorer's repaint. It was brought in this state to H. P. Baard, Director of the Frans Hals Museum on 13 May 1964 for an attribution. He rightly identified it as a work painted by Hals around 1643–45. When it was sold in London in 1965 it fetched £75,500, an increase of 29,400% in the price paid for it in 1963.

Baard (*op. cit.*, p. 212) dated the frame in which the picture was sold about 1860–70 and dated fragments of a sales catalogue on the back of the frame around the same time. On the basis of this evidence Baard suggests that the repaint seen in Fig. 37 was probably done around or before 1860–70, perhaps to give the portrait a more finished look. The removal of repaint has not damaged the painted surface. When the painting was restored at the Frans Hals Museum in 1964–65, and relined and restored again in 1969,

there was little evidence of abrasion; there are a few scattered losses and one L-shaped tear in the right centre. The treatment of the head and collar as well as the tonality of the painting relate it closely to the *Portrait of a Man* at Edinburgh (Cat. no. 156; Plate 239). The summary painting of the thing the model holds in his hand makes it difficult to identify. Perhaps it is a glove or a swatch of cloth. It has also been suggested that it is a bundle of hops or grouse tail feathers (*ibid.*, pp. 213–214). If it is the former the hops probably refer to the model's activities as a brewer; if it is the latter, Hals employed an attribute which is as difficult to decipher as a Mayan hieroglyph.

159. **Portrait of a Man** (Plate 242; text, pp. 129, 153–154). Amsterdam, Six Collection.
Oval panel, 74·5 × 60·8 cm. Inscribed on the verso: A 16[4]4/den 12 augst.

EXHIBITION: Amsterdam, Six Collection, 1900, no. 39.
BIBLIOGRAPHY: Bode 1883, 21 (*ca.* 1655); *Icon Bat.*, no. 8113–5 (Nicolaes Tulp); Moes 79 (Nicolaes Tulp); HdG 234 (Nicolaes Tulp?, canvas); Bode-Binder 210 (Nicolaes Tulp?, canvas); J. Six, 'Naar Aanleiding van de Frans Hals Tentoonstelling in 's Rijksmuseum', *Onze Kunst*, XXIX, 1916, pp. 98*ff.* (Nicolaes Tulp); KdK 218 (Nicolaes Tulp, canvas); A. Heppner, 'Twee geleerden geportretterd door Rembrandt en tevens door Frans Hals', *Op de Hoogte*, XXXIV, 1937, pp. 236*f.* (Nicolaes Tulp); W. R. Valentiner, 'Jan van de Cappelle', *The Art Quarterly*, IV, 1941, p. 296, note 7 (Nicolaes Tulp).

The third digit of the year inscribed on the verso of the panel appears to be a *3* which has been transformed into a *4*; however, the former numeral is now more distinct than the latter. Adjustment of the date from 1634 to 1644 suggests the painting was originally made in 1634 and repainted by the artist a decade later. In any event there can be no question that the collar was changed and the hat was an afterthought. Pentimenti in these areas are visible to the naked eye and clearly evident on the X-ray photos, which are on file at the Rijksmuseum, Amsterdam. The X-rays distinctly show that the model originally wore a large ruffled collar similar to those worn by most of the officers in Hals' St. Hadrian militia piece of 1633 (Cat. no. 79; Plate 127) and in other portraits done around this time, and the density pattern of the whites visible on the forehead in the X-rays reveal that the hat is a later addition. The modernized high flat collar and the size and shape of the brim of the hat as well as the dark tonality of the portrait are all consistent with the 1644 date.
Comparison with numerous other portrayals of Nicolaes Tulp proves there is no foundation for the identification offered by some critics that the model is the famous Amsterdam doctor; for a partial list of portraits of Tulp, see *Icon. Bat.*, no. 8113. Dr. A. Staring has kindly informed

me (letter, 25 July 1966) that the erroneous identification of the model as Tulp dates from the nineteenth century when the Six family acquired the portrait. I have been unable to establish the origin of the mistaken identification or the early history of the work. Possibly the painting is identical with the portrait by Hals identified as Nicolaes Tulp which appeared in the sale, Jan Matthias Cok, Amsterdam, 16 December 1771, no. 94 (HdG 234a).
Although it cannot be claimed that Cat. no. 159 is a portrait of Tulp and there is no evidence that it had been in the Six collection during the seventeenth or eighteenth centuries, it is noteworthy that Tulp's daughter, who married Jan Six (28 June 1655) had one of the artist's paintings. It is listed in the 'Witte Zaal' in the 9 October 1709 inventory of the estate of Margaretha Tulp, widow of Jan Six (Amsterdam Archives, NAA no. 4845, p. 748; information from S. A. C. Dudok van Heel). Neither the painting's subject nor its subsequent history is known.

160. **Joseph Coymans** (Plate 243; text, pp. 159, 170, 172, 185; text, Figs. 178, 183). Hartford, Connecticut, Wadsworth Atheneum (inv. no. 1958.176).
Canvas, 84 × 69·5 cm. Inscribed and dated to the right of the model's head: AETA SVAE 52/1644. The sitter's coat-of-arms appears above the inscription: three black oxen's heads and necks on a gold field.

PROVENANCE: According to an inscription on the stretcher the painting was: 'Bought from MR/[William] Forest (Strand)/Oct. 1850/[by] James Carnegie'; Sir James Carnegie became the Earl of Southesk in 1855; Maurice Kann, Paris; dealer Duveen, London, 1910; dealers Dowdeswell, London, 1911; dealers Reinhardt, New York, 1913; John N. Willys, Toledo; sale, Isabel Van Wie Willys, New York (Parke-Bernet) 25 October 1945, no. 17; Louis and Mildred Kaplan, New York, from whom it was acquired by the Atheneum in 1958.
EXHIBITIONS: London, Grafton Galleries, National Loan Exhibition, 1909, no. 36 (Duveen); Toledo, Museum of Art, 1913; New York 1939, no. 189; Haarlem 1962, no. 52.
BIBLIOGRAPHY: Possibly Moes 146; [anon.] 'A Portrait by Hals at the Grafton Galleries', *B.M.*, XVI, 1909, pp. 109–110 (identification of the sitter as Joseph Coymans). The painting is not listed in the 1910 German edition of HdG; in the English translation made by Edward G. Hawke, HdG 304 confuses the provenance of a portrait formerly in the Lionel Straus collection (see our Cat. no. D 53) with the painting now in Hartford. Hawke corrected his error in vol. IV, 1912, p. viii, of his translation of Hofstede de Groot's catalogue and numbered the Hartford painting 304a. Bode-Binder, 211; KdK 210; Valentiner 1936, 75; W. R. Valentiner and Paul Wescher, *A Catalogue of Paintings in the Collection of Louis and Mildred Kaplan*, New York, 1950, unpaginated and unnumbered; Seymour Slive,

'Frans Hals' Portrait of Joseph Coymans', *Wadsworth Atheneum Bulletin*, Winter, 1958, pp. 12–23.

Companion picture to Cat. no. 161. The sitter's identity and his relationship to Dorothea Berck were established by the anonymous author of a note which appeared in the *B.M.* in 1909 (*op. cit.*). Joseph Coymans, born in Hamburg 1 August 1591, was Lord of Bruchem and Nieuwwaal. He and other members of his family were active as merchants and bankers in Amsterdam. His brothers Balthazar and Joan commissioned Jacob van Campen to build them a stately double house in Amsterdam in 1625 (Keizersgracht 177). It was Van Campen's first architectural commission, the beginning of a triumphal series (see P. T. A. Swillens, *Jacob van Campen*, Assen, 1961, p. 20). The house was described in 1662 as a '... huys gelijck een Kerck in 't aanzien, hier in zijn heerlijcke groote zalen, met kostelijkke Schilderijen en andere vercierselen verciert' (Melchior Fokkens, *Beschrijving der wijdt-vermaarde koop-stadt Amstelredam...*, Amsterdam, 1662, p. 71). In 1645, a year after Hals painted Joseph Coymans' portrait, Balthazar Coymans and Brothers Bank had transactions which amounted to about 4,140,000 florins, more than any other Amsterdam bank during that year (Elias, vol. II, p. 767, note 2). One cannot help wondering what sum Hals received for the portraits he painted for members of this enormously wealthy family.

Joseph Coymans married Dorothea Berck of Alblasserdam at Dordrecht 22 November 1616; her father served the Dutch as ambassador to England, Denmark and the Venetian Republic. She is cited as a widow in a document dated 26 February 1677 (see A. A. Vorsterman-Van Oijen, *Stam-en Wapenboek...*, Groningen, 1885, vol. I, p. 167 and Elias, vol II, pp. 762–763). Isabella Coymans, a daughter of the couple, was married on 4 October 1644 to Stephanus Geraerdts; possibly the companion portraits Hals painted of her parents were done for her new home. Mature Hals received other commissions from the Coymans' family. In 1645 he painted a man who can be tentatively identified as Willem Coymans (Cat. no. 166; Plate 253), and in the early fifties he painted Isabella Coymans and Stephanus Geraerdts (Cat. nos. 188, 189; Plates 290, 291).

161. **Dorothea Berck, wife of Joseph Coymans** (Plates 244, 246; text, pp. 159–160, 185). Baltimore, The Baltimore Museum of Art (inv. no. 38.231).
Canvas, 83·8×69·8 cm. Inscribed and signed with the connected monogram to the left of the model's shoulder: AETA SVAE 51/AN° 1644/FH (Fig. 61). Her arms appear above the inscription: a cinquefoil of birch leaves (Berck=birch).

PROVENANCE: Frederick Wollaston, London; Mrs. Wollaston, London; Rodolphe Kann, Paris; purchased by Duveen, Paris, with the entire Kann collection in 1907;

Mrs. Collis P. Huntington, New York (died 1924), who bequeathed it to H. E. Huntington; dealer Duveen, New York, who sold it to Henry Barton Jacobs in 1929 ($330,000); Mary Frick Jacobs, who bequeathed it to the museum in 1938.

EXHIBITIONS: New York, Hudson-Fulton Celebration, 1909, no. 36; Baltimore, Museum of Art, *A Century of Baltimore Collecting: 1840–1940*, 1941, p. 74; Montreal 1944, no. 29; Philadelphia, Museum of Art, *Diamond Jubilee*, 1950–51, no. 36; Haarlem 1962, no. 53.

BIBLIOGRAPHY: W. Bode, *Gemäldesammlung des Herrn Rudolf Kann*, Vienna 1900, no. 48; *Catalogue of the Rodolphe Kann Collection*, vol. I, Paris 1907, no. 41; C. J. Holmes, 'Recent Acquisitions by Mrs. C. P. Huntington from the Kann Collection: I. Pictures of the Dutch and Flemish Schools', *B.M.*, XII, 1908, p. 201; John C. van Lennep, 'Portraits in the Kann Collection', *B.M.*, XIII, 1908, pp. 293-294 (identification of the model as Dorothea Berck); Moes 29 and HdG 170 (wrongly called a pendant to our Cat. no. 145); Bode-Binder 246; KdK 211; Valentiner 1936, 76; *The Collection of Mary Frick Jacobs*, Baltimore, 1938, no. 58; Seymour Slive, 'Frans Hals' Portrait of Joseph Coymans', *Wadsworth Atheneum Bulletin*, Winter, 1958, p. 15f.; A. Staring, 'Frans Hals als copist', *O.H.*, LXXIX, 1964, pp. 125-127.

Companion picture to Cat. no. 160. A. Staring (*op. cit.*) argues that Hals did not paint this portrait from life but copied it from a half-length portrait which does not show her hands; inscribed 'Aet suae 48' and dated 1641, by an unidentified artist (Fig. 40; the portrait may have been painted by Dirck Santvoort). The possibility that Hals based a portrait of a patron who was still alive on a likeness made by another painter must of course be entertained but in my judgement must be rejected in this case. The congruencies are due to the similar poses, but there are telling differences. Hals emphasizes the model's heavy eyelids, the puffy bags under her eyes, and the soft flesh around her chin. These aspects of Dorothea's physiognomy are minimized by the anonymous painter; I fail to understand how Hals could have stressed these highly individual facial features if he worked from the bland portraitist's work. Changes in the coiffure and her different collar also suggest Hals did his painting 'naer het leven'. In addition, Staring maintains that Hals' portrait shows failings in the drawing of the torso because he did not work from the model. Admittedly, Homer nods and Hals fumbles. However, I find it hard to imagine that Hals was at a loss when he had to draw a torso without a sitter before him; if he ever was, I do not see how his portrait of Dorothea Berck can be used to prove the point.

It is also noteworthy that the anonymous artist's portrait of *Joseph Coymans* (Fig. 39), the pendant of his portrayal of Dorothea Berck, cannot by any stretch of the imagination be said to have served as the model for Hals' portrait of Coymans. Staring understandably notes that he cannot

explain why Hals was asked to copy one portrait and not the other. In my view he did not even copy one of them. The inscription on the anonymous artist's portrait of Joseph has probably been tampered with or is a later addition. It reads: AET. SVAE 49/1648; this does not tally with Joseph's age (b. 1591) nor is it consistent with the date on the pendant (1641). It should also be noted that Staring mistakenly states that Hals' portrait of Joseph Coymans is dated 1642; it is dated 1644.

Franklin Robinson (written communication) observed the striking resemblance between Dorothea Berck and the sitter in Flinck's signed portrait of a *Woman with a Fan*, now in the coll. D. Cevat, London, and rightly suggested that the paintings most likely represent the same model (see J. W. von Moltke, *Govaert Flinck: 1615–1660*, Amsterdam, 1965, p. 143, no. 375, repr., latter half of the forties; exhibited Leiden, Stedelijk Museum, Rondom Rembrandt: De Verzameling Daan Cevat, 11 April–16 June 1968, no. 13, repr.).

162. **Portrait of a Woman** (Plate 249). Cape Town, The Old Town House, The Michaelis Collection (Cat. 1967, no. 28).

Canvas, 74·9×62·2 cm. Inscribed to the left of the model's collar: AETA 35/1644, and signed below the inscription with the connected monogram: FH.

PROVENANCE: Sale, Baron de Beurnonville, Paris, 9 May 1881, no. 300; Maurice Kann, Paris, purchased by the London dealers Duveen in 1909; Sir Hugh Lane, London, who sold it with 67 other paintings to Sir Max Michaelis in 1913; given by Sir Max, with the other paintings he had acquired from Sir Hugh, to the Union Government, 16 May 1914.
EXHIBITION: London, Grafton Galleries, National Loan Exhibition, 1909, no. 38 (Duveen).
BIBLIOGRAPHY: Bode 1883, 49; Moes 191; HdG 417; [anon.], 'A Collection of Dutch Old Masters for South Africa', *B.M.*, XXII, 1913, p. 237; Bode-Binder 212; KdK 221.

This fine portrait of 1644 ends the series of Hals' existing dated portraits of women done in the 1640's. The notable similarities in style between it and Hals' 1640 *Portrait of a Woman* at Cologne (Cat. 138; Plate 217) underscore the difficulty of assigning precise dates to Hals' mature works solely on the basis of stylistic evidence. The analogies between the treatment of each model's right hand are particularly striking.

163. **Portrait of a Man** (Plate 250). London, National Gallery (Cat. 1960, no. 2528).
Canvas, 78·5×67·3 cm.

PROVENANCE: This painting and the *Portrait of a Woman Holding a Fan* at the National Gallery, London (our Cat. no. 141; Plate 221) are said to have been in the possession of the London dealer Joseph Flack *ca.* 1865 (*cf.* W. S. Spanton, *An Art Student and His Teachers in the Sixties with other Rigmaroles*, London, 1927, p. 33); sale, H. W. Cholmley, London, 1 February 1902, no. 40 (£3,780; Agnew); sold by Agnew to George Salting in 1902; Salting Bequest, 1910.
EXHIBITION: London, National Gallery, *Cleaned Pictures*, 1947–48.
BIBLIOGRAPHY: Moes 159 and 160; HdG 289 (between 1640–50); Bode-Binder 190; KdK 190 (*c.* 1640); Trivas 78; Neil MacLaren, *National Gallery Catalogues, Dutch School*, 1960, p. 148.

Cleaned in 1941. Rather worn and retouched; a large tear through the face and breast.

Spanton's report (see Provenance above) that this picture and the *Portrait of a Woman* now at the National Gallery (Cat. no. 141; Plate 221) were in the hands of the same London dealer *ca.* 1865 (*op. cit.*) may be correct, but it would be erroneous to conclude they were intended as companion pieces. Valentiner's suggestion (KdK 191) that the painting may be the pendant to the *Portrait of a Woman* formerly in the collection of Miss M. S. Davies, Gregynog, Montgomeryshire (Cat. no. D 73; Fig. 194) has been rightly rejected by Neil MacLaren (*op. cit.*). MacLaren also justifiably assigns Cat. no. 163 a date in the mid-forties and notes that this agrees with the style of the costume (*ibid.*). The bold animation of the light passages relates the painting to Hals' 1644 *Portrait of an Artist* at Chicago (Cat. 164; Plate 251).

164. **Portrait of an Artist** (Plate 251; text, p. 160). Chicago, The Art Institute of Chicago (Cat. 1961, inv. no. 94.1023).
Canvas, 82·6×64·8 cm. Inscribed at the lower right: AETA 32/1644, and signed below the inscription with the connected monogram: FH.

PROVENANCE: Sale, Prince Anatole Demidoff, San Donato near Florence, 15 March 1880, no. 1105; Prince Paul Demidoff, Pratolino, Italy, 1890; presented to the institute by Charles L. Hutchinson in 1894.
EXHIBITIONS: Chicago 1933, no. 63; Chicago 1934, no. 91; Detroit 1935, no. 40.
BIBLIOGRAPHY: *Icon. Bat.*, no. 3140 (Harmen Hals); Moes 39 (Harmen Hals); HdG 185 (Harmen Hals?); Bode-Binder 241 (Harmen Hals?); KdK 216 (portrait of a painter); Valentiner 1936, 77 (portrait of a painter); Van Hall, no. 822-2 (Harmen Hals).

The painting is moderately to severely abraded in the dark areas; discoloured old repaint covers scattered losses. The inscription is worn and has been retouched.

There is no reason to suppose that the painting was a pendant to Cat. no. 170 (KdK 217; Valentiner 1936, 77).

The palette hanging on the wall at the upper right is the basis for the title. In the earlier literature the model was identified as Frans' son Harmen Hals (1611–69). Hofstede de Groot (185) expressed scepticism about this identification and since he published his catalogue in 1910 it has either been doubted or rejected. And rightly so: not a scrap of evidence has been found to support the assertion that it is a portrait of Harmen. Whether the eighteenth-century wash drawing of Harmen Hals (Fig. 38) at the Haarlem Municipal Archives is an accurate copy of a lost portrait of Harmen Hals is not known, but it is evident that the Haarlem and Chicago portraits do not represent the same man.

Valentiner (KdK 216; Valentiner 1936, 77) proposed that the Chicago portrait may represent Leendert van der Cooghen, but it has been established that this gifted Haarlem amateur was born 9 May 1632, not in 1610; therefore this identification must be rejected (for Van der Cooghen's birthdate, see C. A. van Hees, 'Nadere gegevens omtrent de Haarlemse vrienden Leendert van der Cooghen en Cornelis Bega', O.H., LXXI, 1956, pp. 243–244). Hals' portrait of Leendert van der Cooghen cited in the sale of the artist Cornelis Dusart, 21 August 1708, no. 381 (HdG 195) and his portrait of him which was with the dealer Otto Mündler, Paris, 1868 (Icon. Bat. 1687; Moes 26; HdG 167) have not been identified.

Hofstede de Groot 230 describes a so-called portrait of David Teniers by Hals; it is similar in size to the Chicago portrait and is listed as bearing the same inscription. To judge from Hofstede de Groot's description, it is a copy in reverse of the Chicago painting. Canvas, 80×60 cm. Sale, Louis Miéville, London, 20 April 1899 (Lesser, for F. Muller and Co., Amsterdam). Exhibited at the Royal Academy, London, 1878, no. 91. This untraceable portrait is also listed by Bode 1883, 142.

165. **Johannes Hoornbeek** (Plates 258, 260; text, p. 160). Brussels, Musée Royal des Beaux-Arts (Cat. 1957, no. 202). Canvas, 79·5×68 cm. Inscribed at the lower right: AET. SVAE/27./1645.

PROVENANCE: Sale, D. Vis Blokhuyzen of Rotterdam, Paris, 1 April 1870, no. 22 (11,600 francs; Gauchez); purchased by the museum (20,000 francs), 13 May 1870 from Léon Gauchez, Paris.

EXHIBITIONS: London, 1929, no. 353; Haarlem 1937, no. 90; Haarlem 1962, no. 55.

BIBLIOGRAPHY: Bode 1883, 32; Icon. Bat. 3728-1; Moes 48 (incorrectly dated 1651); HdG 193; Bode-Binder 224, plate 143b (the reproduction is confounded with the version now in the collection Emory Ford, Detroit, Bode-Binder 225, plate 144a); KdK 223; Trivas 91.

Johannes Hoornbeek was born in Haarlem in 1617 and died in Leiden in 1666. In July 1644 he became professor of theology at Utrecht University; Hals' portrait may have been made to commemorate the event. The following year Hoornbeek became a preacher at Utrecht. He left Utrecht for Leiden University, where he gave his inaugural address in 1654. A modern biographer emphasizes that he was not a run-of-the-mill professor; he had thirteen languages and his publications indicate that he took a lively part in the theological controversies of his day (see J. P. de Bie and J. Loosjes, *Biographisch Woordenboek van Protestantsche Godgeleerden in Nederland*, vol. IV, The Hague, 1931, pp. 277–286).

Jonas Suyderhoef (ca. 1613–86) faithfully engraved the portrait in reverse. Impressions exist describing Hoornbeek as a professor at Utrecht and as a professor at Leiden (Wussin 40 only lists four states of the former). Cataloguers of Suyderhoef's prints have not noted that an anonymous hand cut down and considerably reworked his plate, giving it an unusual *trompe l'oeil* effect (Fig. 41). This reworked state of the print was published in *Fundatoris, Curatorum et Professorum . . . Academia Lugduno*, Leiden, Pierre van der Aa, [1716?], which includes other portraits printed from reworked plates by Suyderhoef, Van Dalen, C. Visscher and others acquired by Van der Aa. The illusionist frame around the portrait was printed from a separate plate and was used to embellish other portraits in the book. Hals' portrayal of Hoornbeek was also engraved by Jan Brouwer (ca. 1626—still active 1662).

The drawing of 'A Gentleman' which was ambitiously catalogued as 'Frans Hals' in the sale, Francis Wellesley, London (Sotheby), 28 June–2 July 1920, no. 411, repr. (pencil, 14·3×16·5 cm.) is a copy after one of the engravings of Hals' portrait of Hoornbeek.

Another drawing after one of the prints, which has been attributed to Salomon de Bray, is at the Kupferstich-kabinett, Staatliche Museen, Berlin-Dahlem, inv. no. 597: metal point on paper prepared with a grey ground, 20·5×17 cm.; ex coll. Suermondt, acquired by the museum in 1874. F. Lippmann (*Zeichnungen Alter Meister im Kupferstichkabinett . . .*, Berlin, 1910, p. xiii, no. 303, repr.) notes that the drawing is in the same direction and has the same measurements as Suyderhoef's engraving and is probably based on it. He adds that the signature and date on the drawing (S. de Bray 1650) are probably false and the attribution to De Bray is very doubtful. Bock-Rosenberg (Berlin, Staatliche Museum, *Catalogue*, 1930, p. 96, no. 597) question the attribution to S. de Bray. J. W. von Moltke, ('Salomon de Bray', *Marburger Jahrbuch für Kunstwissen-schaft*, XI–XII, 1938–39, p. 411, Z153) accepts the attribution to Salomon de Bray but adds that the signature is doubtful. He calls it a drawing after the Brussels painting and fails to note that it reverses it; the attribution of this weak drawing to De Bray is dubious. Alfred von Wurzbach's conclusion that it is a preliminary study by Frans Hals himself for the Brussels painting is certainly wrong (*Repertorium für Kunstwissenschaft*, II, 1879, pp. 409–410).

Painted copies of the portrait are known and unidentified ones have been cited in the literature:

1. Detroit, Emory Ford (Fig. 42). Panel, 30·7 × 24 cm. PROVENANCE: Sale, Miss James, London, 20 June 1891, no. 31 (£241.10); Mrs. Joseph, London; dealer Knoedler, New York; dealer Reinhardt, New York; Mrs. Emory L. Ford, Detroit. EXHIBITIONS: London, Royal Academy, 1871, no. 250 (Miss James); Detroit 1935, no. 42. BIBLIOGRAPHY: Moes 49; HdG 194 (replica, 75 × 60 cm.); Bode-Binder 225, plate 143a (the reproduction is confused with the original in Brussels; 75 × 60 cm.); KdK 222 (study for the Brussels painting; 75 × 60 cm.); Valentiner 1936, 78 (study for the Brussels painting; 30·7 × 24 cm.). This replica is a reduced copy by another hand after the Brussels painting.

2. Utrecht, University, see *Icon. Bat.*, no. 3728-2.

3. Leiden, University, *Icon. Bat.*, no. 3728-3; *Senaatskamer der Leidsche Universiteit*, Catalogue, 1932, no. 61.

4. HdG 193 lists a copy on canvas which appeared in Amsterdam sales from 1799 until 1849. I have not been able to determine if they are one and the same picture, identical with one of the known versions, or references to lost copies.

5. Sale, Daniel Mansveld, Amsterdam, 13 August 1806, no. 70 (61 florins); HdG 194a.

6. A poor modern copy of the bust was in the Steiner Gallery, New York (photo: FARL).

A pastiche (canvas, 74 × 58·5 cm.) which dresses the distinguished professor of theology in a costume never worn in the seventeenth or any other century was in the collection F. Woltereck, Basel (photo: RKD); Trivas 91-i (fake, or copy painted over and changed).

166. **Portrait of a Member of the Coymans Family, probably Willem Coymans** (Plates 253, 255; text, pp. 160, 185). Washington, National Gallery of Art, Andrew W. Mellon Collection (Cat. 1965, acc. no. 69). Canvas, 77 × 64 cm. Inscribed to the right of the model's head: AETA SVAE 26/1645; the last numeral of the sitter's age has been altered from a 2 into a 6. Above the inscription, the sitter's coat-of-arms: three black oxen's heads and necks on a gold field.

PROVENANCE: Dealer C. Sedelmeyer, Paris, Catalogue 1898, no. 54; Rudolphe Kann, Paris, purchased by Duveen, Paris, with the entire Kann collection in 1907; Mrs. Collis P. Huntington (died 1924); bequeathed to Archer E. Huntington, from whom it was acquired by Andrew W. Mellon, Washington, who gave it to the gallery in 1937.
EXHIBITIONS: New York, Hudson-Fulton Celebration, 1909, no. 37 (Balthasar Coymans; the identification is uncertain); San Francisco 1939, no. 80a (Balthasar Coymans).

BIBLIOGRAPHY: *The Illustrated Catalogue of 300 Paintings...of the Sedelmeyer Gallery*, Paris, 1896, p. 66, no. 2 (Koeymans Loon van Alblasserdam); *Icon. Bat.*, no. 1779 (Balthasar Coymans); W. Bode, *Gemälde-Sammlung des Herrn Rudolph Kann*, 1900, Vienna, plate 49 (Koeymanszoon van Alblasserdam), *Catalogue of the Rodolphe Kann Collection*, vol. I, Paris, 1907, no. 40 (Koeijmanzoon van Alblasserdam); C. J. Holmes, 'Recent Acquisitions by Mrs. C. P. Huntington from the Kann Collection: I. Pictures of the Dutch and Flemish Schools', *B.M.*, XII, 1908, pp. 201–202 (Koeijmanszoon of Alblasserdam); John C. van Lennep, 'Portraits in the Kann Collection', *B.M.*, XIII, 1908, pp. 293–294 (most likely Johan Koeymans); Moes 27, HdG 168, Bode-Binder 245, KdK 225, and Valentiner 1936, 82, all identify the model as Balthasar Coymans; Seymour Slive, 'Frans Hals' Portrait of Joseph Coymans', *Wadsworth Atheneum Bulletin*, Winter, 1958, pp. 20–21, note 7 (not Balthasar Coymans); Katrina V. H. Taylor, 'A Note on the Identity of a Member of the Coymans Family by Frans Hals', *National Gallery of Art, Report and Studies in the History of Art 1969*, Washington, 1970, pp. 106–108 (Willem Coymans).

The coat-of-arms on the painting establishes that this dandy was a member of the Coymans family, and as noted in the Bibliography above various attempts have been made to pinpoint his identity. The name that has gained widest currency is Balthasar Coymans (1618–90), Lord of Streefkerck and Nieuw-Lekkerland and holder of many high offices. The fact that Joseph Coymans and Dorothea Berck (Cat. nos. 160, 161; Plates 243, 244) were the parents of Balthasar, and Isabella Coymans (Cat. no. 189; Plate 291) was his sister, lent support to this identification. The age of 26 inscribed on the painting, which is dated 1645, appeared to clinch it; Balthasar was born 15 March 1618 (Elias, vol. II, p. 763).

However, this identification is solely based on tampered evidence: it is evident that the age inscribed on the painting has been altered from 22 to 26. The documentary evidence inscribed on the portrait was most likely altered after 1898. The *Illustrated Catalogue of 300 Paintings . . . of the Sedelmeyer Gallery*, Paris, 1898, p. 66, no. 52, states the painting is inscribed: AETA SVAE 22, 1645; this reading is corroborated by the reproduction in Sedelmeyer's 1898 catalogue (*ibid.*, p. 67). In subsequent literature the sitter's age is given as 26 and later reproductions show the second numeral muddled.

The age of 22 in 1645 rules out Balthasar as the model; it also excludes Joseph Coymans' other two sons (see Slive, *op. cit.*). In the Text Volume (p. 160) he is neutrally called an unidentified member of the family. Subsequent research published by Katrina V. H Taylor (*op. cit.*) has revealed that none of Joseph Coymans' known nephews can qualify as the sitter either. She did, however, learn about the existence of a man who belonged to another branch of the family and may very well have been the model for the

Washington portrait. He is Willem (or Guilliam) Coymans, who was baptized in Amsterdam on 20 August 1623 and buried at St. Bravo Church in Haarlem 28 April 1678.

Willem was the son of Coenraet Coymans and Maria Schuyl, who were married in Amsterdam in 1614. Coenraet's name is cited in notarial acts in Amsterdam until 1640. The appearance of his name on documents in the Haarlem Municipal Archives dated in the forties indicates that he moved to Haarlem around this time; he was buried at St. Bavo Church in Haarlem on 29 November 1659 (*ibid.*). In April 1660 an inventory was made of his effects. This document has been known since A. Bredius cited it in 'Archiefsprokkels betreffende Frans Hals', *O.H.*, XLI, 1923–24, p. 27, and is of special interest because it shows that as late as 1660 Hals and his sometime collaborator Pieter Molyn were called upon to appraise the paintings cited in Conraet Coymans' inventory (Bredius, *ibid.*, reproduces Hals' signature as it appears on the document). Mrs. Taylor's investigation of the inventory indicates that it reveals more: 'The names of Coenraet's son Willem and his son-in-law, Johan Fabry, appear at the beginning of the document as they do several other times together on other notarized business records in Amsterdam and in Haarlem' (*op. cit.*, p. 106). Since Hals was asked in 1660 to appraise pictures which belonged to Willem's father there can be no question that the artist had contact with Willem Coymans in that year. The crucial question is whether Hals had painted his portrait fifteen years earlier. The fact that the date of Willem's birth agrees with the age inscribed on the Washington painting lends strong support to Mrs. Taylor's proposal that he did (*ibid.*).

167. **Portrait of a Seated Man** (Plate 256; text, pp. 52, 160–161, 193). Washington, D.C., National Gallery of Art, Andrew W. Mellon Collection (Cat. 1965, acc. no. 71). Canvas, 68 × 56 cm. Signed to the right of the sitter's shoulder with a connected (double?) monogram (see text below, and Fig. 60).

PROVENANCE: Sir Robert Walpole, First Earl of Orford, by 1736; acquired by Catherine II for £40 when she purchased the Houghton collection of pictures for the Hermitage in 1779. Andrew W. Mellon, Washington, D.C., who gave it to the gallery in 1937.

BIBLIOGRAPHY: The painting is listed in the manuscript of Horace Walpole's autograph copy of *A Catalogue of the Hon^ble Sir Robert Walpole's Collection of Pictures*, 1736, which lists 430 paintings in his father's various houses; the list he titled 'A Catalogue of Sr. Robert Walpole's Pictures at Chelsea', pp. 33–34, cites: 'Francis Halls, Master to Godfrey Kneller ... Francis Halls' (the autograph ms. is at the Pierpont Morgan Library, New York). Horace Walpole, *Aedes Walpolianae: or a Description of the Collection of Pictures at Houghton Hall in Norfolk ...* London, 1747,

p. 46, lists in the Common Parlour: 'Francis Halls, Sir Godfrey Kneller's Master, a Head by himself'. Ermitage, Catalogue, 1863, no. 770 (self-portrait); Waagen, Ermitage, 1870, p. 172 (said to be a self-portrait); Bode 1883, 128 (*ca.* 1660; portrait of a man, perhaps by Harmen Hals); M. P. Sémenoff, *Etudes sur l'histoire de la peinture néerlandaise*, vol. I, St. Petersburg, 1885, p. 254 (portrait of Frans Hals the Younger); Ermitage, Catalogue, 1895, no. 770 (portrait of Frans Hals the Younger); Moes 180; HdG 307 (*ca.* 1645); Bode-Binder 213; KdK 234 (*ca.* 1646–47); Valentiner 1936, 91 (*ca.* 1646–47); Trivas 92 (*ca.* 1646–47); *Preliminary Catalogue of Paintings and Sculpture*, National Gallery of Art, Washington, D.C., 1941, no. 71.

Closely related in style to Cat. nos. 165, 166 which are dated 1645.

The painting has the distinction of appearing in Horace Walpole's *Aedes* published in 1747 (*op. cit.*), the first catalogue published by an Englishman of a private collection (see W. S. Lewis, *Horace Walpole*, New York, 1960, p. 148). As far as Hals was concerned the beginning was not an auspicious one. Walpole wrongly catalogued his picture as a self-portrait. It was given the same title when it was engraved in reverse by J. B. Michel in 1777. Michel's print is inscribed: FRANCIS HALLS./ In the Common Parlour at Houghton/Size of the Picture 1 F 3¼ I[nches] by 1 F 7½ I[nches] high/Published May 1st, 1777 by John Boydell Engraver in Cheapside, London./F. Halls Pixit. G. Farington del. J. B. Michel sculpsit. The dimensions cited by Boydell suggest that he had never seen the original.

Walpole stated in the introduction to his account of his father's collection of pictures that he intended it to be a catalogue rather than a description of them: 'The mention of Cabinets in which they have formerly been, with the Addition of the Measures, will contribute to ascertain their Originality, and be a kind of Pedigree to them' (*op. cit.* 1747, p. vii). Regrettably he provided nothing on the history of the painting before it was acquired by the Earl of Orford. Perhaps he was ignorant of it. On the other hand, he probably had little interest in investigating the provenance of a Dutch portrait. He writes that in his 'Opinion, all the Qualities of a Perfect Painter, never met but in Raphael, Guido, and Annibal Caracci' (*ibid.*, p. xxxv), and notes that, as far as he is concerned, Dutch painters were servile imitators and 'drudging Mimicks of Nature's most uncomely Coarseness ...' (*ibid.*, xi).

The painting was sold as a self-portrait in 1779 with the Houghton pictures to Catherine of Russia. For evidence of the dismay the sale of this outstanding collection caused in some English circles, see text, p. 161 and the *European Magazine and London Review*, February, 1782, pp. 95*ff.*; the latter reference includes a list of the paintings sold to the Empress with the prices paid for each work. J. B. Michel's engraving after the portrait appears again in different states in *A Set of Prints Engraved After the Most Capital Paintings in the Collection of Her Imperial Majesty, Lately in the Possession*

of the Earl of Orford at Houghton in Norfolk Published by John and Josiah Boydell, London, 1 January 1788, vol. 1, p. 4, plate XXXIX.

The painting continued to be called a self-portrait until Bode noted in 1883 (128) that this erroneous identification was probably based on a misinterpretation of the unusual ligated monogram (Fig. 61). Since his time the old identification has been abandoned. The curious monogram had produced some wild speculation. Bode (1883, 128) transcribed it as a ligated FHHF; he interpreted it as possibly Harmen Fransz. Hals' signature and suggested that the portrait may have been painted by Hals' son Harmen around 1660. Sémenoff (*op. cit.*) proposed that the double monogram indicates that it is a portrait by Frans Hals of Frans Hals the Younger, and claimed that he saw a family resemblance between the sitter and Frans Hals. Neither Bode's nor Sémenoff's solutions are acceptable. Valentiner (1936, 91) attempted to solve the problem when he wrote: 'The double monogram occurs elsewhere, rarely to be sure, and mostly in the early period (*ca.* 1627)'; he cited as evidence our Cat. nos. 36, 37; Plates 60, 61. But the monograms which appear on Cat. nos. 36 and 37 are not identical with the one on the Washington pictures. They are distinctly comprised of the letters FHF (Frans Franszoon Hals or Frans Hals Fecit). The unusual monogram on the Washington painting remains unexplained. Perhaps it once bore only the conventional one and it was repainted, then a second one was added adjacent to it. The repainted one may have reappeared, forming what can now be read as a double monogram.

168. **Jasper Schade van Westrum** (Plates 261–263; text, pp. 88, 158, 161–162). Prague, National Gallery (inv. no. O 638).
Canvas, 80×67·5 cm.

PROVENANCE: Sale, John W. Wilson of Brussels, Paris, 14 March 1883, no. 58 (43,100 francs); Prince Liechtenstein, Vienna, who gave it to the Rudolphinum at Prague.
EXHIBITIONS: Brussels, 1873; Haarlem 1937, no. 91; Haarlem 1962, no. 56.
BIBLIOGRAPHY: *Collection de M. John W. Wilson, exposée dans la galerie du cercle artistique et littéraire de Bruxelles*, Paris, 1873, p. 83; Charles Tardieu, 'Les Grandes Collections Étrangères, II, M. John W. Wilson', *G.B.A.*, VIII (1873), p. 217ff.; E. P. Matthes *et al.*, 'Schilderij van Frans Hals', *Navorscher*, XXV, 1875, pp. 13–15, 239–240; XXVI, 1876, pp. 511–512; XXVII, 1877, p. 28; *Icon. Bat.*, no. 6803; Bode 1883, 124 (1644); Moes 68; HdG 221; Bode-Binder 244; KdK 226; A. J. van de Ven, 'Een Nederlandsch schilderij te Praag', *Maandblad van het Genealogisch-Heraldisch Genootschap: 'De Nederlandsche Leeuw'*, L (1932), pp. 243–246, reprinted in *Historia*, III (1937), pp. 201–203.

Jasper Schade van Westrum (12 August 1623–25 October

1692), who belonged to an old patrician family, was Lord of Tull and 't Waal. Hals' unmatched characterization of the vain fop who was destined to serve as deacon of the chapter of Oudmunster at Utrecht, as representative to the States-General, and as president of the Court at Utrecht, is confirmed by a contemporary report that handsome and haughty Jasper Schade spent extravagant sums on his wardrobe. In a letter dated 7 August 1645 Louis van Kinschot admonished his son Kaspar, then in France, not to run up tremendous bills with his tailors the way his cousin Jasper Schade had done (C. P. L. van Kinschot, *Genealogie van het Geschlacht van Schooten*, vol. 1, 1910, p. 324).

Bode (1883, 124), who saw the painting when it was in the gallery of Prince Liechtenstein, Vienna, stated that it was dated 1644. Later students wrote that it was dated 1645. Today, the picture bears no trace of a date or of a signature. However, the costume and the style of the work, particularly the similarity of the crackling brushwork on his costume to the treatment of the costume in Hals' portrait of young Coymans dated 1645 (Cat. 166; Plate 253) support the date assigned to it by earlier critics. Moreover, the date 1645 appears on its elaborately carved frame (see Van den Ven, *op. cit.*, 1937, p. 202). Although the frame is probably a nineteenth-century one, some of the coats-of-arms which decorate it appear to be much older; they were probably taken from the old frame and set into the new one. To judge from the style of the painting, there is good reason to believe that the woodcarver who made the new frame copied the 1645 date from the old one.

While trying to salvage bits and pieces of the old frame the framemaker apparently confused the order of the nine coats-of-arms which now appear on it. According to the rules of heraldry the quarter Schade belongs in the upper left corner; it appears as the second from the top on the right (for a discussion of the other arms on it, and diagrams showing their present and their proper positions, see Van den Ven, *ibid.*). In spite of the armorial confusion, there can be no question that Jasper Schade van Westrum was the model for the picture. The portrait which Cornelis Jonson van Ceulen (1593–1661 or 1662) made of him in 1654 (text, Fig. 163) clearly shows the same man about a decade older.

169. **Portrait of a Man** (Plate 257; text, p. 169, text Fig. 176). Bielefeld, Germany, August Oetker.
Canvas, 76×66 cm.

PROVENANCE: Gotha, Museum.
EXHIBITION: Haarlem 1937, no. 101; Zurich, 'Meisterwerke holländischer Malerei des 17. Jahrhunderts', 1953, no. 47; Rome 1954, no. 47; Milan 1954, no. 56.
BIBLIOGRAPHY: Bode 1883, 107 (*ca.* 1655); Katalog der Herzoglichen Gemäldegalerie, Gotha, 1890, no. 108; Moes 171; HdG 277 (*ca.* 1650-55); Bode-Binder 255; KdK 250 (*ca.* 1650; erroneously identified as HdG 177); Marianne Bernhard *et al. Verlorene Werke der Malerei*, Munich, 1965,

p. 126, plate 113 (incorrectly states the work was lost in World War II).

The portrait's close connection with the style of Cat. nos. 166, 167, 168 suggests a date around 1645. The figured design on the jacket has been boldly emphasized. Hals faced the task of painting a similar black on black pattern when he painted *Joseph Coymans* in 1644 (Cat. no. 160; Plate 243); in his portrait of a fifty-two-year-old man he understated it.

170. **Portrait of a Woman** (Plate 259). Uccle, Belgium, formerly M. van Gelder.
Canvas, 84.3 × 68 cm.

PROVENANCE: According to HdG 394 purchased by the London dealers Agnew in Vienna around 1898; dealer Norman Forbes-Robertson, London; dealer P. Mersch, Paris; F. Kleinberger, Paris; dealer C. Sedelmeyer, Paris; M. van Gelder, Uccle; dealer D. Katz, Dieren; dealer H. S. Schaefer, New York; dealer Wildenstein, New York.
EXHIBITIONS: Munich 1897; London, Royal Academy, 1902, no. 133; Paris 1921, no. 18; London 1929, no. 356; Haarlem 1937, no. 88; New York 1937, no. 20; Rotterdam 1938, no. 81; Rhode Island 1938, no. 19; San Francisco 1939, no. 80; Chicago 1942, no. 18; Los Angeles 1947, no. 20.
BIBLIOGRAPHY: Moes 191b; HdG 394 (*ca.* 1650); Bode-Binder 256; KdK 217 (*ca.* 1644).

The background and parts of the face are moderately abraded.
Valentiner speculated (KdK 217) that the portrait may be a pendant to the *Portrait of an Artist* at Chicago (Cat. no. 164; Plate 251), and apparently on the basis of this supposition he dated the painting around 1644. This is one of the worst matches Valentiner tried to arrange; the portraits are worlds apart in spirit and finish and nothing known about their respective histories indicates they were ever mates. The style and costume point to a date around 1648; a similar costume is worn by the standing young woman on the extreme right of the *Family Portrait* at the National Gallery, London (Cat. no. 176; Plate 272). The portrait is an outstanding example of Hals' sympathetic portrayal of homely women.

171. **Portrait of a Woman** (Plates 252, 254). Paris, Louvre (inv. no. M. I. 927).
Canvas, 108 × 80 cm.

PROVENANCE: Louis La Caze, Paris, who bequeathed it to the Louvre in 1869.
EXHIBITIONS: Rome 1928, no. 44; Tokyo 1966, no. 40; Paris, Galerie Mollien, Hommage à Louis La Caze, 1969, unnumbered; Paris 1970–71, no. 98.
BIBLIOGRAPHY: Bode 1883, 42 (*ca.* 1650); Louvre, Catalogue, 1890, no. 2385; Moes 193; HdG 389; Bode-

Binder 269; L. Demonts, Louvre, Catalogue, 1922, p. 26, no. 2385; KdK 257 (*ca.* 1650–52); Trivas 94 (1647–50).

Most likely the portrait had a companion piece but I see no reason to accept Valentiner's unsubstantiated assertion (KdK 257; Valentiner 1936, 97) that it was the *Portrait of a Man* now at the National Gallery, Washington (Cat. no. 191; Plate 302). The woman's portrait is datable a few years before 1650; the broader and more economic touch of the Washington painting places it at the beginning of Hals' final phase.

172. **Portrait of a Seated Woman, presumably Maria Vernatti** (Plate 265; text, p. 159). Heemstede, formerly Mrs. Catalina von Pannwitz.
Panel, 35 × 29 cm.

PROVENANCE: According to Bode and Friedländer (1912) from the collection of the Earl of Gainsborough, England; Carl von Hollitscher, Berlin.
EXHIBITIONS: Berlin, Kaiser-Friedrich Museum, May 1914, no. 60; Haarlem 1937, no. 87; Rotterdam, Museum Boymans, Kerstentoonstelling 1939–40, no. 29.
BIBLIOGRAPHY: W. Bode and Max J. Friedländer, *Die Gemälde-Sammlung des Herrn Carl von Hollitscher in Berlin*, Berlin, 1912, no. 41; Bode-Binder 236; KdK 215 (*ca.* 1644); Max J. Friedländer, *Die Kunstsammlung von Pannwitz*, vol. 1, Munich 1926, no. 31 (*ca.* 1645); Trivas 90 (*ca.* 1644–50).

I have not seen the painting and its present location is unknown. To judge from photographs, it is an authentic work painted in the second half of the 1640's. The model has been given the same informal pose Hals used for his lovely *Portrait of a Woman* in the Taft Collection, Cincinnati (Cat. no. 174; Plate 269).
The little portrait was first published by Bode and Friedländer in 1912 (*op. cit.*). They noted that the model is probably Maria Vernatti, who belonged to a Dutch family which settled in England in the seventeenth century, and add that the Earl of Gainsborough, who owned the picture, is said to be a descendant of the Vernatti family. In 1926 Friedländer (*op. cit.*) wrote that a label on the back identifies the model as Maria Vernatti.
Scraps of historical evidence support the traditional provenance and identification. Genoveva Maria Vernatti (born in Rotterdam *ca.* 1622–23, married Frederick Becker at Delft in 1648) was the daughter of Sir Philibert Vernatti (1590–*ca.* 1646), a Dutch hydraulic and sanitary engineer who settled in England in 1628 and was knighted by Charles I. Vernatti drained lands in Norfolk, Northampton-shire, Lincolnshire, Cambridgeshire and Yorkshire. In the middle of the fen district of Lincolnshire near Spalding there is a drainage canal called the Vernatti Drain; it is named after him. He was naturalized in 1631 (see Mol-huyzen, IX, columns 1200–1203).

173. **Portrait of a Seated Man Holding a Hat** (Plates 268, 271; text, pp. 158–159). Cincinnati, Ohio, Taft Museum (Cat., n.d., no. 477, inv. no. 1931.451).
Canvas, 109·8 × 82·5 cm.

PROVENANCE: Lord Talbot of Malahide, Malahide Castle near Dublin; dealer Sulley and Co., London; dealer Scott and Fowles, New York; acquired by Charles P. Taft in 1909.
EXHIBITIONS: Haarlem 1937, no. 95; New York 1939, no. 187; San Francisco 1940, no. 190; Los Angeles 1947, no. 16; New York, Toledo, Toronto 1954–55, no. 32; Haarlem 1962, no. 59.
BIBLIOGRAPHY: W. Walton, 'Art in America', *The Burlington Magazine*, XVI (1910), p. 368; Bode-Binder 253; Maurice W. Brockwell, *A Catalogue of . . . the Collection of Mr. and Mrs. Charles P. Taft*, New York 1920, no. 27; KdK 238 (*ca.* 1648–50); Valentiner 1936 (*ca.* 1645–48).

Companion picture to Cat. no. 174. Painted around 1648–50. M. M. Danzig called the vivacious pair modern forgeries ('Twee Portretten van Frans Hals of . . . Moderne Vervalschingen', *Maandblad voor Beeldende Kunsten*, XVII, 1940, pp. 149*ff*. His unconvincing arguments were successfully demolished by A. J. Moes-Veth ('Nog Eens: Twee Portretten van Frans Hals', *Maandblad voor Beeldende Kunsten*, XVII, 1940, pp. 202*ff*.) and J. H. der Kinderen-Besier ('Het Kostuum der Vrouw op het aan Frans Hals toegeschreven portret te Cincinnati', *ibid.*, pp. 205–206).

174. **Portrait of a Seated Woman Holding a Fan** (Plates 269, 270; text, pp. 158–159). Cincinnati, Ohio, Taft Museum (Cat., n.d., no. 479, inv. no. 1931.455).
Canvas, 109·5 × 82·5 cm.

PROVENANCE: Lord Talbot of Malahide, Malahide Castle near Dublin; dealer Sully and Co., London; dealer Scott and Fowles, New York, acquired by Charles P. Taft in 1909.
EXHIBITIONS: Haarlem 1937, no. 96; Los Angeles 1947, no. 17; New York, Toledo, Toronto 1954–55, no. 33; Haarlem 1962, no. 60.
BIBLIOGRAPHY: W. Walton, 'Art in America', *The Burlington Magazine*, XVI (1910), p. 368; Bode-Binder 254; Maurice W. Brockwell, *Catalogue of . . . the Collection of Mr. and Mrs. Charles P. Taft*, New York 1920, no. 28; KdK 239 (*ca.* 1648–50); Valentiner 1936, 90.

Companion picture to Cat. no. 173. Brockwell (*op. cit.*) saw a resemblance between the model and the woman in the right foreground of Hals' 1664 regentess group portrait (Cat. no. 222; Plate 349). I find his proposal far-fetched. His identification of the regentess as Adriana Bredenhof is groundless (see Cat. no. 222).

175. **René Descartes** (Plate 264; text, pp. 17, 19, 154, 164–168). Copenhagen, Royal Museum of Fine Arts, on loan from the Ny Carlsberg Glyptothek (Glyptothek inv. no. 998).
Panel, 19 × 14 cm.

PROVENANCE: According to the Royal Museum of Fine Arts, Copenhagen, Catalogue, 1951, p. 120, no. 290, the painting was purchased from a Copenhagen second-hand dealer by Herman Gram; the latter sold it in 1896 to Carl Jacobsen, founder of the Ny Carlsberg Glyptothek.
EXHIBITIONS: Paris, Bibliothèque Nationale, 'Descartes Exposition organisée pour le III^e Centenaire du Discours de la Méthode', 1937, no. 355; Amsterdam 1952, no. 49.
BIBLIOGRAPHY: Karl Madsen, 'Frans Hals-Descartes', *Tilskueren*, 1896, pp. 133–146; HdG 172; KdK 242 (*ca.* 1649; preparatory study for the Louvre version); G. Falck, 'Museets Tilvaekst af Aeldre Malerkunst', *Kunstmuseets Aarsskrift*, XI–XII, 1924–25, p. 42 (authentic); G. Falck, 'Frans Hals Mansportraet . . .', *ibid.*, XVI–XVIII, 1929–31, p. 133; Copenhagen, Royal Museum of Fine Arts, Catalogue, 1951, p. 120, no. 290; Johan Nordström, 'Till Cartesius Ikonographie', *Lychnos*, 1957–58, pp. 194–250 (with an English summary).

René Descartes, Hals' most famous sitter, was born at La Haye in Touraine in 1596. He spent his early manhood as a professional soldier, and served in the Netherlands under Prince Wilhelm of Orange and in Bohemia with the Imperial forces. He settled in the Netherlands in 1628 and dedicated the rest of his life to developing his original philosophy and new mathematical theories. While in the Netherlands he lived at Franeker, Amsterdam, Leiden and Utrecht. In September 1649 he left Holland for Sweden, where he entered the service of Queen Christina. He died in Stockholm on 11 February 1650.
Although the literature on Descartes' iconography is extensive, a comprehensive study of the subject has not been written and no systematic attempt has been made to publish all the contemporary portraits of him. Abundant material for both projects is found in the catalogue prepared for the Descartes exhibition, Paris 1937, nos. 350–404 and in Nördstrom, *op. cit.*; also see the valuable references in Gregor Sebba, *Bibliographia Cartesiana: A Critical Guide to the Descartes Literature, 1800–1960*, The Hague, 1964. Portraits of the French philosopher by Hals' younger Dutch contemporaries Jan Lievens (1607–63) and Jan Baptist Weenix (1621–63) are reproduced in text, Fig. 169 (Groningen, Museum voor Stad en Lande, inv. no. 1913-173) and text, Fig. 170 (Utrecht, Centraal Museum, Cat. 1952, no. 337) respectively. The brush drawing by Rembrandt of Descartes mentioned in the manuscript catalogue of the Valerius Röver collection (Library of the Municipal University, Amsterdam) is untraceable.
Hals' portrait of the philosopher exists in many versions (see below). The best one, and in my opinion the only existing

original by the artist, is Cat. no. 175. The small Copenhagen sketch is badly scratched and moderately abraded; repaint covers the losses. The unusual format (elongated upright rectangle), the cramped space allotted the figure, and the cropped hand suggest the little picture has been cut; if the panel was originally its present size it is hard to imagine Hals incorporating merely the tips of three fingers. The possibility that the fingers were added by the restorer who painted in the losses and strengthened some of the contours cannot be excluded. As stated above, the sketch cannot be considered a preparatory study by Hals for any of the existing versions; however, the possibility that an original life-size painting based on the Copenhagen sketch may turn up one day cannot be excluded either. Until that day arrives the Copenhagen portrait can be accepted as the modello Jonas Suyderhoef used for his excellent reversed engraving of the portrait (text, Fig. 165; Wussin 23), and we can assume the print shows the state of the Copenhagen portrait before it was cut. Suyderhoef's engraving is inscribed at the top: NATVS HAGAE TURONVM PRIDIE CAL. APR. 1596. DENATVS HOLMIAE CAL. FEB. 1650, and below: RENATUS DESCARTES NOBILIS GALLUS PERRONI DOMINUS SUMMUS MATHEMATICUS ET PHILOSOPHUS, followed by a Latin verse; at the bottom: F. Hals pinxit J. Suyderhoeff sculpsit.

Descartes' departure from Amsterdam for Sweden in September 1649 (Adrien Baillet, *La Vie de Monsieur Des-Cartes*, vol. II, Paris, 1691, pp. 386–87, and Charles Adam and Paul Tannery, *Oeuvres de Descartes*, vol. V, Paris, 1903, p. 411) serves as a *terminus ante quem* for Hals' portrait; to judge from its style it was probably painted around the same time. Circumstantial evidence presented by Baillet, one of Descartes' earliest biographers, indicates that the portrait was probably commissioned by Descartes' friend Augustijn Bloemaert, a Catholic priest of Haarlem:

> Plusieurs de ses amis de Hollande, qui avoient voulu se rendre à Amsterdam pour luy dire adieu, ne purent le quiter sans faire paroître l'affliction oú les mettoit le pré-sentiment qu'il avoit de sa destinée. L'un de ceux qui en furent le plus touchez etoit le pieux M. Bloemaert, à qui il avoit rendu de si fréquentes et de si longues visites à Harlem durant son séjour d'Egmond. Ils avoient toujours été trés édifiez l'un de l'autre: celuy-là, des grands sentimens de Religion dans nôtre Philosophe; et celuy-cy, de la charité admirable de cet Ecclésiastique, qui avoit employé plus de vingt mille écus de son bien, qui étoit grand, à protéger, à nourrir et à faire instruire les Catholiques en Hollande. M. Bloemaert n'avoit pû laisser partir M. Descartes, qu'il ne luy eût donné auparavant la liberté de le faire tirer par un peintre, afin qu'il pût au moins trouver quelque légère consolation dans la copie d'un original dont il risquoit la perte. (Baillet, *op. cit.*, p. 387.)

Nordström (*op. cit.*) notes that Erasmus Bartholinus, a mathematician and physicist who knew Descartes, con-sidered the engraving made in 1644 by Frans van Schooten the Younger (text, Fig. 171) a much better likeness than either the one Suyderhoef faithfully engraved after Hals' portrait (text, Fig, 165), or the one made by Cornelis van Dalen (text, Fig. 172). On the basis of Bartholinus' statement he concludes that Descartes never sat for Hals, and that Hals' famous likeness is a posthumous one based on his fantasy and Van Schooten's 1644 engraving. As for the painting which Descartes' Haarlem friend Bloemaert commissioned in 1649, Nordström suggests it is probably the anonymous portrait now in the collection of the Municipal University, Amsterdam (reproduced, *ibid.*, p. 213, fig. 9). My reasons for rejecting Nordström's interpretation of the con-temporary evidence he discusses are stated in the text, pp. 166–168. A partial list of copies after the portrait and references to unidentified ones cited in the literature follows:

1. Paris, Louvre (text, Fig. 166). Canvas, 76×68 cm.
 EXHIBITIONS: Paris, Bibliothèque Nationale, 'Des-cartes' 1937, no. 354; Amsterdam 1952, no. 50.
 BIBLIOGRAPHY: Karl Madsen, 'Frans Hals-Descartes', *Tilskueren*, 1896, pp. 133–146; Bode 1883, 40 (*ca.* 1655); Olof Granberg, 'Descartes' porträtt pa Stockholms Observatorium och i Louvre', *Nordisk Tidskrift*, XXXI, 1908, pp. 173–180; Moes 31 (contemporary copy); HdG 173 (very weak; probably a copy); Charles Adam and Paul Tannery, *Oeuvres de Descartes, Supplement*, Paris, 1913, pp. 45*ff.*; Bode-Binder 285; L. Demonts, Catalogue, Louvre, 1922, no. 2383; KdK 243 (*ca.* 1649); Trivas App. 6 (not by Hals).
 Reservations about the attribution of this well-known and frequently reproduced version were expressed by Waagen as early as 1839: 'Obgleich für den breiten Vortrag, worin dieser Meister sich so sehr hervorthat, recht characteristisch, ist es doch weniger lebendig in den Halbtönen und Schatten grauer, als andere Bilder von ihm' (G. F. Waagen, *Kunstwerke und Künstler in Paris*, vol. III, Berlin, 1839, p. 567). Most later critics were justifiably more outspoken in their criticism of the portrait's weaknesses. Valentiner (KdK 242), who maintained that the Copenhagen sketch was a pre-paratory study for the Louvre portrait, was the only modern cataloguer of Hals' works who championed the attribution; he ascribed it to Hals, without reservation, as late as 1957 (W. R. Valentiner, *Rembrandt and Spinoza*, London, 1957, p. 14). The ascription is untenable: the anonymous artist who painted it only achieved a pale reflection of Hals' animated brush-work. X-rays of the painting on file at the Louvre confirm that the copyist had a meticulous touch which is inconsistent with Hals' technique. The portrait was rightly excluded from the 'Répertoire' of Hals' paintings in public French museums published by the compilers of the exhibition 'Le Siècle de Rembrandt', Paris, 1970–71.

2. Hälsingborg, Museum (inv. no. 209–229; text, Fig. 167).

Canvas, 73 × 58·5 cm.

PROVENANCE: According to the records of the museum it was purchased by consul Erik Banck, Hälsingborg, from a dealer in the same city who is said to have procured the painting in Prague. Given to the museum by Erik Banck on 22 August 1929.

EXHIBITION: Stockholm, National Museum, 'Christina Drottning av Sverige . . .' 1966, no. 299 (attributed to Hals).

A copy by an anonymous artist who seems to have a better understanding of the intensity of the philosopher's expression than of the painter's technique.

3. Kiev, State Museum (Cat. 1961, no. 113). Panel, 29 × 24 cm. Signed at the upper right with the connected monogram FH.

PROVENANCE: Acquired in 1885 by Ed. F. Weber, Hamburg; sale, Weber, Berlin, 20–22 February 1912, no. 224; from which it was acquired by B. I. and V. N. Khanenko.

BIBLIOGRAPHY: *Gemälde alter Meister der Sammlung Weber*, Lübeck, 1898, repr.; Weber Gallery, Hamburg, Cat. 1907, no. 224; HdG 173, note (a weak copy, reversed); *Collection Khanenko, Tableaux des écoles Néerlandaises*, Kiev, 1911–13, plate 150; Catalogue, State Museum, Kiev, 1927, no. 241 (Frans Hals?); *ibid.*, 1961, no. 113 (Frans Hals).

A poor copy in the same direction as Suyderhoef's engraving; probably painted after it, or one of the many other prints done after the portrait. Wrongly accepted as an authentic Frans Hals in the 1961 catalogue of the Kiev State Museum (no. 113). A label on the back of the panel bears the stamp 'Weber Hamburg' and is inscribed in ink 'Franz Hals (oder Spanisch)'—a concrete example of the adage: 'If you cannot give a picture an attribution, call it Spanish.'

4. Paris, Musée Carnavalet: 81 × 65 cm. (photo at Witt).

5. Tours, Musée des Beaux Arts: canvas, 51 × 39 cm.; only the bust (photo RKD).

6. Newbattle Abbey and Crailing House, Marquess of Lothian; sale, Edinburgh (Dowells), 1 July 1971, no. 170, canvas, 76·2 × 63·5 cm. (photo: National Portrait Gallery, Scotland, neg. no. B-4400).

7. Munich, dealer J. Böhler, *ca.* 1930–33: 72 × 56·5 cm. (photo at RKD).

8. HdG 174 lists an untraceable, loosely painted version which was exhibited at Leiden, 1850, no. 50 (collection D.D.). Provenance: sale, J. Smies, J. H. Koop, and others, Amsterdam, 4 February 1834, no. 44; Bijo, Amsterdam, 14 May 1839, no. 410 (10 florins; Roos), canvas, 83 × 73 cm.; sale, P. de Leeuw and P. Barbiers, Amsterdam, 11 June 1843, no. 165, canvas, 80 × 70 cm.

Possibly one of the unidentified copies cited above is identical with an unfinished portrait of Descartes listed in the 1704 inventory made of Cornelis Dusarts effects: no. 134. Descartes van Corn. Dusart gedood verwt (Bredius, vol. I, p. 34).

The printmakers who made engravings after versions of the painting, Suyderhoef's engraving, or other prints of it include Gerard Edelinck (1640–1707), Carel Allard (1648–after 1705), Jacques Lubin (1659–after 1708), Jacob Gole (*ca.* 1660–*ca.* 1737), Etienne Ficquet (Fiquet; 1719–1794); Jean-Baptiste de Grateloup (1735–1817), Joachim Oortman (1777–1818), Pierre François Bertonnier (1791–still active 1847).

A medal made after Hals' portrait of Descartes (text, Fig. 168) was done by Jan Smeltzing (1656–93). Miss G. van der Meer of the Koninklijk Kabinet van Munten, Penningen en Gesneden Stenen, The Hague, has kindly informed me that Smeltzing produced a number of retrospective medals, and that the style of his Descartes medal suggests it belongs to a series he made between 1681 and 1687 (for Smeltzing's work of these years, see H. Enno van Gelder, 'Portrait Medals of Hugo Grotius', *Numismatiska Meddelanden*, XXX, 1965, pp. 202–206).

The Penningkabinet at The Hague possesses two silver specimens of the medal. One bears a rhyme on the reverse (inv. no. 1951–276) which is described in G. van Loon, *Beschrijving der Nederlandsche Historiepenningen . . .*, vol. II, The Hague, 1726, p. 355 and in the exhibition 'Descartes. . .' Paris, 1937, Catalogue no. 404, repr. plate II (wrongly dated 1650). The other bears an anagram on the reverse; Miss Van der Meer has noted that it must be the later one since the obverse shows two cracks in the die. The reverse of this specimen is unpublished (inv. no. 1951–275).

176. **Family Group in a Landscape** (Plates 272–275; text, pp. 133, 174, 176). London, National Gallery (Cat. 1960, no. 2285).

Canvas, *ca.* 148·5 × 251 cm.

PROVENANCE: Perhaps identical with the 'Family Piece, containing 10 Figures', by F. Hals in the Buckingham House sale, London, 24–25 February 1763, no. 68, 25½ gns. (reference from Neil MacLaren, *National Gallery Catalogues, The Dutch School*, London 1960, p. 147, no. 2285, where it is noted that the National Gallery picture is the only known Hals family group with ten figures); Lord Talbot de Malahide, Malahide Castle, near Dublin, from whom it was purchased with the aid of the National Art-Collections Fund by the National Gallery in 1908 for £25,000.

EXHIBITION: Haarlem 1962, no. 57.

BIBLIOGRAPHY: Laurence Binyon, 'Hals and Rembrandt', *The Saturday Review*, CVI, 1908, pp. 325–326; 'The New Hals in the National Gallery', *B.M.*, XIV, 1908–09, pp. 3–4; Moes 88; HdG 439; Bode-Binder 271; KdK 248 (*ca.* 1649–50); Neil MacLaren, *National Gallery Catalogues, The Dutch School*, London 1960, p. 147 (late forties or

early fifties); Gregory Martin, *National Gallery London, Dutch Painting*, Munich 1971, pp. 12–13 (second half of the 1640's).

Painted around 1648. Except for losses in the sky, which have been repainted, the general condition of the paint surface is very good. MacLaren (*op. cit.*) notes that an additional 2·5 cm. of the original painted surface is turned over the edge of the stretcher on the left, and 1·5 cm on the right. Laurence Binyon commented that 'one craves more air and space at the top of the design' (*op. cit.*); Hofstede de Groot remarked (439) that the painting was probably cut at the top and the bottom. Hofstede de Groot was right. MacLaren (*op. cit.*) has pointed out that there are marks of an earlier stretcher along the sides but not at the top and bottom edges. Juxtaposition of the family portrait with the one in the Thyssen-Bornemisza collection (Cat. no. 177; Plate 279), which is also datable around 1648, suggests that a rather wide strip (*ca.* 15 cm.) has been cut from the top; if this is correct the London family group originally had the air and space at the top for which Binyon craved.

Although I agree that some heads in the group portrait are more interesting than others I am not convinced by MacLaren's statement that 'The baby held by the girl on the left is distinctly inferior to the rest of the figures and may be by an assistant' (*ibid.*). I find nothing inconsistent with the way the baby is painted and Hals' style of the late forties. On the other hand, his observation that 'the landscape background is clearly by another hand' (*ibid.*) is valid. He also notes that the way the landscape overlaps the contours of the two standing boys, especially the one towards the right, indicates that the landscape was painted in after the figures were completed. The landscape background can be attributed to Pieter Molyn. The treatment of the panoramic view as a series of wedges in the National Gallery picture shows striking similarities with the schema Molyn began to use for his extensive landscapes in his early phase (see text, Fig. 188, *Landscape*, around 1628, Poznan, National Museum, inv. no. Mo 818) and which he continued to employ in the following decades. The fan-like arrangement of the outermost foliage of the trees behind the figures into a cluster of clumps is also characteristic of Molyn. For other examples of collaboration between Molyn and Hals, see Cat. nos. 42, 102, 177.

The compiler of the National Gallery catalogue, 1925, noted that the father in the group portrait resembles Mattheus Everswijn, who appears as the second man from the left in Hals' regent piece of 1664 (Cat. no. 221; Plate 340). Admittedly the two sitters resemble each other, but, as MacLaren notes, it is hard to believe that the man would have aged so little during the years between the two pictures (*op. cit.*). Perhaps the two men were members of the same family. In any event, the man portrayed in the National Gallery cannot be Mattheus Everswijn (1617–1688) who married Johanna Olycan (daughter of Jacob Pietersz and Aletta Hanemans [*cf.* Cat. nos. 32, 33]) in 1645;

this marriage was his first and only one, and the couple had no children (Haarlem Archives, Trouwboek van 1638 tot 1645, no. 51; information kindly provided by C. C. van Valkenburg). More than one scholar has suggested that the father is identical with the unidentified man who posed for the portrait painted *ca.* 1652–54 in Budapest (see Cat. no. 194; Plate 304); I cannot accept this identification without reservation.

When the National Gallery acquired the painting in 1908, it only owned two half-lengths by Hals (Cat. nos. 81, 131). The large group portrait, which represents a rare and important aspect of Hals' achievement, filled a real gap in the gallery's collection. However, the general outcry at the price of £25,000, which was paid for it, leaves no doubt that many people believed the price was excessive. The anonymous author of an editorial which appeared in *The Burlington Magazine* in 1908 (*op. cit.*) commented:

> The price paid for the picture naturally seems a high one to those who have no experience of what important pictures cost; but, as we have frequently attempted to show, a profound misconception underlies the common talk about 'inflated prices'. Though only four men and three nations may at present bid for unique works of art, this limited competition, being backed by long purses, is quite sufficient to make the things for which they bid sell at the highest price any single competitor can afford for them. If the wealth of Germany and America ran the risk of speedy dissipation in the near future, we might be justified in waiting for lower prices to prevail. But though political and financial events may cause prices to fluctuate slightly from season to season, no intelligent observer can reasonably expect any serious decline in present rates: if anything, indeed, prices tend steadily to rise.

A review of the prices paid after 1908 for works by Hals and other old masters proves that the author's crystal ball was not cloudy.

177. **Family Group in a Landscape** (Plates 276–281; text, pp. 133, 174, 176, 178–181; text, Fig. 190). Lugano-Castagnola, Thyssen-Bornemisza Collection (Cat. 1969, no. 124).

Canvas, 202 × 285 cm.

PROVENANCE: Colonel Warde, Squerryes Court, Westerham, Kent. According to a newspaper clipping in Hofstede de Groot's copy of his Hals catalogue at the RKD, which was published at the time the painting was sold to Otto H. Kahn, the group portrait had been in the possession of the Warde family since 1759, when John Warde bought it from the estate of William Bristow in London, whose brother, a vice-president of a South Sea company, had married a daughter of Paul Foisin, an East India merchant in Paris. According to the English edition of HdG 441 'sold to a

continental collection, October 1909 (for, it is said £55,000)'; dealers Duveen, New York; Otto H. Kahn, New York; The Mogmar Art Foundation, New York; acquired by Baron Heinrich Thyssen-Bornemisza in 1934.
EXHIBITIONS: London, Royal Academy, 1906, no. 102; Paris, Jeu de Paume, 1921, no. 17; Detroit 1935, no. 44; Brussels, Exposition Mondiale, 1935, no. 728; Lugano 1949, no. 106; New York-Toledo-Toronto 1954-55, no. 29; Rotterdam 1955, no. 69; Rotterdam-Essen 1959-60, no. 82; London, National Gallery 1961, no. 61.
BIBLIOGRAPHY: Moes 89; HdG 441 (ca. 1640); Bode-Binder 272; KdK 229; (ca. 1645); Sammlung Schloss Rohoncz, Lugano, 1937, no. 183; The Thyssen-Bornemisza Collection, Castagnola-Ticino, 1969, no. 124.

The condition of the painting is very good. Datable around 1648. The landscape background can be attributed to Pieter Molyn; close parallels can be found between it and Molyn's *Wayfarers on a Road*, signed and dated 1647, at the Frans Hals Museum, Haarlem, inv. no. 214a (text, Fig. 189). The analogies between the treatment of trees and extensive landscape on the right and Molyn's handling of young trees and the distant view in his 1647 landscape at Haarlem are particularly close. However, all of the foliage in the painting cannot be attributed to Molyn; the plant in the lower left corner shows Hals' touch.
The traditional allegorical meaning of the couple's clasped hands and the possible symbolic significance of the shaggy dog on the right are discussed in the text, pp. 179–181.
This family, like others painted by Hals (see Cat. nos. 15, 16, 102, 176), has not been identified. The compiler of the Rotterdam-Essen exhibition catalogue, 1959, no. 82, suggests that the presence of the Negro servant might be an indication that the head of the family made his fortune in the West Indies. This may very well have been the case, but it should be noted that blacks were also brought to the Netherlands in the seventeenth century by men who made their fortunes in other parts of the world.

178. Portrait of a Man, presumably John Livingston
(Plate 266). New York, formerly Livingston Welch.
Canvas, 58·4×47 cm.

PROVENANCE: Van Brugh Livingston, New York; Mrs. Charles J. Welch, New York; Livingston Welch, New York.
BIBLIOGRAPHY: Edwin Brockholst Livingston, *The Livingstons of Callendar and Their Principal Cadets. A Family History*, 'Part II: America', 1887, p. 337 (without an attribution); Edwin Brockholst Livingston, *The Livingstons of Livingston Manor*, New York 1910, repr. facing p. 33 (without an attribution) and p. 54, note 2.

The painting is badly abraded and has been retouched throughout. Three irregular holes (ca. 6 cm. in diameter) have been patched with the original canvas. The patches

and multiple scattered losses have been filled and repainted. The painting has probably been cut on all four sides. The poor condition makes the attribution a marginal one; however, on the basis of what remains of the original paint surface it is possible to ascribe the portrait to Hals and date it around 1650, or perhaps later.
Identification of the painting as a portrait of the Scottish divine John Livingston (or Livingstone) of Ancrum (1603–72) is also problematic. Livingston was one of the delegates appointed in 1650 by the Church of Scotland to receive an oath of fidelity from young Charles II at Breda and to treat with him as to conditions upon which he would be permitted to land in Scotland. The negotiations lasted from early March until June, 1650 (Livingston, *op. cit.*, pp. 36–40). We can only conjecture about the circumstances which may have enabled him to sit for Hals during his three-month stay in Holland. Afterwards Livingston opposed Charles' coronation and came into conflict with Cromwell as well as the bishops and government of his country. On his refusal to recognize Charles II as supreme head of the Church of Scotland, he was banished in December, 1662. He selected Rotterdam as his place of exile, and was a resident there from 1663 until his death in 1672 (*ibid.*, pp. 48–51). Livingston's second stay in Holland raises the remote possibility that the portrait was painted by Hals during his final years.
However, is the painting a portrait of John Livingston? The resemblance of the model to the anonymous portrait of the reverend in the collection of the Earl of Wemyss, Gosford House, Scotland (repr. *ibid.*, facing p. 47) is vague. I have not been able to find the source for the identification of the Wemyss painting as Livingston and its early provenance remains unclear. It cannot be identified in the list compiled of the paintings at Amisfield House in 1771 (*Archaeologia Scotica*, I, 1792, pp. 77ff.). R. E. Hutchison, Keeper, Scottish National Portrait Gallery, has kindly informed me that his gallery has no data which might throw light on the provenance or identification of the Wemyss portrait. Moreover, I cannot see a close connection between Cat. no. 178 and two other anonymous portraits which are said to be portrayals of Livingston (repr. *ibid.*, facing p. 24, coll. John Henry Livingston of Clermont; repr. *ibid.*, facing p. 40, coll. Mrs. Robert Ralston Crosby, New York). An old photograph of yet another presumed portrait of John Livingston (formerly collection Johnstone Livingston of Callander House, Tivoli, New York) is in the files of the Scottish National Portrait Gallery; it does not help clinch the identification of Cat. no. 178 either.
According to tradition Cat. no. 178 belonged to the Livingston family since it was painted. The story is a romantic one. John Livingston's son Robert (1654–1725) emigrated to Charlestown, in the Massachusetts Bay colony, in 1673; he moved to Albany, New York, in 1675. Robert established the American branch of the family, which included his great-grandson Philip, a signer of the Declaration of Independence, and Robert R. Livingston,

who administered the oath of office to George Washington on his inauguration as first President of the United States. One would like to believe that Robert brought his father's portrait with him when he arrived in the new world in 1673, and that conditions in the colonies, which were less than ideal for the preservation of paintings, account for the portrait's present poor state. But the earliest reference to it appears in a volume published in 1887 (Livingston, *op. cit.*, p. 337), which places it in the possession of Van Brugh Livingston, New York. Until more is known about its early history and until John Livingston's iconography rests on a firmer foundation, the traditional identification must be taken the way others are: with a pinch of salt.

179. **Nicolaes Stenius** (Plate 267; text, pp. 182–183). Haarlem, Bisschoppelijk Museum.
Canvas, 100 × 75·5 cm. Inscribed at the upper left: AETA SVAE 45/AN° 1650, and signed below the inscription with the connected monogram: FH.

PROVENANCE: According to J. J. Graaf (see references cited below) he discovered the painting in storage at the Catholic parish church at Akersloot on 1 May 1878.
EXHIBITION: Haarlem 1937, no. 99.
BIBLIOGRAPHY: J. Z[wartendijk], 'De Frans Hals van Akersloot', *Onze Kunst*, XXX, 1916, pp. 135–136; J. J. Graaf, *ibid.*, XXXI, 1917, pp. 95–96; M. D. H[enkel], 'Ein neuer Frans Hals', *Zeitschrift für bildende Kunst: Kunstchronik*, XXVII, 1916, pp. 226–227, 246–247; Otto Hirschmann, 'Neu aufgetauchte Bilder von Frans Hals', *Cicerone*, VIII, 1916, pp. 233–236; J. J. Graaff, 'De Frans Hals van Akersloot', *Bulletin van der Nederlandschen Oudheidkundigen Bond*, IX, 1916, pp. 258–261; and reply by J. Z., *ibid.*, X, 1917, pp. 37–38; J. J. Graaf, 'Het Portret van Nicolaus Stenius, Pastoor van Akersloot, door Frans Hals Geschilderd A°. 1650', *De Katholiek*, CXLIX, 1916, pp. 233–239; KdK 249.

From 1631 to 1670 Nicolaes Stenius was the Catholic parish priest at Akersloot, a village about ten miles northeast of Haarlem.
J. J. de Graaf (see bibliographical references above, especially *De Katholiek*, *op. cit.*, 1916) reports that he discovered the portrait in storage at the parish church at Akersloot in May 1878. He states that the painting was out of its frame, only attached to the one remaining member of its stretcher, and wrinkled and cracked when he found it among a stack of pictures. As secretary of the Bisschoppelijk Museum, Haarlem, he arranged to have it re-stretched and exhibited at his museum, where it hung from 1878 until 1915. If there was an attempt to restore the painting during these years, the published reproductions, which show its pitiful state before the portrait was restored by Dowes Brothers in Amsterdam, November 1915–February 1916, do not reveal it (reproduced *Onze Kunst*, XXX, 1916, p. 136; *Bull. Ned. Oudheidk.*, X, 1917, p. 38; *Cicerone*, VIII, 1916,

p. 254). To judge from these reproductions the painting was once badly crumpled and there are major losses along all the folds as well as many other scattered losses. The paint surface is also severely rubbed. After its restoration in 1916 the painting was heralded as a rediscovered Hals (see Bibliography above), but it only gives a dim idea of the artist's mature achievement. The restored portrait was exhibited for an extended period at Akersloot, and is now on view at the Bisschoppelijk Museum.
The inscription, date, and monogram were on the painting when it was discovered by De Graaf in 1878 (*De Katholiek*, *op. cit.*, p. 234); the date of 1650 is consistent with what we know of Hals' late development. However, the position of the inscription and the shape of the letters, numerals and the monogram suggest they may not be contemporary with the painting. This point bears emphasis because Hals' dated works of the 1650's and 1660's are exceedingly scarce. Merely four are dated, and two others can be dated with reasonable certainty. It would be erroneous to assume that all of the dates assigned to these late works are positively irrefutable (see text, p. 182 and Cat. nos. 180, 181, 201, 221, 222).
A good copy by Ludolph de Jongh (text, Fig. 195), which is in the collection Freiherr von Hövell, Donsbrüggen, Kleve, is inscribed: AEta 47/L. D. Jongh f . . ./A° 1652.
I can neither accept the attribution to Thomas de Keyser nor offer a name for the artist who painted *Nicolaes Stenius Holding a Book*; panel, 37 × 28 cm.; dealer J. Goudstikker, Amsterdam, Catalogue, 1917, no. 33; dealer P. Cassirer, Berlin, 1935; dealer H. Shickman, New York, 1965.

180. **Portrait of a Man** (Plate 282; text, pp. 182, 184). Penrith, Cumberland, Heirs of Sir Algar Stafford Howard.
Canvas, 83·7 × 64·7 cm. Inscribed to the right of the head: AETAT 73/1650.

PROVENANCE: According to a letter received from Sir Algar Stafford-Howard, Greystoke Castle, Penrith (23 April 1958) the painting 'was bought in about 1900 by my late maternal grandfather—Sir Arthur Cowell-Stepney, Bt., of Llanelly, South Wales—at a sale in London. It had been damaged by water during a fire, and all that was clearly visible was the hand. On the strength of this hand my grandfather bought it for £11.' Sale, London (Christie), 24 November 1961, no. 76 (bought in); by descent to the present owners.

I have not examined the painting. To judge from photographs the head, the ruff and the background are badly abraded. However, Hals' touch appears to be evident in the portrait, particularly in the hand. Sir Arthur Cowell-Stepney showed exceptional perception of quality when he bought the portrait on the basis of what he could see of it (see Provenance above). Close correspondences between the arrangement of the sitters, the dimensions, and the shapes of

the letters and numerals of the inscription on Cat. nos. 180 and 181 suggest the portraits were pendants.

181. **Portrait of a Woman** (Plates 283, 292; text, pp. 182, 184). Houston, Texas, Museum of Fine Arts.
Canvas, 84·6×69·2 cm. Inscribed to the left of the head: AETAT 62/1650.

PROVENANCE: Marquess of Cholmondeley, Cholmondeley Castle, Malpas, Cheshire; sale, Marquess of Cholmondeley, London (Christie) 14 July 1922, no. 43 (£6,510); dealer Knoedler, New York; dealer Matthiesen, Berlin; Mr. and Mrs. Michael M. Van Beuren, Newport, Rhode Island; Mrs. Robert Lee Blaffer, who gave it to the museum in 1951 as part of Robert Lee Blaffer Memorial Collection.
EXHIBITIONS: Dealer Kleykamp, The Hague 1929, no. 20; Detroit 1935, no. 47; Cleveland 1936, no. 222; New York 1940, no. 80; Baltimore, Museum of Art, Man and His Years, 1954, no. 37; Raleigh 1959, no. 66.
BIBLIOGRAPHY: Alec Martin, 'A Portrait of a Lady by Frans Hals', B.M., XL, 1922, p. 224; KdK 259; W. R. Valentiner e.a., *Das unbekannte Meisterwerk in öffentlichen und privaten Sammlungen*, vol. I, New York 1930, no. 50, entry by Hans Schneider; Valentiner 1936, 99; Trivas 95.

Probably a companion picture to Cat. no. 180. The painted surface is thin and moderately abraded.
When the painting was published by Alec Martin in 1922 (*op. cit.*) he noted that it was on canvas mounted on panel and that the sitter is unidentified. At the exhibition held at the Kleykamp Gallery in 1929 (no. 20) she was identified as Elizabeth van der Meeren. In 1930 Hans Schneider (*op. cit.*) wrote that an inscription on the back identified the model as Elizabeth van der Meeren, the wife of Adriaen van Hoorn, and added that this identification proved to be inconclusive. He also stated that the inscription could not have been written before the eighteenth century and was probably added to make the portrait fit into a series of ancestral portraits. During the 1930's the canvas was removed from its panel support (it is listed on canvas in the 1935 Detroit Exhibition Catalogue, no. 47) and the inscription, which was probably on it, disappeared. Today there is no physical evidence on the front or back of the canvas to support the short-lived identification of the sitter as Elizabeth van der Meeren, and investigation in the Dutch archives has turned up nothing to corroborate it. Until some evidence is found the sitter is best classified with the large group of unidentified women painted by Hals.

182. **Portrait of a Man** (Plate 284; text, p. 184). Kansas City, Missouri, The William Rockhill Nelson Gallery of Art (acc. no. 31.90).
Canvas, 104·6×89·8 cm.

PROVENANCE: Count Maurice Zamoyski, Warsaw; in the coll. John MacCormack, New York; dealer Bachstitz, The Hague; acquired by the gallery in 1931.
EXHIBITIONS: Haarlem, Frans Hals Museum, 1911; dealer New York, Reinhardt Galleries, March, 1924; London 1929, no. 123; Detroit 1935, no. 46; Indianapolis 1937, no. 21; Haarlem 1937, no. 100; New York 1937, no. 34; Raleigh 1959, no. 65.
BIBLIOGRAPHY: Moes 117; HdG 320 (last period); J. O. Kronig, 'Een Tijdelijke aanwinst van 't Gemeentelijk Museum te Haarlem', *Kunst en Kunstleven*, I, 1911, pp. 137–138; Bode-Binder 261; KdK 240 (ca. 1648–50); Valentiner 1936, 95.

Companion picture to Cat. no. 183 Related in style to Cat nos. 184, 185. Painted around 1650–52; except for the background, which is rubbed and has been retouched on the left side, the painting is well preserved.

183. **Portrait of a Woman** (Plate 285; text, p. 184) St. Louis, Missouri, City Art Museum (inv. no. 272.55). Canvas, 103.8×90.3 cm.

PROVENANCE: Count Maurice Zamoyski, Warsaw; Robert Sterling Clark, New York, from whom it was acquired for the museum, with Knoedler as agents, in 1955 for $150,000 as a gift of the Friends of the City Art Museum.
EXHIBITIONS: Haarlem, Frans Hals Museum 1911; San Francisco-Toledo-Boston 1966–67, no. 20.
BIBLIOGRAPHY: Moes 118; HdG 396; J. O. Kronig, 'Een Tijdelijke aanwinst van 't Gemeentelijk Museum te Haarlem, *Kunst en Kunstleven*, I, 1911, pp. 137–138; Bode-Binder 262; KdK 241 (ca. 1648–50); ' "Portrait of an Unknown Woman..." in the City Art Museum of St. Louis', *The Art Quarterly*, XVIII (1955), p. 417; *Arts*, XXX, 1956, no. 4, January, p. 8.

Companion picture to Cat. no. 182. Hofstede de Groot, who did not know the pendants first hand, listed them on the basis of information he received from A. Bredius (HdG 320, 396). Thus the comment found in HdG 396 that the woman is 'hässlich', must be attributed to Bredius. Tastes differ. I find the woman attractive. The woman was separated from her husband around 1920 but it is consoling to know that both have now found permanent homes in museums in the state of Missouri.

184. **Portrait of a Man** (Plate 286; text, p. 184). Vienna, Kunsthistorisches Museum (Cat. 1963, no. 184, inv. no. 9091).
Canvas, 107·8×79·7 cm.

PROVENANCE: Sale J. H. C[remer], Brussels, 26 November 1868, no. 31 (5,900 francs, Sedelmeyer); sale, Gsell, Vienna,

14 March 1872, no. 37 (25,000 Kr., Sedelmeyer); G. R. von Epstein, Vienna, 1873; dealer C. Sedelmeyer, Cat. 1898, no. 52; Baron Albert Rothschild, Vienna; Baron Louis Rothschild, who bequeathed it to the museum in 1947.
EXHIBITION: Vienna 1873, no. 103.
BIBLIOGRAPHY: Bode 1883, 126 (*ca.* 1655); Moes 115; HdG 322; Bode-Binder 248; KdK 246 (*ca.* 1649–50); Trivas 89 (*ca.* 1643–45).

Although the painting is slightly different in size and has a different provenance until it was joined with Cat. no. 185 in the von Epstein collection in 1873, the two works were probably intended as pendants.
Painted around 1650–52.

185. **Portrait of a Woman** (Plates 287, 293; text, p. 184).
Vienna, Kunsthistorisches Museum (Cat. 1963, no. 185, inv. no. 9092).
Canvas, 100·7 × 81·5 cm.

PROVENANCE: See Cat. no. D 78 for references to the painting's confused history. Inscribed on the stretcher: 'De la Collection de M. Perignon . . . Par Franck Hals'; Urzaïs Gallery, Madrid; sale, Péreire, Paris, 6–9 March 1872, no. 121 (21,000 francs); G. R. von Epstein, Vienna, 1873; dealer C. Sedelmeyer, Paris, Cat. 1898, no. 51; Baron Albert von Rothschild, Vienna; Baron Louis Rothschild, Vienna, who bequeathed it to the museum in 1947.
EXHIBITION: Vienna 1873, no. 107.
BIBLIOGRAPHY: W. Bürger [Thoré], 'Galerie de Mme. Péreire', *G.B.A.*, XVI, 1864, pp. 299–301; Bode 1883, 125 (dated 1638); Moes 116; HdG 397; Bode-Binder 249; KdK 247 (*ca.* 1649–50).

Most likely the companion picture of Cat. no. 184. No trace of the date of 1638, which Bode (1883, 125) stated was inscribed on the painting, is visible today. Both the style and costume place the portrait and Cat. no. 184 in the early fifties. The handling of the plum- and russet-coloured shot silk panel, stitched with gold, in her skirt is analogous in treatment to a similar panel in the full skirt worn by the model who posed for the *Portrait of a Woman* in St. Louis (Cat. no. 183; Plate 285).
A weak coloured chalk drawing after the painting was in the collection of Lord Ronald Sutherland Gower, Penshurst, Hammersfield; it is described (35·5 × 28 cm.) and reproduced as a possible original in Gerald S. Davies, *Frans Hals*, London, 1902, pp. 123, 137, reproduced facing p. 124. Davies did not note that it was a copy after the painting now in Vienna. The drawing appeared as a Frans Hals in the sale, Earl of Caledon and others, anonymous property, London (Christie) 9 June 1939, no. 102 with the following provenance: Sir. C. Burton; Lord Ronald Sutherland Gower; C. Fairfax Murray.
Another drawing after the painting (Fig. 43) appeared at the

sale, Francis Wellesley, London (Sotheby) 28 June–2 July 1920, no. 496 (plumbago on vellum; 26 × 20·3 cm.). According to the catalogue it also came from Lord Ronald Gower's collection. The sale catalogue attributed it to Thomas de Keyser and dated it 1636 on the basis of a monogram and date in the upper left corner of the sheet. However, it is most likely an eighteenth-century copy, and its close similarity to Jan Gerard Waldorp's (1740–1809) drawings done after Hals supports an attribution to him. For other copies by Waldorp see Cat. nos. 102, 146, 147, L 20.

186. **Portrait of a Painter Holding a Brush** (Plate 288; text, pp. 129, 184, 185). New York, The Frick Collection (Cat. 1968, vol. I, p. 215, inv. no. 06.1.71).
Canvas, 100·3 × 82·9 cm. Signed and dated at the base of the column on the right: FH/16[5?]--; the last digit is cut off at the right margin. Neither the date nor the signature is genuine.

PROVENANCE: S. K. Mainwaring, Otley Park, Ellesmere, Shropshire; dealer Knoedler, New York, from whom it was acquired by Henry Clay Frick in 1906.
EXHIBITIONS: Wrexham, Art Treasures of North Wales and the Border Counties, 1876, no. 148, and London, Royal Academy, 1882, no. 87 (lent in both cases by S. K. Mainwaring). New York, Hudson-Fulton Celebration, 1909, no. 28, and Boston, Museum of Fine Arts, 1910, no. 4 (lent in both cases by Henry Clay Frick).
BIBLIOGRAPHY: Bode 1883, 140 (1635, not Frans Hals); Moes 37 (1635, self-portrait); HdG 147 (1635, self-portrait); Bode-Binder 151 (1635, a painter); KdK 126 (1635, self-portrait); Valentiner 1925, p. 153 (probably 1645, self-portrait); Valentiner 1935, p. 90 (about 1645, self-portrait); Valentiner 1936, 83 (about 1645, self-portrait); Trivas 97 (*ca.* 1650; self-portrait?); Van Hall, 820–7; Dirk Vis, *Rembrandt en Geertje Dircx*, Haarlem, 1965 (*ca.* 1643, portrait by Hals of Rembrandt), reviewed by R. W. Scheller, *O.H.*, LXXXI, 1966, pp. 117–118 (not a portrait of Rembrandt).

The portrait was last cleaned in 1948. Its dark areas as well as the chair and the right hand are abraded and have been reworked; the paint surface has been flattened. The hat has been enlarged and its shape changed and it is difficult to determine if the brush is a later addition or has been retouched by another hand. It is, however, evident that the conspicuous column, which is damaged in the centre, was added later. All four sides of the canvas have been cut.
Early critics dated the work 1635 on the basis of an erroneous reading of the spurious date. Valentiner (*op. cit.*, 1925, p. 153), who recognized that the date was untrustworthy, dated it around 1645 on the basis of its style. However, the loose handling of the costume, and the style of the collar and the slashed sleeve of the jacket place the work in the

early fifties. The weaknesses in the arm, hand and chair-back, which are noted in the Frick catalogue, 1968, vol. I, p. 215, are patent. In my view they are the result of the poor state of these parts and the efforts of an early restorer to make the portrait exhibitable. The restorer may have relied heavily on analogous passages in Hals' 1626 portrait of Massa at Toronto (Cat. no. 42; Plate 64) in order to make the work presentable but I do not think he had to start from scratch. For the portrait Hals employed a schema he used at least a half-dozen times after he had invented it in 1626 (see Cat. nos. 86, 155, 166, 167, 216, 217; text pp. 54–56).

Valentiner (KdK 1921, 119 and 120) was the first to suggest that the portrait was a companion picture to Cat. no. 187. Arguments can be offered to support his conclusion. Both works are approximately the same size and can be assigned approximately the same date. Their attitudes also correspond. Both models turn their bodies, if not their heads, toward each other, and both have compatible informal poses; the man is seated with his arm resting on the back of his chair, and the woman has been portrayed with her arm hooked over the upright of the back of a chair (for Hals' only other uses of this unusual casual pose for portraits of women, see Cat. nos. 172, 174). However, when Cat. no. 187 was brought to the Frick Collection in December, 1966, for comparison with Cat. no. 186 the relationship between the two works looked less compelling. This is partially due to the later addition by another hand of the column, pilaster and cityscape in the background of Cat. no. 187. These elements do not appear to have been painted at the same time or by the same artist who added the large column in the background of Cat. no. 186. The latter is pinkish in colour, while the curious mixture of architectural elements in the middleground of the Metropolitan Museum portrait are a cool grey. Moreover, the head of the woman is badly abraded, passages of the hair have virtually disappeared and the cap is completely repainted; a judgement about its relationship to the well-preserved ruddy head of her presumed mate must be tentative. As noted above, the hand of Cat. no. 186 has been reworked, while the hands of Cat. no. 187 are in excellent state (see Plate 289); comparison of these passages tells little.

The Frick catalogue (vol. I, 1968, p. 216) concludes that the works are not pendants and reasonably states that conceivably the two portraits entered the same collection at some time and one or both were altered to make them appear as mates. Yet repeated study of the two portraits over a number of years makes it hard for me to reject categorically the notion that they were painted as companion pictures.

There is no convincing evidence to support Valentiner's repeated claim (see Bibliography above) that Cat. nos. 186 and 187 are portraits of Frans Hals and his second wife Lysbeth Reyniers. Dirk Vis' contention (*op. cit.*) that they are portraits of Rembrandt and his common-law wife Geertje Dircx is also unacceptable (*cf.* text, pp. 185–186, and Scheller, *op. cit.*).

187. **Portrait of a Seated Woman Holding a Fan** (Plates 289, 296; text, pp. 159, 184, 185–186). New York, The Metropolitan Museum of Art (Cat. 1954, inv. no. 91.26.10).
Canvas, 97·4 × 79·2 cm.

PROVENANCE: Earl of Bessborough; it may have appeared in the sale, Bessborough, London, 5–7 February 1801, no. 50, 'A Lady's Portrait by F. Hals'. According to HdG 387 it was sold by Bessborough to Lewis Jarvis of King's Lynn, Norfolk; sale, Jarvis, London (Christie), 21 June 1890, no. 35, 'The Wife of the Artist'; dealer M. Colnaghi, London, who sold it to Henry G. Marquand; given to the museum by Henry G. Marquand in 1890.
EXHIBITION: New York, Hudson-Fulton Celebration, 1909, no. 40.
BIBLIOGRAPHY: Moes 205; HdG 387 ('erroneously called the artist's wife'); Bode-Binder 175; KdK 127 (*ca.* 1635; the artist's wife); Valentiner 1936, 84 (*ca.* 1645, the artist's wife); Trivas 98 (*ca.* 1650; wife of the artist?); Dirk Vis, *Rembrandt en Geertje Dircx*, Haarlem 1965 (*ca.* 1643; portrait of Geertje Dircx), reviewed by R. W. Scheller, *O.H.*, LXXXI, 1966, pp. 117–118 (not a portrait of Geertje Dircx).

Painted around 1650–52. Conceivably a pendant to Cat. no. 186. The architectural elements in the middle ground and the view of a town in the background are later additions. The paint surface, which was flattened during the course of an old relining, is generally abraded and retouched. Severe abrasion in the hair; the model's cap and the lower left part of her pink satin skirt have been repainted. The hands, however, are well preserved (see Plate 296).
Efforts made to identify the model have not been successful. The attempts to identify her as Hals' second wife Lysbeth Reyniers (see Bibliography above) are based on the erroneous assumption that the painting's possible companion piece, Cat. no. 186, is a self-portrait by Hals. Vis' unacceptable identification of the sitter as Rembrandt's mistress Geertje Dircx rests solely on his wrong conclusion that Cat. no. 186 is a portrait done around 1643 by Hals of Rembrandt (see text, pp. 185–186, and Scheller, *op. cit.*).

188. **Stephanus Geraerdts** (Plates 290, 294; text, pp. 51, 160, 184–185). Antwerp, Musée Royal des Beaux-Arts (Cat. 1958, no. 674).
Canvas, 115·4 × 87·5 cm. The Geraerdts' coat-of-arms is painted to the right of the head.

PROVENANCE: Perhaps sale, C. J. Nieuwenhuys, London, 10 May 1833, no. 46 (Yates); Newman Smith, London; dealer E. Warneck, Paris, acquired it and the pendant in England; dealer Stephen Bourgeois, Cologne and Paris; Coll. Prince Demidoff, San Donato, Italy (returned both to Bourgeois); Bourgeois separated the pendants, selling *Geraerdts* to Antwerp and *Isabella Coymans* to Alphonse

Rothschild; the former was purchased by the museum in 1886 for 85,000 francs.

EXHIBITIONS: London, Royal Academy Winter Exhibition, 1877, no. 29; Haarlem 1937, no. 102; Haarlem 1962, no. 62.

BIBLIOGRAPHY: C. J. Nieuwenhuys, *A Review of the Lives and Works of the Eminent Painters*..., London, 1834, pp. 129–130, no. 26. The dimensions and description Nieuwenhuys gives of the work and its pendant (our Cat. no. 189) fit the Antwerp and Rothschild pictures; however, he notes: 'The arms of the family in these portraits are painted on the bottom of the picture' (*ibid.*, p. 130). *Icon. Bat.*, no. 2688 (Frans Hals?); Moes 34; HdG 180 (probably *ca.* 1645); Bode-Binder 258; KdK 262 (*ca.* 1650–52); Trivas 99 (*ca.* 1650–52); Seymour Slive, 'Frans Hals' Portrait of Joseph Coymans', *Wadsworth Atheneum Bulletin*, Winter, 1958, pp. 21ff.

Steven Gérard, called Stephanus Geraerdts, was born at Amsterdam and died at Haarlem 27 January 1671. At the time of his marriage to Isabella Coymans on 4 October 1644 at Haarlem, he lived on the Kaisergracht in Amsterdam. He served Haarlem as an alderman and councillor (see Elias, vol. II, p. 764).

Painted around 1650–52. Companion picture to *Isabella Coymans*, Paris, Coll. Baronne Edouard de Rothschild (Cat. no. 189). In these pendants Hals not only related husband and wife by inventing compositions and using colour harmonies and brushwork which complement and complete each other, but he also arranged an action between the two figures. The portrait of Isabella Coymans, which was designed to hang to the right of this portrait, shows her standing and turning toward her husband to offer him a rose. While one of these masterworks hangs in Antwerp and the other in Paris, the point of this small drama can only be appreciated when reproductions of them are juxtaposed (see Plates 290, 291).

The small oil sketch on paper mounted on panel (Fig. 44; 20 × 18·5 cm.) published by Valentiner (KdK 1921, 246; KdK 261) as a preliminary study by Hals for the bust of Stephanus Geraerdts is a copy by another hand. PROVENANCE: H. E. ten Cate, Almelo; dealer D. Katz, Dieren; dealer H. Schaefer, New York.

A reduced copy (91·5 × 71·1 cm.) which shows the model wearing a dark green suit (instead of a black one) and bearing armorials in the corner appeared in the sale, J. C. O'Connor and others, London (Robinson and Fisher) 5 July 1928, no. 203 (files of the RKD). It is noteworthy that the painting that appeared in the sale, Nieuwenhuys, London, 10 May 1833, no. 26 (116·8 × 88·8 cm.) and may be identical with the Antwerp portrait (115·4 × 87·5 cm.) is described as bearing its coat-of-arms at the bottom; as noted in the Bibliography above, the pendant was also described in 1833 with its coat-of-arms at the bottom. It has not been possible to determine if these were removed after 1833 and subsequent cleaning revealed

the arms now visible on the pendants. Therefore, the possibility that the Nieuwenhuys' pictures are not identical with the Antwerp and Paris portraits cannot be excluded. To judge from the dimensions, the reduced copy showing Geraerdts in a green suit appeared again in the following sales: Lord Acton and others, London, 26 April 1929, no. 25; John Turner and others, London (Sotheby), 6 May 1953, no. 93 (£20; Mameli). The Antwerp Catalogue, 1958, p. 102, no. 674, cites a version of Cat. no. 188 in the Baszanger collection, Geneva; I have not been able to locate it or determine its relation to the versions cited above.

189. Isabella Coymans, wife of Stephanus Geraerdts
(Plates 291, 295, 297; text, pp. 51, 160, 184–185). Paris, Baronne Edouard de Rothschild.
Canvas, 116 × 86 cm. The Coymans' family coat-of-arms is painted to the left of the head.

PROVENANCE: Perhaps sale, C. J. Nieuwenhuys, London, 10 May 1833, no. 45 (£22, Pennel); Newman Smith, London; dealer E. Warneck, Paris; dealer Stephan Bourgeois, Cologne and Paris, sold it and the pendant to Prince Demidoff, San Donato, Italy; Prince Demidoff returned them to Bourgeois and the latter separated the couple, selling *Isabella Coymans* to Alphonse de Rothschild, Paris; Edmond de Rothschild, Ferrières.

EXHIBITION: London, Royal Academy, Winter Exhibition, 1877, no. 38; Haarlem 1962, no. 63 (in the catalogue but not exhibited).

BIBLIOGRAPHY: C. J. Nieuwenhuys, *A Review of the Lives and Works of Some of the Eminent Painters*..., London, 1834, p. 129, no. 25. The dimensions and description Nieuwenhuys gives of the portrait and its pendant (our Cat. no. 188) fit the painting and the Antwerp picture; however, he notes the arms of both portraits are painted at the bottom (*ibid.*, p. 130); Bode-Binder 259; KdK 263 (*ca.* 1650–52); Trivas 100 (1650–52); Seymour Slive, 'Frans Hals' Portrait of Joseph Coymans', *Wadsworth Atheneum Bulletin*, Winter, 1958, pp. 21ff.

Companion picture to Cat. no. 188. Isabella Coymans was the daughter of Joseph Coymans and Dorothea Berck (see Cat. nos. 160, 161). She was born at Haarlem, married Stephanus Geraerdts in her native town on 4 October 1644; two years after Stephanus' death she married Samuel Gruterus (13 June 1673). She died in Haarlem 7 October 1689 (see Elias vol. II, p. 764). For references to Hals' other portraits of the Coymans family, see Cat. no. 160.

Early in the century a weak copy (canvas, 114 × 86 cm.), which first made its appearance in the Rudolphe Kann collection, Paris, was confused with the original. Moes rightly questioned the attribution of the Kann version to Hals in 1897 (*Icon. Bat.*, no. 1785). Around 1906 the copy was sold by Durand-Ruel, Paris, to P. A. B. Widener of Philadelphia (see F. J. M., 'Notes on the Widener Collec-

tion, I. Frans Hals: The Lady with a Rose', *B.M.*, XI, 1907, pp. 129–130, reproduced p. 125). It was erroneously exhibited as the original in the Hudson-Fulton Exhibition, New York 1909, no. 38, repr. The copy is catalogued as a work by Frans Hals in *Pictures of P. A. B. Widener at Lynnewood Hall, Elkins Park, Pennsylvania, Early German, Dutch and Flemish Schools...*, notes by C. Hofstede de Groot and Wilhelm R. Valentiner, Philadelphia, 1913, unpaginated. In 1909 Moes listed the copy without question (no. 35) and Hofstede de Groot listed it with a provenance confused with the original's in his 1910 catalogue (no. 181). By the time Bode-Binder published their Hals study in 1914 the error must have been discovered; they only cite the Rothschild version (no. 259). The copy has been untraceable since it made a modest appearance at an anonymous sale, Amsterdam (Muller) 14 October 1918, no. 32, 'Haarlem School, Smiling Lady', and fetched 750 guilders.

190. **Portrait of a Man** (Plates 298, 301; text, p. 194). New York, The Metropolitan Museum of Art (Cat. 1954, inv. no. 91.26.9).
Canvas, 110·5 × 86·3 cm. Signed in the lower right corner with the connected monogram: FH

PROVENANCE: Sale, Earl of Buckinghamshire, London, 17 March 1890, no. 131; Henry G. Marquand, New York, who bequeathed it to the museum in 1890.
EXHIBITIONS: New York, Hudson-Fulton Celebration, 1909, no. 40; Haarlem 1937, no. 105; Haarlem 1962, no. 61.
BIBLIOGRAPHY: Moes 184; HdG 297; Bode-Binder 260; KdK 266 (*ca.* 1652–54); Valentiner 1936, 102 (*ca.* 1652–54).

Painted around 1650–52. One of Hals' most penetrating characterizations as well as an outstanding example of his use of the classic frontal pose he favoured for three-quarter lengths during his late phase.
A reduced copy wrongly attributed to Harmen Hals appeared in the sale, New York (Parke-Bernet) 14 March 1951, no. 9 and the sale, New York (Parke-Bernet), 5 March 1952, no. 31: (panel, 38 × 29 cm.).

191. **Portrait of a Man** (Plate 302). Washington, National Gallery of Art, Joseph E. Widener Collection (Cat. 1965, acc. no. 625).
Canvas, 114 × 85 cm.

PROVENANCE: According to HdG 294 bequeathed by Lord Frederick Campbell to an ancestor of Earl Amherst; Earl Amherst, Montreal, Sevenoaks, Kent, untill 1911; dealer Sedelmeyer, Paris, Cat. 1911, no. 11; P. A. B. Widener, Elkins Park, Pennsylvania; Joseph E. Widener, Elkins Park, Pennsylvania, who presented it to the gallery in 1942.

EXHIBITIONS: London, Royal Academy, 1894, no. 81; London, Arundel Club, 1909, no. 9; London, Royal Academy, 1910, no. 89.
BIBLIOGRAPHY: Moes 162; HdG 294 (about 1645); *Pictures of P. A. B. Widener at Lynnewood Hall, Elkins Park, Pennsylvania, Early German, Dutch and Flemish Schools...*, notes by C. Hofstede de Groot and Wilhelm R. Valentiner, Philadelphia, 1913, unpaginated; Bode-Binder 247; KdK 256 (*ca.* 1650–52); *Paintings in the Collection of Joseph Widener at Lynnewood Hall*, Elkins Park, 1923, unpaginated; *ibid.*, 1931, p. 84; Valentiner 1936, 97 (*ca.* 1650–52); National Gallery of Art, *Works of Art from the Widener Collection*, Catalogue, 1942, no. 625.

Painted around 1650–52. Valentiner (KdK 256) claimed that it was 'ohne Zweifel' a companion piece to the *Portrait of a Woman* at the Louvre (Cat. no. 171; Plate 252) and he repeated this assertion in 1936 (no. 97), but I see no reason to conclude they were pendants. The looser handling of the Washington painting points to a later date and if we imagine the Louvre portrait enlarged to match the size of its so-called pendant the ample space around the figure would make an even more incongruous contrast with its presumed mate.

192. **Portrait of a Man, probably Adriaen van Ostade** (Plate 303; text, p. 190, text Fig. 203). Washington, National Gallery of Art, Andrew W. Mellon Collection (Cat. 1965, acc. no. 70).
Canvas, 94 × 75 cm.

PROVENANCE: Dealer Knoedler, London; Andrew W. Mellon, Washington, D.C., who presented it to the gallery in 1937.
BIBLIOGRAPHY: Valentiner 1935, pp. 86, 102, no. 21 (*ca.* 1650–52); Valentiner 1936, 100 (*ca.* 1652–54); National Gallery of Art, Washington, D.C., *Preliminary Catalogue of Painting and Sculpture*, 1941, no. 70. Eduard Trautscholdt, 'Zu einer Bilderzeichnung des Adriaen van Ostade', *Miscellanea I. Q. van Regteren Altena*, Amsterdam 1969, pp. 152ff.; Claus Grimm, 'Ein meisterliches Künstlerporträt: Frans Hals' Ostade-Bildnis, *O.H.*, LXXXV, 1970, pp. 170ff.

Painted around 1650–52. An old painted inscription on the back of the picture reads 'Nicholas Berghem' (photo in Fine Arts Library, Harvard University). Valentiner, who published the painting in 1935 (*op. cit.*), treated this identification with scepticism; comparison of the portrait with the rare known portrayals of Nicolaes Berchem shows why (see *e.g.*, Nicolaes Berchem's *Self-Portrait*, text, Fig. 202; Amsterdam, Rijksmuseum, Prentenkabinet, inv. no. A. 3010). I. Q. van Regteren Altena kindly called my attention to the resemblance between the model of the

Washington portrait (text, Fig. 203) and the self-portrait of Adriaen van Ostade (1610–85) which appears in his *Members of the De Goyer Family* painted around 1650 (text, Fig. 204; Museum Bredius, The Hague, inv. no. 86–1946). Claus Grimm (*op. cit.*) independently arrived at the same identification and argues that Cornelius Dusart's (1660–1704) lost portrait of Ostade, which is only known from the mezzotint of it made by Jacob Gole (*ca.* 1660–1724), was done after the Washington portrait (Fig. 45; J. E. Wessely, *Kritische Verzeichnisse . . .* , vol. v, Adriaen van Ostade, Hamburg, 1888, p. xi, no. 2). There can be no doubt that Dusart based his portrait on someone else's work. Dusart probably made contact with his teacher Ostade in the mid-1670's, when he was around fifteen years old and his master was about sixty-five; he entered the guild at Haarlem in 1679, when Ostade was sixty-nine. It is obvious that he portrayed Ostade much younger than he ever knew him and that he dressed his old teacher in a fashionable late seventeenth-century kimono, scarf and long curly wig.

The resemblance between Dusart's portrayal of Ostade and the model of the Washington painting is striking and Dusart could have used Hals' portrait as his point of departure. However, the possibility that he based his portrait on other works cannot be excluded. Trautscholdt (*op. cit.*), who first emphasized that Dusart could not have made the likeness *ad vivum*, suggested that it was based on a small painting done around 1657 by Terborch which he and Altena identify as a portrait of Ostade (repr. *ibid.*, p. 344, fig. 12; Rotterdam, Museum Boymans-Van Beuningen, no. 2380, on loan from the Rijksmuseum), or on other portraits done of the Ostade in the 1650's. I do not find Grimm's rejection of the Terborch as a portrait of Ostade, his date of 1643–4 for Cat. no. 192, or his suggestion that the small Ottawa panel (Cat. no. 155; Plate 236) is a copy after Cat. no. 192, probably by Frans Hals II, convincing (*op. cit.*, pp. 170ff.).

Although Cat. no. 192 bears a strong resemblance to Ostade's self-portrait in his family portrait at The Hague (text, Figs. 203–204), it should be noted that neither work is very similar to the mezzotint Gole made after Ostade's own lost drawing of himself (Fig. 46; Wessely, *op. cit.*, p. xi, no. 1, p. 58, no. 86). The print, which is inscribed 'A. van Ostade del. effigies', was accepted early in the eighteenth century as a likeness of the artist; it served as the basis of the engraved portraits of Ostade which appear in Houbraken (vol. I, 1718, opposite p. 348) and Weyerman (vol. II, 1729, opposite p. 90). A weak drawing of the self-portrait, in the same direction as Gole's mezzotint, is at the British Museum where it is attributed to Gole (Arthur M. Hind, *Catalogue of Dutch and Flemish Drawings*, vol. III, 1926, p. 102, no. 1, inv. no. 1895.12.14.104, repr. plate LIII). It may, however, be a copy after the mezzotint or Ostade's original drawing by a later eighteenth-century hand and the inscription 'Aetat 46', which appears on it, but not on the print, may be the invention of the copyist. Trautscholdt (*op. cit.*, p. 153) rightly states that if we did not have the age inscribed on the

British Museum sheet we would surmise that the self-portrait drawing which served as the model for Gole's mezzotint shows Ostade in his fifties. For a drawing by Adriaen of his brother Isaack van Ostade (formerly coll. F. Koenigs, Haarlem) with an erroneous added inscription, which gives the wrong date of Isaack's death (1657 instead of 1649), see Ernst Scheyer, 'Portraits of the Brothers van Ostade', *The Art Quarterly*, II, 1939, p. 135*f.*; repr. p. 137, fig. 2. Scheyer suggests that Adriaen's drawing of his brother Isaack and the lost self-portrait drawing Gole used for his mezzotint were intended as pendants.

The Louvre *Family Portrait* (inv. 1679), signed Ostade and dated 1654, was once thought to represent Adriaen's family and Isaack and his wife (nothing is known of Isaack's marriage and he died in 1649), but these identifications are groundless (*cf.* Paris, Exhibition, 'Le Siècle de Rembrandt', 1970–71, no. 153). For a discussion of other portraits of Adriaen van Ostade, see Trautscholdt, *op. cit.*, and Van Hall, 1584, 1–15. Hofstede de Groot lists five self-portraits by Ostade (vol. III, 1910, nos. 873c, 874, 874a, 875, 875a); none of them has been identified. His numbers 874, 875a, which are probably identical, describe Ostade with his right hand raised to the tie of his open collar, and beside him a bust of the Emperor Hadrian, probably an allusion to his name. This self-portrait was etched in reverse by Jean Baptiste Bernard Coclers (1741–1817), repr. F. G. Waller, *Biographisch Woordenboek van Noord Nederlandsche Graveurs*, The Hague, 1938, Plate XL. A copy of it attributed to Jan van Rossum (active *ca.* 1654–*ca.* 1673) by Hofstede de Groot (Thieme-Becker, vol. XXIX, 1935, p. 79) is at Dublin, The National Gallery of Ireland (Fig. 47; Cat. 1971, no. 623). If it were the only portrayal we had of Adriaen van Ostade no one would suggest that Hals' portrait in Washington probably represents the same man.

193. **Portrait of a Man** (Plates 299–300; text, pp. 191–193). Leningrad, Hermitage (Cat. 1958, no. 816).
Canvas, 84·5 × 67 cm. Signed with the connected monogram at the right: FH (Fig. 62).

PROVENANCE: Acquired by Catherine II between 1763 and 1774.
EXHIBITION: Haarlem 1962, no. 79.
BIBLIOGRAPHY: Catalogue, Ermitage, 1863, no. 772; Waagen, Ermitage, 1864, no. 772; Bode 1883, 130 (about 1660, or later); Catalogue, Ermitage, 1895, no. 772; Moes 182; HdG 309 (around 1645, or later); Bode-Binder 266; KdK 258 (*ca.* 1650–52); I. Q. van Regteren Altena, 'Frans Hals Teekenaar', *O.H.*, XLVI, 1929, pp. 149–152; Trivas 96 (*ca.* 1650); I. Q. van Regteren Altena, *Holländische Meisterzeichnungen des siebzehnten Jahrhunderts*, Basel, 1948, p. XVIII, no. 16; H. Fechner, ' "Muzhskoi Portrat" Roboty Fransa Galsa', *Soobshcheniia Gosudarstvennogo Ermitazha*, XIX, 1960, pp. 14–16; W. F. Lewinson-Lessing, e.a., *Meisterwerke aus der Hermitage: Holländische und Flämische*

Schule, Leningrad 1962, no. 28 (the model originally shown with a hat, which the artist later repainted).

One of the finest of the great series of portraits Hals made in the early fifties. The broad, thin washes which render the model's torso and the bold treatment of the cuff suggest a somewhat later date but the restraint in the modelling of the head and hair account for the date assigned to the work here.

I. Q. van Regteren Altena (*op. cit.*, 1929 and 1948), followed by Fechner (*op. cit.*), wrote that a black and white chalk drawing at the British Museum (text, Fig. 205; 1895.12.14. 98) was Hals' preliminary study for the portrait. Of all the drawings which have been attributed to Hals it appears to be the best; however, in my opinion (see text, pp. 191–192) it is not by the artist but the work of an anonymous copyist. Hind, who did not note its connection with the Leningrad portrait, wrote that the attribution of the British Museum drawing was very uncertain and added that the name of Cornelis Saftleven had been suggested (Arthur M. Hind, *Catalogue of Dutch Drawings of the XVII Century*, vol. III, London, 1926, p. 110, no. 3). Trivas (90 and App. 8) called it doubtful.

The sitter as represented in the British Museum drawing wears a hat decorated with a pompom. Altena (*op. cit.*, 1929 and 1948) and Fechner (*op. cit.*) correctly note that the hat was part of Hals' original conception; traces of the hat are still evident on the painting. But it does not follow, as they claim, that evidence of the hat conclusively proves that Hals made the drawing. Their conclusion rests on the assumption that Hals made the drawing, virtually followed it stroke for stroke when he painted the portrait, then had second thoughts about including the rakish hat and painted it out. The hypothesis that Hals himself did away with the hat is also accepted by Lewinson Lessing *e.a.*, *op. cit.* But the dead passages of repaint in the area of the hat cannot be attributed to Hals (see Plate 300); they show that the hat was 'removed' by another hand, probably to suit the whim of some later collector or dealer. The hat originally worn by the model who posed for Hals' *Portrait of a Man* at the Fitzwilliam Museum, Cambridge, was probably painted out for the same reason (Cat. no. 218; Plate 338, text, Fig. 213). When the Cambridge picture was cleaned in 1949 the sitter's hat reappeared. Laboratory tests of the repaint on the Hermitage portrait and the condition of the original paint layer below it may prove that it may be possible to restore the hat.

The resemblance between the model for Cat. no. 193 and the engraved portrait of Hals which appears in Houbraken (text, Fig. 206; Houbraken, vol. I, 1718, facing p. 91) is discussed in the text, p. 193.

I have not been able to trace the small version of the portrait which was in the coll. H. E. ten Cate, Almelo: panel, 20·5 × 18·3 cm. Hofstede de Groot states it is an original study by Hals (RKD notes); to judge from a photograph it is a poor copy.

194. **Portrait of a Man** (Plate 304; text, pp. 129, 174, 189–190; text, Fig. 200). Budapest, Museum of Fine Arts (Cat. 1967, no. 277).
Panel, 64·5 × 46·3 cm.

PROVENANCE: Esterházy Collection, Vienna.
EXHIBITION: Haarlem 1962, no. 75.
BIBLIOGRAPHY: *Catalog der Gemählde Galerie des durchlauchtigen Fürsten Esterhàzy von Galantha zu Laxenburg bey Wien*, Vienna, 1812, VIII, no. 47 (self-portrait by Karel Dujardin); K. Pulszky, *Az Orsz. Képtàr Kivàlóbb müvei*, vol. I, 1878, pp. 42–44 (self-portrait by Hals painted in the 1640's); Bode 1883, 127 (*ca.* 1650); Moes 176; HdG 263 (probably cut); Bode-Binder 234; KdK 264 (*ca.* 1652–54); André Pigler, *Bulletin du Musée Hongrois des Beaux-Arts*, no. 2, 1948, pp. 26–29; 60–61; Anne Charlotte Steland-Stief, *Jan Asselijn*, Amsterdam 1971, pp. 13–14.

Mistaken efforts were made in the early nineteenth century to identify the painting as a self-portrait by Karel Dujardin, and later in the century it was erroneously called a self-portrait by Hals (see Bibliography above). Pigler's attempt to identify the model as the Italianate landscape painter Jan Asselyn (after 1610–52), who was nicknamed 'Crabbetje' because of his crippled left hand, must stand or fall on the resemblance the model bears to Rembrandt's etching of Asselyn (Bartsch 277), done around 1647. In my opinion a juxtaposition of the two heads demonstrates they do not represent the same person (see text, pp. 189–190; text, Figs. 200, 201). Anne Charlotte Steland-Stief, the most recent biographer of Asselyn, has also called Pigler's identification doubtful (*op. cit.*, p. 13). Sturla J. Gudlaugsson and Ernst Brochhagen (see *Kunstchronik*, XVI, 1963, p. 9) as well as Ilse Gerson (oral communication) have noted a resemblance between the model of Cat. no. 194 and the seated man in the *Family Portrait* at London (Cat. no. 176; Plate 272). I do not find the likeness compelling enough to maintain that they represent the same man. It is, however, safe to conclude that the father in the family portrait at London, who is surrounded by six young children, is not a portrait of Asselyn. Four children are mentioned in Asselyn's will dated 28 September 1652 (ages 7, 4, 2½ and 4 months); he was buried in Amsterdam 3 October 1652 (Steland-Stief, *op. cit.*, pp. 17, 19).

The Budapest portrait is related in style to the group of male portraits we have dated in the early fifties. However, I tend to place it at least a few years later on the basis of the free treatment of the model's sleeve, which justifies Gudlaugsson's characterization of the work as 'ein Wunderwerk malerischer Gestaltung' (*Kunstchronik*, XVI, 1963, p. 9). Hofstede de Groot (263) notes that the figure seems rather large for the panel and suggests that the panel was cut down. This seems to be the case. During his mature phase Hals generally put more space around his figures than is found here. Valentiner (KdK 264), however, maintained that the panel has not been cut;

he argues that Hals pushed his figures toward all edges of his pictures during this phase of his career to achieve more monumental effects.

195. Portrait of a Man (Plates 306, 308, p. 194). England, Private Collection.
Canvas, 65 × 56·5 cm.

PROVENANCE: Collection Blackwood; W. R. Cartwright, Aynhoe, Northants; William C. Cartwright, Aynhoe Park, Northants; Sir Fairfax Cartwright, Aynhoe Park, Northants; dealer M. Knoedler and Co., New York; Katherine Deere Butterworth, Moline, Illinois; sale, Butterworth estate, New York (Parke-Bernet), 20 October 1954, no. 27; New York, private collection; dealer Matthiesen Gallery, London.
EXHIBITIONS: London, British Institution, 1839, no. 65; London, Royal Academy, 1878, no. 270; London, Royal Academy, 1891, no. 73.
BIBLIOGRAPHY: Bode 1883, no. 136 (*ca.* 1655); Moes 151; HdG 251 (*ca.* 1655); Bode-Binder 223; KdK 275 (*ca.* 1656).

The picture is reproduced in the older literature as an oval because it had been framed to match a companion picture. But it was conceived as rectangular and the corners are original. The summary handling and liquid touch closely relate the work to *Tyman Oosdorp* at Berlin-Dahlem (Cat. no. 201; Plate 314), which is traditionally dated 1656. Cat. nos. 196, 197, 198, 202, 203, 204, 205 show close similarities in technique; all of them are datable around 1655–60.

196. Portrait of a Woman (Plates 307, 309; text, p. 194). Hull, Yorks., Ferens Art Gallery (no. 526).
Canvas, 60 × 55·6 cm.

PROVENANCE: According to W. Martin (*B.M.*, XCIV, 1952, p. 360) it was possibly acquired 'by the 4th and last Earl of Egremont to replace the pictures removed by his predecessor from Orchard Wyndham to Petworth, which was left away from him when he inherited the earldom in 1836. On the death of his widow, the last Countess of Egremont, in 1876, Orchard Wyndham and all its contents passed to the grandfather of the present owner [George Wyndham], who has come into the property from his uncle, the late Mr. William Wyndham.' George Wyndham, Orchard Wyndham, Wilton, near Taunton, Somersetshire; sale, George Wyndham, London (Christie), 24 November 1961, no. 70; purchased by the gallery in 1963.
EXHIBITIONS: London 1952–53, no. 137; Manchester, Art Treasures Centenary, 1957, no. 118.
BIBLIOGRAPHY: W. Martin, 'An Unknown Portrait by Frans Hals', *B.M.*, XCIV, 1952, pp. 359–360 (*ca.* 1645); *Ferens*

Art Gallery Bulletin, April–May–June, 1963, unpaginated (1655–60).

Moderate abrasion on the forehead, the dress and the background. Until the painting was published by W. Martin in 1952 (*op. cit.*) it was attributed to Aelbert Cuyp. Martin rightly recognized it as an authentic work by Hals but in my opinion he placed it about a decade too early when he dated it around 1645. The frontal pose of the model and the handling closely relate the picture to Cat. no. 195. There is, however, no reason to conclude that the portraits were pendants. The pale, silvery flesh colour anticipates tones found in Hals' regentess group portrait of the 1660's (Cat. no. 222; Plate 349).

197. Portrait of a Man (Plate 305). Rochester, New York, The George Eastman House, University of Rochester.
Canvas, 76 × 67 cm.

PROVENANCE: Possibly sale, William Russell, London (Christie), 5 December 1884, no. 135 (Waters); Lord Glanusk, Glanusk Park, Crickhowell; sale, Lord Glanusk, London (Sotheby) 20 June 1913, no. 110 (bought in for £8,000); dealer A. Preyer, The Hague, 1914; George Eastman, Rochester, who bequeathed it to the University of Rochester.
BIBLIOGRAPHY: Bode-Binder 237; KdK 196 (*ca.* 1642); Valentiner 1936, 68 (*ca.* 1642).

The painting is badly abraded throughout; the paint surface has been flattened during the course of a relining. Extensive repaint in the dark areas; the hand and glove have been clumsily reworked. In spite of the poor state of preservation, I think it is possible to recognize Hals' hand in the portrait. In my view Valentiner's date of about 1642 is too early; I tentatively place it with the group of portraits datable around 1655–60 (see Cat. no. 195). Valentiner's suggestion (KdK 196; Valentiner 1936, 68) that the model may be identical with Dirk Dirks Del, the second figure from the left in Hals' 1641 regent group portrait (Cat. no. 140; Plate 226) is unconvincing.
A weak copy of the portrait appeared in the sale, Flaxley Abbey (Gloucestershire), Gloucester (Burton Knowles and Co.), 29 March 1960, no. 1248, repr.: canvas, 74 × 61 cm.

198. Portrait of a Man (Plate 310). Washington, National Gallery of Art, Joseph E. Widener Collection (Cat. 1965, acc. no. 624).
Canvas, 63·5 × 53·5 cm. Signed at the lower left with the connected monogram: FH.

PROVENANCE: According to the Widener Catalogue, 1885–90, no. 207, from the coll. Roo van Westmaas. According to HdG 311 in the coll. Remi van Haanen.

Vienna, and then with the London dealer T. Lawrie in March, 1898, and subsequently with the dealer Bourgeois in Paris, and the New York dealer L. Nardus; P. A. B. Widener, of Ashbourne, Elkins Park, Pennsylvania; Joseph E. Widener, Elkins Park, who gave it to the gallery in 1942.

EXHIBITIONS: Vienna 1873, no. 38; New York, Hudson-Fulton Celebration 1909, no. 32.

BIBLIOGRAPHY: Bode 1883, 122 (*ca.* 1655; Vienna, coll. H. Remy van Haanen, 'wohl verkauft?'); *Catalogue of Paintings . . . of P. A. B. Widener, Ashbourne Near Philadelphia*, Part II, 1885–90, no. 207; HdG 311; W. Martin, 'Notes on Some Pictures in American Private Collections' *B.M.*, XIV, 1908, p. 60 (*ca.* 1640–45); *Pictures of P. A. B. Widener at Lynnewood Hall, Elkins Park, Pennsylvania, Early German, Dutch and Flemish Schools . . .*, notes by C. Hofstede de Groot and Wilhelm R. Valentiner, 1913, unpaginated; Bode-Binder 191; KdK 251 (*ca.* 1650); *Paintings in the Collection of Joseph Widener at Lynnewood Hall*, Elkins Park, 1923, unpaginated; *ibid.*, 1931, p. 80; Valentiner 1936, 96 (*ca.* 1650); *National Gallery of Art, Works of Art from the Widener Collection, Catalogue*, 1942, no. 624.

Painted around 1655–60; see Cat. no. 195 for references to other portraits done around the same time.

An unpublished drawing by Pieter Holsteyn II (*ca.* 1614–1673) after the painting shows the sitter behind a simulated oval frame; it is at the Prentenkabinet, Amsterdam (Fig. 48; inv. no. 2776). The drawing is inscribed: P Holsteyn. fe., and is close in style to the prints made by this gifted Haarlem printmaker and glass painter. Holsteyn's drawing does not identify the handsome model.

199. **Portrait of a Man** (Plate 320). Formerly Berlin, M. Kappel.
Panel, 35 × 26 cm.

PROVENANCE: Sale, G. Rothan, Paris, 29–31 May 1890, no. 50 (6,500 francs); sale, Baron Königswater of Vienna, Berlin, 20 November 1906, no. 34 (29,000 marks); Marcus Kappel, Berlin; dealer Van Diemen, Amsterdam, 1932.

BIBLIOGRAPHY: Bode 1883, 71; Moes 165; HdG 259 (signed); Bode-Binder 229; KdK 278 ('Das Bild macht keinen erfreulichen Eindruck').

I only know this small sketch from photographs. To judge from them it is closely related to Cat. nos. 198 and 200.

200. **Portrait of a Man** (Plate 311; text, pp. 129, 190). Los Angeles, Mr. and Mrs. Norton Simon.
Canvas, 66 × 49.5 cm. Signed at the lower right with the connected monogram: FH.

PROVENANCE: Rodolphe Kann, Paris; purchased with the Kann collection by the Paris dealers Wildenstein and Duveen in 1907; dealer Duveen, Paris; Arthur Granfell, Roehampton, 1913; dealer Knoedler, Paris; dealer Duveen, New York; I. M. Stettenheim, New York; dealer Wildenstein, New York.

EXHIBITIONS: Detroit 1935, no. 48; San Francisco-Toledo-Boston 1966–67, no. 19.

BIBLIOGRAPHY: W. Bode, *Gemäldesammlungen des Herrn Rudolf Kann*, Vienna, 1900, no. 50; *Catalogue of the Rodolphe Kann Collection*, vol. I, Paris, 1907, no. 42; Moes 147; HdG 301 (*ca.* 1640); Bode-Binder 239; KdK 254 (*ca.* 1650); Valentiner 1936, 98 (*ca.* 1650); Trivas 101 (not earlier than 1655); W. R. Valentiner, 'Jan van de Cappelle', *The Art Quarterly*, IV, 1941, pp. 291ff.

Painted around 1655–60. Efforts to identify the sitter have not been successful. Valentiner (KdK 1921, 240; KdK 253) first suggested that the model may be identical with a sitter who was subsequently identified as the Haarlem painter Vincent Laurensz. van der Vinne (see Cat. no. 203; Plate 317). He abandoned this idea in the references he made to the portrait in the 1930's, and in 1941 (*op. cit.*) proposed that the sitter was the Amsterdam marine painter Jan van de Cappelle. It is known that Van de Cappelle posed for Hals. The inventory of Van de Cappelle's effects dated 4 January 1680, which was compiled after his death in 1679, lists among the nine paintings by Hals in his collection: 'Een dito Conterfeijtsel [sijnde den Overleden] van Frans Hals' (Amsterdam Municipal Archives NNA no. 2262 B, p. 1188, no. 32). However, for reasons cited in the text (p. 190) there is no reason to accept Valentiner's argument that Cat. no. 200 is identical with Hals' portrait of Van de Cappelle. His portrayal is lost or remains unidentified.
The inventory of Van de Cappelle's breathtaking collection was published by A. Bredius, 'De Schilder Johannes van de Cappelle, *O.H.*, x, 1892, pp. 31ff.; also see text, pp. 190–191.
Moes (*Icon. Bat.*, no. 5559) states that C. van Noorde made a print after the portrait; I have not been able to locate an impression of it or a reference to it in the standard handbooks.

201. **Tyman Oosdorp** (Plates 314, 315; text, pp. 182, 194). Berlin-Dahlem, Staatliche Museen (Cat. 1966, no. 801H).
Canvas, 89 × 70 cm.

PROVENANCE: Collection von Liphart zu Ratshoff; purchased by the Berlin museums from a Cologne dealer in 1877.

EXHIBITION: Amsterdam 1950, no. 53.

BIBLIOGRAPHY: Bode 1883, 93; *Icon. Bat.*, no. 5559; Moes 63; HdG 213; Bode-Binder 277; KdK 274; Trivas 102.

Inscribed on the stretcher in a nineteenth-century hand: 'Portrait de Tyman Oosdrop peint en 1656 par Frans Hals'.

An inscription on a torn label secured to the stretcher, which appears to have been written in the eighteenth century, reads: 'Tyman Oosdrop'. A second label attached to the stretcher bears an illegible inscription.

These bits of evidence are the basis for the identification of the sitter and for the date of 1656, which has been assigned to the portrait.

According to Hofstede de Groot (213) Tyman Oosdorp was born at Delft and died at Haarlem, 28 February 1668. He married Hester Olycan, and in 1658 married Margarethe Schellinger (1611–68).

202. Portrait of a Man (Plate 316; text, p. 195). Copenhagen, Royal Museum of Fine Arts (Cat. 1951, no. 289; inv. no. 3847).

Canvas, 104 × 84·5 cm. Signed at the lower right with the connected monogram: FH.

PROVENANCE: Collection Suermondt, Aachen, from which it was acquired by the Berlin museums in 1874, inv. no. 801E; sold by the Kaiser Friedrich Museum around 1927; purchased at Amsterdam in 1929 by the Copenhagen museum.

EXHIBITION: Brussels, Exposition . . . au Musée Royal, 1873, no. 80.

BIBLIOGRAPHY: *Verzeichnis der . . . Sammlungen des B. Suermondt*, Berlin, 1875, no. 17; Bode 1883, 88 (*ca.* 1660); Moes 164; HdG 254 (around 1660); *Verzeichnis der Gemälde im Kaiser-Friedrich-Museum*, Berlin, 1912, no. 801E; Bode-Binder 263; KdK 280 (*ca.* 1657–60); G. Falck, 'Frans Hals' Mandsportraet og Philips Konincks Landskab, *Kunstmuseets Aarsskrift*, XVI–XVIII, 1929–31, pp. 127ff.

Painted around 1655–60. Valentiner (KdK 280) suggested that the portrait was probably the companion picture of the *Portrait of a Woman* formerly in the collection Joseph Samson Stevens, New York. In my opinion there is no foundation to his proposal and the attribution of the Stevens painting to Hals is questionable (see Cat. no. D 78; Fig. 201).

203. Vincent Laurensz. van der Vinne (Plate 317; text, pp. 8, 187–188, text, Fig. 197). Toronto, The Art Gallery of Ontario.

Canvas, 64·8 × 49 cm. There is an indecipherable monogram at the lower right; it is not that of Hals.

PROVENANCE: Count Kaunitz, Imperial Chancellor of Austria (died 1794), Vienna; Grünauer, Vienna; Baroness Auguste Stummer von Tavarnok, Vienna; F. Kleinberger, Paris; Frank P. Wood, Toronto, who bequeathed it to the gallery in 1955; stolen in September, 1959, and returned to the gallery in the same year.

EXHIBITIONS: Vienna 1873, no. 138, the catalogue states that it had formerly borne the false signature and date 'Diego Velasquez, 1642'; Toronto, *Dutch Painting: The Golden Age*, 1955, no. 31; Haarlem 1962, no. 64; San Francisco-Toledo-Boston 1966–67, no. 21; Baltimore, The Baltimore Museum of Art, *From El Greco to Pollock: Early and Late Works by European and American Artists*, 1968, pp. 24–25.

BIBLIOGRAPHY: T. von Frimmel, *Verzeichnis der Gemälde im Besitze der Frau Baronin Auguste Stummer von Tavarnok*, Vienna, 1895, p. 30, no. 73. *Icon. Bat.*, no. 8517–2; Moes 178; HdG 324; Bode-Binder 238; KdK 253 (*ca.* 1650); Valentiner 1936, 103 (*ca.* 1655); Hubbard 1956, p. 151.

Losses along the outer edges occurred when the painting was cut out of its stretcher and stolen in 1959. There are scattered losses in the dark areas on the right side, the hair, and background. The rest of the paint surface is in a good state of preservation.

The identification of the portrait is based on Vincent Laurensz. van der Vinne's own mezzotint after it (text, Fig. 196), which bears the title 'Vincent Laur. Vand^r: Vinne' and is inscribed: 'F. Hals Pinxit VvVinne Fec.'.

Van der Vinne (1629–1702) was a Haarlem artist who studied with Hals. According to Houbraken he made portraits in his teacher's manner (Houbraken, vol. II, 1719, p. 210); none of them is identifiable today. His return to Haarlem in 1655 after a three-year journey to Germany, Switzerland and France (*ibid.*), provides a *terminus post quem* for the portrait, which is stylistically related to the group of paintings datable around 1655–60 (see Cat. no. 195). As noted in the text (p. 182), the dearth of dated works makes it difficult to establish a precise chronology for Hals' last period, but the exceptionally fluid brushwork of Cat. no. 203 suggests a date closer to 1660 than 1655.

Artists who were fascinated by paintings done with the utmost economy have been understandably fascinated by the portrait and it is noteworthy that more copies of it are known than of most of Hals' other mature works. In addition to Van de Vinne's print, there is a drawing after it by Lodowyck de Moni (1698–1771) at the British Museum, watercolour copies by Cornelis van Noorde (1731–95) are at Haarlem Municipal Archives (dated 1754) and at the Rijksprentenkabinet, Leiden (dated 1758), and there is an anonymous watercolour copy of it at the Teyler Foundation, Haarlem.

Two inventories were made of Van de Vinne's effects: one in 1668 after the death of his first wife; the second after his own death on 28 July 1702. The former lists a painting by Frans Hals in his possession (Bredius, vol. IV, p. 1259, no. 22); the latter cites 'het portret van den overledene' (*ibid.*, p. 1261, no. 3). These laconic references to a painting by his teacher and a portrait of the deceased may refer to Cat. no. 203.

A poor copy of the painting is in the Gemäldegalerie, Dresden (Cat. 1908, no. 1362); panel, 63 × 47·5 cm.

PROVENANCE: Sale, L. van Oukerke, 19 May 1818, no. 14, said to be on canvas (20 florins, Lebe); coll. van der Vinne, Haarlem, from which it was acquired by A. van der Willigen in 1859; sale, A. and A. P. van der Willigen, Haarlem, 20 April 1874, no. 36 (215 florins, Vegtel).

BIBLIOGRAPHY: *Icon. Bat.*, no. 8517-3 (I have been unable to locate the print by C. van Noorde which is mentioned in this reference); Moes 82; HdG 236a ('probably derives from a genuine lost painting'; Hofstede de Groot did not recognize that his no. 324 was the original); Valentiner 1936, 103 note (copy, possibly late eighteenth century or even later).

The portrait of Van de Vinne with a drawing in his hand, painted in the manner of Frans Hals, which appeared in the sale, van der Marck, Amsterdam, 25 August 1773, no. 472 (canvas, 31 × 25d.) has not been identified.

The miserable painting called a portrait of Vincent Laurensz. van der Vinne (panel, 25 × 20 cm.) which is listed in Bode-Binder 284, plate 190d and KdK 272, repr., is neither a portrait of Van der Vinne nor an authentic work by Hals. In 1914 it was with the London dealer E. H. Gorett, and in 1923 in the Lucerne art market.

204. **Portrait of a Man** (Plate 312). Wassenaer, Sidney J. van den Bergh.
Canvas, 65 × 49 cm. Signed at the lower right with the connected monogram: FH.

PROVENANCE: The portrait and its pendant (Cat. no. 205) are said to have been in the possession of Stanislaus August Poniatowski, King of Poland (died 1798); Elizabeth (Pani) Grabowska (née Szydlowska); private collection or art market, Milan before 1926; dealer Paul Bottenwieser, Berlin, 1926; dealer J. Goudstikker, Amsterdam, 1927; Heinrich Baron Thyssen-Bornemisza, Schloss Rohoncz, Hungary, and then at Villa Favorita, Lugano-Castagnola; Countess Batthyany (née Thyssen-Bornemisza); dealer Duits Ltd., London.

EXHIBITIONS: Amsterdam, dealer Goudstikker, 1927, cat. XXXII, nos. 31 and 32; *ibid.*, cat. XXXIII, nos. 62 and 63; Rome 1928, nos. 45 and 46; London 1929, nos. 79 and 80; Munich, Neue Pinakothek, Sammlung Schloss Rohoncz, 1930, nos. 146 and 147; Lugano 1949 and 1952, nos. 107 and 108; Haarlem 1962, nos. 65 and 66.

BIBLIOGRAPHY: Valentiner 1928, p. 249; Valentiner 1935, p. 103, nos. 23 and 24 (*ca.* 1660); Sammlung Schloss Rohoncz 1930, nos. 184 and 185 ('Nach W. v. Bode, A. Bredius, M. J. Friedländer, Hofstede de Groot und W. R. Valentiner aus der späten Periode von Frans Hals, zwischen 1655 und 1660 entstanden'); *Sammlung Schloss Rohoncz*, 1949 and 1952, nos. 107 and 108; A. B. de Vries, 'Old Masters in the Collection of Mr. and Mrs. Sidney van den Berg', *Apollo*, LXXX, 1964, pp. 357, 359. *Verzameling Sidney J. van den Bergh*, Wassenaar, 1968, pp. 58–59.

Companion picture to Cat. no. 205; probably painted around 1655–60. Their thinly painted surfaces suggest they are closely related to Hals' portrait of Vincent Laurensz. van der Vinne (Cat. no. 203; Plate 317); however, their poor state of preservation compounds the normal difficulty of assigning hard and fast dates to the late works. Both paintings have been badly rubbed throughout. There is scarcely a trace left of Hals' characteristic detached brushwork in the dark areas of the man's portrait. Abrasion of the light passages in the companion piece accounts for the flatness of the woman's collar and the loss of half-tones in her hand give it a claw-like appearance. Only a reflection of the intensity of expression which Hals gave the man and the tender, calm mood he gave the woman are still evident.

205. **Portrait of a Woman** (Plate 313). Wassenaer, Sidney J. van den Bergh.
Canvas, 64 × 49 cm. Signed at the lower left with the connected monogram: FH.

For provenance, exhibitions and bibliography, see Cat. no. 204, the pendant of the portrait.

206. **Frans Post** (Plate 318; text, pp. 186, 197). Evanston, Illinois, Mrs. David Corbett.
Panel, 27·5 × 23 cm.

PROVENANCE: Possibly sale, Amsterdam, 10 May 1830, no. 142 (1 florin, Gruyter); possibly sale, J. Smies, J. H. Knoop and others, Amsterdam, 24 February 1834, no. 45; sale, Albert Levy, London, 6 April 1876, no. 338 (£157: 10s.); J. Walter, Bearwood; dealer C. Sedelmeyer, Catalogue, 1902, no. 19; H. Teixeira de Mattos, Vogelenzang; dealer F. Muller and Co., Amsterdam; P. A. B. Widener, Elkins Park, Pennsylvania; sale, P. A. B. Widener, Amsterdam (Muller), 10 July 1923, no. 110; dealer Knoedler, New York; George Lindsay, St. Paul, Minnesota, who bequeathed it to his nephew Edwin B. Lindsay, Davenport, Iowa; by descent to the present owner.

EXHIBITIONS: London, Royal Academy 1873, no. 97; London, Royal Academy 1882, no. 123; The Hague, 'Tentoonstelling van Oude Portretten', 1903, no. 39; Amsterdam 1906, no. 57; Davenport, Iowa, Municipal Art Gallery, 1953–54.

BIBLIOGRAPHY: Bode 1883, 144 (*ca.* 1650); Van Someren, vol. III, 1891, p. 503, no. 4290 (incorrectly identified as Pieter Post); *Icon. Bat.*, no. 6034; G. W. Moes, 'Frans Post geschilderd door Frans Hals', *Bulletin Nederlandschen Oudheidkundigen Bond*, VI, 1905, pp. 57–59; 93 (also see a note by M. G. Wildeman, *ibid.*, p. 92); Moes 64; HdG 215; *Pictures in the Collection of P. A. B. Widener at Lynnewood Hall, Elkins Park, Pennsylvania, Early German, Dutch and Flemish Schools . . .*, notes by C. Hofstede de Groot and Wilhelm R. Valentiner, 1913, unpaginated; Bode-Binder 228; KdK 271 (*ca.* 1655).

The sitter is identified on the basis of an inscription written in yellow ink on the lower margin of an impression of the first state ('avant la lettre') of Jonas Suyderhoef's reversed engraving (Wussin 68) of the portrait which is at the Albertina (Fig. 49; inv. no. H.I. 61, p. 60): 'Francois Post, Peinctre de prince Mauriti Gouverneur des Indes Occidentales.' Wussin also lists a second state of the engraving 'avec la lettre'; I have been unable to locate an impression of it.

Frans Post (*ca.* 1612–80), brother of the gifted architect Pieter Post (1608–69), earned a special place in the history of landscape painting when he accompanied Count Johan Maurits of Nassau Siegen on his expedition to the northeastern part of Brazil. The landscapes Post made there from 1637 to 1644 were the first ones of the New World done by a trained European painter. Upon his return to Holland in 1644 he settled in Haarlem. Hals' portrait of him is datable around 1655, and is probably one of the earliest of the existing small portraits (see Cat. nos. 199; 207–13) the artist painted during his last phase. The dates assigned to this group are based solely on stylistic evidence; none of these little portraits is dated.

If the description given in the catalogue of the sale J. van der Marck, Amsterdam, 25 August 1773, no. 441 (42 florins, Fouquet), is correct, Hals painted a second portrait of Post. The painting is described as 'Frans Post, Westindisch landschapschilder. . . . Men ziet hem verbeeld met een hold op t' hoofd en een lauwertak in de hand, zittende en rustende met zyn arm op de leuning van de stoel. Door Frans Hals fix en kragtig geschilderd, op paneel, h. 17½ br. 12¾ duim.' However, this painting may very well be identical with the small portrait of a *Seated Man Holding a Branch* which is now at Ottawa (see Cat. no. 155; Plate 236). If it is, the claim that the Ottawa picture is also a portrait of Frans Post is not tenable.

M. G. Wildeman (*op. cit.*) and E. Larsen, *Frans Post,* Amsterdam-Rio de Janeiro, 1962, p. 222, note 209, incorrectly state that a wash drawing by the Haarlem artist Cornelis van den Berg (1699–1774) after the painting described in the 1773 van der Marck sale is at the Municipal Archives at Haarlem (XIII, 42). Van den Berg's drawing is a copy after Cat. no. 206 and since it reverses the portrait it was probably done after Suyderhoef's engraving.

207. **Adrianus Tegularius** (Plate 319; text, p. 197). Oslo, Ludv. G. Braathen.
Panel, 27·9 × 22·8 cm.

PROVENANCE: Sale, Jer. de Bosch, Amsterdam, 6 April 1912, no. 27; sale, Amsterdam, 9 April 1848, no. 20 (14.50 florins; De Vries); M. Unger, Berlin; sale, von Friesen of Dresden, Cologne, 26 March 1885, no. 65; Werner Dahl, Düsseldorf, who sold it in 1901 to Adolph Schloss, Paris. The painting remained in the Schloss collection until World War II, when it was stolen by the Nazis. It was listed as missing in *Répertoire des Biens spoliés en France durant la guerre 1939–1945,* vol. II, 151, 32–663. There is a gap in its history until it appeared at the sale, Princess Labia and others, property of a gentleman, New York (Parke-Bernet), 3 November 1967, no. 32 (bought in); sale, property of Ludv. G. Braathen of Oslo, London (Christie), 24 March 1972, no. 83 (bought in).
EXHIBITIONS: Düsseldorf 1886, no. 135; The Hague, 'Tentoonstelling van Oude Portretten', 1903, no. 37.
BIBLIOGRAPHY: *Icon. Bat.,* no. 7869; Moes 76; HdG 229; Bode-Binder 189; KdK 282 (*ca.* 1658).

The little oil sketch served as a modello for Jonas Suyderhoef's reversed engraving (Fig. 50), which is inscribed: F. Hals pinxit. J. Suyderhoef sculpsit, and bears an eight-line verse (Wussin 89) identifying the sitter and praising the work he did as a preacher in Haarlem for thirty years. The back of the panel is inscribed with the verse which appears on the print. The painting is abraded; comparison of it with Suyderhoef's copy indicates that the fine gradations in the blacks have been lost and suggests that the chiaroscuro effect was originally more pronounced.

According to Moes (*Icon. Bat.,* no. 7869), Adrianus Tegularius was born in 1605 and Molhuysen (vol. X, col. 1014) notes that he died in September 1654, which establishes a *terminus ante quem* for the painting—unless it was a posthumous portrait. The verse on Suyderhoef's engraving establishes that the print was published after Tegularius' death ('. . . Maar nu sijn eedle Ziel leeft eewigh bij den Heer . . .'). Hals' small sketch may also have been done after the preacher's death. The best known posthumous portraits in seventeenth-century Dutch art are Rembrandt's etchings of *Jan Cornelis Sylvius,* 1646 (Bartsch 280) and *Jan Antonides van der Linden,* 1655 (Bartsch 264); the former was made eight years after the death of the subject, the latter was etched a year after the subject had died.

208. **Portrait of a Preacher** (Plate 321; text, p. 198). Amsterdam, Rijksmuseum (Cat. 1960, no. 1091 A1).
Panel, 37 × 29·8 cm. Signed at the right near the shoulder with the connected monogram: FH.

PROVENANCE: Purchased from J. B. Luyckx, Hilversum, for 30,000 florins by the museum, with the aid of the Vereeniging Rembrandt, in 1916.
EXHIBITIONS: Rome 1928, no. 43; Haarlem 1937, no. 106; Schaffhausen 1949, no. 49; Sheffield, Graves Art Gallery, 'Dutch Masterpieces', 1956, no. 19; Rome 1956–1957, no. 128.
BIBLIOGRAPHY: M. D. H[enkel], 'Ein neuer Frans Hals im Ryksmuseum in Amsterdam', *Kunstchronik,* N.F., XVII, 1915–16, col. 359–60; W. Steenhoff, 'Kunstberichten . . . Amsterdam', *Onze Kuunst,* XXX, 1916, pp. 57–58; W. Steenhoff, 'Een mansportret door Frans Hals in het

Rijksmuseum , *Jaarverslag vereenmgen Rembrandt over 1916*, pp. 6–7. Hofstede de Groot, 'Frans Hals. Mansportret. Rijksmuseum te Amsterdam', *Oude Kunst*, I, 1915–16, pp. 321–23 (*ca.* 1640–45; possibly a portrait of Jan Ruyll); Otto Hirschmann, 'Neu aufgetauchte Bilder von Frans Hals', *Cicerone*, VIII, 1916, pp. 233–235 (*ca.* 1645); KdK 269 (*ca.* 1653–55); Trivas 88 (*ca.* 1641–44).

A perpetual calendar was pasted over the painting when it was in the possession J. B. Luyckx of Hilversum. After he noticed that his calendar was mounted on an old painting he removed it and discovered the well preserved portrait (Henckel, *op. cit.*, Hirschmann, *op. cit.*). Comparison with the small *Portrait of a Man* dated 1643 in the George L. Weil collection (Cat. no. 151; Plate 235) indicates that the date of around 1640–45 assigned to the Amsterdam picture by some critics is too early. Valentiner's date of about 1653–55 is closer to the mark and I would not rule out the possibility that it was painted a few years later.

The intense expression of the model and his skull cap account for the traditional identification as a preacher, but we know that both were also worn by seventeenth-century Dutchmen who were not divines. There is no evidence to support Hofstede de Groot's suggestion that the portrait (*op. cit.*, 1915–16) may represent Jan Ruyll, the Haarlem preacher, whose portrait by Hals was celebrated in a verse written by Arnold Moonen in 1680 and published in his *Poëzij*, Amsterdam, 1700, pp. 679–680. Hofstede de Groot's earlier proposal (HdG 273) that Cat. no. 209 may represent Ruyll, and Moes' suggestion that Cat. no. 210 may be a portrait of the Haarlem preacher are also hypothetical. Hals' portrait of Ruyll is lost or remains unidentified. Arnold Moonen's verse (*op. cit.*, also see text, pp. 201–202) reads:

> Joannes Ruil, door Frans Hals geschildert.
> Dit is de beeltenis van uw' getrouwen Ruil,
> O Haerlem, uwen helt, uw kerkpilaer, en zuil
> Der tempelvrede, zoo natuurlyk of hy leefde.
> Men dank' dit Hals, wiens kunstpenseel dus geestigh zweefde
> Met hoog en diep. Doch heeft 's Mans geest us ooit bekoort,
> Bewaer de lessen, uit zijn'gulden mont gehoort.
> 1680

209. **Portrait of a Preacher** (Plate 322; text, p. 198).
Philadelphia, formerly Mrs. Efrem Zimbalist.
Panel, 35·5 × 29·5 cm. Signed at the lower right corner with the connected monogram: FH.

PROVENANCE: Baron von Liphart, Rathshof near Dorpat, later of Dresden. Edward W. Bok, Philadelphia; Mrs. Edward W. Bok, later Mrs. Efrem Zimbalist, Philadelphia; Cary William Bok, Philadelphia; sale, estate of C. W. Bok, London (Christie), 25 June 1971, no. 18 (£54,000; Brod).

EXHIBITIONS: New York 1937, no. 25; Haarlem 1962, no. 76; London, Brod Gallery, 'Twelve Portraits', 1971, no. 1.
BIBLIOGRAPHY: Moes 179; HdG 273 (*ca.* 1650; possibly a portrait of Jan Ruyll); Bode-Binder 274; KdK 283 (*ca.* 1658); Valentiner 1936, 104 (*ca.* 1658).

Painted around 1658–60. Valentiner (KdK 1921, 267; KdK 283) states that the painting was in the collection Heilbuth, Copenhagen. I have not been able to substantiate this statement. He may have confused the portrait with another small one (our Cat. no. 210), which was in the Heilbuth collection. Valentiner deleted this reference in the provenance he gave for the portrait in his 1936 catalogue of *Frans Hals Paintings in America*, no. 104.
The model for this outstanding portrait has not been identified. For Hofstede de Groot's unsupportable suggestion that it may represent the Haarlem preacher Jan Ruyll, see Cat. no. 208. Moes' hypothesis that Hals' little portrait at the Mauritshuis is probably Ruyll is also without foundation (see Cat. no. 210).

210. **Portrait of a Man** (Plates 323, 324; text, pp. 198–199).
The Hague, Mauritshuis (Cat. 1968, no. 928).
Panel, 31·6 × 25·5 cm.

PROVENANCE: Wilhelm Gumprecht, Berlin, acquired in London, 1882; sale, W. Gumprecht, Berlin (Cassirer), 17–21 March 1918, no. 24; H. Heilbuth, Copenhagen; W. H. Bixby, St. Louis, Missouri; dealer H. Schaeffer Galleries, New York; acquired by the museum with the aid of the Stichting Johan Maurits van Nassau in 1957.
EXHIBITIONS: Berlin, Ausstellung von Gemälden Älterer Meister, 1883, no. 78; Berlin 1890, no. 81; The Hague 1903, no. 40; Copenhagen 1920, no. 59; Detroit, 1935, no. 50; Los Angeles 1947, no. 21; Haarlem 1962, no. 69; San Francisco-Toledo-Boston 1966–67, no. 22; The Hague, 'Vijfentwintig jaar aanwinsten Mauritshuis: 1945–1970', 1970, no. 16.
BIBLIOGRAPHY: Bode 1883, p. 612; W. Bode, 'Die Ausstellung von Gemälden Älterer Meister in Berliner Privatbesitz', *Jahrbuch der königlich preussischen Kunstsammlungen*, IV (1883), p. 199 (1655–60); Moes, pp. 66–67, p. 103, no. 67 (perhaps Jan Ruyll); HdG 257 (last period); Bode-Binder 275; KdK 286 (*ca.* 1660); Valentiner 1936, 105 (*ca.* 1660); Trivas 103 (*ca.* 1656–60).

Hofstede de Groot (257) and Valentiner (1936, 105) state that the portrait was in the sale, Richard Foster, London, 3 June 1876; the catalogue of that sale does not list the portrait. Since the sitter is bare-headed and without the traditional prop of a book there is even less reason to accept Moes' idea that the picture may represent the Haarlem preacher Jan Ruyll than Hofstede de Groot's two

candidates for Hals' unidentifiable portrait of Ruyll (see Cat. nos. 208, 209).

The small portrait, which is datable around 1660, captures in miniature the mood and intensity of the artist's last regent pieces. It is one of Hals' most compelling and haunting late works.

211. **Portrait of a Seated Woman** (Plates 326, 328; p. 199). Oxford, Christ Church, Senior Common Room. Panel, 45·5 × 36 cm. Signed in the lower right corner with the connected monogram.

PROVENANCE: Bequeathed to the Senior Common Room of Christ Church by William Scoltock, M.A., in 1886.
EXHIBITIONS: Haarlem 1937, no. 111; London, Royal Academy, Seventeenth-Century Art in Europe, 1938, no. 271; London, Arts Council of Great Britain, Dutch Paintings of the Seventeenth Century, 1945, no. 8; Amsterdam 1952, no. 52; London 1952–53, no. 115; Haarlem 1962, no. 68.
BIBLIOGRAPHY: Trivas 90.

This superb painting of an unidentified fat woman is Hals' only extant small female portrait which can be dated in his last period. Apparently frankness and free brushwork—things we value so highly in Hals' late works—were qualities which not many seventeenth-century Dutch ladies looked for when they employed a portraitist. The disposition of the figure on the panel suggests that the painting was one of a pair.

The painting may be identical with 'A Small Portrait of a Woman, showing both hands', which appeared in the sale, Amsterdam, 15 April 1739 (Hoet, I, 581), no. 99 (21 florins); HdG 399f.

212. **Cornelis Guldewagen** (Plate 325; text, pp. 144, 199–200). Urbana, Illinois, University of Illinois, Krannert Art Museum.
Panel, 41·6 × 31·4 cm.

PROVENANCE: See below for the problems raised by older references to the history of the painting; dealer E. and A. Silberman Galleries, New York; Mr. and Mrs. Merle J. Trees, Chicago, Illinois, who gave it to the University of Illinois in 1953.
EXHIBITIONS: Urbana, University of Illinois, 'Great Traditions in Painting from Midwestern Collections', 1955, no. 15; Haarlem 1962, no. 67 (incorrect provenance).
BIBLIOGRAPHY: *Icon. Bat.*, no. 2994 (described on the basis of C. van Noorde's watercolour); Moes 36 (listed as in the Coll. Schwabe, London, 1871); HdG 183 (described on the basis of C. van Noorde's watercolour; listed as exhibited in London, 1871 and in the Coll. Schwabe at that time); Bode-Binder 188 (listed as lost since it was recorded

in the Coll. Schwabe, 1871: C. van Noorde's watercolour is reproduced vol. II, plate 119a); KdK 268 (listed as in the coll. Schwabe, 1871; C. van Noorde's watercolour reproduced, but Valentiner failed to note that it is a copy after the painting and erroneously states that the painting was sold in London at Christie's on 26 June 1891); *College Art Journal*, XIII, 1954, pp. 253–254.

The painting has been confounded with Cornelis van Noorde's (1631–1795) faithful watercolour after it (Fig. 51), and its history has apparently been confused with the provenance of a weak painted copy of it. The latter appeared in the sale, property of a gentleman, London (Christie), 23 November 1962, no. 83, 22·9 × 18·8 cm., repr. (purchased by S. Eidinow, London).

All of the authors cited in the Bibliography above recorded the painting on the basis of Van Noorde's watercolour copy now at the Haarlem Archives (probably sale, de Quarles, Amsterdam, 19 October 1818, no. 7; sale, C. Ekema of Haarlem, Amsterdam, 8 April 1891, no. 764). Moes (36) and Hofstede de Groot (183) note that the portrait was in the collection Schwabe, London, 1871. No available evidence supports their statements. Hofstede de Groot also notes that the painting was exhibited at the Royal Academy in 1871. However, as the compiler of Christie's 1962 catalogue (*op. cit.*) correctly observes, both pictures by Hals at the Academy in 1871 were lent by a Miss James, not by Schwabe, and one (no. 58) was described as *Cornelis E. de Wagen*. After Miss James' death her picture was sold at Christie's, 20 June 1891, no. 30 (41·2 × 31·5 cm.; catalogued as *Cornelius Niedwagen*) and it is probably this painting that KdK 322, erroneously states was sold on 26 June 1891. The compiler of the 23 November 1962 Christie catalogue also helpfully states that notes made on the picture in 1891 record it in poor condition, and that the version offered in the 1962 sale 'has clearly been cut down on all sides and the panel planed and cradled; with the exception of the head it is not in a good state and the body is particularly damaged and thin'.

The conclusion which can be drawn from this involved story is that the 1962 Christie painting is possibly identical with the Miss James version which was exhibited at the Academy in 1871, sold at Christie's in 1891, and subsequently cut down. However, there is no justification for the 1962 cataloguer's conclusions that the painting offered at Christie's in that year is possibly the one illustrated by Valentiner, KdK 268. Valentiner reproduced Van Noorde's watercolour, a work which is not mentioned in the 1962 sale catalogue.

On the basis of its style the Urbana portrait can be dated around 1660, or perhaps a few years later. This conclusion is supported by the little that can be gleaned from the Haarlem archives about Cornelis Guldewagen. The date of his birth has not been established. His father was Dirk Corneliszoon, sometimes called Coeckebacker. He married twice, first with Guurtje Laurensdr. (Grauwert), then

on 25 November 1601 as a widower from Alkmaar with Anna Dirksdr. He must have lived for a time in Alkmaar, where perhaps his first wife was buried, as references to her death have not been found in Haarlem's records. The conclusion that Cornelis was a child of his first marriage is contradicted by a document (Transportregister 25 December 1649, fol. 268) wherein Cornelis Guldewagen and his sister Claertje Dirksdr. are called children of Anna Dirksdr. On 30 September 1604 Claertje, daughter of Dirk Cornelisz. and Anna Dirksdr., was baptized but the date of Cornelis' baptism has not been found. Possibly he was baptized in Alkmaar before the marriage in Haarlem. In brief, his birth can be placed around the beginning of the seventeenth century. This date is consistent with the inscription on Van Noorde's watercolour copy: AEtatis/60. Guldewagen died at Haarlem 7 November 1663, a date which serves as the probable *terminus ante quem* for Hals' portrait.

Guldewagen was a burgomaster of Haarlem in 1642 and owner of the 'Rode Hert' (Red Hart) brewery there. The wooden beer jug which figures prominently in Cat. no. 74 (Plate 118) has a red deer painted on it and probably belonged to Guldewagen's brewery (information from C. A. van Hees). Guldewagen married Agatha van der Hoorn (1602–80) at Haarlem, between 30 July and 13 August 1623. Her portrait was painted as a companion picture to Cat. no. 212 by Jan de Bray (text, Fig. 212): panel, 41 × 32 cm.; signed and dated 1663, and inscribed 'AEtatis suae 60'. De Bray's portrait is now at Luxembourg, Musée J. P. Pescatore; see J. W. von Moltke, 'Jan de Bray', *Marburger Jahrbuch für Kunstwissenschaft*, XI–XII, 1938–39, p. 478, no. 124, p. 341, fig. 9, incorrectly reproduced in reverse. A watercolour copy after De Bray's portrait by Cornelis van Noorde inscribed 'Aetatis 60/1663' is at the Haarlem archives (it probably appeared in the sale, C. Ekema of Haarlem, Amsterdam, 8 April 1891, no. 764, with Van Noorde's copy of the pendant).

213. **Portrait of a Man (Willem Croes?)** (Plate 327; text, p. 200). Munich, Alte Pinakotek (Cat. 1967, no. 8402).
Panel, 47·1 × 34·4 cm. Signed at the lower left with the connected monogram: FH.

PROVENANCE: Steengracht van Oosterland, The Hague; Baron C. C. A. van Pallandt, The Hague; Countess van der Linden (née Van Pallandt), Lisse; Van Stolk, Haarlem; from whom it was acquired by the museum for 85,000 marks in 1906.
EXHIBITIONS: Amsterdam, 'Arti et Amicitiae', 1872, no. 88 (Mansportret); The Hague 1881, no. 150; Rome 1928, no. 42.
BIBLIOGRAPHY: Bode 1883, 26 (dated 1658); *Icon. Bat.*, no. 1808 (dated 1658); K. Voll, 'Frans Hals in der Alten Pinakothek in München, *Kunst und Künstler*, IV, 1906, pp.

319–321 (*ca.* 1650); K. Voll, 'Frans Hals in der Alten Pinakothek', *Münchner Jahrbuch der bildenden Kunst*, I, 1906, pp. 33–35 (*ca.* 1658); Moes 30 (dated 1658); HdG 171 (*ca.* 1658); Bode-Binder 276; KdK 267 (*ca.* 1653–55); Trivas 104 (not earlier than 1655).

The model for this brilliantly executed late sketch has been called Willem Croes. Moes states (1909, p. 61) that he was buried at Haarlem 11 August 1666, but does not cite a source; nothing else is known about Croes (information from the Iconographisch Bureau at The Hague). Bode (1883, 26) and Moes (*Icon. Bat.* no. 1808; Moes 80) note that the painting was dated 1658. It does not bear a trace of a date today, and as early as 1906 Voll noted that it was not dated (*op. cit.*). Its style suggests that it was painted a few years later than 1658.

A trifle faded but still impressive brush drawing after the portrait, by Jean-Honoré Fragonard (Fig. 52), is in the collection George Baer, Stone Mountain, Georgia: brush and brown bistre; 25·8 × 18·3 cm.; signed: *frago*.
PROVENANCE: Charles Gasc; M. de Castellane, Paris; Lucien Guiraud, Paris; private collection, London; sale, London, Christie, 6 December 1972, no. 174 ($1,890; Maison).
BIBLIOGRAPHY: Alexandre Ananoff, *L'Oeuvre Dessinée de Jean-Honoré Fragonard*, 1970, vol. IV, no. 2544, fig. 634.

214. **Portrait of a Man** (Plate 329; text, pp. 195–197; text, Figs. 207, 208). New York, The Frick Collection (Cat. 1968, vol. I, pp. 218–220, no. 17.1.10).
Canvas, 113 × 81·9 cm. Signed on the left, on the level with the collar, with the connected monogram: FH (Fig. 63).

PROVENANCE: Bought between 1850–57 from a dealer, possibly C. Redfern, Warwick, by Frederick, fourth Earl Spencer, Althorp House, Great Brington, Northamptonshire; dealer Duveen; acquired by Henry Clay Frick, New York, in 1917.
EXHIBITIONS: Manchester, Art Treasures, 1857, no. 671; London, Guildhall, 'Painters of the Dutch School', 1903, no. 175; The Hague, 'Tentoonstelling van Oude Portretten', 1903, no. 38; London, Royal Academy, 1907, no. 47.
BIBLIOGRAPHY: W. Bürger, *Trésors d'art en Angleterre*, Brussels, 1860, pp. 243–244; Moes 148; HdG 247; Bode-Binder 252; KdK 265 (*ca.* 1652–54); Valentiner 1936, 101 (*ca.* 1652–54)

Last cleaned in 1952. Apart from a few scattered paint losses and a slight flattening of the paint surface, the result of relining, the painting is in an excellent state of preservation.
It was shown at all of the Exhibitions cited above as a portrait of the famous Dutch Admiral de Ruyter but as early as 1860 W. Bürger (*op. cit.*) pointed out that this identification is untenable if one compares the model with

Ferdinand Bol's portrait of De Ruyter at the Rijksmuseum (Cat. no. 549).
The style and costume suggest a date of around 1660.

215. **Herman Langelius** (Plates 330, 332; text, pp. 199, 200–201, 202). Amiens, Musée de Picardie (Cat. 1899, no. 96).
Canvas, 76×63 cm. Signed at the right, at shoulder level, with the connected monogram: FH.

PROVENANCE: Sale, Alphonse Oudry, Paris, 15–20 April 1869, no. 34; Olympe and Ernest Lavalard, Paris; bequeathed by the Lavalard brothers to the museum in 1890, and accessioned in 1894.
EXHIBITIONS: Haarlem 1937, no. 108; Amsterdam 1952, no. 51; London 1952–53, no. 48; Haarlem 1962, no. 70; Paris 1970–71, no. 99; Amsterdam, Rijksmuseum, 'Hollandse schilderijen uit Franse musea', 1971, no. 39.
BIBLIOGRAPHY: Bode 1883, no. 46; Amiens, Musée de Picardie, Cat. 1899, p. 199, no. 96 ('Un professeur de l'Université de Leyde'); A. Bredius, 'Nederlandsche Kunst in Provinciale Musea van Frankrijk', O.H., XIX (1901), pp. 11–12; Icon. Bat., no. 4362; Moes 51; HdG 197; Bode-Binder 281; KdK 284 (ca. 1659).

Moes (1909, pp. 68, 102, no. 51) identified the model as the leading Amsterdam minister Herman Langelius (1614–66). He recognized that the penetrating portrait served as the model for Abraham Blooteling's (1640–90) engraving of the preacher, which is inscribed 'F. Hals pinxit. A. Blooteling sculpsit.' (Hollstein, vol. II, p. 176, no. 25, repr.). There is little reason to doubt that Hals' portrait also served as the subject for a poem by Herman Frederik Waterloos, Hollantsche Parnas, Amsterdam, vol. I, 1660, p. 408:

Wat pooght ghy ouden Hals, Langhelius te maalen?
Uw ooghen zyn te zwak voor zyn gheleerde strallē;
En Uwe stramme handt te ruuw, en kunsteloos,
Om 't bovenmenschelyk, en onweêrgaadeloos
Verstant van deeze man, en Leeraar, uit te drukken.
Stoft Haarlem op uw kunst, en jonghe meesterstukken,
Ons Amsterdam zal nu met my ghetuighen, dat
Ghy 't weezen van dit licht, niet hallef hebt ghevat.

Waterloos' poem, which is one of the rare contemporary appraisals of Hals' work, is certainly critical of the artist's performance, but we can be less critical of Waterloos' harsh judgement if we recall that his verse follows the established convention of praising the model at the expense of the portraitist (see J. A. Emmens, 'Ay Rembrandt, maal Cornelis stem', N.K.J., VII, 1956, pp. 133ff., and text, pp. 201–202). The publication of Waterloos' poem in 1660 establishes a truthworthy terminus ante quem for the portrait and its style places it around the same time.

216. **Portrait of a Man** (Plate 331; text, pp. 202, 204). Paris, Jacquemart-André Museum (Cat. no. 427).
Canvas, 69×60·5 cm.

PROVENANCE: Purchased from the dealer Rupprecht, Munich, in 1884 by Madame Edouard André, Paris, who bequeathed it to the Institut de France in 1912.
EXHIBITIONS: Paris, Jeu de Paume, 'Exposition retrospective des grands et petits maîtres hollandais', 1911, no. 52; Haarlem 1937, no. 110; New York, Wildenstein Gallery, 'Treasures of Musée Jacquemart-André', 1956, no. 17; Haarlem 1962, no. 73; Paris 1970–71, no. 100.
BIBLIOGRAPHY: Bode 1883, no. 69 (ca. 1655); Moes 145; HdG 300 (erroneously described as wearing a hat, 'Nach Bredius um 1650–55 gemalt'); W. Martin, 'Ausstellungen altholländischer Bilder in Pariser Privatbezitz', Monatshefte für Kunstwissenschaft, IV, 1911, p. 438 (late 1640's); G. Lafenestre, 'La Peinture au Musée Jacquemart-André', G.B.A., XI, 1914, pp. 36–37; Bode-Binder 265; KdK 288 (ca. 1661–63); Trivas 105 (ca. 1660–63).

Painted around 1660–66. The concentrated power of the brushwork of the hand and grey costume is related to Hals' treatment of the memorable grey cloak worn by the man who posed for the portrait at the Fitzwilliam Museum (Cat. 218; Plate 338). In the latter work the streaming strokes are even bolder and more summary, and they suggest that the work postdates Cat. no. 216. However, I hesitate to propose a year by year chronology, solely on the basis of stylistic evidence, for the works Hals painted when he was in his late seventies or early eighties. The pose Hals gave his patron is a variation on the one he had employed as early as 1626 for his portrait of Massa (Cat. no. 42; Plate 64).
A variant (modern?) based on Cat. no. 216 appeared in the sale, Valkenburg, Geneva (Moos), 23 May 1936, no. 72, repr.: panel, 19·5×15·5 cm.

217. **Portrait of a Man in a Slouch Hat** (Plates 333–335; text, pp. 57, 202–203, 212). Cassel, Hessisches Landesmuseum (Cat. 1958, no. 219).
Canvas, 79·5×66·5 cm. Signed on the left near the shoulder with the connected monogram: FH.

PROVENANCE: Listed in the Haupt-Catalogus von Sr Hochfürstl. Durchlt Herren Land Grafens Wilhelm zu Hessen, sämtlichen Schildereyen, und Portraits . . . Verfertiget in Anno 1749: 'No. 833 Hals (Franz) Ein Portrait mit ein Grossen Huth in Schwartzer Kleidung lehnent auf einen Armstuhl, auf Leinen in Verguldeten Rahmen vom M: Tarno (Höhe. 2 Schuh 6½ Zoll; Breite 2 Schuh 1 Zoll). Taken to Paris by Denon in 1806 and returned in 1816.
EXHIBITIONS: Haarlem 1937, no. 113; Schaffhausen 1949, no. 48; Haarlem 1962, no. 74.
BIBLIOGRAPHY: Bode 1883, 101 (ca. 1660); Moes 174;

HdG 268 (of the last period); Bode-Binder 280; KdK 289 (*ca.* 1661–63); Trivas 107 (1661–64).

The portrait, which is done with an unprecedented economy of touch, is datable around 1660–66. In the 1962 Haarlem Exhibition Catalogue (no. 74), I wrote that when Hals began the portrait he apparently had no intention of painting his sitter in the enormous hat, which has become one of the most famous in the history of western art. I thought I saw traces of a narrow brim underneath the well-known large one. However, a fresh examination revealed there are no pentimenti in this area. The dark strokes that can be read as a narrow brim are in fact part of the original design (I am grateful to Lisa Oehler, Curator, Hessisches Landesmuseum and to Sturla Gudlaugsson for their observations on this point). The model's pose as well as the suggestion of a view of a landscape through a window is yet another variation on the scheme Hals had first introduced in his 1626 portrait of Massa (Cat. no. 42; Plate 64).

Hofstede de Groot (268) notes that a copy of the painting was in the English art market in 1910.

218. **Portrait of a Man** (Plate 338; text, pp. 192, 203–204, 213; text, Fig. 213). Cambridge, Fitzwilliam Museum (Cat. 1960, no. 150).
Canvas, 80×67 cm. Signed at the lower right with the connected monogram: FH (Fig. 64).

PROVENANCE: Possibly Rev. R. E. Kerrich; Joseph Prior, Cambridge, who gave it to the museum in 1879.
EXHIBITIONS: London 1929, no. 105; London 1952–53, no. 72; London, Goldsmith's Hall, 'Treasures of Cambridge', 1959, no. 323.
BIBLIOGRAPHY: Moes 152; HdG 106, identical with HdG 264; Bode-Binder 240; KdK 287 (*ca.* 1661–63); J. W. Goodison, 'A Cleaned Frans Hals in the Fitzwilliam Museum', *B.M.*, XCI, 1949, pp. 197–198.

Before the painting was cleaned by H. A. Buttery in 1949, the background was uniformly opaque dark brown and the hat was painted out (see text, Fig. 213). Cleaning revealed the original silver-grey background and the large black hat. Buttery estimated that the original background and hat had been painted out in the late eighteenth or early nineteenth century (Goodison, *op. cit.*, also see text, pp. 203–204). The repainted passages were found to have suffered only slight damage, and the head and unusually thin washes of paint used for the grey cloak were found in a remarkable state of preservation after the removal of a layer of heavily toned varnish.
Painted around 1660–66. The dominant grey colouristic harmony as well as the handling is related to Cat. no. 216. However, the paint, particularly in the lower half of the portrait, is thinner—indeed, it is so thin that driblets of it

ran where Hals placed decisive broad accents on the right side of the cloak. The unusual streaming ribbon-like strokes on the cloak recur in the kimono of the man who posed for the portrait now at Boston (Cat. 220; Plate 337).
In this portrait Hals was apparently as economical with his palette as he was with his touch. Goodison notes (*ibid.*) that the painting, which was done on a canvas primed with a red-brown, appears to have been executed with only four pigments: black, white, yellow ochre, and Venetian red.
A poor, reduced copy of the portrait, made after the hat was repainted, is in the Hallwyl collection, Stockholm (text, Fig. 114); canvas, 54·5×47·4 cm.; *Hallwylska Samlingen*, grupp XXXII, 1930, p. 339, no. B.146, repr.

219. **Portrait of a Man** (Plates 336, 339; text, p. 208). Zürich, Bührle Foundation.
Canvas, 70·5×58·3 cm.

PROVENANCE: Earl of Cowper, Panshanger; Lady Cowper, Panshanger; Lord Desborough, Panshanger; acquired in 1946 from dealer N. Katz, Basel, by Emil Georg Bührle, Zürich.
EXHIBITIONS: Manchester 1929, no. 41; London 1929, no. 109; Zürich, Kunsthaus, 'Europäische Kunst 13.–20. Jahrhundert', 1950, p. 21; Amsterdam 1952, no. 53; Zürich, Kunsthaus, 'Holländer des 17. Jahrhunderts', 1953, no. 49; Zürich, Kunsthaus, 'Sammlung Emil G. Bührle', 1958, no. 68.
BIBLIOGRAPHY: Bode 1883, 152 (*ca.* 1650); Moes 161 (attribution doubtful); HdG 283 (*ca.* 1650); Bode-Binder 278; KdK 292 (*ca.* 1664–66); Trivas 106 (*ca.* 1661–63).

The doubts expressed by Moes (161) about the attribution of the painting to Hals are unjustifiable. Bode's date of about 1650 (1883, 152), repeated by Hofstede de Groot (283), who did not know the original, is too early. Valentiner (KdK 292) and Trivas (106) rightly placed it in the sixties. As in the other rare single portraits done in the last phase (Cat. nos. 216–218, 220), Hals worked up the head and only summarily sketched the torso and hand, seemingly to suggest that concentrated attention upon a face puts other parts of a figure out of focus.

220. **Portrait of a Man** (Plate 337; text, p. 208). Boston, Museum of Fine Arts (acc. no. 66·1054).
Canvas, 85·1×66·6 cm. Signed at the lower right with the connected monogram: FH.

PROVENANCE: Max Strauss, Vienna; Dr. Leon Lilienfeld, Vienna, and later of Winchester, Massachusetts; Mrs. Antonie Lilienfeld, Winchester, Massachusetts, who presented it to the museum in 1966 in memory of Dr. Leon Lilienfeld.
EXHIBITIONS: Vienna, Katalog der Gemälde alter Meister

... ausgestellt im K. K. Österreichischen Museum, August–September 1873, no. 41; Tokyo-Kyoto 1968–69, no. 25; Boston, Museum of Fine Arts, 'Centennial Acquisitions', 1970, no. 50.

BIBLIOGRAPHY: HdG 323; Bode-Binder 279; G. Glück, *Niederländische Gemälde aus der Sammlung des Herrn Dr. Leon Lilienfeld in Wien*, Vienna, 1917, pp. 54f. and 63, no. 25; KdK 293 (*ca.* 1664–66).

A strip of canvas about 4 cm. wide has been added to the left edge. There is slight abrasion in the darks of the head and losses in the paint layer along the bottom edge. When the painting was relined and restored by Mario Modestini in 1968, minor retouches in the shadows of the head, the mouth and eyes were removed.

The painting strikes an unusual note in the *oeuvre* of the artist because the model is portrayed wearing a fashionable reddish-brown kimono (see text, pp. 208–209), not the expected black suit and white collar, and, unless he allowed his own hair to grow until it reached his chest, he is wearing a modish long wig. However, the style of the portrait is entirely consistent with Hals' works of the sixties. The model's pose as well as the vigorous handling relate the work to Cat. no. 219, and the unorthodox streaming brush strokes used to depict the highlights and shadows of his shot silk kimono find a parallel in Hals' treatment of the great cape worn by the man who posed for the Fitzwilliam portrait (Cat. 218; Plate 338). Close stylistic analogies can be found in the regent portrait traditionally dated 1664 (Cat. no. 221; see Plates 343, 345). The portrait is probably one of Hals' last existing works.

221. Regents of the Old Men's Alms House (Plates 340–345; text, pp. 12, 17, 174, 182, 210–215). Haarlem, Frans Hals Museum (Cat. 1929, no. 129).

Canvas, 176·5 × 256 cm.

PROVENANCE: Old Men's Alms House (*Oude-Mannenhuis*), Haarlem; on exhibit at the Frans Hals Museum since 1862.

EXHIBITIONS: Haarlem 1937, no. 114; Amsterdam 1945, Weerzien der Meesters, no. 38; Brussels 1946, Bosch tot Rembrandt, no. 43; Haarlem 1962, no. 71.

BIBLIOGRAPHY: Bode 1883, 7; Moes 8; HdG 437; Bode-Binder 287; KdK 290; Trivas 108; G. D. Gratama, *Frans Hals, les Régents et les Régentes de l'Hospice de Vieillards, Les Grandes Oeuvres d'Art* (Etudes et Documents Photographiques), Brussels, Paris, The Hague, 1937; P. J. Vincken and E. de Jongh, 'De boosaardigheid van Hals' regenten en regentessen', *O.H.*, LXXVIII, 1963, pp. 1ff.

Companion picture to Cat. no. 222. Both paintings are moderately abraded and both have probably darkened considerably since they were painted. Wybrand Hendrick's (1774-1819) watercolour copy of the male group portrait (text, Fig. 219: 38 × 56·7 cm.; Haarlem, Teylers Stichting, W. 45) indicates that spatial relationships and the modelling of the figures as well as the deep burgundy-coloured table cloth and swag of drapery at the upper left were much more distinct around 1800. It seems safe to predict that if a waercolour by Hendricks after the regentesses group portrait is ever discovered it will tell a similar story about the pendant. The dazzling light areas of both pieces have suffered less.

There is no documentary evidence for the traditional date of 1664 assigned to the group portraits. In the manuscript of the Haarlem Archives, 'Regenten van 't Oude Mannen Huys binnen d'Stad Haerlem beginnende den eersten May Ao. 1607', p. 453, the five men portrayed here are listed as regents from 1662 through 1665. They are: Jonas de Jong, Mattheus Everswijn, Dr. Cornelis Westerloo, Daniel Deinoot and Johannes Walles. It has not been possible to correlate these names with the men Hals portrayed. The servant has not been identified.

Hals was destitute during the last years of his life and from 1662 until his death in 1666 he received a small subsidy from the city of Haarlem. He did not, however, live in the Old Men's Alms House. On 22 January 1665 Hals signed a guarantee of 458.11.0 florins for his son-in-law Abraham Hendricksz. Hulst (Bredius, *O.H.*, XLI, 1923-24, p. 29). This amount was more than twice his yearly subsidy. Perhaps the payment he received for his last two group portraits accounts for his sudden affluence.

The earliest known reference to the portraits was published by Vincken and De Jongh (*op. cit.*, p. 10, note 19). It is found in Pieter Langedijk's manuscript 'Plaatschelijke en Historische Beschrijving van het oude mannenhuis binnen Haerlem, meest uit Handschriften opgemaakt' which is at the Haarlem Archives. The manuscript is part of Langedijck's projected history of Haarlem, begun around 1750 and left unfinished at his death in 1756. Langedijck wrote:

> ... Ook ziet men er een konstig stuk van Frans Hals, verbeeldende een colegie van Regenten, die voordien het Gôdtshuis bestuurd hebben. Deeze kamer heeft haar uitzicht over de tuin. Van daar gaat men na de kamer der Regentessen; dat een schoon vertrek is. Voor de schoorsteen ziet men een stuk van Frans Hals, konstig gedaan, verbeeldende een vergadering van Regentessen na de oude mode gekleed. Wie zij geweest zijn heb ik niet kunnen ontdekken.

Langedijck's statement that the group portraits were placed in different rooms shows they were not hung as pendants around 1750. If they were mounted the same way in Hals' time they were not intended to be seen as mates. However, it would be perverse to argue that the group portraits are not companion pictures.

Langedijck wrote that he was unable to discover the names of Hals' models and he did not say a word about the quality or character of Hals' late masterworks. As Vincken and De Jonge have shown in their thorough study of the

history of the criticism of the portraits (*op. cit.*) late eighteenth- and early nineteenth-century critics did not have much more to say about them. Things changed in 1877, when the obscure critic Jo. de Vries ('Een bezoek aan Haarlems Museüm van Oude Kunst', *Eigen Haard*, 1877, p. 254) claimed that Hals represented the regent wearing a large hat at a rakish angle as a drunkard (Plate 344). Vincken and De Jonge have shown that the charge is an unsupportable one and that recent critics who have seen the portraits as Hals' biting revenge on a society which allowed him to die misunderstood and impoverished are guilty of overinterpretation. However, their conclusion that no portraitist can show an aspect of a sitter's character is not convincing.

There have also been critics who have considered Hals' late group portraits the feeble efforts of an octogenarian who has spent his genius. For example, the sensitive painter-critic Eugène Fromentin, who had a keen appreciation for the artist's achievement, wrote in his influential *Les maîtres d'autrefois*, published in Paris, 1876, and frequently reprinted and translated, that by the time they were painted everything had failed Hals—clearness of vision, certainty of hand. The great virtuoso has disappeared; he is now nothing more than a shadow of himself. It is true that the virtuoso who painted intricate lace and brocades with exquisite ease in the 1610's and 1620's is not at work here. But Hals' brush has neither fumbled nor has he lost his nearly miraculous surety of touch. He is using the shorthand the greatest masters discover in their old age. Like the old Titian, Rembrandt, and Goya, the late Hals eliminated all details which interfered with his profound vision of the men and women who confronted him and, with abbreviated touches of ochre, red, white and black, created two of the most moving portraits ever painted.

222. Regentesses of the Old Men's Alms House (Plates 346–352; text, pp. 12, 17, 174, 182, 184, 210–25). Haarlem, Frans Hals Museum (Cat. 1929, no. 130).
Canvas, 170·5 × 249·5 cm.

PROVENANCE: Old Men's Alms House (*Oude-Mannenhuis*), Haarlem; on exhibit at the Frans Hals Museum since 1862.
EXHIBITIONS: Haarlem 1937, no. 115; Amsterdam 1945, Weerzien der Meesters, no. 39; Brussels 1946, Bosch tot Rembrandt, no. 44; Haarlem 1962, no. 72.
BIBLIOGRAPHY: Bode 1883, 8; Moes 9; HdG 438; Bode-Binder 286; KdK 109; Trivas 109; HdG 438; Bode-Binder 286; KdK 291; Trivas 109; G. D. Gratama, *Frans Hals, les Régents et les Régentes de l'Hospice de Vieillards, Les Grandes Oeuvres d'Art* (Études et Documents Photographiques), Brussels, Paris, The Hague, 1937; P. J. Vincken and E. de Jongh, 'De boosaardigheid van Hals' regenten en regentessen', *O.H.*, XXVIII, 1963, pp. 1*ff*.

Companion picture to Cat. no. 221. The names of the regentesses portrayed are Adriaentje Schouten, Marijte Willems, Anna van Damme, Adriana Bredenhof. However, no source tells us who is who. The name of the servant is unknown. The large landscape in the background, which looks like a painting by Hercules Seghers or Joos de Momper, has not been identified. It is singular that no landscape painting in a seventeenth-century interior has been firmly identified with an existing work (see W. Stechow, 'Landscape Painting in Dutch Seventeenth-Century Interiors', *N.K.J.*, XI, 1960, pp. 165*ff*).
John Singer Sargent made a copy of the servant and regentess on the extreme right; Provenance: Alvan T. Fuller, Boston, Massachusetts; Mrs. Robert L. Henderson, Chestnut Hill, Massachusetts. For two other copies by Sargent of Hals' work, see Cat. no. 46; Figs. 20, 21.

LOST PAINTINGS

L 1. **Banquet in a Park** (Fig. 66; text, Figs. 13, 14; text, pp. 31–33, 38, 67). Formerly Berlin, Kaiser-Friedrich-Museum (Cat. 1931, no. 1691).
Panel, 65 × 87 cm.

PROVENANCE: Sale, Revon, Lintz and others, Amsterdam, 17 April 1909, no. 102 (as Frans Hals); dealer Kleinberger, Paris, who presented it to the museum in 1912. Untraceable since World War II.

BIBLIOGRAPHY: W. Bode, 'Ein Bankett im Freien in der Richtung des jungen Frans Hals,' *Amtliche Berichte aus den königl. Kunstsammlungen*, XXXIII, 1912, pp. 161–163 (attribution uncertain; perhaps Frans Hals, but also recalls Buytewech); Bode-Binder, vol. I, p. 17, Plate B (*ca.* 1610; perhaps Frans Hals, Dirck Hals or Buytewech); W. Martin, 'Hoe schildere Willem Buytewech?', *O.H.*, XXXIV, 1916, p. 202 (attribution to Buytewech is doubtful); Kurt Zoege van Manteuffel, 'Ein Gemälde Willem Buytewechs im Kaiser-Friedrich-Museum', *Berliner Museen*, XLII, 1920–21, pp. 44–47 (Buytewech); G. Steinboemer, *Die Entstehung des niederländischen Geselligkeitsbildes*, dissertation, Berlin, 1924, p. 107 (not Buytewech); Georg Poensgen, 'Beiträge zur Kunst des Willem Buytewech, *Jahrbuch der preuszischen Kunstsammlungen*, XLVII, 1926, pp. 87*ff.* (Buytewech); J. G. van Gelder and N. F. van Gelder-Schrijver, 'Adam van Breen, Schilder', *Oudheidkundig Jaarboek*, ser. 4, I, 1932, p. 112 (probably not Buytewech); W. Martin, *De Hollandsche Schilderkunst in de 17ᵉ Eeuw*, vol. I, Amsterdam [1935], pp. 356, 358, 450 (*ca.* 1610–15; Buytewech); I. Q. van Regteren Altena, 'Carel van Mander', *Elsevier's Geïllustreerd Maandschrift*, XCIII, 1937, p. 169 (Frans Hals); F. Würtenberger, *Das holländische Gesellschaftsbild*, Schramberg, 1937, pp. 49–51 (Frans Hals); E. Plietzsch, *Frans Hals*, Burg b. M., 1940, p. 7 (probably Frans Hals); K. Bauch, 'Haarlemer Figurenbilder aus der Frühzeit des Frans Hals', *O.H.*, LVIII, 1941, pp. 90–91 (early work by Frans Hals); K. G. Boon, *De schilders voor Rembrandt*, Antwerp-Utrecht, 1942, p. 15 (probably Frans Hals); K. Goossens, *David Vinckboons*, Antwerp-The Hague, 1954, pp. 91*ff.* (Frans Hals); E. Plietzsch, 'Randbemerkungen zur holländischen Interieurmalerei am Beginn des 17. Jahrhunderts', *Wallraf-Richartz-Jahrbuch*, XVIII, 1956, p. 186 (probably an early work by Frans Hals but it cannot be assigned to him with absolute certainty); S. Slive, review of K. Goossens' *David Vinckboons*, *The Art Bulletin*, XXXIX, 1957, p. 315 (Frans Hals); E. Haverkamp Begemann, *Willem Buytewech*, Amsterdam,

pp. 23*f.*, 63, 78–79 (no. XVII), 100, 152 (not Buytewech; possibly Frans Hals); S. Slive, 'Frans Hals Studies, I: Juvenilia', *O.H.*, LXXVI, 1961, p. 173 (*ca.* 1610; probably Frans Hals); J. Richard Judson, *Dirck Barendsz.: 1534–1592*, Amsterdam, 1970, pp. 94, 96 (*ca.* 1610; Frans Hals); J. Rosenberg, S. Slive, E. H. ter Kuile, *Dutch Art and Architecture: 1600–1800*, revised ed., Harmondsworth-Baltimore-Ringwood, 1972, pp. 48, 170 (*ca.* 1610; probably Frans Hals).

The painting has been untraceable since the end of World War II. If it was not looted, it was most likely destroyed between 5 and 10 May 1945 at the Flakturm Friedrichshain, Berlin. For a comprehensive discussion of the German losses which were a result of World War II, see Hans Huth's review of *Die Berliner Museen*, Berlin, 1953, and *Bonner Berichte aus Mittel- und Ostdeutschland: Die Verluste der öffentlichen Kunstsammlungen . . .*, Bonn, 1954, which appeared in *The Art Bulletin*, XXXVI, 1954, pp. 310–318. In reports of the losses the *Banquet in a Park* is listed as it was catalogued in *Beschreibendes Verzeichnis der Gemälde im Kaiser-Friedrich-Museum . . .*, 9th ed., Berlin, 1931, p. 75, no. 1691: 'Buytewech? *Gastmahl im Freien* Tannenholz, h. 0,65, br. 0,87 . . .'. The 1931 Berlin catalogue noted: 'Die Zuschreibung an Buytewech ist nicht sicher.'

As the Bibliography cited above makes abundantly clear, much ink has been spilled over the attribution of the painting, but little of it by cataloguers of Frans Hals' works. Bode, who published the picture in 1912 (*op. cit.*) as a painting 'in der Richtung des jungen Frans Hals', did not list it in his 1914 catalogue. Binder, who wrote the introduction to Bode's 1914 catalogue, stated: 'Der Author des Stückes ist unbekannt'; he added that he did not exclude young Hals as the artist, but also suggested that it may have been painted by Buytewech or Dirck Hals (Bode-Binder, vol. I, p. 17). Neither Valentiner nor Trivas included the painting in their catalogues.

I never saw the original and therefore cannot make an unqualified statement about its attribution. However, unless one is determined to ascribe the lost work to an exceptionally talented nameless Dutch painter who disappeared from the scene after he executed the picture around 1610, I believe there is excellent reason to endorse the opinion of experts who studied the original and concluded that it was done by Frans Hals. Its distinctive fresh brushwork in the parts which are worked up as well as those

which are broadly laid are closely related to Hals' *Portrait of Zaffius*, dated 1611 (Cat. no. 1; Plate 1).

The only other serious contender was Willem Buytewech, but Haverkamp Begemann's study of his paintings establishes that he can no longer be considered a prospective candidate (*op. cit.*). Nothing in Buytewech's known painted *oeuvre* matches the bold, fluid touch recognizable in photographs of the lost painting. Buytewech's staunchest proponents (Zoege van Manteuffel, *op. cit.*; Poensgen, *op. cit.*) principally rested their case on a signed Buytewech drawing which they concluded was a preliminary study by 'Geestige Willem' for the man seated on the right of the painting. The crucial drawing, formerly at the Kunsthalle, Bremen, and yet another casualty of World War II, is catalogued and reproduced by Haverkamp Begemann (*op. cit.*, pp. 124-125, no. 73, fig. 68). There is, to be sure, a relationship between the two works—close enough to have led G. Knuttel ('Willem Buytewech; van Manierisme tot Naturalisme', *Mededeelingen van den Dienst voor Kunsten en Wetenschappen der Gemeente 's-Gravenhage*, II (1929), p. 197, note 2) and Würtenberger (*op. cit.*, p. 49, note 1) to conclude that the signed drawing was a copy by Buytewech after the figure in the lost painting. But Haverkamp Begemann rightly notes that there is no justification for assuming that the Bremen drawing was either a preparatory study or a direct copy after the Berlin painting. The attitude of the fashionably dressed man in both works was part of the stock-in-trade of late sixteenth- and early seventeenth-century artists who showed dandies seated at a table. The figures can be considered similar but independent solutions of the same problem.

There is no doubt that the artist who painted the lost painting was familiar with the way other late sixteenth- and early seventeenth-century Dutch artists had treated banquet scenes. The general disposition of the principal figures and the banquet table is closely analogous to an engraving Claes Jansz. Visscher made in 1608 after David Vinckboons' drawing of an outdoor *Prodigal Son* scene, also dated 1608, which is now at the British Museum (Poensgen, *op. cit.*; Goossens, *op. cit.*); Vinckboons' drawing and the print made after it (repr. Goossens, *op. cit.*, pp. 91–92, figs. 46, 47) establish a probable *terminus post quem* of 1608 for the lost painting. The spirit of the Berlin painting is also connected to pictures done by Dirck Barendsz. and the Haarlem mannerists. The way its perky author successfully put together an anthology of motifs derived from their works is not the least interesting aspect of the painting. The classical ruins in the distance were taken from an engraving Jacques de Gheyn made in 1596 after an invention by Hals' teacher Carel van Mander (*Prodigal Son*; repr. Poensgen, *op. cit.*, p. 89, fig. 3). The wine-cooler in the foreground was borrowed from the print Hendrick Goltzius made in 1584 after Dirck Barendsz.' *Venetian Wedding* (Würtenberger, *op. cit.*, p. 51; repr. Judson, *op. cit.*, fig. 67) and although the large drapery hung between two trees is found in many outdoor scenes of the period, Judson (*op. cit.*, p. 96) has noted a

striking similarity between the one in the Berlin painting and the one in Barendsz.' *Mankind before the Flood*, which was engraved by Jan Sadeler (repr. *ibid.*, fig. 41); it too was probably borrowed from Barendsz.

Conceivably the Berlin painting, like most of the works cited above and so many others done around the same time of young people dancing, feasting and making love, had a moralizing or didactic intent (see text, p. 33). If it was designed as a *Prodigal Son* scene it was possibly identical with Hals' Prodigal Son pictures cited in inventories made at Amsterdam in 1646 and 1647 (see Cat. no. 20). However, the one cited in the 1646 inventory was described as a large painting, which suggests that it may have been identical with Hals' so-called *Jonker Ramp* rather than the Berlin picture.

L 2. **Merry Trio** (Fig. 68; text, Fig. 17; text, pp. 34–35; 38, 85). Recorded as monogrammed and dated 1616 (see below).

PROVENANCE: According to Bode (1886, p. 46), who tells us virtually everything known about the lost original, the painting was in Belgium around 1873, and he adds 'so viel ich weiss' it was sold to an American collection. The 1931 Berlin, Kaiser-Friedrich-Museum Catalogue (p. 207, no. 801D, note) states that the monogrammed original, dated 1616, was in the English art market in 1928. I have not been able to confirm this statement, and as far as I have been able to ascertain, the original has not been seen by students of Hals' work since Bode's pioneer study was published in 1883. Valentiner, who knew American collections well, informed me that he tried to find the whereabouts of the painting for more than fifty years without success. My shorter search has failed too.

BIBLIOGRAPHY: Bode 1883, pp. 46–48 (dated 1616); Moes 1909, p. 24; Bode-Binder 4 (original lost); KdK 297 (original untraceable).

Versions:

1. Catalogued as Dirck Hals in the sale, Beurnonville, Paris, 9–16 May 1881, no. 308: canvas, 78 × 61 cm. (Sedelmeyer). Possibly identical with the painting catalogued as 'Ecole de F. Hals' which appeared at the sale, Paris (Drouot), 14 November 1967, no. 26: monogrammed and dated 16[?]6; canvas, 79 × 61 cm. (Fig. 67). A photograph of another version of the Drouot painting is at the Witt; the photograph bears no data.

2. Berlin, formerly Kaiser-Friedrich-Museum (Cat. no. 801D). Looted or destroyed in World War II (Fig. 68; text, Fig. 17).

 Canvas, 81 × 62 cm.

 PROVENANCE: Acquired by the museum from the collection Suermondt, Aachen, in 1874.

 EXHIBITIONS: Brussels [Coll. Suermondt], 1873, no.

73 (as Frans Hals, *ca.* 1615); Brussels, Exposition de tableaux et dessins d'anciens maîtres . . . , 1873, no. 20 (as Frans Hals).

BIBLIOGRAPHY: W. Unger and C. Vosmaer, *Etsen naar Frans Hals* . . . , Leiden, 1873 (etching by Unger); Bode 1883, pp. 46–48 (copy); Moes 1909, p. 24 (copy); Kaiser-Friedrich-Museum Catalogue, 1911, no. 801D ('erinnert . . . an Dirck Hals'; helpful colour description); Bode-Binder 4 (copy); KdK 297 (copy); Georg Poensgen, 'Gemälde des Willem Buytewech im Kaiser-Friedrich-Museum,' *Berliner Museen: Berichte aus den preussischen Kunstsammlungen*, XLVII, 1926, pp. 83–85 (ascribed to Buytewech); Kaiser-Friedrich-Museum Catalogue, 1931 no. 801D (erinnert . . . an Dirck Hals); G. Knuttel, 'Willem Buytewech; van Manierisme tot Naturalisme', *Mededeelingen van de Dienst voor Kunsten en Wetenschappen der gemeente 's-Gravenhage*, II, 1926–31, p. 197, note 2 (if Buytewech, then his earliest known painting); W. Martin, *De Hollandsche schilderkunst in de 17ᵉ eeuw*, vol. I, Amsterdam [1935], p. 449, note 478 (probably not Buytewech); S. J. Gudlaugsson, *De Komedianten bij Jan Steen en zijn tijdgenooten*, The Hague, 1945, p. 57 (Buytewech; the man identified as Hanswurst); J. S. Kunstreich, *Der 'Geistreiche Willem'*, Kiel, 1959, p. 30, no. x ('Buytewech's Autorschaft sehr gut möglich'); E. Haverkamp Begemann, *Willem Buytewech*, Amsterdam, 1959, pp. 61–62, no. 1 (Buytewech, *ca.* 1616).

Poensgen's (*op. cit.*) ascription of the lost Berlin variant to Buytewech has won general acceptance; also see the convincing arguments offered by Haverkamp Begemann to support the attribution.

To judge from the style and costumes of the variants there is no reason to doubt the 1616 date Bode (1883, p. 46) read on the lost original. *Shrovetide Revellers* (Cat. no. 5; Plate 8), which includes the seated model seen in both copies, was probably painted around the same time. According to Bode (1883, p. 48) Hals' original showed 'ein munterer Bursche mit dichtem Haarwuchs' instead of the girl seen behind the couple in the Berlin painting. Since the Drouot variant (Fig. 67) includes the boy described by Bode it may be closer to the original than the Berlin copy. However, the close similarity of the boy in the Drouot version to types employed by Judith Leyster around 1630 suggests that he too may have been an invention of a later copyist; most likely the copyist fitted him out in a plumed beret. In the original described by Bode, the lively boy with a thick head of hair was probably more closely related to the vigorously brushed grinning figure in the right background of Hals' *Shrovetide Revellers* (Cat. no. 5; Plate 8) than to the androgynous youth in the Drouot variant. A sketch derived from the seated man appears on the painting on an easel in the Louvre version of the so-called *Itinerant Painter* done by a follower of Hals (see Cat. no. D 22-1, Fig. 137).

L 3. The Rommel Pot Player (Figs. 69–74; text, Figs. 20, 21, 24, 25; text, pp. 36–39, 191).

The many known versions and references to this lost painting may in fact be based on two lost variants by Hals of the composition: one with five children, with the second child from the bottom looking at the spectator, as seen in the Kimbell painting (Cat. no. L 3-1; text, Fig. 20); the other with six children, with the second child from the bottom looking at the rommel pot player and some other changes, as seen in the Wilton House version (Cat. no. L 3-2; Fig. 70).

1. Fort Worth, Texas, Kimbell Art Museum (Fig. 69; text, Fig. 20).
 Canvas, 106 × 80·3 cm.
 PROVENANCE: Sir Frederick Cook, Doughty House, Richmond, Surrey, by 1903; by descent to Sir Francis Cook, and in his collection until after 1946; dealer Newhouse, New York, who sold it to Kay Kimbell, Fort Worth, Texas.
 EXHIBITIONS: London Guildhall, 1903, no. 173; Fort Worth, Texas, Fort Worth Art Association, 'Twenty-One Paintings from the Kimbell Art Foundation', 1953, no. 8.
 BIBLIOGRAPHY: HdG 137-5 (replica); Bode-Binder 10 (copy); KdK 24 (replica; *ca.* 1623); Cook Collection, Cat. 1932, p. 44, no. 265; Trivas App. 3 (variant); Kimbell Art Museum, Catalogue 1972, pp. 52*ff*.
 One of the best existing versions. The loosening of the crowded composition suggests that the lost original was painted a few years after Hals' *Shrovetide Revellers* (Cat. no. 5; Plate 8). In my opinion Valentiner (KdK 24) dated it a bit too late when he placed it around 1623, and his effort to identify the five children as Hals' own daughter and sons on the basis of his estimate of the ages of the children portrayed is fanciful.

2. Wilton House, The Earl of Pembroke (Fig. 70; text, Fig. 24).
 Canvas, 109·2 × 86·3 cm.
 PROVENANCE: The painting was at Wilton before 1730 and according to the 1968 Wilton House Catalogue (no. 107) was probably bought by Thomas, 8th Earl of Pembroke (died 1733).
 BIBLIOGRAPHY: C. Gambarini, *A description of the Earl of Pembroke's pictures*, Westminister, 1731, p. 74 (in the yellow Damask Room: 'Francis Halls, all the Persons are laughing'); James Kennedy, *A new description of the Pictures . . . and other Curiosities at the Earl of Pembroke's House at Wilton*, Salisbury, 1758, p. 89; Bode 1883, 154; HdG 137-6 (replica); Bode-Binder 12 (replica); KdK 299 (weak studio piece after a lost original); Sidney, 16th Earl of Pembroke, *A Catalogue of the Paintings . . . at Wilton House . . . ,*

London-New York, 1968, p. 42, no. 107 (School of Frans Hals; perhaps by Judith Leyster).

Relined and cleaned in 1930. According to the 1968 Wilton Catalogue: 'pentimenti in the top right-hand corner: three additional faces painted out, and in the top left-hand corner one face, all of older people. These were invisible before cleaning.' The engraving by François Hubert (see Cat. no. L 3-13; Fig. 72) probably gives some indication of the way the painting looked before the faces of the older people were painted out. It will be recalled that five of the figures in the background of Hals' *Shrovetide Revellers* were painted out, and were only revealed when the painting was cleaned in 1951 (see Cat. no. 5). If the figures in the background of the Wilton House picture were as sketchily indicated as those in Hals' *Shrovetide Revellers* they may have been painted out to conform to the taste of a later generation, which demanded a higher finish than Hals gave to ancillary figures in his genre pieces.

The painting was described in 1758 by James Kennedy in his catalogue of the pictures at Wilton House as: 'An old Man with some Sorts of Sweetmeat in a Pot, which he sells to the Children; there are six about him; an extraordinary Pleasure appears in all their Countenances By Fran. Halls.' We have no way of knowing if ignorance of rommel pots or a heavy layer of discoloured varnish made this early cataloguer interpret the instrument as a container of sweetmeats.

Passages of the Wilton variant are clumsier than those in the Kimbell version (Cat. no. L 3-1); the sleeve of the rommel pot player and the hands and drapery of the boy on the far right are particularly weak. I am unable to name the artist who painted the picture; I cannot, however, see any reason to accept the proposal that it may have been done by Judith Leyster (Wilton Catalogue 1968, no. 107). The composition and the expressive heads of the laughing children leave little doubt that the painting is based on a Hals original. If this hypothesis is correct, it supports the suggestion that Hals himself made two variants of the composition: one with six children as seen here; the other with five children as seen in the Kimbell painting (Cat. no. L 3-1; text, Fig. 20) as well as some other variants listed below.

Watteau's chalk drawing after one of the boys in the Wilton picture is at Rotterdam, Boymans-van Beuningen Museum (no. F. I. 305; text, Fig. 25).

3. Chicago, The Art Institute of Chicago (Cat. 1961, inv. no. 47·78; Fig. 71; text, Fig. 21). Panel, 39·1 × 30·5 cm.
PROVENANCE: Sale, Friedrich Jacob Gsell, Vienna, 14 March 1872, no. 38; Dr. Carl von Lützow, Berlin; sale, H. Schorer, Groot Bentveld, 26 April 1892, no. 36 (6,000 florins; Goedhart); M. Goedhart, Frankfurt a.M.; Salomon Goldschmidt Jr., Frankfurt

a.M.; dealer Reinhardt Gallery, Chicago; William J. McAneeny, Detroit; dealer Lilienfeld Galleries, New York; Charles H. and Mary F. S. Worcester, Chicago, who gave it to the Art Institute in 1947.
EXHIBITIONS: Detroit 1929, no. 26; Detroit 1935, no. 2; Haarlem 1937, no. 24; New York 1942, no. 9; Los Angeles 1947, no. 1; Raleigh 1959, no. 55.
BIBLIOGRAPHY: W. Bode, 'Die Galerie Gsell in Wien', *Zeitschrift für Bildende Kunst*, VII, 1872, p. 183; Bode 1883, 96; HdG 137-4 (replica); Valentiner 1928, p. 237 (original sketch for our Cat. no. L 3-1); Valentiner 1936, 10 (very likely the first study for the large composition; about 1626); *Paintings in the Art Institute of Chicago*, Catalogue, 1961, p. 209 (original; ca. 1626).

Bode accepted the painting in 1872 and 1883 but deleted it from his 1914 catalogue. Hofstede de Groot (137-4) recorded it as a copy, and Valentiner did not include it in his 1921 or 1923 catalogues. In 1928 Valentiner argued that the small painting was the preparatory study for the variant in the Kimbell collection (Cat. no. L 3-1). In 1935 he noted that the children's head coverings and collars in Cat. no. L 3-1 seem to be of an earlier type and he no longer asserted that it was the preliminary study for it. The costumes worn by the children indicate that the Chicago version post-dates the Kimbell variant (see Cat. no. L 3-16, Fig. 73, for a version which dresses the children in costumes which can be dated after 1650).

The close similarity of the style of the painting to Judith Leyster's monogrammed painting of *Two Children with a Cat* (Fig. 75; dealer F. Mont, New York, 1959) suggests that the Chicago painting was done around 1630 by this gifted follower of Hals. Both pictures can be grouped with two other paintings which have wrongly been ascribed to Hals: *Standing Man*, Buckingham Palace (see Cat. no. 31 and Fig. 16) and *Three Merry Youths*, Oslo (Cat. no. D 26, Fig. 143).

Students of our time can take heart when they learn that contemporaries of the artists confused Leyster's works with those of Hals. (It is also known that their contemporaries found it impossible on at least one occasion to distinguish an early Rembrandt from an early Lievens; in a 1632 inventory of Frederick Henry's paintings a 'Presentation in the Temple' is recorded as 'by Rembrandt or Lievens'.) Leyster's painting was engraved by Cornelis Danckerts (1603-56) as a Frans Hals (Fig. 76; Hollstein, V, p. 125, no. 79). A weak replica of her painting, showing only the boy with the cat, was in the sale, London (Christie) 20 June 1913, no. 61, and in the sale, Blakeslee Galleries, New York (American Art Association) 21 April 1915, no. 65: 75 × 67·2 cm. ($350). Another copy of it, showing only the boy with the cat (wearing green instead of blue breeches)

is cited in the coll. Mrs. Ebba Warberg, Stockholm, by Olof Granberg, *Inventaire Général des Trésors d'Art . . . en Suède*, vol. II, Stockholm, 1912, vol. II, p. 58, no. 215. Granberg states that it was engraved by Jasper Isaacs (died 1654); I have been unable to locate an impression of the print.

4. New York, formerly E. R. Bacon.
 Canvas, 100×82·5 cm.
 PROVENANCE: Sale, Count Mniszech, Paris, 9 April 1902, no. 126 (35,000 francs); sale, H. J. A. Eyrie and others, London, 9 December 1905, no. 59; Edward R. Bacon, New York; sale, Mrs. V. P. Bacon, London, 12 December 1919, no. 79; sale, London (Sotheby), 28 April 1965, no. 7.
 BIBLIOGRAPHY: Bode 1883, 61 (original); Moes 223; HdG 137-13 (replica); Bode-Binder 11 repr., plate 7a (replica); Coll. E. R. Bacon, New York.
 A crude copy, which is related to the Wilton variant (Cat. no. L 3-2). The copyist hopelessly confused the hands of the standing boy on the right; the same error occurs in the late eighteenth-century engraving by Hubert (Cat. no. L 3-13; Fig. 72).

5. Sale, London (Christie) 29 June 1923, no. 103; canvas, 105·5×87·5 cm. A weak replication of the Kimbell type (Cat. no. L 3-2); photo in FARL. To judge from fuzzy photos at the RKD it was with the dealer Wm. T. White, Edinburgh in 1928; possibly it was the variant which appeared in the sale, London (Sotheby), 12 December 1934, no. 60, and in the sale, London (Christie), 1 June 1945, no. 13.

6. Berlin, formerly Carl von Hollischer.
 Panel, 49×38 cm.
 EXHIBITION: Berlin 1890, no. 82.
 BIBLIOGRAPHY: HdG 137-1 (the girl looks at the spectator).

7. Hölscher-Stumpf, Berlin; sale, J. Stumpf, Berlin, 7 May 1918, no. 32, repr.; B. J. Ottink, The Hague, 1963.
 Canvas, 67×49 cm.
 BIBLIOGRAPHY: HdG 137-2 (the second child from the bottom looks at the spectator); photo RKD, neg. no. 23203. Related to the Kimbell variant (Cat. no. L 3-1).

8. Dessau, Amalienstift (Cat. 1877, no. 109); 'Ein Knabe, den Rommelpot reibend.'
 Panel.
 HdG 137-3.

9. Sale, J. van der Veen, Amsterdam, 14 April 1851, no. 112 (HdG 137-11).

10. Collection Tolen, Emden; sale, Néville D. Goldsmid of The Hague, Paris, 4–5 May 1876, no. 43; 100×80 cm. (Bode 1883, 27; HdG 137-12).

11. Sale, Paul Giersberg of Wesel, Cologne, 16 April 1907, no. 33. Canvas, 106×86 cm. The girl looks at the spectator (HdG 137-14). A late copy related to the Wilton type (Cat. no. L 3-2); photo at the RKD.

12. Sale, Paul Mersch, Paris, 8 May 1908, no. 39. Only five children; the second from the bottom, a girl, looks at the spectator (HdG 137-15); photo at the RKD. Related to the Kimbell variant (Cat. no. L 3-1).

13. Le Brun, Paris, around 1783; sale, Madame Leuglier, Paris, 10 March 1788 (370 francs); sale, Destouches, Paris, 21 March 1794 (HdG 137-9).
 Engraved by François Hubert (1744–1809) in *Septième Livraison de Douze Estampes Gravée sous la Direction de M. Le Brun, Peintre, D'après les différents Tableaux . . . Ces Tableaux ont été & sont encore en la possession de M. Le Brun*, Paris, February, 1783 (Fig. 72). Hubert's engraving appears again in the 1792 edition of Le Brun's *Galerie*, p. 71.
 Panel, 54×43·2 cm.
 The engraver has confused the hands of the boy standing behind the player on the left of the print. In this variant, which is derived from the Wilton type (Cat. no. L 3-2; Fig. 70), the boy strikes his hand in his open fist; in the engraving the hands have become a messy bunch of folds. The same error occurs in Cat. no. L 3-4.

14. Recorded in the inventory made after the death of Jan van de Cappelle, dated 4 January 1680, no. 99 'een rommelpot van Frans Hals' (Amsterdam Municipal Archives NAA no. 2262 B, p. 1190; see also text, p. 191 and *O.H.*, x, 1892, p. 34); HdG 137-7.

15. Sale, H. van der Vugt, Amsterdam, 27 April 1745, no. 104, 107×76 cm. (55 florins, Pieter Yves); HdG 137-8.

16. Mezzotint by Jan van Somer (*ca.* 1645-after 1699) inscribed 'jan Livens pinx.' (Fig. 73). The print is obviously yet another variant after Hals' composition and was not done after a painting by Lievens. It is not listed in H. Schneider, *Jan Lievens, sein Leben und seine Werke*, Haarlem, 1932. The children's costumes post-date 1650.

17. *Rommel Pot Player with a Boy Offering Him a Coin*
 Engraved by Pieter de Mare (1757–96) and inscribed 'F. Hals pinx.' (Fig. 74). The substitution of a bow for a fox tail on the rommelpot player's hat indicates that the significance of the latter as an allusion to a fool had probably been lost by the time De Mare made his print.

18. *A Rommel Pot Player and Two Laughing Children*
 Sale, P. M. Kesler, C. Apostool and others, Amsterdam, 13 May 1844, no. 37 (50 florins, Roos); sale, J. A. de Lelie and others, Amsterdam, 29 July 1845, no. 78 (HdG 137-10).

19. Rommel Pot Player
 Uccle, Belgium, formerly M. van Gelder.
 Panel, 50×38·5 cm.
 EXHIBITION: Haarlem 1937, no. 14, repr. fig. 17.
 BIBLIOGRAPHY: Bode-Binder 14.
 A travesty of the principal figure.

20. *Laughing Man Holding a Jug*, Montreal, Mrs. William

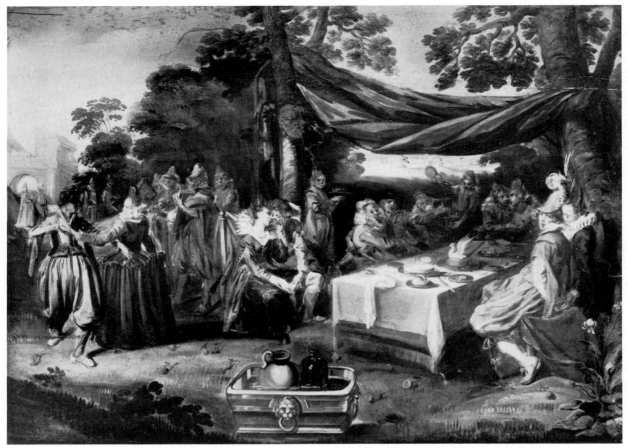

66. Attributed to Frans Hals: *Banquet in a Park*. Destroyed. Formerly Berlin, Kaiser–Friedrich Museum. Cat. no. L 1.

67. *Merry Trio*. Variant after a lost original. Paris (Drouot), 14 November 1967, no. 26. (Cat. no. L 2-1.)

68. *Merry Trio*. Copy after a lost original. Destroyed. Formerly Berlin, Kaiser–Friedrich Museum. Cat. no. L 2-2.

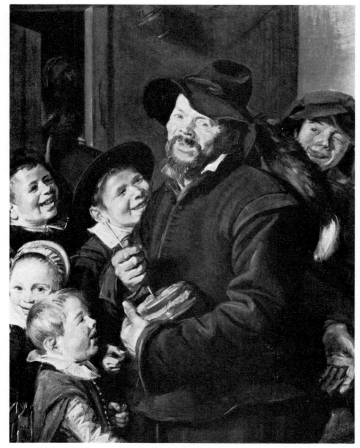

69. *The Rommel Pot Player*, after Hals. Fort Worth, Texas, The Kimbell Art Museum. Cat. no. L 3–1.

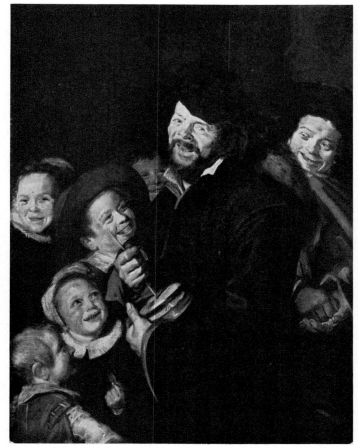

70. *Rommel Pot Player*, after Hals. Wilton House, The Earl of Pembroke. Cat. no. L 3–2.

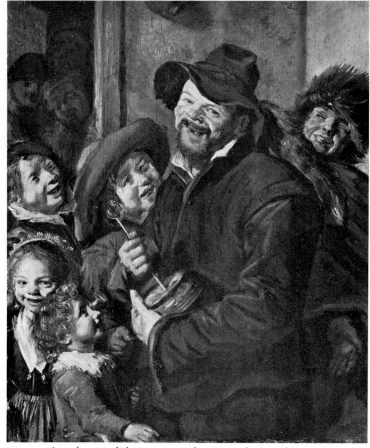

71. Attributed to Judith Leyster: *The Rommel Pot Player*, after Hals. Chicago, The Art Institute of Chicago, Charles H. and Mary F. S. Worcester Collection. Cat. no. L 3–3.

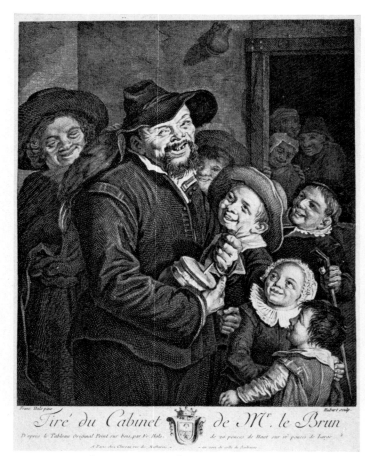

72. François Hubert: engraving after a variant of Hals' lost *Rommel Pot Player*. Cat. no. L 3–13.

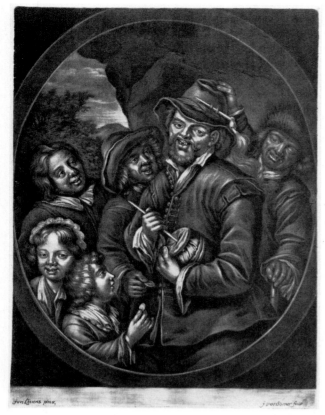

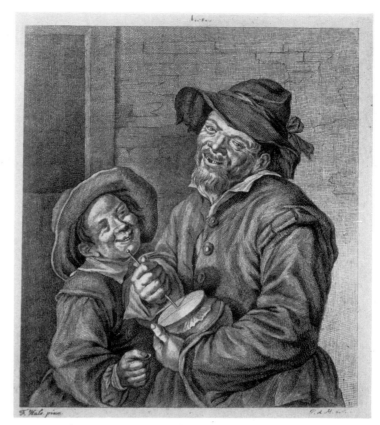

73. Jan van Somer: mezzotint after a variant of Hals' lost *Rommel Pot Player*. Cat. no. L 3-16.

74. Pieter de Mare: engraving after a variant of Hals' lost *Rommel Pot Player*. Cat. no. L 3-17.

75. Judith Leyster: *Two Children with a Cat*. Formerly New York, dealer F. Mont. (See Cat. no. L 3-3.)

76. Cornelis Danckerts: engraving after Leyster's *Two Children with a Cat* (erroneously inscribed 'f. Hals pinxit'). (See Cat. no. L 3-3.)

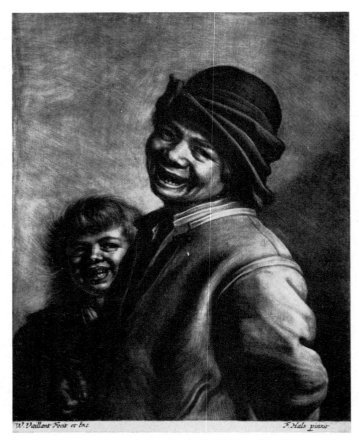

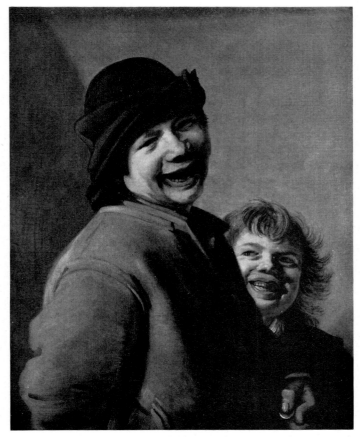

77. Wallerant Vaillant: mezzotint after Hals' lost *Two Laughing Boys, one holding a coin*. Cat. no. L 4.

78. *Two Laughing Boys, one holding a coin*, after a lost original. Washington, D.C., Kingdon Gould Jr. Cat. no. L 4-1.

79. Johannes de Groot: mezzotint after Hals' lost *Laughing Fisherboy*. Cat. no. L 5.

80. Abraham Blooteling: mezzotint after Hals' lost *Man Holding a Tankard and a Pipe*. Cat. no. L 6.

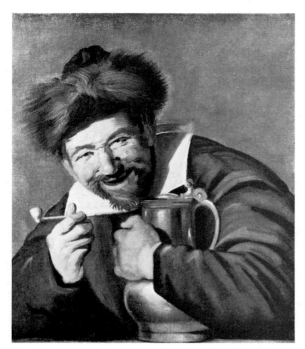

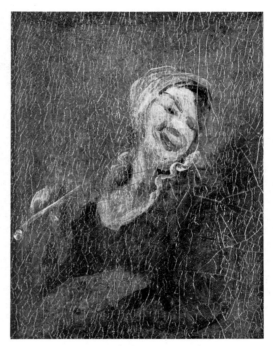

81. *Man Holding a Tankard and a Pipe*, after a lost original. Formerly Paris, M. de Werth. Cat. no. L 6-1.

82. Jan Steen: Detail from *The Baptismal Party*. Berlin-Dahlem, Staatliche Museen. Probably a copy after Hals' lost *Woman with a Pipe* (Malle Babbe?). Cat. no. L-7.

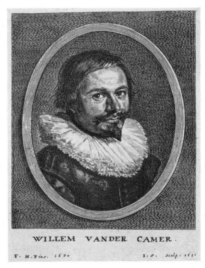

83. Jan van de Velde: engraving after Hals' lost *Johannes Bogardus*. Cat. no. L 8.

84. Jonas Suyderhoef: engraving after Hals' lost *Willem van der Camer*. Cat. no. L 10.

85. Adriaen Matham: engraving after Hals' lost *Pieter Bor*. 1634. Cat. no. L 11.

86. Lucas Kilian: engraving after Hals' lost *Arnold Möller*. Cat. no. L 9.

87. Jonas Suyderhoef: engraving after Hals' lost *Casparus Sibelius*. 1637. Cat. no. L 12.

88. Theodor Matham: engraving after Hals' lost *Theodore Blevet*. 1640. Cat. no. L13.

89. Jonas Suyderhoef: engraving after Hals' lost *Jacobus Revius*, first state. Cat. no. L 16.

90. Jonas Suyderhoef: engraving after Hals' lost *Theodor Wickenburg*. Cat. no. L 17.

91. Attributed to Isaac van der Vinne: woodcut after Hals' lost *Self-Portrait*. (Cat. no. L 15.)

92. Anonymous: woodcut after Hals' lost *Self-Portrait*. (See Cat. no. L 15.)

93. Cornelis van Noorde: mezzotint after Hals' lost *Self-Portrait*. (See Cat. no. L 15.)

94. *Self-Portrait*, copy after a lost original. Indianapolis, The Clowes Fund, Inc. Cat. no. L 15-1.

95. *Self-Portrait*, copy after a lost original. German Private Collection. Cat. no. L 15-2.

96. *Self-Portrait*, copy after a lost original. New York, Metropolitan Museum of Art. Cat. no. L 15-3.

97. George Vertue: drawing after Hals' lost *Thomas Wyck*, Pen and wash. San Marino, California, Huntington Library. Cat. no. L 14.

98. Warnaar Horstink: drawing after Hals' lost *Jacob van Campen*. 1798. Black chalk. Haarlem, Municipal Archives. Cat. no. L 18.

99. *Portrait of a Woman* (Maria van Teylingen?), possibly after a lost original. Dublin, James A. Murnaghan. Cat. no. L 19.

100. Jan Gerard Waldorp: drawing after Hals' lost *Portrait of a Woman*. 1779. Black chalk on parchment. Haarlem, Frans Hals Museum. Cat. no. L 20.

van Horne. A pastiche derived from the rommel pot player; see Cat. no. D17, Fig. 131.

Studies of three heads, connected with the Rommel Pot player appeared in the sale, A. Beurdeley, Paris, 8–10 June 1920, no. 189, repr.: black chalk, heightened with white on buff paper; 36·5 × 29·5 cm., and in the sale London (Sotheby), 14 April 1948, no. 17: Frans Hals (attributed to).

L 4. Two Laughing Boys, one Holding a Coin (Figs. 77, 78). Mezzotinted, probably in reverse, by Wallerant Vaillant (1623–77); inscribed: W Vaillant Fecit et Exc. F. Hals pinxit (Fig. 77; Wessely 162).

To judge from Vaillant's print, the original was done around the mid-twenties. The rather schematic handling of the older boy's jacket recalls Hals' treatment of the drapery worn by *St. Luke* and *St. Matthew*, datable around 1625 (Cat. nos. 43, 44; Plates 72, 73). The composition is related to the latter work as well as to *Two Boys Singing* at Cassel done around 1623-25 (Cat. no. 23; Plate 44), and *Laughing Boys, one with a jug* at Rotterdam, executed about 1626-28 (Cat. no. 60; Plate 90). Vaillant's print suggests that the characteristic hatched strokes used to model the head of the principal figure in the Rotterdam painting (see Vol. II, *Plates*, colour plate opposite Plate 88) were employed to model the head of the boy holding the coin.

Other variants and copies:
1. Washington, D.C., Kingdon Gould Jr. (Fig. 78).
 Canvas, mounted on panel, 62 × 51 cm. Signed at the left of the boy's head with the connected monogram: FH.
 PROVENANCE: Sale, Pieter Lyonet, Amsterdam, 11 April 1791, no. 122 (10.50 florins; Spaan); M. Hoofman, Haarlem; sale, Amsterdam, 16 May 1877, no. 11; Jhr. P. N. Quarles van Ufford, The Hague; George J. Gould, Lakewood, New Jersey; Kingdon Gould, Washington, D.C.
 EXHIBITION: The Hague 1881, no. 149.
 BIBLIOGRAPHY: Bode 1883, 14 (*ca.* 1625); W. Martin, 'Notes on Some Pictures in American Private Collections', *B.M.*, XIV, 1908, p. 60 (1630-40); HdG 138; Bode-Binder 47; KdK 70 (*ca.* 1627-30); Valentiner 1936, 27 (*ca.* 1627-30).
 The painting is badly abraded. But even after making allowances for its state of preservation I fail to recognize Hals' touch in its smooth surfaces. In my judgement it is an old copy after the lost original, and it is evident that the copyist ran into enormous difficulty when he copied the hand of the boy holding a coin. The authors cited in the Bibliography above accept the painting as an authentic Frans Hals.
2. Mezzotint, probably in reverse, by Pieter Louw (died in Amsterdam before 1800), Hollstein, vol. VIII, p. 216, no. 41.

3. A weak (eighteenth-century?) watercolour, probably after Vaillant's print, is in the possession of Mrs. Paul Richfield, Chicago, Illinois.

L 5. Laughing Fisherboy (Fig. 79). Mezzotinted, probably in reverse, by Johannes de Groot (born 1688–89, still active 1722); inscribed: F. Hals [the F and H ligated] Pinxit J. de Groot Fe.

The original was probably done in the late twenties and related to the *Fisherboy* at Burgsteinfurt (Cat. no. 55; Plate 86) and the *Left-handed Violinist* at Lugano (Cat. no. 56; Plate 87).

Other variants and copies:
1. The Hague, formerly C. Hofstede de Groot.
 Panel, 37 × 33 cm.
 PROVENANCE: Sale, Willem Trübner, Berlin (Lepke), 8 June 1918, no. 278 as 'Frans Hals?'; C. Hofstede de Groot, The Hague.
 BIBLIOGRAPHY: KdK 113, repr. (*ca.* 1633-35); Valentiner 1928, p. 238.
 Valentiner (1928) wrote that the painting may have been a preparatory study for Cat. no. L 5-2, which he also attributed to Hals. Neither painting is autograph.
2. Formerly Berlin, private collection.
 Canvas, 80 × 65 cm.
 First published by Valentiner 1928, p. 237, repr. p. 241, fig. 5. However, he rightly deleted it from the supplement to his catalogue which he published in *Art in America*, XXIII, 1935, pp. 101ff. The copy is of interest because it indicates that the original may have had a dunescape background, which De Groot deleted in his mezzotint (Fig. 79). The schema of the landscape as well as the tower are analogous to those employed for the Lugano *Left-Handed Violinist* (Cat. no. 56; Plate 87).
 According to a note on the cover of *The Connoisseur*, March, 1961, repr., the painting entered an American collection early in the 1960's.

L 6. A Man Holding a Tankard and a Pipe (Figs. 80, 81). Engraved in mezzotint by Abraham Blooteling (1640–90); the print is inscribed: F. Hals Pinx. A. Blooteling F. et Ex. (Fig. 80).

The prominent parapet is an unusual device in Hals' *oeuvre*; perhaps it was over-emphasized by Blooteling. The engraver, not Hals, must be held responsible for the unconvincing corrugated folds of the jacket. The original may have been identical with 'Een tobacq drinker met een Kan van Hals, 12 florins' cited in an inventory made at Amsterdam in 1640 of the effects of the art dealer Johannes de Renialme (Bredius, I, p. 228, no. 7).

Two versions of the composition have been wrongly ascribed to Hals.
1. Location unknown (Fig. 81).
 Canvas, 60·4 × 48·9 cm.
 PROVENANCE: Sale, Baron de Beurnonville, Paris, 3 June 1884, no. 243; dealer Sedelmeyer, Catalogue, 1897, no. 9; sale, Fischhof-Blakeslee, New York, 9–10 March 1900, no. 126; dealer F. Kleinberger, Paris; M. de Werth, Paris; dealer Wildenstein, London and New York.
 EXHIBITIONS: Des Moines, Art Center, Master Painters, 1951, no. 4; Havana, Museo Nacional, Obras clasicas de la pintura europea, 1957, no. 10.
 BIBLIOGRAPHY: Bode 1883, no. 52; HdG 69 possibly identical with HdG 69b; Bode-Binder 50; KdK 66 (ca. 1627–30).
2. Bayonne, Museum (Cat. 1930, no. 964).
 Panel, 24 × 18·5 cm.
 PROVENANCE: Dealer E. Warneck, Paris; Léon Bonnat, Paris.
 BIBLIOGRAPHY: E. D[urand-Gréville], 'Le Fumeur, gravure de H. Bérengier, d'après Frans Hals', La Revue de l'art ancien et moderne, XXX, 1911, p. 194; Bode-Binder 51, repr. plate 20b; KdK 66, note (appears to be a copy.

L 7. **Woman Holding a Pipe (Malle Babbe ?)** (Fig. 82; text, Fig. 91; text, pp. 96, 145).

The only record of the lost painting is its appearance in Jan Steen's Baptismal Party (text, Fig. 93; Berlin-Dahlem, Staatliche Museen, Cat. 1966, no. 795 D), where it hangs as a companion picture to Hals' Peeckelhaering at Cassel (Cat. no. 64; Plate 102). Whether or not it was actually intended as the pendant to the Cassel picture is moot, but nothing about Steen's miniature copy suggests that the original was not a life-size, half-length painted by Hals.

L 8. **Johannes Bogardus** (Fig. 83; text, Fig. 10, text, p. 28). Engraved by Jan van de Velde (1593–1641). Inscribed: '. . . AETAT. LX. A° XVIᶜ XIIII . . . F. Hals. pinxit. I.v. Velde sculpt Anno 1628 . . .'; in the lower margin in a six-line verse by T. Schrevelius (Franken and van der Kellen, no. 4).

BIBLIOGRAPHY: Icon. Bat., no. 815; Moes 19; HdG 159; Bode-Binder 291; KdK 6 right.

Johannes Bogardus (Bogaert) was born in The Hague in 1554. After serving as a preacher in Bruges he was called to Haarlem in 1588; he died in Haarlem in 1614. The style of the portrait as well as the date of the model's death establishes 1614 as the probable terminus ante quem for the portrait. Its close relation to miniature portraits done by

Goltzius and De Gheyn (see text, Figs. 11, 12) suggests that the original may have been painted slightly before 1614.

L 9. **Arnold Möller** (Fig. 86). Engraved by Lucas Kilian (1579–1637). Inscribed: 'ARNOLD MÖLLER: NATUS A° M.D. LXXXI . . . Lucas/Kilian/Aug: /Sculpsit' and below the verse on the lower margin: 'Franz Hals Harlem: pinxit'.

BIBLIOGRAPHY: Moes 57; HdG 204; Bode-Binder 294; KdK 74.

The prolific Augsburg engraver Lucas Kilian, or someone in his shop, can be given credit for inventing the allegorical figures of 'Diligentia', 'Experientia', 'Orthographia', and 'Arithmetica', which accompany this print after Hals' lost portrait of the writing master. The two dates of 1629 inscribed on the tablet held by 'Arithmetica' provide a terminus ante quem for the portrait. Probably a small oil sketch served as the modello, and to judge from the print's similarity to Hals' little portraits done in the late twenties and early thirties (see Cat. nos. 47, 48, 76, L 10) the lost original was probably done around 1629.

L 10. **Willem van der Camer** (Fig. 84). Engraved by Jonas Suyderhoef; inscribed: F.H. Pins. 1630 I.S. sculp. 1651.

BIBLIOGRAPHY: Someren, vol. II, no. 947; Icon Bat., no. 1386; Moes 22; HdG 162; Bode-Binder 293; KdK 88.

Suyderhoef's engraving after this lost portrait dated 1630 has been published by Hals' catalloguers, but it was apparently unknown to Wussin and Hymans, who catalogued Suyderhoef's work (1862). Nothing has been discovered about the model.

L 11. **Pieter Christiaansz. Bor** (Fig. 85; text, Fig. 120; text, p. 125). Engraved by Adriaen Matham; inscribed: 'F. Hals pinxit A. Matham schulpsit . . . OVT LXXV JAER. M.D.C.XXXIIII'
Panel, 24 × 20·5 cm. Signed on the right with the monogram; inscribed on the oval: AEta. 75 Ano 1634.

PROVENANCE: At the Boymans Museum, Rotterdam, by 1849; one of 300 paintings burnt in the disastrous fire which destroyed the museum on 16 February 1864.
BIBLIOGRAPHY: W. Bürger, Musées de La Hollande, vol. II, Brussels-Ostend-Paris, 1860, pp. 199–200; Icon. Bat. no. 869-1; Moes 20; HdG 160; Bode-Binder 292; KdK 123.

Pieter Christiaanz Bor was born in Utrecht in 1559, settled in Haarlem as a notary in 1578, and died there in 1635. He was a prolific historian of the events of his time and made excellent use of contemporary documents and archival

material in his monumental study of the beginning and middle phases of the Dutch war against the Spanish: *Oorspronck, begin ende vervolgh der Nederlantsche oorlogen . . . ,* 6 vols., Leiden-Amsterdam, 1621-34.

Other copies and variants:
1. Engraved in reverse by Antony van Sylevelt (born *ca.* 1643-still active *ca.* 1687); Wurzbach no. 1, Hollstein, vol. VIII, p. 218, no. 77. Sylevelt included the simulated oval frame but eliminated the hand.
2. Aachen, Städtisches Suermondt Museum (Cat. 1932, no. 181). Copper, 29 × 24 cm. Signed at the lower right with the connected monogram: FH, and inscribed on the painted oval: AEta 75 An° 1633.
 PROVENANCE: B. Suermondt bequest.
 BIBLIOGRAPHY: Ernst Günther Grimme, *Aachener Kunstblätter*, Heft 28, *Das Suermondt-Museum, Eine Auswahl*, Aachen, 1968, pp. 258-259, no. 141, repr. (as Frans Hals).
 I do not accept the argument offered in the museum catalogue (1932) and repeated by Grimme (1968) that the painting is an original. In this variant the copyist has introduced a book resting on the painted oval.
3. Rotterdam, Museum Boymans-van Beuningen (Cat. 1902, no. 101).
 Panel, 24 × 20·5 cm. Signed at the lower right with the connected monogram FH, and inscribed on the painted frame: Aeta. 75 An° 1634.
 PROVENANCE: Presented by T. Humphrey Ward, 1895.
 BIBLIOGRAPHY: Museum Boymans, Catalogue, 1902, no. 107 (modern copy); HdG 160, note (copy). The copyist included a book resting on the simulated oval frame.
4. Sale, London (Sotheby) 7 July 1954, no. 41: canvas, 21·5 × 17·8 cm.; signed with the monogram at the lower right and catalogued as giving the model's age as 75 and dated 1634.
 PROVENANCE: Sale, Galerie Emil Goldschmidt of Frankfurt a. M., Berlin (Lepke), 27 April 1909, no. 32; Bernhard Koehler, Berlin.
 The copy does not include the book found in Cat. nos. L 11-2 and L 11-3.

Hofstede de Groot (160, note) also mentions a copy in the Paris art market, 1910 (copper 25·5 × 24 cm.) and another in the collection Counts E. and V. Bloudoff, St. Petersburg, 1910, signed with the monogram and without the painted oval.

L 12. **Caspar Sibelius** (Fig. 87; text, Fig. 122; text, p. 127). Engraved twice by Jonas Suyderhoef. In one print (text, Fig. 122; Wussin 79) the model faces left and holds a book in his left hand; this large print (29·7 × 22·8 cm.) is inscribed: AEtatis 48/a° 1637 . . . F. Hals Pinxit J. Suyderhoef Sculpsit. The other print (Wussin 80) is smaller (19·9 ×

12 cm.), reverses the portrait, and is inscribed: AEtatis 53 A° 1642 . . . F. Hals Pinxit J. Suyder-hoef Sculpsit. Wussin (80) notes that impressions of it bear a Latin text on the verso and suggests it was probably used to illustrate a book.

Caspar Sibelius (1590-1658) was a Deventer divine; in his autobiography (ms. at Deventer Municipal Library, no. 1716) he states that he preached there for about thirty years. Moes (1909, p. 52) notes that Hals' portrait was probably made during Sibelius' visit to the Haarlem area when his daughter married a preacher at Bloemendaal near Haarlem on 8 January 1637.

The small painting, which has been catalogued by earlier critics as the original which served as the modello for Suyderhoef's prints, was destroyed by fire in 1956, when it was in the possession of Billy Rose (see below). It shows the model in the same direction as he appears in Wussin 80. To judge from photos, it was either very badly abraded and clumsily restored or was a copy by another hand after one of Suyderhoef's prints. If the latter was the case, there is a chance that the original may be rediscovered some day. Data on the lost Rose version follow:

Panel, 26·2 × 22·5 cm. Inscribed at the right centre: AETAT SVAE 47/AN° 1637, and signed below the inscription with the connected monogram: FH. Above the head, the inscription: NATUS 1590/S M FUNCTUS 40. The inscription, which appears to have been largely restored, was not visible to Hofstede de Groot when he published the painting in 1910 (226). He wrote: 'Ich sah auf dem Bilde dunklere Flecke, die eine Signatur und Datum enthalten könnten. Jedoch hing das Gemälde für eine genauere Untersuchung zu hoch.'

PROVENANCE: according to HdG 226 in the collection Hendrick Gijselaar-Assendelft, Amsterdam, April, 1891; dealer Bourgeois, Paris; M. C. D. Borden, New York; sale, M. C. D. Borden, New York (American Art Association) 13-14 February 1913, no. 10; F. D. Stout, Chicago; dealer Knoedler, New York; sale, Frank D. Stout of Chicago, New York (Parke-Bernet) 3 December 1942, no. 25, repr.; Billy Rose, New York and Mt. Kisco; destroyed when the Rose residence at Mt. Kisco burned down 2 April 1956.
EXHIBITIONS: Paris, Palais du Corps Législatif, 1874; New York, Hudson-Fulton Celebration, 1909, no. 29; Haarlem 1937, no. 70.
BIBLIOGRAPHY: *Icon. Bat.*, no. 7176, 1 and 2; Moes 74; HdG 226; Bode-Binder 165, repr.; KdK 162, repr.; Valentiner 1936, 63, repr.

The 1942 Parke-Bernet sales catalogue reproduces a Dutch inscription on the back of the panel (in a late eighteenth- or nineteenth-century hand) which states that the painting was given to a 'doktor prof. Hoffman' by Sibelius. Hofstede de Groot (226) notes that a modern copy,

probably from the sale, Countess Reigersberg, Cologne, 15 October 1890, was long in the market.

A wash drawing by Jan Stolker (1724–85) after the bust of Hals' portrait of Sibelius, seen in an oval frame, is at the Rijksprentenkabinet, Amsterdam (inv. no. 48: 291). The copy shows the model facing left, as in Wussin 79, but it bears the age and date inscribed on Wussin 80, and is inscribed: F. Hals Pinxt: J. Stolker Del:. The recto is inscribed: door J. Stolker naar het Seltzamen orrigineel berustende in de bibliotheek der Remonstrantsche kerke te Amsterdam.

L 13. Theodore Blevet (Fig. 88; text, Fig. 124; text, pp. 121, 127). Engraved by Theodore Matham; inscribed AEtatis/XLII/1640 . . . F. Hals/Pinxit/T. [or J?] Mathan Sculpsit.

BIBLIOGRAPHY: *Icon. Bat.*, no. 713; Wurzbach, vol. I, p. 640, no. 32; Moes 18; HdG 156; Bode-Binder 290; KdK 188; Hollstein, vol. VIII, p. 216, no. 47 and vol. XI, p. 237, no. 37.

Wurzbach and Hollstein ascribed the print to the prolific printmaker Jacob Matham (1571–1631); apparently they read the first initial of the engraver's name inscribed on the print as a 'J'. Since the 1640 portrait was made nine years after Jacob Matham's death their attribution must be discarded. The other authors cited in the Bibliography above read the first initial as a 'T' and ascribed the print to Jacob's son Theodor (1605/6–1676). Their attribution is consistent with Theodor's existing graphic oeuvre, and until more is known about the prints made by the hazy Jan Matham (1600–48), another son of Jacob's, it seems reasonable to credit Theodor Matham with providing us with the only evidence of the untraceable painting.

Theodore (Dirck) Blevet (1598–1661), like so many calligraphers in seventeenth-century Holland, was also a French schoolmaster (for a discussion of the activities of the Dutch calligraphers of the period see B. P. J. Broos, 'The "O" of Rembrandt', *Simiolus*, IV, 1971, p. 151). On 3 April 1621 at Amsterdam he declared his intention to marry Sara van Breen, who was 32, nine years his senior; his marriage notice states he came from the French town of St. Jean-d'Angély (dept. Charente-Maritime); see *O.H.*, III, 1885, p. 70.

J. van Venetien has kindly given me the following unpublished information about Blevet. In 1626 he settled at Beverwijk, a town which lies about eight miles north of Haarlem. There he established a French boarding school. It appears that he and his wife settled in Haarlem several times. An inventory (Rijksarchief Noord-Holland, Notar. arch. no. 248, fol. 62 e.v.) made at Beverwijck in 1664 of his widow's effects lists: 'In de beste camer':

een schilderije van Sara Blevet
een dito van Mr. Blevet
een dito van sijn huijsvrouw

Sara Blevet was most probably the daughter of the couple who died at an early age.

The name of the artist who painted the portraits listed in the 1664 inventory is not cited—and of course it is possible that all three were not done by the same painter. But the possibility that two of the items refer to Hals' lost portrait of Blevet and to an untraceable pendant of his wife cannot be excluded. The *Portrait of a Woman* at Ghent (Cat. no. 136; Plate 210) is Hals' only half-length of a woman which is dated 1640, the year inscribed on the print of Blevet. But this formidable lady does not qualify as the schoolmaster's wife. She was 53 in 1640; Blevet's wife was 51 or 52 in 1640.

L 14. Thomas Wyck (Fig. 97). San Marino, California, The Huntington Library.
Pen and Wash, 17·8 × 12 cm. Inscribed: Thomas Van Wyke Painter/Father of John Wyke painter/G. V.

PROVENANCE: Acquired by the library in 1906.
BIBLIOGRAPHY: G. Vertue, *Notebooks*, Published by the Walpole Society, XXIV (Vertue IV), p. 45; Robert Raines, *Marcellus Laroon*, London, 1966, p. 56; Robert R. Wark, *Early British Drawings in the Huntington Collection*, San Marino, California 1969, p. 58, no. N.

Thomas Wyck (1616–77) was a Haarlem artist who painted genre and harbour scenes, Italianate landscapes, and views of London; for a list of the works which indicate that he probably travelled to London see Hilda F. Finberg, 'Canaletto in England', *Walpole Society*, IX, 1920–21, pp. 47–48.

George Vertue's (1684–1756) drawings of Wyck and thirteen other artists are in an extra-illustrated edition of Horace Walpole's *Anecdotes of Paintings . . . with additions by the Rev. James Dalloway . . .*, London, 1826, which is at the Huntington Library (Rare Book 83528). Wark, who first published the Huntington set (*op. cit.*, pp. 56–58, nos. B–P), notes that the drawings appear for the most part to be sources from which the related plates in the 1762 edition of the *Anecdotes* were engraved, and that other drawings from the same series are in the collection of Wilmarth Lewis.

The drawing of Wyck is in vol. III, facing p. 266, of the Huntington's extra-illustrated 1826 edition of the *Anecdotes*. It was engraved in reverse with a portrait of Jan Wyck by Alexander Bannerman (*ca.* 1730—still active *ca.* 1780) for the 1762 edition, vol. III, facing p. 133.

In his *Notebooks* George Vertue cites portraits of Thomas Wyck and his wife by Frans Hals in the possession of Marcellus Laroon the Younger (1679–1772): 'a picture painted of Thomas Wijck . . . & another of his Wife both painted by Frans Hals. and in pose$_s$ of Capt. Laroon' (*op.*

cit.). Robert Raines, to whom we are indebted for the only close study of Laroon's life and work, notes that the paintings do not appear in newspaper advertisements of the two sales of Laroon's pictures held in London in 1775; catalogues of these sales have not been discovered (*op. cit*.). Presumably the Hals portraits were sold before the sales, or perhaps they were not considered worth advertising in 1775. In any event, Vertue's drawing is the only known visual record of the lost painting; to judge from its style the original was done in the late forties or early fifties. Hals' portrait of Wyck's wife is lost or unidentifiable.

Johannes Verspronck (1597–1662) painted pictures which have been traditionally called portraits of Thomas Wyck and his wife. His so-called portrait of Wyck appeared in the sale, Nathan Katz, Paris (Charpentier), 7 December 1950, no. 69, repr. Except for the rather large mouth and heavy lips, Vertue's drawing of Wyck is not similar to Verspronck's presumed portrait of him. The pendant was exhibited in the Dutch exhibition at the Royal Academy 1952–53, no. 326 as a 'Portrait of a Woman', dated 1641, collection Mrs. Stephenson R. Clark (repr. in *B.M.*, II, 1903, p. 53); it appeared in the sale, Anon., London (Christie), 29 June 1973, no. 73, repr.: 76·8 × 57·1 cm. (once an oval). For other portraits of Wyck, see Van Hall, 2426.

L 15. **Self-Portrait** (Figs. 91–96; text, Figs. 2, 164; text, pp. 12, 13–14, 163, 193).

The numerous versions of the small painting are most likely based on a lost portrait done in the late forties. The old tradition that the original was a self-portrait is supported by its resemblance to the portrait Hals painted of himself in his large militia piece of 1639 (Cat. no. 124; Plate 201; text, Fig. 1), and the many old copies of it. To the best of our knowledge it was Hals' only independent portrayal of himself. The Text Volume states (p. 163) that the earliest dated reference to it as a self-portrait is Cornelis van Noorde's *Apotheosis of Frans Hals*, which includes a copy of the painting inscribed 'ipse pinxit' and is dated 1754 (text, Fig. 164). Subsequent investigation has revealed that there is an earlier reference to it as a self-portrait. It is found in a 1722 inventory reference to a painted version of it which was formerly in the Dresden Gallery (Cat. no. L 15-2). Van Noorde also made a reversed mezzotint of it inscribed: ipse Pinxit, CV Noorde fe 1767 (Fig. 93; Hollstein, vol. VIII, p. 217, no. 52). The portrait does not bear a striking resemblance to the engraving of the artist which Houbraken included in his *Groote Schouburg* published in 1718, vol. I, facing p. 91 (text, Fig. 206); this led Hofstede de Groot (148) and Bode-Binder (217) to doubt that it is a portrait of the artist. However, Houbraken's engravers did not always produce faithful reproductions of their subjects. They had a tendency to endow their seventeenth-century models with eighteenth-century chic (see text, p. 193).

Two old woodcuts after the painting, which have Hals' name cut into their blocks, also support its traditional identification as a self-portrait. One of them, which is rather crudely cut and reverses the painting (Fig. 91), has been ascribed to Isaac van der Vinne (1665–1740) by Karel Boon. Another state of the print, in a rectangular format and without the ornamental border, is at the Haarlem Municipal Archives, where it is erroneously attributed to Salomon de Bray (1597–1664). The print has also been attributed to Salomon's son Dirk de Bray (active after 1650); see Frans Hals Museum, *Catalogue of the Pictures . . .*, 1929, p. 65, no. 133. The rather coarse print may very well have been copied from the second existing woodcut after the portrait (Fig. 92); its style suggests that it antedates Isaac van der Vinne's woodcut. Karel Boon has informed me that it has been tentatively suggested that it was made by Cornelis van den Berg (1699–1775), a Haarlem dilettante who made prints in the manner of earlier woodcutters, but in his opinion, until more is known about Van den Berg's efforts as a graphic artist, it seems reasonable to withhold Van den Berg's name and provisionally maintain that it was made by an anonymous printmaker before Van den Berg appeared on the scene.

At one time or another most of the many known versions of the portrait have been called authentic works by the master. In my opinion all of them are copies or variants after the lost original.

Copies and variants:
1. Indianapolis, The Clowes Fund, Inc. (Fig. 94; text, Fig. 2).
 Panel, 33 × 28 cm. Inscribed in the lower right corner: 147.
 PROVENANCE: This version and our Cat. no. L 15-2 were both in the Dresden Gallery. Its history was confused with Cat. no. L 15-2 by Valentiner when he published the picture (1935, pp. 85*ff*), and it has been erroneously given in subsequent published references to it. As the number inscribed on the painting indicates it was listed in the 1722 inventory of the Dresden Gemäldegalerie as no. A 147; presumably sold from the depot of the Dresden Gallery. According to a note written by Hofstede de Groot in March, 1912 (RKD files), it was in the collection Crouan, and Hofstede de Groot added that he examined the painting in Paris in 1912 at the request of Brunner at the home of the latter's son-in-law Mr. Lagotellerie, Rue Varenne, Paris; he also noted that the painting is not an original. Dealer Silberman Galleries, New York; H. Klaus, Minneapolis; Dr. G. H. A. Clowes, Indianapolis.
 EXHIBITIONS: Detroit 1935, no. 49 (*ca.* 1655–60); Indianapolis 1937, no. 20; Haarlem 1937, no. 98; New York 1939, no. 188; Los Angeles 1947, no. 19; Raleigh 1949, no. 67; Haarlem 1962, no. 58.
 BIBLIOGRAPHY: Valentiner 1935, pp. 86*ff*., 102, no. 20 (wrong provenance; original, not much later than 1645); Valentiner 1936, 88 (wrong provenance;

original, *ca.* 1648–50); L. Goldscheider, *Fünfhundert Selbstporträts*, Vienna, 1936, no. 162; K. G. Boon, *Het Zelfportret in de Nederlandsche en Vlaamsche Schilderkunst*, Amsterdam, 1947, pp. 41–42, fig. 23; Van Hall no. 820–9.

Slightly abraded; dark areas in the face, hair and torso have been retouched. Although the copyist's brush misses Hals' vivacious touch, it is the best of the known versions and probably reflects something of the intense expression of the original.

2. Germany, Private Collection (Fig. 95).
Panel, 34 × 25 cm. Inscribed at the lower right corner: 191
PROVENANCE: Gemäldegalerie, Dresden, 1722, inventory no. 191 (as an authentic self-portrait of Frans Hals; see Dresden Catalogue, 1887, p. 434, no. 1366). According to the Dresden Catalogue, 1862, no. 940, it was acquired by Raschke, and put on public view in 1861 (*ibid.*). It is found listed in the gallery's numerous catalogues from 1862 until 1920 (see Bibliography below). Presumably sold by the gallery in 1937. Walter Franke of Baden-Baden, who sold the painting to its present owner, informed me that his father purchased it in 1946.
BIBLIOGRAPHY: Dresden catalogues 1862, 1867, 1868, 1870, 1872, 1876, no. 940 (Frans Hals, *Portrait of a Man*); Dresden catalogues 1880, 1884, no. 1022 (Frans Hals, *Portrait of a Man*); Bode 1883, p. 87, note 1 (good copy of our Cat. no. 15-3; perhaps by one of Frans Hals' sons). In the Dresden catalogues published from 1887 until 1920 it is no. 1360, and listed as a copy after Frans Hals. HdG 148-1 (*ca.* 1650; good copy of our Cat. no. L 15-3); KdK 1923, p. 305 (replica; hardly original).

3. New York, The Metropolitan Museum of Art (Cat. 1954, inv. no. 32.100.8; Fig. 96).
Panel, 32·4 × 28 cm.
PROVENANCE: Dealer E. Warneck, Paris; L. Goldschmidt, Paris; Jules Porgès, Paris; M. Friedsam, New York, who gave it to the museum in 1931.
EXHIBITIONS: The Hague 1903, no. 34.
BIBLIOGRAPHY: Bode 1883, 77 (as a portrait of a young man; *ca.* 1650); Moes 38 (original); HdG 148 (original, but doubtful if it is a self-portrait; *ca.* 1650); Bode-Binder 217 (so-called self-portrait); KdK frontispiece and p. 305 (*ca.* 1650; original); Valentiner 1925, p. 153 (*ca.* 1650; self-portrait?); Bryson Burroughs, 'The Michael Friedsam Collection', *Bulletin, Metropolitan Museum of Art*, XXVII, 1932, no. 2, pp. 48–49 (*ca.* 1650; self-portrait?); Valentiner 1935, pp. 89–90 (copy; the original is our Cat. L 15-1); Metropolitan Museum Catalogue, 1954, p. 46, no. 32.100.8 (Frans Hals); Van Hall no. 820–9a.
Slightly abraded; the scattered losses which have been retouched have darkened. Until Cat. no. L 15-1 reappeared around 1935, most critics considered this

version the original. The sitter's black cloak is in a better state of preservation than the one seen in the Clowes version and probably gives a good suggestion of the highlights which enlivened the original.

4. New York, formerly Mrs. Charles H. Senff.
Panel, 31·7 × 25·4 cm.
PROVENANCE: Sale, T. Humphrey Ward, London (Christie) 11 June 1926, no. 6.
BIBLIOGRAPHY: Bode-Binder 218, repr. fig. 139C; KdK 1923, p. 305 (replica; hardly original).

5. Haarlem, Frans Hals Museum (Cat. 1929, no. 133).
Circular panel, diameter 17 cm.
PROVENANCE: Sale, A. van der Willigen of Haarlem, The Hague, 23 February 1875, no. 13; sale, The Hague, 31 January 1877, no. 20; sale, The Hague, 27 March 1879, no. 54; P. C. Nahuys (née F. M. Hodgson) and C. F. Royer (née Kerst) and others, Amsterdam, 14 November 1883, no. 62; given to the museum by A. J. Enschedé, Haarlem, in 1883.
BIBLIOGRAPHY: *Icon. Bat.*, no. 3139-3; HdG 148-3 (copy); Bode-Binder 219, repr. fig. 139a (so-called self-portrait); KdK 1923, p. 305 (replica; hardly original); Frans Hals Museum, Catalogue, 1929, no. 133 (copy after Frans Hals); Van Hall no. 820–9c.

6. Helsinki, Paul and Fanny Sinebrychoff Collection (Cat. 1936, no. 9).
Panel, 34 × 28 cm.
PROVENANCE: Dealer Heinemann, Munich; dealer Ricard, Frankfurt; dealer Kirchheim, Paris; sale, H. J. A. Eyre and others, London, 9 December 1905, no. 121 (£294, Banley). According to KdK 1923, p. 305 it was subsequently with Nardus, Suresnes and J. P. Widener, Elkins Park, Pennsylvania. Anne Lindrom, Director of the Art Gallery of Ateneum, Helsinki, has informed me that an earlier owner was Mr. Kirchner and the painting was purchased for the collection Sinebrychoff from Jac. Hecht, Hamburg.
EXHIBITION: The Hague, 1903, no. 34a.
BIBLIOGRAPHY: HdG 148-2 (copied from our Cat. no. L 15-3 when it was covered with a thick yellow varnish); KdK 1923, p. 305 (replica; hardly original); *Paul och Fanny Sinebrychoff Konstsamlingar Katalog*, 1936, p. 6, no. 9 (Frans Hals); Van Hall no. 820–9b.

7. Denver, Colorado, Denver Art Museum.
Panel, 27 × 23 cm. Signed at the left centre with the connected monogram: FH.
PROVENANCE: Given to the museum by Horace Havemeyer of New York in 1934.
BIBLIOGRAPHY: Trivas App. 7, repr. Pl. 158 (variant).

8. Sale, Brussels, 14 December 1927, no. 59, repr.; sale, Lucerne, 23–25 August 1928, no. 308, repr.: panel, 25 × 19 cm. This weak version is bust length.

Drawings after the portrait are at the Kupferstichkabinett, Berlin-Dahlem (no. 2505), and at Teylers Museum, Haarlem (attributed to one of the Van de Vinnes).

The earliest reference to a painting which can be interpreted as a self-portrait by Hals is found in Jan van de Cappelle's 1680 inventory: no. 132. Het Conterfeytsel van Frans Hals. Van de Cappelle also had a portrait by Hals of his wife: no. 76. Een vrouwetrony van Frans Hals, sijnde sijn vrouw. These unidentifiable portraits are listed in the ms. of the 4 January 1680 inventory at the Amsterdam Archives NAA no. 2262B, pp. 1189, 1192; also see *O.H.*, x, 1892, pp. 34–35.

Small self-portraits which may be identical with some of the versions cited above are listed in many eighteenth- and nineteenth-century sales catalogues; copies of the popular painting continue to appear with tedious regularity in sale rooms in our time.

L 16. **Jacobus Revius** (Fig. 89; text, Fig. 211; text, pp. 197–198). Engraved by Jonas Suyderhoef (*ca.* 1613–86). The first state is erroneously inscribed: A. V. Dyk. Pinsit./J. Suyderhoef Sculp. (text, Fig. 211). In the second state Van Dyck's name has been removed and the credit line reads: F. Hals Pinsit (Wussin 71).

BIBLIOGRAPHY: *Icon. Bat.* no. 6373-1; Moes 65; HdG 217; Bode-Binder 295; KdK 252 (*ca.* 1650).

Jacobus Revius (Reefsen) was born in Deventer in 1586 and died in Leiden in 1658. He was a militant Calvinist theologian, historian and poet. His *Daventriae Illustrate . . .*, Leiden, 1651 is a standard history of Deventer; his *Over-IJsselsche Sangen en Dichten*, Deventer, 1630, and Dutch translations of the psalms show his gift as a lyric poet. For a representative anthology of his verse see Henrietta Ten Harmsel, *Jacob Revius: Dutch Metaphysical Poet, a parallel Dutch-English edition*, Detroit, 1968. Daniel Heinsius (1580–1655), Revius' friend and one of the outstanding poets of Holland's heroic age of literature, is the author of the six-line Latin verse inscribed in the lower margin of Suyderhoef's print.

The style suggests a date of around 1650–55 for the lost portrait; Hals used a similar pose for his untraceable portrait of Wickenburg (Cat. no. L 17; text, Fig. 209) and for the *Portrait of a Man* now at Washington (Cat. no. 198; Plate 310). The broader handling and costume of the latter picture place it a few years later than the portrait of Revius. An impression of a crude, anonymous engraving of the portrait, most likely done after Suyderhoef's print, is at the Haarlem Municipal Archives (V.S. VIII, no. 71). It reduces the half-length to a bust portrait in an oval frame crowned and wreathed with laurel, and flanked by two poorly drawn trumpeting putti. This copy reverses Suyderhoef's print.

L 17. **Theodor Wickenburg** (Fig. 90; text, Fig. 209; text, p. 197). Engraved by Jonas Suyderhoef (*ca.* 1613–86); inscribed: F. Hals pinsit I. Suyderhoef sculp. (Wussin 97).

Wickenburg (died 1655) was a Haarlem preacher. To judge from the style of the print the original was done in the first half of the fifties; Wickenburg's death in 1655 most likely provides a *terminus ante quem* for the portrait. The model's pose with his hand across his chest and the tips of his fingers tucked under his cloak is similar to the one Hals used for his portrait of Revius (Cat. no. L 16) and his more informal *Portrait of a Man* at Washington (Cat. no. 198; Plate 310). In the older literature a small portrait, which was in the collection Josef Block, Berlin, in 1928, was accepted as the original modello for Suyderhoef's engraving. The sketch, which is now untraceable, was done in oil on paper. Photographs of it which I have examined do not suggest that it was painted by Hals, but final judgement must be reserved until it reappears. If it is authentic it will earn the distinction of being Hals' only existing original done on paper. It should be added that its unusual support does not rule out an attribution to Hals. Like other seventeenth-century artists—most notably Rembrandt, Van Goyen, and his brother Dirck—Frans Hals may have occasionally sketched in oil on paper. These works are conspicuously rare today because with age paper becomes a brittle support for oil paint. If Hals made any they may have simply disintegrated. The Block portrait reverses Suyderhoef's engraving. Data on it follow:

Paper mounted on canvas, 32 × 26 cm.
PROVENANCE: Berthold Richter, Berlin; Josef Block, Berlin, 1928.
EXHIBITIONS: Berlin 1890, no. 80; Berlin 1906, no. 54; Berlin, Ausstellung Josef Block, 1928, no. 10; Berlin, Ausstellung dealer Schäffer, 1932, no. 47.
BIBLIOGRAPHY: *Icon. Bat.*, no. 9036; Moes 85; HdG 244; Bode-Binder 267, repr. plate 174a; KdK 270, repr. (*ca.* 1654).

A weaker version, which also reverses Suyderhoef's print, was in the collection D. H. Cevat, London, in 1959: oval canvas mounted on panel, 29·5 × 23·8 cm. Four corners have been added to the canvas by a later hand to give the work a rectangular format; the corners have been coarsely painted to simulate an oval frame.

L 18. **Jacob van Campen** (Fig. 98; text, Figs. 198, 199; text, pp. 188–189). Amiens, Musée de Picardie (on loan to the Museum at Doullens near Amiens).
Panel, 58 × 45 cm.

PROVENANCE: Olympe and Ernst Lavalard, Paris; bequeathed by the Lavalard brothers to the museum.
BIBLIOGRAPHY: Amiens, Musée de Picardie, Cat. 1899, p. 199, no. 97: ('Portrait of a Man' by Frans Hals the Younger); HdG 250 ('Portrait of a Man'; ascribed to Frans Hals the Younger, but good enough to be the father's work); Bode-Binder 283 ('Portrait of a Man' by Frans Hals); C. Hofstede de Groot, 'Een portret van Jacob Campen door Frans Hals', *O.H.*, XXXIII, 1915, pp. 16–18;

'Jacob van Campen' by Frans Hals); KdK 277 ('Jacob van Campen' by Frans Hals; *ca.* 1657); P. T. A. Swillens, *Jacob van Campen*, 1961, p. 257 ('Jacob van Campen' by Frans Hals); Van Hall, nos. 347-3.

Jacob van Campen (1595–1657) was a Haarlem-born painter and architect. His designs for houses for the Coymans brothers (see Cat. no. 160) and Constantin Huygens, for the Amsterdam theatre, for the Mauritshuis at The Hague, and above all for the new Town Hall at Amsterdam establish his reputation as the leading representative of the classical phase of Dutch Baroque architecture.

The painting at Amiens (text, Fig. 198) was catalogued as a 'Portrait of a Man' by Frans Hals the Younger until Hofstede de Groot (250) suggested that it was good enough to be the father's work. I do not find either attribution acceptable. Not enough is known about Frans the Younger's work to even accept a tentative attribution to him (see Cat. no. 155) and the resemblance of its technique to Hals' originals is only superficial. In my opinion it is probably a cropped copy by an anonymous follower after a lost original done in the mid-fifties. However, Hofstede de Groot's observation (*op. cit.*, 1915) that the portrait bears an unmistakable resemblance to an engraved portrait of Jacob van Campen (text, Fig. 199) securely identifies the model, and as noted in the text (pp. 188–189), the close analogies between the Amiens portrait and the reversed print indicate that the print was either based upon the copyist's work or both were derived from an untraceable original. The unsigned engraving, which can be tentatively ascribed to Abraham Lutma II (active *ca.* 1650; Hollstein, vol. XI, p. 108, no. 1), appears as the frontispiece of *Afbeelding van't Stadt Huys van Amsterdam, in dartigh coopere plaaten, geordineert door Jacob van Campen en geteeckent door Iacob Vennekool*, Amsterdam, 1661 (text, Fig. 199), a volume of engravings of Van Campen's designs for his masterpiece, the Town Hall of Amsterdam (see Katherine Freemantle, *The Baroque Town Hall of Amsterdam*, Utrecht, 1959, p. 202).

A signed black chalk drawing by Warnaar Horstink (1756–1815) dated 1798 done after the Amiens portrait before it (or the lost original?) was cut is at the Haarlem Municipal Archives, P.V. II, 45 (Fig. 98). An inscription on the verso supports the attribution to Hals, the identification of the sitter as Jacob van Campen, and states that the drawing was made from the painting which was at Van Campen's estate at Randenbroeck near Amersfoort ('na 't schildery van F. Hals op de Buytenplaats Randenbroek bij Amersfoort door v. Kampen aangelegd, dese plaats behoord toen aan den Heer de Bruin te Haarlem').

There is also a print of the portrait by Reinier Vinkeles (1741–1816), in the same direction as the painting and framed in a wreathed border.

A drawing that reverses the engraving but is closely related to it is at the Rijksprentenkabinet, inv. no. 481. In it the model wears a hat and more of the figure is seen, and it has been embellished with a drape, architectural elements and a distant view of the new Town Hall. The sheet is signed on the right with Jan Lievens' monogram IL; it appeared in eighteenth- and nineteenth-century sales as a work by Lievens. According to Hofstede de Groot (*op. cit.*, 1915, repr. facing p. 18) it is an eighteenth-century forgery based on Hals' painting and the print. H. Schneider (Jan Lievens, Haarlem, 1932, p. 249, Z II, with provenance) rejected it as an original Lievens. M. D. Henkel (*Catalogus ... Rijksmuseum*, vol. I, *Teekeningen van Rembrandt en zijn School*, The Hague, 1943, p. 93, no. 12, repr. Pl. 164) also rejected it as an original Lievens but suggested that it may be a copy after a lost Lievens based on the work of another artist. Henkel notes (*ibid.*) that Van Regteren Altena accepts the old attribution to Lievens. In my opinion the drawing is by an anonymous copyist who based his effort on elements of the painting and the engraving.

L 19. **Portrait of a Woman, possibly Maria van Teylingen, wife of Theodorus Schrevelius** (Fig. 99). Dublin, James A. Murnaghan.
Oval panel, 14.5 × 10 cm.

The companion picture to this painting by an unidentifiable hand, which is also in the Murnaghan collection, is a copy of Hals' 1617 portrait of Theodorus Schrevelius (Cat. no. 8; Plate 23). This suggests that Hals' 1617 portrait originally had a pendant and Cat. no. L 19 is a copy of it. If it is a replica after the lost Hals it is evident that the copyist either did not succeed or did not make a major effort to imitate Hals' distinctive brushwork. His copy of Schrevelius tells the same story.

Schrevelius married Maria van Teylingen (1570–1652) at Alkmaar 25 July 1599. Cat. no. 51 (Plate 76) has also been called a portrait of Schrevelius' wife, but the two pictures seem to show different women.

L 20. **Portrait of a Woman** (Fig. 100). Haarlem, Frans Hals Museum.
Black chalk on parchment, 31 × 25 cm. Signed and dated: J. G. Waldorp del/1779, with the first three letters ligated. Inscribed above the signature with the connected monogram: FH pinx/1644.

PROVENANCE: Possibly sale, H. van Eyl Sluyter, Amsterdam 26 September 1814, Kbk p. no. 2: 'Twee stuks een Mans- en een Vrouwepourtret, beider halverlijf zittende. Meesterlijk met zwart krijt geteekend, naar F. Hals, door J. G. Waldorp; possibly sale, G. van der Pals, Rotterdam, 1 April 1840, Kbk I, no. 28: Een Vrouweportret, met zwarte krijt, alleruitvoerigst, door J. G. Waldorp, naar F. Hals. No. 29, the following lot in the 1840 sale, probably refers to Waldorp's copy of the lost painting's presumed

pendant: Een Mansportret; als voren, door en naar denzelven. Presented to the museum with Waldorp's copy of Cat. no. 155 by Paul Brandt, Amsterdam, 1954.
BIBLIOGRAPHY: Bode-Binder 243 (copy after a lost original; pendant of our Cat. no. 155); KdK 213 (copy after a lost original; pendant of our Cat. no. 155).

Although the drawing cannot be ranked with Jan Gerard Waldorp's (1740–1809) most successful copies of Hals' works it probably reflects a lost original. The only justification I can find to support the claim, first put forward by Bode-Binder and repeated by Valentiner, that it is a copy of the lost companion picture to the portrait of a *Seated Man Holding a Branch* at Ottawa (Cat. no. 155; Plate 236) is the possibility that a copy by Waldorp of the latter picture, which is also at the Frans Hals Museum, appeared with it in some nineteenth-century sales (see Provenance above). The considerable difference in the scale of the figures and the absence of a correspondence in their poses as well as the fact that Waldorp did not make his copies at the same time (the copy of the man is dated 1778, the copy after the woman's portrait 1779) indicate the originals were not pendants.

For other copies by or attributed to Waldorp after Hals' paintings, see Cat. nos. 102, 146, 147, 185. I. Q. van Regteren Altena has recognized that a carefully finished drawing of a *Seated Old Woman Holding a Book* formerly attributed to Cornelis Visscher (1629–58) is by Waldorp: Groninger Museum voor Stad en Lande, black chalk on parchment, 31·6×25·2 cm. (*cf.* J. Bolten, *Dutch Drawings from the Collection of Dr. C. Hofstede de Groot*, Utrecht,

1967, pp. 131–132, repr.). For reference to a drawing by Waldorp's contemporary Cornelis van Noorde done in Visscher's style, see Cat. no. 20. The Groningen drawing recalls Hals' three-quarter length portraits of elderly women (*cf.* Cat. nos. 78, 82, 107, 129, 150) and possibly is yet another copy by Waldorp after a lost painting by Hals. However, Hals did not have a monopoly on this conventional portrait scheme. It was used by Rembrandt, Bol and other portraitists of the period. Perhaps the drawing was copied after a lost painting by another artist. Bolten (*ibid.*) suggested yet another possibility: the drawing may have been Waldorp's invention done in the manner of his great seventeenth-century predecessors. He notes that the absence of an inscription stating that it is a copy lends support to his supposition. But was this Waldorp's invariable practice? If the suggestion offered here that he made the copy of the Vienna *Portrait of a Woman* is correct (see Cat. no. 185, Fig. 43), he did not always provide this information.

Two eighteenth-century drawings by an unknown hand after three-quarter lengths of a man and woman at Berlin-Dahlem, Kupferstich kabinett (brush and ink on blue paper, each 43×29·8 cm.) have been called copies after lost pendants by Hals (KdK 193 left and right; E. Bock and J. Rosenberg, *Die niederländischen Meister, Beschreibendes Verzeichnis . . .*, Berlin, 1930, p. 149, nos. 11959, 11960). Both appear to have been made after untraceable portraits done *ca.* 1640–43, and could conceivably have been drawn after lost originals by Hals, but the possibility that they were done after portraits by another Dutch artist active in the early 1640's cannot be excluded.

DOUBTFUL AND WRONGLY
ATTRIBUTED PAINTINGS

D 1. Laughing Child
Versions:

1. Detroit, The Detroit Institute of Arts (acc. no. 48.383). Fig. 101.
 Panel, 33·5×31·5 cm.
 PROVENANCE: E. Warneck, Paris, sale, Warneck, Paris (Petit), 27–28 May 1926, no. 47; dealer Howard Young, New York, 1928; Mr. and Mrs. William A. Fisher, who gave it to the Museum in 1948.
 EXHIBITIONS: Amsterdam, Rembrandt Exhibition F. Muller and Co., 1906, no. 58.
 BIBLIOGRAPHY: Bode 1883, 78 (unfinished); Moes 246; HdG 20; Bode-Binder 33; KdK 33 right (*ca.* 1623–25); A. M. Frankfurter, 'Paintings by Frans Hals in the United States', *The Antiquarian*, VIII, 1929, no. 2, p. 86; E. P. Richardson, 'Frans Hals' "Laughing Boy"', *Bulletin, Detroit Institute of Arts*, XXIX, 1949–1950, pp. 12–14.
 The lower quarter of the painting (a strip about 8 cm. wide) is the work of a later hand; the rest of the painted surface is moderately abraded.

2. Helsinki, Paul and Fanny Sinebrychoff Collection (Fig. 102).
 Circular panel, diameter 32·5 cm.
 PROVENANCE: Inscribed on the verso: 'Voor mijn Neef/F. Walter Adv./Tongelaar 17 Aug/1874'; Pelzer, Cologne; dealer K. A. Stauff, Cologne; dealer Muller and Co.; acquired by Paul Sinebrychoff in 1909.
 BIBLIOGRAPHY: Moes 243, identical with Moes 242a; HdG 19; *Paul och Fanny Sinebrychoffs Konstsamlingar, Katalog.* 1936, p. 6, no. 10.
 Moderately abraded throughout. This tondo and the variant in Detroit, which shows the child in a painted circular frame, may have been based on a lost original done in the early twenties or they may have been painted by followers who attempted to emulate the oil sketches Hals made of children during this period, *e.g.*, the tondo of a *Laughing Boy* at The Hague (Cat. 29; Plate 49).

3. Philadelphia, formerly George W. Elkins.
 Panel, 33×32 cm.
 BIBLIOGRAPHY: Moes 248; HdG 21; Bode-Binder 35, repr. plate 14c.
 More coarsely painted than the Detroit and Helsinki versions. The author of this variant adopted a square format and dispensed with the painted oval.

D 2. Laughing Boy (Fig. 103). Baltimore, The Baltimore Museum of Art.
Panel, 26·5×19 cm.

PROVENANCE: Sale, Carl Gossmann, Cologne (J. M. Heberle), 26–27 November, 1906, no. 28; Clara Herrlich, Coburg; dealer Eugene Fischof, Paris, who sold it in 1910 for $12,000 to Mrs. Henry Barton Jacobs, Baltimore; Mary Frick Jacobs, Baltimore, who bequeathed it to the museum in 1938.
EXHIBITIONS: Haarlem 1937, no. 15; Baltimore, Museum of Art, *A Century of Baltimore Collecting: 1840–1940*, 1941, p. 61.
BIBLIOGRAPHY: Sedelmeyer Gallery. Catalogue, 1911, no. 12; Bode-Binder 40; KdK 35 (*ca.* 1623–25; hardly authentic); *The Collection of Mary Frick Jacobs*, Baltimore, 1938, no. 52.

Valentiner (KdK 35) rightly noted that the painting is not as free and spirited in execution as Hals' other studies of children. The uniformly broad brushwork indicates it was done by an imitator; an analysis of the white pigment made in 1957 by Miss Elizabeth H. Jones, Chief Conservator at the Fogg Art Museum, indicates that he probably worked in the nineteenth century. An analysis of samples taken from the touches of white at the sleeve in the lower left corner and at the collar demonstrated that both are zinc white, a pigment which was first suggested as a substitute for lead white in 1782, and was commercially available about fifty years later (see Rutherford J. Gettens and George L. Stout, *Painting Materials*, New York 1942, p. 177, and *Technical Studies in the Field of the Fine Arts*, IV, 1936, pp. 222*f*). Since it is clear that the touches of white are not later additions upon the panel, their composition bolsters the conclusion that the work is a late imitation done in Hals' style.
A crude version of the painting is (or was) in Ecole Municipale de Dessin de Saint-Nazaire-sur-Loire.

D 3. Laughing Boy (Fig. 104). Paris, Musée Jacquemart-André (Cat. no. 422).
Panel, 48×29 cm. Signed at the lower right with the connected monogram: FH, and dated 1636.

PROVENANCE: Madame André-Jacquemart, who bequeathed it to the Institut de France in 1912.

BIBLIOGRAPHY: HdG 99 (Frans Hals); Musée Jacquemart-André, Catalogue, n.d., p. 36, no. 422 (attributed to Judith Leyster).

A weak copy after a painting at Hampton Court, panel, 49·5×38·6 cm., bought by George III in 1762 (Fig. 105). Juliane Harms attributed the Hampton Court picture to Judith Leyster (*O.H.*, XLIV, 1927, pp. 120, 235, no. 8), but in my opinion it was correctly catalogued as a work by Jan Miense Molenaer in C. H. Collins Baker *Catalogue of the Pictures at Hampton Court* [1929] p. 106, no. 682, and exhibited as a painting by Molenaer in the London exhibition of the King's Pictures, 1946, no. 346. The Hampton Court picture is closely related to Molenaer's signed *Man with an Empty Glass*, Städelsches Kunstinstitut, Frankfurt (no. 221) and his signed and dated 16[3?]4, *Taste* at Brussels (no. 313). Another copy of the Hampton Court Molenaer is in the collection of George St. Tsirmonis, Athens; a third one appeared in the sale, London (Christie) 4 May 1962, no. 20.

D 4. Laughing Child with a Flute
Versions:

1. Washington, D.C., formerly Dwight W. Davis (Fig. 106).
 Circular panel, diameter 28 cm.
 PROVENANCE: Jules Porgès, Paris; Dwight W. Davis, St. Louis and Washington, D.C.
 BIBLIOGRAPHY: Moes 245; HdG 31B; Bode-Binder 17; KdK 30 left; Valentiner 1936, 7.
 Erroneously called a pendant to the *Laughing Boy* in the Cohn Collection (Cat. no. 28; Plate 51) by Hofstede de Groot (31B) and Valentiner (KdK 30 left; 1936, no. 7) The schema used for the boy's head as well as the light grey background vaguely recalls Hals' *Drinking Boy* at Schwerin (Cat. no. 58; Plate 91) but neither the brushwork nor the awkward drawing in this or other variants of the composition can be attributed to him.
2. Glasgow, Art Gallery (Cat. 1961, no. 717) (Fig. 107).
 Circular panel, diameter 29·2 cm.
 PROVENANCE: Sale, Fountaine, London, 7 July 1894, no. 27; (Lawrie and Co.); purchased by the gallery in 1894.
 EXHIBITIONS: London 1929, no. 69; Manchester 1929, no. 48; Haarlem 1937, no. 18; Bristol 1946, no. 6; Amsterdam, Stedelijk Museum, 'Vals of Echt?', 1952, no. 68 (as a fake).
 BIBLIOGRAPHY: Moes 232; HdG 27; Bode-Binder 18; KdK 32 right (reproduced in reverse; ca. 1623–1625); *Dutch and Flemish . . . Paintings*, Glasgow Art Gallery, 1961, no. 717 (imitator of Frans Hals).
 The painting appeared as a pendant of the *Boy with a Dog* (Cat. no. D 8-1), which is at the same gallery,

in the 1894 Fountaine sale. The tradition that the pair belongs together can be traced back to 1801, when Thomas Gaugain (*ca.* 1748–1810) engraved both subjects (Gaugain's engraving of Cat. no. D 8-1 does not include the dog or the boy's hand). Both works are now catalogued at Glasgow as paintings by an imitator of Hals. In our time I do not believe that any student of the artist's work would question the gallery's attribution; however, the serious charge that the pendants are fakes (Exhibition Catalogue, Amsterdam, 1952, nos. 5, 6) cannot be accepted until the intent of the artist who made them has been established. Possibly they were done in Hals' manner by an innocent artist who had no intention of passing them off as originals. A technical examination made at the Courtauld Institute in 1955 (on file at the Glasgow Gallery) establishes that there is no anachronism in the structure of the paintings or their pigments (black, ochre, vermilion, madder [or similar transparent lake], and azurite or verditer). Valentiner (KdK 32 right) reproduced the painting in reverse and incorrectly states that our Cat. no. D 4-1 is an authentic replica which reverses the Glasgow composition. A red chalk drawing (12·3 × 9·8 cm.), apparently done after the Glasgow variant, was in the collection J. K. Thannhauser, New York.

3. Paris, Jean Stern
 Circular panel, diameter 22·5 cm.
 PROVENANCE: Ernesta Stern, Paris; Jean Stern, Paris.
 BIBLIOGRAPHY: Bode-Binder 19, repr. plate 10a; KdK 32 right, note (authentic replica which is less free in execution).

D 5. Boy with a Flute
Versions:

1. Cincinnati, Mrs. E. W. Edwards (Fig. 108).
 Circular panel, diameter 29·5 cm. Signed at the right with the connected monogram: FH.
 PROVENANCE: Baron Albert von Oppenheim, Cologne; sale, Albert von Oppenheim, Berlin (Lepke), 19 March 1918, no. 15; art market, New York; E. W. Edwards, Cincinnati.
 EXHIBITION: Düsseldorf 1886, no. 133.
 BIBLIOGRAPHY: Bode 1883, 112 (*ca.* 1625); Moes 236; HdG 29; Bode-Binder 22; KdK 31 left (*ca.* 1623–25; the best of many variants); Valentiner 1936, 26 (*ca.* 1623–25).
 Hofstede de Groot (29) and Valentiner (KdK 31 right; 1936, 26) called it a pendant to the *Laughing Boy* at the Mauritshuis (Cat. no. 29; Plate 49). The only support I can find for this assertion is the fact that both works are the same size and both were in the Oppenheim collection. In my opinion Cat. no. D 5-1 is not authentic. It and the many variants of it, which

come in sundry sizes, shapes and qualities, are probably based on a lost original.

2. Paris, formerly Jules Porgès (Fig. 109).
Circular panel, diameter 38 cm.
BIBLIOGRAPHY: HdG 31A; Bode-Binder 23; Valentiner 1936, 26 note (the best of several workshop repetitions of our Cat. no. D 5-1)

3. Sale, Hauptmann, Paris (Drouot) 22 March 1897, no. 27, repr.; sale, Sedelmeyer, Berlin (Lepke) 18 November 1897, no. 15, repr.; Munich, dealer J. Böhler, 1914.
Circular panel, diameter 39 cm.
BIBLIOGRAPHY: Bode-Binder 24, repr. plate 11c.

4. Sale, New York (Parke Bernet) 15 November 1945, no. 44, with wrong provenance (Fig. 110).
Panel (lozenge), 29 × 29 cm.
BIBLIOGRAPHY: Probably identical with Bode-Binder 25, repr. plate 11d (as a tondo), in the possession of the New York dealer V. G. Fischer.

5. London, Sir G. Cecil J. Newman (Fig. 111).
Circular panel, diameter 29·8 cm.
EXHIBITION: London 1952–53, no. 79.
BIBLIOGRAPHY: E. Plietzsch, *Kunstchronik*, VI, 1953, p. 123 (workshop).

6. New York, dealer Spencer A. Samuels and Co., 1967 (Fig. 112).
Circular panel, diameter 27·9 cm.
PROVENANCE: Dealer French and Co., around 1950.
EXHIBITIONS: South Hadley, Massachusetts, Mount Holyoke College, 'The Eye Listens', 1950, no. 33; New York, dealer Spencer A. Samuels and Co., 'The Portrait . . .', 1967, no. 4.

7. Bridlington, Yorkshire, formerly J. Lloyd Graeme of Lowerby Hall (Fig. 113).
Circular panel, diameter 30·9 cm.
The author of this crude work can be called the 'Fat Boy Master'; Cat. no. D 6-4 can also be ascribed to him. Both paintings were in the London art market in 1958 (see *The Connoisseur*, CXLII, 1958, August, p. 44).

D 6. **Two Laughing Children, one holding a Flute**
Versions:

1. Cincinnati, Taft Museum (acc. no. 1931.401) (Fig. 114).
Panel, 35 × 32·9 cm.
PROVENANCE: Sale, Mathieu Neven, Cologne, 17 March 1879, no. 85; sale, Niesewand, London, 9 June 1886, no. 52; dealer Scott and Fowles, New York; acquired by Charles Phelps Taft, Cincinnati, in 1905.
EXHIBITIONS: Düsseldorf 1886, no. 134; Amsterdam, Fred. Muller, Rembrandt Exhibition, 1906, no. 58; Detroit 1935, no. 5.
BIBLIOGRAPHY: Bode 1883, 115 (replica of our Cat. no. D 6-2); HdG 132 (replica of Cat. no. D 6-2);

Bode-Binder 28; Maurice W. Brockwell, *A Catalogue of . . . the Collection of Mr. and Mrs. Charles P. Taft*, New York, 1920, no. 19 (wrongly said to be on canvas); KdK 33 left (*ca.* 1623–25; authentic); Valentiner 1936, 9 (*ca.* 1623–25; authentic); Taft Museum Catalogue, *n.d.*, p. 36, no. 131 (Frans Hals). Hofstede de Groot, Bode-Binder and Valentiner (KdK 33 left) erroneously state that the painting is signed with the monogram.
Valentiner (KdK 33 left; 1936, 9) accepted this version as an original; Bode, Moes, Hofstede de Groot, and Bode-Binder accepted our Cat. no. D 6-2 as authentic (see below). In my opinion neither of them nor any other known variant of the composition is acceptable as autograph. They may, however, be based upon a lost original.

2. New York, formerly Mrs. Wimpfheimer (Fig. 115).
Circular panel, diameter 32 cm.
PROVENANCE: L. Knaus, Berlin; sale, L. Knaus, Berlin, 30 October 1917, no. 10.
BIBLIOGRAPHY: Bode 1883, 94 (*ca.* 1630; authentic); Moes 228 (authentic); HdG 124 (authentic); Bode-Binder 26 (authentic); KdK 33 left, note (studio replica); Alfred M. Frankfurter, 'Paintings by Frans Hals in the United States', *The Antiquarian*, VIII, 1929, no. 2, pp. 32, 84.

3. Stockholm, Hallwyl Collection.
Circular panel, diameter 28 cm.
BIBLIOGRAPHY: HdG 33; *Hallwylska Samlingen, Catalogue*, Grupp XXXII, B. 123, repr.
The author of this bad copy transformed the flute held by the boy into a nut and his companion into a kind of a guinea pig.

4. Bridlington, Yorkshire, formerly J. Lloyd Graeme of Lowerby Hall.
Circular panel, diameter 35 cm.
Probably by the inferior 'Fat Boy Master' who painted Cat. no. D 5-7. Both pictures were in the London art market in 1958 (see *The Connoisseur*, CXLII, 1958, August, p. 44).

5. Uccle, Belgium, formerly Madame M. van Gelder.
Panel, 38·5 × 20·5 cm.
EXHIBITION: Haarlem 1937, no. 12, repr. Fig. 15.
Probably a modern copy. According to the Witt files it was stolen from Belgium, 1939–45.

6. Newport, Rhode Island, formerly Margaret Louise Van Alen Bruguiere.
Panel, 34·5 × 30·5 cm.
PROVENANCE: H. J. Pfungst, London, from whom it was acquired by James Van Alen, London, in 1904; Margaret Louise Van Alen Bruguiere, Newport, Rhode Island; sale, estate of M. L. Van Alen Bruguiere, London (Christie), 5 December 1969, no. 69, repr.
EXHIBITIONS: London, Royal Academy, 1902, no. 201; London, Whitechapel Art Gallery, 1904, no. 283.
BIBLIOGRAPHY: Moes 233 (authentic); HdG 30

(authentic); Bode-Binder 27, repr. plate 12a, (authentic).

This crude variant omits the child in the background; Valentiner (KdK 33 left, note) rightly observed that the prototype must have included the second child since the composition is out of balance without him. When the picture was sold at Christie's in 1969 it was properly catalogued as a work in Hals' style; however, it is not identical with Bode 1883, no. 27, as the sale catalogue erroneously stated.

D 7. **Laughing Boy with a Soap Bubble (Vanitas?)**
Versions:
1. Paris, Louvre (Fig. 116).
 Circular panel, diameter 30 cm.
 PROVENANCE: Sale, Baron de Beurnonville, Paris, 9 May 1881, no. 301; Henri Péreire, Paris; André Péreire, Geneva; bequeathed to the Louvre.
 EXHIBITION: Trésors des Collections Romandes, Musée Rath, Geneva, Cat. 1954, no. 19.
 BIBLIOGRAPHY: Bode 50; HdG 37; Bode-Binder 21; KdK 34 left (ca. 1623–25).
2. Richmond, The Virginia Museum of Fine Arts (acc. no. 49.11.38) (Fig. 117).
 Panel, 34×29·5 cm.
 PROVENANCE: Jacob M. Heimann, New York; R. Swabach, Amsterdam; Adolph D. and Wilkins C. Williams collection.
 EXHIBITION: Montreal 1944, no. 24, repr. on the cover of the catalogue.
 BIBLIOGRAPHY: *European Art in the Virginia Museum of Art*, Richmond, 1966, p. 52, no. 77 (after Frans Hals).

Both variants are closely related to the *Laughing Boy Holding a Flute* in Lady Munro's collection (Cat. no. 27; Plate 50) and may have been derived from it. However, it is also conceivable that they are based on a lost original. For the relationship of soap bubbles to the *vanitas* theme see Cat. no. 28.

An indifferent version of the painting appeared in the sale Brussels (Trussart), 20 May 1957, reproduced plate XVII.

D 8. **Boy with a Dog**
Versions:
1. Glasgow, Art Gallery (Cat. 1961, no. 716) (Fig. 118).
 Circular panel, diameter 29·2 cm.
 PROVENANCE: Sale, Fountaine, London, 7 July 1894, no. 26; (Lawrie and Co.); purchased by the gallery in 1894.
 EXHIBITIONS: London 1929, no. 70; Manchester

1929, no. 50; Haarlem 1937, no. 19; Bristol 1946, no. 5; Amsterdam, Stedelijk Museum, 'Vals of Echt?', 1952, no. 69 (as a fake).
BIBLIOGRAPHY: Moes 231; HdG 38; Bode-Binder 15; KdK 32 left (reproduced in reverse); *Dutch and Flemish . . . Paintings*, Glasgow Art Gallery, 1961, no. 716 (imitator of Frans Hals).
The painting appeared in the 1894 Fountaine sale as a pendant of the *Boy with a Flute* (Cat. no. D 4-2), which is also at Glasgow. The tradition that the works are pendants can be traced back to 1801, when Gaugain (*ca.* 1748–1810) engraved both pictures (Gaugain's engraving of Cat. no. D 8-1 does not include the dog or the child's hand). The paintings are now rightly catalogued at Glasgow as works by an imitator of Hals. For a summary of a technical examination made in 1955, which supports the view that both are seventeenth-century works, see Cat. no. D 4-2.
Valentiner (KdK 32 left), who reproduced the work in reverse, called it superior to the Rothschild version (Cat. no. D 8-2).
2. Vienna, formerly Baron Louis Rothschild (Fig. 119).
 Panel, 35×29·8 cm.
 PROVENANCE: Albert von Rothschild.
 EXHIBITION: Haarlem 1937, no. 26.
 BIBLIOGRAPHY: Moes 242; HdG 39 (incorrectly described as a tondo); Bode-Binder 16; KdK 32 left, note (less good than the Glasgow version); L. Baldass, *B.M.*, XCIII, 1951, p. 181 (original; Glasgow variant is not original).
 The handling as well as the type of painted circular frame is related to Cat. no. D 1-1; possibly both works were painted by the same imitator.
3. New York, formerly John N. Willys (Fig. 120).
 Circular panel, diameter 20 cm.
 PROVENANCE: Sir Edgar Speyer, London; dealer Reinhardt Galleries, New York, 1919; John N. Willys, New York; sale, Willys, New York (Parke-Bernet) 25 October 1945, no. 14; sale, property of the Ward M. and Mariam C. Canaday Educational and Charitable Trust, London (Sotheby), 6 July 1966, no. 115 (£3000).
 EXHIBITION: New York, Reinhardt Galleries, Paintings of Women and Children, 1929, no. 9.
 BIBLIOGRAPHY: P. M. Turner, 'The House and Collection of Mr. Edgar Speyer', *B.M.*, v, 1904, p. 547, repr. p. 555, Plate IV; A. M. Frankfurter, *The Antiquarian*, 'Paintings by Frans Hals in the United States', VIII, 1929, no. 2, pp. 32, 84.
4. Oslo, National Gallery (inv. no. 1360) (Fig. 121).
 Panel, 27·3×27·3 cm.
 PROVENANCE: Jules Porgès, Paris; dealer J. Böhler, Munich, 1912; Chr. Langaard, Christiania, who bequeathed it to the gallery.
 The tondo is painted on a square panel, which has been secured to another panel.

D 9. **Fisherboy** (Fig. 122). Allentown, Pennsylvania, Allentown Art Museum, Samuel H. Kress Collection (Cat. 1960, p. 120).
Canvas, 65·4 × 56·5 cm. Signed at the lower right with an unusually large and laboured connected monogram: FH.

PROVENANCE: Dealer Agnew and Sons, London, 1921; Count A. Contini Bonacossi, Rome; acquired by Samuel H. Kress in 1933 (K 255).
EXHIBITIONS: Rome 1928, no. 41; Detroit 1935, no. 30; Indianapolis 1937, no. 24; Haarlem 1937, no. 63; New York 1937, no. 14; Allentown 1965, no. 38.
BIBLIOGRAPHY: KdK 133 (ca. 1635); Valentiner 1936, 53 (1635–40).

It seems that Hals invented the theme of a single half-length, life-size painting of a fisherboy or girl, and to judge from the number of old copies and variants, they were as popular in his time as his portraits of children. However, the prices they fetched in eighteenth- and early nineteenth-century sales indicate that later collectors lost their taste for them. At the sale, Gerard Vervoort, 19 September 1746, lot no. 49, 'A Fisherboy with a Basket on His Back' and 'A Woman Selling Anchovies' fetched 49 florins (HdG 55 and 112, respectively). In 1799 a 'Laughing Fisherman, seated. He points with his right hand to a fish-basket he carries on his back' brought 5.25 florins at an Amsterdam sale (HdG 58a); see D-10. A decade later a 'Merry Fish Merchant' sold in Amsterdam was carried away for 10 florins (HdG 58c). But the situation changed around the end of the nineteenth century, when works by Hals as well as those done in his manner began to fetch top prices. Since that time some of the fisherfolk painted by the artist's anonymous followers have entered the literature as authentic works. Ten of them as well as some variants of the dubious ones, which in my opinion do not meet the high standard set by Hals' originals, are listed in this section of the catalogue (Cat. nos. D 9–16, D 33–34). It would be convenient if all of them could be assigned to a single artist who could be called the 'Master of the Fisherfolk' but in my view they cannot be assigned to the same hand.
In the Allentown *Fisherboy* the failure of the bold brushstrokes to express forms and surfaces, and the ambiguous spatial arrangement of the principal figure betray the hand of the imitator. The cropped figure behind the seated boy suggests that the painting was originally considerably larger.

D 10. **Fisherboy** (Fig. 123). Raleigh, North Carolina Museum of Art, Samuel H. Kress Collection (inv. no. GL 60.17.67).
Canvas, 80·2 × 64·3 cm.

PROVENANCE: Sale, London (Christie), 20 February 1920, no. 135 (Agnew, 4800 gns.); dealer Duveen, New York;

acquired by Samuel H. Kress, New York in 1933 (K 274).
EXHIBITIONS: Detroit 1935, no. 31; Indianapolis 1937, no. 23; Haarlem 1937, no. 64, New York 1937, no. 15; San Francisco 1939, no. 81.
BIBLIOGRAPHY: KdK 135 (ca. 1635); Valentiner 1936, 54; *The Samuel H. Kress Collection*, North Carolina Museum of Art, Raleigh [1960], p. 136 (ca. 1640; authentic).

Valentiner (KdK 134; 1936, 54) suggested it may be a pendant to our Cat. D 11, but in my opinion these coarse imitations were painted by different followers and were not intended as mates. Possibly identical with or a copy after a painting attributed to Hals (HdG 58a) which appeared in the sale, Amsterdam 21 August 1799, no. 58, canvas, 82·5 × 67·5 cm. A Laughing Fisherman, seated. He points with his right hand to a fish-basket which he carries on his back. Painted in a broad and sketchy manner (fl. 5.25; Valet).

D 11. **Fisherboy** (Fig. 124). Winterthur, Stiftung Oskar Reinhart (Cat. no. 81).
Canvas, 76·7 × 63·5 cm.

PROVENANCE: Dealers Asscher and Koetser, Amsterdam, 1923.
EXHIBITION: Düsseldorf 1929, no. 31; Winterthur, Kunstmuseum, Die Privatsammlung Oskar Reinhart, Cat. 1955, no. 84.
BIBLIOGRAPHY: KdK 134 (ca. 1635).

The heavy, brownish-black strokes and simplistic highlights used to define the forms mock rather than simulate Hals' technique. Valentiner's suggestion (KdK 134) that the painting was probably the companion picture of Cat. no. D 10 is unacceptable. A copy of the bust is in the Musée des Beaux-Arts, Arras, Cat. 1907, no. 185; canvas, 45 × 39 cm. Formerly coll. La Caze. Exhibition: Saarbrücken-Rouen, Chefs d'Oeuvre Oubliés, Cat., 1954, no. 35, repr.

D 12. **Fisherboy** (Fig. 125). Eindhoven, Philips Collection.
Panel, 49 × 67·5 cm.

PROVENANCE: Earl of Hopetoun, Hopetoun House, Scotland; Marquess of Linlithgow, Hopetoun House, Scotland; A. F. Philips, Eindhoven.
EXHIBITION: Haarlem 1937, no. 57.
BIBLIOGRAPHY: Bode 1883, 147 (ca. 1630); Moes 256; HdG 53 (ca. 1630); Bode-Binder 82; KdK 132 left (ca. 1635).

The picture was hidden during World War II and during this period the entire paint layer was severely damaged. It is now heavily restored throughout and only bears a vague resemblance to works by Hals. Old photographs

suggest that it was originally a work by an anonymous follower who based his painting on the *Fisherboy* at Antwerp (Cat. no. 71; Plate 115).

D 13. **Fisherboy** (Fig. 126). Assheton Bennet Collection, on permanent loan to the Manchester City Art Gallery (Cat. 1965, no. 22).
Panel, 28·5×21·5 cm. Signed at the top right with the connected monogram: FH.

PROVENANCE: Sale, Baron de Beurnonville, Paris, 9 May 1881, no. 304; bought from Rudolf Kann, Paris, by Alfred Thieme of Leipzig in 1888; Leipzig Museum, 1916–36; dealer P. de Boer, Amsterdam, 1936; dealers E. and A. Silberman, New York, 1937.
EXHIBITIONS: Leipzig 1889, no. 96; Haarlem 1937, no. 55; London, Royal Academy, *The Assheton Bennet Collection*, 1965, no. 7.
BIBLIOGRAPHY: Bode 1883, 53; Moes 252; HdG 54 (*ca.* 1630–40); Bode-Binder 81; KdK 131 (*ca.* 1635); Manchester Art Gallery, *Catalogue of Paintings and Drawings from the Assheton Bennet Collection*, 1965, no. 22.

There is no connection between the slack handling in this little painting and Hals' authentic works.

D 14. **Fisherman with a Basket**
Versions:
1. Gorhambury, St. Albans, Herts., The Earl of Verulam (Fig. 127).
 Canvas, 83·8×63·5 cm.
 EXHIBITION: London 1952–53, no. 90 (Frans Hals), Manchester 1957, no. 97 (Frans Hals).
 BIBLIOGRAPHY: possibly identical with HdG 58b and HdG 58c; E. Plietzsch, *Kuntschronik*, VI, 1953, p. 123 (forgery).
2. Washington, D.C., George Eric Rosden.
 Canvas, 74·8×61 cm.
 PROVENANCE: Collection Flaming; Collection Van Beuren; P. A. B. Widener, Philadelphia, Pennsylvania; Prince Ludwig Ferdinand of Bavaria; art market, Munich.
 BIBLIOGRAPHY: *Catalogue of Paintings . . . of P. A. B. Widener, Ashbourne near Philadelphia*, Part II, 1885–1900, no. 206, repr.
3. Location Unknown.
 PROVENANCE: Sale, Zürich (T. Fischer), 2–5 May 1934, no. 1261, repr.; sale, Amsterdam (Muller) 9 April 1940, no. 406, repr.; dealer D. Katz, The Hague, 1942; sale, Brussels (Palais des Beaux-Arts) 14 December 1953, repr.

The best variant is the one in the collection of the Earl of Verulam, but the difficulty the author of it had portraying the fisherman's foreshortened arm suggests that he most likely based his work on yet another version—perhaps a

lost original. The model portrayed in D 14-2 has a long clay pipe in his hat and a cat in his basket. The model depicted in D 14-3 has shrimp in his basket; this version is miserably painted.

D 15. **Man with a Herring Barrel** (Fig. 130). Augsburg, Städtische Kunstsammlungen.
Panel, 68·7×50·3 cm.

PROVENANCE: Alfred Beit, who gave it to the Kunsthalle, Hamburg, in 1891; exchanged by the Kunsthalle 30 March 1931 with the Berlin dealer Karl Haberstock; given to Augsburg by the Karl and Magdalene Haberstock Stiftung, 1957.
BIBLIOGRAPHY: Moes 257; HdG 52 (very sketchy but good); Bode-Binder 80; *Katalog der Alten Meister*, Kunsthalle, Hamburg, 1921, p. 69, no. 329 (doubtful; also doubted by A. Bredius; similar school pieces formerly in collection Thieme and Carstanjen [our Cat. nos. D 13 and D 32 respectively]); KdK 147 (1635–40; the authenticity of the painting is wrongly questioned in the Kunsthalle catalogue); *Gemälde der Stiftung Karl und Magdalene Haberstock*, Städtische Kunstsammlungen, Augsburg, 1960, p. 15; *Hundert Bilder aus der Galerie Haberstock Berlin*, Munich 1967, no. 23.

Done by an imitator who had a good understanding of Hals' mature style, but the sketchy character of his bold brush work disintegrates into an un-Halsian slovenliness in some passages. It is difficult to tell if the man is holding a herring barrel or embracing an immense beer jug (see Cat. no. 74). It would be far-fetched to suggest that the vine-tendril behind him indicates he is a bacchant with a wine keg, but its formlessness is additional proof that the painting is not autograph. In my view the vine-tendril as well as the young woman in the picture he did in collaboration with Van Heussen (Cat. no. 70; Plate 112) was done by Hals. It shows the way his suggestive touch organizes forms into a coherent design while retaining the structure of its individual parts.

D 16. **Two Fisherboys, one holding a crab** (Fig. 128). New York, formerly dealer Schaeffer Galleries.
Canvas, 75·5×70·5 cm.

PROVENANCE: Miss Laird, Brighton, England; sale, London, 20 December 1935, no. 120 (2,800 gns., Spink); dealer D. Katz, Dieren; dealer Schaeffer Galleries, New York.
EXHIBITIONS: Haarlem 1937, no. 8; New York 1937, no. 2; Providence 1938, no. 18; Montreal 1944, no. 27 (the catalogue notes that the painting was lent by the Detroit Institute of Arts).
BIBLIOGRAPHY: G. D. Gratama, 'Twee vischersjongens

van Frans Hals, *O.H.*, LIII (1936), pp. 141–44; *Apollo*, February (1936), p. 121.

Shortly before the painting appeared at Christie's in 1935 it was auctioned at a sale on the South Coast of England and purchased for £3 (*The Illustrated London News*, 4 January 1936, p. 21). To judge from reproductions, it is a nineteenth-century painting done in Hals' style. The same hand may have painted the anachronistically dressed *Boy in Profile* (Fig. 129) which was wrongly ascribed to Judith Leyster when it was exhibited at the Amsterdam dealer De Boer, Amsterdam, in 1969 (circular panel, 19 cm.).

D 17. **Laughing Man Holding a Large Jug** (Fig. 131). Montreal, Mrs. William van Horne.
Canvas, 76 × 62·5 cm.

PROVENANCE: Sir William C. van Horne, Montreal; by descent to the present owner.
EXHIBITION: Pittsburgh, Carnegie Institute, 'Pictures of Everyday Life', 1954, no. 15.
BIBLIOGRAPHY: Bode-Binder 13 (66 × 55 cm.); KdK 65 (*ca.* 1627–30); Valentiner 1936, no. 11 (*ca.* 1625–27); Hubbard 1956, p. 150 (perhaps by Judith Leyster).

Bode and Valentiner accepted the painting as an original. Valentiner wrote that it represented the same model represented in the *Rommel Pot Player* (see Cat. no. L 3) and is probably a little later in date. In my opinion it is a weak pastiche derived from the central figure in Hals' *Rommel Pot Player*; see Cat. no. L 3-20. Valentiner's suggestion (1936, no. 11) that it is very likely the companion to the *Young Woman Holding a Flagon* at the Corcoran Gallery (Cat. no. 22; Plate 43) is far-fetched. A comparison of the deft accents and subtle shifts in value of the tones which convincingly model the hand of the woman holding the flagon (it is one of the few well preserved passages of the Corcoran painting) with the superficial modelling of the man's hand on the handle of his jug points up the difference between Hals' work and an unsuccessful attempt to imitate it. I see no reason to accept the suggestion that the work was painted by Judith Leyster (Hubbard 1956, p. 150).

D 18. **Laughing Man Holding a Mug** (Fig. 132). Location unknown.

PROVENANCE: Baron Sloet, Zwolle; sale, London, 3 July 1908, no. 123 (£154); dealer J. Böhler, Munich; sale, Linlithgow, London (Christie), 5 July 1929, no. 23; M. Godfroy Brauer, Nice, 1929; Gino Pertile; Luigi Pertile; sale, L. Pertile, London (Christie), 18 March 1955, no. 58 (3,000 gns.).
BIBLIOGRAPHY: Moes 272; HdG 67; Bode-Binder 84; KdK 26.

Valentiner (KdK 26) rightly expressed serious reservations about its authenticity. He suggested it was painted around 1623 but noted it is difficult to date, and added it may have been painted later if it is in fact by Hals and not by one of his sons or pupils. I can see no reason to attribute it to Frans Hals.

D 19. **Laughing Man Holding a Mug, and raising his hat** (Fig. 133). Brussels, Duc d'Arenberg.
Canvas, 70·5 × 59·5 cm.

PROVENANCE: Possibly sale, J. van der Linden van Slingeland, 22 August 1785, no. 168 (43 florins; Fouquet); W. Bürger (see Bibliography below) notes that it is listed in the 1829 catalogue of La Galerie d'Arenberg, no. 32.
EXHIBITION: Düsseldorf 1904, no. 319.
BIBLIOGRAPHY: W. Bürger, *Galerie d'Arenberg à Bruxelles*, Catalogue 1859, p. 131, no. 18; Bode 1883, 34 (*ca.* 1635); Moes 273; HdG 64; Bode-Binder 83; KdK 116 right (*ca.* 1633–35; possibly earlier).

I have not seen the painting, but to judge from good photos the failure of the free brushwork to define forms (particularly the hands, jug and hat) makes the attribution to Hals dubious. Moreover, the momentary gesture and attitude is not consistent with Hals' depiction of a fleeting instant. He chose moments which burst with vitality and intense emotion. To be sure, they are not always as high-pitched as the instant he depicted in the life of *Malle Babbe* (Cat. no. 75; Plate 120) but I know none which are as tame in effect as the one depicted here.
The painting possibly appeared in the same 1785 sale as our Cat. no. D 27; this appears to be the only support for Hofstede de Groot's proposal that the pictures are pendants. According to Valentiner (KdK 116 right) the painting is signed at the lower right with the artist's monogram; other authors do not mention the signature.

D 20. **Man Holding a Pipe** (Fig. 134). Location unknown. Canvas, 58·5 × 49 cm. Signed at the lower left: f. hals.

PROVENANCE: Sir George Chetwynd, Bart.; Leopold Hirsch, London; sale, L. Hirsch, London (Christie), 11 May 1934, no. 106 (£1723.10).
EXHIBITION: The Hague, dealer Kleykamp, 1925, no. 21.
BIBLIOGRAPHY: Bode-Binder 299; KdK 146 (*ca.* 1635-1640).

The form of the signature can be related to the unusual one on Hals' *Peeckelhaering* at Cassel (Cat. no. 64; Fig. 56) but I cannot find a connection between the painting and genuine works by the artist. The so-called *Coal Heaver* is an equally dubious work related to the Hirsch painting but done by a less gifted imitator. It is now at the Sterling and

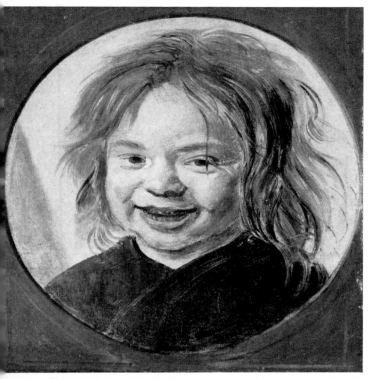

01. *Laughing Child.* Detroit, The Detroit Institute of Arts. Cat. no. D 1-1.

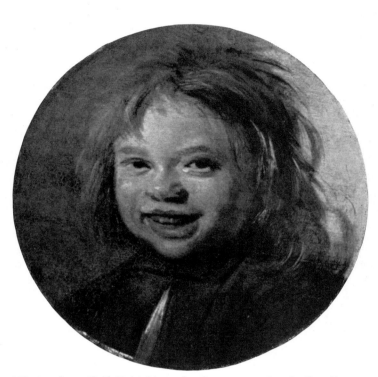

102. *Laughing Child.* Helsinki, Paul and Fanny Sinebrychoff Collection. Cat. no. D 1-2.

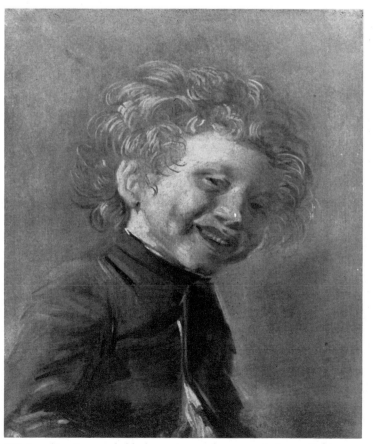

103. *Laughing Boy*, probably by a nineteenth-century imitator. Baltimore, The Baltimore Museum of Art. Cat. no. D 2.

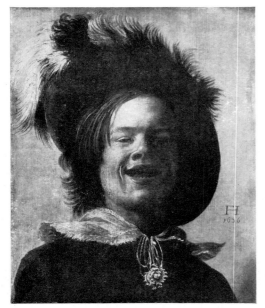

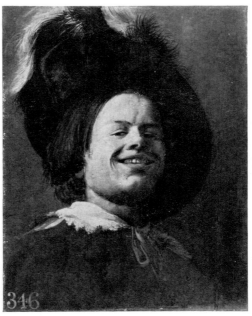

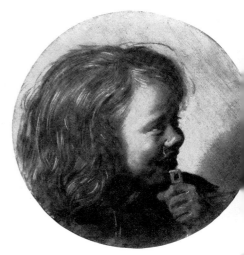

104. *Laughing Boy*. Paris, Musée Jacquemart-André. Cat. no. D 3.

105. Jan Miense Molenaer: *Laughing Boy*. Hampton Court. (See Cat. no. D 3.)

106. *Laughing Child with a Flute*. Former[ly] Washington, D.C., Dwight W. Davi[s]. Cat. no. D 4-1.

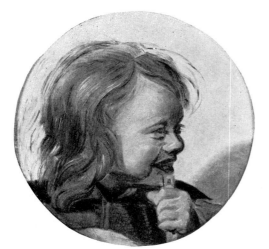

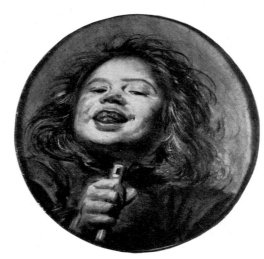

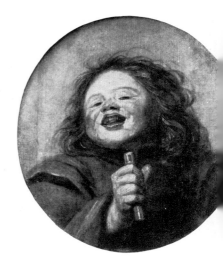

107. *Laughing Child with a Flute*. Glasgow, Art Gallery. Cat. no. D 4-2.

108. *Boy with a Flute*. Cincinnati, Mrs. E. W. Edwards. Cat. no. D 5-1.

109. *Boy with a Flute*. Formerly Paris, Jules Porgès. Cat. no. D 5-2.

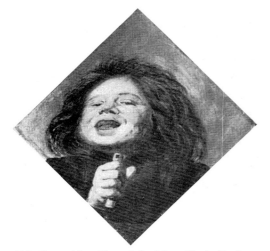

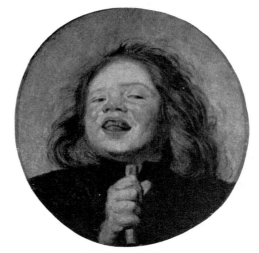

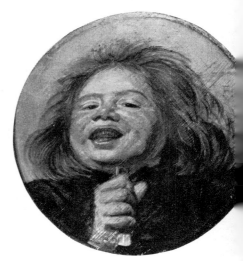

110. *Boy with a Flute*. Sale, New York (Parke-Bernet), 15 November 1945, no. 44. Cat. no. D 5-4.

111. *Boy with a Flute*. London, Sir G. Cecil J. Newman. Cat. no. D 5-5.

112. *Boy with a Flute*. New York, dealer Sp[encer] A. Samuels, 1967. Cat. no. D 5-6.

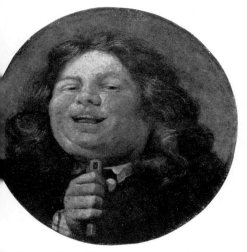

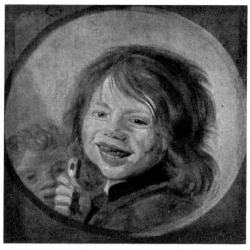

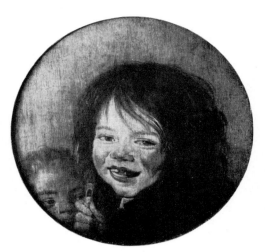

. *Boy with a Flute.* Formerly Bridlington, Yorkshire, J. Lloyd Graeme. Cat. no. D 5-7.

114. *Two Laughing Children, one holding a flute.* Cincinnati, Taft Museum. Cat. no. D 6-1.

115. *Two Laughing Children.* Formerly New York, Mrs. Wimpfheimer. Cat. no. D 6-2.

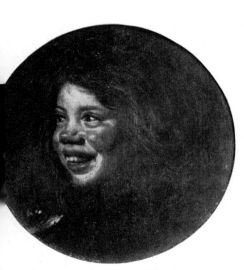

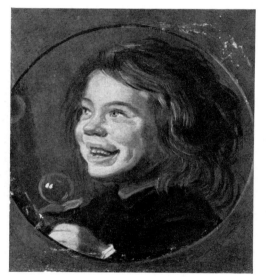

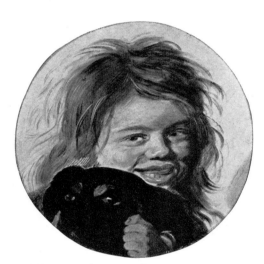

Laughing Boy with a Soap Bubble. Paris, Louvre. Cat. no. D 7-1.

117. *Laughing Boy with a Soap Bubble.* Richmond, The Virginia Museum of Fine Arts. Cat. no. D 7-2.

118. *Boy with a Dog.* Glasgow, Art Gallery. Cat. no. D 8-1.

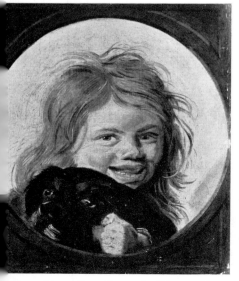

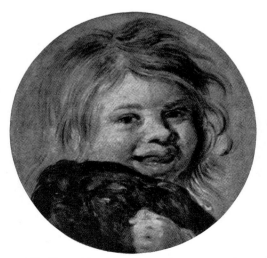

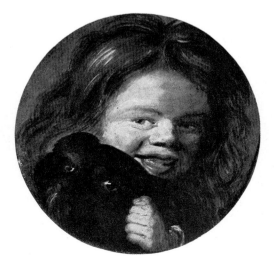

Boy with a Dog. Formerly Vienna, Baron Louis Rothschild. Cat. no. D 8-2.

120. *Boy with a Dog.* Formerly New York, John N. Willys. Cat. no. D 8-3.

121. *Boy with a Dog.* Oslo, National Gallery. Cat. no. D 8-4.

122. *Fisherboy*, Allentown, Pennsylvania, Allentown Art Museum, Samuel H. Kress Collection. Cat. no. D 9.

123. *Fisherboy*. Raleigh, North Carolina Museum of Art, Samuel H. Kress Collection. Cat. no. D 10.

124. *Fisherboy*. Winterthur, Stiftung Oskar Reinhart. Cat. no. D 11.

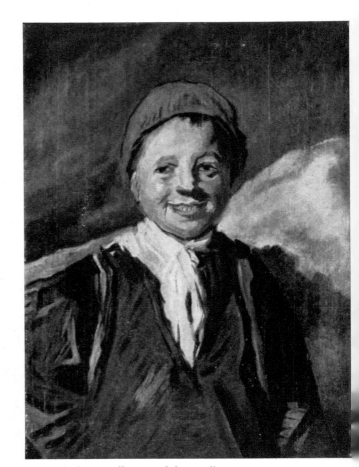

125. *Fisherboy*. Eindhoven, Philips Collection. Cat. no. D 12.

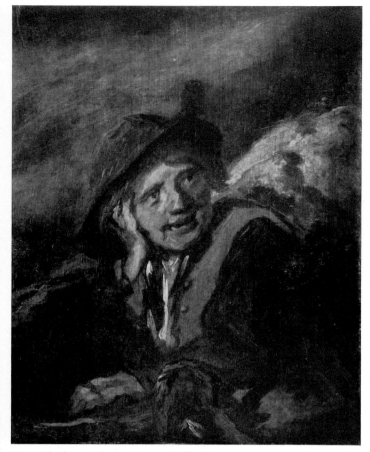

126. *Fisherboy*. Assheton Bennet Collection, on permanent loan to the Manchester City Art Gallery. Cat. no. D 13.

127. *Fisherman with a Basket*. St. Albans, Herts., Earl of Verulam. Cat. no. D 14-1.

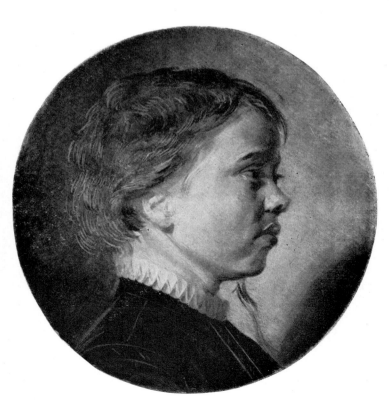

128. *Two Fisherboys, one holding a crab*. Formerly New York, dealer Schaeffer Galleries. Cat. no. D 16.

129. *Boy in Profile*. Amsterdam, dealer De Boer, 1968. (See Cat. no. D 16.)

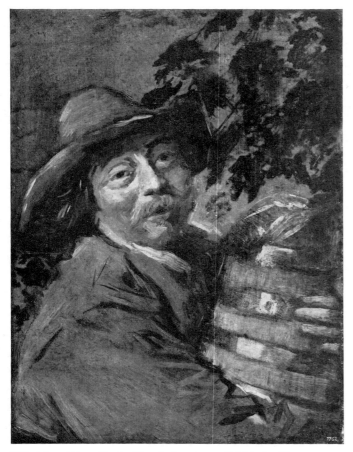

130. *Man with a Herring Barrel*. Augsburg, Städtische Kunstsamm-
lungen. Cat. no. D 15.

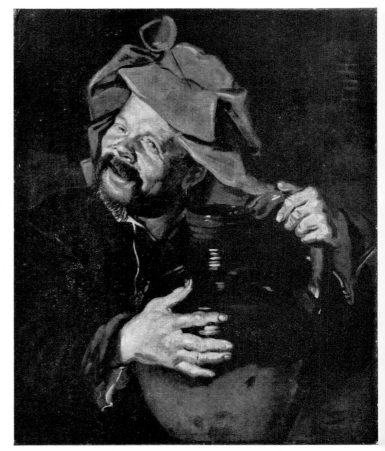

131. *Man Holding a Large Jug*. Montreal, Mrs. William van Horne.
Cat. no. D 17.

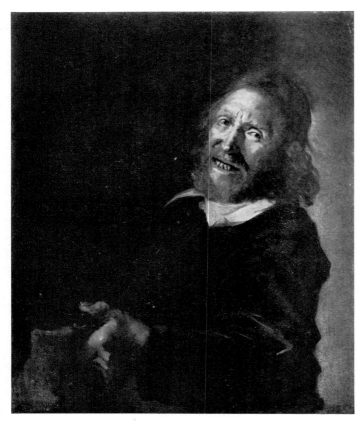

132. *Laughing Man Holding a Jug*. Location unknown. Cat. no. D 18.

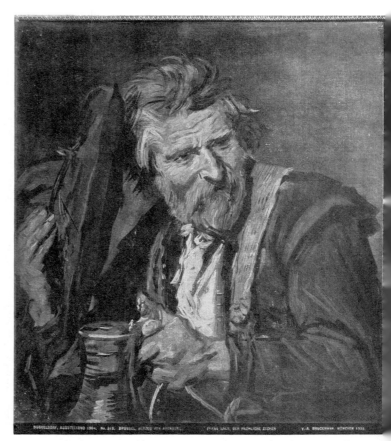

133. *Laughing Man Holding a Mug, and raising his hat*. Brussels, Duc
d'Arenberg. Cat. no. D 19.

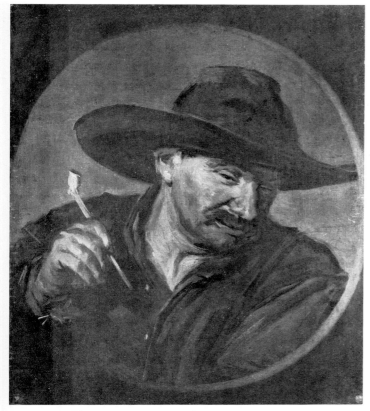

134. *Man Holding a Pipe*. Location unknown. Cat. no. D 20.

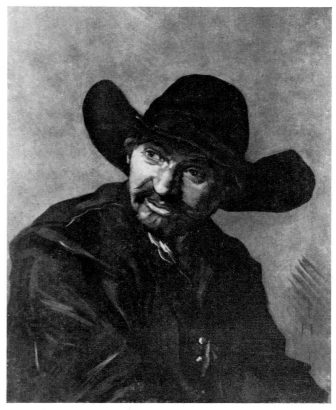

135. So-called *Coal Heaver*. Williamstown, Massachusetts, Sterling and Francine Clark Art Institute. (See Cat. no. D 20).

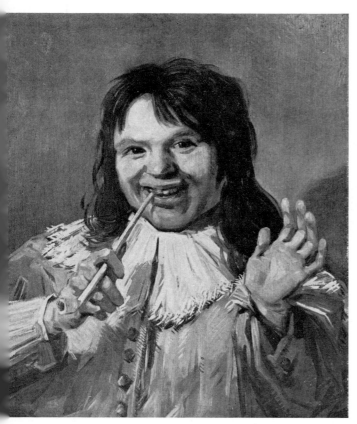

Twentieth-century forgery: *Boy Smoking a Pipe*. Groningen, Museum voor Stad en Lande. Cat. no. D 21.

136a. Forgery: *Portrait of a Laughing Man*. Rotterdam, Private Collection. (See Cat. no. D 21.)

137. So-called *Itinerant Painter*. Paris, Louvre. Cat. no. D 22-1.

138. Attributed to Judith Leyster: *Boy Playing a Violin*. Richmond, Va., The Virginia Museum of Fine Arts. Cat. no. D 24-1.

139. Detail from Fig. 138.

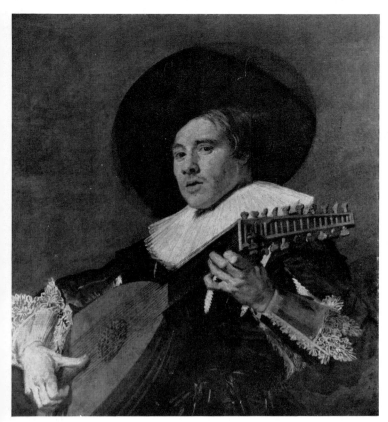

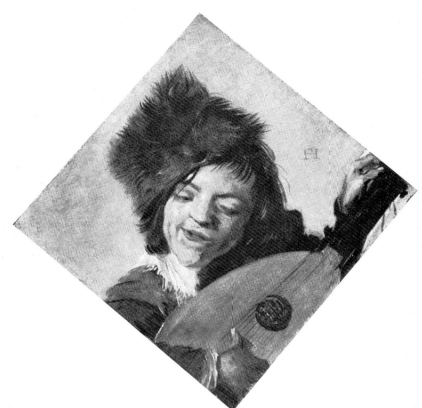

140. Attributed to Judith Leyster: *Lute Player*. Blessington, Ireland, Sir Alfred Beit. Cat. no. D 25.

141. *Boy Playing a Lute*. England, Private Collection. Cat. no. D 23.

142. Detail from Fig. 140.

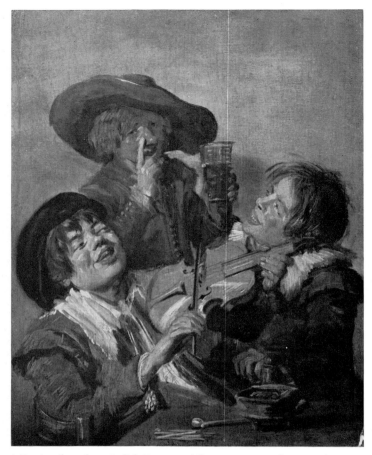

143. Attributed to Judith Leyster: *Three Merry Youths, one playing a Violin*. Oslo, National Gallery. Cat. no. D 26.

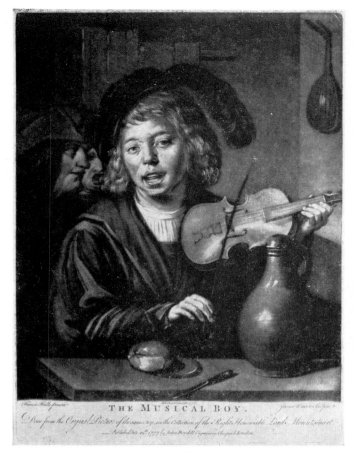

144. James Watson: Mezzotint after *Violinist and Other Figures*, probably after a painting by Judith Leyster. (See Cat. no. D 26.)

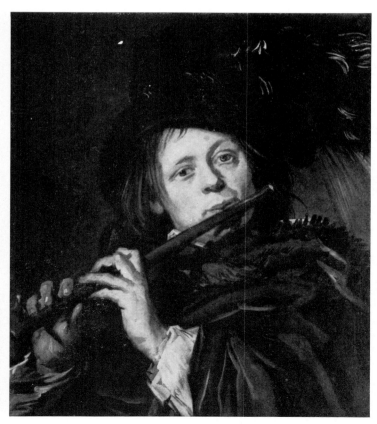

145. *Young Man Playing a Flute*. Nyon, Switzerland, Count de Bendern. Cat. no. D 28-1.

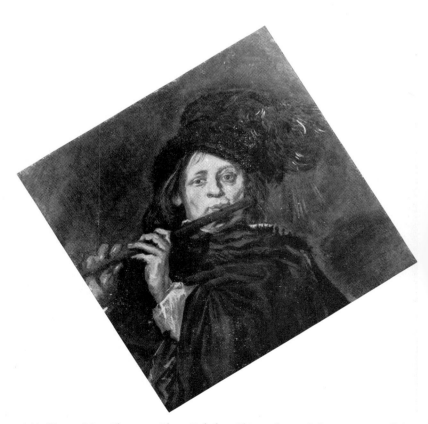

146. *Young Man Playing a Flute*. Toledo, Ohio, The Toledo Museum of Art. Cat. no. D 28-2.

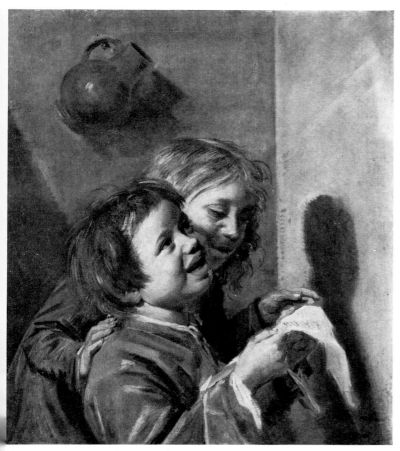

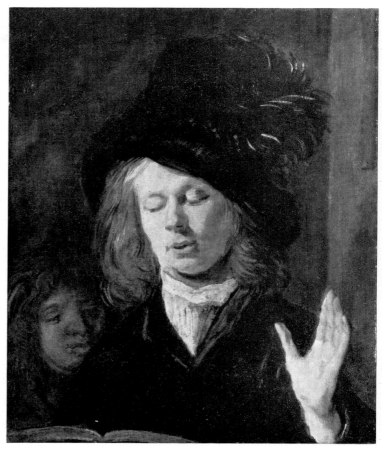

147. *Two Singing Youths*. Formerly Paris, A. Seligman. Cat. no. D 27.

148. *Singing Youth, with a boy at his right*. Formerly Cincinnati, Mrs. William Taft Semple. Cat. no. D 29.

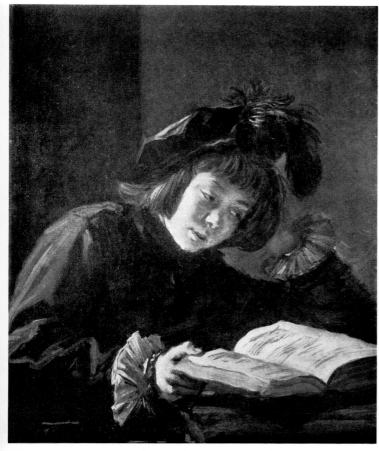

149. *Boy Reading*. Winterthur, Stiftung Oskar Reinhart. Cat. no. D 30.

150. *Young Man in a Plumed Hat*. Detroit, Mrs. Edsel B. Ford. Cat. no. D 31.

151. *Fishergirl*. Cologne, Wallraf-Richartz-Museum. Cat. no. D 32.

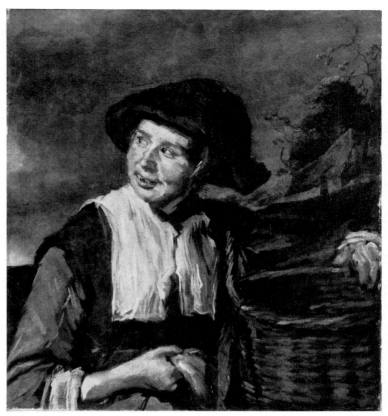

152. *Fishergirl*. Duisburg, Günther Henle. Cat. no. D 32-1.

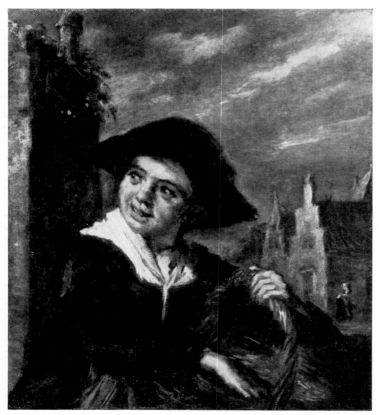

153. *Fishergirl*. Location unknown. Cat. no. D 32-2.

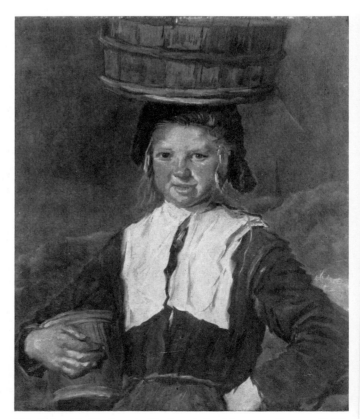

154. *Fishergirl*. Cincinnati, Cincinnati Art Museum. Cat. no. D 33.

155. *Malle Babbe*. New York, Metropolitan Museum of Art. Cat. no. D 34.

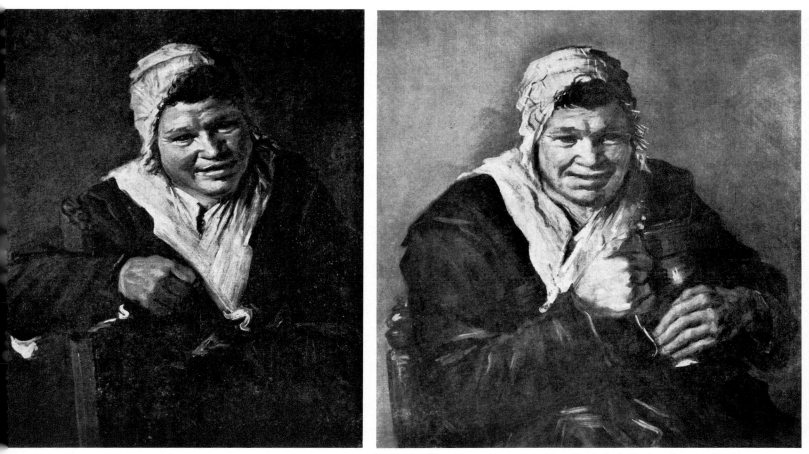

56. *Seated Woman*. Lille, Musée des Beaux-Arts. Cat. no. D 35.

157. *Seated Woman Holding a Jug*. New York, Jack Linsky. Cat. no. D 36.

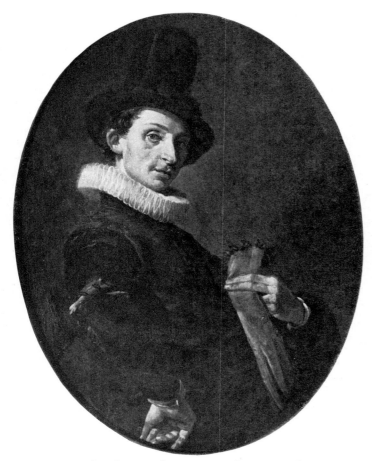

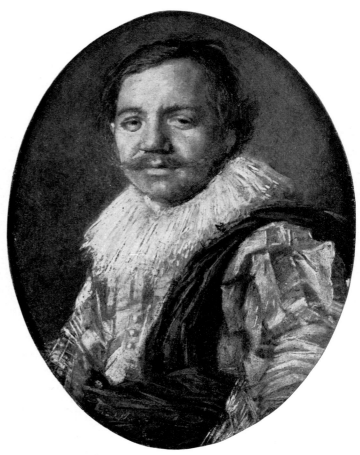

158. Attributed to Willem Buytewech: *Portrait of a Man*. Formerly Berlin, Ludwig Knaus. Cat. no. D 37.

159. *Portrait of a Man*. Paris, Baroness G. W. H. M. Bentinck-Thyssen-Bornemisza. Cat. no. D 39.

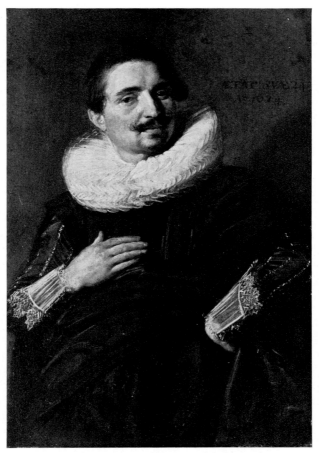

160. *Portrait of a Man*. Frankfurt, Städelsches Kunstinstitut. Cat. no. D 38.

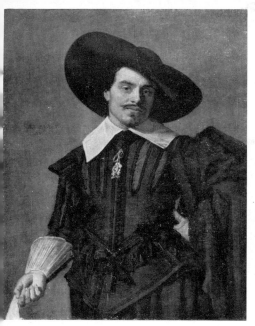

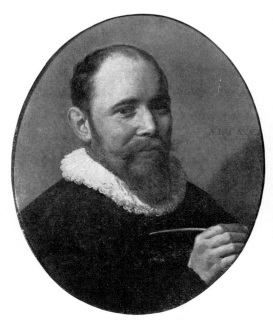

161. *Portrait of a Man.* New York, Metropolitan Museum and Mrs. Constance W. McMullan. Cat. no. D 44.

162. Attributed to Judith Leyster: *Portrait of a Boy.* Stockholm, National Museum. Cat. no. D 40.

163. *Portrait of a Man.* Utrecht, Kunsthistorisch Instituut, Rijksuniversiteit Utrecht. Cat. no. D 43.

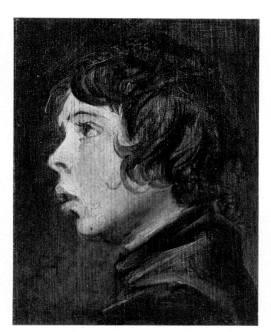

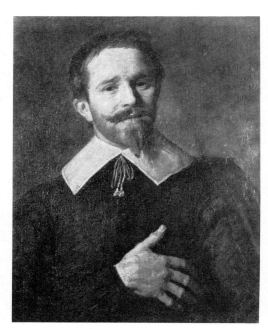

164-165. *Portrait of a Boy, profile to the right,* and *Portrait of a Boy, profile to the left.* Philadelphia, John G. Johnson Collection. Cat. nos. D 41, D 42.

166. *Portrait of a Man.* Bordeaux, Musée des Beaux-Arts. Cat. no. D 45.

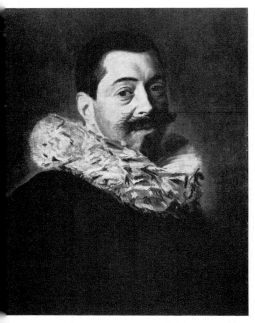

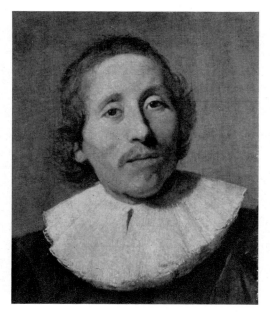

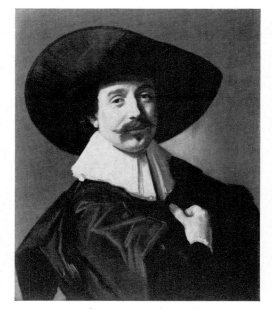

167. *Portrait of a Man.* Essen, Berthold von Bohlen und Halbach. Cat. no. D 46.

168. *Portrait of a Man.* Schwerin, Staatliches Museum. Cat. no. D 47.

169. *Portrait of a Man.* Gotha, Schlossmuseum, Schloss Friedenstein. Cat. no. D 48.

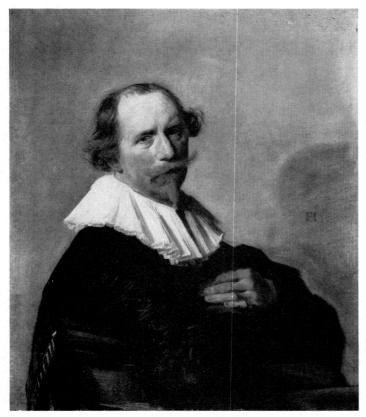

170. *Portrait of a Man*. Formerly Beverly Hills, California, Mrs. Elizabeth Taylor Fisher. Cat. no. D 49.

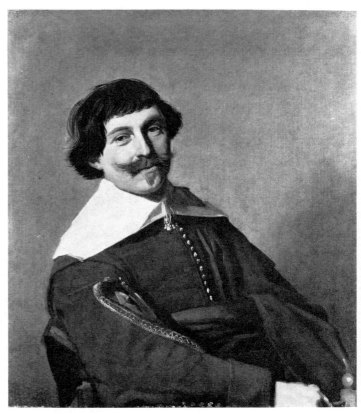

171. *Portrait of a Man*. Location unknown. Cat. no. D 50.

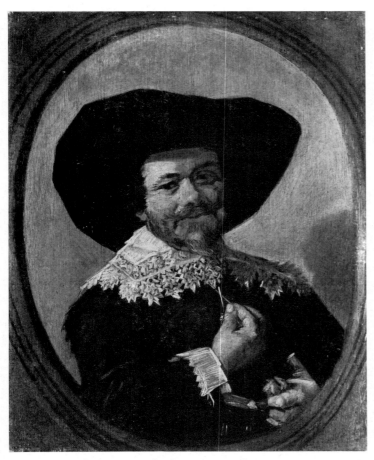

172. *Portrait of a Man*. England, Private Collection. Cat. no. D 51.

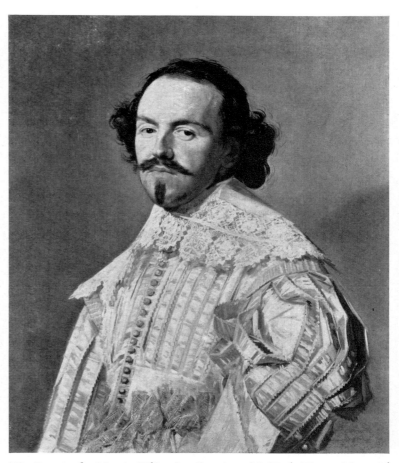

173. *Portrait of a Man in White*. San Francisco, M. H. de Young Memorial Museum, The Roscoe and Margaret Oakes Foundation. Cat. no. D 52.

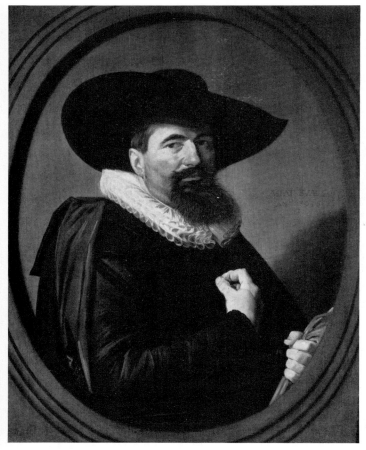

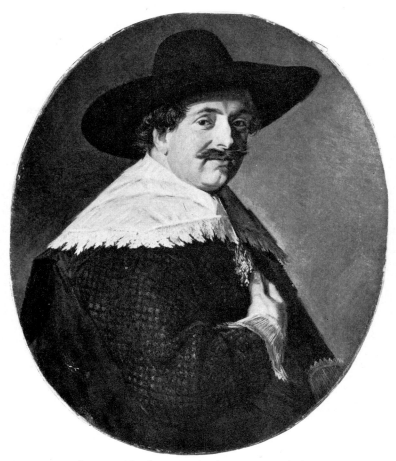

174. *Portrait of a Man in a Painted Oval.* Formerly New York, Lionel Straus. Cat. no. D 53.

175. *Portrait of a Man.* Glyndon, Maryland, Mrs. Gary Black. Cat. no. D 54.

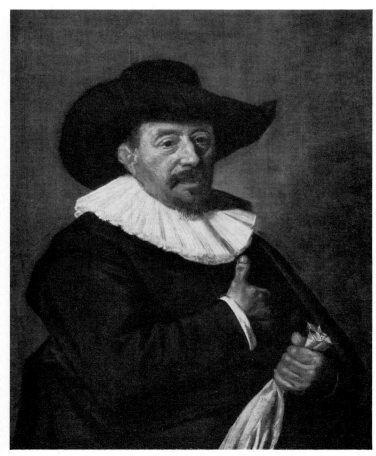

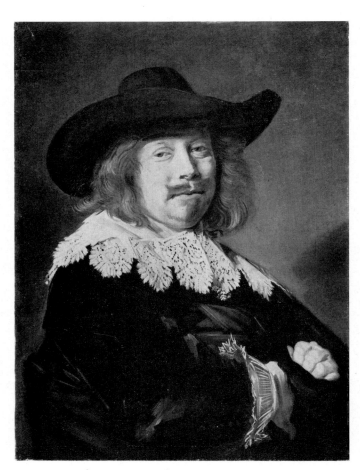

176. *Portrait of a Man.* San Antonio, Texas, Urschel Estate. Cat. no. D 55.

177. *Portrait of a Man.* Formerly Warsaw, Count Xavier Branicki. Cat. no. D 56.

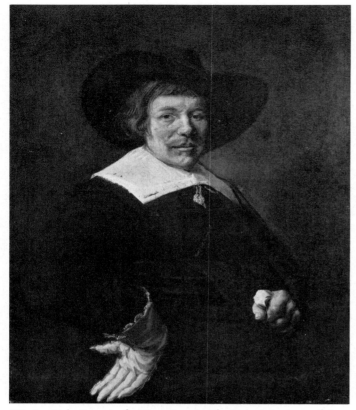

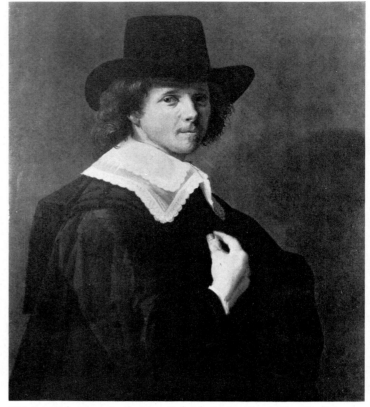

178. Jan Hals: *Portrait of a Man*. Detroit, The Detroit Institute of Arts. Cat. no. D 57.

179. Jan Hals: *Portrait of a Man*. Raleigh, N.C., North Carolina Museum of Art. Cat. no. D 58.

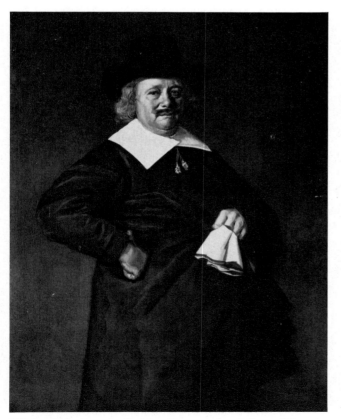

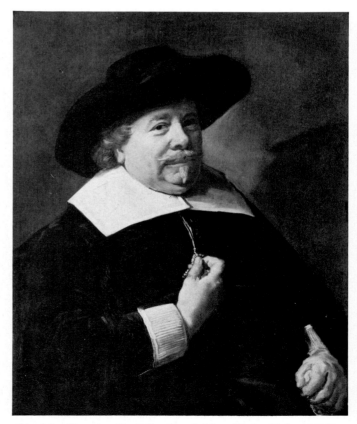

180. Jan Hals: *Portrait of a Man*. Toronto, Art Gallery of Ontario. Cat. no. D 59.

181. *Man Fingering his Collar Tassel*. New York, Barker Welfare Foundation. Cat. no. D 60.

182. *Portrait of a Man*. Formerly Hamburg, Carl Mandl. Cat. no. D 61.

183. *Portrait of a Man in a Painted Oval*. Dortmund, H. Becker. Cat. no. D 62.

184. *Portrait of a Man*. Zürich, Kunsthaus, Ruzicka-Stiftung. Cat. no. D 63.

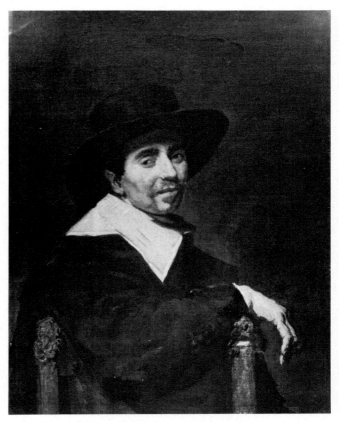

185. *Portrait of a Man*. Amiens, Musée de Picardie. Cat. no. D 64.

186. *Portrait of a Woman*. Atherstone, Warwickshire, Sir William Dugdale. Cat. no. D 65.

187. *Portrait of a Woman*. Formerly Toronto, Albert L. Koppel. Cat. no. D 66.

188. *Portrait of a Girl, profile to the right*. Indianapolis, Indiana, Mr. and Mrs. A. W. S. Herrington. Cat. no. D 67.

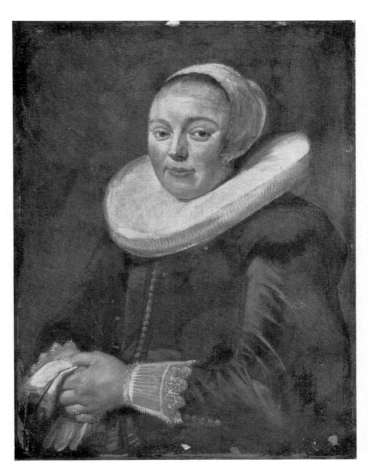

189. *Portrait of a Woman*. Gothenburg, Art Gallery. Cat. no. D 68.

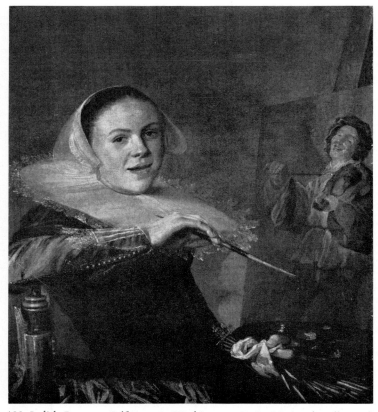

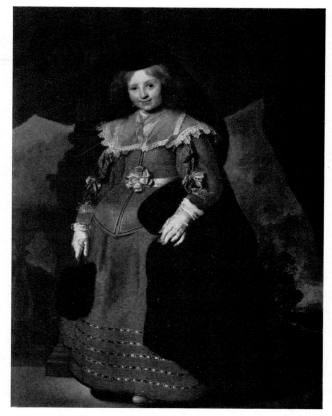

190. Judith Leyster: *Self-Portrait*. Washington, D.C., National Gallery of
Art. Cat. no. D 69.

191. Attributed to Pieter Soutman: *Emerentia van Beresteyn*.
Waddesdon Manor, National Trust. Cat. no. D 70.

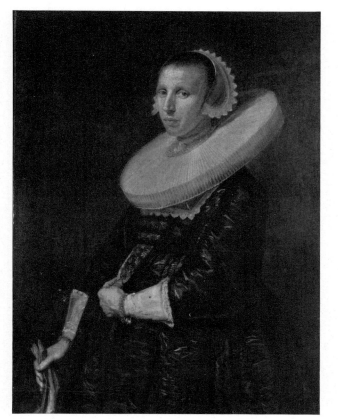

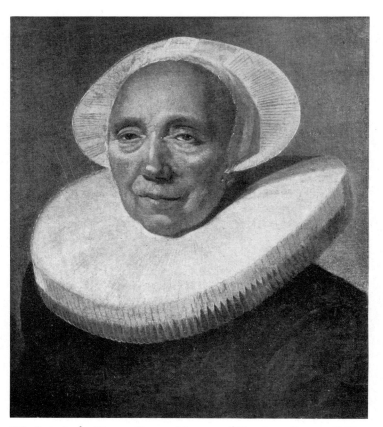

192. *Portrait of a Woman*. Moscow, Pushkin Museum.
Cat. no. D 71.

193. *Portrait of a Woman*. Boston, Museum of Fine Arts. Cat. no. D 72.

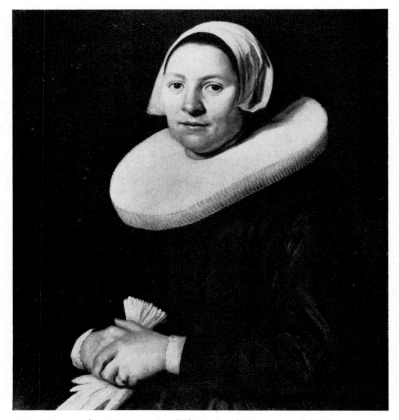

194. *Portrait of a Woman*. Cardiff, National Museum of Wales. Cat. no. D 73.

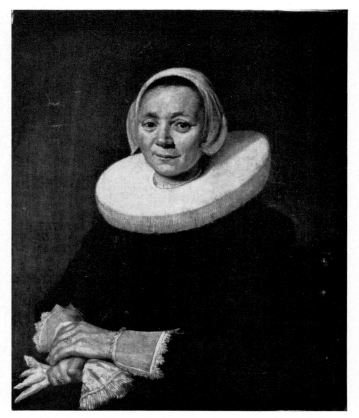

195. *Portrait of a Woman*. Coburg, Landesmuseum Veste Coburg, on loan from Stiftung Preussischer Kulturbesitz. Cat. no. D 74.

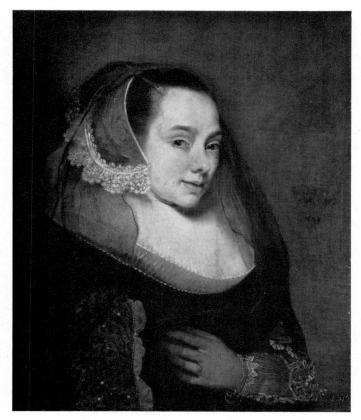

196. Attributed to Pieter Soutman: *Portrait of a Woman*. Warsaw. National Gallery. Cat. no. D 75.

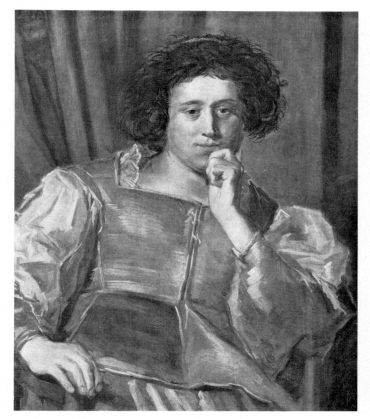

197. *Portrait of a Woman*. Location unknown. Cat. no. D 79.

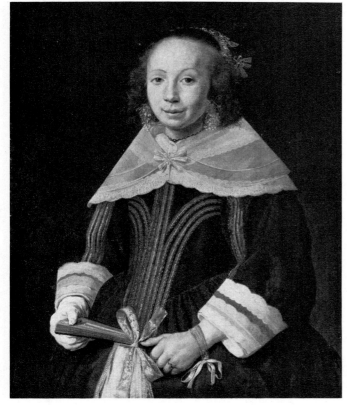

198. Jan Hals: *Portrait of a Woman*. Los Angeles, Los Angeles County Museum. Cat. no. D 76.

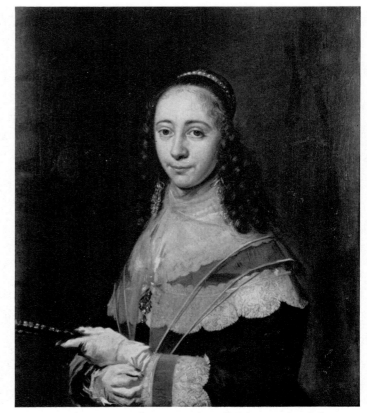

199. Jan Hals: *Portrait of a Woman* (so-called 'Frau Schmale'), 1644. Dresden, Gemäldegalerie. (See Cat. no. D 76.)

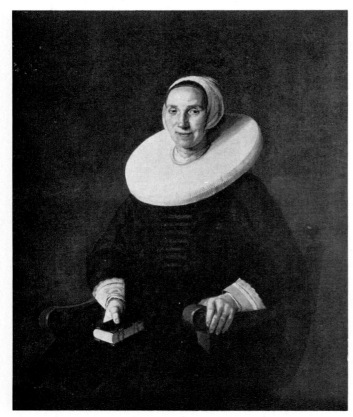

200. Jan Hals: *Portrait of a Woman*. 1648. Boston, Museum of Fine Arts. Cat. no. D 77.

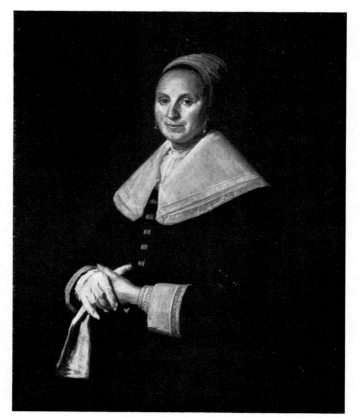

201. *Portrait of a Woman*. Formerly New York, Joseph Samson Stevens. Cat. no. D 78.

202. Attributed to Pieter Soutman: *Paulus van Beresteyn and His Family*. Paris, Louvre. Cat. no. D 80.

203. *Family Group in a Landscape*. San Diego, Fine Arts Gallery. Cat. no. D 81.

Francine Clark Art Institute, Williamstown, Massachusetts (Fig. 135):

> Canvas, 62·2 × 48·2 cm. Signed at the lower right with the connected monogram: FH
> PROVENANCE: Dealers Colnaghi, London, who sold it to Sterling Clark in 1914.
> BIBLIOGRAPHY: KdK 245 (ca. 1649–50).

First published by Valentiner (KdK 245), who stated that it had been in an English collection since the beginning of the eighteenth century. A photograph of a second version of the Clark painting, which was with the dealer H. Paatof, Teheran, 1928, is in the files of the RKD.

D 21. **Boy Smoking a Pipe** (Fig. 136). Groningen, Museum voor Stad en Lande.
Panel, 57·5 × 49 cm.

PROVENANCE: Art dealer, Th. van Wijngaarde; C. Hofstede de Groot, The Hague, who bequeathed it to Groningen, 1923.
BIBLIOGRAPHY: C. Hofstede de Groot, 'Some Recently Discovered Works by Frans Hals', B.M., XLV, 1924, p. 87; W. Froentjes and A. Martin de Wild, 'A Forged Frans Hals', B.M., XCII, 1950, p. 297; Bernard Keisch, 'Dating Works of Art Through Their Radioactivity: Improvements and Application', Science: American Association for the Advancement of Science, CLX, 1968, pp. 413–416.

Erroneously published as an original by Hofstede de Groot in 1924 (op. cit.); its style has nothing in common with Hals or his contemporary followers. Froentjes and De Wild report (op. cit.) that the painting was put through standard laboratory tests to determine its authenticity and most of them revealed nothing conclusive. The density pattern of X-ray photographs revealed that the structure of the panel is normal, the paint surface is in good condition, and there are no pentimenti. A microchemical and spectrographic analysis of the pigments showed the use of lead white, yellow and red ochre, and carbon black, and no pigments which could not have been used in Hals' time, and no modern adulterants. But when Froentjes and De Wild analysed the medium used they made an important discovery:

> After removing the resin-varnish by means of an appropriate organic solvent like alcohol or acetone, the paint-layer resisted this action perfectly, just as a seventeenth-century painting would do. But when brought into contact with water, the paint-layer gradually swelled and could afterwards be removed by the gentlest action. The medium was subsequently identified as a gelatine glue by a special microchemical method of analysis, the so-called partition-chromotography. It was now evident that the picture was a deliberate forgery, and the particular medium had been used for the purpose

of making the paint resist superficial solvent tests, which were in vogue, in order to confirm the age of a painting, and also to produce the hardness of a seventeenth-century paint-film (ibid.).

A subsequent study of the white lead used in the painting confirms that the work is a modern forgery. This study was made in 1968 by Bernard Keisch (op. cit.), who improved a method for approximately dating white lead which is based upon the decay of lead-210 present in recently refined lead. His analysis of white lead samples taken from the painting establish that they date from the twentieth century. For Keisch's analysis of samples of the lead white used in Van Meegeren's *Woman Drinking* see Cat. no. 75.

Along with a *Boy Smoking a Pipe*, Hofstede de Groot published (op. cit.) three other paintings which he wrongly attributed to Frans Hals:

> *A Boy in a Black Hat*, oval canvas, 56 × 46 cm.; purchased from an old Dutch family by a German dealer (repr. ibid., p. 84, Fig. B).
> *An Old Lady*, canvas, 73·5 × 59 cm.; discovered by the Dutch dealer, N. van Slochem, in an English house (repr. ibid., p. 85, Fig. C).
> *Portrait of a Laughing Man* (Fig. 136a), circular panel, diameter 36 cm.; presumably acquired in 1922 or by 1923 by the picture restorer Th. van Wijngaarde in London from a private person (ibid.; also see, B.M., XLVI, 1925, p. 193). On the basis of a certificate of authenticity written in 1923 by Hofstede de Groot the painting was acquired by H. A. de Haas, who sold it in June, 1923 to the dealers Fred. Muller and Co., Amsterdam (fl. 50,000). Shortly afterwards it was recognized by some experts as a modern forgery based on Hals' *Merry Drinker* (Cat. no. 63; Plate 107) and became the subject of an acrimonious law suit in the Dutch courts. For publication of documents related to the case and Hofstede de Groot's heated defence of his attribution see his *Echt of Onecht? Oog of Chemie?*, The Hague, 1925. Otto Kurz, *Fakes*, 2nd revised ed., New York, 1967, pp. 60–61, gives a summary of the pros and cons of the case. A chemical analysis of the painting revealed that the colours are remarkably soft and painted in a gummous medium soluble in water and that the artist used zinc white, which was not commercially available until the end of the eighteenth century, as well as Thénard's blue and artificial ultramarine, which were not produced for artists until the first quarter of the nineteenth century. Hofstede de Groot dismissed the results of the chemical analysis as inconclusive and irrelevant. He argued that only the trained eye of the connoisseur can pass judgement on the authenticity of a work of art. Kurz (ibid., p. 61) rightly notes that Hofstede de Groot's 'antithesis does not exist, and that the evidence of style and science, if correct, will always agree'. The case was settled out of court after Hofstede de Groot bought the painting for

his own collection for fl. 50,000. The portrait is now in a private Rotterdam collection.

D 22. **So-called Itinerant Painter** ('Le Peintre Ambulant')
Versions:
1. Paris, Louvre (R. F. 2130) (Fig. 137).
 Canvas, 85 × 70 cm. Signed and dated on the upper left corner of the painting on the easel: F.H./1640.
 PROVENANCE: According to Hofstede de Groot (306), in the Lemprière collection, Jersey, since 1805; sale, Boymans, Utrecht, 31 August, 1811, no. D 26; possibly Roxard de la Salle, Paris, 28 March 1881; Comte Boni de Castellane; dealer Sedelmeyer, Paris, Catalogue, 1902, no. 18; Baron de Schlichting, Paris, who bequeathed it to the Louvre in 1914.
 EXHIBITIONS: Paris 1911, no. 50; Haarlem 1937, no. 80; Amsterdam, 1952, no. 48; Paris, Louvre, Exposition de 700 Tableaux . . . tirés de Réserves, 1960, no. 419 (attributed to Frans Hals).
 BIBLIOGRAPHY: Moes 40 (presumably the artist's son Reynier Hals); HdG 306 (erroneously dated 1648); Bode-Binder 61 (erroneously dated 1648); M. A. Troubnikoff, 'Paintings in the Schlichting Collection' [in Russian], *Starye Gody*, 1911, April, p. 10; Paul Jamot, 'Acquisitions of the Louvre during the War', *B.M.*, XXXVII, 1920, p. 70; L. Demonts, Louvre, Catalogue, 1922, p. 167, unnumbered (Frans Hals); KdK 244 (erroneously dated 1648; perhaps one of the sons of the artist [Nicolaes? b. 1628]); Trivas, App. 1, note (erroneously dated 1648; apparently a copy).
 The figure depicted on the painting within the painting is related to the old man in Hals' lost *Merry Trio* (Cat. no. L 2; text, Fig. 17). However, the painting within the painting and the easel are most likely later additions. The signature and date of 1640 are false. The pronounced foreshortening and the youth's costume relate the work to Hals' half-length genre pieces of the twenties (see Cat. nos. 24, 26, 61) but the thin execution cannot be ascribed to the artist. The Louvre no longer accepts the old attribution to Frans Hals. There is no foundation for the suggestion made by Moes and Valentiner that the picture may represent one of Hals' sons. Since the easel and painting on it appear to be later additions it is conceivable that the picture was not meant to represent an artist. This supposition is supported by three variants which do not include these props (see below). I have not been able to determine if this portrayal of a youth holding a flower (lily?) or the three weaker versions of it (see below) bear a special meaning which might have been patent to some seventeenth-century observers.
2. Location Unknown.
 Canvas, 78·2 × 62·5 cm.

PROVENANCE: Possibly sale, Roxard de la Salle, Paris (Drouot) 28 March 1881 (77 × 60 cm); dealer K. Erasmus, Berlin, 1925; possibly sale, Earl Howe and others, London (Christie), 7 December 1933, no. 107 (79·5 × 60·4 cm.).
In this version the youth holds a carnation (photo RKD).
3. Miami Beach, Florida, The Bass Museum of Art.
 Canvas, 76·5 × 69 cm.
 PROVENANCE: Art market, Amsterdam, around 1941; John and Johanna Bass, Miami Beach, Florida.
 BIBLIOGRAPHY: Trivas 28 and App. 1, repr. plate 41 (variant); *The John and Johanna Bass Collection at Miami Beach*, Florida, n.d. p. 6, no. 4, repr. on the cover (with incorrect bibliographical references).
 A weak variant.
4. Sale, London (Sotheby), 4 November 1970, no. 87. Canvas, 74 × 62 cm. Wrongly attributed to Jan Miense Molenaer.

D 23. **Boy Playing a Lute** (Fig. 141). England, Private Collection.
Lozenge panel, 18 × 18 cm. Signed at the right with the connected monogram: FH.

PROVENANCE: Baron von der Wense, Lüneberg; dealer A. S. Drey, Munich, 1921; dealer Ch. A. de Burlet, Berlin, 1927.
EXHIBITION: London 1929, no. 56.
BIBLIOGRAPHY: KdK 1921, 285 (*ca.* 1627–30); KdK 67 (*ca.* 1627–30).

Published in 1921 by Valentiner, who noted that the painting is related to the small lozenge panels now at Chicago (Cat. nos. 53, 54; Plates 88, 89) and rightly added 'doch ist die Ausführung weniger prägnant als bei diesen'. In my judgement the painting lacks the incisive brushwork and accents of Hals' little oil sketches.

D 24. **Boy Playing a Violin**
Versions:
1. Richmond, The Virginia Museum of Fine Arts (acc. no. 49.11.32) (Figs. 138, 139).
 Canvas, 75 × 66 cm. Signed at the lower right with the connected monogram: FH.
 PROVENANCE: Possibly sale C. Buys, Amsterdam, 4 April 1827, no. 27, canvas, 78 × 65 cm. (HdG 90a); dealer Sedelmeyer, Paris, Catalogue 1898, no. 45, with the reference that the painting was etched by Ch. Courtrey, for Sedelmeyer's sale catalogue, Vienna, 1872. Baron Albert Rothschild, Vienna; Adolph D. and Wilkins C. Williams collection.
 BIBLIOGRAPHY: Possibly HdG 90a; Catalogue, *European Art in the Virginia Museum of Fine Arts*,

Richmond, 1966, pp. 52–53, no. 78 (attributed to Frans Hals).

The paint layer is considerably abraded and repainted. A relining layer of white lead totally obscures the density pattern of the pigments in X-rays. A chemical analysis made by Rutherford J. Gettens at the Freer Gallery, Washington, D.C., confirmed that the painting does not contain pigments which could not have been used by a seventeenth-century artist.

The best existing version of the composition; related to works by Jan Miense Molenaer and Judith Leyster. I tend to favour an attribution to Judith, and see a connection between it and the group of her paintings which, if not signed, would be attributed to the 'Master of the Upward Glance'; see e.g., *The Serenade* monogrammed and dated 1629, Rijksmuseum (inv. no. 1455 A1); *A Boy and a Girl with a Cat and an Eel*, signed, London, National Gallery (no. 5417); *Flute Player*, monogrammed, Stockholm, National Gallery (inv. no. 1120). Passages of the painting are also similar to the *Lute Player* at Blessington (see Figs. 140, 142; Cat. no. D 25) and to Judith's signed *Portrait of a Woman* dated 1635 at the Frans Hals Museum (Cat. 1969, no. 731, plate 34; also see text, Fig. 112). Horst Gerson also attributes the Richmond painting to Judith Leyster (Virginia Museum, Catalogue, *op. cit.*).

2. Norfolk, Virginia, Chrysler Museum.
 Panel, 78·5 × 67 cm.
 PROVENANCE: Dealer Sulley and Co., London, 1921; Carl Schoen, New York, 1923; dealer John Levey, New York, 1935; L. M. Flesch, New York and Piqua, Ohio; dealer Acquavella, New York; acquired by Walter P. Chrysler, Jr. around 1950.
 EXHIBITIONS: Detroit 1925, no. 5; Detroit 1935, no. 10; New York 1939, no. 175; San Francisco 1940, no. 188; Los Angeles 1947, no. 2; Provincetown, Massachusetts, Chrysler Art Museum of Provincetown, Inaugural Exhibition, 1958, no. 28 (see this catalogue for a list of ten other galleries which exhibited the work after it entered the Chrysler collection around 1950).
 BIBLIOGRAPHY: Possibly HdG 90a? (see Provenance of D 24-1 above); KdK 1921, 284, repr. (*ca.* 1627); KdK 60, repr. (*ca.* 1627); Valentiner 1936, 32, repr.
 When Valentiner published the painting in 1921 and 1923 (KdK 60), he cautiously noted that it may be identical with a picture sold at Amsterdam in the Buys sale, 1827 (see Cat. no. D 24-1). In subsequent publications he and compilers of other catalogues stated that it was identical with the Buys painting. This is doubtful. The Buys painting was painted on canvas; the Chrysler picture is on panel. The painting is a weaker version of D 24-1.
 The Chrysler replica appears to be identical with a variant published in an anonymous article 'Franz or —?', *The Connoisseur*, XLVI, 1916, p. 100, repr.

p. 101; no support or dimensions cited. The author correctly states the painting lacks the supreme quality which one associates with Frans Hals' work. He reveals his male chauvinism when he writes: 'The drawing is uncertain, the expression rather sentimental and wooden (suggesting a woman's work, perhaps Judith Leyster) . . .' (*ibid.*). He adds that this was doubtless the general impression of experts when the picture was sold at the Levy sale in 1876 and only fetched £89, the same year an unquestioned smaller Hals fetched £399. According to him the painting 'was until recently in the Bignold collection' (*ibid.*).

D 25. **The Lute Player** (Figs. 140, 142). Blessington, Ireland, Sir Alfred Beit.

Canvas, 82·8 × 75 cm. Signed at the lower right with the connected monogram: FH.

PROVENANCE: Lord Howe, London; acquired by Sir Otto Beit, London, around 1912.

EXHIBITIONS: Haarlem 1937, no. 42; Cape Town 1952, no. 18; Dublin, Municipal Gallery of Modern Art, *Paintings from Irish Collections*, 1957, no. 91.

BIBLIOGRAPHY: W. Bode, *Catalogue of the Collection of . . . Otto Beit*, London, 1913, pp. 27, 75, no. 24 (*ca.* 1625–1630); Bode-Binder 193; KdK 97 (*ca.* 1631–33; 'Nach HdG eher Judith Leyster. Ich halte das Bild mit Bode für ein zweifelloses und besonders anziehendes Werk des Frans Hals'); E. Plietzsch, 'Randbemerkungen zur holländischen Interieurmalerei . . . , *Wallraf-Richartz-Jahrbuch*, XVIII, 1956 p. 187 (Judith Leyster).

Large areas of the painting have been moderately to severely abraded: the background, around the hat where *pentimenti* are visible, the head, and the lower left section. These parts have been unevenly restored.

In my opinion the attribution to Judith Leyster made by Hofstede de Groot and Plietzch is probably correct. There are striking analogies in style between the left hand of the lutist—which is in a good state of preservation (Fig. 142)—and the left hand of the young *Violinist* at the Virginia Museum of Art (Fig. 139). The tradition that the Beit picture was painted by Hals can be traced back to the middle of the eighteenth century when it was mezzotinted in England by John Faber II (The Hague, 1684-London 1756); his print is inscribed: FRANS HALS PINX[t]. I. FABER FECIT 1754 (Hollstein, vol. VIII, p. 216, no. 24). However, the eighteenth-century tradition is not necessarily correct. For a signed Leyster which was incorrectly engraved in the seventeenth century as a work done after Frans Hals, see Figs. 75, 76.

A copy appeared in the sale, London (Sotheby), 25 June 1947, no. 65; canvas, 82·5 × 75 cm. (B. Barnett).

D 26. **Three Merry Youths, one playing a violin**
(Fig. 143). Oslo, National Gallery (inv. no. 1388).
Panel, 27·3 × 20·9 cm.

PROVENANCE: Sale, Miss Mabel Mosley of Thornhill,
Derby, London (Christie), 15 June 1914, no. 64; dealer J.
Böhler, Munich, who sold it to C. Langaard, Christiania.
BIBLIOGRAPHY: KdK 28 (ca. 1623).

Valentiner, who did not know the original, stated that it
was attributed to Hals by Hofstede de Groot (KdK 28).
In my view its stylistic affinities with Judith Leyster's
monogrammed and dated *Serenade* of 1629 at the Rijks-
museum (Cat. no. 1455 A1; repr. *O.H.*, XLIV, 1927, p. 115,
fig. 2), her nocturnal piece of a *Two Merry Youths* in the
Johnson Collection, Philadelphia (Cat. 1972, no. 440, ('The
gay Cavalier'), repr.; *O.H.*, XLIV, 1927, p. 148, fig. 9), and
her monogrammed painting of *Children Playing with a Cat*
(Fig. 75) place the small painting in Judith's *oeuvre*. Its
close relation to the version of Hals' *Rommel Pot Player* at
Chicago (Fig. 71) and to the oil sketch of a *Standing Man*
at Buckingham Palace (Fig. 16) supports the attribution of
those works to Leyster.
A weak, enlarged variant of the painting was in the
collection of Colonel Warde, Squerryes Court, Westerham,
Kent, panel, 47 × 34·3 cm. A copy of the Warde picture is
in the collection of Neely Grant II, Memphis, Tennessee
(panel, 47 × 37 cm.).
The Oslo picture may be identical with: 'A Violinist and
other Figures' in the manner of Frans Hals (Een Fioolspeeler
en andere Beelden, de manier van Frans Hals) which
appeared in the sale, Anthony Deutz, Amsterdam, 7 March
1731, no. 44 (30 guilders); Hoet, I, p. 363. Another picture,
possibly identical with the 'Violinist and Other Figures'
which appeared in the 1731 sale, is known from a mezzo-
tint by James Watson (Fig. 144) published by John Boydell
in 1777. Although Watson's print of 'The Musical Boy' is
inscribed 'Francis Halls pinxit' it also appears to qualify as
a work done in Hals' manner, perhaps by Leyster. A
painting after Watson's print was formerly in the coll.
H. E. ten Cate, Almelo; a variant which eliminates the
figures in the background is in the coll. W. G. Carr,
Ditchingham Hall, Norwich; exhibited Agnew, June–
July, 1960, Cat. no. 36.

D 27. **Two Singing Youths** (Fig. 147). Paris, formerly
A. Seligman.
Canvas, 71 × 61 cm. Signed at the lower left with the
connected monogram: FHF. Vertical strokes follow the last
F but is doubtful if they were intended to form a second H.

PROVENANCE: Possibly sale, P. van der Eyck, Leiden, 28
November 1769, no. 24 (83·2 × 76·6 cm.; 21 florins, sold
to van Leijden); possibly sale, J. van der Linden van
Slingeland, Dordrecht, 22 August 1785, no. 169 (66·2 ×
56·2 cm.); sale, Leiden, 26 August 1788, no. 49 (7 florins,

Delfos); sale, Coupry Dupré, Paris, 21 February 1811;
Galerie d'Arenberg, Brussels; Ch. T. Yerkes, New York;
sale, C. T. Yerkes, 5–8 April 1910, no. 120; Arnold
Seligmann of Paris and New York, sale, A. Seligman, Paris,
4 June 1935, no. 29.
EXHIBITION: Detroit 1935, no. 13.
BIBLIOGRAPHY: W. Bürger, *Galerie d'Arenberg à Bruxelles*,
Catalogue, 1859, p. 132, no. 19; Bode 1883, no. 33 (ca.
1627); HdG 136 (it is said they are the artist's sons); Bode-
Binder 48; KdK 116 left (1633–35; possibly earlier).

Bürger [Thoré] wrote that the painting was attributed to
Frans Hals in the 1829 catalogue (no. 31) of the Galerie
d'Arenberg but he ascribed it to Frans Hals the Younger. He
found the painting 'très-vive et très adroite, dont
l'exécution rappelle beaucoup celle de Frans le père; mais
le dessin des mains plus petit, plus faible' (*op. cit.*). I have
not seen the original but to judge from good photographs
I agree that the work cannot be given to Frans Hals. The
slickness of the paint which models the heads and hands
as well as lapses in the drawing noted by Thoré-Bürger
show the work of a follower. However, the attribution of
the work to Frans II, which Bürger based on his interpre-
tation of the monogram (FHF = Frans Hals Franszoon) is
not acceptable. The father had the same initials and
occasionally used the FHF monogram (see Cat. nos. 36, 37),
and there is no reason to suppose that it was not employed
by followers and copyists who wanted to pass off their
works as originals. The invention of D 27 is an attractive
one and may have been derived from a lost bright, blond
Hals of the twenties, but it is doubtful if the original
showed the two children in a corner singing to a blank
wall. Hofstede de Groot's claim (136) that it is a com-
panion picture of Cat. no. D 19 is improbable.
A poor copy by an artist who had much greater difficulty
emulating Hals' technique was in the sale, Viscount
Leverhulme, New York (Anderson), 17–19 February 1926,
no. 118, repr., and appeared in the New York market in
the 1950's (canvas, 76·2 × 61 cm.).

D 28. **Young Man Playing a Flute**
Versions:

1. Nyon, Switzerland, Count de Bendern (Fig. 145).
 Canvas, 59 × 53 cm. Signed at the lower left with the
 connected monogram: FH.
 PROVENANCE: Baron de Beurnonville, Paris; dealer
 C. Sedelmeyer, Paris, Cat. 1898, no. 47; Baroness
 Hirsch de Gereuth, Paris; Baron de Forest, Paris,
 who is now Count de Bendern.
 BIBLIOGRAPHY: Moes 221; HdG 88 (replica of our
 Cat. no. D 28-2, but composed in a rectangular
 instead of a lozenge format); Bode-Binder 60;
 KdK 81 left (ca. 1629–30; probably this variant and
 our Cat. no. D 28-2 are both authentic); Valentiner
 1936, 56 note (around 1625).

2. Toledo, Ohio, The Toledo Museum of Art (acc. no. 26.67) (Fig. 146).
Lozenge canvas, 67 × 66 cm. Traces at the lower right of the unusual connected monogram: HF.
PROVENANCE: Lady de Clifford, London; dealer Colnaghi, London, 1907; dealer Knoedler, London; dealer Henry Reinhardt, New York, who sold it to Edward Drummond Libbey, Toledo, in 1908; given to the museum by E. D. Libbey in 1925.
EXHIBITIONS: New York, Hudson-Fulton Celebration, 1909, no. 24; New York, Reinhardt Galleries, 1910; Toledo Museum of Art, Inaugural Exhibition, 1912, no. 178; Cleveland Museum of Art, Inaugural Exhibition, 1916, no. 9; New York, Reinhardt Galleries, 1928; Detroit 1935, no. 14; New York, Wildenstein Gallery, Exhibition in Honor of Her Majesty Queen Wilhelmina, 1952.
BIBLIOGRAPHY: Moes 222; HdG 85; Bode-Binder 59; KdK 81 left, note (probably this variant and our Cat. no. D 28-1 are both authentic); Valentiner 1936, 56 (ca. 1635–40); Toledo Museum of Art, Catalogue of European Paintings, 1939, pp. 88–91 (ca. 1630).

Hofstede de Groot (88) considered the variant now at Nyon the original. Valentiner (KdK 81 left) stated that both are authentic, and wrote (1936, 56) that the Nyon version was probably done around 1625 and the Toledo painting about ten or fifteen years later. I have not seen the Nyon painting but to judge from photographs it has a surety of drawing which the Toledo version lacks. Nevertheless, I find it is as difficult to relate it to Hals' authentic works as to see the artist's hand in the Toledo lozenge. Their liquid touch and dark tonalities indicate that they were done by a follower (or followers?) familiar with Hals' mature style.
Bode 1883, 76, lists a *Young Flute Player* (ca. 1640) with the dealer E. Warneck, Paris, 1878; also see HdG. 33a. The Warneck picture is possibly identical with the Nyon or Toledo picture.

D 29. Singing Youth, with a boy at his right (Fig. 148). Cincinnati, formerly Mrs. William Taft Semple.
Canvas, 60·3 × 50·8 cm.

PROVENANCE: Sale, Albert Levy, London, 16 June 1876 (£267:10s); sale, Baron de Beurnonville, Paris, 9 May 1881, no. 299; dealer C. Sedelmeyer, Paris, Catalogue, 1898, no. 48; dealer E. Warneck, Paris; Charles Stewart Smith, New York; sale, C. Stewart Smith, New York (Anderson), 4 January 1935, no. 56; dealers Scott and Fowles, New York, who sold it to Mrs. William Taft Semple in 1938.
EXHIBITIONS: New York, Hudson-Fulton Celebration, 1909, no. 23; Detroit 1935 (not in catalogue); Haarlem 1937 no.' 21; New York 1937, no. 4.

BIBLIOGRAPHY: Bode 1883, 48 (ca. 1650); Moes 225, identical with 226; HdG 135; Bode-Binder 62; KdK 81 right (ca. 1629–30); Valentiner 1936, 6 (ca. 1623–25).

Related to the versions of the *Flute Player* at Nyon and Toledo (Cat. nos. D 28-1, D 28-2), but coarser in execution. The formlessness of the figures cannot be attributed to the state of preservation. An examination made at the Intermuseum Laboratory, Oberlin, Ohio, in 1963 showed that, except for some abrasion of the hair of the principal figure, abrasion of the paint surface is not serious. X-rays reveal two distinct systems of paint in some areas. The light areas seen in the X-rays follow one design, the light areas on the surface follow another. It is not possible to determine the character of painting beneath the visible surface but in my opinion it is patent that the latter was not painted by Frans Hals.
Valentiner (1935, pp. 100; 101, no. 7; 102, no. 8) erroneously attributed two feeble pictures to Hals which he related to Cat. no. D 29. Both works appear to be modern imitations:

1. *A Singing Youth, with a boy at his left* (repr. Valentiner, 1935, p. 93, Fig. 8) Switzerland, formerly private collection; sale, London (Christie), 22 July 1938, no. 66.
Octagonal panel, 30·5 × 24 cm.
2. *Boy Singing* (repr. Valentiner, 1935, p. 93, Fig. 9).
Panel, 26·5 × 20·3 cm. Signed at the centre right with the connected monogram: FH.
PROVENANCE: K. Eberth, Nürnberg, 1929; Theo. Stroefer, Nürnberg; sale, Stroefer, Munich (J. Böhler), 28 October 1937, no. 46.
Probably derived from a sixteenth-century Netherlandish work.

D 30. Boy Reading (Fig. 149). Winterthur, Stiftung Oskar Reinhart (Cat. no. 80).
Canvas, 76·3 × 63·4 cm. Signed at the lower right with the connected monogram: FH.

PROVENANCE: F. Fleischmann, London; Mrs. Fleischmann, London; Oskar Reinhart, Winterthur.
EXHIBITIONS: London, dealer T. Lawrie, 1903, no. 3; Bern, Collection Reinhart, 1939–40, Cat. no. 119; Winterthur, Kunstmuseum, Die Privatsammlung Oskar Reinhart, 1955, no. 85.
BIBLIOGRAPHY: Moes 250; HdG 41 (ca. 1635); Bode-Binder 55; KdK 192 (ca. 1640; 'Das reizende Bild wirkt in der Komposition fast zu zahm für Frans Hals, doch urteile ich nur nach der Photographie'); J. Harms, *O.H.*, XLIV, 1927, pp. 124–25; p. 242, no. 29 (Judith Leyster).

Neither the attribution made by earlier cataloguers to Frans Hals nor Harms' ascription to Judith Leyster (*op. cit.*)

is convincing. Valentiner (KdK 192) suggested that the model may have been the same youth who posed for our Cat. no. D 31, and is probably one of Hals' sons, perhaps Nicolaes Hals (born 1628). I cannot accept these suggestions. However, the messy treatment of the boy's heavy hair and the plume on his beret relates the painting to Cat. no. D 31. It also bears some resemblance to the variants of the *Flute Player* at Nyon and Toledo (Cat. nos. D 28-1, D 28-2). The subject is as unusual for Hals as it is in seventeenth-century Dutch painting. Apart from Rembrandt's portrait of *Titus* at Vienna (Bredius-Rembrandt 122), I cannot cite another life-size, half-length of the period which shows a youth engrossed in reading.

D 31. **Young Man in a Plumed Hat** (Fig. 150). Detroit, Mrs. Edsel B. Ford.

Canvas, 76·2×63·5 cm. Signed in the lower right corner with the connected monogram: FH.

PROVENANCE: W. A. Coats, Skelmorlie Castle, Dumfries; dealer Lawrie and Co., London, 1908; dealer Duveen, New York; Edsel B. Ford, Detroit.
EXHIBITIONS: London, dealer T. Lawrie, 1903, no. 13; The Hague 1903, no. 40a; Detroit 1935, no. 43; Haarlem 1937, no. 94.
BIBLIOGRAPHY: Moes 163; HdG 103, identical with HdG 364c; Bode-Binder 63; KdK 228 (*ca.* 1645); W. R. Valentiner *e.a.*, *Unbekannte Meisterwerke in öffentlichen und privaten Sammlungen*, vol. I, New York, 1930, no. 49, entry by F. Schmidt-Degener; Valentiner 1936, no. 86 (*ca.* 1645).

The overly conspicuous monogram is dubious. Vaguely related to Cat. no. D 30 but not to Hals' originals. Hofstede de Groot (103) most likely erred when he wrote that the right hand, stretched out to the right foreground, formerly rested on a skull, which has been painted out. The painting does not show a trace of the skull and it requires a wild leap of the imagination to conjure up an image which fits Hofstede de Groot's description. Perhaps Hofstede de Groot confused the painting with Hals' *Young Man Holding a Skull* (Cat. no. 61; Plate 97), which was also with the London dealer Lawrie. The anonymous follower's laboured touch in the hair, the plume and the collar, and his failure to give form to the mantle draped around the figure, become painfully patent when the painting is compared to Cat. no. 61. The architectural background— if one can call it that—is hard to decipher.
A small, weaker variant showing the youth resting his right arm on a pier was in the London art market in 1971. In this version a skull rests on the ledge behind the model and an incongruous and poorly painted landscape is seen in the background. The painting is signed with the connected monogram in the lower right corner.

D 32. **Fishergirl** (Fig. 151). Cologne, Wallraf-Richartz-Museum (no. 2531).

Canvas, 65·5×56 cm.

PROVENANCE: Sale, F. J. Gsell, Vienna, 14*ff.*, March 1872, no. 41; Wilhelm Adolph von Carstanjen; acquired by the museum in 1936.
EXHIBITIONS: Düsseldorf 1904, no. 318; Haarlem 1937, no. 48; Schaffhausen 1949, no. 44.
BIBLIOGRAPHY: Bode 1883, 95 (*ca.* 1625); Moes 258; HdG 110; Bode-Binder 75; KdK 115 (*ca.* 1633-35); H. Vey and Annamaria Kesting, *Katalog der niederländischen Gemälde* . . . , Wallraf-Richartz-Museum, 1967, pp. 51-52, no. 2531 (manner of Hals; done in his time).

The paint surface is severely abraded and flattened; many scattered losses; extensive retouching in the background. Although allowances must be made for the poor state of preservation, the brushwork is too indecisive and the forms remain too amorphous for it to be accepted as an original by Hals. It was probably done by an anonymous contemporary follower and to judge from the dark tonality and streaming brushwork this artist was active after Hals painted his genre pieces of the 1630's. Analysis of the pigments established that the painting contains none which indicate it was done by an eighteenth- or nineteenth-century imitator (Wallraf-Richartz-Museum Cat. 1967, p. 52). Similarities between the treatment of the head, hair and white blouse, and analogous passages in the *Fishergirl* at Cincinnati (Cat. no. D 33; text, Fig. 142) and *Malle Babbe* at the Metropolitan Museum (Cat. no. D 34, text, Fig. 146) suggest these works may have been painted by the same artist.
The appearance of the Cologne fishergirl in paintings by Jan Miense Molenaer which include copies of other fisher children painted by Hals (see text, pp. 143-144; text, Figs. 143-144) as well as two variants of the composition support the view that the known versions are based upon a lost original. The variants, which show less of Hals' style than the Cologne version, are:

1. Duisburg, Günther Henle (Fig. 152).
 Canvas, 69×64 cm.
 PROVENANCE: Sir Stafford Howard, London; Lady Howard, Stepney; Mrs. Howard, Stepney.
 EXHIBITION: Cologne, Wallraf-Richartz-Museum, *Die Sammlung Henle*, Catalogue, 1964, no. 15.
2. Location unknown (Fig. 153).
 Panel, 31×27·3 cm. Signed at the lower right with the connected monogram: FH.
 PROVENANCE: Private collection, Dublin; sale, London (Christie) 20 March 1959, no. 91; dealer L. Koetser, London, 1959; Graham Baron Ash, Wingfield Castle, Diss, Norfolk; sale, anon., London (Christie), 4 October 1967, no. 138 (£5,040).

D 33. **Fishergirl** (Fig. 154; text, Fig. 142; text, p. 143). Cincinnati, Cincinnati Art Museum (inv. no. 1946.92). Canvas, 76·8×63 cm. Signed with the connected monogram on the keg: FH.

PROVENANCE: In the previous literature (see Bibliography below) the painting is said to be identical with HdG 113, a picture Hofstede de Groot listed from the sale catalogue, J. van der Velden, Amsterdam, 3 December 1781, no. 29 (28 florins, 10; with its untraceable pendant [HdG 57]). That picture, however, is described as on panel, 63·7× 50 cm., 'A Young Girl. Half Length. She wears a Fisherman's Hat'; it is doubtful if it is identical with the Cincinnati painting. According to the files of the museum the painting was in the collection of John Lambert and then with Sir Richard Paget, Bart. Dealer Sulley and Company, London; dealer Scott and Fowles, New York; Mary Hanna, Cincinnati, who gave it to the museum in 1946.
EXHIBITIONS: Detroit 1935, no. 29; Haarlem 1937, no. 56; New York 1937, no. 12; Los Angeles 1947, no. 10.
BIBLIOGRAPHY: Bode-Binder 85; KdK 132 right (ca. 1635); Valentiner 1936, 51 (ca. 1635).

Except for slight abrasion in the background the painting is in a good state of preservation. The detached brushwork which animates the surface without effectively defining spatial relationships and the absence of middle tones used by Hals to fuse lights and darks relate the work to Cat. nos. D 32, D 34. Perhaps these three border-line pictures were done by the same anonymous hand.
The fishergirl, like the Cologne fishergirl (Cat. no. D 32) appears in paintings by Jan Miense Molenaer along with other fisherfolk painted by Hals, suggesting that the painting is based on a lost authentic work (see text, pp. 143–144; text, Figs. 143–144).
A reduced copy of the upper part is in the Hallwyl Collection, Stockholm, Grupp XXXII, B. 105, p. 248, repr.; canvas, 25·3×19·7 cm.
 PROVENANCE: Dealer F. Muller and Co., Amsterdam, 1903.
 BIBLIOGRAPHY: HdG 111; Granberg 1911, p. 106, no. 475; Bode-Binder 86; KdK 132 right, note (studio replica).

D 34. **Malle Babbe** (Fig. 155; text, Figs. 146, 156; text, pp. 146, 151–152); New York, The Metropolitan Museum of Art (Cat. 1954, no. 71.76).
Canvas, 73×58·5 cm. Signed at the lower right with the connected monogram: FH.

PROVENANCE: Comte Cornet, Brussels; Lord Palmerston, Broadlands; purchased by the museum in 1871.
EXHIBITIONS: Haarlem 1937, no. 62; Haarlem 1962, no. 31.
BIBLIOGRAPHY: Moes 261; Icon. Bat. 748-2; HdG 109;

Bode-Binder 69; KdK 141 (ca. 1635–40); Metropolitan Museum, Cat. 1931, no. H. 161-I (probably Frans Hals the Younger); Valentiner 1936, 57 (1635–40); Trivas 33 b (repetition by a contemporary of Hals); Metropolitan Museum, A Concise Catalogue, 1954, p. 46, no. 71.76 (Frans Hals).

The New York picture or another version of it was etched in reverse (text, Fig. 152) by Louis Bernhard Coclers (1740–1817) and inscribed: 'Fr Halls pinxt. L. B. Coclers sculpt./Babel van Harlem/uw uil schijne u een valk, o Babel! 'k ben te vreen/Speel met een valsche pop, gij zijt het nit alleen' (Babel of Haarlem, to you, your owl is a falcon. O Babel, I am glad of it, Play with an illusion. You are not alone); Siccama, no. 23.
This is the best of the known variants of Hals' Malle Babbe but it falls short of his originals. It may be a copy of a lost painting by the artist or a variation done by a gifted follower (also see text, p. 146). Its technique suggests that it was possibly painted by the anonymous artist who painted the fishergirls at Cologne and Cincinnati (Cat. nos. D 32, D 33; Figs. 151, 154). Valentiner's claim (KdK 141; 1936, 57) that it is a pendant to Peeckelhaering at Cassel (our Cat. no. 64) is not convincing.
Hille Bobbe [sic] and a Smoker (text, Fig. 155), attributed to Frans Hals the Younger at Dresden (Cat. 1930, no. 1406), is a pastiche of the New York Malle Babbe, the Smoker by Adriaen Brouwer (text, Fig. 154) at the Louvre and a fish still life similar to those Abraham van Beyeren painted during the 1650's and 1660's (see text, Fig. 157). There is no foundation for the attribution of the Dresden picture to Frans Hals the Younger, and Moes' suggestion (Icon. Bat., 748-4) that the Dresden potpourri was conceivably painted by Hals' son after an original by his father is incomprehensible. The ascription of the New York Malle Babbe to Frans the Younger (Metropolitan Museum, Cat. 1931, no. H. 161-I) is also baseless. According to I. Bergström (Dutch Still-Life Painting in the Seventeenth Century, New York, 1956, p. 230) the earliest fish still life by Van Beyeren is dated 1651; the latest are dated 1666. I do not accept F. Winkler's attribution of the Louvre Smoker to Brouwer's follower Joost van Craesbeeck (Pantheon, XVII [1936], p. 163).
A poor copy of the Metropolitan Museum's painting was in a private collection, Rumson, New Jersey, around 1960 (canvas, 75·8×60·9 cm.).

D 35. **Seated Woman** (Fig. 156; text, p. 146; text, Fig. 147). Lille, Musée des Beaux-Arts (Cat. 1893, no. 370; Inv. P. 302).
Canvas, 72×59 cm.

PROVENANCE: Dealer Warneck, Paris; purchased by the museum in 1872.
BIBLIOGRAPHY: Bode 1883, 81 (ca. 1645; not 'Hille Bobbe'); Icon. Bat. 784-3 ('Hille Bobbe'); Moes 262

('Hille Bobbe'); HdG 115 (not 'Hille Bobbe' but painted around the same time as the Berlin picture; the background appears to be completely overpainted); Bode-Binder 70 (Malle Babbe?); KdK 144 (ca. 1635–40; Malle Babbe?); Trivas 33, note (erroneously attributed to Hals).

According to *Cent Chefs-d'Oeuvre du Musée de Lille*, 1970, p. 110, a technical examination of the work established that it does not contain pigments which could not have been used by the artist. The author of the entry also maintains (*ibid.*) that the painting was executed by Hals after the same model who posed for *Malle Babbe* at Berlin-Dahlem (Cat. no. 75; Plate 120). I do not find the reasons offered to support these conclusions acceptable.

A poor variant showing the woman holding a pipe was in the sale, Zürich (Gal. am Neumarkt), 6 November 1940, no. 54, repr. (canvas, 80 × 66 cm.).

D 36. Seated Woman Holding a Jug (Fig. 157; text, p. 146, text, Fig. 148). New York, Jack Linsky.
Canvas, 65 × 60 cm.

PROVENANCE: Purchased by Edward W. Mills *ca.* 1850; inherited by Brigadier General R. J. Cooper, London; sale, London (Christie), 12 December 1947, no. 8; dealer Agnew, London, 1952.
EXHIBITIONS: London, Royal Academy, 1910, no. 75; London 1938, no. 161.
BIBLIOGRAPHY: HdG 121a?; KdK 1921, 134; KdK 145; Trivas 33, note (erroneously attributed to Frans Hals).

When Valentiner (KdK 1921, 134) published the painting he dated it *ca.* 1635–40 and suggested it may represent Malle Babbe. He added that it 'Wirkt etwas schwach im Vergleich zu den anderen Darstellungen der Malle Babbe'. In my opinion it neither represents Malle Babbe nor can it be justifiably attributed to Hals.

D 37. Portrait of a Man (Fig. 158). Berlin, formerly Ludwig Knaus.
Oval panel, 25 × 18·5 cm.

PROVENANCE: Ludwig Knaus, Berlin, sale Knaus, Berlin (Lepke), 30 October, 1917 no. 11; sale, Camillo Castiglioni of Vienna, Amsterdam, 17–20 November 1925, no. 63; dealer K. W. Bachstitz, The Hague, 1926.
EXHIBITION: Berlin 1890, no. 78.
BIBLIOGRAPHY: Moes 167; HdG 260 (very early; *ca.* 1610–12; when it was exhibited at Berlin, 1890, several connoisseurs called it T. de Keyser); Bode-Binder 87; KdK 7 (*ca.* 1615; neither De Keyser nor Buytewech but Hals); George Poensgen, 'Beiträge zur Kunst des Willem Buytewech, *Jahrbuch der preussischen Kunstsammlungen*, XLVII, 1926, pp. 96*f.* (Buytewech, *ca.* 1615); Jan S. Kunstreich,

Der 'Geistreiche Willem': Studien zu Willem Buytewech, Kiel, 1959, p. 31, no. XVIII (doubtful if it is Buytewech); E. Haverkamp Begemann, *Willem Buytewech*, Amsterdam, 1959, p. 76, no. 13 (possibly Buytewech).

The portrait has been untraceable since 1926. No definitive attribution can be given until it is located but I can see no reason to attribute it to either Hals or De Keyser. The most probable candidate is Buytewech. Haverkamp Begemann rightly points out the close relationship of the little portrait to Buytewech's silvery pen drawing of a *Boy in an Oval Medallion* at Düsseldorf (*op. cit.*, repr. fig. 105).

D 38. Portrait of a Man (Fig. 160). Frankfurt, Städelsches Kunstinstitut (inv. no. 292).
Copper, 21·6 × 14·4 cm. Inscribed at the upper right: AETAT: SVAE 24/A° 1624.

PROVENANCE: Collection of Johann Friedrich Städel (1728–1816), founder of the museum.
BIBLIOGRAPHY: Bode 1883, 110 ('earlier called an "imitation of A. van Dyck" now "manner of F. Hals"'); HdG p. 140, note 9 (not Frans Hals); KdK 39 (Frans Hals); *Städelsches Kunstinstitut, Verzeichnis der Gemälde*, 1966, p. 50 (school of Frans Hals).

Bode accepted the work in 1883 but omitted it from his 1914 catalogue. The little portrait was rejected by Hofstede de Groot. Valentiner championed the attribution and found similarities between it and Hals' *Laughing Cavalier* (Cat. no. 30; Plate 52). I find the execution as well as the model's attitude too tame for Hals. The work is of the period and was evidently done by an artist who had close contact with Hals but I do not recognize the hand of its author.

D 39. Portrait of a Man (Fig. 159). Paris, Baroness G. W. H. M. Bentinck-Thyssen-Bornemisza.
Oval copper, 12·4 × 9·7 cm.

PROVENANCE: Collection Schiff, Paris; A. Beit, London; F. Kleinberger, Paris; Collection Tietjen, Amsterdam; Heinrich Baron Thyssen-Bornemisza, Lugano-Castagnola.
EXHIBITIONS: Birmingham, 'Some Dutch Cabinet Pictures of the 17th Century', 1950, no. 24; Amsterdam, 1952, no. 43; Paris, Institut Néerlandais, Choix de la Collection Bentinck, 1970, no. 25.
BIBLIOGRAPHY: HdG 205; Bode-Binder 227; KdK 40 (*ca.* 1624; the attribution is not certain); *Sammlung Schloss Rohoncz, Verzeichnis der Gemälde*, 1937, pp. 67–68, no. 182.

Valentiner (KdK 40) expressed justifiable doubts about the attribution. The tiny portrait can be dated around 1625–30

on the basis of the high falling ruff and the slashed sleeves of the jacket. A comparison with Hals' small portraits done around this time (see Cat. nos. 35, 36, 37, 48, 50, 51; Plates 67, 60, 61, 82, 74, 76 respectively) shows that the head lacks the lively touch Hals gave his miniature-like paintings during these years.

D. 40. **Portrait of a Boy** (Fig. 162). Stockholm, National Museum (inv. no. 3384).
Irregular oval panel, 16·6 × 16·3 cm.

PROVENANCE: Possibly Earl Spencer, Althorp; dealer Sulley, London; acquired by Carl von Hollitscher, Berlin in 1905; bequeathed to the museum by Hj. Wicander in 1940; stolen in August, 1963; returned to the museum in the same year.
BIBLIOGRAPHY: Possibly identical with Moes 149 and Moes 150; HdG 40, possibly identical with HdG 268; Bode-Binder 36; KdK 1921, 89 (*ca.* 1630; the attribution is not certain); KdK 92 (*ca.* 1630); Axel Sjöblom, 'Ett gossporträtt av Frans Hals . . .', *Konsthistorisk Tidskrift* x, no. 1, 1941, pp. 20–25 (Frans Hals); Stockholm, National Museum, Catalogue, 1958, p. 87, no. 3384 (school of Frans Hals).

In 1921 Valentiner expressed doubts about the attribution; he withdrew them in the second edition of his catalogue (KdK 92). Sjöblom's attempt (*op. cit.*) to establish the authenticity of the picture has been rightly rejected by the author of the 1958 Stockholm catalogue, whose suggestion that it may be by Judith Leyster is probably right. To be sure, the small portrait does not approximate the quality of Judith's masterwork, *The Flute Player*, which is also at Stockholm (inv. no. 1120); however, its stylistic affinities with her *Serenade*, monogrammed and dated 1629, Rijksmuseum (inv. no. 1455 A1) make the attribution a possible one.
According to Valentiner (KdK 92) F. Lugt owned an inscribed drawing which indicated that the portrait was a copy after a work by Joos van Cleve. I have been unable to locate the drawing and Carlos van Hasselt, Director, Fondation Custodia, Paris, has kindly informed me that no drawing answering the description is now in the Lugt collection. However, there can be no question that the small beret the boy wears is anachronistic and that similar ones are worn by the youths and men portrayed by Van Cleve and Jan van Scorel. The late Dutch mannerists frequently copied or drew inspiration from their great sixteenth-century predecessors. The little Stockholm portrait indicates that their successors continued their practice.
I have not seen the *Portrait of a Boy, profile to the left*, Private Collection, on loan at the Museum, Elberfeld in 1923 (circular panel, diameter 25 cm., HdG 317, KdK 93 repr.). It also appears to be derived from sixteenth-century portraiture. Its relation to Hals' authentic works

appears to be remote; Valentiner understandably wrote: 'Die Zuschreibung ist nicht ganz sicher' (KdK 93). To judge from photographs, Hans Schneider's suggestion that it is Hals' portrait of Brouwer is improbable (see Hans Schneider, 'Bildnisse des Adriaen Brouwer' in *Festschrift für Max J. Friedländer*, Berlin, 1927, p. 154, repr. p. 152, Fig. 5). Provenance: sale, P. A. B. Widener of Philadelphia, Amsterdam (Muller) 30 June 1909, no. 8, repr.; Nardus, Suresnes; dealer Goudstikker, Amsterdam.

D 41. **Portrait of a Boy, profile to the right** (Fig. 164). Philadelphia, John G. Johnson Collection (Cat. 432).
Panel, 14·3 × 11·4 cm. Signed at the lower right with the connected monogram: FH.

PROVENANCE: P. A. B. Widener, Philadelphia; dealer Duveen, New York, from whom it was purchased in 1909 by John G. Johnson, Philadelphia.
EXHIBITION: Detroit 1935, 17a.
BIBLIOGRAPHY: Probably Moes 249; HdG 44; W. R. Valentiner, [*Johnson*] *Catalogue . . . Flemish and Dutch Paintings*, vol. II, Philadelphia, 1913, no. 432; Bode-Binder 38; KdK 78 left (*ca.* 1629–30); Valentiner 1936, 28 (*ca.* 1629–30); *Catalogue, John G. Johnson Collection*, 1941, no. 432 (Frans Hals); *John G. Johnson Collection: Catalogue of Flemish and Dutch Paintings*, 1972, no. 432 (school of Frans Hals).

Companion picture to Cat. no. D 42. Valentiner's suggestion that these tiny oil sketches represent Hals' sons Pieter and Jacob is fanciful (KdK 78 left; 1936, 28). The style of both oil sketches is only superficially related to the artist's small portraits, and the large monograms are dubious. The paintings are probably the work of a late imitator.

D 42. **Portrait of a Boy, profile to the left** (Fig. 165). Philadelphia, John G. Johnson Collection (Cat. 433).
Panel, 14·3 × 11·2 cm. Signed at the lower left with the connected monogram: FH.

PROVENANCE: P. A. B. Widener, Philadelphia; dealer Duveen, New York, from whom it was purchased in 1909 by John G. Johnson, Philadelphia.
EXHIBITION: Detroit 1935, 17b.
BIBLIOGRAPHY: Probably Moes 251; HdG 43; W. R. Valentiner, [*Johnson*] *Catalogue . . . Flemish and Dutch Paintings*, vol. II, Philadelphia, 1913, no. 433; Bode-Binder 39; KdK 78 right (*ca.* 1629–30); Valentiner 1936, 29 (*ca.* 1629–30); *Catalogue, John G. Johnson Collection*, 1941, no. 432 (Frans Hals); *John G. Johnson Collection: Catalogue of Flemish and Dutch Paintings*, 1972, no. 433 (school of Frans Hals).

Companion picture to Cat. no. D 41.

D 43. **Portrait of a Man** (Fig. 163). Utrecht, Kunsthistorisch Instituut, Rijksuniversiteit Utrecht, on loan from Dienst voor 's-Rijks Verspreide Kunstvoorwerpen, The Hague, inv. no. NK 2301.
Oval panel, 43 × 36·5 cm. Inscribed at the centre right: AETAT SVAE 30.

PROVENANCE: dealer Goudstikker, Amsterdam, Cat. no. 14, 1919–1920.
EXHIBITIONS: Amsterdam, Goudstikker, 1926, no. 66; Haarlem 1936, no. 17; Haarlem 1937, no. 38.
BIBLIOGRAPHY: KdK 1921, 80 (ca. 1630; Willem Warmondt); KdK 83 (ca. 1630; Willem Warmondt).

The sitter has been identified as Willem Warmondt (1583–1649) on the basis of his resemblance to the portrait of Warmondt in Hals' group portrait of the St. Hadrian civic guards of Haarlem done around 1627 (Cat. no. 45; Plate 78). In the latter work Warmondt is the prominent Captain seated, with his arm akimbo, in the right foreground. I do not find the likeness close enough to accept the identification. Moreover, the pen which the model for Cat. no. D 43 holds suggests he was a calligrapher, teacher or scholar. Warmondt held some municipal positions (alderman and burgomaster of Haarlem) which could justify the quasi-emblem, but he was a brewer by profession. In the light of seventeenth-century pictorial traditions, it is doubtful if a brewer of the 'Gecroonde Ancker' at Haarlem would have himself portrayed with pen in hand. Warmondt's age also speaks against the identification. The painting can be dated around 1630 on the basis of its style. At that time Warmondt was 47; this sitter, the inscription tells us, was painted when he was thirty.
The attribution of the portrait to Hals is without foundation but it appears to have been done by a Haarlem artist who knew his paintings. J. G. van Gelder's suggestion (oral communication) that it may be one of Bartholomeus van der Helst's early portraits is an attractive one. Van der Helst had moved from Haarlem to Amsterdam by 1636; at that time he was about 23. His earliest traceable dated picture is dated 1637 (*Regents of the Walenweeshuis*, Amsterdam, Walenweeshuis; see J. J. de Gelder, *Bartholomeus van der Helst*, Rotterdam, 1921, p. 229, cat. no. 834, repr. plate 1). Conceivably Cat. no. D 43 shows us what young Van der Helst did before he left his native city.

D 44. **Portrait of a Man, presumably Cornelis Coning** (Fig. 161). New York, Metropolitan Museum of Art (acc. no. 65. 214), and Mrs. Constance W. McMullan, New York.
Canvas, 106·5 × 81 cm. Inscribed at the left: AET SVAE 29/AN° 1630.

PROVENANCE: Acquired by Lord Frederick Campbell from Lord Cremorne in exchange for a Rubens (HdG

295); bequeathed by Lord F. Campbell to an ancestor of Earl Amherst; Earl Amherst, Montreal, Sevenoaks, Kent, 1910; dealer C. Sedelmeyer, Paris, 1914; Collection Gary, New York; sale, Gary, New York (American Art Association) 20 April 1928, no. 33; Charles B. F. McCann, Oyster Bay, Long Island; Helena W. McCann; Mrs. Constance W. McMullan and Mrs. Helena McCann Charlton, New York; half interest of Mrs. Charlton bequeathed to the Museum, 1965, Mrs. McMullan retaining life interest.
EXHIBITIONS: London, Royal Academy 1894, no. 86 (age: 26; date: 1636); London, Royal Academy, 1910, no. 78 (age: 29; date: 1630); Detroit 1925, no. 19; Haarlem 1937, no. 36; Los Angeles 1947, no. 4.
BIBLIOGRAPHY: Moes 134 (age: 26; date: 1636); HdG 295 (date: certainly 1631); Bode-Binder 124 (date: 1631); KdK 91 (1630); Valentiner 1936, 33 (1630); Ella S. Siple, 'Paintings from American Collections now on loan in the Frans Hals Museum at Haarlem, *B.M.*, LXXI, 1937, pp. 90–91 (identification of the sitter as Cornelis Coning); David Reder, *Collection*, XI, no. 35, 28 August 1937, p. 1 (identification of the sitter as Cornelis Coning).

In 1937 Ella S. Siple (*op. cit.*) and David Reder (*op. cit.*) independently identified the sitter as Cornelis Coning (1601–71). They based their identification upon the similarity between the model and the portrait of Coning which appears in Hals' St. George militia piece of 1639 (Cat. no. 124; Plate 201); Coning appears as a Lieutenant in that group portrait (no. 8).
The identification appears to be fairly certain. However, the attribution to Hals is not. The work has Halsian features but all of them are watered down, and even if one assumes that the portrait has been considerably cropped on the right and at the bottom, the figure is awkwardly placed on the canvas and the silhouette it makes lacks the grand baroque sweep of the artist's original designs. Hals' uncanny ability to portray the position of forms in space is lacking here; the model's outstretched right arm (which is curiously short) appears to be in one plane. In my opinion the portrait was painted by an unidentified imitator.

D 45. **Portrait of a Man** (Fig. 166). Bordeaux, Musée des Beaux-Arts (inv. no. 7087).
Canvas, 62 × 52 cm. Inscribed at the right: AETATIS SVAE.../AN° 1632/FRANZ HAALS/PINXIT.

PROVENANCE: Collection Marquis de Lacaze; purchased by the city in 1829.
EXHIBITIONS: Bordeaux, Musée de Peinture, 'La Vie de Musée de 1939 à 1947', 1947, no. 48; Tel-Aviv, Museum, Les Trésors des Musées de Bordeaux, 1964, no. 26; Bordeaux, La Peinture Hollandais du XVIIe Siècle dans les Collections du Musée des Beaux-Arts, 1966, no. 25.
BIBLIOGRAPHY: Bode 1883, 82; Catalogue, Musée de Bordeaux, 1894, no. 237; A. Bredius, 'Nederlandsche

Kunst in Frankrijk', *O.H.*, XXII, 1904, p. 109; Moes 128; HdG 262; Bode-Binder 136; KdK 96.

Hofstede de Groot, followed by Bode-Binder and Valentiner, correctly observed that the last three words of the inscription are false; the rest has either been heavily reworked or is not contemporary with the painting.
Valentiner's penchant for giving names to portraits by or attributed to Hals did not lapse when he catalogued this portrait (KdK 96). He saw a similarity between the model and Van Dyck, as we know the Flemish master from his self-portraits, and asked if it could be the portrait Houbraken tells us Hals painted of Van Dyck (see text, p. 186). In my opinion the answer to his question is negative and the attribution of the portrait to Hals is untenable. The work, which appears to be a fragment from a larger portrait done by an unidentified Haarlem artist active in the 1630's, has rightly been excluded from the helpful *Répertoire* of paintings by Hals and other seventeenth-century Dutch artists in French public collections which was compiled by the authors of the catalogue of *Le Siècle de Rembrandt* exhibition, Paris, 1970–71, pp. 267ff.
A poor copy of the work appeared in the sale, Valdelomar, Lucerne, 31 July 1923, no. 26: panel, 42 × 37·5 cm. (photo RKD).

D 46. **Portrait of a Man** (Fig. 167). Essen, Berthold von Bohlen und Halbach (inv. no. KH 179).
Canvas mounted on panel, 60·2 × 49·2 cm.

PROVENANCE: Richter collection, Leipzig; sale, Richter Gemälde-Kabinett, Leipzig, 8ff., October 1810, probably lot no. 70. Count Wedel, Gross-Zschocher, near Leipzig.
EXHIBITION: Haarlem 1937, no. 46; Essen, Villa Hügel, 'Aus der Gemäldesammlung der Familie Krupp', 1965, no. 35.
BIBLIOGRAPHY: Felix Becker, 'Ein neu aufgefundenes Porträt von Frans Hals', *Zeitschrift für bildende Kunst*, XXII, 1911, pp. 158–160; Bode-Binder 146; KdK 112 (*ca.* 1633); E. Trautscholdt, 'Zur Geschichte des Leipziger Sammelwesens' in *Festschrift Hans Vollmer*, Leipzig, n.d., pp. 227, 250.

The painting was discovered by Felix Becker in a collection near Leipzig and published by him in 1911 (*op. cit.*). He wrote that it appeared in the 1810 Richter sale as a copy after Van Dyck and was sold as a pendant to a putative Van der Helst which was, in fact, a Mierevelt (*ibid.*). Trautscholdt states (*op. cit.*) that Becker probably over-complicated the matter. He notes that no. 70 in the 1810 sale is catalogued as: 'Franz Hals. Ein männliches Bildnis, 26 Zoll hoch, 23 Zoll breit'; the measurements are close enough to suggest that the painting is identical with the Krupp von Bohlen portrait.

The paint surface is flattened and badly abraded; heavily restored in the dark areas of the face, hair, moustaches, beard, torso and background. The shadows in the ruff confuse rather than define forms. Perhaps the portrait once showed some of the fine gradations and intense light effect seen in Hals' *Portrait of a Man* dated 1633 at the National Gallery, London (Cat. no. 81; Plate 148). However, they are lost today and on the basis of what can be seen of the original paint layer I find the ascription to Hals dubious.

D 47. **Portrait of a Man** (Fig. 168). Schwerin, Staatliches Museum (inv. no. 53).
Panel, 42 × 35·2 cm.

PROVENANCE: Acquired by the museum before 1836.
BIBLIOGRAPHY: F. C. G. Lenthe, *Verzeichnis der Grossherzoglichen Gemälde Sammlungen . . . in Schwerin . . .*, 1836, no. 49 (Van Dyck); F. Schlie, *Verzeichnis . . . Schwerin*, 1882, no. 446 (Frans Hals); Bode 1883, 116 (*ca.* 1630; Frans Hals); HdG p. 140, note 10 (school of Frans Hals); *Katalog holländische Maler des XVII Jahrhunderts im Mecklenburgischen Landesmuseum*, Schwerin, 1951, no. 87 (Frans Hals); *Holländische Maler des XVII Jahrhunderts*, Staatliches Museum, Schwerin, 1962, no. 52 (school of Frans Hals).

This portrait, which is probably a fragment, has been correctly rejected as an original by cataloguers of Hals' works since 1910, when Hofstede de Groot called it a school piece. It is close to Pieter de Grebber's works of the thirties.

D 48. **Portrait of a Man** (Fig. 169). Gotha, Schlossmuseum, Schloss Friedenstein (Cat. 1890, no. 109).
Canvas, 64 × 52 cm.

PROVENANCE: The painting was taken to the Soviet Union during or after World War II; returned to the museum in 1959.
BIBLIOGRAPHY: Bode 1883, 108 (*ca.* 1635; not a self-portrait); Moes 141; HdG 278 (*ca.* 1630–35; perhaps a self-portrait); Bode-Binder 127; KdK 100 (*ca.* 1631–33; perhaps a bit earlier); *Schlossmuseum, Gotha, Schloss Friedenstein*, 1959, unpaginated.

I have not seen the painting but to judge from good photographs its mechanical execution makes the attribution to Hals dubious. Ruffs similar to those worn by the model are worn by officers in the Amsterdam militia piece Hals began in 1633 (Cat. no. 80; Plate 134). This helps date the portrait. It also appears to have closer stylistic affinities with the officers in the group portrait who were painted by Pieter Codde than with those done by Hals.

D 49. **Portrait of a Man** (Fig. 170). Beverly Hills, California, formerly Mrs. Elizabeth Taylor Fisher.
Canvas, 77·6×65·9 cm. Signed at the middle right with the connected monogram: FH.

PROVENANCE: Anthony F. Reyre, New York, 1947; Michael Todd, Los Angeles; Mrs. Elizabeth Taylor Todd, Beverly Hills; Mrs. Elizabeth Taylor Fisher, Beverly Hills, sale, Mrs. Eddie [Elizabeth Taylor] Fisher, London (Sotheby) 14 June 1961, no. 88.
EXHIBITIONS: Los Angeles 1947, no. 8 (*ca.* 1635); Raleigh 1959, no. 60 (*ca.* 1635).

The painted surface is moderately abraded. According to Valentiner, who first published the painting in the 1947 Los Angeles exhibition catalogue, the picture was in an English private collection before it was acquired by Anthony F. Reyre. It bears some resemblance to works of the early thirties (*e.g. Portrait of a Man* at Berlin-Dahlem, Cat. no. 88; Plates 150, 152; *Portrait of a Man*, 1633, National Gallery, London, Cat. no. 81; Plate 148), but the confused depiction of the arm resting on the back of the chair, the drapery and chair identify it as the work of an imitator.

D 50. **Portrait of a Man** (Fig. 171). Location Unknown.
Canvas, 77·5×65 cm.

PROVENANCE: Montague Browning, London; Sir Hugh Lane, London; dealer Arthur Ruck, London; dealer Levy Galleries, New York; Mrs. B. F. Jones Jr., Sewickley, Pennsylvania; sale, B. F. Jones, New York (Parke-Bernet), 4–5 December 1941, no. 29; dealer Schneider Gabriel, New York; Ira S. French, New York; sale, London (Christie), 24 May 1963, no. 24 (Acquavella); private collection, Winston-Salem, North Carolina; sale, London (Christie), 26 November 1971, no. 80 (11,000 gns.; Hoteug).
BIBLIOGRAPHY: KdK 1921, 65 (*ca.* 1627–30); KdK 189 (*ca.* 1640); Valentiner 1936, 35 (*ca.* 1630).

First published by Valentiner in KdK 1921, 65. In his 1936 reference to it he states that the sitter wears a warm red jacket. In the painting I have examined, which is reproduced here and which appears to be identical with the one he published, the model's jacket is grey. The portrait is a weak imitation.

D 51. **Portrait of a Man** (Fig. 172). England, Private Collection.
Panel, 24×20 cm.

PROVENANCE: Sale, Double, Paris, 30 May 1881, no. 11 (to Gaucher, for Demidoff; 30,000 francs). In 1883 Bode (1883, 43) wrote that the painting was in the collection Henri Hecht, Paris. However, it did not appear in the

sale, Henri Hecht, Paris, 8 June 1891 as noted by Hofstede de Groot (189). Charles L. Hutchinson, Chicago, who bequeathed it in 1925 to the Art Institute of Chicago (acc. no. 1925.713); sold by the Art Institute to dealers E. and A. Silberman, New York, 1949.
EXHIBITIONS: Paris, Palais du Corps Législatif, 1874; New York, Hudson-Fulton Celebration, 1909, no. 26; Chicago 1933, no. 65; Chicago 1934, no. 92; Detroit 1935, no. 35.
BIBLIOGRAPHY: Bode 1883, 43 (Willem van Heythuyzen) *Icon. Bat.*, no. 3407–4 (Willem van Heythuyzen); Moes 47 (presumably Willem van Heythuyzen); HdG 189 (Willem van Heythuyzen); Bode-Binder 226; KdK 164 (*ca.* 1637; Willem van Heythuyzen?); Valentiner 1936, 39 (*ca.* 1630–1632; Willem van Heythuyzen?).

Moes (47), Valentiner (KdK 164; 1936, no. 39), and the compilers of the 1933, 1934, and 1935 exhibition catalogues rightly raised doubts about the identification of the sitter as Willem van Heythuyzen. The person represented bears only a vague resemblance to Hals' other portraits of him (Cat. no. 31, Plates 56, 57; Cat. no. 123, Plates 196, 198). In my opinion the little painting's affinities with Hals' originals are also vague and its attribution to the artist is dubious. The style suggests a date in the 1630s, but a comparison of the drawing of the head and hands and the treatment of the lace collar with analogous passages in Hals' incisive small oil sketches of the decade (see Cat. nos. 76, 90, 91, 92, 103, 122, 123; Plates 139, 140, 141, 142, 168, 194, 196) reveals a clumsiness and coarseness alien to Hals.
A weak life-size variant attributed to Hals is at the Musée de Castres, France (Cat. 1911, p. 25, no. 76: canvas, 77×62 cm.). This version, which is called a *Portrait of a Painter*, shows the model clasping a chalk holder instead of the tassels of his collar. The change is most likely the invention of a late copyist since the variation on the pose is hardly one which Hals or any of his contemporary followers would set for a colleague. Hofstede de Groot (189, note) cites a copy attributed to Hals in the sale, W. C. P. Baron van Reede van Oudtshoorn, Amsterdam, 14 April 1874 (23×19 cm.); perhaps identical with a copy which appeared in the sale, Cardon (St. Gudule) 28 June 1921, no. 75: canvas, 25×19·5 cm. (photo at RKD).

D 52. **Portrait of a Man in White** (Fig. 173). San Francisco, M. H. de Young Memorial Museum, The Roscoe and Margaret Oakes Foundation (inv. no. L 55.45).
Canvas, 67·2×57·2 cm.

PROVENANCE: Said to have been in the collection Andrew W. Mellon, Washington, 1923; dealer A. Sulley, London; dealer Knoedler and Co., New York; Mrs. Samuel S. Rotan, Philadelphia.

EXHIBITIONS: Dealer Kleykamp, The Hague, 1925, no. 20; Detroit 1935, no. 20; New York 1939, no. 178.

BIBLIOGRAPHY: KdK 106 (*ca.* 1632–34); Valentiner 1936, 38 (*ca.* 1630–32); *European Works of Art in the M. H. de Young Memorial Museum*, 1966, p. 123.

The picture was first published by Valentiner in 1923 (KdK 106). At that time he stated that the portrait was in the possession of Andrew W. Mellon; I have been unable to substantiate this part of the painting's history. He also wrote that the portrait was as masterly as the *Laughing Cavalier* (Cat. no. 30; Plate 52), although done a little later. The painting does indeed have the ingredients which could conceivably make a portrait rivalling the impact of the *Laughing Cavalier*, or more to the point, approximating the effect of the smashing one done around 1633 of the standing ensign on the extreme left of Hals' Amsterdam civic guard portrait (Cat. no. 80; Plates 132, 134). The black-haired model is handsome, and he is dressed to kill in an elaborate lace collar and a white satin suit trimmed with rich golden bows. But the portrait lacks the compelling immediacy and vivacity of those portraits as well as of Hals' other authentic works. The anonymous artist who painted it had a good understanding of Hals' technique but not good enough to lay in the broad tonal relationships which would clearly establish the spatial arrangement of the model's torso and the complex planes of his slashed sleeve before putting in highlights and shadows.

D 53. **Portrait of a Man in a Painted Oval** (Fig. 174). New York, formerly Lionel Straus.
Canvas, 87·5 × 68·5 cm. Inscribed to the right of the head: AETAT SVAE 50/AN° 1635, and signed below the inscription with the connected monogram: FH.

PROVENANCE: Sale, Amsterdam, 21 June 1797, no. 90 (20 florins, with pendant, Aiman); Cassel, Akademie; sale, Lippman von Lissingen of Vienna, Paris, 16 March 1876, no. 21; dealer C. Sedelmeyer, Cat. 1898, no. 49; Maurice Kann, Paris; dealer Kleinberger, New York, Cat. 1911, no. 28; dealers Scott and Fowles, New York; sale, Fowles Estate, New York (American Art Association) 17 January 1922, no. 16; Lionel Straus, New York; sale, Straus Estate, New York (Parke-Bernet) 11 March 1953, no. 9 (Acquavella).

EXHIBITIONS: Vienna, 1873, no. 158; Paris, Jeu de Paume, 1911, no. 61.

BIBLIOGRAPHY: Bode 1883, 38; Moes 95; HdG 304 (incorrect provenance); Bode-Binder 155; KdK 150; Valentiner 1936, 55.

Edward G. Hawke, the English translator of Hofstede de Groot, confused the provenance of this portrait with that of *Joseph Coymans*, which is now at Hartford (Cat. no. 160;

Plate 243). He corrected his error in a subsequent volume of his translation of Hofstede de Groot, *A Catalogue Raisonné of the Works of the Most Eminent Dutch Painters . . .*, London, 1912, vol. IV, pp. vii–viii, no. 304.

The portrait appeared as a pendant of the *Portrait of a Woman* dated 1640, now at Ghent, in sales held in 1797, 1876 and probably in 1819 (see Cat. 136; Plate 210), and the work has been accepted as a companion picture of the Ghent painting by the authors cited in the Bibliography above. Although the Straus painting is related to Hals' portraits of men placed behind simulated stone frames done in the second half of the thirties (see Cat. nos. 108, 111, 113), its feeble execution, poor drawing (particularly of the hands), and the conspicuous absence of an atmospheric effect indicate that it is the work of a follower.

D 54. **Portrait of a Man** (Fig. 175). Glyndon, Maryland, Mrs. Gary Black.
Oval canvas, 78·9 × 63·5 cm. Signed at the left centre with the connected monogram: FH, and dated 163[0?].

PROVENANCE: Dealer Colnaghi, London; Marquis d'Aoust, Paris; dealer Kleinberger, Paris; dealer C. Sedelmeyer, Paris, Catalogue, 1896, no. 18; A. M. Beyers, Pittsburgh; J. Frederic Beyers, Pittsburgh.

BIBLIOGRAPHY: Moes 126; HdG 312; (the numerals look doubtful); Bode-Binder 123; KdK 90; Valentiner 1936, 42.

The signature and date are false. X-rays (file, the Walters Art Gallery, Baltimore) show distinctive tack pulls at the top and bottom of the canvas, indicating that the painting has been cut down from a rectangular format to an oval one (for a painting by Hals which suffered a similar fate, see Cat. no. 133; Plate 215). There are scattered losses.

The style suggests a date closer to the late 1630s than to the false date of 1630 inscribed on it (see Cat. nos. 113, 115, 117 all dated 1638; Plates 182, 184, 186, 188); however, the execution—particularly the gradations of the whites of the collar and cuffs and the blacks of the suit—falls short of the handling seen in Hals' paintings. Perhaps the portrait is an original which suffered and has been heavily restored; this hypothesis helps explain why it was cut into an oval. On the other hand, I would not rule out the possibility that it has been touched up in order to pass as a work by Hals.

D 55. **Portrait of a Man** (Fig. 176). San Antonio, Texas, Urschel Estate.
Canvas, 81·3 × 53·5 cm.

PROVENANCE: Sale, D. P. Sellar of London, Paris, 6 June 1889, no. 37; James Ross, Montreal, Canada; sale, Ross, London (Christie), 8 July 1927, no. 10 (Knoedler, £5,880); dealer Knoedler, New York; Joseph A. Moore,

New York; dealer Knoedler, New York; dealer Howard Young Galleries, New York, 1938.
EXHIBITIONS: London, Royal Academy, 1887, no. 97; The Hague, dealer Kleykamp Galleries, 1927, no. 13; Detroit 1935, no. 41; Haarlem 1937, no. 89.
BIBLIOGRAPHY: Moes 185; HdG 296 (incorrectly called an oval); Bode-Binder 206 (incorrectly called an oval; reproduced plate 130 as rectangular); KdK 220 (*ca.* 1644); Valentiner 1936, 80 (*ca.* 1644).

The paint layer is moderately to severely abraded and retouched throughout by a later hand. The portrait appears to have been derived from Hals' works of the forties but I can see no evidence of his hand in it. I see no reason to accept Valentiner's tentative suggestion that it may be a companion picture to the *Portrait of a Woman* at Cape Town (Cat. no. 162; Plate 249).

D 56. **Portrait of a Man** (Fig. 177). Warsaw, formerly Count Xavier Branicki.
Canvas, 79·3 × 58·4 cm.

PROVENANCE: Collection Konstanty Branicki, Paris, 1882; Count Xavier Branicki, Paris; sale, Countess Rey, Château de Montrésor, London (Sotheby), 26 March 1969, no. 86 (£8,000; P. Truman).
BIBLIOGRAPHY: Moes 183; HdG 319; Bode-Binder 205; KdK 200.

The style but not the execution can be related to Hals' portraits done during the first half of the forties, e.g., *The Portrait of a Man* at Stettin (Cat. no. 148; Plate 228). Since the conception is so close to Hals' half-lengths done during these years it may be a copy of a lost original. Valentiner's suggestion (KdK 201) that the work may have been a pendant to the *Woman Holding a Fan* at the National Gallery, London (Cat. no. 141; Plate 221), is without foundation.

D 57. **Portrait of a Man** (Fig. 178). Detroit, The Detroit Institute of Arts (acc. no. 52.144).
Canvas, 86·2 × 70·8 cm. Signed at the centre right with the connected monogram: iH, and inscribed: AETAT SUA . . . [37?]/1644.

PROVENANCE: Dealer S. T. Smith and Sons, London, 1921; dealer A. Sulley, London, 1923; Walter O. Briggs, Detroit.
EXHIBITION: Detroit 1935, no. 39 (Frans Hals).
BIBLIOGRAPHY: KdK 1921, 198 (Frans Hals); KdK 219 (Frans Hals); Valentiner 1936, 79; Seymour Slive, 'Frans Hals Studies: III, Jan Franszoon Hals', *O.H.*, LXXVI, 1961, p. 180 (Jan Hals).

A badly abraded and badly restored monogrammed Jan Hals which has been erroneously ascribed to his father. A

technical examination may reveal whether the double collar alteration was made by the portraitist or by a later hand. For other portraits by Jan Hals see Cat. nos. D 58, 59, D 76, 77.

D 58. **Portrait of a Man** (Fig. 179; text, Figs. 184, 185, 186; text, pp. 172, 174). Raleigh, North Carolina Museum of Art (acc. no. 52.9.42).
Canvas, 76·2 × 63·5 cm. Inscribed at the centre right: AETATIS·SVAE 24/ANNO 1644. Most probably signed with the connected monogram iH, which has been altered by a later hand into FH (text, Fig. 185; also see diagram below).

PROVENANCE: Von Segesser collection, Zürich; Frans von Segesser, Lucerne.
EXHIBITION: Raleigh 1959, no. 62 (Frans Hals).
BIBLIOGRAPHY: Ludwig Baldass, 'Two Male Portraits by Frans Hals', *B.M.*, XCIII, 1951, pp. 181–182 (Frans Hals); North Carolina Museum of Art, Catalogue of the Paintings, 1956, p. 49, no. 50 (Frans Hals); Seymour Slive, 'Frans Hals Studies: III. Jan Franszoon Hals', *O.H.*, LXXVI 1961, pp. 179–180 (Jan Hals).

The portrait was published in 1951 by Baldass (*op. cit.*) as a monogrammed work by Frans Hals and acquired by the museum as an original. However, the style secures the attribution to his son Jan and most likely it originally bore Jan's monogram (see text, pp. 172, 174). Ben F. Williams, Curator, The North Carolina Museum of Art, kindly provided me with a report of the results of his technical examination of the monogram. For other works by Jan Hals which have been erroneously attributed to his father, see Cat. nos. D 57, D 59, D 76, D 77.

D 59. **Portrait of a Man** (Fig. 180; text, Figs. 181, 182; text, p. 172). Toronto, Art Gallery of Ontario (inv. no. 2523).
Canvas, 127 × 101·6 cm. Inscribed at the centre right: AETATIS SVAE 55/1648, and signed with the connected monogram: iH.

PROVENANCE: Colin Anson, who is preparing a study of the picture collection at Stowe before the memorable 1848 sale, has kindly informed me that the painting and its pendant (Cat. no. D 77) are probably identical with two portraits which appeared in the 1848 Stowe sale cited below. He also provided the other references to the

companion pieces at Stowe which are cited here. The earliest is found in a guide book compiled by B. Seeley (bookseller and stationer in Buckingham), *A Description of the House and Gardens*, 1788, p. 52: 'The State Dressing Room/Over the doors two capital pictures of a Burgomaster and his wife, by *Van-horst*...' The same description is found in the 1797 edition of Seeley's guide book (p. 60); they are not cited in the 1817 edition. In the editions of 1827 (p. 52) and 1832 (p. 55) they are listed in: 'An Ornamented Vestibule/162 A Burgomaster.....Van Hoerst/163 The Burgomaster's Wife.....Ditto.' The attribution of the companion pieces was changed to 'Frank Hals' in a guide book specially printed for the first Duke of Buckingham and Chandos, *A Description of the House and Gardens*, 1838, p. 13: 'The Clarence Rooms [a bedroom and two dressing rooms, west of Hall] 45. Portrait of a Burgomaster, name unknown. Inscribed "Aetatis suae 55, 1648" Frank Hals' and '53. The Burgomaster's Wife. Inscribed "Aetatis suae 47, 1648" Frank Hals'. The inscriptions cited in the 1838 guide book are the basis for the identification of the Stowe portraits as the paintings now at Toronto (Cat. no. D 59) and Boston. The inscriptions cited in the 1838 guide book are the basis for the identification of the Stowe portraits as the paintings now at Boston (Cat. no. D 77) and Toronto (Cat. no. D 59). The probability that the paintings are identical is high. Apart from the fact that Cat. no. D 77 is inscribed '...SVA', not '...suae' (see text, Fig. 179), the inscriptions tally with those on Cat. nos. D 59 and D 77, and no other known companion pieces by Hals or portraits done in his style bear these inscriptions. The portraits appeared in the Stowe sale, 14 September 1848: 'West Staircase. 306 A burgomaster, in a black dress (F. Hals) [Anthony £11·0·6] 307 Portrait of a Lady—the companion —(Ditto) [Anthony £7·7·0].' Richard Rumsey Forster, *The Stowe Catalogue Priced and Annotated*, London, 1848, p. 177, notes: 'These portraits are respectively inscribed "AEtatis suae 55, 1648"; and "AEtatis suae 47, 1648.".' Forster's note was most likely based on information he found in the 1838 guide book cited above. Sale, Sir Cecil Miles...and others, anon., London, 13 May 1899, no. 90 (£3,150; Colnaghi); dealer Colnaghi, London; dealer Knoedler, New York; Charles M. Schwab, New York; dealer Knoedler, New York; gift to the gallery of The T. Eaton Co., Ltd., together with Colonel R. Y. Eaton, 1939; stolen in 1959 and returned to the gallery in the same year.
EXHIBITIONS: New York, Hudson-Fulton Celebration, 1909, no. 39 (Frans Hals); Haarlem 1937, no. 97 (Frans Hals); Montreal 1944, no. 26 (Frans Hals).
BIBLIOGRAPHY: Moes 107 (Frans Hals); HdG 299 (Frans Hals; genuine and well preserved but unattractive); Bode-Binder 250 (Frans Hals); KdK 236 (Frans Hals; thin and somewhat hastily painted); Valentiner 1936, 93 (Frans Hals); Helen Comstock, 'A Frans Hals Portrait for Toronto,' *The Connoisseur*, CIII, 1939, p. 217; Hubbard 1956, p. 151 (Frans Hals); Seymour Slive, 'Frans Hals Studies: III,

Jan Franszoon Hals', *O.H.*, LXXVI, 1961, p. 179 (Jan Hals).

Companion picture to Cat. no. D 77. A monogrammed portrait by Jan Hals which was erroneously ascribed to his father. For a reproduction of the monogram, date and inscription on the painting, see Slive, *op. cit.*, p. 193, fig. 18. Other works by Jan Hals are discussed in Cat. nos. D 57, D 58, D 76.

D 60. **Man Fingering His Collar Tassel** (Fig. 181). New York, Barker Welfare Foundation.
Canvas, 82·5×66·6 cm.

PROVENANCE: Sale, Rev. Robert Gwilt, London, 13 July 1889, no. 79 (Agnew); sold by Agnew to Mr. Samuel Cunliffe-Lister, of Swinton Park, who became first Lord Masham in 1891; Lady Cunliffe-Lister, who became Viscountess Swinton; purchased by George Schicht around 1942; Mr. and Mrs. Charles V. Hickox, New York.
EXHIBITIONS: Leeds 1936, no. 9; London, Arts Council, Dutch Paintings of the 17th Century, 1945, no. 7; London 1949, no. 13; London 1952–53, no. 75; New Haven, Yale Alumni, Yale University Art Gallery, May, 1960, no. 14.
BIBLIOGRAPHY: C. H. Collins-Baker 'Two Unpublished Portraits by Frans Hals', *B.M.*, XLVI (1925), p. 42; Valentiner 1928, p. 248; Valentiner 1935, p. 102, no. 19.

Done by an anonymous follower in the style of Hals' half-lengths of the 1640s. Although the painting appeared in the same 1889 sale as the *Portrait of a Woman Holding a Fan* now at the National Gallery, London (Cat. no. 141, Plate 221), there is no justification for concluding they are companion pieces.

D 61. **Portrait of a Man** (Fig. 182). Formerly Hamburg, Carl Mandl.
Panel, 31×24·5 cm.

PROVENANCE: Sale, Amsterdam (Muller) 30 June 1909, no. 7; sale, Amsterdam (Muller), 10 July 1923, no. 117 (15,400 florins), Carl Mandl, Hamburg; sale, property of a lady, London (Sotheby), 25 November 1970, no. 107 (£1400); sale, Amsterdam (Brandt) 11–17 May 1971, no. 6.
BIBLIOGRAPHY: Possibly HdG 318; KdK 273 (ca. 1655; Frans Hals); W. R. Valentiner, 'Jan van de Cappelle', *Art Quarterly*, IV, 1941, p. 296, note 6.

Valentiner (KdK 273) states that before the painting was in the Mandl collection it had belonged to: [L.] Nardus, Suresnes; [P. A. B.] Widener, Philadelphia; dealer Goudstikker, Amsterdam. The compiler of Sotheby's 1970 sale catalogue notes that it is possibly identical with HdG 318: Portrait of a Man, in profile to the right and looks round at the spectator; he wears a wig and is dressed in black;

coll. L. Nardus, Suresnes, near Paris; panel 32×26 cm. Its history from the time it was mentioned as in the Mandl collection in 1930 until it reappeared at Sotheby's in 1970 is unknown.

I have not seen the original. To judge from good photographs, it can be related to Hals' small portraits of the 1650's. They also indicate that the cloak and background have been extensively repainted and the hair appears to be new, being painted over worn passages. Conceivably the sitter was given a wig by another hand at a later date (see HdG 318); and subsequently it may have been removed and repainted. The dark areas of the face also appear to have been reworked. The grainy texture and narrow range of values in the light parts have little in common with Hals' originals of the period. The sitter's right eye is uncommonly large and lacks Hals' decisive modelling. Valentiner (*op. cit.*, 1940) found his nose and mouth out of joint. He explained this by stating: 'the sitter of this portrait suffers from syphilis, to judge from the distorted shape of his nose and mouth' and he suggested that it may be a portrait of the Dutch painter and theorist Gerard de Lairesse (1640–1711), who had this ailment. Valentiner's identification of the model and diagnosis of his disease can be rejected without reservation. It seems that the painting, not the sitter, suffered from a disfiguring malady. Although final judgement must be postponed until the original is examined, I have serious reservations about attributing much of the visible painted surface of the little portrait to Hals.

D 62. **Portrait of a Man in a Painted Oval** (Fig. 183). Dortmund, H. Becker.
Panel, 36·2×29·8 cm.

PROVENANCE: Paul von Schwabach, Berlin, 1914; sale, Meier Mossel and others, Amsterdam (Muller), 11–18 March 1952, no. 695; dealer Schaeffer Galleries, New York.
EXHIBITION: Haarlem 1937, no. 112 (private collection).
BIBLIOGRAPHY: Bode-Binder 268 (Frans Hals); KdK 285 (*ca.* 1660; Frans Hals); Rolf Fritz, *Sammlung Becker: I, Gemälde Alter Meister*, Dortmund 1967, no. 67 (Frans Hals).

Rolf Fritz (*op. cit.*) incorrectly identifies the painting as identical with HdG 261, a portrait which was also in the Schwabach collection and now belongs to the Ruzicka Stiftung, Zürich (Cat. no. D 63). A date in the fifties is suggested by the style. Although the characterization of the face is moving and is close in handling to Hals' late small portraits, it is difficult to reconcile the rest of the painting with Hals' originals of the period: the dull treatment of the hair; the part of the cape, which refuses to fall over his left shoulder, the stringy highlights and the superficial touches used to depict the tassels of the collar. In addition, the painted oval is as unconvincing as it is exceptional in Hals' late phase. It fails to serve the function simulated frames consistently perform in the artist's

authentic works; it does not create the illusion that it establishes the foremost plane. Extensive later reworking by another hand may account for the patent deviations from Hals' mature small oil sketches.

D 63. **Portrait of a Man** (Fig. 184). Zürich, Kunsthaus, Ruzicka-Stiftung.
Panel, 56·5×45 cm.

PROVENANCE: H. Pickersgill Cunliffe, London; sale, Cunliffe, London, 9 May 1903, no. 100 (£892:10s; Simons); Comte Cavens, Brussels, 1909; Paul von Schwabach, Berlin; acquired for the Ruzicka collection from the Basel art market, 1948.
EXHIBITIONS: *Les 100 Portraits, Collection du Comte Cavens*, Galerie Royale, Brussels, 1 May–1 June 1909, no. 29 (Frans Hals); Berlin, Kaiser-Friedrich-Museumverein, 1909, no. 49; London 1929, no. 52; Haarlem 1937, no. 107 (private collection); The Hague, 'Herwonnen Kunstbezit', 1946, no. 24; Zürich, Kunsthaus, 'Gemälde der Ruzicka-Stiftung', 1949, no. 12; Zürich 1953, no. 48; Rome 1954, no. 48; Milan 1954, no. 48.
BIBLIOGRAPHY: Moes 158, identical with Moes 168 (Frans Hals); HdG 261, identical with HdG 281a and HdG 364 (Frans Hals); Bode-Binder 264 (Frans Hals); KdK 276 (*ca.* 1657; Frans Hals).

Valentiner (KdK 276) noted a relation between this work and the three-quarter length *Portrait of a Man* at Copenhagen (Cat. no. 202; Plate 316). In my opinion it was executed by an anonymous follower who attempted to imitate Hals' portraits of this type. He managed an approximation of Hals' suggestive touch in his treatment of the head, but suffered defeat in his depiction of the hand holding gloves.

D 64. **Portrait of a Man** (Fig. 185). Amiens, Musée de Picardie (Cat. 1899, no. 95).
Canvas, 91×71·5 cm.

PROVENANCE: Olympe and Ernest Lavalard, Paris; bequeathed by the Lavalard brothers to the museum in 1890, and accessioned in 1894.
EXHIBITIONS: Paris, Palais du Corps Législatif, 1874; Haarlem 1937, no. 108.
BIBLIOGRAPHY: Bode 1883, 47 (Frans Hals); Amiens, Musée de Picardie, Cat. 1899, p. 199, no. 95 (wrong dimensions; Frans Hals); A. Bredius, 'Nederlandsche Kunst in Provinciale Musea van Frankrijk', *O.H.* XIX, 1901, pp. 11–12 (Frans Hals; late); Moes 144 (Frans Hals); HdG 249 (Frans Hals); Bode-Binder 282 (Frans Hals); KdK 279 (*ca.* 1657–60; Frans Hals); Paris, Le Siècle de Rembrandt', Petit Palais, 1970–71, Répertoire: p. 270 (Frans Hals).

Bode (1883, 47) erroneously called it a *Portrait of a Woman* and a pendant of *Herman Langelius*, which is also at Amiens (Cat. no. 215). Hofstede de Groot (249) corrected these errors; the dimensions he, Bode-Binder (282), and Valentiner (KdK 279) cite (76×63 cm.) are wrong.

Done by a close follower in the broad, summary style of Hals' last phase. Details of the costume are unusual. The hat bears a closer resemblance to the one worn by Arnolfini in his well-known marriage portrait than to the large hats fashionable in Hals' day, and the angular shape of the collar is uncommon.

Close imitations of Hals' highly personal late style are relatively scarce. Another one, probably by a different artist, is the *Portrait of a Man* (canvas, 76·2×63·5 cm.) which has been inscribed 'Admiral Van Tromp' by a later hand.

PROVENANCE: Possibly Sir William Burrell (1733–1802); Sir Charles Merrik Burrell (1774–1862); sale, Lt. Colonel W. Burrell, Knepp Castle, Sussex, London (Sotheby), 26 March 1952, no. 34, repr. (bought in).
EXHIBITIONS: London, British Institution, 1853, no. 77; Worthing Art Gallery, 'Treasures from Sussex Houses' 1951, no. 175; London 1952–53, no. 77.

The portrait has been mistakenly attributed to Hals in the references cited above. For an extensive note on its possible eighteenth-century history, see the 1952 Sotheby catalogue cited above.

D 65. **Portrait of a Woman** (Fig. 186). Atherstone, Warwickshire, Sir William Dugdale.
Canvas, 116×87 cm.

PROVENANCE: According to the London 1952–53 exhibition catalogue, no. 92: 'Sava Vrij, a descendant of the sitter, married the present owner's ancestor, John Stratford of Merevale in about 1700, bringing this picture as part of her dowry.'
EXHIBITIONS: London 1880, no. 64; London 1902, no. 97; London 1952–53, no. 92.
BIBLIOGRAPHY: Moes 199 (Frans Hals); HdG 383 (*ca.* 1635; Frans Hals; very prettily rendered, and therefore at first sight not convincing but it is certainly genuine, and is not smoother than, for example, *Aletta Hanemans* at the Mauritshuis [our Cat. no. 33; Plate 59]); Bode-Binder 154 (Frans Hals); KdK 85 (*ca.* 1630; Frans Hals).

A portrait done around 1625–35 but in my opinion the execution is too mechanical and tame to support the traditional attribution. I cannot accept Valentiner's suggestion (KdK 85) that this routine painting is probably a companion piece to the *Portrait of a Man* at Buckingham Palace (Cat. no. 68).

D 66. **Portrait of a Woman** (Fig. 187). Formerly Toronto, Albert L. Koppel.
Canvas, 112×90 cm.

PROVENANCE: Dealer F. Kleinberger, Paris; Leopold Koppel, Berlin.
EXHIBITIONS: Haarlem 1937, no. 27; Montreal 1944, no. 31.
BIBLIOGRAPHY: Bode-Binder 99 (Frans Hals); KdK 49 (*ca.* 1626–28).

The landscape in the background is an incongruous note in this weak imitation of Hals' three-quarter lengths of the 1620's. The face appears to be the work of a modern restorer.

D 67. **Portrait of a Girl, profile to the right** (Fig. 188). Indianapolis, Indiana, Mr. and Mrs. A. W. S. Herrington.
Oval panel, 26×20·3 cm. Signed at the lower right with the connected monogram: FH.

PROVENANCE: Earl Spencer, Althorp; P. A. B. Widener, Elkins Park, Pennsylvania; sale, Widener, Amsterdam (Muller) 10 July 1923, no. 109; dealer Knoedler, New York; Julius H. Haas, Detroit; Mrs. Lillian Henkel Haas, Detroit; dealer P. de Boer, Amsterdam, 1957; dealer Newhouse, New York, 1957.
EXHIBITIONS: Detroit 1935, no. 16; Detroit, 'Masterpieces from Detroit Collections of Paintings', 1949, pl. 13; Indianapolis-San Diego, 'The Young Rembrandt and His Times', 1958, no. 49.
BIBLIOGRAPHY: Moes 196 (Frans Hals); HdG 120, identical with HdG 365 (Frans Hals); *Pictures in the Collection of P. A. B. Widener at Lynnewood Hall, Elkins Park, Pennsylvania, Early German, Dutch and Flemish Schools . . .*, notes by C. Hofstede de Groot and Wilhelm R. Valentiner, 1913, unpaginated and unnumbered; Bode-Binder 37 (Frans Hals); KdK 80 (*ca.* 1629–30; Frans Hals); Valentiner 1936, 31 (*ca.* 1629–30; Frans Hals).

In the manner of Hals' works of the twenties by an anonymous follower who probably was familiar with the artist's *Drinking Boy* at Schwerin (Cat. no. 58; Plate 91). Juxtaposition of it with the latter work shows the imitator's inability to convey the animation, the variety of textures and sparkling light effects Hals achieves, and the drawing of the ear reveals that this follower was at a loss when he attempted to imitate Hals' suggestive touch.

Valentiner's proposal (1936, 31) that the painting may be a portrait of Hals' daughter Sara (b. 1617) is unacceptable. He also suggested that the *Portrait of a Girl, profile to the left* (formerly E. Warneck, Paris) and *Portrait of a Girl, profile to the right* (sale, Habich, Cassel, 1892) are portrayals of Hals' daughters Adriaentjen and Sara. I have not seen these untraceable small oil sketches but to judge from

photos the reason for ascribing them to Hals appear to be as flimsy as Valentiner's identification of the models:

1. Paris, E. Warneck, sale, E. Warneck (Paris), 27 May 1926, no. 48; dealer P. de Boer, Amsterdam, 1940.
 Panel, 13 × 12 cm.
 BIBLIOGRAPHY: HdG 45; Bode-Binder 42, repr., plate 16 C; KdK 79 left, repr.

2. Sale, G. Habich, Cassel, 9 May 1892, no. 73 (3050 marks).
 Panel, 13 × 12 cm.
 BIBLIOGRAPHY: Bode 1883, 104; HdG 26; Bode-Binder 49, repr. plate 16 d; KdK 79 right, repr.

D 68. Portrait of a Woman (Fig. 189). Gothenburg, Art Gallery (inv. no. 733).
Canvas, 69·3 × 52·5 cm.

PROVENANCE: Dealer E. Warneck, Paris; Rudolph Kann, Paris; dealer C. Sedelmeyer, Paris, Cat. 1898, no. 53; Karl von der Heydt, Berlin; dealer Goudstikker (Swedish cat. no. 33, plate v); Gustav Werner, who presented it to the museum in 1923.

EXHIBITIONS: Düsseldorf 1904, no. 312; Berlin 1906, no. 50.

BIBLIOGRAPHY: Moes 201 (Frans Hals); HdG 369 (Frans Hals); Bode-Binder 129 (Frans Hals); KdK 101 (ca. 1631–1633; Frans Hals; perhaps a pendant to our Cat. no. D 48); Axel L. Romdahl, 'Tva Frans Hals Porträtt', Konsthistorisk Tidskrift II, 1935, pp. 117–118 ('Frans Hals; perhaps a portrait of Hals' wife Lysbeth Reyniers); Göteborge Konstmuseum, Katalog, 1945, p. 107, no. 733 (Frans Hals).

Probably a nineteenth-century falsification. Fig. 189 shows the portrait during the course of its 1939 restoration when it became patent that neither the original canvas support nor the paint surface dates from Hals' time; the picture has scattered false patches which were put over non-existent paint losses to help suggest that it is an old painting which has suffered a bit (files of the museum).

D 69. Self-Portrait of Judith Leyster (Fig. 190). Washington, National Gallery of Art (Cat. 1965, no. 1050).
Canvas, 72·3 × 65·3 cm.

PROVENANCE: E. M. Grainger, Hastings, Sussex; sale, London (Christie) 16 April 1926, no. 115, catalogued as Judith Leyster (Smith, 720 gns.); private collection or art trade, Paris, 1927; dealer Ehrich Galleries, New York, from whom it was purchased ($250,000) 9 May 1929 by Mr. and Mrs. Robert Woods Bliss, Dumbarton Oaks, Washington, D.C.; gift to the gallery of Mr. and Mrs. Robert Woods Bliss, 1949.

EXHIBITIONS: Chicago, A Century of Progress Exhibition 1933, no. 64 (Frans Hals; Dr. Bredius is strongly inclined to consider it an excellent self-portrait by Judith Leyster); Indianapolis 1937, no. 22 (Frans Hals); Haarlem 1937, no. 9 (Frans Hals); New York 1937, no. 3 (Frans Hals).

BIBLIOGRAPHY: Valentiner 1928, pp. 238–247 (probably slightly earlier than 1625; portrait of Leyster by Frans Hals); G. D. Gratama, 'Het Portret van Judith Leyster door Frans Hals', O.H., XLVII, 1930, pp. 71–75 (ca. 1620–35; portrait of Leyster by Frans Hals; perhaps Leyster painted the painting of the violinist on the easel; Gratama notes he examined the picture in Paris in 1927). D. C. Rich, 'Die Ausstellung . . . in Chicago', Pantheon, XII, 1933, p. 380 (Portrait of Leyster by Frans Hals); D. C. Rich, review of W. R. Valentiner, Frans Hals in America, 1936, in Art in America, XXV, 1937, p. 136 (now seems definitely not by Hals; Bredius from the first had been strongly inclined to consider it an excellent self-portrait by Judith Leyster).

The paint surface is moderately to severely abraded and has been flattened during the course of an old relining. There is extensive repaint in the bodice, hair, the background and on the painting on the easel.

The painting was published by Valentiner in 1928 (op. cit.) and again by Gratama in 1930 (op. cit.) as Hals' portrait of his gifted follower Judith Leyster (1609–60). Bredius doubted the attribution from the beginning and was inclined to see it as a self-portrait by Leyster (see Chicago, Exhibition Catalogue, 1933, no. 64; D. C. Rich, op. cit., 1937). Valentiner deleted it from his catalogue of Hals' paintings in America published in 1936 and since that time it has been generally accepted as one of Leyster's most appealing paintings. The self-portrait is datable between 1630 and 1635 on the basis of style and costume. The age of the model is consistent with H. F. Wijnman's discovery ('Het Geboortejaar van Judith Leyster', O.H., XLIX, 1932 pp. 62–65) that Judith was born in 1609 (not ca. 1600).

The painting of a violinist on her easel can be related to the genre pieces Leyster painted during the first half of the thirties. The violinist appears as one of the three principal figures in her untraceable Merry Company (canvas, 88 × 73 cm.); see J. Harms, 'Judith Leyster', O.H., XLIV, 1927, p. 147, fig. 8 and p. 237, no. 15; the painting is also reproduced in Gratama, op. cit., p. 74, fig. 3.

There is no documentary proof that the model is Judith Leyster but in this case rejection of the identification would be a sign of perverse stubbornness rather than healthy scepticism. Naturally, it is conceivable that the painting is Judith's portrait of another painter. One could propose, for example, that it is possibly a portrayal of Maria Fransdr. de Grebber (born after 1600), the sister of Pieter de Grebber. Apart from one painting (dated 1631) all of Maria's works are lost or unidentified and little is known about her life; however, to judge from written sources she made a name for herself as a painter and was active in Haarlem while Leyster was there. But why would Judith depict Maria, or for that matter any other painter, seated at an easel before

one of her own inventions with brush and palette in hand? Moreover, the model of the Washington portrait bears a close resemblance to *A Lady at a Harpsichord with Two Children* by Jan Miense Molenaer at the Rijksmuseum (Cat. 1960, no. 1635), which can be dated about 1635–40. The harpsichordist in Molenaer's Amsterdam painting has been identified as Judith Leyster, the woman he married in 1636. It has been argued that this identification is incorrect because the ages of the children in the painting do not tally with the known ages of the couple's two children (*ibid.*). This objection is based on the assumption that the Amsterdam picture is a family portrait; but I see no reason to accept the assumption. Molenaer most likely used Judith as a model for his harpsichordist. The case was not exceptional. Judith's oval face, high forehead and heavy nose can also be recognized in the woman singing in Molenaer's *Musical Couple* at Budapest, Museum of Fine Arts (Cat. 1967, no. 53.495).

Works by Molenaer and Leyster in the early 1630's can be deceptively similar. Is the Washington painting Molenaer's portrait of Judith (and is the Louvre's *Le Peintre Ambulant*, Cat. no. D 22, based on a painting Judith painted of her husband)? I have posed, tested and rejected this tantalizing hypothesis.

D 70. **Emerentia van Beresteyn** (Fig. 191). Waddesdon Manor, National Trust (P 10/b).
Panel, 146 × 105.2 cm.

PROVENANCE: Acquired from the Hofje van Beresteyn, Haarlem on 17 November 1882 (210,000 francs) by Baroness Wilhelm von Rothschild, Frankfurt am Main, who bequeathed it in 1924 to her grandson Baron Albert von Goldschmidt-Rothschild; acquired from him in 1933 by Baroness Edmond de Rothschild, at whose death in 1935 it came to Waddesdon; bequeathed by James A. de Rothschild to the National Trust in 1957.

EXHIBITIONS: Frankfurt am Main, Staedelsches Kunstinstitut, 'Meisterwerke alter Malerei aus Privatbesitz', 1925, no. 100 (Frans Hals); London, Arts Council, 'Children Painted by Dutch Artists', 1956, no. 17 (Frans Hals).

BIBLIOGRAPHY: Bode 1883, 12 (*ca.* 1630–33; Frans Hals); *Icon. Bat.*, no. 514 (Frans Hals); M. G. Wildemann, 'De portretten der Beresteijn's in het Hofje van Beresteijn te Haarlem, *O.H.*, XVIII, 1900, pp. 129ff. (Frans Hals); Moes 14 (attribution doubtful; executed with the assistance of an anonymous collaborator); HdG 153 (the original not seen by him; notes that the flesh colour strongly reminds one of Pot, but the picture is almost too good for him); E. A. van Beresteyn, *Genealogie van het Geslacht van Beresteyn*, vol. II, The Hague, 1941, pp. 78–79, no. 156 (Frans Hals); *ibid.*, vol. I, The Hague, 1954, pp. 291–292; Christopher White, 'Dutch and Flemish Paintings at Waddesdon Manor', *G.B.A.*, LIV, 1959, pp. 72–73 (D. C. Roëll's attribution to Pieter Soutman is plausible); Ellis

Waterhouse, *The James A. de Rothschild Collection at Waddesdon Manor: Paintings*, 1967, pp. 165–166, no. 70 (ascribed to Pieter Claesz. Soutman).

Emerentia van Beresteyn (*ca.* 1623–74) was the daughter of Paulus van Beresteyn (Cat. no. 12; Plate 27) and his third wife Catherina Both van der Eem (Cat. no. 13; Plate 28). She married Egbertus Rentinck on 1 February 1663 at Haarlem; one of the witnesses of her marriage settlement made 7 January 1663 was Johan Soutman (Beresteyn, *op. cit.*, vol. I, 1954, p. 291). Johan Soutman was not a brother of the painter Pieter Claesz. Soutman (active *ca.* 1619–57), but he may be presumed to have been his kinsman (Waterhouse, *op. cit.*).

The attribution of the attractive portrait to Frans Hals has been rightly doubted since Moes expressed reservations about the ascription in 1909 (Moes 14). However, his conclusion that it was done by Hals with the help of an unidentified assistant is improbable. The painting shows no indication that Hals worked on it and there is every reason to believe it was painted by one hand. The most plausible attribution, to Pieter Soutman, was made by D. C. Roëll and first published by Christopher White (*op. cit.*). Soutman settled in his native city of Haarlem by 1628 after working with Rubens in Antwerp (*ca.* 1619–24) and serving for a period in Poland at the court of Sigismund III, King of Poland. The works he made after his return to Holland show the influence of both Rubens and Hals; the combination is seen in the Waddesdon portrait. The group portrait of the *Paulus van Beresteyn Family* at the Louvre (Cat. no. D 80; Fig. 202), which includes a portrait of Emerentia seated in the right foreground, can also be provisionally attributed to Soutman. The family portrait was probably painted around 1630, a few years after Soutman had established himself in Haarlem; the full-length of Emerentia, which shows her about five years older, can be dated around 1635.

Waterhouse (*op. cit.*) cautiously notes that a member of the Soutman family was a witness to Emerentia's marriage settlement and this fact may slightly corroborate the attribution of the Waddesdon painting to Pieter Soutman. White (*op. cit.*) has correctly observed that Soutman's signed and dated portrait group of *Four Children and Two Dogs*, 1641, Countess of Ilchester (Amsterdam, 1952, no. 158, repr.), 'has much in common with the Waddesdon portrait, though it lacks the softness in the painting of the faces and the fluid brushwork in some of the details, such as the gloves. The attribution of the Waddesdon portrait to Soutman has much to recommend it but it is by no means conclusive.' Attribution of the Louvre's *Beresteyn Family Portrait* (Cat. no. D 80; Fig. 202) must also remain provisional. The principal difficulty in clinching these reasonable ascriptions is the gap in our knowledge of what Soutman painted from the time he settled in Haarlem around 1628 until he signed and dated the Ilchester portrait in 1641. As far as I know no documented painting can be

assigned to this phase of his career. The case for the attributions is not strengthened by Soutman's rather dry, large group portraits of Haarlem civic guards painted in 1642 and 1644 (Haarlem, Frans Hals Museum, Cat. 1929, nos. 267, 268); they are only vaguely related to the Waddesdon and Louvre paintings. The dated *Portrait of a Woman* at the National Museum, Warsaw (Cat. no. D 75; Fig. 196), which has also been attributed to Soutman, appears to have been painted by the same hand as the Waddesdon and Louvre portraits; it is dated 1644.

D 71. **Portrait of a Woman** (Fig. 192). Moscow, Pushkin Museum (inv. no. 2640).
Canvas, 119 × 84 cm.

The paint surface is extensively abraded; the light area of the face is disfigured by the pronounced crackle of the paint. Style, pose and costume relate the work to Hals' portraits of standing women done in the 1630's (Cat. nos. 94, 96, 97, 120; Plates 155, 157, 147, 190 respectively); it may be an old copy after a lost original. I am indebted to A. Guber and M. S. Senenko, curators at the Pushkin Museum, for calling my attention to the portrait.

D 72. **Portrait of a Woman** (Fig. 193). Boston, Museum of Fine Arts (inv. no. 21.1449).
Canvas, 39·8 × 37·7 cm.

PROVENANCE: Acquired by William Sturgis Bigelow, Boston, in the late 1880's and presented by him to the museum in 1921.
EXHIBITIONS: Boston, Copley Hall, Portraits, 1896, no. 163; New York 1937, no. 11.
BIBLIOGRAPHY: Charles C. Cunningham, 'A Recently Discovered Portrait by Frans Hals', *B.M.*, LXXII, 1938, pp. 87–88 (Frans Hals); Museum of Fine Arts, Catalogue, 1955, p. 31, no. 21.1449 (school).

The painting is probably a fragment of a larger portrait. During the course of an old relining it was enlarged about two and one half centimetres along three sides and around five centimetres at the bottom. The paint surface is moderately abraded. The attribution to Hals has been rightly rejected by W. G. Constable, the compiler of the museum's 1955 catalogue. There is, however, no reason to doubt that it was done by one of Hals' contemporaries, perhaps in Haarlem in the late 1630's. Rather unskilful restoration done shortly before it was published in 1938 veils the painting's quality. Removal of some of its repaint may make it lose some of its superficial resemblance to Hals' work but it would reveal the high level of craftsmanship achieved by one of his colleagues.

D 73. **Portrait of a Woman** (Fig. 194). Cardiff, National Museum of Wales (inv. no. 968).
Canvas, 73·6 × 61 cm.

PROVENANCE: Purchased from the dealer Hugh Blaker in 1920 by Miss Margaret S. Davies, Gregynog, Montgomeryshire; bequeathed by her to the Museum in 1963.
BIBLIOGRAPHY: KdK 1921, 177 (*ca.* 1640; Frans Hals); KdK 191 (*ca.* 1640; Frans Hals); Neil MacLaren, *National Gallery, The Dutch School*, Cat. 1960, p. 148, no. 2528, note.

Published by Valentiner in 1921. Mr. Eyre, the owner given by Valentiner in his references, was Hugh Blaker's father-in-law; apparently pictures which were in the possession of Mr. Blaker occasionally were said to belong to Mr. Eyre. I can accept neither Valentiner's attribution of the portrait to Frans Hals nor his suggestion that it is a pendant to the *Portrait of a Man* at the National Gallery, London (Cat. no. 163; Plate 250). Neil MacLaren (*op. cit.*) also rejects the latter proposal.

D 74. **Portrait of a Woman** (Fig. 195). Stiftung Preussischer Kulturbesitz, on loan to Coburg, Landesmuseum Veste Coburg.
Canvas, 78 × 65 cm. Inscribed at the left near the shoulder: AETATIS 46/SVAE/1643, and signed below the inscription with the connected monogram: FH.

PROVENANCE: In the collection of Mr. Scheeffer, Stettin, about 1850, with its presumed pendant (see Cat. no. 148). Both portraits were given by his daughter Frau Regierungsrat Woldermann to the Municipal Museum, Stettin, in 1863. They were evacuated from Stettin to Coburg, in spring, 1945, and were acquired by the Stiftung Preussischer Kulturbesitz in 1965 when the government of the Federal Republic of Germany made the Stiftung the custodian-executor of all art and cultural treasures which had been evacuated from the former eastern provinces of the German Reich.
BIBLIOGRAPHY: Bode 1883, 120; Moes 104; HdG 392; Bode-Binder 198; KdK 199; *Führer durch das Museum der Stadt Stettin*, 1924, pp. 64, 69; Kunze, 'Zwei Gemälde des Frans Hals', *Die Weltkunst*, XI, nos. 36–37, 12 September 1937, p. 1 (report on a restoration).

The Provenance cited above was kindly provided by Professor Wolfgang J. Müller, Kiel University.
Until the painting was cleaned around 1937 it was generally accepted as a companion picture of the *Portrait of a Man* formerly at Stettin (Cat. no. 148; Plate 228). However, it should be noted that as early as 1910 Hofstede de Groot (392) observed that the background and signature appeared to have been repainted and the signature was probably false; he added that the painting was not as good as its pendant. The 1937 cleaning revealed that it had been

enlarged at a later date to make it a pendant of Cat. no. 148 (see Kunze, *op. cit.*). Kunze reported that the inscription and monogram are genuine (*ibid.*).

I have not seen the portrait, but I find the form of the inscription highly unusual and to judge from photos the attribution to Hals is dubious. It is difficult to recognize a passage in the portrait which shows the fluent technique found in Hals' works of the forties. Perhaps it was executed by the unidentified artist who painted the feeble copy of its putative pendant which was on the London art market in 1959 (see Cat. no. 148).

D 75. **Portrait of a Woman** (Fig. 196). Warsaw, National Gallery (inv. no. 130884).

Panel, 69 × 56·7 cm. Inscribed at the centre right: AETATIS SVAE 38/1644 (the first line of the inscription is exceedingly difficult to decipher).

PROVENANCE: Stanislaw August; Lazienki Palace, Warsaw.

EXHIBITION: Poznan, National Gallery, 'Portret Holenderski XVII Wiekw w Zbiorach Polskich', 1956, no. 86 (attributed to Pieter Claesz. Soutman by A. van Schendel).

BIBLIOGRAPHY: A. Somow, *Katalog Kartin nachodiaszczychsia w Łazienkowskom Impieratorskom dworce . . .*, Warsaw, 1895, no. 76 (unknown master, Flemish school). HdG 395 (the picture is hung too high to determine the authorship precisely, but it almost gives the impression of being a work of Frans Hals). T. Mańkowski, *Galeria Stanisława Augusta*, Lwów, 1932, no. 1374 (attributed to J. A. van Ravesteyn when it was in Stanislaw's collection); J. Białostocki and M. Walicki, *Malarstwo europejskie w zbiorach polskich*, 1955, no. 262 (Hendrick Gerritsz. Pot); J. Białostocki and M. Walicki, *Europäische Malerei in polnischen Sammlungen* [Warsaw] 1957, no. 262 (Pieter Soutman?; suggested by A. B. de Vries; A. van Schendel; H. Gerson); Warsaw, National Gallery, Catalogue, 1970, p. 124, no. 1232 (Pieter Soutman?).

The attribution of the lovely portrait to Pieter Claesz. Soutman (Poznan Exhibition Catalogue, 1956, no. 86) is supported by its close relation to Soutman's signed and dated group portrait of *Four Children and Two Dogs*, 1641, Countess of Ilchester (Amsterdam, 1952, no. 158, repr.). It is probable that the same hand painted *Emerentia van Beresteyn* at Waddesdon (Cat. no. D 70) and the large *Beresteyn Family Portrait* at the Louvre (Cat. no. D 80).

D 76. **Portrait of a Woman** (Fig. 198). Los Angeles, Los Angeles County Museum (acc. no. A. 5770.47-11).

Canvas, 80 × 65·4 cm.

PROVENANCE: Dealer Sedelmeyer, Paris, Catalogue, 1907, no. 17; Carl von Hollitscher, Berlin; dealer K. W.

Bachstitz, The Hague; dealer Kleinberger, Paris; Marion Davies, Los Angeles; gift to the Museum, Hearst Magazines 1947.

EXHIBITION: Berlin, Ausstellung von Meisterwerken des Kaiser-Friedrichs-Museumvereins, Berlin 1906, no. 33.

BIBLIOGRAPHY: Moes 202 (Frans Hals); HdG 370 (Frans Hals); Bode-Binder 130 (Frans Hals); KdK 87 (*ca.* 1630; the attribution to Frans Hals is not quite certain); F. van Thienen, *Das Kostüm der Blütezeit Hollands: 1600–60*, Berlin, 1930, p. 1, note 1 (the costume indicates that the portrait could never have been painted before the forties); Valentiner 1936, 87 (Frans Hals; dated too early in KdK 87; to judge from the costume, not done until 1645); Los Angeles County Museum, *Catalogue of Flemish, German, Dutch and English Paintings*, 1954, p. 54, no. 58 (Frans Hals the Younger); Seymour Slive, 'Frans Hals Studies: III, Jan Franszoon Hals', *O.H.*, LXXVI, 1961, p. 180 (Jan Hals).

Painted around 1645. Valentiner rightly questioned the attribution to Frans Hals in 1923 (KdK 87), then withdrew his reservations about the ascription (1936, 87). He changed his mind again when he catalogued the picture for the Los Angeles Museum in 1954 (*op. cit.*); in that work he assigned the portrait to Frans Hals the Younger.

In my opinion it falls far short of Frans Hals' originals and I can see no justification for attributing it to Frans' nebulous namesake. However, the picture can be assigned to another one of his sons: Jan Hals. It shows Jan's characteristic meticulous detached brushwork (see Cat. nos. D 57, D 58, D 59); the model wears the same smile seen in Jan's *Portrait of a Woman*, 1648, at Boston (Cat. no. D 77; text, Fig. 180) and in his *Portrait of a Woman* (so-called 'Frau Schmale'), 1644, at Dresden, Catalogue, 1930, no. 1361 (Fig. 199).

D 77. **Portrait of a Woman** (Fig. 200; text, Figs. 179, 180; text, p. 171). Boston, Museum of Fine Arts (inv. no. 01.7445).

Canvas, 122 × 98 cm. Inscribed at the left near the model's shoulder: AETATIS·SVA [sic] 47/1648, and signed with the connected monogram: IH.

PROVENANCE: For the early history of the portrait see Cat. no. D 59. Sale, Sir Cecil Miles . . . and others, anon., London, 13 May 1899, no. 91 (£2,100; Lawrie); dealer Blackslee, New York; purchased by the museum, H. L. Pierce Fund, 1901.

EXHIBITIONS: Detroit 1935, no. 45; New York 1937, no. 11; Los Angeles 1947, no. 18; Raleigh 1959, no. 64.

BIBLIOGRAPHY: Moes 108 (Frans Hals); HdG 372 (Frans Hals); Bode-Binder 251 (Frans Hals); KdK 237 (Frans Hals; more carefully executed than the pendant); Valentiner 1936, 94 (Frans Hals); Trivas 93 (Frans Hals); Boston, Museum of Fine Arts, Catalogue of European Paintings, 1955, p. 31, no. 01.7445 (Frans Hals); Seymour Slive,

'Frans Hals Studies: III, Jan Franszoon Hals', *O.H.*, LXXVI, 1961, pp. 178–179 (Jan Hals).

Companion picture to Cat. no. D 59. In 1954 J. G. van Gelder recognized that this painting bears the monogram IH (see text, Fig. 179) not FH, and rightly suggested that the work was painted by the son, not the father (files of the Museum of Fine Arts, Boston). The schema Jan used for the portrait is closely related to those his father used for his memorable portraits of seated women done in the 1630's (see Cat. nos. 78, 82, 129; Plates 124, 135, 207). For other works by Jan Hals, see Cat. nos. D 57, D 58, D 59, D 76.

D 78. **Portrait of a Woman** (Fig. 201). New York, fomerly Joseph Samson Stevens.
Canvas, 99 × 81 cm.

PROVENANCE: Sale, G. Rothan, Paris, 29–31 May 1890, no. 49 (38,000 francs); possibly M. Siron, Paris; Joseph Samson Stevens, New York, 1923.
BIBLIOGRAPHY: Bode 1883, 70 (incorrect provenance; Frans Hals); HdG 423 (incorrect provenance; Frans Hals); Bode-Binder 270 (Frans Hals); KdK 281 (*ca.* 1657–60; Frans Hals; incorrect provenance). P. Mantz, 'Galerie de M. Rothan', *G.B.A.*, VII, 1873, pp. 274–275.

The size, style and pose of the portrait are closely related to the *Portrait of a Woman* at Vienna (Cat. no. 185; Plate 287) and its provenance has been confused with that of the Vienna portrait. According to earlier cataloguers (Bode 1883, 70; KdK 281) it was in the Péreire collection, and Hofstede de Groot (423) wrongly states that it was in the sale, Péreire (Paris) 6–9 March 1872, no. 121 (21,000 francs). Lot 121 in that sale is identical with the *Portrait of a Woman* at Vienna, formerly collection Pérignon and Gallery Urzaïs, Madrid. An engraving after the Vienna portrait by Félix Bracquemond appears in the special edition of the 1872 sale catalogue, facing p. 80. W. Bürger [Thoré] mentions only one painting by Hals in his article on the Péreire collection published in 1864 (*G.B.A.*, XVI [1864], pp. 299–301); there can be no question that the *Kniestück* he praises is the portrait now in Vienna.
In 1873 Paul Mantz discussed Cat. no. D 78 in his article on the Rothan collection (*G.B.A.*, *op. cit.*, an etching of the portrait by Emile Boilvin appears *ibid.*, facing p. 274). When the painting appeared in the 1890 Rothan sale at Paris the compiler of the catalogue did not provide a provenance; Emile Boilvin's print after the portrait is also published in the sale catalogue, facing p. 34. Bode (1883, 70) and Bode-Binder 270 state Cat. no. D 78 was formerly in the collection Siron, Paris.
I have not seen the painting; to judge from photos its status is doubtful. It appears to be related to Jan Hals' *Portrait of a Woman*, 1648, at Boston but final judgement

must be postponed until the painting is examined. Valentiner's suggestion (KdK 281) that it is possibly a pendant of the *Portrait of a Man* at Copenhagen (Cat. no. 202; Plate 316) is improbable.

D 79. **Portrait of a Woman** (Fig. 197). Location unknown.
Panel, 78·5 × 62·2 cm.

PROVENANCE: Sale, H. Th. Höch, Munich, 19 September 1892, no. 81 (Braams); Gerhard Braams, Arnhem; sale, Braams, Amsterdam (Muller) 24 September 1918, no. 85; possibly collection Uhlenbroek, Holland; M. van Gelder, Uccle; dealer Schaefer, New York, late 1930's; dealer French and Co., New York 1956.
EXHIBITIONS: Haarlem 1937, no. 103; Toronto Art Gallery, 'Paintings of Women . . .', 1938, no. 14; Columbus Gallery of Fine Arts, 1941, no. 7.
BIBLIOGRAPHY: HdG 366 (Frans Hals); Bode-Binder 235 (Frans Hals); KdK 260 (*ca.* 1650–52; Frans Hals; 'Namentlich in der Farbe merkwürdiges, bedeutendes Bild (gelbgrünliches Kostüm vor lila Grund), das in der Technik in einigen Teilen von der des Meisters abweicht. Vielleicht früher entstanden').

Reproductions in Bode-Binder (235; plate 148b) and Valentiner (KdK 260) show the state of the picture before extensive repaint was removed. In my opinion removal of the repaint (before the 1937 Haarlem exhibition) displayed a painting done by a follower whose broad but muddled brushwork only bears a feeble resemblance to Hals' technique. However, the anonymous imitator has some claim to originality: the unusual colour accord he established by posing his model in a chartreuse-coloured dress and placing a reddish-brown drape behind her is as exceptional in seventeenth-century Dutch portraiture as the cut of her dress and her pensive pose.

D 80. **Paulus van Beresteyn and His Family** (Fig. 202). Louvre, Paris (inv. no. RF 426).
Canvas, 167 × 241 cm.

PROVENANCE: Acquired with Cat. nos. 12 and 13 from the Hofje van Beresteyn, Haarlem, by the Louvre in March, 1885 (100,000 florins for the lot).
EXHIBITION: Amsterdam 1952, no. 127 (Hendrick Gerritsz. Pot, but an attribution to Pieter Soutman is worth consideration).
BIBLIOGRAPHY: Bode 1883, 11 (*ca.* 1630; Frans Hals; Nicolaas van Beresteyn); *Icon. Bat.*, no. 519–1 (Frans Hals; Family of Nicolaas van Beresteyn); M. G. Wildeman, 'De Portretten der Beresteijns in het Hofje van Beresteijn te Haarlem', *O.H.*, XVIII, 1900, pp. 129ff. (*ca.* 1620; Frans Hals; identifies father as Paulus van Beresteyn); Moes 17

(attribution to Hals doubtful); HdG p. 139, note 1 (the attribution to Hals is generally doubted; critics are not agreed as to its probable painter. H. G. Pot's authorship is perhaps received with most favour); L. Demonts, Louvre, Catalogue, 1922, p. 25, no. 2388 (Frans Hals, but perhaps H. G. Pot); W. Martin, *De Hollandsche Schilderkunst in de Zeventiende Eeuw*, vol. I, Amsterdam, 1935, p. 42, Fig. 22 (H. Pot?); E. A. van Beresteyn, *Genealogie van het Geslacht van Beresteyn*, vol. II, The Hague, 1941, pp. 62–64, no. 127 (Frans Hals); *ibid.*, vol. I, 1954, pp. 219–220. Christopher White, 'Dutch and Flemish Paintings at Waddesdon Manor', *G.B.A.*, LIV, 1951, p. 66 (J. R. Roëll's attribution to Pieter Soutman is plausible); E. Waterhouse, *The James A. de Rothschild Collection at Waddesdon Manor: Paintings*, 1967, pp. 165–166 (probably by Pieter Soutman); Paris, *Le Siècle de Rembrandt*, 1970–71, Cat. no. 96, note (Soutman according to Gudlaugsson, Van Schendel and Van Gelder).

A strip of canvas about 40 cm. wide on the right has either been entirely repainted by another artist or is a later addition. In either case, the hand which painted the child on the right as well as the rest of that strip is not identical with the one which executed the other part of the picture. Since the composition of the large group portrait would be out of balance without the strip and the family portrait would be incomplete without the sixth child (see below) most likely the section in question was part of the portraitist's original conception. Probably it was damaged and repainted or replaced at a later date. The age of the child on the strip virtually precludes the possibility that she was born after the portrait group was finished and added by another artist to give a full visual record of the family. (For the later addition of a young child by Salomon de Bray to a completed *Family Portrait in a Landscape* by Hals, see Cat. no. 15.)

The portrait represents Paulus van Beresteyn and his third wife Catherina Both van der Eem (see Cat. nos. 12, 13; Plates 27, 28) seated under a cherry tree with their six children and two servants. The couple married at Haarlem, 12 December 1619. Their three daughters and three sons can be identified with some certainty as:

1. Elizabeth (1620–1672); on the extreme right; she married the Haarlem painter Pieter Verbeecq in 1643.
2. Hendrick (1622—?); the boy in the centre reaching for the branch held by the servant picking cherries.
3. Emerentia (*ca.* 1623–79); seated on the ground at the right; for her charming full-length portrait, formerly attributed to Hals, see Cat. no. D 70.
4. Johanna (*ca.* 1625–49); bringing her mother a bouquet of flowers.
5. Aernout (*ca.* 1627–54); the child at the left of the kneeling maid; in 1637, when he was a boy, he studied with the still-life painter Willem Heda.
6. Nicolaas (1629–84); the baby held by the kneeling servant; he was a pupil of Salomon de Bray and became a dilettante draughtsman and etcher. He

established the Hofje van Beresteyn at Haarlem in 1684. The Hofje sold Cat. no. D 70 to Baroness Wilhelm von Rothschild in 1882, and three years later it sold Cat. no. D 80 and Cat. nos. 12, 13 to the Louvre.

To judge from the ages of the children as well as from the style of the family portrait, it was painted around 1630. The pictorial type is related to Hals' reconstructed *Family Portrait in a Landscape*, painted about a decade earlier (Cat. nos. 15, 16) but the attribution to him is untenable; the suggestion that it was done by Hendrick Pot is not fully convincing. D. C. Roëll's proposal that it was painted by Pieter Claesz. Soutman (White, *op. cit.*) is the best that has been offered but this attribution is not certain. It is noteworthy that the portrait of *Emerentia van Beresteyn* done around 1635 (Cat. no. D 70) and the *Portrait of a Woman*, 1644, Warsaw (Cat. no. D 75), which have also been tentatively ascribed to Soutman, show more of Rubens' influence than the Beresteyn family group. Logically we should expect the reverse. Soutman left Antwerp around 1624 after spending five or six years in Rubens' orbit. After serving in the Polish court he settled in Haarlem not later than 1628. Perhaps Soutman renewed contact with Rubens' works or with the Flemish master himself by making a journey to Antwerp in the 1630's.

The artist who painted or repainted the strip on the right has not been identified.

D 81. **Family Group in a Landscape** (Fig. 203). San Diego, Fine Arts Gallery.
Panel, 76·2 × 111·8 cm.

PROVENANCE: Borchard, Moscow; Quissling (Wissling?), Oslo; dealer Lilienfeld, New York, 1935; gift to the gallery of the Misses Anne and Amy Putnam in memory of their sister Irene, 1936.

EXHIBITIONS: Detroit 1935, no. 37 (*ca.* 1638–40; Frans Hals); Indianapolis-San Diego, 'The Young Rembrandt', 1958, no. 50 (*ca.* 1635; attributed to Frans Hals; 'the matter of attribution is a difficult problem').

BIBLIOGRAPHY: Valentiner 1935, pp. 99–100, 102, no. 18 (*ca.* 1639; Frans Hals and Jan Vermeer of Haarlem); Valentiner 1936, 67 (Frans Hals and possibly Jan Vermeer of Haarlem); San Diego, Fine Arts Gallery, *Catalogue of European Paintings*, 1947, p. 121 (mid-thirties; Frans Hals and a collaborator).

There is general moderate abrasion in the paint layer; scattered losses have been repainted.

Valentiner first attributed the four figures and the landscape to Frans Hals (Detroit 1935, no. 37), then he wrote that the landscape must have been painted by Jan van der Meer of Haarlem (Valentiner 1935, p. 100), and subsequently he made the ascription of the landscape to Van der Meer more tentative (Valentiner 1936, 67).

The ascription of any part of this rather naïve portrait group to Frans Hals is unacceptable. There is no link between either the handling of the puny figures or the treatment of the landscape and his autograph works. To judge from the costumes the painting dates from the forties and the view of the dunes in the background, which offers good reason to believe it was painted in Haarlem, places it late in the decade or even in the fifties. The relation of the figures to the landscape feebly recalls the compositional schemes Hals used for his family portraits done *ca.* 1648, which are now at London and Lugano (Cat. nos. 176, 177; Plates 272, 279); this connection also suggests a date around the same time or a bit later for the San Diego picture. It will be noticed that the handbag carried by the girl is identical to the one carried by the young woman on the extreme right of the London family group (Plate 272). I am not qualified to assign dates to handbags and to the best of my knowledge a comprehensive history of seventeenth-century Dutch ones has not yet been written but the similarity may suggest the paintings were done around the same time.

I do not rule out the possibility that the figures and landscape were painted by the same artist. Is the picture's primitive quality the result of a landscape specialist's attempt to paint a portrait group? On the other hand, the squat proportions of the figures are reminiscent of the dwarf-like children in Jan Hals' rare early genre pieces; *e.g.*, *Playing Children*, signed and dated, 16[35?], Frans Hals Museum, Cat. 1929, no. 136, and his less than well preserved *Two Children*, signed and dated 1640, sale, Lucerne (Fischer), June 1961, no. 1992, repr., dealer A. Brod, London. Works of this type suggest that the figures can be provisionally ascribed to Jan. However, if we accept the conclusion that the painting was not done before the late forties the attribution to Jan becomes an unlikely one. Around this time his touch acquired some of the fluidity and vigour found in his father's work. Jan Hals' *Young Woman Holding a Mug, with a Man*, signed and dated, 1648, formerly Schloss collection, Paris (repr. Moes, facing p. 86) and the portraits he did after 1644, which are occasionally de-

ceptively close to this father's (see text, pp. 168–174; Cat. nos. D 57, D 58, D 59, D 76, D 77), do not lend much support to the supposition that they were executed by the artist who painted the china-doll figures in the San Diego group portrait.

The dense foliage behind the group is schematically painted while the view of the dunes in the distance is more sensitively realized. Valentiner must have had the latter part in mind when he attributed the landscape to the Haarlem painter Jan van der Meer I (1628–91). But it is hard to understand how he squared this attribution with Van der Meer's age in 1638–40, the date he assigned to the picture. During these years Van der Meer was a boy of 10 or 12; nothing known about him indicates he was precocious.

The dunescape belongs to the type which began to be painted in Haarlem in the late forties by artists who departed from Salomon van Ruysdael's and Pieter Molyn's thinly brushed tonal landscapes by introducing vivid colour accents and strong alternations of light and shadow to achieve spatial and atmospheric effects. Jacob van Ruisdael (1628/9–1682) was the foremost member of this group. By no stretch of the imagination can the view of the dunes in the San Diego picture be assigned to him and I can find no firm reason to attribute it to Van der Meer or a half dozen other Haarlem landscapists who helped break ground for Ruisdael's innovations, worked in the same manner, or followed his lead.

One of the less known members of this group is Frans Hals' son Claes (1628–86). Although we only have a very dim idea of his work, his signed *Village Street* at the Ashmolean (Cat. no. 191; repr. *B.M.*, xxxviii, 1921, repr. p. 93, Fig. A) and especially his monogrammed *View of Haarlem* (formerly Lord Downes; reproduced W. Martin, *De Hollandsche Schilderkunst in de Zeventiende Eeuw*, vol. 1, Amsterdam, repr. p. 383, fig. 229) place him in Ruisdael's circle and earn him a position as a long shot on the slate of contenders for the authorship of the minor picture puzzle offered by the San Diego *Family Portrait*.

CONCORDANCE

In order to find in the present catalogue any painting mentioned in the older catalogues listed below, look up the *old* catalogue number of the painting (from whatever catalogue it may be taken) in the first column of this concordance; its number in the *present* catalogue will be found on the same line in the column which corresponds to the older catalogue in question. Examples: no. 11 of Bode's 1883 catalogue is no. D 80 of the present catalogue; no. 11 of Trivas' catalogue is no. 45 of this.

	Bode 1883	Moes	HdG	Bode-Binder	KdK 1921	KdK	Valentiner 1936	Trivas
Frontispiece					L 15–3	L 15–3		
1	7	7	see 20	5	see 1	see 1	4	14
2	46	46	see 20 and L 1	20	see 1	see 1	6	2
3	45	45	see 43	see 20	1	1	5	3
4	79	79	see 43, 44	L 2–2	2	2	20	7
5	124	80	see 43, 44	21–1		12	21	10
5 left					4			
5 right					L 8			
6	140	124	see 43, 44	21	D 37	11	D 29	11
6 left						4		
6 right						L 8		
7	221	140	see 43, 44	59–2	7	D 37	D 4–1	12
8	222	221	see 43	58	58	7	28	13
9	12	222	see 61	59	59	see 7	D 6–1	18
10	13	47	see 58	L 3–1	6	see 7	L 3–3	57
11	D 80	135	59	L 3–4	5	6	D 17	45
12	D 70	76		L 3–2	8	5	22	30
13	20			D 17	9	8	34	17
14	L 4–1	D 70	see 60	L 3–19	3	9	42	23
15	17	12		D 8–1	D 66	14	41	60
16	see 19	13		D 8–2	12	12	66	35
17	63			D 4–1	13	13	36	34
18	129	L 13	29–1	D 4–2	10	10	37	32
19	80	L 8	D 1–2	D 4–3	11	11	see 46	33
19A			28					
20		L 11	D 1–1	27	14	17	26	42
21	159	84	D 1–3	D 7–1	17	see 15	24	39
22		L 10		D 5–1	see 15	16	D 24–2	104
23			see 200	D 5–2	20	20	54	66
24	32	104		D 5–3	L 3–1	L 3–1	53	48
25	33	105		D 5–4?	56–2	56–1	see 60	25
26	213	see 164	D 67–2	D 6–2	D 18	D 18	D 5–1	61
27	L 3–10	166	D 4–2	D 6–6	21–1	21–1	L 4–1	26
28		145	29	D 6–1	D 26	D 26	D 41	D 22–3
29	60	161	D 5–1	29	29–2	19	D 42	58
29 left					D 4–1			
29 right					28			
30	106	213	D 6–6	29–2				59

	Bode 1883	Moes	HdG	Bode-Binder	KdK 1921	KdK	Valentiner 1936	Trivas
30 left					D 5–1	D 4–1		
30 right					29	28		
31	123	175–1	27	29–1			D 67	46
31A			D 5–2					
31B			D 4–1					
31 left					D 8–1	D 5–1		
31 right					D 4–2	29		
32	165	see 46	58	29–3				63
32 left					D 6–1	D 8–1		
32 right					D 1–1	D 4–2		
33	D 27	119	D 6–3	D 1–1			D 44	75
33a			see D 28–1 see D 28–2					
33b								D 34
33 left					D 7–1	D 6–1		
33 right					27	D 1–1		
34	D 19	188		28	D 2		76	65
34 left						D 7–1		
34 right						27		
35	102	see 189	see 28	D 1–3		D 2	D 50	64
36	16	212	see 28	D 40	45			62
37	71	186	D 7–1	D 67	30	45		68
38	D 53	L 15–3	D 8–1	D 41	D 38	30	D 52	77
39	136	164	D 8–2	D 42	D 39	D 38	D 51	78
40	175–1	D 22	D 40	D 2	32	D 39	67	67
41	62		D 30		33	18	82	82
42	171	86		D 67–1	18	32	D 54	84
43	D 51	87	D 42	60	35	33	52	81
44	see 123	31	D 41	see 60	42	35	85	79
45	19	see 123	D 67–1	53	38	42	96	106
46	215	123		54	39	38	100	100
47	D 64	D 51		L 4–1		39	101	101
47 left					36			
47 right					37			
48	D 29	165		D 27	58	3		98
49	162	165–1		D 67–2	59	D 66	107	99
50	D 7–1	122	55	L 6–1	66		56–2	88
50 left						36		
50 right						37		
51	72	215	73	L 6–2		66	D 33	89
51 left					47			
51 right					48			
52	L 6–1	103	D 15	23	25	58	72	95
53	D 13	77	D 12	63	23	59	D 9	69
54		78	D 13	see 63			D 10	135
54 left						47		
54 right						48		
55	149	38	see D 9	D 30	26	25	D 53	92
56	150	39		25	24	23	D 28–2	90
57	38?	L 9	see D 33	24	see 46		D 34	91
58	39	32		26	46	26	102	105
58a			D 10?					
58b			D 14?					

	Bode 1883	Moes	HdG	Bode-Binder	KdK 1921	KdK	Valentiner 1936	Trivas
58c			see D 9; D 14-1?					
59	94	33		D 28-2	63	24	119	107
60	96	see 128		D 28-1	22	D 24-2	109	86
61	L 3-4	see 129		D 22	D 17	63	110	87
62		129		D 29	L 6-1	see 46	83	119
63	22	201	63	D 31	86	46	L 12	see 31
64	38?	206	D 19	61	87	22	117	31
65	36	L 16		65	D 50	D 17	118	108
66	37	94		64		L 6-1	128	112
66 upper					53			
66 lower					54			
67	84	210	D 18	see 64	60	D 23	D 81	113
68	73	168	see 60	75	L 4-1		197	114
68 upper						53		
68 lower						54		
69	216	8	L 6-1	D 34	49	60	146	115
69b			L 6-1?					
70	D 78	49		D 35	50	L 4-1	147	116
71	199	8?		19	51	49	151	117
72		36		see 19	L 9	50	149	118
73	85	37		62	135	51	150	129
74		L 12	24?	55		L 9	144	125
74 left					D 41			
74 right					D 42			
75	5	126		D 32			160	124
75 left					D 67-1			
75 right					D 67-2			
76	see D 28-1							
	see D 28-2	207		71		135	161	134
77	L 15-3	108	57	73	D 67		164	133
78	D 1-1	112		56-2			165-1	163
78 left					D 28-1	D 41		
78 right					D 29	D 42		
79	8?	159		135	76		D 57	137
79 left						D 67-1		
79 right						D 67-2		
80		57		D 15	D 43	D 67	D 55	138
81	D 35	152	25	D 13	L 10		see 143	140
81 left						D 28-1		
81 right						D 29		
82	D 45	see 203	26	D 12	68	76	166	153
83	88	85	59-1	D 19	D 65	D 43	186	154
84	89	see 85	59-2	D 18	95	68	187	143
85	47	see L 17	D 28-2	D 33	D 76	D 65	177	144
86	48	1	24	see D 33	69	95	D 31	147
87	14	102	53	D 37	D 54	D 76	D 76	146
88	202	176	D 28-1	2	D 44	L 10	L 15-1	208
88a			see 19					
89	35	177		6	D 40	69	173	184
90	25	17		4	see D 40	D 54	174	172
90a			D 24-1?					
			D 24-2?					
91		16		3	77	D 44	167	165

	Bode 1883	Moes	HdG	Bode-Binder	KdK 1921	KdK	Valentiner 1936	Trivas
92	75	14		7	78	D 40	125	167
93	201	50		8	D 45	see D 40	D 59	D 77
94	D 6–2	51		35	88	77	D 77	171
95	D 32	D 53	64	9	89	78	182	181
96	L 3–3	136	65	17	D 48	D 45	198	193
97	64	113		10	D 68	D 25	191	186
98	23	114	19	11	D 25	88	200	187
99	10	115	D 3	D 66	98	89	181	188
99a			see 64					
100	11	116	see 5	30	99	D 48	192	189
101	217	137		120	79	D 68	214	200
102	154	138	61	32	67	86	190	201
103	153	148	D 31	33	82	87	203	210
104	D 67–2	D 74		88	D 46	98	209	213
105	90	149		89	81	99	210	216
106	91	150	218	36	131	D 52		219
107	169	D 59		37	55	79		217
108	D 48	D 77	75	42	D 32	67		221
109	115, 116	156	D 34	47		82		222
109 left					D 27			
109 right					D 19			
110	D 38	157	D 32	48		81		
110 left					72			
110 right					71			
111	100	88	see D 33	16	73	131		
112	D 5–1	89	see D 9	45	80	D 46		
113	29	99	see D 33	46	85	L 5–1		
114	21–1	98	72	119	96	55		
115	D 6–1	184	D 35	86	94	D 22		
116		185		87	L 11			
116 left						D 27		
116 right						D 19		
117	59	182	22	49	100			
117 left						72		
117 right						71		
118	58	183	54	see 46	101	73		
119	148	9	62	50	186	80		
120	D 74	30	D 67	51	187	85		
121	133	35		12	62	96		
121a			D 36?					
121c			70					
122	198	42		13	19	94		
123	31	48		D 54	D 13	L 11		
124	168	130	D 6–2	D 44		100		
124 left					D 12			
124 right					D 33			
125	185	68	60	130	106	101		
126	184	D 54		68	107	186		
127	194	83		D 48	104	187		
128	167	D 45		76	105	52		
129	134	81		D 68	64	103		
130	193			D 76	D 34	62		
131	125	93		14	75	D 13		

	Bode 1883	Moes	HdG	Bode-Binder	KdK 1921	KdK	Valentiner 1936	Trivas
132	131	100	D 6-1	99	65			
132 left						D 12		
132 right						D 33		
133		111	21-1	98	D 35	D 9		
134	68	D 44	23	77	D 36	D 11		
135	152	117	D 29	78	D 20	D 10		
136	195	144	D 27	D 45	D 15	106		
137	18	151		79	D 53	107		
137, 1-15			see L 3					
137b			see 5					
137h			5?					
138		125	L 4-1	82	136	104		
139			20	81		105		
139 left					see 111			
139 right					see 112			
140	186		see 20	131	111	64		
141	30	D 48	5	38	112	D 34		
142	see 164	92		39	103	75		
143	6	106	5-3?	94	see 31	65		
144	206	D 64		96	31	D 35		
145	3	216		100	119	D 36		
146	see 31	67?, 160?		D 46	92	D 20		
147	D 12	200	186	95	90	D 15		
148		214	L 15-3	103	91	102		
148, 1-3			see L 15					
148l			81					
149	50	D 40?	47	67	102	111		
150	51	D 40?	135	107	L 12	D 53		
151		195	76	186	84	136		
152	219	218		18	D 51	see 31		
153	119		D 70	111	123	31		
154	L 3-2		12	D 65	83	119		
155	111		13	D 53	109	92		
156		18	L 13	136	110	90		
157		18	149	101	122	91		
158		D 63	150	132	117			
159		163	L 8	80	118	see 15		
160		163	L 11	104	108	see 15		
161		219	84	105	113	see 15		
162		191	L 10	109	114	L 12		
163		D 31	see 200	110	115	84		
164		202	122	83	116	D 51		
165		199	104	L 12	133	123		
166		155	105	122	132	109		
167		D 37	see 164	22	124	110		
168		D 63	166	85	130	83		
169		90	145	156	120	122		
170		91	161	157	212	117		
171		169	213	113		118		
171 left					see 128			
171 right					see 128			
172		154	175	114	139	108		
173		153	175-1	115	137	112		

	Bode 1883	Moes	HdG	Bode-Binder	KdK 1921	KdK	Valentiner 1936	Trivas
174		217	175–8	116	138	113		
175			see 46	187	L 13	114		
176		194	119	117	163	115		
177		133		118	D 73	116		
178		203		108	D 30	133		
179		209		112	see 140	132		
180		167	188	124	140	124		
181		134	see 189	84	see 140	129		
182		193		129	197	130		
183		D 56	212	127	134	120		
184		190		see 127	148			
184 left						see 128		
184 right						see 128		
185		D 55	164	106	D 74	139		
186		82	86	137	D 56	137		
187		96	87	138	141	138		
188		101	123	212	151	L 13		
189		107	D 51	207	149	D 50		
190		121	see 123	163	150	163		
191		162	31	198		D 73		
191 left					146			
191 right					147			
191b		170						
192		141	see 123	102	144	D 30		
193		171	165	D 25	156			
193 left						see L 20		
194 right						see L 20		
194			165–1	134	157	140		
194a			165–5					
195		120	see 164	133	145	see 140		
196		D 67		140	160	197		
197		3	215	148	161	134		
198		131		D 74	D 57	148		
199		D 65	103	146	52	D 74		
200		132	77	147	152	D 56		
201		D 68	78	see 128	172	141		
202		D 76	38	see 128	155	151		
203		132	39	152	L 20			
203 left						146		
203 right						147		
204			L 9	151	164	149		
205		187	6	D 56	170	150		
206		118		D 55	D 55	156		
207		see 127		145	162	157		
208		5	32	149	159	144		
209		20	33	150	165–1	145		
210		24	see 128	159	165	160		
211		21–1	see 129	160	143	161		
212		21	129	162	166	155		
213			201	167	168	L 20		
214		see 26		125	61	152		
215			206	153	D 31	172		
216		19		154	177	164		

	Bode 1883	Moes	HdG	Bode-Binder	KdK 1921	KdK	Valentiner 1936	Trivas
217			L 16	L 15–3	126	170		
218		25	94	L 15–4		159		
218 left					127			
218 right					see 127			
219		59–1	see 208	L 15–5	167	D 57		
220		59–2		31	153	D 55		
221		D 28–1	168	see 123	154	162		
222		D 28–2	8	123	125	165–1		
223		L 3–4	49	195	D 59	165		
224		23	36	165	D 77	143		
225		D 29	37	165–1	D 22	166		
226		D 29	L 12	D 51	173	168		
227		60		D 39	174	61		
228		D 6–2	126	206	182	D 31		
229		59	207	199	183	177		
230		58	see 164	92	175	126		
231		D 8–1	108	91	175–1			
231 left						127		
231 right						see 127		
232		D 4–2	112	90	see D 20	153		
233		D 6–6		90–1	184	154		
234			159	194	185	167		
234a			see 159					
235		29	57	D 79	176	125		
236		D 5–1	152	172	179	D 59		
236a			see 203					
237		53		197	169	D 77		
238		54		203	198	173		
239		D 6–3		200	L 16	174		
240		27		218	203	182		
241		see 60		164	200	183		
242		D 8–2	85	155	191	175		
242a		D 1–2						
243		D 1–2	see 85	L 20	171	175–1		
244		29–1	L 17	168	193	D 22		
245		D 4–1	1	166	D 79	see D 20		
246		D 1–1	42	161	see 188	184		
247			214	191	188	185		
248		D 1–3	D 40?	184	189	176		
249		D 41?	D 64	185	194	179		
250		D 30	L 18	D 59	214	169		
251		D 42?	195	D 77	190	198		
252		D 13	48	214	213	L 16		
253		55	88	173	212	203		
254		71	202	174	208	200		
255		73	35	169	see L 17			
256		D 12	137	170	206	191		
257		D 15	210	141	see 203	171		
258		D 32	155	188	201	193		
259		6	199	189	195	181		
260		75	D 37	190	D 63	D 73		
261		D 34	D 63	182	L 18	see 188		
262		D 35	D 45	183	192	188		

	Bode 1883	Moes	HdG	Bode-Binder	KdK 1921	KdK	Valentiner 1936	Trivas
263		62	194	202	D 64	189		
264		63	218	D 63	202	194		
265			10	216	D 78	214		
266		see 64	154	193	207	190		
267		64	153	see L 17	209	213		
268		65	217	D 62	215	212		
269			171		D 62	208		
270		see 60	9	D 78	210	see L 17		
271			90	176	218	206		
272	D 18		91	177	216	see 203		
273	D 19		209	144	217	D 61		
274			156	209	221	201		
275			83	210	222	195		
276			115	213	219	D 63		
277			169	201	220	L 18		
278			D 48	219		199		
279			92	220		D 64		
280			100	217		202		
281			81	215	16	D 78		
281a			D 63					
282			117	D 64		207		
283			219	L 18	D 52	209		
284			see 63	see 203	D 24–2	215		
285			see 31	175–1	D 23	D 62		
286			68	222	see 15	210		
287			18	221	see 15	218		
288			130	72	see 15	216		
289			163		L 5–1	217		
290			143	L 13	D 9	221		
291			30	L 8		222		
292			50	L 11		219		
293				L 10	D 61	220		
294			191	L 9				
295			D 44	L 16				
296			D 55	126				
297			190	57	L 2	L 2		
298				1	see 20	see 20		
299			D 59	D 20	L 3–2	L 3–2		
300			216					
301			200					
302			151					
303			67					
304			see 160; D 53					
304a			160					
305			D 39					
306			D 22					
307			167					
308			134					
309			193					
310			125					
311			198					
312			D 54					
313			106					

HdG	
315	148
316	113
317	see D 40
318	D 61?
319	D 56
320	182
321	133
322	184
323	220
324	203
325	111
326	99
332	146
347	130
349c	40?
354	93
360	144
364	D 63
364c	D 31
365	D 67
366	D 79
367	89
368	138
369	D 68
370	D 76
371	82
372	D 77
373	see 127
374	11
375	96
376	132
377	157
378	116
379	136
380	101
381	131
382	3
383	D 65
384	118
385	141
386	51
387	187
388	107
389	171
390	
391	120
392	D 74
393	114
394	170
395	D 75
396	183

HdG	Valentiner 1936	Trivas
397	185	
398	121	
399	98	
399f	211?	
402	147	
417	162	
423	D 78	
427	17	
428	80	
429	14	
430	16	
431	7	
432	46	
433	45	
434	79	
435	124	
436	140	
437	221	
438	222	
439	176	
440	102	
441	177	
444	15	
supplement		139
appendix 1		D 22–3
appendix 2		20
appendix 3		L 3–1
appendix 4		see 19
appendix 5		123
appendix 6		175–1
appendix 7		L 15–7
appendix 8		see 193

LIST OF ILLUSTRATIONS

168

47. Attributed to Jan van Rossum: *Adriaen van Ostade*. Dublin, National Gallery of Ireland. (See Cat. no. 192.)

48. Peter Holsteyn II: drawing after Hals' *Portrait of a Man*. Rijksmuseum, Rijksprentenkabinet, Amsterdam. (See Cat. no. 198.)

49. Jonas Suyderhoef: engraving after Hals' *Frans Post*, first state. Vienna, Albertina. (See Cat. no. 206.)

50. Jonas Suyderhoef: engraving after Hals' *Adrianus Tegularius*. (See Cat. no. 207.)

51. Cornelis van Noorde: watercolour after Hals' *Cornelis Guldewagen*. Haarlem, Municipal Archives. (See Cat. no. 212.)

52. Jean-Honoré Fragonard: drawing after Hals' *Portrait of a Man* (Willem Croes?). Stone Mountain, Georgia, George Baer. (See Cat. no. 213.)

53. *Shrovetide Revellers* (Cat. no. 5). About 1615.

54. *Two Singing Boys* (Cat. no. 23). About 1623–5.

55. *Merry Drinker* (Cat. no. 63). About 1628–30.

56 *Peeckelhaering* (Cat. no. 64). About 1628–30.

57. *Portrait of a Man* (Cat. no. 81). 1633.

58. *The Armourer*, attributed to Frans Hals the Younger. (See Cat. no. 155.)

59. *Portrait of a Man* (Cat. no. 149). 1643.

60. *Portrait of a Seated Man* (Cat. no. 167). About 1645.

61. *Dorothea Berck* (Cat. no. 161). 1644.

62. *Portrait of a Man* (Cat. no. 193). About 1650–2.

63. *Portrait of a Man* (Cat. no. 214). About 1660.

64. *Portrait of a Man* (Cat. no. 218). About 1660–6.

65. Inscription on the stretcher of *Malle Babbe* (Cat. no. 75). Berlin-Dahlem, Staatliche Museen.

66. Attributed to Frans Hals: *Banquet in a Park*. Destroyed. Formerly Berlin, Kaiser-Friedrich Museum. Cat. no. L 1.

67. *Merry Trio*. Variant after a lost original. Paris (Drouot), 14 November 1967, no. 26. Cat. no. L 2–1.

68. *Merry Trio*. Copy after a lost original. Destroyed. Formerly Berlin, Kaiser-Friedrich Museum. Cat. no. L 2–2.

69. *The Rommel Pot Player*, after Hals. Fort Worth, Texas, The Kimbell Art Museum. Cat. no. L 3–1.

70. *Rommel Pot Player*, after Hals. Wilton House, The Earl of Pembroke. Cat. no. L 3–2.

71. Attributed to Judith Leyster: *The Rommel Pot Player*, after Hals. Chicago, The Art Institute of Chicago, Charles H. and Mary F. S. Worcester Collection. Cat. no. L 3–3.

72. François Hubert: engraving after a variant of Hals' lost *Rommel Pot Player*. Cat. no. L 3–13.

73. Jan van Somer: mezzotint after a variant of Hals' lost *Rommel Pot Player*. Cat. no. L 3–16.

74. Pieter de Mare: engraving after a variant of Hals' lost *Rommel Pot Player*. Cat. no. L 3–17.

75. Judith Leyster: *Two Children with a Cat*. Formerly New York, dealer F. Mont. (See Cat. no. L 3–3.)

76. Cornelis Danckerts: engraving after Leyster's *Two Children with a Cat* (erroneously inscribed 'f. Hals pinxit'). (See Cat. no. L 3–3.)

77. Wallerant Vaillant: mezzotint after Hals' lost *Two Laughing Boys, one holding a coin*. Cat. no. L 4.

78. *Two Laughing Boys, one holding a coin*, after a lost original. Washington, D.C., Kingdon Gould Jr. Cat. no. L 4–1.

79. Johannes de Groot: mezzotint after Hals' lost *Laughing Fisherboy*. Cat. no. L 5.

80. Abraham Blooteling: mezzotint after Hals' lost *Man Holding a Tankard and a Pipe*. Cat. no. L 6.

81. *Man Holding a Tankard and a Pipe*, after a lost original. Formerly Paris, M. de Werth. Cat. no. L 6–1.

82. Jan Steen: Detail from *The Baptismal Party*. Berlin-Dahlem, Staatliche Museen. Probably a copy after Hals' lost *Woman with a Pipe* (Malle Babbe?). Cat. no. L 7.

83. Jan van de Velde: engraving after Hals' lost *Johannes Bogardus*. Cat. no. L 8.

84. Jonas Suyderhoef: engraving after Hals' lost *Willem van der Camer*. Cat. no. L 10.

85. Adriaen Matham: engraving after Hals' lost *Pieter Bor*. 1634. Cat. no. L 11.

86. Lucas Kilian: engraving after Hals' lost *Arnold Möller*. Cat. no. L 9.

87. Jonas Suyderhoef: engraving after Hals' lost *Casparus Sibelius*. 1637. Cat. no. L 12.

88. Theodor Matham: engraving after Hals' lost *Theodore Blevet*. 1640. Cat. no. L 13.

89. Jonas Suyderhoef: engraving after Hals' lost *Jacobus Revius*, first state. Cat. no. L 16.

90. Jonas Suyderhoef: engraving after Hals' lost *Theodor Wickenburg*. Cat. no. L 17.

91. Attributed to Isaac van der Vinne: woodcut after Hals' lost *Self-Portrait*. Cat. no. L 15.

92. Anonymous: woodcut after Hals' lost *Self-Portrait*. (See Cat. no. L 15.)

93. Cornelis van Noorde: mezzotint after Hals' lost *Self-Portrait*. (See Cat. no. L 15.)

94. *Self-Portrait*, copy after a lost original. Indianapolis, The Clowes Fund, Inc. Cat. no. L 15–1.

95. *Self-Portrait*, copy after a lost original. German Private Collection. Cat. no. L 15–2.

96. *Self-Portrait*, copy after a lost original. New York, Metropolitan Museum of Art. Cat. no. L 15–3.

97. George Vertue: drawing after Hals' lost *Thomas Wyck*, Pen and Wash. San Marino, California, Huntington Library. Cat. no. L 14.

98. Warnaar Horstink: drawing after Hals' lost *Jacob van Campen*. 1798. Black chalk. Haarlem, Municipal Archives. Cat. no. L 18.

99. *Portrait of a Woman* (Maria van Teylingen?), possibly after a lost original. Dublin, James A. Murnaghan. Cat. no. L 19.

100. Jan Gerard Waldorp: drawing after Hals' lost *Portrait of a Woman*. 1779. Black chalk on parchment. Haarlem, Frans Hals Museum. Cat. no. L 20.

101. *Laughing Child*. Detroit, The Detroit Institute of Arts. Cat. no. D 1–1.

102. *Laughing Child*. Helsinki, Paul and Fanny Sinebrychoff Collection. Cat. no. D 1–2.

103. *Laughing Boy*, probably by a nineteenth-century imitator. Baltimore, The Baltimore Museum of Art. Cat. no. D 2.

104. *Laughing Boy*. Paris, Musée Jacquemart-André. Cat. no. D 3.

INDEX OF COLLECTIONS AND OWNERS PAST AND PRESENT

INDEX OF SUBJECTS

INDEX OF ENGRAVINGS AND OTHER PRINTS AFTER FRANS HALS' PAINTINGS

INDEX OF DRAWINGS SOMETIMES ATTRIBUTED TO, AND AFTER, FRANS HALS

INDEX OF ARTISTS